Photography

Portfolio to Profession

Third Edition

by

Jack Klasey

Writer/Editor/Photographer
Kankakee, Illinois

Publisher
The Goodheart-Willcox Company, Inc.
Tinley Park, IL
www.g-w.com

Library of Congress Catalog Card Number 2015035863

ISBN 978-1-63126-305-7

3 4 5 6 7 8 9 – 17 – 20 19 18 17

Cover image: karamysh/Shutterstock.com
Back cover image: ©iStock.com/DougLemke

Library of Congress Cataloging-in-Publication Data

Klasey, Jack, author.
 Photography : portfolio to profession / Jack Klasey, writer,
 editor, photographer, Kankakee, Illinois. -- 3rd edition.
 pages cm
 Previous edition: Photography : capture to presentation /
 Jack Klasey. c2012.
 Includes index.
 ISBN 978-1-63126-305-7
 1. Photography. I. Title.
 TR146.K547 2017
 770--dc23
 2015035863

Preface

The third edition of this textbook has been renamed as *Photography: Portfolio to Profession* to emphasize learning and applying skills that can lead to a photographic career. The content has been extensively revised to reflect the fact that digital imaging is accepted as the standard method of photography, while still meeting the needs of both film and digital equipment users. Additions include extensive career information, text and images reflecting newer technology, such as the use of smartphones for photography. New Portfolio Assignments promote practice of a variety of photographic skills while providing the opportunity to build a portfolio.

The three sections of the text are *The Basics*, *Shooting*, and *Postprocessing*. The eight chapters in Section 1 provide a knowledge base that includes development of the photographic medium and the essential tools of the photographer—cameras, lenses, light, and image capture media. An important addition to this section is a chapter exploring the career field of commercial photography. While these chapters present a fair amount of theory, practical hands-on elements are included wherever appropriate.

In Section 2, Chapters 9–14 present many specific techniques in image composition and exposure determination. Particular photographic situations, including action and event photography, outdoor photography, travel photography, and portrait and studio photography, are addressed in individual chapters. These chapters introduce a variety of specialized and advanced techniques for use in both the field and the studio. The content of this section allows beginning photographers to build on and expand the basic skills introduced earlier in the text.

Section 3, which includes Chapters 15–19, explores the areas of film-to-digital file conversion via scanning, electronic image input, image processing, and the devices and methods used for digital-image output and presentation. The concept of the "digital darkroom" for processing and enhancing or manipulating images is covered in chapters devoted to basic and advanced techniques. Described are the many types of image manipulation and combination that can be carried out to realize the photographer's artistic vision. Also included in this section is a chapter devoted to traditional darkroom work—film development and printmaking.

Photography: Portfolio to Profession is designed to provide beginning photographers with a blend of theory and practice that builds a solid foundation of photographic skills. While the continuing development of digital cameras, camera-equipped smartphones, and related software provides photographers with ever-better and more convenient tools, the basic skills of photography will always be essential to the effective use of those tools. The photographer's need to produce a meaningful photograph that is well composed, properly lighted, and correctly exposed is constant—whether the capture device uses a glass plate covered with wet collodion, film with a highly sensitive emulsion on a flexible plastic base, or an array of millions of tiny electronic sensors.

About the Author

Jack Klasey is the author of three books and is currently at work on a fourth. Mr. Klasey has several decades of experience in various areas of technical and educational communication as a writer, photographer, and editor. In addition to authoring books, he has done photographic illustrations for a number of publications and has developed dozens of audiovisual programs in the education and technical training fields.

Jack Klasey

Reviewers

The author and publisher wish to thank the following industry and teaching professionals for their valuable input into the development of *Photography: Portfolio to Profession*.

Enrique Crosby
Mexia High School
Mexia, TX

Batavia Domingue-Yost
Community Christian School
Stockbridge, GA

Wesley G. Force
Valdosta High School/Valdosta State University
Valdosta, GA

Karen James
Maypearl High School
Maypearl, TX

Elizabeth Karp
Riverwood High School
Atlanta, GA

Gregory Lewis
Washoe Co SD-Region 2
Reno, NV

Becky Raffalovich
Phoenix High School/Gwinett County
 Public Schools
Lawrenceville, GA

Rodney Ragsdale
Coffee High School
Douglas, GA

Antonia Seltzer
Del Valle High School
El Paso, TX

Acknowledgments

The author and publisher would like to thank the following individuals for their valuable input in the development of *Photography: Portfolio to Profession*.

American Society of Media Photographers, 2015
Amy Stroo Photography
Andrea Rose
Anna Hunte
Anna Rose Jurevich
Anne Milaneses
Arizona Office of Tourism
Auriana Mayer
Better Light, Inc.
Bill "BJ" Jurevich
Bogen
Bogen Kata
Pelican
Bonnie Knight/Kankakee Camera Club
Cailyn Porterfield
CanonUSA
Caroline Klasey
Casio America, Inc.
Charles A. Hulcher Co., Inc.
Charles Beseler Company
CJ Grzincic
Clayton Pratt
Cokin Filters
Delkin Devices
DigMyPics.com
Eastman Kodak Company
Ed Cayot
Epson America, Inc.
Eric Penrod Photography
Foveon, Inc.
FUJIFILM North America Corporation, 2015
Glory Klasey
Gossen
Gwyneth Stroo
Hannah Swale
Heidelberg
IFF Repro-System/Bogen Photo Corp.
Image Group Photography, LLC
Istabilizer
Jack O.P. Klasey
Jacqueline Rose

Jayger Erickson
Jeep and Wrangler, registered trademarks of FCA US LLC
Jeff Walter
Jessica Thorson
Jillian Gorham
Jobo Fototechnic, Inc.
Judith Pretto
Joette Walter
Justus Hayes/Shoes on Wires/ shoesonwires.com
Kankakee County Museum archives
Kari Neveau
Katelyn Moore
Katie Gorham
Kevin Klasey
Kirk Enterprises
Kodak
Kodak Alaris
Kristen Markech
Landon Latham
Larry Morris
Lensbaby
Lensbaby Photo by Ben Hutchison
Leonard Rue Enterprises
Lexar
Library of Congress
Linhof/H.P. Marketing Corp.
LPA Design photo by Zachary Gauthier
Lucinda Doogan
Manfrotto
Manfrotto/Kata
Marcia Klasey
Matt McBurnie
Matthew Milaneses
Meredith Rennewanz
Metz
Microtek
NASA
National Aeronautics and Space Administration
National Archives and Records Administration

Nikon, Inc., Melville, New York
NOAA/Harald Richter
Nokia
Norman Enterprises, Inc., Division of Photo Control Corporation
Olympus America, Inc.
Panasonic
Paul C. Buff, Inc.
Phase One
Phase One photo by Alexander Flemming
Photodisc
Polaroid Corporation
Polaroid/PLR IP Holdings, LLC
Porter's Camera Store
Professional Photographers of America
Rachel Duffield
Randolph, North Carolina Community College
Regal/Arkay
Rende Langlois
Rob Gorham
Rollei Fototechnic
SanDisk
Seal/Bienfang
Sekonic
Shannon Keener
Shutterfly, Inc.
Siemens
Sinar Bron Imaging
Smith-Victor Corporation
Smugmug
Socialmatic LLC
Sony Electronics, Inc.
Stroboframe
SUNWAYFOTO
Suzanne M. Silagi
Vivitar
Wacom
Walgreen Company
Wendy Langlois
William V. Porter

G-W Integrated Learning Solution

Together, We Build Careers

At Goodheart-Willcox, we take our mission seriously. Since 1921, G-W has been serving the career and technical education (CTE) community. Our employee-owners are driven to deliver exceptional learning solutions to CTE students to help prepare them for careers. Our authors and subject matter experts have years of experience in the classroom and industry. We combine their wisdom with our expertise to create content and tools to help students achieve success. Our products start with theory and applied content based on a strong foundation of accepted standards and curriculum. To that base, we add student-focused learning features and tools designed to help students make connections between knowledge and skills. G-W recognizes the crucial role instructors play in preparing students for careers. We support educators' efforts by providing time-saving tools that help them plan, present, assess, and engage students with traditional and digital activities and assets. We provide an entire program of learning in a variety of print, digital, and online formats, including economic bundles, allowing educators to select the right mix for their classroom.

Student-Focused Curated Content

Goodheart-Willcox believes that student-focused content should be built from standards and accepted curriculum coverage. Standards from Precision Exams were woven throughout this text. *Photography: Portfolio to Profession* is structured to provide a logical teaching progression that helps students build on their learning. We call on industry experts and teachers from across the country to review and comment on our content, presentation, and pedagogy. Finally, in our refinement of curated content, our editors are immersed in content checking, securing and sometimes creating figures that convey key information, and revising language and pedagogy.

Precision Exams Certification

Goodheart-Willcox is pleased to partner with Precision Exams by correlating *Photography: Portfolio to Profession* to their Basic Digital Photography Standards. Precision Exams Standards and Career Skill Exams were created in concert with industry and subject matter experts to match real-world job skills and marketplace demands. Students that pass the exam and performance portion of the exam can earn a Career Skills Certification™. Precision Exams provides:

- Access to over 150 Career Skills Exams™ with pre- and post-exams for all 16 Career Clusters.
- Instant reporting suite access to measure student academic growth.
- Easy-to-use, 100% online exam delivery system.

To see how *Photography: Portfolio to Profession* correlates to the Precision Exams Standards, please visit http://www.g-w.com/photography-2017 and click on the Correlations tab. For more information on Precision Exams, including a complete listing of their 150+ Career Skills Exams™ and Certificates, please visit https://www.precisionexams.com.

I earned a CAREER SKILLS™ Certificate in BASIC DIGITAL PHOTOGRAPHY. You can earn one too!

Ask your instructor how you can earn a CAREER SKILLS™ Certificate for your resume.

800.470.1215 PRECISION EXAMS precisionexams.com

www.BillionPhotos.com/Shutterstock.com

Features of the Textbook

Features are student-focused learning tools designed to help you get the most out of your studies. This visual guide highlights the features designed for the textbook.

G-W Learning Companion Website Activity Icon appears throughout the text to lead students to additional materials.

Objectives clearly identify the knowledge and skills to be obtained when the chapter is completed.

Technical Terms list the key terms to be learned in the chapter.

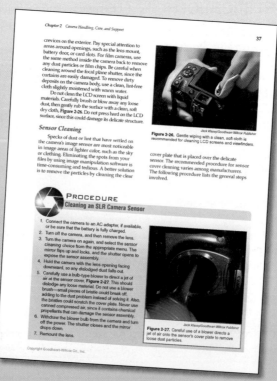

Procedures are highlighted throughout the textbook to provide clear instructions for hands-on service activities. You can refer to these procedures easily.

Illustrations have been designed to clearly and simply communicate the specific topic and show photographic techniques. Illustrations have been replaced and updated for this edition. New photographic images show the latest equipment and digital postprocessing techniques.

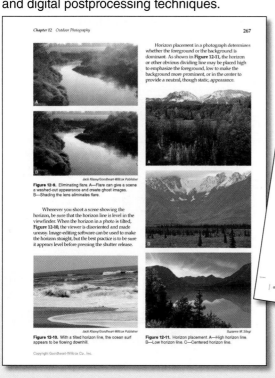

Portfolio Assignments are assignments designed to help you improve your skills through practice while you build a portfolio.

Review Questions allow you to demonstrate knowledge, identification, and comprehension of chapter material.

Suggested Activities extend your learning and help you apply knowledge and photographic skills.

Communicating about Photography consists of photography-related activities that help improve your speaking, listening, and writing skills.

Critical Thinking questions develop higher-order thinking, problem solving, personal, and workplace skills.

Student Resources

Textbook

The *Photography: Portfolio to Profession* textbook provides an exciting, full-color, and highly illustrated learning resource. The textbook is available in print or online versions.

G-W Learning Companion Website

The G-W Learning companion website is a study reference that contains matching activities, review questions, vocabulary exercises, and more! Accessible from any digital device, the G-W Learning companion website complements the textbook and is available to the student at no charge.

Workbook

The student workbook provides minds-on practice with questions and activities. Each chapter corresponds to the text and reinforces key concepts and applied knowledge.

Online Learning Suite

Available as a classroom subscription, the Online Learning Suite provides the foundation of instruction and learning for digital and blended classrooms. An easy-to-manage shared classroom subscription makes it a hassle-free solution for both students and instructors. An online student text and workbook, along with rich supplemental content, brings digital learning to the classroom. All instructional materials are found on a convenient online bookshelf and are accessible at home, at school, or on the go.

Online Learning Suite/Student Textbook Bundle

Looking for a blended solution? Goodheart-Willcox offers the Online Learning Suite bundled with the printed text in one easy-to-access package. Students have the flexibility to use the print version, the Online Learning Suite, or a combination of both components to meet their individual learning style. The convenient packaging makes managing and accessing content easy and efficient.

Instructor Resources

Instructor resources provide information and tools to support teaching, grading, and planning; class presentations; and assessment.

Instructor's Presentations for PowerPoint®

Help teach and visually reinforce key concepts with prepared lectures. These presentations are designed to allow for customization to meet daily teaching needs. They include objectives, outlines, and images from the textbook.

ExamView® Assessment Suite

Quickly and easily prepare, print, and administer tests with the ExamView® Assessment Suite. With hundreds of questions in the test bank corresponding to each chapter, you can choose which questions to include in each test, create multiple versions of a single test, and automatically generate answer keys. Existing questions may be modified and new questions may be added. You can prepare pretests, formative, and summative tests easily with the ExamView® Assessment Suite.

Instructor's Resource CD

One resource provides instructors with time-saving preparation tools such as answer keys; rubrics; lesson plans; correlation charts to Precision Exams certification standards; and other teaching aids.

Online Instructor Resources

Online Instructor Resources provide all the support needed to make preparation and classroom instruction easier than ever. Available in one accessible location, support materials include Answer Keys, Lesson Plans, Instructor Presentations for PowerPoint®, ExamView® Assessment Suite, and more! Online Instructor Resources are available as a subscription and can be accessed at school or at home.

Brief Contents

Section 1 The Basics

1 Our Visual World.. 4
2 Camera Handling, Care, and Support....................... 22
3 Commercial Photography ... 54
4 From Pinholes to Pixels ... 78
5 The Camera System ... 96
6 Lenses .. 116
7 Light and Exposure... 134
8 Image Capture Media ... 162

Section 2 Shooting

9 Making a Picture .. 186
10 Making Exposure Decisions 210
11 Action and Event Photography 230
12 Outdoor Photography.. 260
13 Travel Photography .. 294
14 Portrait and Studio Photography.............................. 316

Section 3 Postprocessing

15 Image Input and Scanning.. 340
16 Digital Darkroom Basics ... 360
17 Advanced Digital Darkroom Techniques 390
18 Image Output and Presentation 422
19 Film and Print Processing 446
 Appendix.. 474
 Technical Vocabulary ... 486
 Index ... 502

Contents

Section 1

The Basics

Chapter 1

Our Visual World..**4**

Photography Is Everywhere.. 6

Photographic Career Opportunities.....................................10

Learning to See...13

Building Your Portfolio...18

Chapter 2

Camera Handling, Care, and Support**22**

Learning about Your Camera ...24

Physical Care of Your Camera ..34

Camera Carrying Methods ...39

Camera Support Methods ...40

Chapter 3

Commercial Photography**54**

What Is Commercial Photography?.....................................56

How Do You Enter the Commercial Photography Field?57

Setting Up Your Business ..59

Building Your Business ...64

Working with Clients, Employees, and Independent Contractors...........68

Operating Your Business ...70

Growing Professionally ...73

Chapter 4

From Pinholes to Pixels**78**

The Birth of Photography ..80

The Future of Photography ..90

Chapter 5

The Camera System ...**96**

Viewing/Focusing System ...98

Light Control System ...101

Image Receiver System ...104

Camera Varieties ...108

Chapter 6

Lenses .. **116**

How a Lens Works118
Camera Lens Types 124

Chapter 7

Light and Exposure **134**

Basic Light Theory 136
Controlling Light with Filters141
Controlling Exposure147
Measuring Light150
The Zone System 156

Chapter 8

Image Capture Media **162**

Image Capture–Digital vs. Film 164
The Digital Imaging Process 165
Traditional (Film) Image Capture 172
Film Types, Forms, and Sizes 177

Section 2

Shooting

Chapter 9

Making a Picture **186**

"Taking" a Picture vs. "Making" a Picture188
Composition Considerations 190
Creating Visual Effects While Shooting202

Chapter 10

Making Exposure Decisions **210**

Proper Exposure212
Determining Exposure214
Correcting Exposure Problems215
Equivalent Exposures217
Capturing the Light223
Types of Lighting223

Chapter 11
Action and Event Photography**230**

Stopping Motion 233
Focus Techniques 236
Blurring for Visual Interest 238
Photojournalism 239
Working with Flash 251

Chapter 12
Outdoor Photography**260**

Landscape Photography 262
Water Photography 276
Animal Photography 280
Close-Up Photography 287

Chapter 13
Travel Photography**294**

Traveling with a Camera 296
What Will You Shoot? 299
When Will You Shoot? 305

Chapter 14
Portrait and Studio Photography**316**

Types of Portrait Photography 318
Working with Ambient Light 319
Working with Studio Lighting 321

Section 3

Postprocessing

Chapter 15
Image Input and Scanning**340**

Types of Input from a Camera 342
Other Image Input Methods 344
Image Management 354

Chapter 16
Digital Darkroom Basics**360**

Digital vs. Conventional Darkroom 362
Image-Editing Software 363

Chapter 17

Advanced Digital Darkroom Techniques390

Ethical Conduct and Image Manipulation392
Selecting Parts of Images392
Combining Images399
Applying Transformations and Filters410
Adding Color to a Monochrome Image414
Restoring Damaged Photos415

Chapter 18

Image Output and Presentation422

Electronic Display424
Making Prints ..426
Print Mounting and Matting431
Preparation for Mounting431
Mounting a Print437
Overmatting a Print441

Chapter 19

Film and Print Processing446

Film-Developing Requirements448
Mixing Chemicals449
Developing 35 mm Film451
Reading the Negative456
The Darkroom458
Working in the Darkroom463
Evaluating and Improving Prints465
Finishing Prints469

Appendix474

Technical Vocabulary486

Index502

Feature Contents

Portfolio Assignment

Exploring a Subject .. 19
Shake It Up! .. 113
Extract a Detail ... 131
Backlit Subject .. 159
Extracting Images ... 207
Minus and Plus ... 227
Stop It! .. 257
Photographer's Choice .. 291
Brace Yourself! ... 312
Finding the Right Ratio .. 335
Scan It! ... 357
Monochrome Conversion ... 387
Fix It! .. 418

PROCEDURE

Making a Framing Viewer .. 17
Changing Lenses .. 35
Cleaning an SLR Camera Sensor ... 37
Finding the Hyperfocal Distance ... 222
Using Image-Editing Software .. 364
Using Curves to Alter Contrast ... 376
Correcting a Color Cast .. 378
Converting to Monochrome with a Black & White Adjustment Layer 382
Eliminating a Spot Using the Clone Stamp Tool 383
Using the Quick Selection Tool ... 395
Making Scrap Pixels More Visible to Simplify Cleanup 399
Creating a Layer Mask .. 404
Creating Irregular Borders .. 407
Creating a Clipping Mask That Fills Type with an Image 408
Correcting a Tilted Horizon ... 410
Using the Lens Blur Filter to Reduce Depth of Field 413
Cold-Adhesive Mounting ... 438
Dry Mounting .. 439
Cutting a Rectangular Window Mat ... 442
Loading 35 mm Film onto a Developing Reel 452
Spotting a Print ... 471

Section 1

The Basics

Chapter 1 Our Visual World

Chapter 2 Camera Handling, Care, and Support

Chapter 3 Commercial Photography

Chapter 4 From Pinholes to Pixels

Chapter 5 The Camera System

Chapter 6 Lenses

Chapter 7 Light and Exposure

Chapter 8 Image Capture Media

Jack Klasey/Goodheart-Willcox Publisher

3

Photography: The act of "drawing with light," or capturing reflected light to form an image. From the Greek roots *photos* (light) and *graphos* (drawing).

While studying this chapter, look for the activity icon **to:**

- **Assess** your knowledge with self-check pretest and posttest.
- **Practice** vocabulary terms with e-flash cards and matching activities.
- **Reinforce** what you learn by submitting end-of-chapter questions.

*G-W*LEARNING.com

www.g-wlearning.com/visualtechnology/

Our Visual World

Objectives

When you have finished reading this chapter, you will be able to:

- Discuss the significance of photography in our visual society.
- Describe the various methods of entering the field of commercial photography.
- Identify the major photographic career fields.
- Describe the basic skills important to succeeding as a commercial photographer.
- Demonstrate a variety of ways to photograph a given subject.
- Create a portfolio for use as a career tool.

Check Your Photography IQ

Before you read this chapter, assess your current understanding of the chapter content by taking the chapter pretest.

www.g-wlearning.com/visualtechnology/

Technical Terms

abstractionism	freelancers
cinematographers	photojournalists
commercial photographers	portfolio
composition	portraiture
documentation	videographers

We live in a visual world, surrounded by imagery—monochrome or color, still or moving, entertaining or instructional, ugly or beautiful. The overwhelming majority of that imagery is photographic. In less than 200 years, photography has gone from capturing patterns of light and shadow on sensitized pitch (a form of tar) to digitally recording highly detailed images on an array of electronic pixels. In that relatively short time span, photography has become our dominant means of visual expression.

In this chapter, you will be introduced to different types of photography and to the career possibilities available in the photographic field. You will also learn to "see pictures" and will complete a photographic assignment to practice your seeing skills. Finally, you will select one of the images from that assignment as the first item in your photographic portfolio.

Photography Is Everywhere

When a company wants to introduce an item to consumers, a compelling photograph is a priority. The photograph is typically a carefully composed, well-lighted picture with the product as its focal point.

See **Figure 1-1**. The photo becomes the centerpiece of the advertising campaign by wordlessly conveying the message "This is a great product—you have to buy it!" The image will appear in many different contexts—on billboards, in magazine and newspaper advertisements, in television spots, on packaging and point-of-purchase displays, and on websites.

Product Photography

Photographs of products for advertising and packaging are a major use of photographic illustration. Advertising photography provides a livelihood for a large number of commercial photographers who specialize in such areas as food, automobiles, clothing, or health and fitness equipment, **Figure 1-2**. The rapid growth of Internet and mail-order buying has created new opportunities for studios specializing in catalog illustrations. In addition to photos aimed at consumers, a large volume of advertising photography is done each year to sell products to business clients, **Figure 1-3**.

People Photography

Like product photography, people photography (*portraiture*) is a major activity for commercial photographers. Even small towns typically have a portrait studio; large communities have dozens or

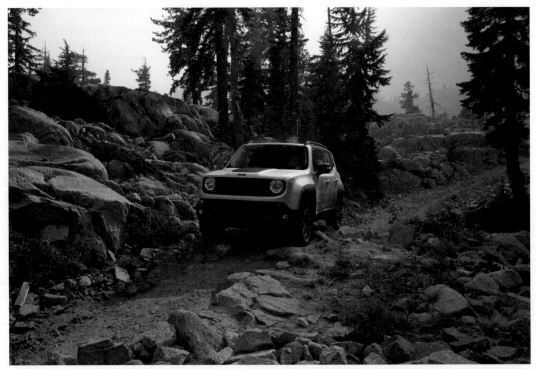

Jeep and Wrangler are registered trademarks of FCA US LLC

Figure 1-1. Photographing this vehicle in a rugged, natural setting was designed to appeal to adventurous car buyers.

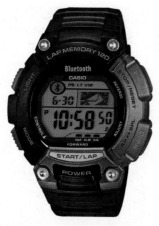

Figure 1-2. This image of a fitness watch was created for use in advertisements and in print and on-line catalogs aimed at runners, hikers, and cyclists.

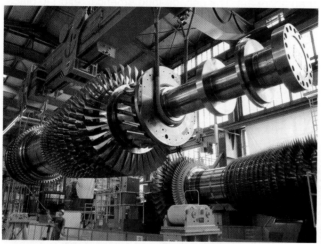

Figure 1-3. Industrial and commercial firms use photographic illustrations of products, such as this turbine for electrical power generation, to reach potential customers.

Figure 1-4. Environmental portraits, made outdoors or in other informal settings, are popular with high school seniors and other young adults.

even hundreds of photographers who create portraits on either a full-time or part-time basis. Many families and individuals "sit" for professionally taken portraits as a formal photographic record. The early years of childhood and such milestones as high school and college graduation account for a large share of portrait photography, **Figure 1-4.** Many commercial photographers contract with schools and organizations to produce individual or group photos.

Documentation

In a sense, all forms of photography can be classified as *documentation,* a record of what the photographer saw—a scene, event, person, or object. Each of these photographs records a bit of history that has meaning to the photographer, **Figure 1-5.**

Figure 1-5. Snapshots are taken by the millions each year to document family events such as vacation trips, birthday parties, graduations, and weddings.

The entire consumer photographic industry is built on the public's fascination with recording people and events.

A major area of documentation is photographic illustration for use in newspapers, magazines, and electronic media. *Photojournalists* produce thousands of still pictures and many hours of video each day to meet the demand for news ranging from political developments and international conflicts to fires, auto accidents, and sporting events, **Figure 1-6**.

At times, journalistic photos go far beyond being mere record shots. Some become icons, summing up the emotions or events of a particular period. Astronaut Neil Armstrong's 1969 photo of Edwin Aldrin Jr. walking on the moon, **Figure 1-7**, not only records a moment in history, but carries a full load of associations with the changes in American society resulting from the "space race" with Russia.

Beyond breaking news, a great deal of photography is needed to illustrate informational articles in newspapers and magazines. While such

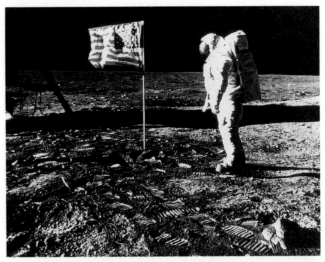

National Aeronautics and Space Administration

Figure 1-7. A single photograph may capsulize an event or an entire era. The decade-long American effort to place astronauts on the moon before Russia could do so is summed up in this 1969 photograph.

photos may be produced by a publication's staff photographers, this area represents a significant opportunity for self-employed photographers, often referred to as *freelancers*.

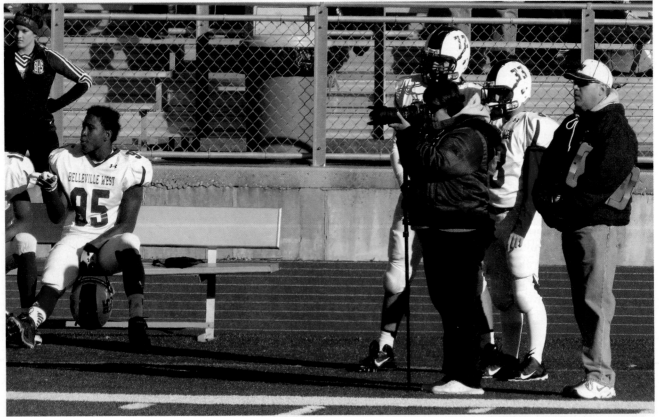

Jack Klasey/Goodheart-Willcox Publisher

Figure 1-6. A photojournalist at work on the sidelines of a high school football game.

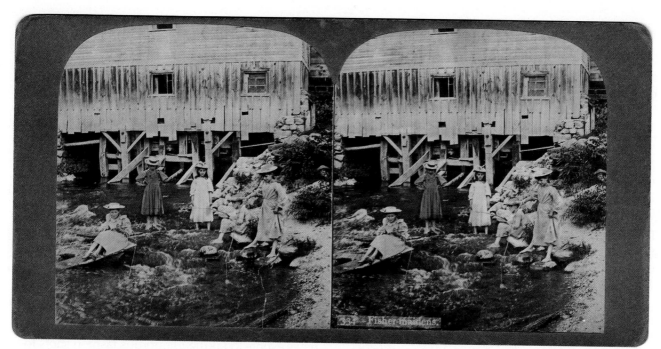

Goodheart-Willcox Publisher

Figure 1-8. Stereo cards were sometimes hand-colored for added realism. The tinting of this group of young girls posed in front of a covered bridge was rather clumsily done. Look carefully at the differences in the dresses in the two panels, especially those of the two girls standing in the stream.

Photography as Entertainment

The first form of photographic entertainment to achieve wide popularity was the stereoscope, invented during the 1860s. It was a handheld device used to view pairs of photographs, giving the viewer the illusion of depth or three-dimensional space. Stereoscope cards introduced viewers to natural wonders and to exotic locales and peoples, **Figure 1-8**.

Today's dominant forms of entertainment, television and motion pictures, convey their messages through moving photographic images. While some *cinematographers* (those recording on film) and *videographers* (those using electronic capture methods) work exclusively with moving images, many commercial photographers offer both still and motion image capture. In addition to entertainment, career opportunities in this area include the production of audiovisual programs for education, training, and motivation.

Scientific and Technical Photography

In the scientific realm, photography is a useful investigative tool for dealing with subjects as small as molecules and as large as entire galaxies. Scanning electron microscopes allow scientists to

investigate the structure of the very building blocks of matter. At the other end of the scale, astronomers use photography as an aid to forming theories on the development of the universe, **Figure 1-9**.

Since specialized equipment and knowledge is needed for most scientific and technical photographic work, this field presents limited opportunities for commercial photographers. Those with corporate clients in medical, pharmaceutical, and other science-related fields, however, may be called upon to handle photo assignments in those areas.

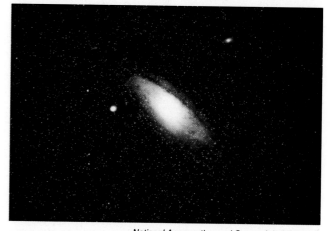

National Aeronautics and Space Administration

Figure 1-9. The light rays that made this exposure of the Andromeda galaxy left that galaxy approximately two million years ago.

Photography as Art

The use of the photograph as a form of artistic expression, and the continuing debate over whether photography is art or craft, dates back almost to the beginning of photography. The earliest practitioners were most concerned with merely obtaining a recognizable and permanent image. For a time, photography was used as an imitation of painting. It then evolved into what was termed *naturalistic photography*, which did not attempt to mimic the look of a painted image. A later development was the growth of **abstractionism**, which placed strong emphasis on forms and their relationships, **Figure 1-10**.

The advent of digital image manipulation has opened new avenues of expression for the photographer/artist. With appropriate computer software, processes such as combining, abstracting, distorting, emphasizing, texturizing, or recoloring image elements can be used to realize the artist's vision, **Figure 1-11**.

Photographic Career Opportunities

Relatively few photographers can earn a living as strictly fine art practitioners whose works are sold to collectors, galleries, and museums. In most cases, they must rely upon work in commercial photography, teaching, or non-art occupations to pay the bills while continuing to produce their photographic art.

Commercial photography is an occupation in which photographic skills are used to create images in exchange for payment. That simple definition covers a broad area ranging from capturing historic news events to taking glamorous fashion shots to shooting team and individual portraits for local youth sports programs, **Figure 1-12**.

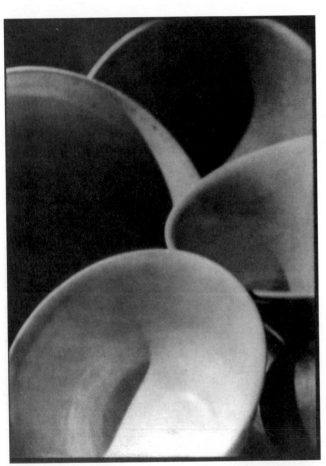

Courtesy of Library of Congress

Figure 1-10. In this 1917 abstract study, photographer Paul Strand explored the interplay of light and shadow on four white bowls.

William V. Porter

Figure 1-11. By combining and manipulating images, a photographer/artist can lead the viewer to see a subject in new ways.

Jack Klasey/Goodheart-Willcox Publisher

Figure 1-12. In many communities, commercial photographers contract with youth sports leagues and other organizations to photograph groups and individuals. The photographer then takes orders from parents for prints.

The Commercial Photography Field

Commercial photographers, also known as professional photographers, make all or most of their living from photographic work. Jobs in this field can be divided into two broad groups—salaried and self-employed. Government statistics show slightly more than 136,000 workers classified as photographers, about two-thirds of whom are self-employed. About half of self-employed photographers operated their business on a part-time basis. A typical part-time photographer might do wedding photography on weekends, while working at another job during the week.

Salaried photographers often work for large companies, such as manufacturing firms or studios specializing in advertising or industrial photography, **Figure 1-13.** They may also work

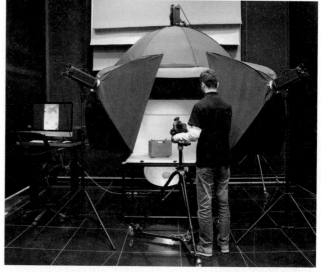

Selin Aydogan

Figure 1-13. This commercial photographer works for a studio specializing in catalog photography. Catalog photographers often use complex lighting setups.

for institutions such as universities, government agencies, or national organizations like trade associations or nonprofit organizations. Once a major employer of photographers, newspapers and newsgathering organizations have seriously reduced their salaried staffs. However, this reduction has created opportunities for self-employed photographers willing to work on an assignment-by-assignment basis.

A majority of self-employed photographers, or freelancers, own and operate photo studios doing primarily portraiture, wedding photography, and similar community-based work. Professional Photographers of America estimates that seven out of ten of their 28,000 members are sole proprietors or partners in a photographic business. Many freelancers do not operate a physical studio. They actively seek business from many sources and take on assignments of various types from weddings and organization events to high school or college senior portraits to breaking news stories.

Photographic Career Requirements

Some areas of commercial photography require a college or technical school degree in photography, but many photographers begin their careers with only a high school diploma. A degree is usually needed to gain entry to corporations or organizations offering full-time salaried positions. Photographic studios or photo service companies, such as those doing advertising or product photography, are more open to hiring candidates who have less formal education but a strong portfolio of creative work.

One traditional entry route into commercial photography is to be hired as a professional photographer's assistant. Assistants do many of the routine tasks of organizing equipment and materials for a shoot, whether in studio or on location, **Figure 1-14**. Working as an assistant provides many learning opportunities. A talented assistant may progress to doing actual photography work within the organization, or eventually begin an independent career.

Artistic ability and well-developed photographic skills are basic requirements for successfully entering the commercial photography field. Just as important, though, are "people skills" and a business-oriented attitude.

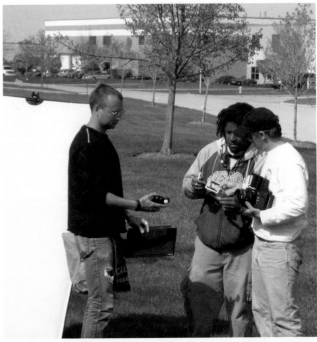

Jack Klasey/Goodheart-Willcox Publisher

Figure 1-14. On a location shoot, a commercial photographer and his two assistants discuss lighting conditions.

A photographer must relate well to people, since she or he is in constant contact with others while working. For example, a portrait photographer must be able to help the client relax and act naturally when the shutter clicks. A fashion photographer on a complex, high-budget shoot must motivate a team to work together smoothly and efficiently.

The ability to communicate information clearly to clients, assistants, and fellow professionals is vital. Listening carefully to what others are communicating is also critical. Misunderstandings cause mistakes that cost money and time. In some cases, such as an industrial assignment being carried out in hazardous conditions, failure to communicate clearly can lead to serious injury.

Business skills are very important to a photographer. When used effectively, they help him or her stay in business. When ignored or used inconsistently, they usually result in business failure. To be successful, a photographer must reach out to potential clients through advertising and marketing activities, **Figure 1-15**. Successful photographers also apply interpersonal and customer service skills to persuade the customer to say "yes," deliver high quality finished projects

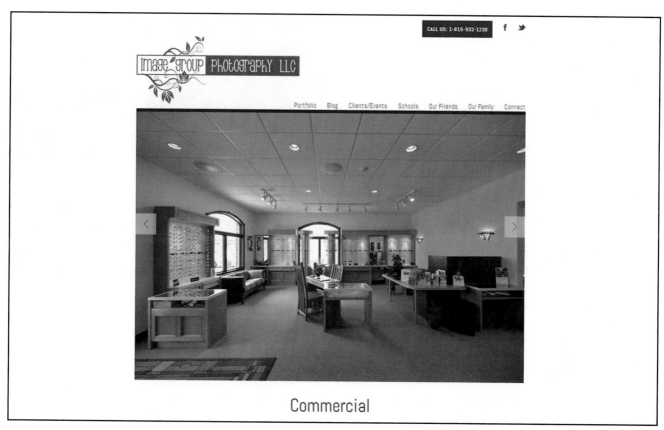

Commercial

Figure 1-15. A well-designed website is an important tool for communicating with potential customers.

on time and within budget, and promptly bill the customer for the work. The skills and abilities required to develop and succeed in a commercial photography operation are covered in greater detail in Chapter 3, *Commercial Photography*.

Learning to See

For a photographer, *seeing* is a specialized skill, something far different from the way most people look at the world around them. A nonphotographer standing at the rim of the Grand Canyon will likely take snapshots of the overall scene, some posed photos of companions with the canyon as background, and perhaps a selfie. A photographer, on the other hand, will see and capture subjects like patterns of light and shadow on formations, the colors and textures of the rock layers and vegetation, and a line of hikers on a distant trail.

Seeing in the photographic sense involves awareness of the relationship of masses and colors, the emotional content of the scene, the play of light and shadow, and meaning that goes beyond the obvious. For example, while tourists marvel over a spectacular sunset, a photographer is more likely to turn his or her back to the sun to capture the warm evening light on an old barn or a rock formation, **Figure 1-16**.

Figure 1-16. The golden light of the setting sun bathes a rock formation on Mount Washington in Maine's Acadia National Park.

Where others see an unsightly auto graveyard, the photographer may see hundreds of subjects to photograph, such as patterns, relationships, and isolated details.

Seeing a Photograph

Selecting a subject to photograph depends on many factors, but the first is personal interest. You must recognize a possible subject for photography and then decide that you want to photograph it. You might want to photograph a given subject for a wide variety of reasons:

- It is a simple and straightforward record to show others that you have been to Disney World or a rock concert. Most snapshots fall into this category.

- It is a subject that you have been conditioned to photograph, such as a parade, **Figure 1-17**, a birthday party, a bed of colorful spring flowers, or a city skyline. Our constant exposure to visual media trains us to think of what a suitable subject is and how it should be photographed.

- It engages your emotions. You may be awed by the stark beauty of a desert landscape, saddened by the ugliness of a vandalized abandoned building, **Figure 1-18**, or delighted by the energetic play of children.

Jack Klasey/Goodheart-Willcox Publisher

Figure 1-18. Debris and graffiti in an abandoned building can generate an emotional response in the viewer.

- It appeals to you aesthetically because of its shapes, colors, composition, or visual impact.

- It can be a means of stating your political, moral, or social views. For example, in the late nineteenth century, published photographs of very young factory workers, **Figure 1-19**, led to the passage of child labor laws.

Jack Klasey/Goodheart-Willcox Publisher

Figure 1-17. Colorful floats in a high school homecoming parade are popular subjects for snapshots.

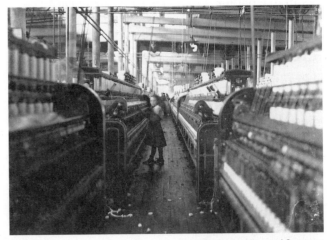

Courtesy of the Library of Congress

Figure 1-19. Photographer Lewis W. Hine documented the exploitation of children. This view from 1908 shows a very young girl working as a spinner in a South Carolina textile mill.

Composing a Photograph

Once you decide *what* you want to photograph, you must next decide *how* to photograph it. Too often, our first impression of a scene becomes the viewpoint from which we capture it—a standing, eye-level, horizontal view, **Figure 1-20**.

That first-impression image is not the only possible way to capture a subject and often is not the most effective or most pleasing way of photographing it. Experienced photographers look at a subject from different angles and distances, **Figure 1-21**. They may return at different hours of the day, or even different seasons, to see the subject under various lighting or weather conditions.

Cameras capture images within a four-sided space, or *frame*. The arrangement of visual elements, such as shapes, colors, and textures, within that frame form the photograph's *composition*. The two broadest categories of composition are *horizontal framing* (landscape format) and *vertical framing* (portrait format). As illustrated in **Figure 1-20** and **Figure 1-21**, photographing the same subject in both formats results in images with distinctly different impressions. Commercial photographers whose work is intended for use in magazines and books strive for dramatic vertical shots to be used as cover illustrations.

Arrangement of the visual elements within the frame is governed by various design principles, such as pattern, balance, and emphasis. Design principles and their application are covered in detail in Chapter 9, *Making a Picture*. The following are a few examples:

- **Pattern.** A repetition of elements within the frame. The repetition may present a feeling of rhythm. See **Figure 1-22**.

- **Balance.** The arrangement of major visual elements within the frame. Balance may be symmetrical (formal) or asymmetrical (informal). See **Figure 1-23**.

- **Emphasis.** The relative prominence of the most important visual element. The element may be larger, closer, lighter, or more vivid in color. See **Figure 1-24**.

Jack Klasey/Goodheart-Willcox Publisher

Figure 1-20. The most common photographic approach is a horizontal image taken from a standing, eye-level position.

Jack Klasey/Goodheart-Willcox Publisher

Figure 1-21. This image captures the scene from Figure 1-20 in a different way. The vertical image was taken from a greater distance and a lower angle.

Figure 1-22. This colorful array of ventilation pipes forms a striking pattern with a strong rhythm.

Figure 1-24. The size, shape, and dark color of the foreground gaslight fixture establish it as the most important visual element in this image.

Figure 1-23. A composition may exhibit formal or informal balance. Left—Formal balance. Right—Informal balance.

PROCEDURE
Making a Framing Viewer

To examine different compositions even when you are not carrying your camera, make a simple framing viewer that can easily be carried in a pocket or purse.

You will need:

- piece of poster board or mounting board, 4″ × 6″ *
- pencil, pen, or fine-point marker
- medium or wide black marker
- metal ruler, 12″ in length
- craft knife

*If possible, the board should be black or another dark color. If only a light-colored board is available, it can be colored later with a black marker.

Cutting out the Viewer

As shown in the following illustration, use the pencil, pen, or marker and the ruler to draw a 2″ × 3″ rectangle centered on the 4″ × 6″ piece of board.

1. With the metal ruler as a guide, use the craft knife to cut along the marked lines on all four sides of the 2″ × 3″ rectangle. *Work carefully—craft knife blades are very sharp!*
2. Remove and discard the 2″ × 3″ rectangle. Use the marker to blacken the cut edges of the opening in the 4″ × 6″ board. If you used a light-colored board, darken one side with the black marker.

Using the Viewer

Hold the framing viewer at eye level and look at the scene. Move the viewer closer or farther away from your eyes to see how the movement changes the view. Rotate the viewer 90° to compare vertical and horizontal framing. To see how the composition will change, step to the right or left, move closer or farther away from the subject, squat down for a lower-angle view, or climb for a higher-angle perspective.

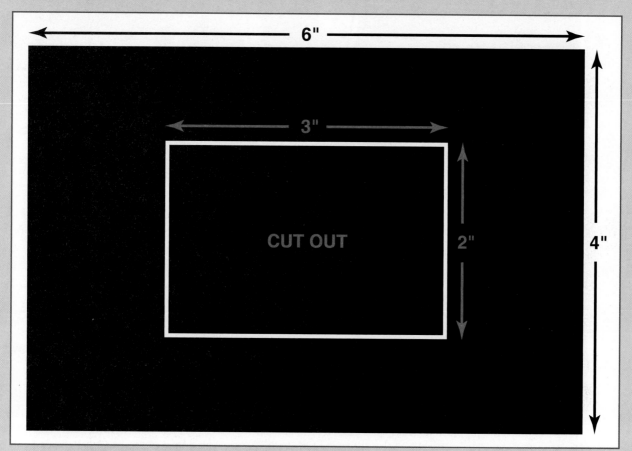

Goodheart-Willcox Publisher

Building Your Portfolio

As an aspiring photographer, you will want to develop a *portfolio*, which is a book or binder of your best work to show potential clients or employers. In many of the chapters in this text, you are given a photographic assignment that will produce one or more images to add to your portfolio. The assignments reflect different photographic skills or types of photography, resulting in a variety of images in your portfolio.

Although portfolios vary in size and some other details, their common element is individual clear sleeves that allow prints to be seen clearly while protecting them from damage and fingerprints. The sleeves, holding one print on each side, are contained in a loose-leaf or post binder, **Figure 1-25**, allowing them to be easily rearranged, added, or removed.

Unless your instructor specifies a different size or format, your portfolio will be a three-ring binder that holds standard 8 1/2″ × 11″ sleeves. The binder should have at least 1″ rings.

As you complete each assignment, add the best image from that activity to your portfolio. In a few cases, an assignment will result in the addition of more than one print. As you pursue your development as a photographer after completing this class, you will add more samples of your work to the portfolio. You will also replace some images with better examples as your skill level increases. Your portfolio will become an important tool as you pursue a career in photography.

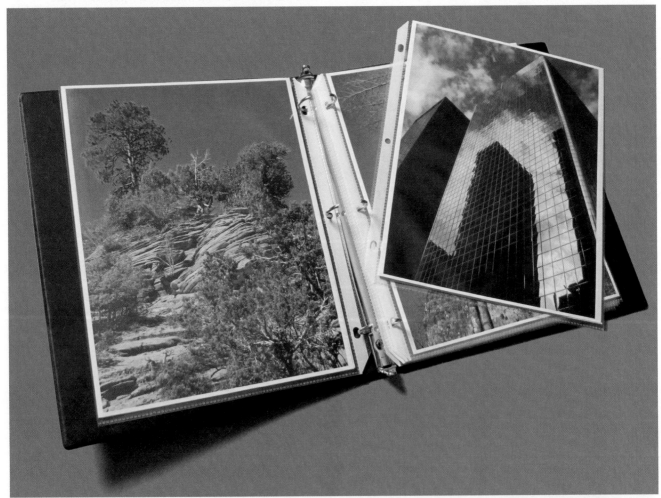

Jack Klasey/Goodheart-Willcox Publisher

Figure 1-25. A portfolio is an important tool for a photographer. A ring binder with images in transparent sleeves can be easily assembled and rearranged as needed.

Portfolio Assignment

Exploring a Subject

A good way to practice seeing photographically is to select a simple subject and photograph it as many different ways as you can visualize. This exploration of a subject helps you improve your creativity and seek unusual ways to look at what you are photographing.

Example A shows some of the many ways of photographing a common object—a fire hydrant. Although only 10 photos are shown, the photographer shot more than 30 different images in about 15 minutes.

For this activity, choose a subject that you feel is interesting and can be photographed in a number of ways. It could be an object like the fire hydrant, a piece of playground equipment, or a car. It might be a person, a building, or a tree—turn your imagination loose. The only requirement is that all the images should feature the exact same subject, not individual examples of the same *kind* of subject.

When you have completed the assignment, examine each image critically. Reject those with obvious defects, such as being out of focus or including some distracting element you did not notice when you pressed the shutter. Select two or three of your best images. For each of these, ask yourself several questions:

- What makes this image more interesting than the others?
- Why would someone want to hang a print of this photo on a wall, share it on social media, or display it on a smartphone or computer screen?
- What does this image tell the viewer about the subject?

The answers to these questions should help you decide which of the images is your best shot, the one that is most successful at capturing your subject. Make a print of that image on 8 1/2″ × 11″ photo paper to place in your portfolio.

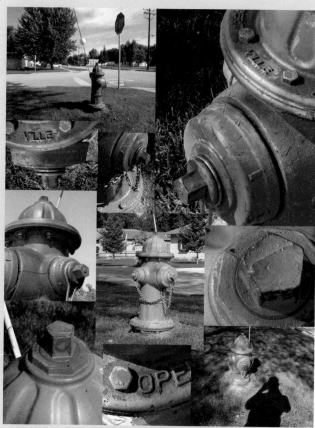

Jack Klasey/Goodheart-Willcox Publisher

Example A. Ten views of a fire hydrant.

Check Your Photography IQ ➦

Now that you have finished this chapter, see what you learned by taking the chapter posttest.

www.g-wlearning.com/visualtechnology/

Review Questions ➦

Answer the following questions using the information provided in this chapter.

1. How is a photograph used in advertising to persuade consumers to purchase a product?

2. List some of the ways a photograph might be used in marketing a new product.

3. A vacation snapshot is an example of the type of photography described as _____.

4. The two major activity areas for commercial photographers are _____ photography and _____.

5. Approximately _____ of the more than 136,000 workers in the United States who are classified as photographers are self-employed.

6. A traditional route of entry into commercial photography is working as a(n) _____ to a professional photographer.

7. What has trained us to think of what a suitable subject might be and how it should be photographed?

8. What social change resulted from the publication of photographs taken by Lewis Hine in the early 1900s?

9. The two types of framing used by photographers are called _____.
 A. formal and informal
 B. abstract and realistic
 C. horizontal and vertical
 D. objective and subjective

10. The repetition of elements within the frame of a photographic composition is called _____.

11. Name an obvious defect that would cause you to critically reject a photograph.

12. What is a photographic portfolio and why is it important?

Suggested Activities

1. Use the information in this chapter to do one of the following:
 A. Write a short proposal to your instructor describing creation of a fundraising calendar using photographs taken by class members.
 B. Create a help-wanted newspaper ad for a photographic assistant, describing needed skills. The ad should be fewer than 50 words.
 C. Compose an e-mail to send to members of your photo class, proposing formation of a school photo club.

2. Use your smartphone or tablet to browse Internet "job boards" such as Monster.com or CareerBuilder.com to find advertisements for photographic employment. Try to identify which geographic areas provide the largest numbers of job opportunities. Write a short report with your findings.

Critical Thinking

1. For a class assignment, you must create a photo that illustrates the emotion of "loneliness." How would you convey this emotion photographically?

2. Think about how your interests and your personality relate to the different types of photography you read about in this chapter. Does one or more of them seem to be a good match for you?

Communicating about Photography

1. **Speaking.** Debate the topic of whether photography is art or craft. Divide into two groups. Each group should gather information in support of either the argument that photography is art or that it is craft. Use definitions and descriptions from this chapter to support your side of the debate and to clarify word meanings as necessary. Do Internet research to examine various opinions on this topic.

2. **Listening.** As classmates deliver their presentations, listen carefully to their arguments. Take notes on important points and write down any questions that occur to you. Later, ask questions to obtain additional information or clarification from your classmates as necessary.

Snapshot: A photo taken—often with a point-and-shoot camera or a camera phone—to record an event, activity, or location (vacation destination, for example).

While studying this chapter, look for the activity icon ↗ **to:**

- **Assess** your knowledge with self-check pretest and posttest.
- **Practice** vocabulary terms with e-flash cards and matching activities.
- **Reinforce** what you learn by submitting end-of-chapter questions.

G-WLEARNING.com

www.g-wlearning.com/visualtechnology/

Jack Klasey/Goodheart-Willcox Publisher

Camera Handling, Care, and Support

Objectives

When you have finished reading this chapter, you will be able to:

- Describe the controls and features common to both film and digital cameras.
- Identify controls and features specific to digital cameras.
- Discuss the importance of protecting cameras from moisture and dust.
- Demonstrate proper procedures for cleaning lenses and image sensors.
- Describe the proper techniques for supporting different types of cameras.
- Explain the components of and appropriate use of a tripod.

Check Your Photography IQ ➦

Before you read this chapter, assess your current understanding of the chapter content by taking the chapter pretest.
www.g-wlearning.com/visualtechnology/

Technical Terms ➦

Adobe RGB	Program AE
aperture priority	shutter lag
ball head	shutter priority
burst mode	sRGB
histogram	stabilizing systems
LCD (liquid crystal display) screen	tripod
manual exposure	ultraviolet (UV) filter
monopod	white balance

Imagine that you must drive a car that is unfamiliar to you across town for an important appointment. You start the car and, using the familiar basic controls, you are on your way and on schedule. But what if a storm arises and you have to turn on the headlights and use the windshield wipers? You would probably have to pull over to the curb and figure out where the headlight and wiper controls are on this car, and how to use them. By the time you do that, you are probably running late for your appointment.

Many people approach a new camera in the same way. They can "point and shoot" using the basic controls, but are not prepared to handle an unexpected situation. By the time they figure out what to do, the picture opportunity may be lost.

Learning about Your Camera

Today's cameras are sophisticated pieces of equipment. Most have dozens of controls and features that allow you to make an image successfully in almost any situation. It takes time and effort to learn what those controls and features do, and how and when to use them. To move beyond the level of birthday party and vacation snapshots, you must take the time to learn about your camera.

Some people learn about a new camera by simply experimenting with various controls; others virtually memorize the owner's manual before using the camera. In other words, some people are "hands-on" learners, while others learn by studying instructions. A good method is to blend those approaches. First, study the manual on how to use a feature or control, and then use the camera to practice with that control or feature.

Begin on the manual page that displays a drawing or photo of the camera and labels the controls. Locate each of the labeled controls. The first time you do this, rest the camera on a surface with the lens pointing toward you to make it easier to locate the controls on the front and top of the camera, **Figure 2-1**. Next, turn the camera to point away from you so you can identify the controls on the camera back, **Figure 2-2**. Practice operating, or at least touching, each of the controls on the camera front, top, and back from behind the camera.

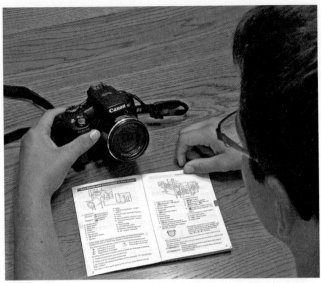
Jack Klasey/Goodheart-Willcox Publisher

Figure 2-1. Using your manual and camera together is the best way to learn about basic camera controls and features.

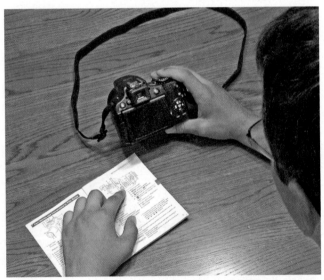
Jack Klasey/Goodheart-Willcox Publisher

Figure 2-2. Camera controls and their locations are clearly labeled in the owner's manual.

This builds muscle memory that helps you locate and operate frequently used controls.

Common Controls and Features

Film cameras and digital cameras have a number of common features and controls. Not all cameras or all models will have a particular feature or control, but most will. For this reason, the following section describes controls and features in general terms.

Exposure Mode Selection

The most basic camera models do not provide any shooting choices—shutter speed, aperture, and ISO are all preset or automatically adjusted. Most cameras, however, offer at least four ways to operate the camera. See **Figure 2-3**. These exposure modes are automatic, aperture priority, shutter priority, and manual.

Often designated as AE, the automatic exposure mode lets the camera make all the decisions. The camera's processor uses readings from the built-in exposure meter to select an aperture/shutter speed combination that provides a properly exposed photograph. On a film camera, the film speed (ISO) setting is factored into the exposure decision. Digital cameras also factor in the ISO setting, but may alter the value to improve the exposure. Auto exposure is the simplest mode to use and gives acceptable results much of the time. However, it cannot cope with certain kinds of photographic situations, such as backlighted subjects or rapid motion.

Some camera models have a *Program AE* mode to allow limited control. In this mode, the camera's processor selects exposure settings based on the meter reading, but you can change either the shutter speed or aperture. The processor will then make the appropriate adjustment for a proper exposure.

In *aperture priority* mode, you select the aperture setting, and the camera sets a shutter

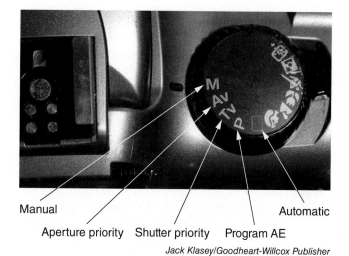

Manual
Aperture priority Shutter priority Program AE
Automatic

Jack Klasey/Goodheart-Willcox Publisher

Figure 2-3. The exposure modes commonly found on film and digital cameras.

speed based on its meter reading. The advantage of using aperture priority is the ability to control depth of field—the portion of the image, from near to far, that is in acceptable focus. As aperture size decreases, depth of field increases. At f/2, a large aperture, depth of field is quite shallow. At f/16, a small aperture, depth of field is much greater. Aperture priority is often selected when shooting landscapes. See **Figure 2-4**.

When a moving subject is involved, *shutter priority* mode is typically selected. In this mode, you select the shutter speed, and the camera chooses an aperture based on its meter reading. Slower shutter speeds, resulting in longer exposures, capture motion blur.

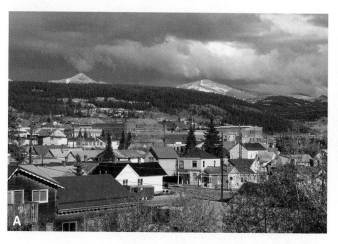
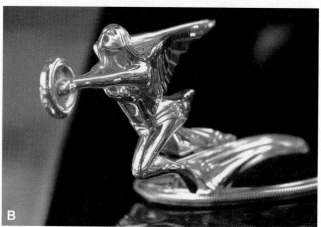

Jack Klasey/Goodheart-Willcox Publisher

Figure 2-4. Depth of field increases as aperture decreases. A—In this scenic shot, depth of field is great, with focus sharp from the nearest house to the distant mountains. Aperture was f/20 at 1/60 second using a 50 mm lens. B—A 300 mm telephoto lens and an aperture of f/5.6 at 1/100 second result in very shallow depth of field. Focus is sharp only for the central figure in this antique auto hood ornament.

Faster shutter speeds, giving shorter exposures, stop motion. See **Figure 2-5**. The effect of the selected shutter speed is relative to the motion involved. A relatively fast shutter speed of 1/250 second freezes a jogger's movement in mid-stride, but records a baseball pitcher's 95 mph fastball as a streak. Sports photography, the performing arts, and photojournalism are obvious uses for shutter priority.

The *manual exposure* mode provides the greatest degree of control—you choose the aperture, shutter speed, and ISO. See **Figure 2-6**. To successfully use this mode, you must be thoroughly familiar with the use of equivalent exposures so you can select the proper combination of shutter speed and aperture for the situation. See **Figure 2-7**. Equivalent exposures will be covered in detail in Chapter 10, *Making Exposure Decisions*.

Many digital cameras allow you to choose an exposure mode that is preset for a particular situation, **Figure 2-8**. The following are some typical preset exposure modes:

- **Portrait.** Uses a shallow depth of field to blur the background and focus attention on the subject.

- **Landscape.** Preset for maximum depth of field.

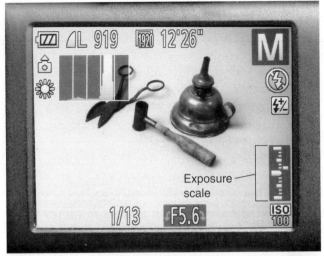

Jack Klasey/Goodheart-Willcox Publisher

Figure 2-6. Manual mode allows you to separately select an aperture and a shutter speed that result in a correct exposure. The exposure scale at the right side of the camera's viewfinder indicates proper exposure. When the movable small bar is aligned with the pointed mark at the center of the scale, exposure is correct.

- **Sports.** Selects a fast shutter speed. On some cameras, it also activates a focus tracking feature that helps keep a moving subject in focus.

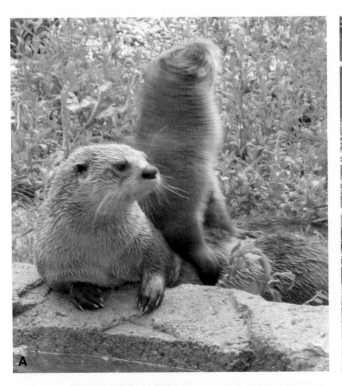

Jack Klasey/Goodheart-Willcox Publisher

Figure 2-5. Using shutter priority to control motion blur. A—A relatively slow shutter speed of 1/40 second resulted in strong motion blur as one of these otters turned rapidly. B—Using a faster shutter speed (1/125 second) froze the motion of the swimming otters.

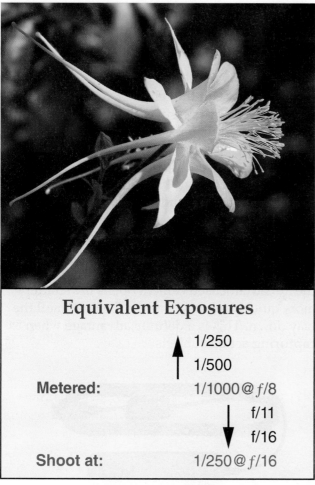

Goodheart-Willcox Publisher

Figure 2-7. Selecting an equivalent exposure. If your meter reading is 1/1000 second at f/8, you can stop down from f/8 to f/16 (two stops) for greater depth of field. This would require a shutter speed two steps slower (1/1000 second to 1/250 second) to obtain an equivalent exposure value.

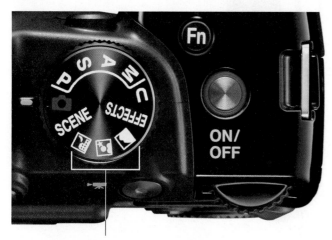

Preset exposure modes

Jack Klasey/Goodheart-Willcox Publisher

Figure 2-8. Most digital cameras have several preset exposure modes for use in specific situations. They are usually selected by rotating a dial.

- **Close-up.** Used at the closest focusing distance of the camera's lens.
- **Night scene.** Uses both flash and a slow shutter speed to balance foreground and background exposures.

ISO Selection

Single-use, or disposable, film cameras come loaded with film rated at either ISO 400 or ISO 800, but almost all other cameras allow the user to select the sensitivity of the image receiver. The receiver may be film or a digital sensor; in either case, sensitivity to light is expressed as an ISO rating. In older film cameras with built-in meters, the ISO was used to establish the exposure reading. On cameras without built-in meters, the ISO setting was merely a reminder for the photographer, who used a handheld meter or experience to determine exposure. In later film cameras with electronic features, setting ISO ratings manually was not usually necessary. Film cassettes are imprinted with a visual code, called *DX coding*, which can be read by the camera to establish the ISO rating. Digital cameras display a list of ISO equivalents from which you can select a setting, **Figure 2-9**. In either film or digital photography, image quality declines as the ISO rating increases.

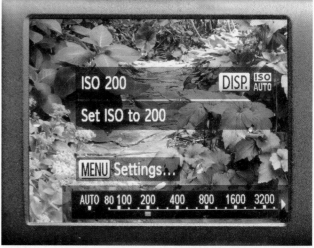

Jack Klasey/Goodheart-Willcox Publisher

Figure 2-9. On digital cameras, the ISO setting is usually selected from a menu displayed on the LCD screen. Increasing the ISO setting makes the camera's image receiver more sensitive to light, permitting photography under lower light conditions.

Shutter Release

The shutter release on modern 35 mm and digital cameras is a button located on the top right side of the body. To avoid moving the camera when pressing the shutter button or lever, a shutter release device is often used, **Figure 2-10**. For older cameras, the device is a stiff wire called a *cable release*, or a piece of tubing with a squeeze bulb. The wire or air pressure physically presses the shutter release without causing camera movement. Newer cameras with electronic controls use a wired connection or a radio signal to release the shutter.

If a shutter release device is not available, the camera's self-timer can be used to operate the shutter without vibration. When the shutter button is pressed, the timer performs a countdown for a set number of seconds, and then operates the shutter. The delay permits any vibration from pressing the shutter release to die out.

On cameras using autofocus, pressing the shutter button also activates the focusing system. The camera focuses, and then opens the shutter to take the picture. One advantage of this two-step process is the ability to select a focus point that may not be in the center of your picture and lock the focus by pressing the button halfway down. You can then recompose your scene and capture it by pressing the button the rest of the way down. A second advantage is the ability to minimize *shutter lag*. In some digital cameras—especially compacts and older models—there is a noticeable delay between pressing the shutter button and the actual opening of the shutter. This is caused by the slow operation of many autofocus systems. With the two-step method, the already-focused camera opens the shutter more quickly when you press the button all the way down. This is a definite advantage when capturing action subjects.

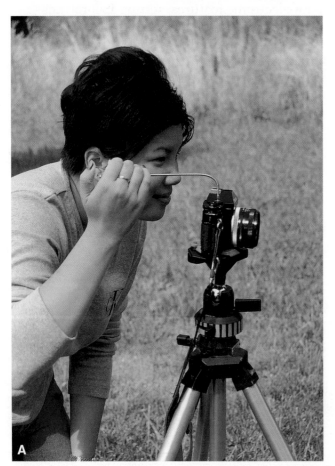

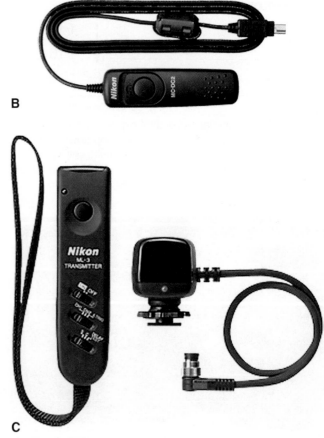

Jack Klasey/Goodheart-Willcox Publisher; Courtesy of Nikon Inc., Melville, New York

Figure 2-10. A shutter release device operates the camera's shutter without causing vibration. A—Cable releases for older film cameras frequently offer a locking feature that holds the shutter open for time exposures. B—Wired electronic releases connect to the camera with a cord several feet in length. C—Wireless releases using radio signals can operate the shutter from a number of feet away.

Exposure Compensation

Exposure compensation, **Figure 2-11**, allows you to increase or decrease exposure in shutter priority, aperture priority, or program AE modes. Increasing the exposure lightens the image; decreasing the exposure darkens it. Exposure compensation can provide an increase or decrease of as much as three stops, typically in one-third stop increments.

Depth of Field Preview

When you look through the viewfinder of an interchangeable-lens camera (usually referred to as a single-lens reflex, or SLR), the scene you see is not an accurate view of what will be in sharp focus when the image is captured. To make the viewfinder image as bright as possible, the lens is set to its widest aperture. When you press the shutter release, the lens stops down to the chosen aperture a fraction of a second before the shutter opens.

Unless you are making your exposure using the lens' widest aperture, you cannot tell how much of the scene will be in focus. For example, when shooting a portrait where you want the background in soft focus, the scene might look fine at your lens' widest aperture of f/4. Your selected aperture of f/16, however, could render the background as sharp as the portrait subject.

The depth of field (DOF) preview control, found on most SLRs, allows you to see what the scene will look like at the selected aperture. DOF preview is usually activated by pressing a button. This stops down the lens to the desired aperture. The scene in the viewfinder will be darker, since less light is entering, but will accurately show the depth of field that will appear in your captured image.

Focus Lock/Exposure Lock

As described in the preceding section on shutter release, the focus lock function allows you to set and hold focus, then recompose the image. The exposure lock (*AE lock*) function works similarly—after focusing on the desired subject, the exposure reading for that subject can be locked and the scene recomposed if necessary. Exposure lock is useful for shooting subjects that are backlit and for panoramic photography.

Burst Mode

For sports and other types of action photography, making a series of exposures in a second or less can allow you to capture the peak of action or to show a sequence of actions, **Figure 2-12**. Film cameras with electronic controls and virtually all digital cameras can operate in a continuous shooting mode, often referred to as a *burst mode*. Depending on the camera model, the number of possible exposures in the burst mode ranges from two to eight or more per second.

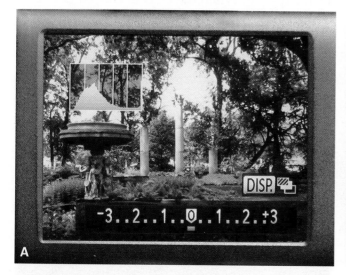 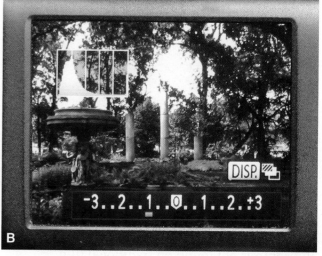

Jack Klasey/Goodheart-Willcox Publisher

Figure 2-11. Exposure compensation. A—The indicator is centered under the 0 point of the scale; the photo will be exposed at the metered values. B—With the indicator moved to the left -1, the exposure will be darker; it will be made at one stop under the metered values.

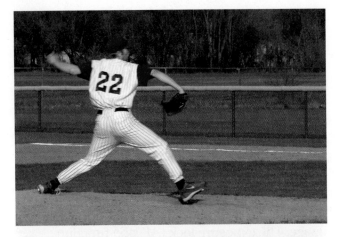

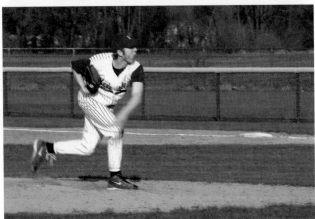

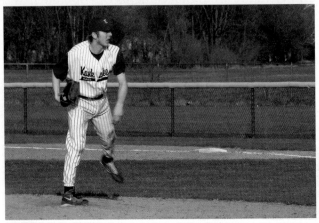

Figure 2-12. These three shots of a baseball pitcher's delivery were taken in a span of approximately one second using the camera's continuous shooting (burst) mode.

Digital Controls and Features

Digital cameras have a number of features and controls not found on traditional film cameras. Since camera brands and models can vary considerably, the following section describes these features and controls in general terms.

LCD Screen

The *LCD (liquid crystal display) screen* is a small viewing screen on the back side of a digital camera that allows review of each image immediately after it is exposed, **Figure 2-13**. This allows you to quickly evaluate composition and exposure and determine whether the image is a "keeper" or should be reshot. On compact cameras, the LCD screen is typically used as the viewfinder for composing the image. It can also display information on such camera settings as shutter speed, aperture, and ISO.

A useful feature on some models is an LCD screen that swings out from the camera body. The screen can be positioned to aid in composing pictures taken from various angles. See **Figure 2-14**.

Because of their design, older digital SLRs did not permit using the camera-back LCD as a viewfinder. Today, many camera models have a live-view LCD that can be used for composing the image. A digital SLR has an additional small LCD display on the top or back side of the camera to show exposure settings, battery status, and other information. On most SLR models, the camera-back LCD is used strictly for reviewing images.

Although camera controls allow you to zoom in on an image to judge sharpness or examine details, the LCD does not allow you to accurately assess whether the image is well-exposed. When the LCD is viewed under

Figure 2-13. After a digital camera makes an exposure, it displays the image on the LCD screen for review.

Jack Klasey/Goodheart-Willcox Publisher

Figure 2-14. A pivoting LCD can be used as a viewfinder for situations such as shooting over a crowd, capturing flowers silhouetted against the sky, or even making "around the corner" photographs.

bright lighting conditions, for example, the image can appear overexposed or "washed out." For critical evaluation of exposure, the display can be switched to show a histogram and image information.

Histogram/Exposure Display

The *histogram* is a bar graph showing all of the tonal values of an image, **Figure 2-15**. The graph is composed of 256 bars or columns that represent the number of tones in an 8-bit image. Ranging from pure black at the left to

pure white at the right, each bar represents the number of pixels of a specific value in the image. The result is a mountain range appearance with peaks and valleys—peaks indicate a large number of pixels, while valleys are indicators of few or no pixels.

Learning to read the histogram is the key to evaluating your exposures and making necessary adjustments to obtain the best possible image. This topic is discussed in Chapter 10, *Making Exposure Decisions*.

White Balance

The human eye compensates for the color of light, but a camera does not. To capture and display colors accurately, film photographers load their cameras with either daylight-balanced (outdoor) or tungsten-balanced (indoor) film. Digital camera users achieve the same results by selecting a *white balance*. By adjusting the camera's response to make a white object *appear* white under specific light conditions, all other colors seen under that lighting will be shown accurately.

Most digital cameras allow you to select automatic white balance (AWB) or one of a number of presets for such conditions as sunlight, shade, tungsten lighting, fluorescent lighting, or flash. See **Figure 2-16**. AWB or one of the presets provides good results in most situations.

Jack Klasey/Goodheart-Willcox Publisher

Figure 2-15. A camera's histogram display is an essential tool for the digital photographer. A—The display is a bar graph showing all the tones in the image, allowing you to evaluate exposure and make any needed changes. B—Some cameras allow you to select an additional histogram display that shows the values for each the three primary colors.

Figure 2-16. Automatic white balance usually provides good results, but some situations call for selecting one of the other preset white balances from the camera's menu.

Image Quality (Resolution/ Compression) Settings

Digital cameras can produce images at different quality levels to meet particular photographic needs. An image to be used in a book or displayed as an 11" × 14" inkjet print has different requirements from a 4" × 6" snapshot or an image to be displayed on a web page.

The quality level for JPEG image files is typically described as large, medium, or small, and is based on the size of the output that can be produced from that file. See **Figure 2-17**. The definition of large, medium, and small, in turn, depends on the camera's resolution.

A large quality image from a 12Mp camera is approximately 4000 × 3000 pixels and can produce an excellent inkjet print approximately 9" × 12" in size. In contrast, a large quality print from a 6Mp camera is approximately 3000 × 2000 pixels and can produce an excellent 7" × 10" print. The medium and small sizes are relative to the large size—for a 12Mp camera, a medium quality would produce a 7" × 10" print, and a small quality print would be 4" × 5.5".

Compression is the "squeezing" of an electronic file to reduce its size. The size reduction allows more images to be stored on a memory card, faster copying from camera to computer, and faster transmission via e-mail. Compression of JPEG files is called *lossy*, since some image data is discarded in processing. The amount of discarded data affects image quality—the more a file is compressed, the greater the data loss. The amount of compression applied to an image file can be selected from a camera menu.

Sophisticated cameras may offer the ability to capture RAW images, **Figure 2-18**. These images include all of the information captured by the camera's sensor and are not compressed or processed in any way. With special computer software, RAW images can be adjusted and then converted to a conventional image file, such as JPEG or TIF.

On-Board (Built-In) Flash

With the exception of high-end professional models, virtually every camera available today includes an on-board flash, **Figure 2-19**.

Figure 2-17. Relative sizes of high-quality prints that could be made from large, medium, and small JPEG files produced by a 12Mp camera.

Figure 2-18. Professional digital cameras and some advanced amateur models allow you to choose output of both RAW and JPEG files for greater flexibility.

When shooting in automatic mode, most cameras fire the flash whenever needed; in other situations, the photographer selects when to use the flash. On-board flashes have limited range. Many compact cameras and all interchangeable-lens models have a hot shoe for mounting a more powerful flash unit, **Figure 2-20**. Use of a separate flash is described in Chapter 11, *Action and Event Photography*.

Color Space Selection

A color space is a specific description of the range, or gamut, of colors that can be provided by a particular device. Most digital cameras capture images in the color space called *sRGB*, which stands for standard Red, Green, Blue. This color space was defined by the computer industry for consistent display of colors on monitors. The other major RGB color space is *Adobe RGB*, developed by the manufacturer of Photoshop and other graphics software.

If your camera offers both color spaces, the reason for choosing one over the other depends primarily on how the image will be seen.

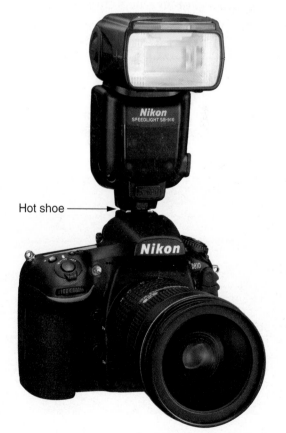

Figure 2-19. An on-board flash provides light when needed or desired to capture an image under lower-light conditions. A—Many larger-bodied cameras, such as SLRs, have a pop-up flash that can be raised when needed. Most also have a hot shoe for mounting a separate flash unit. B—Compact cameras typically have a small flash built into the camera body.

Hot shoe

Figure 2-20. A camera's hot shoe is a bracket that provides a separate flash unit with both physical support and electronic connection to the camera.

The sRGB color space reproduces more vividly for viewing on a computer monitor. Adobe RGB would be the choice for inkjet printers and traditional printing presses, which use inks that can reproduce the wider gamut of this color space.

Exposure Numbering

For identification, the frames on a roll of exposed 35 mm film are numbered from 1 to 24 or 1 to 36, depending on roll length. Negatives are edge-numbered on the margins of the frame, while slides have numbers printed on the mounts. Many photographers assign a number or date code to each roll, so a specific frame can be identified as needed.

Digital images are numbered by the camera's software. Each image is electronically tagged with an identifying number that becomes a part of the file and is usually used as the filename, such as IMG_2237. Most cameras offer a choice of continuous numbering of up to 9999 images or of restarting numbering each time a new memory card is inserted. Since continuous numbering minimizes the possibility of images with duplicate numbers, most photographers choose that method.

Physical Care of Your Camera

Cameras and lenses are precision instruments that can be damaged by rough handling or by

exposure to water, dust, sand, or other environmental dangers. Protecting your camera from damage is mostly a matter of common sense. You would not use the camera in a driving rainstorm without some form of waterproof covering, nor would you set it down in the sand while shooting at the beach.

Wet-Weather Protection

Rainy weather can often allow you to make good photographs. To protect both you and the camera while photographing under rainy conditions, use various forms of shelter—a building doorway or porch, a vehicle with the window rolled down, or an umbrella. See **Figure 2-21**. When conditions are both wet and windy, however, such shelter may not be enough to keep your camera dry.

Better protection is offered by flexible plastic housings that fit over the camera and lens barrel. These housings do not cover the front of the lens, since the material would cause distortion of the image. The housings may have cutouts or other provisions for using camera controls. See **Figure 2-22**.

An inexpensive alternative can be made with a large plastic food storage bag and a rubber band. For SLRs with telephoto lenses, either a one-gallon or two-gallon zip-closure bag is adequate. Cut off one of the bottom corners of the bag to leave a hole approximately the diameter of the lens hood. Place the camera in the bag with the lens protruding from the hole, then use the rubber band to secure the plastic around or just behind the lens hood. The open end of the bag lets you use the viewfinder and operate camera controls.

Jack Klasey/Goodheart-Willcox Publisher

Figure 2-21. A tree on the bank of a small pond provided shelter for the photographer and his camera on this rainy spring morning at the Magnolia Plantation near Charleston, South Carolina.

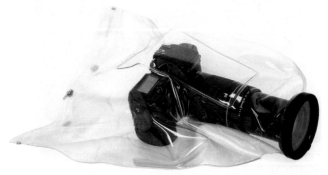

Ewa-marine Gmbh

Figure 2-22. Plastic rain covers protect the camera's delicate electronics from moisture on rainy or snowy days, or when photographing from a boat or canoe. Various sizes are available to accommodate different zoom lens lengths.

Jack Klasey/Goodheart-Willcox Publisher

Figure 2-23. This S-shaped black object, probably a piece of lint, settled on the camera's sensor. Dust spots are typically not visible on the camera's LCD screen and are detected only when the image is displayed on the larger screen of a computer. Proper lens-changing techniques and regular sensor cleaning will help prevent dust spots.

A large plastic bag can also serve as emergency protection for your camera. If you are caught in the open when a rainstorm comes up, or are on a boat or a beach where wind-whipped spray becomes a problem, you can quickly slip the camera into the bag for protection.

If you are caught in a wet situation without protection, shelter the camera as well as you can inside a jacket or other article of clothing. As soon as you are in a dry area, carefully wipe off all visible moisture with a dry cloth or paper towels. If possible, use a hair dryer to evaporate any water that remains in crevices of the camera body and lens.

Dust Protection

Like water, dust is a major enemy of your camera. Fine particles of dirt or sand can lodge between moving parts and cause costly wear. Particles on the glass surface of a lens, if ground in by improper cleaning methods, leave scratches that diminish optical performance. Dust inside an SLR camera body can settle on the sensor, resulting in unsightly spots that appear on every image, **Figure 2-23**. Newer camera models use ultrasonic vibration or other methods to shake loose particles off the sensor every time the camera is turned on.

To keep dust out of the camera body, always turn off the camera before changing lenses. If the lens is removed with the camera still switched on, the electrical charge on the sensor will attract dust particles.

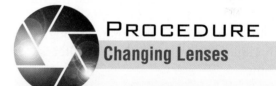

PROCEDURE
Changing Lenses

1. Turn off the camera's power switch.
2. Hold the camera body with the lens facing downward. This allows any loose dust to fall away when the lens is dismounted. Grasp the lens firmly.
3. Press the release button on the camera body, then rotate and remove the lens from the mount.
4. Place a rear cap on the lens to keep out dust. Often, you will just switch the rear cap from the new lens to the one just dismounted.
5. Insert the new lens into the mount, and rotate it until it is firmly in place.
6. Turn on the camera's power again.

When changing a lens in a windy environment, protect the equipment from flying particles by making the change under some form of cover. If possible, move into a building, a vehicle, or other protected area. If such an area is not available, work beneath the cover of a jacket, shirt, or towel draped over your hands. If no other method is available, turn your back to the wind and shelter the operation with your body as much as possible.

Protecting Lens Elements

Most lens elements are inside the lens barrel, where they are protected against possible causes of damage. The front element, however, is exposed to both abrasion damage from dust or sand and physical damage from bumping against hard objects.

An inexpensive form of protection used by many photographers is the virtually clear *ultraviolet (UV) filter*, also called a haze filter or skylight filter. Screwed into place on the front of the lens, **Figure 2-24**, the filter protects the front lens element from dust, salt spray, and bumps against hard objects. A damaged UV filter can be replaced easily and at much less cost than the front lens element.

Some photographers claim that a UV filter, even one of good optical quality, can degrade the quality of the image. Others consider the slight quality loss to be offset by the protection the filter provides. A compromise is to leave the filter in place except when actually shooting, although constantly removing and replacing the filter is cumbersome.

Cleaning a Lens or Filter

Frequent lens or filter cleaning is important to maintain optical quality, and proper cleaning methods are vital to preventing damage. See **Figure 2-25**. If a UV filter normally remains on

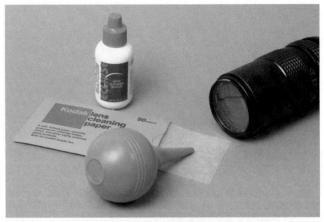

Jack Klasey/Goodheart-Willcox Publisher

Figure 2-25. Tools used for cleaning a lens or filter include a blower or soft brush for loose dirt and lens cleaning paper used with a cleaning solution for oily deposits.

the lens, the front lens element seldom, if ever, needs to be cleaned. However, the filter should be cleaned frequently to minimize its effect on optical quality. When the back element of a lens is accessible, it should be cleaned from time to time.

Cleaning is a two-step process. First, hold the lens facing downward so any loose material falls away and use a soft brush or squeeze-bulb air blower to clear away any particles. Second, place a drop of lens cleaning solution on a piece of lens cleaning tissue (a soft, lint-free paper), then gently rub the lens in a circular motion. Work outward from the center of the lens to the rim to remove oily deposits such as fingerprints. If left on the lens, fingerprints can permanently etch the surface. Many photographers carry a small microfiber cleaning cloth and use it in place of cleaning solution and tissue. The cloth must be washed regularly to remove particles that can cause scratches.

Camera Body Cleaning and Maintenance

Keeping equipment clean and in good working order is the mark of a skilled professional who shows pride in his or her work. Keeping equipment clean helps to minimize wear and damage and make the equipment easier to use.

Cleaning the Camera Body and LCD Screen

Examine the camera body regularly, and use a soft brush to remove dust, grit, or lint from any

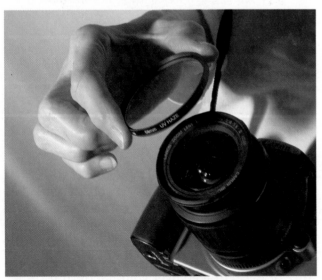

Jack Klasey/Goodheart-Willcox Publisher

Figure 2-24. Mounting a UV filter on a lens protects the coating on the front element and helps to eliminate atmospheric haze in landscape photos.

crevices on the exterior. Pay special attention to areas around openings, such as the lens mount, battery door, or card slots. For film cameras, use the same method inside the camera back to remove any dust particles or film chips. Be careful when cleaning around the focal plane shutter, since the curtains are easily damaged. To remove dirty deposits on the camera body, use a clean, lint-free cloth slightly moistened with warm water.

Do not clean the LCD screen with liquid materials. Carefully brush or blow away any loose dust, then gently rub the surface with a clean, soft dry cloth, **Figure 2-26**. Do not press hard on the LCD surface, since this could damage its delicate structure.

Sensor Cleaning

Specks of dust or lint that have settled on the camera's image sensor are most noticeable in image areas of lighter color, such as the sky or clothing. Eliminating the spots from your files by using image manipulation software is time-consuming and tedious. A better solution is to remove the particles by cleaning the clear

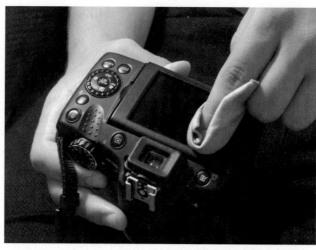

Jack Klasey/Goodheart-Willcox Publisher

Figure 2-26. Gentle wiping with a clean, soft cloth is recommended for cleaning LCD screens and viewfinders.

cover plate that is placed over the delicate sensor. The recommended procedure for sensor cover cleaning varies among manufacturers. The following procedure lists the general steps involved.

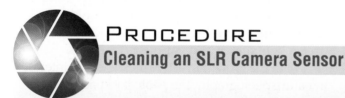

PROCEDURE
Cleaning an SLR Camera Sensor

1. Connect the camera to an AC adapter, if available, or be sure that the battery is fully charged.
2. Turn off the camera, and then remove the lens.
3. Turn the camera on again, and select the *sensor cleaning* choice from the appropriate menu. The mirror flips up and locks, and the shutter opens to expose the sensor assembly.
4. Hold the camera with the lens opening facing downward, so any dislodged dust falls out.
5. Carefully use a bulb-type blower to direct a jet of air at the sensor cover, **Figure 2-27**. This should dislodge any loose material. Do not use a blower brush—small pieces of bristle could break off, adding to the dust problem instead of solving it. Also, the bristles could scratch the cover plate. Never use canned compressed air, since it contains chemical propellants that can damage the sensor assembly.
6. Withdraw the blower bulb from the camera and turn off the power. The shutter closes and the mirror drops down.
7. Remount the lens.

Jack Klasey/Goodheart-Willcox Publisher

Figure 2-27. Careful use of a blower directs a jet of air onto the sensor's cover plate to remove loose dust particles.

If one or more dark spots are still visible on your images after using the blower, the dust is most likely adhered to the sensor cover. Camera manufacturers discourage any form of cleaning other than use of a blower, often warning that other cleaning methods will void the camera's warranty. Manufacturers recommend having the sensor cleaned by a trained technician. However, products for cleaning adhered particles from the sensor are used by many photographers. The most common is a swab with a very small amount of a solvent that is carefully rubbed across the sensor's cover plate. Single-use individual swabs are sealed in air-tight packaging.

To identify the need for sensor cleaning or to check its effectiveness, a special magnifying viewer can be placed over the camera's lens mount opening. This device provides a brightly lit, magnified view of the sensor to reveal the presence of dust particles or other debris. See **Figure 2-28**.

Camera Storage and Transportation

If you plan to take photographs at locations other than your home or studio, you must have some way to transport your equipment. A simple compact camera or even an SLR with a single zoom lens can be hand-carried or slung around your neck with a camera strap. Most photographers, however, use a bag or case to carry and store equipment, **Figure 2-29**.

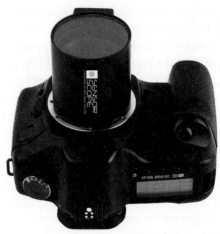

Delkin Devices

Figure 2-28. A magnifying device can be used to inspect the digital camera sensor. This model includes LEDs to illuminate the sensor and show dust particles.

The traditional method of storing and carrying photographic equipment is the camera bag. Made of a strong woven material and padded for protection against bumps, most bags have partitions to hold different-sized items, such as lenses and camera bodies. Bags vary in size from small handheld or belt-mounted cases for compact cameras to very large bags capable of holding several camera bodies, a selection of lenses, a flash unit, a light meter, and various accessories.

With the growth in active lifestyles and interest in nature photography, the photo backpack has become popular. A backpack allows safe and comfortable transport of camera gear and other items while hiking, climbing, skiing, or bicycling. In areas

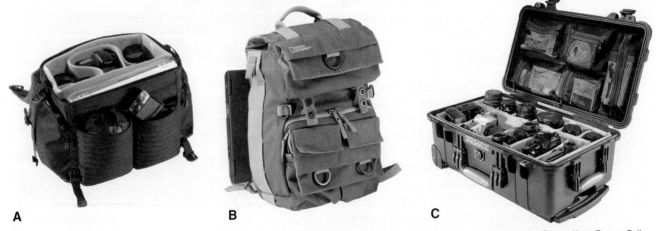

A B C

Bogen Kata; Bogen; Pelican

Figure 2-29. There are many choices for camera storage and transportation equipment. A—The traditional camera bag comes in many sizes. B—Backpacks with padded dividers to protect equipment are particularly popular with nature photographers. C—Hard cases are most often used by professionals who must travel with a large amount of equipment.

where equipment theft is a problem, a backpack is less obvious than a traditional camera bag.

The ultimate protection from the elements, or from baggage-handling damage while traveling, is the hard case. Made from high-impact plastics or metal, these cases are sealed against water and dust and have padded interiors to prevent equipment damage.

Camera Carrying Methods

When a photo opportunity suddenly arises, a camera in a bag or backpack is not of much use. For this reason, and for convenience, most people prefer to carry a camera in a way that allows immediate use, **Figure 2-30**.

SLRs and similar-size cameras are usually carried with a strap around your neck and the camera resting on the front of your body somewhere between the chest and the waist, **Figure 2-30A**. The camera can be lifted into position quickly for a picture. One drawback to this method, especially with a longer zoom lens attached, is the free-swinging movement of the camera. Some photographers also dislike the constant bouncing of the equipment against their bodies as they walk.

Two variations of the neck strap carry can overcome these problems. In **Figure 2-30B**, your arm is inserted through the strap, so the camera rests between that arm and the side of your body. Arm pressure keeps the camera from bouncing or swinging as you walk. The other variation is to place the strap on one shoulder, instead of around your neck, and carry the camera between your arm and body. Either variation allows the camera to be brought into shooting position easily.

A less secure method, used by some photographers who find the neck strap uncomfortable, is to carry the camera in one hand, with the strap looped around the wrist, **Figure 2-30C**. This provides some degree of safety if the camera slips out of your hand.

Jack Klasey/Goodheart-Willcox Publisher

Figure 2-30. Camera carrying methods for an SLR. A—Strap around the neck and the camera in front of the body. B—One arm through the strap, with the camera between the arm and body. C—Camera held in one hand, with the strap looped around the wrist for safety.

Compact cameras and camera phones are often carried in a pocket, purse, or small case clipped to the belt. If it has a wrist strap, a camera or camera phone can be carried in the hand with a strap used for safety. Allowing a camera to swing free, supported only by the wrist strap, is poor practice because the camera could be damaged by striking a hard object.

Camera Support Methods

Two kinds of blur that can be seen in photographs are those caused by subject motion and those caused by camera movement. Camera support methods and devices are used to avoid blur by holding the camera motionless during the vital period when the shutter is open. That period may range from a fraction of a second to minutes. The camera to be supported might be a tiny point-and-shoot weighing a few ounces or a large studio view camera weighing several pounds.

Hand-Holding a Camera

Poor hand-holding technique is the most common cause of blur due to camera movement. When proper methods are used, the human body can be an effective camera support, allowing photos to be taken at fairly slow shutter speeds.

Effective hand-holding begins with using the correct grip. The camera should be held with both hands in a firm but relaxed grip. Clenching the camera body too tightly is tiring and more likely to make your hands shake.

Most professionals recommend holding an SLR camera as shown in **Figure 2-31**. Use the fingers and palm of your right hand to grip the right end of the camera, leaving the index finger free to press the shutter release. This positioning permits the thumb to be used to operate the manual film advance lever if the camera has one.

Cradle the lens with the fingers of your left hand, allowing the left side of the camera's baseplate to rest on the heel of your left palm. This provides support for the weight of the camera and allows you to use your fingers to rotate the lens barrel for manual focusing or zooming.

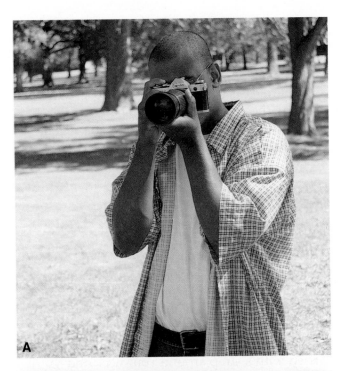

Jack Klasey/Goodheart-Willcox Publisher

Figure 2-31. Holding an SLR camera. A—Horizontal camera position. B—Vertical camera position.

Your head is also part of the camera support system. When the camera is held horizontally, **Figure 2-31A**, the back should be pressed lightly against your nose and cheek as you look through the viewfinder. In the vertical position, **Figure 2-31B**, your forehead and nose help to hold the camera steady.

Proper positioning of your arms and good breath control provide additional steadiness. When holding the camera horizontally, tuck your elbows in against your sides. Like your handgrip on the camera, elbow pressure should be firm but light—pressing too hard can cause you to shake. If you are using the vertical position, only one elbow will be tucked into your side.

Most people who take photos with a digital compact camera, and some who shoot with SLRs, use the LCD screen to compose their shots. To see the LCD, the camera must be held a comfortable distance away from the eye, **Figure 2-32**. For steadiness, arm positions should be the same as those used for SLRs. Compact cameras are often gripped with the thumb and index finger of both hands. Holding the camera one-handed or at arms-length can cause camera shake, although this method is commonly successful when shooting selfies with a camera phone, **Figure 2-33**.

When you are ready to make an exposure with any handheld camera, take a deep breath, then exhale about half of it. Press the shutter release with a light, steady movement of your index finger. Jabbing the shutter release with a quick, sharp movement will almost always cause camera blur.

Medium format cameras of the twin-lens reflex type are usually held at waist or chest level, rather than eye level. While the method of breathing and pressing the shutter is the same as used for 35 mm cameras, the grip and steadying

Caroline Klasey

Figure 2-33. The popular selfie, such as this one taken in the Roman Forum, is typically shot with the camera held in one hand at arm's length. Care must be taken to avoid blurring from camera shake.

Jack Klasey/Goodheart-Willcox Publisher

Figure 2-32. Compact camera shooters most often use the LCD as a viewfinder, extending their arms to obtain a good view.

methods differ. The camera is grasped at both sides and pulled downward to place tension on the neck strap. This tension helps hold the camera steady during exposure.

At times, you may be taking photos from a sitting, kneeling, or lying position. **Figure 2-34** shows methods of properly supporting the camera when using these positions to achieve more creative camera angles.

Shutter Speeds for Hand-Holding

The slowest practical shutter speed for most people is 1/30 second; a few can achieve acceptable results at 1/15 second. Those speeds, however, are with 50 mm or shorter lenses. As focal lengths increase, shutter speeds for hand-holding must become faster. Digital cameras display a flashing "shake warning" in the viewfinder when the speed is too slow for a hand-held exposure.

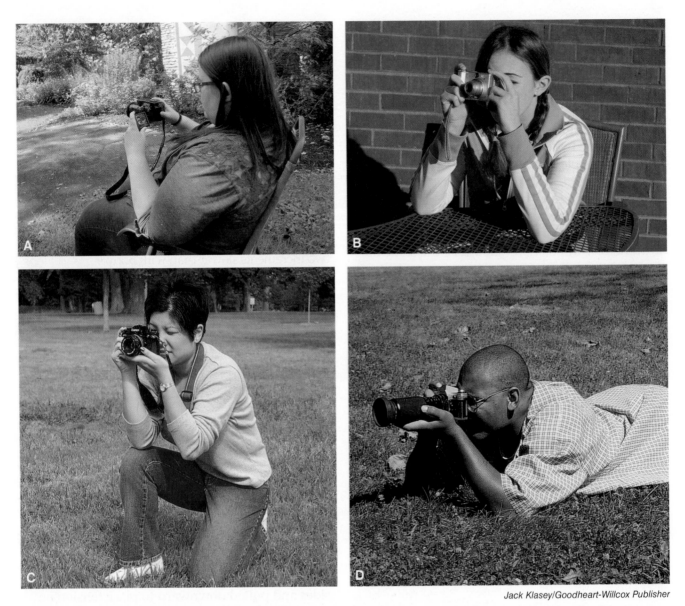

Jack Klasey/Goodheart-Willcox Publisher

Figure 2-34. Additional methods for steadying a camera. A—Using chair arms for support while sitting. B—Placing elbows on a table or other support surface when sitting, standing, or kneeling. C—Sitting back on your heels and resting one elbow on the heavy muscle of your thigh, when in a kneeling position. D—Using your chest and elbows as the three legs of a tripod when lying on your stomach.

The denominator, or bottom number, of the shutter speed fraction should be larger than the focal length of the lens to decrease the chance for camera movement. If you are using a 100 mm lens, for example, your shutter speed should be 1/125 second or higher; with a 300 mm lens, shoot at 1/500 second or faster. There are both physical and optical reasons for this practice. Physically, longer focal length lenses extend farther from the camera and are often heavier than short lenses, making them harder to hold steady. Optically, you are dealing with a magnified image of a distant object, so any movement is exaggerated. See **Figure 2-35**.

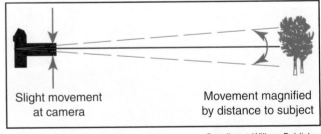

Goodheart-Willcox Publisher

Figure 2-35. When a telephoto lens is focused on a distant object, the slightest movement of the camera is greatly magnified.

By selecting a shutter speed to match the focal length, you improve your chances of overcoming the effects of lens weight and exaggerated movement. The faster shutter speed is a thinner slice of time, capturing the image before movement is detectable.

The introduction of anti-shake or *stabilizing systems* in digital cameras has made it easier to avoid camera shake when hand-holding. Many cameras are using stabilization to permit handheld exposures at up to four shutter-speed increments lower than normally possible. With stabilization, a shot that would normally require a 1/500 second shutter speed to avoid blur from camera movement might be successfully made at a speed as low as 1/30 second. See **Figure 2-36**.

There are two basic approaches to stabilizing images—lens-shift and sensor-shift. Both systems combat camera shake by detecting movement and making a compensating movement of a lens element or the image sensor in the opposite direction.

In effect, this cancels out the unwanted movement. Even with the advantage of a faster shutter speed or anti-shake technology, using proper holding and support techniques are vital to avoid camera movement.

Camera Support Devices and Methods

In addition to the body as a support system, there are many other ways to steady a camera. Some of these provide greater convenience or comfort, while others permit shooting at shutter speeds one or two increments slower than with body support alone.

Monopods

The *monopod*, **Figure 2-37**, is a one-legged device that combines improved camera support with good mobility, especially when telephoto lenses are used.

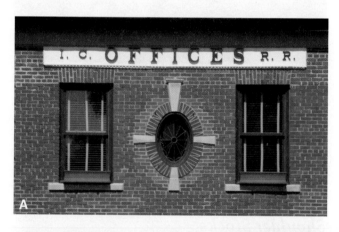

Jack Klasey/Goodheart-Willcox Publisher

Figure 2-36. Shots made with and without stabilization. A—This handheld exposure, made at a focal length of 460 mm with a shutter speed of 1/30 second, is very sharp with stabilization. B—Without stabilization, a handheld exposure made at the same settings shows significant blurring from camera shake.

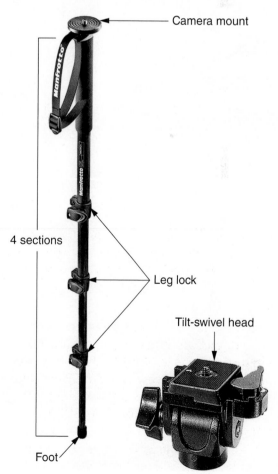

Manfrotto

Figure 2-37. This monopod has four telescoping sections. The tilt-swivel head at lower right can be attached to the camera mount for easy leveling of the camera. The head has a quick-release plate and mechanism.

This makes the monopod a favorite for those who shoot sports and similar activities. A typical monopod has three to four telescoping sections, allowing it to extend to about 5′ for use and collapse down to about 18″ for storage. All monopods have some device for mounting a camera at the top. Ideally, the mounting device should swivel and tilt to adjust the angle of the camera and be capable of being locked in place.

The monopod works in combination with the photographer's body to provide a firm and steady support. As shown in **Figure 2-38**, by spreading your feet apart slightly and then leaning into a slightly angled monopod, you can create a firm three-point support for the camera. Unlike the more cumbersome tripod, a monopod can be quickly picked up, relocated, and set up again at a different location to follow action.

Leonard Rue Enterprises

Figure 2-39. When a camera with a heavy telephoto lens is used to photograph birds and similar types of fast-moving subjects, the shoulder stock is a handy accessory.

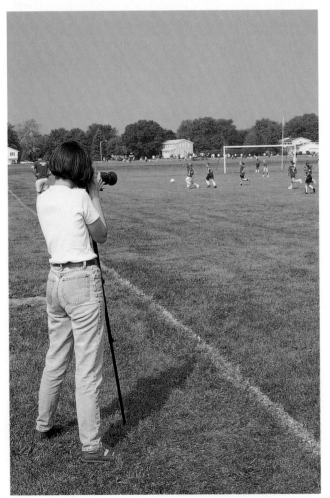

Jack Klasey/Goodheart-Willcox Publisher

Figure 2-38. By forming a three-point support with the monopod and her two legs, the photographer provides a steady camera platform. This is a particular advantage when using a longer lens, which magnifies unwanted movement.

Shoulder Stocks

Wildlife photographers, especially those whose subjects move rapidly and unpredictably, frequently mount their cameras on a shoulder stock, **Figure 2-39**. Since these photographers typically use lenses of 300 mm and longer, the rifle-like stock helps them to better track their target and steady the camera during exposure.

Clamping Devices

One of the most widely used types of clamping support devices is the vehicle window clamp, **Figure 2-40**. Since wild creatures frequently allow a car or truck to approach them more closely than a human on foot, window clamps are the mount of choice for this type of photography. Before shooting, the vehicle engine must be shut off to eliminate vibration.

A

Figure 2-40. This window clamp, called the Groofwin Pod™, is designed for use as a ground-level camera support, a window clamp, or a support on a car or truck roof for large-animal photography.

Other clamping devices, **Figure 2-41**, permit mounting a camera on various supports ranging from door edges and chair backs to walls or tables, fence rails, pipes, or tree limbs. These devices must include some form of camera mount that can be rotated and adjusted for proper leveling.

Beanbags and Onsite Supports

A beanbag is a small pillow-shaped cloth bag filled with dry beans, rice, or similar materials. The beanbag can be placed on a surface and conform to the shape of the camera or lens. The support provided is firm enough that even a time exposure can be made if a shutter release or the camera's self-timer is used to trip the shutter. **Figure 2-42** shows a beanbag, as well as the use of typical onsite supports. These are surfaces that can be used to rest the camera on or against to provide extra support and steadiness.

B

Figure 2-41. Clamping devices for mounting cameras. A—This clamp with ball head can be used on chair backs, doors, table edges, or similar surfaces. B—For flat nonporous surfaces, including walls, ceilings, windows, and even vehicle bodies, a vacuum clamp provides strong and secure camera support.

A

B

C

Kinesis; Jack Klasey/Goodheart-Willcox Publisher

Figure 2-42. Camera support techniques. A—A beanbag filled with beans, polystyrene beads, sand, or water, holds a camera steady enough to make a time exposure. B—Resting a camera on a firm surface helps to avoid movement. C—Extra support can be obtained by pressing the camera against a solid structure, such as a post, door frame, wall, or tree.

Tripods

The best type of camera support is a sturdy and well-made *tripod*. Its design, with each leg's length independently adjustable, allows it to be firmly set in place on almost any kind of terrain. When mounted atop the tripod, the camera can be adjusted to the desired orientation and locked in position. Exposures of any length can be made with little danger of camera movement. Tripods are manufactured in many sizes, from small tabletop models to large, heavy units suitable only for studio use.

Basic components of the tripod are identified in **Figure 2-43**. They consist of the following:

- **Quick-release mechanism.** Part of the tripod head, this mechanism allows rapid dismounting and remounting of the camera.
- **Tripod head.** The device that connects the tripod to the camera and allows various degrees of rotation.
- **Center column or centerpost.** A vertical shaft used on some tripods that can be extended and locked in place.

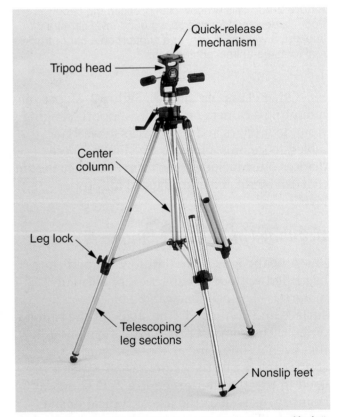

Manfrotto

Figure 2-43. A sturdy tripod is the best camera support available. Basic parts of a tripod are shown.

- **Leg-locking mechanism.** Each leg section needs one to hold it at the desired amount of extension.
- **Telescoping leg sections.** Each leg section can be extended independently.
- **Nonslip feet.** Most feet are rubber for use on smooth or hard surfaces. Some feet can retract to expose spikes for a better grip on soft surfaces.

Traditionally, tripods have been made of aluminum or well-seasoned wood to strike a balance between sturdiness and weight. In recent years, carbon fiber-reinforced composite, a material with an excellent strength-to-weight ratio, has become popular.

Tripod Legs

Better-quality tripods are typically sold as legs-only, **Figure 2-44**, since photographers have different needs and tastes in tripod heads. Although there are several leg patterns, the most common type consists of three or four tubular sections nesting inside each other. The locking mechanism is usually either a lever-type or a collar that is rotated to lock or release the section. When fully closed, legs are usually 18″ to 24″ in length, although some large, heavy-duty tripods may be more than 3′ long when closed. Fully extended, the tripod may be less than 5′ in height, or more than 8′. A practical height for most photographers is between 5 1/2′ and 6′, without the centerpost extended. This height allows the camera to be placed at a comfortable eye-level position.

Tripod Heads

The device attached to the tripod legs to allow mounting and positioning of a camera is typically referred to as a *tripod head*. Depending on the

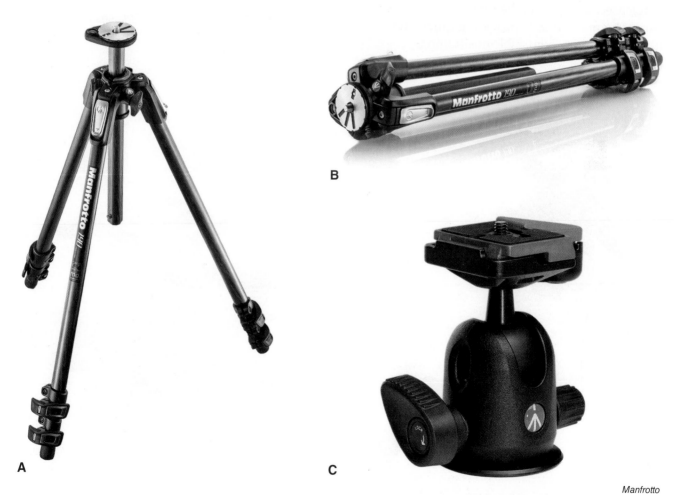

Manfrotto

Figure 2-44. Tripod legs. A—This set of tripod legs is made from strong, lightweight carbon fiber. With the centerpost extended, its height is almost 6′. B—For storage or transportation, the legs can be folded down to only 15″. C—For positioning a camera, a tripod head must be attached to the legs.

method used for positioning the camera, tripod heads can be classified into one of two general categories—pan heads and ball heads.

A pan head allows you to move the camera in either two or three axes. As shown in **Figure 2-45**, a two-axis head can tilt the camera forward or backward, or pan from side-to-side. A three-axis head, or pan-tilt head, allows tilting from side-to-side, as well as forward and back. A variation of the pan-tilt head, the gearhead, uses gears rotated with cranks or knobs to achieve even greater precision of movement.

Although they provide excellent control of the camera's positioning, pan-tilt heads are rather cumbersome and slow to operate. Many photographers have switched to a *ball head*, which uses a single control to lock the camera in position, **Figure 2-46**. A typical ball head has a camera platform attached to a highly polished metal sphere contained in a housing. When a locking device, such as a lever or knob, is released, the ball can be rotated 360° and tilted through an arc of 180°, providing quick and almost infinitely adjustable positioning.

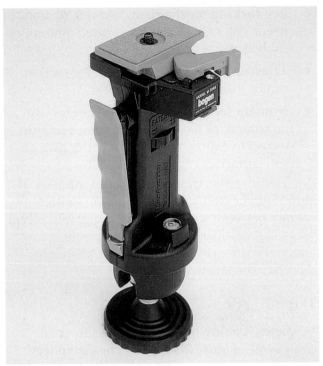

Manfrotto

Figure 2-46. This ball head variation uses a squeeze handle to control movement. When pressure is released, the head locks in position.

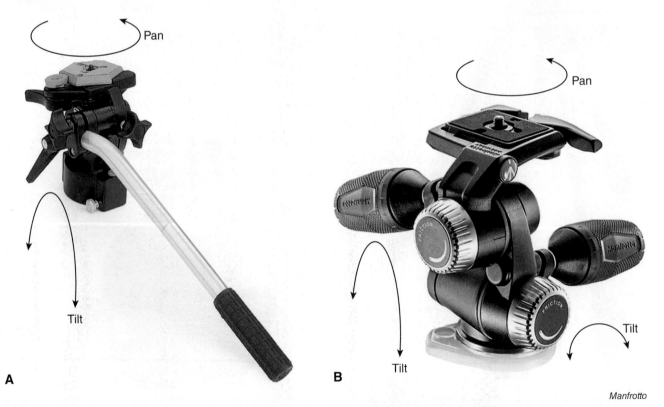

A

B

Manfrotto

Figure 2-45. Pan head operation. A—The two-axis head is able to pan (turn) horizontally and tilt forward or backward. Usually, a single handle is used to control movement in both axes. B—The three-axis head can move in a third plane, tilting from side-to-side. Separate controls are used to adjust and lock each axis.

Quick-release systems built into many tripod heads are convenient for photographers because they allow a camera to be quickly mounted or dismounted without changing any position adjustments. The two components of the quick-release system are a special mounting plate fastened to the camera and a latching mechanism that is attached to the tripod head. See **Figure 2-47**. A lever or spring control on the latching mechanism allows the mounting plate and camera to be quickly installed or released.

Tripod Advantages and Disadvantages

Some photographers make virtually every exposure with a camera mounted on a tripod; others use tripods rarely, if at all. The type of camera and the type of photography determine whether using a tripod will be an advantage or disadvantage.

Reasons for using a tripod include the following:

- Improved image sharpness through eliminating of camera shake.

- Precise camera positioning for better composition.

- Long-exposure capability due to rigid and steady support.

- Freeing your hands to shade the lens or hold a reflector, **Figure 2-48**.

Reasons for *not* using a tripod include the following:

- Weight and cumbersome shape, especially when the tripod must be carried some distance.

- Time-consuming setup and resulting lack of mobility.

- Possible tripping hazard to others in confined areas. Many museums ban tripods for this reason.

Choosing a Tripod

Your camera type and the kind of photography you undertake are major factors when choosing a tripod. Consider the following points:

- *How much weight must the tripod support?* A compact digital camera weighs only a few ounces; most SLR cameras with a zoom lens attached weigh a pound or more. Many medium format cameras will be in the 4 lb to 6 lb range, while the large format field and studio cameras may weigh as little as 8 lb or more than 20 lb.

Mounting plate

Latch

Manfrotto

Figure 2-47. Quick-release systems consist of a mounting plate that attaches to the camera body and fits into a latching mechanism on the tripod head. Some quick-release systems include mounting plates custom-made for use with specific camera models.

Jack Klasey/Goodheart-Willcox Publisher

Figure 2-48. Placing the camera on a tripod leaves your hands free for other tasks, such as using a card, hand, or cap to prevent flare from light from falling directly on the lens.

- *How much does the tripod weigh?* If you are carrying your tripod any distance at all, its weight can be a major consideration, especially when combined with a heavy camera bag. Aluminum tripods suitable for use in the field typically weigh from 3 lb to 10 lb, while carbon fiber units with matching capacities will be approximately 30% lighter. For use with an SLR or medium format equipment, a tripod in the 5 lb to 6 lb range is usually a good choice. It represents a good compromise between sturdiness and weight. The lighter (3 lb–4 lb) tripods are a good choice for photographers who backpack for considerable distances. The tradeoff, of course, is that they are not as sturdy.

- *How well made is the tripod?* To provide a solid support for your camera, a tripod must be strong and rigid, even when fully extended. Leg-locking mechanisms should operate smoothly, but hold the leg position securely. If the tripod has a centerpost, it should move up and down smoothly, without binding, and lock firmly in position. The tripod should have nonslip feet of rubber, not plastic. Retractable spikes for soft surfaces are a desirable feature. The tripod head should be sturdily made, and all controls should operate smoothly and positively.

Jack Klasey/Goodheart-Willcox Publisher

Figure 2-49. When properly set up, a tripod should have one leg pointing toward the subject.

Using a Tripod

When setting up a tripod, extend it to full height unless you know you will be shooting from a lower vantage point. Fully extend and lock the bottom leg sections. Follow suit with the middle sections, then spread the legs and stand the tripod on the ground or floor.

Position the legs so one of the three is pointing toward the subject, **Figure 2-49**. This provides you with more working room between the two legs to the rear, and adds some support and rigidity beneath the extended lens.

Make any necessary leg height or angle adjustments. Try to avoid extending the centerpost more than a few inches—the taller the centerpost extension, the greater the danger of sharpness-destroying vibration. Adjust the tripod head to properly position the camera and frame the subject. Long, heavy telephoto lenses usually

need additional support, such as the special mounting brackets shown in **Figure 2-50**.

For maximum sharpness, eliminate all possible causes of camera movement, even vibrations caused while opening the shutter. If your camera offers mirror lockup, use that feature to eliminate possible vibration caused by the viewing mirror flipping up out of the light path when the shutter release is pressed. Use a cable release, electronic remote control cord, or the camera's self-timer to trip the shutter.

Camera movement can be caused by wind, especially if it comes in intermittent gusts. The classic solution to this problem is to suspend a weight, such as a heavy camera bag, from the tripod to provide greater stability. Some photographers use a container made from canvas or a similar strong fabric and fill it with rocks or sand at the site.

A

B

Manfrotto

Figure 2-50. Longer telephoto lenses are usually mounted with a tripod collar or some form of bracket to steady them and prevent their weight from placing stress on the camera body's lens mount. A—This mount features a support for the front of the lens and a strap to hold the lens firmly in place. B—This bracket provides adjustable support for a long, heavy lens.

Check Your Photography IQ

Now that you have finished this chapter, see what you learned by taking the chapter posttest.

www.g-wlearning.com/visualtechnology/

Review Questions

Answer the following questions using the information provided in this chapter.

1. Which exposure mode should be selected when you want to control depth of field?

2. The night scene preset exposure mode uses both flash and a slow shutter speed. What is the advantage of using this mode?

3. A(n) _____ is a bar graph showing all the tonal values of an image.

4. Automatic white _____ adjusts the camera's response to make a white object appear white under specific light conditions.

5. To capture an image that will produce an excellent 7″ × 10″ inkjet print, the JPEG quality setting of your 6Mp camera should be set to _____.

6. The more an image file is compressed, the greater its _____ loss.

7. Cameras must be protected from both _____ and dust.

8. Why should you turn off the camera before changing lenses?

9. To remove dust from the sensor, use a(n) _____, not a blower brush or canned air.

10. A swab with a small amount of solvent is used to clean adhered dust particles from a digital camera's _____.

 A. LCD

 B. viewfinder

 C. sensor cover plate

 D. UV filter

11. Blurring in a photograph can be due to _____ or _____.

12. When hand-holding a camera with a 50 mm lens, _____ second is the slowest practical shutter speed for most photographers.

13. Why is camera shake more apparent when longer focal length lenses are used?

14. The two basic image stabilizing approaches are lens-shift and _____.

15. List at least three types of camera support other than a tripod.

16. A material that is commonly used for tripods because of its excellent strength-to-weight ratio is _____.

17. A tripod head that uses a single control to lock the camera into position and provides quick and almost infinitely adjustable positioning is the _____ head.

18. A quick release system uses a(n) _____ fastened to the camera and a latching mechanism on the tripod head.

19. Cite several reasons for and against using a tripod.

20. A tripod used with a large format field camera might have to support _____ pounds or more.

21. If a shutter release device is not available, the _____ shutter release option can be used to minimize camera shake.

Suggested Activities

1. Using a digital camera, tablet, or smartphone that has a continuous shooting (burst mode) feature, photograph an interesting moving subject, such as a high jumper at a track meet or a skateboarder doing tricks. Review the individual shots and select three of them to show a sequence of motion. Use the slideshow feature to play back the sequence.

2. Plan and deliver to your class a short demonstration on setting up a tripod. Your demonstration should include extending and locking the tripod legs, leveling the tripod, attaching the camera, using the centerpost (if so equipped), and operating the ball head or other camera-mounting device.

Critical Thinking

1. You are going on a vacation to the seashore, where you will be spending time on the beach, in boats, and other activities that could cause damage to your camera. What different hazards might you encounter? What steps could you take to protect your equipment?

2. The exposure compensation feature found on many digital cameras allows you to increase or decrease exposure in the shutter priority, aperture priority, or program AE exposure modes. It cannot be used in the *Automatic* or *Manual* exposure modes. Why do you think this feature can't be used in those modes?

Communicating about Photography

1. **Speaking and Writing.** In small groups, discuss the appropriate use of tripods and other camera support equipment. Talk about the advantages and disadvantages of using tripods in various situations. Compile a list of various photographic situations and the best camera support choice for each situation. Present your conclusions to the class.

2. **Speaking and Listening.** In groups of three students, choose a digital camera feature or control, such as the histogram or built-in flash. Explain the feature or control in a presentation to the class using visual aids. Take notes while other students give their presentations. Ask questions about any details that you would like clarified.

Photographic assistant: Person who aids a photographer with a variety of tasks in the studio and on location.

While studying this chapter, look for the activity icon ⬈ to:

- **Assess** your knowledge with self-check pretest and posttest.
- **Practice** vocabulary terms with e-flash cards and matching activities.
- **Reinforce** what you learn by submitting end-of-chapter questions.

G-WLEARNING.com

www.g-wlearning.com/visualtechnology/

Jack Klasey/Goodheart-Willcox Publisher

Commerical Photography

Objectives

When you have finished reading this chapter, you will be able to:

- Define the term *commercial photography.*
- Describe the skills and career preparation needed to enter the commercial photography field.
- Describe the four different forms of business organization.
- Identify several different ways of financing a new photography business.
- Compare various methods of marketing a photography business.
- Identify social skills needed to work effectively with clients and with fellow professionals.
- Explain the importance to a photographer of retaining all rights to an image.

Check Your Photography IQ 📳

Before you read this chapter, assess your current understanding of the chapter content by taking the chapter pretest.

www.g-wlearning.com/visualtechnology/

Technical Terms 📳

business plan	marketing
contract	partnership
corporation	photographic assistant
e-commerce capability	profit
entrepreneurship	sole proprietor
intellectual property	targeted marketing
internship	

Ansel Adams, **Figure 3-1**, is probably the most widely-recognized name in photography. His dramatic images of scenes in the American West brought him fame as a fine-art photographer. However, for most of his career, his major source of income was commercial photography. Adams sold family portraits, advertising and publicity photos for industrial and utility companies, and illustrations for books and magazine articles. See **Figure 3-2**. Although income from selling his landscape images grew steadily from the time he began selling them in the late 1920s, he depended on commercial photography assignments until the 1970s.

Programs in most colleges and technical schools focus primarily on the artistic and technical aspects of photography. Their aim is to provide students with the photographic skills and abilities needed to produce good images.

To be successful, however, an aspiring photographer also must develop business and social skills. This chapter is designed to help you learn about the business side of photography, including such areas as getting a job in the field,

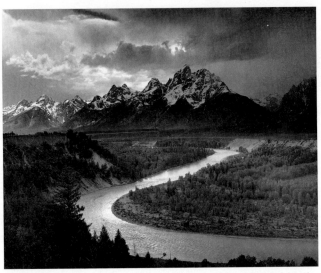

Figure 3-2. Adams' image *The Tetons and the Snake River* was made in 1942 as part of a commissioned project to photograph scenes in national parks for the US Department of the Interior.

starting and operating your own photographic business, and working with clients, employees, and independent contractors.

What Is Commercial Photography?

As noted in Chapter 1, commercial photography is *an occupation in which photographic skills are used to create images in exchange for payment.* While that definition applies to the fairly small number of photographers who make a living from selling their fine-art prints, it usually describes someone who works in the fields of portraiture, advertising/product photography, or photojournalism.

About one-third of all commercial photographers work in salaried positions with publications, corporations, government agencies, or studios. The remaining two-thirds are self-employed individuals who have started independent businesses. These businesses range from specialized single-person operations, such as freelance news photography and studios doing only weddings or portraits, to companies with a number of employees handling assignments as varied as school pictures, event coverage, catalog photography, and industrial/corporate assignments, **Figure 3-3**.

Figure 3-1. Ansel Adams shooting on location in about 1947.

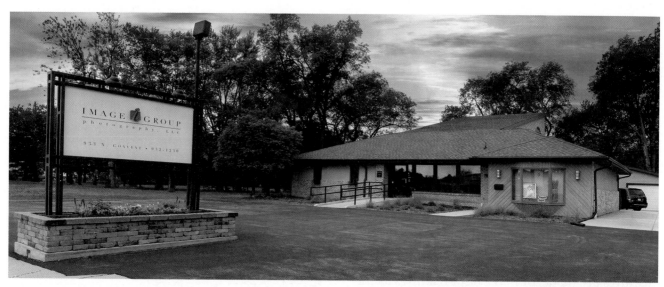

Image Group Photography, LLC

Figure 3-3. This photography business serves a wide variety of clients, handling both studio and on-location assignments.

How Do You Enter the Commercial Photography Field?

There are a number of paths to employment in commercial photography. Jobs in a photographic organization almost always require formal education, practical experience, or a combination of the two. While some successful photographers began their careers in entry-level jobs requiring few or no photographic skills, they are a rarity today.

The most common type of career preparation is formal education at a traditional college or university, at a specialized technical school, or an online institution. College or university programs leading to a four-year degree provide a broad education that includes both training in photographic skills and classes in the humanities. Strong emphasis is placed on the artistic aspects of photography.

Community colleges and technical schools (both classroom-oriented and online) offer two-year or shorter programs, with primary emphasis devoted to learning photographic skills. Some of these programs include classes to prepare students for running a photo business. See **Figure 3-4**.

An important benefit offered by some educational programs is the opportunity to work in a photographic business as an intern.

Randolph, North Carolina Community College

Figure 3-4. Community colleges offer two-year programs in a variety of photographic areas.

An *internship* normally is done for academic credit and may be paid or unpaid. Internships give students experience in a working environment, such as a newspaper, a corporate photo department, or a portrait studio. They typically last a school semester or several summer months. Making a good impression while serving as an intern may lead to a job offer following graduation.

Working as a Photographic Assistant

For many graduates, the next step in developing a career is seeking work as a *photographic assistant*. Depending mostly on the size of the community, an assistant may be an employee of a single studio

or company, or may be an independent contractor working on assignments for different photographers. In larger markets such as New York or Los Angeles, most assistants work on a job-by-job basis. One day they may be helping on a product photo session at a studio; the next day they might be on location for a fashion shoot with a different photographer.

Although she or he will not be (at least initially) shooting photographs, an assistant must have well-developed photographic skills. A thorough knowledge of lighting is important because an assistant usually sets up and adjusts lighting equipment to the photographer's specifications. The assistant may also sit in for a model while light reading and color temperature readings are made, or make light readings as the shoot progresses, **Figure 3-5**.

An assistant is expected to perform many duties that are not photographic in nature.

These might include answering the studio telephone, arranging catering for a daylong location shoot, and picking up clients at the airport. Since he or she will often be working closely with clients, models, and others involved in the photographic process, an assistant must have good people skills.

Working as an assistant provides a great deal of practical experience in the different aspects of the commercial photography business. Experience as an assistant could result in promotion to a photographer's duties with the studio, being hired as a photographer by another studio, or launching your own photographic business.

Entrepreneurship

Many photographers, as well as people in other fields, have a goal of working for themselves. Starting and operating your own business is called *entrepreneurship.* There are a number of approaches to starting a photographic business.

Many entrepreneurs begin doing commercial photography on a part-time basis while relying on a full-time job for regular income. They typically seek assignments that can be done on evenings and weekends. Since few part-timers have access to studio space, they most often contract to do weddings or similar celebrations, **Figure 3-6**, youth team photography, and informal portraiture, often in outdoor settings.

Operating a part-time photography business poses less financial risk and needs a smaller amount of capital than setting up a full-time operation, but still requires a sound business approach. For example, you must realistically identify your business costs before pricing your work. If income is not greater than expenses, your business will not survive.

Another means of becoming an owner is to go into partnership with a photographer who has an established business. This method requires capital—you are buying a share of the business. It also requires strong photographic skills and a good reputation, since you will be expected to "pull your weight" in the new partnership. Some business owners take on a partner as a means of expanding and improving their business; others may be looking forward to retirement and see the new partner as a potential successor.

Instead of buying a share of a business, you can purchase a going business outright.

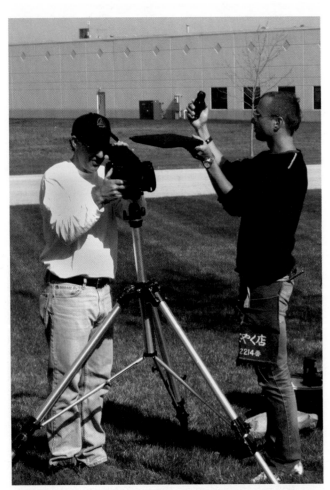

Jack Klasey/Goodheart-Willcox Publisher

Figure 3-5. On a location shoot, an assistant makes an incident light reading while also shading the camera lens to avoid glare.

Eric Penrod Photography

Figure 3-6. Many part-time commercial photographers devote their weekends to shooting weddings.

This method requires a considerable investment, but provides you with an established customer base, a known business name, and a fully-equipped business location.

Creating a new full-time business of your own is often the most expensive and riskiest approach. You will need a good credit record and enough capital to acquire and equip your office/studio and to cover operating expenses until you begin making a profit. You also will need to devote considerable time and money to attracting and keeping paying clients. While this entrepreneurship path is the most difficult to follow, many choose it because it provides opportunity for considerable personal satisfaction and financial success.

Setting Up Your Business

The first step you must take when going into business is to determine which form of organization to use. There are four basic business types, as shown in **Figure 3-7**.

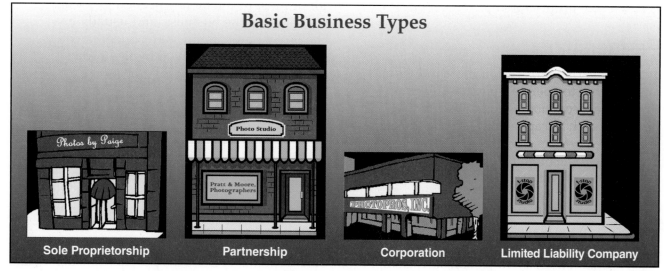

Goodheart-Willcox Publisher

Figure 3-7. Businesses can be organized in different ways.

Each form of organization has its advantages and disadvantages. The type you choose will be determined by your specific needs and interests. The four business types are described in the following sections.

Sole Proprietorship

The federal government defines a *sole proprietor* as *someone who owns an unincorporated business by himself or herself*. The owner of a sole proprietorship typically performs all the work needed to earn the business' income and pays all the expenses of operating the business. Any profit from the business belongs to the proprietor, but if it fails to make a profit, the proprietor is responsible for the unpaid debts.

As a sole proprietor, you must play many different roles beyond making photographs. You are the company's bookkeeper, purchasing agent, sales/marketing/advertising person, equipment manager, and even janitor.

Many sole proprietorships begin as, and remain, one-person businesses. Owners of such businesses are content to earn a sufficient living without the extra responsibility of hiring employees. They may, as needed, bring in assistants or other photographers as independent contractors for specific assignments. Other sole proprietors actively pursue expansion of their business, adding employees and facilities as needed to serve their customers. Even though a business might have dozens of employees and operate in several locations, if it has only a single owner, it is still a sole proprietorship.

Partnership

In a *partnership*, two or more individuals join together to operate a business. Each of the partners contributes something to the business, such as capital, property, labor, or skills. The partners share the profits or losses. This is the route often followed by newspaper photographers and other salaried workers moving into self-employment. A partnership agreement should specify what each partner will bring to the business and what share of the business each will own.

For example, in a two-person partnership, **Figure 3-8**, one partner might be contributing

Jack Klasey/Goodheart-Willcox Publisher

Figure 3-8. Business partners often bring different skills to the organization.

business skills and most of the operating capital needed, while the other partner has the photographic skills, equipment, and a studio location. Depending on the relative value of their contributions, the partners might decide on equal ownership shares or different percentages, such as 60/40 or 70/30.

Sometimes a partnership consists of a general partner and one or more *silent partners*. The general partner operates the business, while the silent partner's involvement is primarily financial. The silent partner provides all or most of the money needed to set up and operate the business, and usually has the largest ownership share. Silent partners typically are not involved in day-to-day operation of the business.

Corporation

A *corporation* is formed by individuals, called *investors* or *shareholders*, who purchase ownership in the form of shares of common stock. There may be only a few investors, each holding a large number of the total shares, or many investors, each holding a small number of shares. The investors elect a board of directors, which in turn appoints or hires the people who operate the corporation.

For example, a photographer decides to form a corporation to operate his studio business, **Figure 3-9**. The photographer and a number of family members each purchase shares of stock in the new corporation. The shareholders elect a board of directors from among themselves. The directors, in turn, appoint the photographer as the corporation's chief operating officer, or president.

Shareholders participate in the profits of the corporation in the form of dividends ordered by the board of directors. These are amounts paid, on a per-share basis, usually quarterly or annually. This means that an investor would receive the specified payment for each share of stock he or she owns. For example, if the dividend is $1, the owner of 50 shares of stock would be paid $50.

The major advantage of a corporation is limited liability. If the business fails, individual shareholders are not responsible for the debt. Only the corporation's assets can be used to pay creditors.

Limited Liability Company

Usually referred to as an *LLC*, a limited liability company is a hybrid organization that combines some of the advantages of a corporation with some of the advantages of a sole proprietorship or a partnership.

An LLC may be owned by a single individual or by two or more individuals or organizations (such as corporations or other LLCs). The owners are described as "members" and share in the company's profits or losses. Like sole proprietors or partners, the members report business income and/or losses on their personal tax returns. However, like corporate stockholders, they are not liable for the LLC's debts if the company fails. Only company assets can be used to settle with creditors.

Limited liability and tax advantages have made the LLC form of organization a favorite for photographers and other professionals.

Goodheart-Willcox Publisher

Figure 3-9. An example of a photo business organized as a corporation.

Finding Your Business Niche

What kind of photography will your business offer? What market segment (niche) will you serve? Some photographers specialize in a single area, such as portrait work, fashion, or entertainment. Others restrict their work to several related areas, such as school and team photography or product photography for clients in a particular industrial category. Still others develop a mix of clients in different areas, such as weddings, portraits, and institutional.

Deciding on your business niche is a process that combines your personal interests and skills with information gathered through market research. That research is a key element of the business plan you will develop before seeking funding to start your business.

Researching your market will take into account several factors, including the following:

- Size of your community or trade area.

- Your area's economic and population characteristics.

- The number and sizes of established commercial photography businesses.

- The types of photography done by businesses in your area.

- Purchasing patterns (for example, do people typically buy from local businesses, or tend to go to a nearby large city to make purchases?).

As part of your research, look for unserved or underserved areas of the market. For example, you may find that while teams in the local Little Leagues and other sports all have contracted with photographers, no one is doing group and individual portraits for dance studios, gymnastics schools, or competitive swimming programs. If you determine that they would be interested in photographic services, you have identified an area with potential clients, **Figure 3-10**.

The size and location of the community where you open your business may be a limiting factor in the type of photography you plan to do. In a small- to medium-size community located far from a major city, it could be difficult to succeed in a business specializing in high-fashion or food photography. Being located in or near cities like New York, Chicago, Los Angeles, Atlanta, or Dallas would provide many more opportunities in such fields.

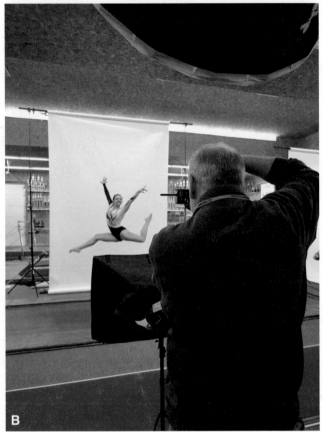

Image Group Photography, LLC

Figure 3-10. Photographing gymnastics school students. A—Posed portrait. B—Action portrait.

While many photographic businesses successfully pursue a specialty, others find a mix of photography types and clients helps them to stay in business and prosper. They follow the model used by many stock market investors— selecting stocks and bonds from a variety of industries and fields

so a decline in one area does not affect the others. At one successful studio in a medium-size Midwestern city, 30% of the work is in weddings and portraits; another 30% is school photography (elementary through college); and the remaining 40% is a mix of industrial, advertising, event, and institutional assignments. The variety of photographic work, with a base of several institutional and industrial clients, helps the studio survive fluctuations in the economy.

Financing the Business

Starting and operating a business takes money. How much money is required depends on a number of factors:

- Will the business be operated from your home, or will office/studio space have to be purchased or rented?

- Will you need to replace, upgrade, or add to your current photographic equipment?

- How much money must be available to pay for business licenses and fees, insurance, taxes, and other business expenses?

- Will you have an income source to pay living expenses until the business starts generating cash flow?

Starting a Part-Time Business

If you begin your photography business on a part-time basis, you will most likely not need to rent or buy studio space because most work will be done on location. While you may already have the basic equipment, you will probably have to upgrade to better quality lenses or add tools such as a portable lighting kit. If you plan to rent photo equipment for specific needs, you must be sure your credit limits are adequate to satisfy the rental company. Good credit is also a must when dealing with suppliers, such as firms that produce wedding or portrait packages. A realistic calculation of what you will need to meet business expenses is critical. To pay your living expenses during the start-up period of your business, you need an income source. A paycheck from other employment, savings or investments, a loan from a financial institution, or support from parents, a spouse, or other individual would be required.

Starting a Full-Time Business

Starting a full-time business from scratch multiplies your financial needs. Acquiring, preparing, and equipping a studio/office location is a major expense, especially if you will be providing a complete range of services (shooting, postproduction, and printing). See **Figure 3-11**. Compared to the part-timer's investment, a larger and more sophisticated array of equipment will be needed. Insurance and other business costs will also increase. A more extensive, and thus expensive, marketing effort will be necessary to bring in enough business to pay the increased costs. An employee, possibly part-time, may have to be hired to staff the business while you are busy shooting.

Seeking Funding

Where will you find the money needed to become a partner in an existing photography business or to start your own? Actually, before you look for financing, you must determine how much money you will need.

The US Small Business Administration recommends that you carefully estimate the costs of doing business for the first months of operation. These include one-time costs, such as a sign in front of the building, and ongoing costs.

Ongoing costs fall into two categories. Fixed expenses include insurance, utilities, and services with a monthly fee. Variable expenses include business supplies, equipment purchase or rental, services of independent contractors such as assistants or makeup artists, and shipping costs.

Image Group Photography, LLC

Figure 3-11. Postproduction services are an important part of a commercial photography business.

Your estimates should include only costs essential to starting the business, such as a professional-level camera system. Optional items, like a high-end music system for your office, should not be part of your estimate.

Once you know how much you will need, you can begin to seek financing. If you are self-funding the start-up from your savings or investments, or are being financed by family members or close friends, your cost estimate could be all you need.

Seeking a loan from a financial institution or a government program requires another step—preparing a business plan. (This step might be needed to borrow from family or friends, as well.) A *business plan* is a document that describes your proposed business in detail and lays out a roadmap for its growth over a period of up to five years. The plan includes sections describing the company and the products/services it will offer, an analysis of the market it will serve, sales strategies and marketing plans, detailed information on your estimated costs, and a financial projection of income and expenses for two to five years.

For help in preparing a business plan, you can attend seminars or classes offered by local community colleges or such organizations as SCORE, a nonprofit organization that helps small businesses get started and grow. The US Small Business Administration's website, **Figure 3-12**, offers extensive information on business planning and seeking financing.

Staffing Your Business

Many self-employed photographers operate one-person businesses and have no employees. Certain tasks are contracted to firms or individuals who provide such services as legal work, bookkeeping, and office/studio cleaning. Photographic assistants are hired as independent contractors for specific assignments, and postproduction work also may be done by an independent contractor.

Growth of the business and demands on the photographer's time are often the major factors in deciding to hire one or more employees. By adding people to handle various business tasks, **Figure 3-13**, the photographer is freed to perform the primary work of creating images for clients.

That freedom comes at a price, however, in the form of added paperwork and expense. Once a company has at least one employee, it must meet government regulations for such matters as wages and hours of work, working conditions, and safety on the job. It must also handle deductions from the employee's pay for income and Social Security taxes and pay the company's share of taxes for Social Security and unemployment compensation.

Building Your Business

A vital activity, across the entire lifespan of your business, is the finding, acquiring, and keeping of clients. This activity, called *marketing*, can be defined as *everything you do to acquire customers and establish an ongoing relationship with them.*

SBA.gov

Figure 3-12. The US Small Business Administration website.

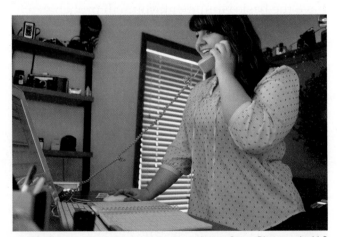

Image Group Photography, LLC

Figure 3-13. As a business grows, employees are hired to handle various responsibilities.

As noted earlier in this chapter, an important first step is marketing research to determine what business niche your company will serve. In other words, you must identify your potential clients. The next step is to develop a plan to attract those clients to your business. For some businesses, like a fast-food restaurant chain, almost every human being is a potential client. For others, such as a studio specializing in pet portraits, there is a much smaller and more specific group of potential clients.

The first type of business uses a mass marketing strategy, while the second uses a targeted marketing approach, **Figure 3-14**. Mass marketing involves large-scale advertising efforts—heavy use of national television spots and extensive advertising in newspapers and magazines. *Targeted marketing* is much more selective, using local media (radio, television, print), advertising in publications that are read by the desired group of potential clients, taking part in events likely to be attended by the potential clients, and so on.

Marketing Methods

Many different methods can be used to attract clients to your photographic business. Traditional media advertising includes print advertising in newspapers and magazines and broadcast commercials on radio and television. While media advertising can be effective when carefully used, it involves considerable expense.

Another traditional method of reaching potential clients is direct mail, in which printed materials are tailored to and delivered to selected people, **Figure 3-15**. Lists of names and addresses of people in particular categories—for example, high school seniors or antique car club members—are rented or purchased for targeted mailings.

Direct telephone contact with possible clients, sometimes called *cold calling*, has developed a negative reputation and probably should be avoided. However, using the telephone to follow up with people who have expressed interest in your product (for example, by returning a postcard or responding to an e-mail) can be very effective.

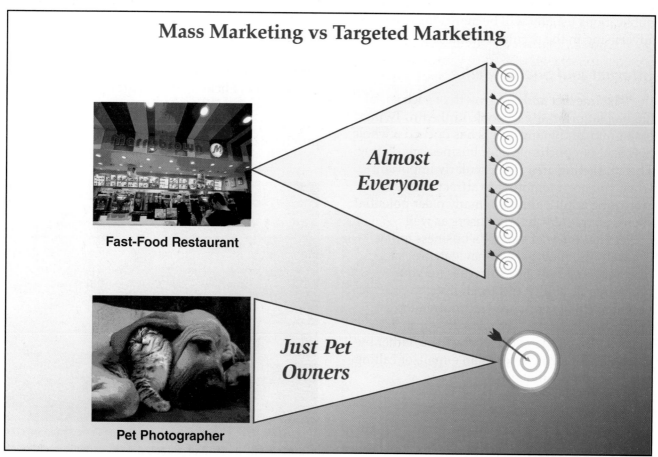

Goodheart-Willcox Publisher

Figure 3-14. Mass marketing is aimed at a broad audience, while targeted marketing is directed to a specific group.

Figure 3-15. Targeted marketing direct mail piece. A—Front of card. B—Back of card.

Participating in events designed to attract certain groups, such as a bridal show at your local shopping mall, lets you interact with exactly the people you want to reach. Newspapers and local magazines often produce special editions or sections devoted to a particular topic. An advertisement in one of these targeted publications usually will be more effective than advertising in the regular editions.

Internet and Social Media

The Internet and the growth of such social media platforms as Facebook, LinkedIn, Twitter, Instagram, and many others has opened a whole new set of opportunities for business marketing. This marketing area is particularly important when you are attempting to attract clients who are young adults, although many older potential clients are regular Internet users as well.

A vital Internet tool for a business today is a well-designed, easy-to-navigate website. The website serves as a showcase for your photographic ability and creativity and provides potential clients with needed information about your business. The site's design should make it easy for people to contact you, either by completing a form, sending an e-mail, or calling your telephone number.

Ideally, your website should have *e-commerce capability*, so clients can view images and order prints or other products. Many portrait and wedding photographers use this system, eliminating the need for printed proofs. After the wedding or portrait session, the images

are processed and the client makes selections. See **Figure 3-16**. The selected images are then posted in a gallery on the studio's website. The client is provided with a password to access the gallery so family and friends can view images and order the desired prints. See **Figure 3-17**. Payments for the print orders are made by credit card.

Social networking and photosharing sites provide greater exposure of your work and are a mechanism to draw people to your website through links in your postings. On sites such as Facebook, Flickr, and Instagram, you can build a regular following for your work. Some sites accept paid advertising, and some permit purchase of posted images.

Figure 3-16. Instead of printed proofs, today's wedding or portrait clients make selections while viewing projected digital images.

Image Group Photography, LLC

Figure 3-17. A gallery on the photographer's website permits family members and friends to order and pay for prints.

E-mail can also be used as a marketing tool, especially in developing additional business through your existing client base. Periodic e-mails can be sent to your list to advertise special promotions or events, while an electronic newsletter can help you develop good customer relations.

Personal Contact

Promoting your business through personal contact is important. Especially when seeking assignments from companies, institutions, and publications, face-to-face meetings are necessary. When you are first in business, many of these meetings will be made on speculation. You hope the investment of your time and effort will result in a promise to consider your services for the next appropriate assignment. Later, you can expect to schedule more meetings on a referral basis, such as when a satisfied client passes on your name as a reliable and creative photographic services provider.

Whenever you meet with a potential client, come to the table well-prepared. Research the company or organization so you can confidently discuss how you would photograph its products or services. If possible, tailor your portfolio to include examples of work in fields similar to that

of the potential client, but avoid images made for their direct competitor.

A good way to become known in the community and develop contacts is to join and be actively involved in organizations such as service/civic clubs, fraternal organizations, and Chamber of Commerce or similar business-oriented groups. Networking with fellow organization members can provide useful leads for business development. If your local high school offers a photography class, you could make an appearance as a guest speaker to discuss career options. Another form of involvement would be to serve as a mentor for a student interested in becoming a professional photographer.

You can also share your knowledge with others. Teaching a photography class or conducting an educational seminar will not only build recognition for your business, but help you develop relationships that could later lead to paying work. For example, you might join with a local travel agency to offer their customers a free one-hour class on how to take better travel pictures, **Figure 3-18**.

Goodheart-Willcox Publisher

Figure 3-18. Partnering with another local business can develop leads for future photo bookings.

Creating a good impression on the attendees would lay the groundwork for future portrait or wedding commissions.

Photographers are often asked to donate their services, usually to a nonprofit organization, with the idea that it could later lead to paying assignments. While it is usually not a good practice to give away your work, making carefully chosen donations is a form of community involvement. For example, you may choose to support a charitable organization by producing photographs that will further its work. An example might be doing portraits of pets being offered for adoption by your local animal shelter.

You might also donate services that demonstrate your abilities to a potential client group. Golf outings sponsored by charitable organizations typically attract local business and industry leaders as participants. Your donation to the charity could take the form of a commemorative photo of each foursome made before it tees off. While the foursome is on the course, the image is processed and placed in a designed template displaying their names, the event title and date, and (of course) your company logo, **Figure 3-19**. As the golfers come off the course, each member receives a copy. Many of these images are likely to be framed and displayed on office walls, where they will serve as a reminder when the person needs photographic services.

Working with Clients, Employees, and Independent Contractors

Operating a photographic business requires far more than the ability to produce excellent images. You need an understanding of good business practices and the ability to put them to use. You need to efficiently manage time—your own, your employees', and your clients'. Above all, you need the ability to work effectively with your clients and with employees and the independent contractors who supply needed services.

Successful salespeople work hard at getting their customers to like them. Studies have shown that people are much more likely to make a purchase from someone they find friendly and likeable than from someone to whom they do not relate well. The benefits of being likeable carry over into areas other than sales. For example, likeability is a benefit when developing and leading a project team or working with various agencies and contractors to organize a complex location shoot.

Meeting with Clients

Meetings with clients may be as simple as sitting down with a young couple to discuss their wedding plans, **Figure 3-20**, or as complex as making a formal, detailed audiovisual presentation to advertising agency executives considering you for product photography

Image Group Photography, LLC

Figure 3-19. Donating your services to a charity event, such as this golf outing, can attract new clients to your business.

Image Group Photography, LLC

Figure 3-20. At the initial meeting with a prospective bride and groom, a photographer describes his services.

assignments. In any meeting with potential clients, you should project confidence and capability, but you also must be open to their ideas or desires.

Your role as a salesperson is not just to talk, but to listen. The prospective bride and groom, for instance, might indicate that they really like the wedding package that you have presented, but seem hesitant to make a decision. While their reluctance might be due to price, it might well be something else. You would have to ask questions and listen carefully to their answers to uncover the true cause of their uneasiness. Once you have identified the problem, you can suggest alternatives that should result in a solution and a signed contract.

Portrait photography has special challenges, since most people are self-conscious and tend to be nervous about "looking good." There may be other negative factors at play—your business-executive client is squeezing the portrait session into a crammed schedule, or the child you are to photograph has a hovering, fussy parent. To create a client-pleasing portrait, you must be able to keep your subjects relaxed and comfortable in front of the camera.

Leading a Team

In many photographic situations, you will find yourself working with additional people. Photographing a high school senior in an outdoor setting is often done with the help of a single assistant, but a shoot involving several models or products, either in-studio or on location, may involve a team of a half-dozen or more. See **Figure 3-21**. Whether simple or complex, these situations call for good use of your social, supervisory, and leadership skills.

Your leadership and team-building skills will be tested when conflicts arise between team members. Resolving such conflicts involves listening carefully to what each person has to say and working to achieve a solution that is fair and acceptable to all parties.

Planning and direction are vital. Whether your team consists of 2 people or 20, you owe its members clear communication of what is expected and how each person fits into the plan. A preshoot meeting with everyone involved, whether employees or independent contractors, helps ensure that everyone is "on the same page."

Image Group Photography, LLC; Goodheart-Willcox Publisher

Figure 3-21. Working with a team. A—Some shoots require only a single assistant for such tasks as aiming a reflector. B—On this location shoot, the photographer meets with assistants and a client representative as models look on. The team also includes a makeup artist.

Encourage team members to ask questions and make suggestions where appropriate. A similar meeting when the shoot is completed can provide information useful for future projects.

As you work with various independent contractors, evaluate their skills and personalities to determine which of them you would engage for future assignments. At the same time, of course, they will be evaluating *you* to decide if they wish to be on your team for future projects.

During the shoot, show respect for members of the team as fellow professionals. Instead of barking orders, make a request, and say "thank you" where appropriate. If someone makes a mistake, correct it and move on. Save any criticism or discussion with the person making the mistake for a later private meeting.

Using such a positive approach will build team morale and help to ensure a successful shoot. At the end of a lengthy or complex shoot, it is a good idea to host a party for everyone involved. A group photo of team members, talent, and client representatives can be made and distributed as a memento.

Operating Your Business

To start a business, you have to spend money. To stay in business, you must spend money as well, but you also have to bring in more money than you spend. The amount left after paying all the expenses is *profit*, **Figure 3-22**.

Operating expenses for a business include lease payments on your studio space, utility fees (heat, electricity, telephone, etc.), equipment purchases and rentals, advertising and marketing costs, office and studio supplies, payments to suppliers and independent contractors, taxes and fees, and employee pay and insurance costs.

Business income is generated by the sale of services and products. As a commercial photographer, you follow a different business model from companies that manufacture and sell many copies of an identical product. Your product, a photograph, is a one-of-a-kind item. Like the works produced by authors, composers, painters, and other artists, your photographs are considered ***intellectual property***.

Generating Income

As the creator of a work of art (your photograph), the law grants you a copyright for a term of your lifetime plus 70 years. You can sell the photograph outright or license for a fee many different rights. Reproduction rights for use in a book or magazine, for example, might be licensed for a single edition or for a term of years. The license might be only for publication in the United States, in a specified group of countries, or worldwide.

Commercial photographers typically retain all rights to their photographs, licensing certain uses to the client. For example, a manufacturer contracts with a photographer to shoot various people producing products in its factory. The purpose of the project is to create a cover illustration for the company's annual report to shareholders. Following the shoot, the photographer provides low-resolution images electronically for the client to review. Once the desired image is chosen, a high-resolution file suitable for reproduction is sent to the client, along with an invoice.

Goodheart-Willcox Publisher

Figure 3-22. To make a profit, your business must have more income than expenses.

The amount of the invoice includes the photographer's professional service fee for creating the image, expenses such as travel and rental of special equipment, and the licensing fee for reproduction rights. In this example, the licensing fee would allow the client to use the image once on the cover of the annual report. Additional uses of that image, such as a magazine ad or brochure, would be licensed separately with appropriate fees.

The image could be licensed for the exclusive use of the manufacturer, usually for a specific period of time, such as one year. If the license is not exclusive, the photographer can offer the image in other markets, such as stock photography or illustration in a textbook.

By retaining all rights to the images he or she creates, a photographer can generate a continuing income from each assignment. Wedding and portrait photographers typically charge a professional fee that includes shooting and post-production work, **Figure 3-23**. Most of their income in these areas, however, comes from the sale of packages or individual prints to the client and the client's family and friends.

Some beginning photographers try to generate business by shooting a wedding for a single flat fee that includes a DVD with all the original images, allowing the bride and groom to have their own prints made. By doing so, they are settling for a relatively small one-time payment instead of generating the continuing income needed to establish a successful business.

Photographers with institutional clients, like hospitals or universities, often work on a retainer basis. Under this business arrangement, the institution pays a flat monthly or annual fee to

Image Group Photography, LLC

Figure 3-23. An invoice showing a portrait sitting fee.

have the photographer's services whenever needed, **Figure 3-24**. Those services might include doing portraits of administrators or faculty members, creating images for promotional materials, or covering a variety of events. Retainers help to provide a steady income for the business.

Another source of regular income is contracting with schools or organizations, such as youth sports programs. Typically, a school would contract with the photographer to produce individual student portraits and classroom groups each year, **Figure 3-25**. Unlike a retainer, this arrangement does not include a payment by the school. The photographer's income is from the sale of portrait packages to students' families.

Doing the Paperwork

You may prefer to spend all your time making images, but as a business owner, you must take care of business. That means dealing with many kinds of paperwork—contracts, releases, reports, tax forms, and invoices, to name a few.

Even if your business is only part-time, you should set up a separate bank account for it. Using that account for all business-related deposits and payments helps you keep personal and business finances separate.

Every photographic project, whether a simple studio portrait or a weeklong multiple-location advertising shoot, requires a written *contract*. This legal document specifies the responsibilities of both the photographer and client and spells out every detail of the arrangement.

Image Group Photography, LLC

Figure 3-25. A high school student portrait.

Sample contracts are available from various sources, but you should work with an attorney who has experience with intellectual property law. The attorney will prepare contracts and other documents that protect your interests and can advise you in matters such as licensing rights.

Image Group Photography, LLC

Figure 3-24. Institutional client services. A—Documenting a student social event for a university. B—Providing coverage at an open house for a hospital's new facility.

Another legal document that often is needed is a model release, **Figure 3-26**. For your protection, you should have a signed model release for any person who appears in a photograph that might possibly be used in advertising or similar applications. Releases should be signed before photography begins. The release gives you the right to use your photograph of that person. The only use that does not require a model release is editorial publication (basically, newspapers and magazines).

To be paid for your work, you must present an invoice to the client. The invoice lists in detail the fees for your services and any expenses or other charges. The invoice should also specify when payment is due (usually 30 days) and may offer a small discount for early payment, **Figure 3-27**. A penalty for late payment may also be shown. Invoicing should be done as soon as possible after work is completed so you can be paid promptly.

Money will also flow in the other direction—you have to pay the invoices presented by your suppliers and contractors, bills from utilities and various taxing agencies, and wages for any employees. Some photographers handle all payments themselves; others employ a bookkeeper or use an outside accounting firm.

INVOICE	
Invoice #	16-00146
Date	March 23, 2016
Terms	2% 10/Net 30
	Over 30, add 10% penalty
...erson	Zach Johnson

Goodheart-Willcox Publisher

Figure 3-27. Typical payment terms on an invoice show a 2% discount for payment in 10 days, or payment in full (net) in 30 days. If payment is not made in 30 days, a 10% penalty is added.

Almost all photographic businesses use an accountant to handle taxes.

Growing Professionally

For a professional person, continuing education is a fact of life. It is important to stay up-to-date with new techniques, as well as further develop and refine existing skills. As a professional photographer and a business person, you must continue to seek education in a number of areas. One of these areas is current events—what is happening in your community, the nation, and the world. The ability to converse comfortably with clients and others is part of creating a relationship. When someone mentions a topic in the news, you should be able to at least indicate that you are aware of it.

An area where you might need knowledge in greater depth is the business area in which a client is operating. For example, if you are doing product photography for a maker of farm equipment, pay special attention to news about agriculture. You should also do specific research using sources such as relevant trade magazines and the manufacturer's product literature, **Figure 3-28**.

Further developing your business skills might involve enrolling in one or more specific classes at a local or online college. You can also attend freestanding seminars or those at national conventions, or participate in workshops and similar educational activities sponsored by organizations such as your local Chamber of Commerce.

Model Release

In exchange for consideration received, I hereby grant to **Zach Johnson (d/b/a F-stop Studio)** the right to publish photograph(s) taken of me at ___Pike County Fair___ on _7/21/2016_. These photos may be used for editorial publication, advertising, calendars, stock photography, or any other legal purpose, and may be altered without restriction. Further, I hereby release **Zach Johnson and F-stop Studio** from all claims and liability related to publication of said photograph(s).

Name (please print): ___Mariana Ortiz___

Signature:* _____

Address: ___847 W. Webster Drive___

City: ___Zebulon___ State: _IA_ Zip Code: _52599_

Telephone: (_468_) _990_ - _6607_

*If person photographed is a minor child, signature of a parent or legal guardian is required:

Signature: ___Hector Ortiz___

Please check one: (X) Parent () Guardian

Goodheart-Willcox Publisher

Figure 3-26. A signed model release allows you to use the person's photograph in various ways. The "consideration" mentioned could be a print of the photograph or a small monetary sum.

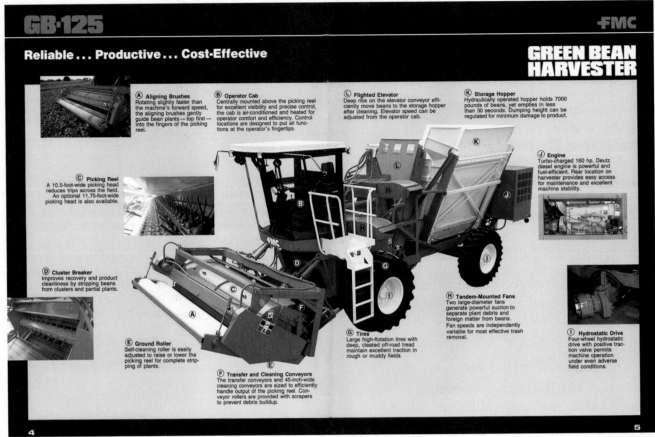

Figure 3-28. Studying product literature helps you become familiar with a client's business.

Photographic Organizations

A broad range of educational programs to improve both business and technical skills are offered to members of professional photographic organizations. These organizations also provide members with services such as insurance, event calendars, advocacy on legal issues involving photographers' rights, and searchable databases usable by agencies and companies seeking photographers, **Figure 3-29**.

The American Society of Media Photographers (ASMP) is devoted primarily to the needs of professionals whose photographs are used in magazines and other publications. The organization has developed standardized forms, such as model releases. Continuing business education for members, including live and recorded webinars, is also provided.

American Photographic Artists (APA) was formerly titled Advertising Photographers of America. This organization offers members educational articles on its website, a

Figure 3-29. Professional photographic organizations provide many services for their members.

downloadable business manual, seminars and workshops, and photo competitions.

Professional Photographers of America (PPA), with more than 28,000 members, is the largest

nonprofit photography organization. It was created by and for professional photographers and is devoted primarily to providing protection, education, and resources for wedding, portrait, and studio photographers. See **Figure 3-30**.

PPA has an extensive educational program lineup ranging from workshops and seminars held at various locations around the country to a catalog of more than 1,100 online courses. The organization offers its members an opportunity to become a Certified Professional Photographer. Certification involves passing a detailed written exam and submitting images for review.

Imaging USA, PPA's annual conference and tradeshow, is one of the largest annual photography conventions and expos in the United States. It offers numerous workshops, classes, and programs presented over a three-day period. Subjects range from business strategies to a variety of photography techniques. The tradeshow showcases vendors of photographic equipment and accessories, computer hardware and software, and many photo-related services. Imaging USA also features many opportunities for networking and a large photo exhibit showcasing the works of many of PPA's International Photographic Competition participants.

Professional Photography Workshops

In addition to workshops and seminars sponsored by professional organizations, many educational programs are available to photographers. An Internet search for "professional photography workshops" results in thousands of listings. Some of these are sponsored by camera manufacturers or equipment sales organizations, but the majority are from individuals or companies that make a business of presenting educational programs. Many of these are one- or two-day workshops held in hotel meeting rooms in various cities; others are week long courses at resorts or other sites that include residence accommodations. Many online programs and courses are also available.

Continuing education should be considered one of the keys to success for a commercial photographer. John Harrington, author of *Best Business Practices for Photographers*, notes that "All photographers should look to have a plan to regularly learn and grow from the knowledge bases of others."

Professional Photographers of America

Figure 3-30. Professional Photographers of America offers its members a variety of services and educational programs.

Check Your Photography IQ

Now that you have finished this chapter, see what you learned by taking the chapter posttest.

www.g-wlearning.com/visualtechnology/

Review Questions

Answer the following questions using the information provided in this chapter.

1. Define the term *commercial photography*.

2. About _____% of all commercial photographers are self-employed.

3. What are the advantages of taking part in a photography internship program?

4. In larger cities with many photographic businesses, assistants are most often _____.
 A. part-time employees
 B. independent contractors
 C. full-time employees
 D. seasonal workers

5. A person who starts his or her own business is referred to as a(n) _____.

6. Explain how a business with no employees and a business with dozens of employees can each be classified as a "sole proprietorship."

7. What is a *silent partner*?

8. For shareholders, the major advantage of the corporation as a form of business is _____.

9. What advantage would a studio owner gain by developing a mix of clients from different areas such as portraits, weddings, product photography, event coverage, and institutional work?

10. Which of the following is considered a fixed expense?
 A. Shipping costs
 B. Equipment rental
 C. Independent contractors' service fees
 D. Insurance

11. What is a business plan, and when is it required?

12. "Everything you do to acquire customers and establish an ongoing relationship with them" is a definition of the term _____.

13. A(n) _____ website allows customers to choose and purchase items online.

14. A detailed audiovisual presentation to a group of advertising agency executives would be considered a(n) _____ presentation.
 A. formal
 B. informal
 C. impromptu
 D. targeted marketing

15. List several ways that you can use leadership skills to work effectively with your team members on a photo shoot.

16. Everyone on the project team, whether employee or independent contractor, should be involved in the _____ meeting.

17. You can help a student explore photography as a career by serving as a(n) _____.

18. Your rights to control and dispose of the images you create are protected by copyright for a period of your lifetime plus _____.
 A. 40 years
 B. 50 years
 C. 60 years
 D. 70 years

19. Why is retaining all rights to her or his work important for a commercial photographer?

20. The only type of image use that does not require a model release is _____.

21. List several ways in which becoming a member of a professional photographic organization can help you achieve professional growth.

22. The professional organization whose members can achieve recognition as a Certified Professional Photographer is the _____.
 A. Professional Photographers of America (PPA)
 B. American Wedding Specialists (AWS)
 C. American Society of Media Professionals (ASMP)
 D. American Photographic Artists (APA)

Suggested Activities

1. Employment options. Look through a current edition of your local newspaper and check some online career sites. What employment ads do you find for careers discussed in this chapter? Choose three careers and identify the requirements listed in the ads for these careers.

2. Investigate the requirements for opening a small photography business in your area. What licenses would you need? How much capital (money) would you need to invest to get the business off the ground? Share your answers with the class.

3. To gain firsthand knowledge of the day-to-day activities of a commercial photographer, arrange to job shadow or assist a photographer on an assignment. Give an oral presentation to the class about your experience.

4. Identify a charity or other organization in your community that you might wish to support. Describe one or more ways you could contribute your photographic skills to help the organization.

Critical Thinking

1. Working in the photography field requires good language skills, including the ability to communicate orally with individuals or groups. Teaching a photography class is one example. What are several other examples?

2. On a location shoot, two of your team members disagree on which one of them should perform a particular task. How would you resolve the problem?

3. Explain what is meant by the statement "Your role as a salesperson is not just to talk, but to listen."

Communicating about Photography

1. **Speaking and Listening.** Interview a studio photographer or photojournalist. Ask the person to describe a typical day at work. Here are some questions you might ask:
 - What is the work environment like?
 - What are the job duties?
 - What types of people do you work with?
 - What types of equipment do you use?

 Report your findings to the class, giving reasons why you would or would not want to pursue a career similar to that of the person you interviewed.

2. **Writing and Listening.** Working in small groups, compile a list of local nonprofit or charitable organizations. Report to the other students in your group, detailing how a photographer could donate services to the organization you chose and how the donated services would demonstrate photographic abilities to a potential client group.

3. **Speaking and Writing.** Research time-management skills. Then, in small groups, discuss the time-management challenges that could occur in a photography business. One person should create a list of time-management skills needed to complete tasks in a photography business.

Tonal range: The spread of tones, from deepest shadows to brightest highlights, represented in a photograph.

While studying this chapter, look for the activity icon to:

- **Assess** your knowledge with self-check pretest and posttest.
- **Practice** vocabulary terms with e-flash cards and matching activities.
- **Reinforce** what you learn by submitting end-of-chapter questions.

G-WLEARNING.com

From Pinholes to Pixels

Objectives

When you have finished reading this chapter, you will be able to:

- Describe the development of the photographic process.
- Explain the significance of Eastman's roll-film camera in making photography a popular activity.
- Compare and contrast film-based and digital photography.
- Discuss the future roles of both film-based and digital methods.

Check Your Photography IQ ↗

Before you read this chapter, assess your current understanding of the chapter content by taking the chapter pretest.

www.g-wlearning.com/visualtechnology/

Technical Terms ↗

ambrotype	dry plate process
Autochrome process	ferrotype
calotype	fixing
camera lucida	latent image
camera obscura	negative/positive system
camera phones	photogram
cellulose nitrate	Polaroid process
collodion	printing-out paper
daguerreotype	prosumer
developing-out paper	tintype
digital photography	wet-plate collodion process
digital backs	

For years, instructors have used the experience of making and photographing with a pinhole camera as an introduction for beginning photo classes. The simple device, constructed from a light-tight cardboard box, has a tiny covered opening in one wall and a sheet of film or photographic paper attached to the opposite wall.

The basic principle of the pinhole camera is that light rays reflected from a subject pass through the tiny opening and form an exact, though inverted, image on the other side, **Figure 4-1**. The pinhole principle was known as early as the fifth century BCE in China, but did not have a practical application until the 1500s, when the *camera obscura* came into use.

Camera obscura means *dark chamber* or *dark room*. By working in an actual room or a room-sized box or tent, an artist could bring an image to focus and trace it onto a piece of paper or canvas. The tracings would later form the basis for a painting.

A simple lens eventually replaced the pinhole, providing a brighter and sharper image. By the 1700s, the "dark room" had shrunk to the size of a large tabletop box. An Englishman, William Hyde Wollaston, did away with the box in the early 1800s when he invented the *camera lucida*. Wollaston's device, a prism mounted on a stand, was placed above a sheet of drawing paper. The scene in front of the camera lucida was projected onto the paper so an artist could trace it, **Figure 4-2**.

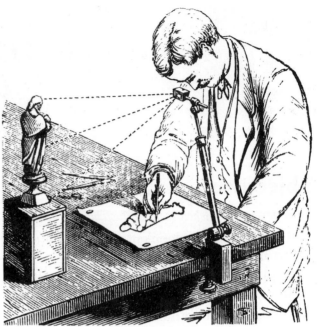

Goodheart-Willcox Publisher

Figure 4-2. Using the camera lucida.

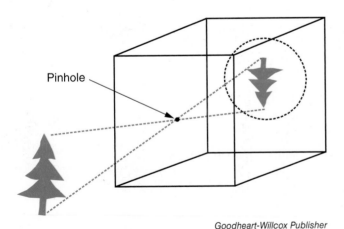

Goodheart-Willcox Publisher

Figure 4-1. Rays of light entering a darkened space through a tiny opening form an image that is inverted in relation to the actual scene. Photographs of surprisingly good quality can be taken with a pinhole camera, which is based on the principle shown in this illustration.

Neither of these methods involved photographic principles—they could not make a picture in permanent form, like a modern camera records a scene on film or electronic medium.

The Birth of Photography

When the recording medium (film) and the recording device (camera) came together, photography was born. The first important step toward a recording medium came in 1727, when Johann Heinrich Schultz observed that certain silver compounds darkened when exposed to light. The stencil images formed this way were not permanent, however.

More than 70 years later, in 1802, English scientists Thomas Wedgwood and Humphrey Davy applied a silver chloride solution to paper, placed opaque objects on it, and exposed the paper to light. Their images were not permanent either, but the method led to the photographic form known as the *photogram*, **Figure 4-3**.

The First Permanent Image

Joseph Nicéphore Niépce, a French experimenter, created a permanent photographic image in 1826. He coated a pewter metal plate with a light gray layer of bitumen of Judea, a type of tar.

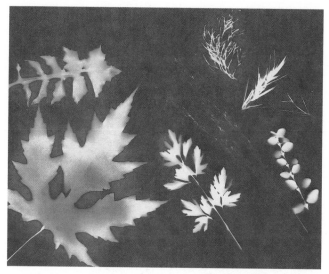

Goodheart-Willcox Publisher

Figure 4-3. Opaque objects placed on a sensitized material form stencil-like images when the material is exposed to light. The resulting picture is called a *photogram*.

Using a camera with a simple lens, he made an eight-hour exposure of the scene outside the window of his home.

The light-sensitive bitumen of Judea hardened in proportion to the amount of light striking it. A solvent was used to process the exposed plate. In shadow areas with little or no exposure, the bitumen dissolved completely, revealing the dark surface of the pewter. Highlight areas—those exposed to the most light—resisted the action of the solvent, remaining light gray. Varying degrees of exposure provided the middle tones. Niépce's positive image was permanent—it remained unchanged when further exposed to light. He later refined his process by using silver plates and was able to reveal the bright metal for highlight areas.

Niépce died in 1833, but his business partner, Louis Jacques Mandé Daguerre, continued to perfect the process. In 1835, Daguerre found that a silver plate made light-receptive by iodine fumes and then exposed in the camera held an invisible *latent image*. That image could be developed, or made visible, by exposing it to fumes from a heated container of mercury.

The final element that made Daguerre's method a practical means of photography was *fixing* the image to prevent further darkening of the silver by exposure to light. In late 1839, the English astronomer John Herschel found that hyposulfite

of soda, or hypo, would make photographic images permanent. Now called *sodium thiosulfate*, hypo fixed the image by dissolving the unexposed silver on the plate's surface.

Word of Daguerre's success in producing permanent photographic images reached the scientific world in 1839. That year, a joint meeting of the French Academy of Sciences and the Academy of Fine Arts heard a detailed description of how a *daguerreotype* was made. A few months later, a small handbook written by Daguerre was on the market, and daguerreotypes were being made in a number of countries. See **Figure 4-4**.

At first, portrait subjects had to sit perfectly still for long exposures of up to twenty minutes. In 1840, however, a new camera lens was introduced that reduced exposures to a much more practical length of a minute or less. The lens was designed by Hungarian mathematician Josef Petzval. Once sitting time was drastically reduced, daguerreotype portrait studios became common.

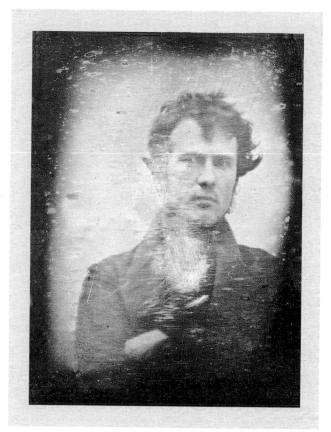

Courtesy of the Library of Congress

Figure 4-4. This self-portrait of Robert Cornelius of Philadelphia was made in 1839, only months after Daguerre's process was described in detail for the first time. It is one of the first daguerreotype images made in the United States.

Each daguerreotype image was unique. The only way to obtain an additional copy was to photograph the original subject again. Eventually, the daguerreotype was supplanted by the more flexible negative/positive system.

Discovery of the Negative

In the early 1830s, English scientist William Henry Fox Talbot began experimenting with methods to make permanent images. Rather than metal plates, Fox Talbot used paper that he coated with silver compounds. In 1835, he captured a detailed image of his home's leaded glass window on paper that had been coated first with a solution of common salt, then with silver nitrate. Following a long exposure, a visible image appeared on the sensitized paper. A paper on which an image appears without the use of a developer, as in this case, is called *printing-out paper*. The paper used today for prints made from film is known as *developing-out paper*, since the latent image must be brought out with a chemical developer.

Fox Talbot's process produced negatives, which are images reversed both in tones and in orientation (left-to-right). He created the basis of chemical-based photographic printing—the *negative/positive system*. See **Figure 4-5**. The original negative image can be placed atop another sensitized sheet and the sandwich exposed to strong light. The resulting print is a positive version, with both tones and orientation matching the photographed scene.

By discovering and refining the negative/positive system, Fox Talbot altered the direction taken by photography. Instead of being limited to one-at-a-time images, photographers could now make as many copies as they wished from each negative.

Fox Talbot next devised the *calotype*, an improved paper negative material that could be exposed in a fraction of the time needed for his original process. The calotype (later renamed the *talbotype*) process was used in 1844 to produce Fox Talbot's *Pencil of Nature*, the first book illustrated with photographs. The 24 photographs were individually printed and adhered to the pages.

Plate-Based Photography

By 1848, a method of adhering a light-sensitive albumen coating to a sheet of glass was found by Abel Niépce de Saint-Victor in France. The clear and smooth glass base of the negative permitted making prints that rivaled the daguerreotype.

An improved coating process using *collodion* (a viscous liquid that dries to form a clear, tough layer) was devised in England by Frederick Scott Archer in 1851. The *wet-plate collodion process* quickly drove both the daguerreotype and the talbotype out of the marketplace.

The wet-plate method required a cumbersome series of steps to prepare, expose, and develop the plate. The collodion, mixed with iodide, was flowed onto the surface of a carefully cleaned sheet of glass. Once the collodion became tacky, the plate was plunged into a silver nitrate solution to make it light-sensitive. From this point until the negative was developed and fixed, the photographer had to work in darkness or under dim red or orange light (emulsions of that time were not sensitive to red light).

Because the sensitivity of the emulsion would be lost if it were allowed to dry, the plate had to be exposed quickly. It was placed in a holder covered with an opaque lid, called a dark slide, and inserted in an already positioned and focused camera. The dark slide was removed and the camera shutter opened. After an exposure of up to 15 seconds, the plate was quickly taken to the darkroom and developed in an open tray. After fixing and washing, the plate was air dried in a rack.

Wet-plate collodion photography typically required at least two persons—the photographer to set up and operate the camera and an assistant to prepare and develop plates. For location photography, a wagon or tent that could be made light-tight to handle the plate chores was needed. See **Figure 4-6**.

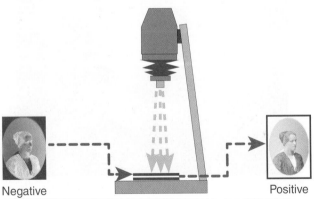

Negative　　　　　　　　　　　　　　Positive

Goodheart-Willcox Publisher

Figure 4-5. In the negative/positive system, the original (negative) is placed against a sheet of sensitized paper and exposed to a light source. After chemical development, a same-size contact print (positive) results. Later, it became possible to expose enlarged copies called *projection prints*.

Figure 4-6. This portable darkroom wagon, parked near the Manassas battlefield in Virginia, was used by Timothy O'Sullivan, one of Matthew Brady's staff of Civil War photographers. The photo was taken July 4, 1862.

Collodion also made possible the ambrotype and ferrotype processes. The *ambrotype* was simply a glass negative placed over a black backing material. The backing changed the appearance of the negative into a positive, and the result resembled a daguerreotype.

Ferrotype was the formal name for the popular *tintype* process used for quick and inexpensive portraiture, **Figure 4-7**. To make a ferrotype, a wet collodion emulsion was applied to a thin iron plate that had been painted with a black or brown enamel. Exposure and processing resulted in a positive-appearing image because of the dark background material. The ferrotype process was widely used in the United States from 1855 until well into the twentieth century.

| Unadorned | Unadorned | With a folder | In a case |

Figure 4-7. The low cost of the tintype made it popular as "the people's photograph." A completed tintype may have been presented to the customer in unadorned form, like the first two examples. Often, however, it was placed in a printed paper folder advertising the photographer's studio. Some tintypes were packaged in a wood and leather case to emulate a daguerreotype. The case at far right is missing its lid.

The invention of the *dry plate process* in 1871 freed the photographer from the need to prepare plates. A British physician, Richard Leach Maddox, discovered that gelatin could be substituted for collodion when coating glass plates. Gelatin emulsions remained light-sensitive after drying, so plates could be prepared and stored for months before being exposed. After exposure, development could be delayed until convenient.

Commercial production of dry plates began in England in 1876. In the United States, Carbutt of Philadelphia began offering them in 1879, and George Eastman founded his Dry Plate Company in 1880. See **Figure 4-8**. The convenience of using dry plates soon ended the general use of the wet-plate method.

Introduction of Roll Film

The dry plate was a major step toward making photography available to a wider audience. The new plates still required access to a darkroom for developing and printing, and retained the drawbacks of the glass support—fragility, bulk, and weight. These problems were resolved in the late 1880s when films consisting of gelatin emulsions adhered to a flexible, transparent base came onto the market.

Truly widespread acceptance of photography as a hobby occurred in 1888, when George Eastman patented and began marketing the first self-contained camera to use roll film, **Figure 4-9**. The box-type camera was simple to operate—the user pulled a string to cock the shutter, pressed a button to release it, and then turned a key-like knob to advance to the next frame.

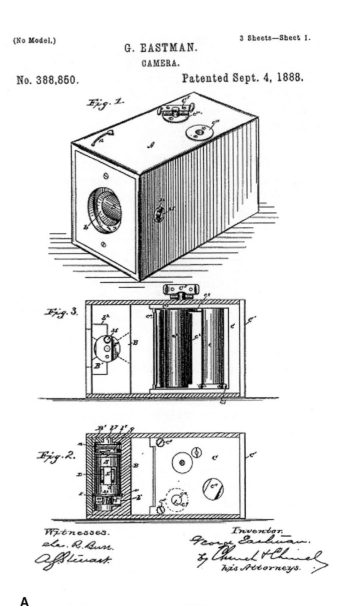

A

Goodheart-Willcox Publisher

Figure 4-8. The invention of the dry plate process allowed photographers to carry a ready-to-use supply of plates, rather than having to prepare each plate just before exposure.

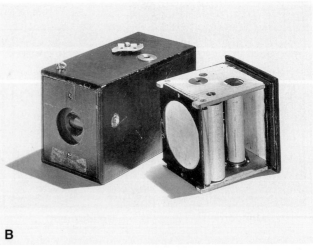

B

US Patent Office; Eastman Kodak Company

Figure 4-9. The simple-to-use roll film camera made photography a popular pastime. A—George Eastman's 1888 patent application. B—The camera.

Sealed inside the camera was a roll of gelatin-emulsion film sufficient for 100 exposures, each 2 1/2" in diameter, **Figure 4-10**.

Eastman's Kodak system eliminated the need for a darkroom. When all the film was exposed, the entire camera was sent back to the company. For a $10 fee, the film was developed and printed, and a new roll was loaded into the camera. Camera, negatives, and prints were returned to the photographer.

Eastman's earliest roll film consisted of a gelatin emulsion applied to a paper backing. Within a year of introducing the roll-film camera, Eastman adopted a simpler and better system—the light-sensitive material was coated onto a backing of clear *cellulose nitrate* rather than the paper support. With the exception of changes in the type of plastic material used for the base, the roll form devised by George Eastman remains the standard for film-based still photography and motion pictures.

The motion picture industry, in fact, owes its existence to Eastman's film. The strong, flexible, transparent base for the light-sensitive emulsion made possible Thomas Edison's development of the first motion picture camera in 1891. Interestingly, the film that evolved as the standard for motion pictures—35 millimeters in width and perforated with holes to accept the drive sprockets of the movie camera—did not became widely used for still photography until many years later.

In 1914, machinist Oskar Barnack of the German optical firm of Ernst Leitz and Co. built a still camera that could be used with the 35 mm film format. The film was loaded into a small, light-tight metal cassette, and rewound into that container when all frames had been exposed. By 1924, the Leitz firm was manufacturing and marketing Barnack's camera under the name Leica, which it still bears today.

For many years after the Leica's introduction, the use of 35 mm cameras was known as *miniature photography*. See **Figure 4-11**. These small cameras appealed primarily to the adventurous person who was already involved with photography. As more and more 35 mm cameras (most of them rangefinders with a single fixed lens) came on the market, they began to be purchased as primary photo equipment, **Figure 4-12**.

Eastman's sensational new "miniature," with Kodak Anastigmat Special *f*.3.5 lens and 1/200 Kodamatic shutter. A new high value in 35 mm. cameras. Built to Eastman precision standards, for both black-and-white and Koda-chrome (full-color) photography. Folding optical finder, exposure counter, film-centering device. Double-exposure prevention, automatic shutter setting, and delayed action.

KODAK 35 (*f*.3.5)

$~~39.50~~ Now $33.50

Goodheart-Willcox Publisher

Figure 4-11. Fifteen years after their introduction, 35 mm cameras were still referred to as "miniature cameras," as shown in this portion of a 1939 Kodak advertisement.

Courtesy of Library of Congress

Figure 4-10. Eastman's slogan "You press the button, we do the rest" pointed the direction that the consumer photographic industry would take. The Kodak camera produced up to 100 small circular prints. This snapshot of two women on a boat deck in Florida was taken in 1889.

Jack Klasey/Goodheart-Willcox Publisher

Figure 4-12. The 1939 Argus C-3 camera introduced many people to "miniature photography." The camera's size, shape, and 1 1/2 pound weight earned it the descriptive nickname "The Brick."

Single-lens reflex (SLR) cameras with interchangeable lenses became more widely available in the late 1950s and 1960s. Their flexibility, light weight, and ability to take photographs under almost any conditions greatly accelerated the trend toward 35 mm. Other formats, such as disc film, 126 and 110 Instamatic films, and the Advanced Photo System (APS) were introduced, but eventually faded away or declined to form only a tiny portion of the film market.

Part of the success of 35 mm photography was due to the growth of its support system. Overnight film processing, once considered an extra-cost rush option, was superseded by the explosive growth of one-hour processing minilabs in shopping centers and retail stores. Those same sites now offer service for prints made from digital media.

Color Photography

While black-and-white photography was being developed and refined in the mid-to-late nineteenth century, some experimenters were also working to achieve photography in full color. The first practical system of color photography, the *Autochrome process*, was introduced in 1907.

Brothers Louis and Auguste Lumiére of France found that applying fine grains of potato starch to a plate, then coating the plate with an emulsion, made it possible to produce a colored image. The starch grains were dyed three different colors—cyan, magenta, and yellow—then thoroughly mixed together. The starch powder was dusted in a thin layer onto a transparent plate covered with wet varnish. A second coat of varnish and another layer of powder were added, and then very finely ground charcoal was applied to fill any spaces between the starch grains. A light-sensitive emulsion was coated over the top starch layer.

During exposure, the starch layers worked together as a filter to condition light by the additive color process. To reach the emulsion, light had to pass through the colored starch-grains. Light passing through a yellow grain, then a cyan grain (or vice versa), produced green; cyan and magenta yielded blue; magenta and yellow made red. After development, the plate was viewed from the emulsion side, so light passed through both the starch grains and the emulsion to the eye. The result was a surprisingly natural-looking color image, **Figure 4-13**.

Like the daguerreotype, each Autochrome image was one-of-a-kind. Despite this limitation, the

process was used extensively until the mid-1930s. Additive color processes such as Autochrome were made obsolete by the introduction of Kodachrome, a subtractive color film, in 1935. Kodacolor, the first color negative film using the subtractive process, was introduced in 1942.

In the subtractive color process, dyes block specific colors from the white light that is used to view the image. A cyan dye absorbs red light and passes blue and green; a magenta dye absorbs green and passes blue and red; a yellow dye absorbs blue and passes red and green. The subtractive color process eliminated the complex mechanical masking involved in additive color processes.

"Instant" Photography— The Polaroid Process

Photographers have always been eager to see the results of their efforts as quickly as possible.

Courtesy of the Library of Congress

Figure 4-13. This Autochrome portrait of a woman with red hair was made by San Francisco photographer Arnold Genthe in the early 1900s.

A unique system introduced in 1947 by American inventor Edwin H. Land, **Figure 4-14**, allowed the photographer to view a fully developed picture only one minute after exposure. The *Polaroid process* achieved this rapid development time by incorporating a small packet of chemicals in each sheet of film. After exposure, the sheet passed through a set of rollers while being ejected from the camera. Roller pressure broke open the packet of chemicals and spread the mixture evenly over the film surface. At the end of the development period, a cover sheet was peeled off the film, revealing the finished photograph, **Figure 4-15**.

A color version was marketed beginning in the early 1960s. The Polaroid SX-70 film system, introduced in 1972, allowed the photographer to watch the picture develop, with no need to remove and discard a cover sheet.

The Polaroid process never achieved the widespread acceptance of conventional film-based photography and saw its market segment greatly eroded by digital cameras. In 2008, Polaroid announced that it was ceasing production of all its

Goodheart-Willcox Publisher

Figure 4-15. Peeling apart Polaroid film to reveal the developed image.

instant film products. Comparable instant films, in both color and black-and-white versions, are still available from Fujifilm.

The Growth of Digital Photography

Although photography without film seemed to burst on the public's consciousness in the late 1990s, it dates back to 1975. Steven Sasson, an Eastman Kodak engineer, developed and demonstrated a prototype camera that captured images electronically. The camera weighed eight pounds and took 23 seconds to capture a low-resolution black-and-white image, **Figure 4-16**.

Courtesy of the Polaroid Corporation archives

Figure 4-14. Edwin H. Land's 1947 Polaroid camera system made possible, for the first time, an immediate assessment of photo results.

Eastman Kodak Company

Figure 4-16. Steve Sasson displays his prototype electronic camera.

In 1984, Canon introduced a prototype "electronic still camera" that recorded an analog (video, rather than digital) signal. The first commercially available electronic camera, the Canon RC-701, was offered for sale in 1986 and was used almost exclusively by journalists. Two years later, the first electronic camera offered to consumers reached the marketplace. Cameras that recorded images in digital form became available in 1990, but their high cost and the low resolution of images made the market slow to develop.

Digital photography using large format cameras was being done in the studios of catalog and advertising photographers by the early 1990s. Also available to photographers were *digital backs* that could be mated with conventional large format cameras. These digital cameras and backs could be used only for photos of stationary objects, since scanning required exposures that often were measured in minutes. The very large arrays provided a high-quality image rivaling and even exceeding the resolution of traditional film. See **Figure 4-17**. Later, digital backs that could capture an image in a single, shorter exposure were developed for both large format and medium format cameras, **Figure 4-18**.

Photojournalists and other photographers working with live subjects needed a camera that could capture an image instantly. They also needed a camera that was flexible and portable, a means of viewing the captured image to evaluate composition

Phase One

Figure 4-18. This digital back, mounted on a Phase One medium format camera body, has an 80Mp sensor.

and exposure, and some form of "on board" storage of completed images. The digital camera would have to retain most of the attributes of the 35 mm film camera, while providing the highly desirable feature of instantly visible results. Those requirements also would be the key to making digital photography accepted in the consumer market.

A method of viewing the completed image became available in 1995, when electronics-maker Casio introduced a digital camera with a small liquid crystal display (LCD). Today, the LCD on many digital cameras acts as the viewfinder for composing the picture as well as a means of reviewing the captured image.

Image storage cards (memory cards) are the equivalent of "digital film." When filled, a card can be removed from the camera and a new one inserted. A card reader that plugs into the computer allows images stored on a memory card to be rapidly transferred to computer memory. See **Figure 4-19**.

Better Light, Inc.

Figure 4-17. Developed to produce extremely high-resolution captures for applications such as fine-art reproductions, this 416Mp scanning back is being used on a 4" × 5" studio camera.

Lexar

Figure 4-19. This card reader is able to accept several different types of memory cards.

Most early cards could hold a small number of very large (high-resolution) images, or a larger number of images at a lower resolution. Today, cards are available that can store thousands of high-resolution images.

Early digital cameras for professional use consisted of a digital array and associated electronic components combined with an existing professional-level 35 mm SLR. By the early 2000s, camera companies were developing and marketing expensive SLR cameras specifically designed for digital capture, rather than film cameras adapted to use a digital array. In August 2003, Canon introduced the EOS Digital Rebel, a 6.3 megapixel (6.3Mp) SLR priced at under $1,000, making a digital SLR affordable to many advanced amateurs. See **Figure 4-20.** Other major camera and electronics manufacturers quickly introduced SLR models aimed at the advanced amateur market (often called the ***prosumer*** market, a blending of the terms *professional* and *consumer*).

The surge in consumer acceptance of digital cameras paralleled the great expansion of home computer use and the explosive growth of the Internet in the late 1990s. Dozens of digital cameras designed for consumer use became available. These cameras varied widely in capabilities and price, appealing to different market segments. Most were the digital equivalent of the 35 mm "point-and-shoot" snapshot camera—focus, aperture, and shutter speed all were automatically set by the camera's electronics. More sophisticated models allowed the photographer to manually set exposure controls.

For a time in the early 2000s, cameras with 3Mp sensors were state of the art for consumers. The pixel count quickly escalated, however, and by 2015 even many low-priced point-and-shoot (compact camera) models offered 16Mp sensors, **Figure 4-21.** More sophisticated advanced compacts and prosumer SLRs typically have sensors in the 16Mp–20Mp range. Professional-level SLRs have sensors as large as 36Mp. Those with full-frame sensors, **Figure 4-22,** have lower pixel counts, since their individual pixels are larger.

Olympus America, Inc.

Figure 4-21. This 16Mp point-and-shoot camera has a 3.74 mm to 18.7 mm (21 mm–105 mm equivalent) zoom lens and is small enough to carry in a pocket or purse.

Jack Klasey/Goodheart-Willcox Publisher

Figure 4-20. The Canon EOS Digital Rebel was the first "prosumer" camera.

Courtesy of Nikon Inc., Melville, New York

Figure 4-22. The Nikon D4S professional digital camera has a 16.2Mp full-frame sensor. A full-frame sensor is the same physical size as a 35 mm film frame.

Virtually all of today's digital cameras are capable of producing printed images that approach or exceed the quality of those made with conventional film.

Camera Phones

Japanese electronics companies began incorporating photo capability in their cell phones in the early 2000s, and by 2004, *camera phones* were available in the United States. According to a 2014 survey by the online photo service Shutterfly, Americans take more than 10 billion photos each month, and 60% of those surveyed consider the camera phone their primary photographic device. Although early cell phone cameras had only 1Mp or 2Mp sensors, most smartphone cameras today have between 8Mp and 16Mp, **Figure 4-23**. Smartphones have large touch screens and combine the functions of a cell phone, camera, and web browser. Users can

Jack Klasey/Goodheart-Willcox Publisher

Figure 4-23. An 8Mp camera is used in Apple's iPhone 6.

download and use many available small special-purpose programs, usually referred to as *apps*.

The Future of Photography

When digital photography became affordable for the consumer in the mid-to-late 1990s, most experts predicted the new medium would gradually become competitive with film, and someday even surpass it in popularity. However, the pace of change was so rapid that it could be called a revolution. According to statistics from the Camera Imaging Products Association, between 2002 and 2003, worldwide shipments of digital cameras increased from 24.5 million to nearly 44.5 million, while traditional film cameras dropped from 23.6 million to 16.3 million. By 2010, digital camera shipments reached their peak, with 121.5 million units shipped, while film camera shipments had dropped well below 1 million units. Since then, the pace of digital camera shipment has slowed steadily as the market became saturated and the shift to smartphones continued.

Factors that contributed to the digital revolution include increased picture quality, rapidly declining camera prices, and the ability to immediately view the captured image. Possibly the most significant factor, however, was the development of a large number of sites for quickly and inexpensively making prints from digital files. According to the Photo Marketing Association, a trade group that monitors the photographic field, the trend in printing shows steady movement toward retail store and Internet printing and away from producing prints at home. Since 1996, when the first digital labs were introduced to retailers, digital processing has spread to virtually every drugstore and major discount store, **Figure 4-24**. Most even offer the photographer the convenience of e-mailing the files, then picking them up at the store an hour later. This overcame what had been a perceived limit to digital photography's growth—the cost and time needed to make prints at home. While digital capture eliminated the cost of film and

Figure 4-24. Easy availability of print processing in retail stores fueled the digital revolution among consumers. Many customers send their files electronically, then pick up the finished prints from the store.

film developing, it required an investment in a computer, printer, ink, and paper. It also required some degree of skill in learning to use computer software.

With the ease of sharing images offered by smartphones, more and more people are choosing to display their photos electronically, rather than making prints. An estimated 250 million photos are uploaded daily to Facebook, and another 40 million to Instagram.

Will Film-Based Photography Survive?

Digital image capture has become almost universal among advertising and commercial photographers, and has achieved wide acceptance by the general public. A significant number of serious amateurs and professionals dedicated to fine art photography, however, can be expected to remain with film-based methods as a creative tool. The process of capturing the image on film and producing it with traditional darkroom practices allows the artist to present a subject in a manner very different from the same subject captured and presented by digital methods. The evolution of film-based photography from a broad popular form of expression to a narrow fine-art specialization seems likely to continue.

Photographers who choose to work with traditional film-based methods will find their equipment and material choices increasingly limited and their costs steadily increasing. Major camera manufacturers have either eliminated or severely cut back production of film cameras. Photographic supplies, particularly film and printing papers, have become more expensive and less readily available. In the face of steadily declining demand, fewer once-popular films and papers will be available. Dedicated film photographers, however, will overcome such equipment and materials limitations, using their skills and experience to continue producing high-quality images.

Milestones in Photography

1500s: Camera obscura first used as aid for artists.
1727: Schultz discovers that certain silver compounds darken when exposed to light.

Niépce records the first permanent photographic image.

Fox Talbot captures a photographic image on a paper base coated with a light-sensitive silver chloride solution.

Daguerre discovers that a sensitized silver plate would capture a latent image that could then be made visible by development.

The Petzval lens greatly reduced sitting times for photographic portraits. Basic principles of portrait photography are developed by Adamson and Hill.

| 1500s–1727 | 1826 | 1834 | 1835 | 1840 |

Kodachrome film invented by Godowsky and Mannes.

Electronic flash invented by Edgerton.

Barnack develops the prototype of the 35 mm still camera.

Lumiére Brothers invent the first practical color photographic method, the Autochrome process.

Panchromatic film emulsions introduced.

| 1935 | 1931 | 1914 | 1907 | 1904 |

1942 ◄ Kodacolor, the first subtractive-process color print film, is introduced.

1946 ◄ Ektachrome, the first color film capable of being processed by the photographer, is marketed.

| 1947 | 1963 | 1976 | 1978 | 1984 |

Land devises the Polaroid instant photography system.

Instamatic cameras and 126-size film are introduced.

Canon introduces the first 35 mm camera with a built-in microprocessor. Inkjet printer developed.

First autofocus point-and-shoot camera marketed by Konica.

The first digital camera (electronic still camera) used to photograph opening of summer Olympic Games.

| 2015 | 2011 | 2009 | 2008 | 2007 |

8Mp and higher cameras become common on smartphones.

Revolutionary "light field" camera announced; will allow focus changes after exposure is made and eliminate need for flash.

Kodak announces the end of production for Kodachrome, its oldest transparency film (invented in 1935).

Polaroid announces that it will cease production of instant film products due to consumer switch to digital photography. Sony announces 25Mp full-frame sensor.

Kodak ceases production of infrared film.

92

The first book illustrated with photographs is published.

Archer develops the wet-plate collodion process.

Ferrotype (tintype) process introduced.

Maxwell describes and demonstrates the additive color process.

Maddox devises the gelatin-based dry-plate process.

| 1844 | 1851 | 1855 | 1861 | 1871 |

Vogel introduces orthochromatic film emulsion, responsive to both blue and green light.

1873

Eastman Dry Plate Company founded in Rochester, New York.

1880

| 1900 | 1891 | 1890 | 1889 | 1888 |

Eastman Kodak introduces the "Brownie," the first mass-marketed camera.

Minolta introduces Maxxum 9000, the first professional autofocus camera; Kodak develops the first megapixel sensor.

Edison develops the first motion picture camera, using a film format devised by Eastman.

Single-use cameras introduced by both Fuji and Kodak.

Herter and Driffield publish research on exposure measurement and emulsion sensitivity (the basis of the "characteristic curve").

Photoshop® image editing software introduced for Apple computers. Photo CD system developed by Kodak.

Eastman introduces the first commercial roll film to use a transparent base.

Casio unveils first digital camera with an LCD screen. First image-stabilized lens introduced by Canon.

Eastman introduces the trade name Kodak; begins marketing the first roll-film camera.

The Advanced Photo System is introduced.

| 1986 | 1987 | 1990 | 1995 | 1996 |

First consumer-level 3-megapixel digital cameras offered.

1999

Nikon and Canon introduce professional-level digital SLR cameras. Sharp markets first camera phone in Japan.

2000

| 2006 | 2005 | 2004 | 2003 | 2002 |

Nikon announces it will cease production of film cameras except for two professional models. Konica\Minolta exits camera and film business. Live preview feature for digital SLRs introduced by Olympus.

Canon introduces the EOS 5D, first full-frame digital SLR priced for the prosumer market. AgfaPhoto ends production of consumer films and files for bankruptcy.

Kodak stops producing film cameras, contracting for digital camera production by Asian company.

Digital cameras begin to outsell film cameras. First prosumer digital SLR cameras reach the market.

Hewlett Packard begins selling printers equipped with memory card slots (for direct printing).

Goodheart-Willcox Publisher

Check Your Photography IQ

Now that you have finished this chapter, see what you learned by taking the chapter posttest.

www.g-wlearning.com/visualtechnology/

Review Questions

Answer the following questions using the information provided in this chapter.

1. The name *camera obscura* literally means _____ chamber.

2. Why was neither the camera obscura nor the camera lucida a "camera" as we know it?

3. The first person to permanently capture an image by photographic means was _____.
 A. Niépce
 B. Fox Talbot
 C. Daguerre
 D. Wedgwood

4. A(n) _____ photographic image must be developed to become visible.

For Questions 5–11, match each of the discoveries with its inventor.

5. Daguerreotype A. Eastman
6. Calotype B. Lumiére
7. Wet-plate collodion brothers
 process C. Daguerre
8. Dry plate process D. Land
9. Roll film E. Fox Talbot
10. Autochrome F. Maddox
 process G. Archer
11. Polaroid process

12. How did the negative/positive system alter the direction of photography?

13. The popular term for the product of the ferrotype process was _____.

14. Describe the photographic product introduced by George Eastman in 1888 and its significance to the growth of photography.

15. The _____ process was the first practical method of producing color photographs.
 A. Orthochrome
 B. Autochrome
 C. Kodachrome
 D. Photochrome

16. Digital photography first became a serious competitor to film in the early _____, when it was adopted by many catalog and advertising photographers.

17. The first digital camera with a(n) _____ was introduced in 1995 by Casio.

18. What was the significance of the 6.3Mp EOS Digital Rebel SLR marketed by Canon in late 2003?

19. A number of digital SLRs are described as being aimed at the *prosumer* market. What does that term mean?

20. What might be considered the most significant factor in making the digital revolution possible?

Suggested Activities

1. Locate a photographer, professional or amateur, who is still shooting film. Your instructor might be able to direct you to such a person, or you could contact your community photography club or local photo studios. Interview the photographer about his or her reasons for continuing to do film-based photography. Ask what challenges and benefits it presents compared to digital photography. Write a report to present to your class or record a video of the interview with your smartphone.

2. Chemicals employed in some early photographic processes, such as the mercury fumes used in creating daguerreotypes, were very dangerous. Using Internet and library resources, research early photographic processes and make a list of the chemical hazards you find.

Critical Thinking

1. In 1888, George Eastman patented and began marketing the first self-contained camera to use roll film. Why do you think the Eastman camera lead to truly widespread acceptance of photography as a hobby?

2. The Polaroid photographic process, introduced in 1947, made it possible to take a photo and have a developed print in about one minute. In 2008, the Polaroid Company stopped producing instant film products and cameras. If digital photography had not been developed, do you think Polaroid photography would still be popular?

Communicating about Photography

1. **Speaking and Reading.** With a group of classmates, make a list of at least 20 words that begin with "photo." Photo comes from the Greek root photos (light). You can use the text glossary, a dictionary, and online sources. With your group, discuss the meaning of each word and use each word in a sentence.

2. **Reading and Speaking.** Select a photographic movement, such as pictorialism or abstractionism. Research the types of images produced in that movement and the artists who used that approach. Explain the movement to the class using visuals, such as PowerPoint. Show examples of photos by noted photographers of the movement and explain why the images represent the movement.

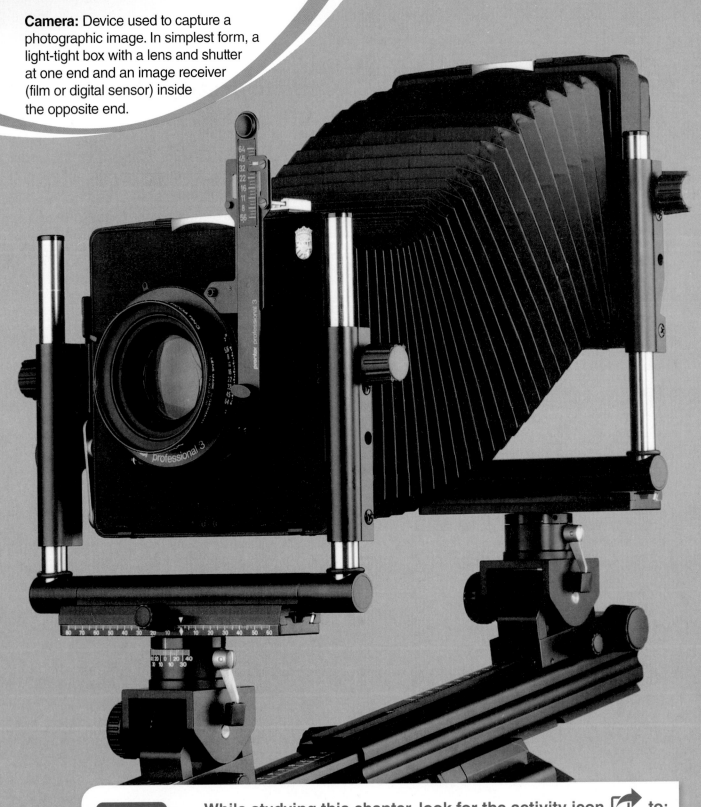

Camera: Device used to capture a photographic image. In simplest form, a light-tight box with a lens and shutter at one end and an image receiver (film or digital sensor) inside the opposite end.

G-WLEARNING.com

While studying this chapter, look for the activity icon to:

- **Assess** your knowledge with self-check pretest and posttest.
- **Practice** vocabulary terms with e-flash cards and matching activities.
- **Reinforce** what you learn by submitting end-of-chapter questions.

www.g-wlearning.com/visualtechnology/

Linhof/HP Marketing Corp.

The Camera System

Objectives

When you have finished reading this chapter, you will be able to:

- Identify the three interactive systems of the camera.
- Describe the differences between manual focus and autofocus methods.
- Explain the light control functions of the aperture and shutter.
- Distinguish between the various film-holding methods.
- Identify the various types of sensors used in digital cameras.
- Recall the characteristics of the major camera types.

Check Your Photography IQ ➤

Before you read this chapter, assess your current understanding of the chapter content by taking the chapter pretest.

www.g-wlearning.com/visualtechnology/

Technical Terms ➤

active autofocus
advanced compact digital cameras
APS-C size sensor
between-the-lens shutters
camera
camera shake
compact digital cameras
diaphragm
electronic viewfinder
film holder
focal plane shutters
image receiver system
large format cameras
medium format cameras

medium format digital cameras
mirrorless cameras
parallax error
passive autofocus
pixel
sensor
separate viewfinder
small format cameras
subject blur
through-the-lens viewing systems
trilinear array
view cameras
Waterhouse stops

In its most basic form, a *camera* is a light-tight box with a closable hole at one side and a light-sensitive material on the opposite inside surface. The camera may be simple or highly sophisticated, but it must accomplish one basic task—getting the picture. To do so, the camera must gather the light rays reflected from an object or scene and focus them on the light-sensitive material (film or an electronic sensor). That material, in turn, is affected by the light rays and captures a representation of the scene. Film records the scene as a latent image, while the sensor captures it as a digital pattern of on/off or high/low voltages that can be stored on a magnetic medium. Later, the film image can be developed and fixed for permanence. The stored electronic image can be displayed on a computer screen or printed to paper.

A camera is a device made up of three interacting systems. They are a viewing/focusing system, a light control system, and an image receiver system.

Viewing/Focusing System

The simple pinhole camera has no viewing system. It is merely pointed at the scene you wish to record and has no means of adjusting focus, since the tiny aperture produces in a moderately sharp image. All other cameras, however, feature some means of viewing the scene to be photographed. Many also allow you to adjust the focus of the image.

Viewing Methods

Cameras may use a system in which the photographer views a scene or subject through the same lens that is used to take the picture, or through a separate viewfinder.

The most common form of *separate viewfinder* is the small viewing window found on cameras ranging from inexpensive single-use film cameras to both classic and modern rangefinder models. Another form of separate viewfinder is used on twin-lens reflex (TLR) cameras, which have one lens for viewing and focusing and another for taking the photo. See **Figure 5-1**.

Jack Klasey/Goodheart-Willcox Publisher

Figure 5-1. Viewing systems. A—Rangefinder and simple cameras use a separate small viewing window. B—On a twin-lens reflex camera, the viewing lens is above the taking lens.

While separate viewfinders work well for many situations, they can cause a problem when you take close-up photos. The problem, called *parallax error*, is a mismatch in what the photographer sees though the viewfinder and what the camera's taking lens sees, **Figure 5-2**.

With *through-the-lens viewing systems*, what you see in the viewfinder is the image you will get...almost. Except for some professional models, cameras with through-the-lens viewfinders often show less of the scene than is recorded on the film or sensor. What you see in the viewfinder may be only 92% to 95% of what

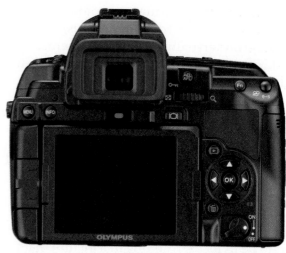

Seen through viewing lens

Seen through taking lens

Goodheart-Willcox Publisher

Figure 5-2. Parallax error can cause part of a subject to be lost when taking a close-up photo. The red line shows the subject as seen through the viewing lens. The black line frames the view that will be captured on film through the taking lens.

Olympus America, Inc.

Figure 5-3. A separate electronic viewfinder, located above the LCD screen, is found on digital SLRs and some advanced compact cameras.

the camera records. This might not be critical for most photographs, but it could allow a distracting element to appear at the edge of a carefully composed picture.

An *electronic viewfinder* is used on some digital cameras. Instead of a mirror to reflect the scene viewed by the lens, the electronic finder makes use of a small LCD (liquid crystal display) that shows the image from the camera's sensor, **Figure 5-3**.

For many digital models, the primary viewfinder is the LCD screen on the back of the camera. The photographer uses the screen to frame the shot, **Figure 5-4A**, and to review the

image after it is captured. A major shortcoming of the LCD screen as the primary viewfinder is its tendency to "wash out" in bright sunlight. To overcome this problem, a number of companies have developed hood-like devices that shade the screen to improve visibility, **Figure 5-4B**.

Focusing Methods

Bringing a subject into sharp focus can be done manually or automatically. Manual focus is used on rangefinder and older 35 mm single-lens reflex (SLR) cameras, many medium format cameras, and all large format cameras.

A

B

Olympus America, Inc.; Delkin Devices

Figure 5-4. LCD viewing screen. A—Non-SLR digital cameras often use the LCD screen for both composing and reviewing images. B—To shade the camera's LCD screen for better visibility under bright lighting conditions, collapsible hoods are available.

It also is an option on many autofocus cameras. Automatic focus (autofocus) is now available on virtually all digital cameras, most 35 mm film cameras, and some medium format cameras.

Manual Focusing

To manually focus a through-the-lens SLR camera, the photographer rotates the lens barrel while looking through the viewfinder. As the barrel rotates, the image in the viewfinder becomes either sharper or more diffused (softer). When the image is at maximum sharpness, it is said to be in focus, resulting in a picture that is sharp as well.

Some cameras have focusing aids to help the photographer judge whether the subject is in focus. The two major types are the split prism and the microprism. Some cameras have one or the other, but many use both, **Figure 5-5**.

- **Split-prism** focusing aids are usually circular and are divided by a horizontal line. As the lens barrel is rotated, the image in the upper and lower halves of the prism shift left or right. When they are aligned, the subject is in focus.

- **Microprism** focusing aids appear as a narrow ring of small diamond-shaped elements surrounding the split prism. They "break up" the image when it is out of focus. As the lens barrel is rotated and the image comes into focus, the image becomes smooth and whole.

Ground Glass Focusing

Ground glass focusing requires the photographer to judge when the image seen in the viewfinder is sharply focused. This makes using a ground glass more open to error than other focusing methods. This method is most common on twin-lens reflex and large format cameras. Some users of 35 mm and medium format cameras prefer a viewfinder with plain ground glass, considering it faster and easier to use than other focusing aids.

Rangefinder Focusing

A number of cameras that have separate viewfinders are of the rangefinder type. The focusing method is similar to split-prism focusing. When the split image comes together, **Figure 5-6**, or when overlapped images are perfectly aligned, the subject is in focus. Compared to SLRs, rangefinders have a brighter viewfinder image, which is an advantage in low-light situations.

Autofocus Systems

Nearly all cameras today have autofocus capability. Using sensors built into the camera's viewing system, they are able to bring the image into sharp focus before the shutter is released. The two broad categories of autofocus systems are *active* and *passive*.

The term ***active autofocus*** is based on the method employed to achieve focus. A beam of

Jack Klasey/Goodheart-Willcox Publisher

Figure 5-5. Cameras with manual focusing often have a split prism surrounded by a microprism.

Jack Klasey/Goodheart-Willcox Publisher

Figure 5-6. When the overlapped or split images are perfectly aligned, the rangefinder camera is focused.

infrared light is emitted to bounce off the subject, **Figure 5-7**. The system times the interval between the departing and returning burst of light, calculates the distance, and focuses the camera to that distance. Active autofocus is widely used in "point-and-shoot" film and digital cameras designed primarily for snapshots.

A problem with active autofocus is a noticeable lag between the time the shutter release is pressed to activate the autofocus system and the opening of the shutter. The length of the autofocus lag varies greatly. In some cameras, it may be long enough that the subject has moved out of the frame before the shutter opens.

More sophisticated cameras use various versions of the *passive autofocus* system. These systems evaluate incoming light, allowing them to react much more rapidly than systems that send out a beam and must wait for its return. They use multiple sensors and computer circuitry to quickly and precisely achieve focus under almost any conditions. See **Figure 5-8**. The user can select which sensor or combination of sensors should be dominant in focusing under given conditions.

SLR cameras generally use a phase detection autofocus method, which reads changing energy levels as the image is brought into focus. Compact cameras and many of the increasingly popular mirrorless SLR cameras use a contrast-based system, which is the electronic equivalent of split-image focusing.

The ability of computer circuits to make decisions and order actions rapidly led to the

Jack Klasey/Goodheart-Willcox Publisher

Figure 5-8. Multiple sensors are used in the passive autofocus systems of many current camera models. The photographer can select one or more sensors to be dominant for specific situations.

development of predictive autofocus. With a fast-moving subject, the system continually calculates speed and direction and makes adjustments to ensure that the focus will be precise at the instant the exposure is made.

Light Control System

The amount of light reaching the camera's sensor or the film's emulsion to record an image is governed by the light control system. The two parts of this system are the lens aperture and the shutter. These two parts function together or independently to regulate how much light strikes the image receiver (film or sensor). The relationship between aperture and shutter speed affects the ability to stop subject motion and dictates how much of a scene will be in sharp focus.

Aperture

The word aperture means *opening*. In photography, it describes the size of the hole through which light passes to strike the image receiver. The aperture may be fixed or variable, and can be located in the camera body or the lens assembly. Some very simple cameras have both a fixed aperture and a fixed-speed shutter. To provide acceptable pictures, they must be used in bright lighting conditions, preferably with subjects that hold still.

Goodheart-Willcox Publisher

Figure 5-7. In active autofocus, a beam of infrared light is bounced off the subject to establish camera-to-subject distance. The camera then focuses to that distance.

Methods for Varying Aperture

There are two basic methods of varying the aperture—a series of different fixed-size openings, or an adjustable device that can be opened or closed to provide holes of various sizes. Early box cameras were equipped with a plate that had two or more openings of different sizes. By pivoting or rotating the plate, the photographer moved the desired-size opening into the light path.

A similar method was used with large view cameras in the nineteenth century. Photographers carried a set of *Waterhouse stops*, which were brass plates, each with a precisely sized hole. The chosen plate was slipped into a slit that was cut in the lens barrel.

A *diaphragm*, or iris, is a variable-aperture device consisting of an assembly of thin, overlapping metal blades, **Figure 5-9**. On SLR cameras, the diaphragm is mounted in the interchangeable lenses, rather than in the camera body. Lenses on film cameras change the aperture by rotating a ring on the lens barrel. This causes the blades to move inward or outward, varying the size of the opening they create. On digital cameras, the aperture is set electronically and is selected on the LCD screen or in the viewfinder. See **Figure 5-10**.

Apertures are presented as specific-size openings called *f-stops*. The f-stop system is explained in detail in Chapter 7, *Light and Exposure*.

Aperture ring

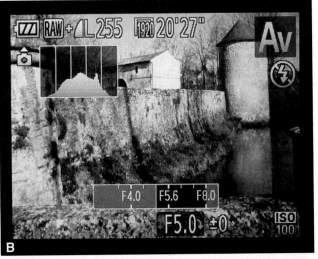

Jack Klasey/Goodheart-Willcox Publisher

Figure 5-10. Aperture selection. A—Aperture ring on lens barrel. B—Aperture display on digital camera LCD screen.

Jack Klasey/Goodheart-Willcox Publisher

Figure 5-9. An iris consists of overlapping metal plates that can form round openings of various sizes.

Aperture and Depth of Field

The size of the opening has a direct relationship to how much of the picture will be in sharp focus. The size of this zone of sharp focus, called *depth of field*, becomes greater as the aperture size decreases, and shrinks as aperture size increases. See Chapter 10, *Making Exposure Decisions*.

Shutter

The shutter acts like a valve, opening and closing to control the flow of light to the image receiver. While the aperture varies the amount of light through changes in size, the shutter regulates light by the length of time it remains open.

Most shutters are mechanical, meaning they physically open and close. Shutters can be divided into two categories based on their location.

Between-the-lens shutters are part of the lens assembly. *Focal plane shutters* are located in the camera body, just in front of the image receiver. Between-the-lens shutters are found in inexpensive small film cameras, in medium format cameras, and large format cameras. Focal plane shutters are almost universally used in SLR digital and film cameras. Some digital cameras use an electronic shutter system that controls the length of time the sensor is actively gathering light.

Between-The-Lens Shutters

Many older film camera designs used a rotating or pivoting disk with a hole in it, **Figure 5-11**. Pressing the shutter release first tensioned a spring, and then released it to rapidly move the shutter opening past the aperture. The length of exposure with this type of shutter is roughly 1/40 second.

A more complex mechanism, which makes it possible to vary shutter speeds, is called the leaf shutter. In appearance, it is quite similar to the diaphragm used to vary apertures. When the release is pressed, the shutter snaps to the fully open position. At the end of the preset exposure time, it snaps back to the fully closed position.

Focal Plane Shutters

The first focal plane shutters were made with a curtain of thin, tough cloth fastened to two rollers equipped with spring drives. Spring tension was varied to move the narrow slit past the film at different rates, or shutter speeds.

Two-piece curtains of fabric or flexible metal are used in modern 35 mm and medium format cameras to achieve a wide range of shutter speeds. At speeds of 1/60 second or slower, the first curtain typically moves all the way across the film before the second curtain begins its travel, **Figure 5-12**. The delay between first-curtain and second-curtain movement is the exposure time. For shutter speeds faster than 1/60 second, the curtains are driven independently to form a moving slit of the desired width. Depending on camera design, the shutter curtains may travel horizontally or vertically. Most digital cameras with focal plane shutters use the vertical type.

To select the shutter speed on a camera equipped with a focal plane shutter, a dial is rotated to the proper setting, **Figure 5-13**. Alternatively, a button or other control may be pressed until the desired speed is shown on an LCD display.

Jack Klasey/Goodheart-Willcox Publisher

Figure 5-11. This early camera had a spring-operated rotating shutter. The camera's outer shell was removed to show the shutter mechanism.

Jack Klasey/Goodheart-Willcox Publisher

Figure 5-12. At a shutter speed of 1/60 second or slower, the first curtain of a focal plane shutter is completely open before the second curtain begins its travel.

Shutter speed dial

Figure 5-13. On a camera with a focal plane shutter, the shutter speed is often selected by rotating a knob or dial.

Figure 5-14. Blurring due to camera shake is evident in this shot of an "exploded engine" display at a museum. The vertical lines are wires supporting the separate parts.

Available shutter speeds vary widely. Older 35 mm cameras generally offered speeds ranging from 1/1000 second to 1 second in length. Newer film and digital models with electronically controlled shutter motors allow exposures as long as 30 seconds and as short as 1/8000 second. Many cameras also have settings to allow longer, manually controlled exposures.

Shutter speeds have a constant relationship, just like the f-stops that are used to indicate aperture. The shutter speed/f-stop relationship is covered in detail in Chapter 7, *Light and Exposure*.

Shutter Speed and Motion Control

Shutter speed is the primary means of controlling camera and subject motion. Blurring of a photograph caused by camera motion is almost always undesirable, while blurring resulting from subject movement has both negative and positive aspects.

Camera shake, the involuntary movement of a camera during exposure, typically occurs when the camera is handheld at shutter speeds slower than 1/60 second. See **Figure 5-14**. Although bracing against a post or other support allows some photographers to hand-hold successfully at slower shutter speeds, a minimum of 1/60 second is usually recommended. Image stabilization technology, available on many cameras, **Figure 5-15**, allows hand-holding at lower shutter speeds.

Figure 5-15. In this camera system, image stabilization is turned on or off using a switch on the lens.

Subject blur occurs when a person or object is moving too fast for the selected shutter speed to stop its motion, **Figure 5-16**. Finding the proper shutter speed to stop motion or allow a desired degree of blur for a given situation is a matter of experience and experimentation.

Image Receiver System

The third major camera system is designed to place a light-sensitive medium at the point where light rays converge after passing though the lens. Depending on the camera type, the *image receiver system* consists of film and the means to hold it in place or a digital sensor and related electronic circuits.

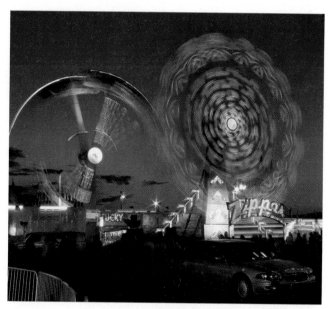

Figure 5-16. A subject moving too rapidly for the selected shutter speed will be blurred, while the rest of the picture is sharp. This fairgrounds scene uses intentional subject blur for creative effect.

Film

For proper and undistorted exposure to the light rays transmitted by the camera lens, photographic film must be held perfectly flat in the plane where the rays are focused. This position is called the film plane, or the focal plane. The focal plane shutter, however, is located very slightly ahead of it to leave space for the film.

Two different mechanical systems hold film in position and exchange an exposed piece of film with an unexposed one to take another picture. For large format film in individual sheets, a holder system allows an exposed sheet to be removed from the camera and a fresh piece of film inserted. For medium format and smaller cameras, film is in strip form. The film is advanced with a roller system that moves the exposed frame out of the light path and positions a fresh frame.

Sheet Film

Sheet film is loaded into a light-tight *film holder*, **Figure 5-17**, that can be inserted in the camera and opened to permit an exposure to be made. It holds two sheets of film, one on each side.

The 4″ × 5″ and 8″ × 10″ sizes of sheet film are most often used. Both color and black-and-white sheet films are available.

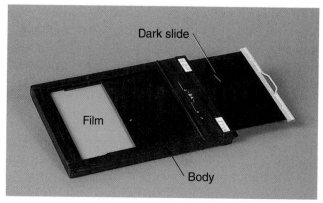

Figure 5-17. A sheet film holder designed to hold one sheet of film on each side.

Roll Film

Medium format roll film cameras use a two-spool system to position film for exposure and advance it from frame to frame. A full roll of film is inserted at one side of the camera back, and its free end inserted in an empty spool on the opposite (take-up) side, **Figure 5-18**.

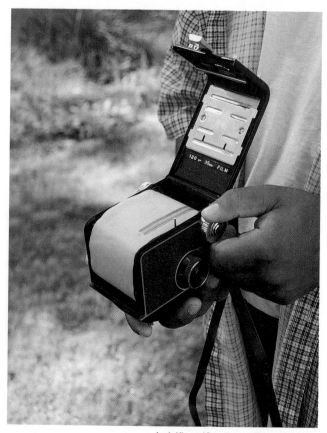

Figure 5-18. A winding knob is used to take up slack when loading roll film in a camera.

The camera is closed and a winding knob or lever is used to advance the film when making exposures.

Roll film consists of a strip of film with smooth, unperforated edges, taped at one end to an opaque paper backing. It is readily available only in the 120 size.

Film Cassette

A film cassette is a light-tight canister that holds and protects the strip of film. Cassettes most commonly have 24 or 36 exposures.

Most 35 mm cameras have a hinged back that is swung open to load the film cassette. The perforations (holes) along the two film edges engage a pair of toothed sprockets, **Figure 5-19**. The sprocket holes on the film edges provide a slip-free method of moving the film forward eight holes (one frame) each time the film advance lever is operated.

Newer 35 mm SLR film cameras and most of the point-and-shoot models have a motor-driven film advance that automates the loading process. After all frames have been exposed, motor-driven camera models may rewind film into the cassette automatically.

Cartridge Films

Over the years, various types and sizes of drop-in film cartridges were developed. The most widely adopted were the 126 and 110 film sizes introduced by Kodak for use in its Instamatic snapshot cameras in the 1970s. See **Figure 5-20**. The 126 cartridge is no longer available in stores, and the 110 cartridge is difficult to find.

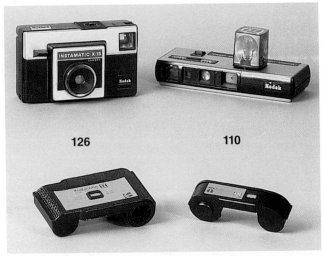

126 110

Jack Klasey/Goodheart-Willcox Publisher

Figure 5-20. Cartridge films in the 126 and 110 sizes were used in Instamatic snapshot cameras.

Digital Sensor

In a digital camera, the light rays entering through the lens when the shutter is opened strike a *sensor* that contains millions of tiny photosites, which are light-sensitive elements. The common term for each individual photosite on a sensor is *pixel*, an abbreviation of the term *picture element*. Pixels are typically arranged in rows to form a grid or area array, **Figure 5-21**. Cameras are often classified by the number of pixels contained in their CCD array. Thus, a camera that has an array of 2000 rows with 3000 pixels per row would have 6 million photosites. The Greek prefix *mega* represents a million, so a camera with 6 million photosites is referred to as a 6-megapixel (6Mp) camera. In most arrays, the individual pixels are square, but some manufacturers use rectangular or even octagonal pixels.

Sensor Types

There are two basic types of camera sensors, the CCD (charge-coupled device) and the CMOS (complementary metal oxide semiconductor). Either type is capable of capturing high-quality images. Detailed information on these sensors and how they operate is presented in Chapter 8, *Image Capture Media*.

Sensor Sizes

Although the number of pixels is often thought of as a means of describing sensor

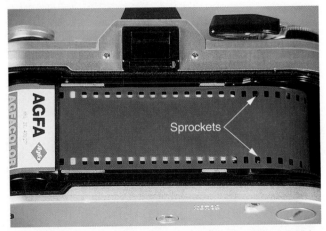

Jack Klasey/Goodheart-Willcox Publisher

Figure 5-19. Two sprockets pull the 35 mm film out of the cassette, one frame at a time, as the film advance lever is operated.

Figure 5-21. A digital camera has an array of millions of tiny sensors, called pixels. A—Pixel size is greatly exaggerated in this diagram of an area digital array. B—This 24.3-million pixel full-frame sensor is used in Nikon's top-of-the-line prosumer digital camera.

size, the true measure of size is the sensor's physical dimensions, **Figure 5-22**. Full-frame 35 mm (24 mm × 36 mm) sensors are expensive to manufacture and are found primarily in professional-level digital SLR cameras. Most digital compact, mirrorless, and prosumer digital SLRs use the smaller *APS-C size sensor*, which is approximately 24 mm × 16 mm. Cameras from Olympus, Panasonic, and Leica employ a still-smaller sensor called the *Four Thirds System*.

Medium format digital cameras have sensors that are slightly smaller than the popular 645 (6 cm × 4.5 cm) film format, with resolutions as high as 40Mp. The larger sensor has physically larger individual pixels, providing higher-quality results. An integrated medium format digital SLR is similar in most respects (other than size) to the 35 mm digital SLR.

Trilinear Arrays

Studio capture devices called *scanning backs* make use of a *trilinear array*, which is a bar containing three rows of sensors that is moved across the image receiver area. One row of sensors is filtered to capture red wavelengths, one is filtered for green, and the third is filtered for blue. This permits image capture in a single pass as the bar is moved in tiny increments by a stepping motor. See **Figure 5-23**.

Full-Frame Sensor

APS-Size Sensor

Figure 5-22. The full-frame sensor is about one and one-half times larger than the APS-C size sensor. Sensors used in the Four Thirds System are smaller still.

Trilinear array moves across image area

Figure 5-23. Three rows of pixels are typically used in scanning backs. The scanning process requires exposures that are usually minutes in length.

Scanning backs are attached to medium format or large format cameras, capturing images that are the equivalent of the 6 cm × 6 cm or 4″ × 5″ film formats. They are used only with subjects that do not move.

Camera Varieties

Since general-use cameras were introduced in the late 1800s, many different designs have developed. Most are variations in size or complexity on a few basic types.

One method of classifying cameras is by their format, or size of image receiver. The traditional format classes are small, medium, and large:

- *Small format cameras* use digital sensors or films ranging from 35 mm size down to tiny subminiature cameras that use 9.5 mm or 16 mm film. See **Figure 5-24**.

- *Medium format cameras* use 2 1/4″ wide (120-size) roll film, but produce negatives in one of five different formats—6 cm × 4.5 cm, 6 cm × 6 cm, 6 cm × 7 cm, 6 cm × 9 cm, or 6 cm × 12 cm. Medium-format digital cameras are offered primarily in the 6 cm × 4.5 cm format.

- *Large format cameras* use film or scanning backs. Film models expose individual sheets, most commonly in 4″ × 5″ or 8″ × 10″ sizes.

Simple Cameras

Simple cameras are the least sophisticated in construction. These point-and-shoot units require little of the user other than to frame the desired subject matter in the viewfinder and press the shutter release.

The single-use film camera is in this category, as are reloadable point-and-shoot film models, **Figure 5-25**. A few cameras in this category use the gradually disappearing 110 film formats.

Virtually every digital camera offers point-and-shoot simplicity. Even the most sophisticated SLR models have an automatic mode that allows the camera to choose all exposure and focus settings. However, digital cameras can be generally categorized as compact, advanced compact, and interchangeable lens (SLR) models.

The earliest digital cameras were developed in the mid-1990s by Apple, Kodak, Casio, Sony, and Nikon. They were simple point-and-shoot models with fixed-focal-length lenses and 1 or 2 megapixel (Mp) sensors. Memory was small and internal; removable memory cards were still several years away.

Within a few years, 3Mp and 4Mp models were common, and zoom lenses were becoming standard. By 2015, *compact digital cameras* typically offered sensors in the 12Mp–16Mp range and were equipped with 4× to 12× optical zoom lenses. See **Figure 5-26**. The term "4×" means that the telephoto end of the zoom range is roughly three times the wide end; for example,

Jack Klasey/Goodheart-Willcox Publisher

Figure 5-24. Subminiature cameras, such as the Minox, are often referred to as "spy cameras" because of their small size.

Kodak

Figure 5-25. Single-use cameras are sent in to have the film developed.

Figure 5-26. Many compact digital cameras on the market today have 12Mp to 16Mp sensors. A—Lumix DMC-TS20. B—XQ1. C—PowerShot ELPH 115. D—Olympus SZ-12.

28 mm–112 mm. Most models offer automatic (program), manual, aperture priority, or shutter priority operation, and some have selectable preset modes for situations such as action, night, or portrait photography. All have built-in flash. Most compacts are small enough to carry in a pocket. Ultracompact models are even smaller, often the length and width of a credit card and a thickness of 3/4″ or less.

Advanced compact digital cameras have most of the same features as SLR cameras, except for interchangeable lenses. Many are categorized as superzooms, with a zoom range of 50×, (24 mm–1200 mm) or more, **Figure 5-27**. Most advanced compact cameras offer image stabilization to counter camera shake and have both a built-in flash and a hot shoe to accept a separate flash unit.

Goodheart-Willcox Publisher

Figure 5-27. Superzoom cameras are a growing segment of the advanced compact digital market.

Camera phones have achieved incredible popularity since being introduced in the early 2000s. Ease of use and the ability to instantly transmit photos to friends have made the devices particularly popular with teens and young adults, **Figure 5-28**.

Camera phones generally have small CMOS sensors and relatively low resolution (typically 3Mp–8Mp), limiting their photographic capabilities to on-screen display or small prints. Most have lower-resolution (2Mp or less) front-facing cameras used for taking selfies. Resolution and image quality continue to improve, however. By early 2015, a variety of smartphone models offered 16Mp–20Mp resolution, and at least two phones included extremely high resolution 41Mp cameras, **Figure 5-29**.

Rangefinder Cameras

Focusing by means of bringing together two overlapping images or two halves of a split image has long been a popular system for cameras. The use of 35 mm film rangefinders declined with the surge in SLR models, but by 2004, the first digital rangefinder model was introduced. In 2013, Leica offered a full-frame 24Mp professional digital rangefinder.

Reflex Cameras

Cameras in the reflex category use a mirror to reflect a scene onto a viewing screen.

Nokia

Figure 5-29. The camera in a Lumia 1020 smartphone has a 41Mp sensor.

The twin-lens reflex (TLR) camera has two lenses positioned one above the other, **Figure 5-30**. The lower lens is the taking lens, which admits light to the film. Light passing through the upper lens

Istabilizer

Figure 5-28. Camera phones are popular because they are small, portable, and easy to use. Resolution and image quality are increasing rapidly, making the camera phone a strong competitor to compact digital models.

Rollei Fototechnic

Figure 5-30. On twin-lens reflex cameras, viewing and focusing are done using a separate lens above the one that is used to take the photograph.

strikes a fixed mirror set at a 45° angle and is reflected onto a ground glass screen for focusing. The reflected image is large and fairly bright, but is reversed left-to-right.

The single-lens reflex (SLR) camera for 35 mm film began coming into wide use in the late 1940s and 1950s. In 1991, the first professional-level digital SLR was introduced. Affordable digital SLRs entered the consumer market in 2003. Medium format film SLRs were first used in the 1980s, digital backs for medium format models were introduced in 2005.

Like the TLR, the SLR uses a mirror to reflect an image onto a viewing screen, but the resemblance ends there. In the SLR camera, the same lens is used for focusing and for taking the picture. Light reflected from the subject passes through the lens, strikes the angled mirror, and is reflected upward onto a screen. The light then passes through a five-sided prism (pentaprism) that corrects the inverted and reversed image for viewing through the eyepiece. See **Figure 5-31**. When the shutter

release is pressed, the hinged mirror flips upward, allowing light to reach the film.

Since both viewing and picture-taking are done through the same lens, there is no parallax error with an SLR. This arrangement also permits selective focusing, depth-of-field preview, and easy interchangeability of different focal length lenses. Selective focus and depth-of-field preview are discussed in Chapter 9, *Making a Picture*.

Mirrorless Cameras

A relatively new category of interchangeable lens equipment, the *mirrorless camera*, has seen rapid growth in the marketplace. Mirrorless cameras, **Figure 5-32**, can be made smaller and lighter than traditional SLR interchangeable lens cameras, since they do away with the mirror assembly and pentaprism. They also are quieter in operation, eliminating the mechanical noise made by pivoting the mirror out of the light path. Although lenses specifically designed for use with mirrorless cameras are increasingly available, older lenses can be used with adaptors.

Sensors on mirrorless cameras vary from the APS-C size common to most compact and prosumer cameras to the full-frame size found on a few high-end models. Most cameras in this category use the LCD screen as both the viewfinder and the review screen.

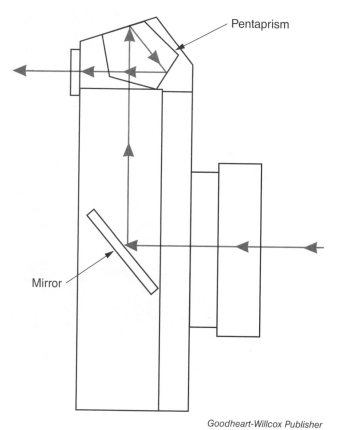

Goodheart-Willcox Publisher

Figure 5-31. In a SLR camera, light entering the lens bounces off an angled mirror, then through a pentaprism to the viewfinder, so the picture can be composed and focused.

Sony Electronics, Inc.

Figure 5-32. Mirrorless cameras with interchangeable lenses are gaining popularity.

View Cameras

The large and cumbersome wooden contraptions used in the 1860s to photograph scenes on Civil War battlefields were called *view cameras*. The photographer composed and focused the scene on a ground glass viewing surface at the back of the camera. Once this was done, a sensitized glass plate was slipped in place behind the ground glass, and the picture exposed.

Today's view cameras are generally constructed of metal and plastic. They capture images using film or a digital back rather than a glass plate. A typical view camera consists of a lens and shutter mounted in a lensboard, a flexible bellows, a ground glass for focusing and some means of clamping a film holder or digital back in place. See **Figure 5-33**.

A drawback of the film-based view camera, aside from its awkward size, is the need to use a hood or focusing cloth for proper viewing of the ground glass while focusing. A further problem is the double inversion of the image on the ground glass—it is both upside-down and reversed left-to-right, **Figure 5-34**. Use of a digital back connected by cable to a computer eliminates the double inversion problem. The image from the sensor is processed to appear on the screen in the proper orientation.

For outdoor or location work, a field camera is typically chosen for its portability and ease of use. Field cameras are more compact than rail cameras and have a flat bed for support. A press camera, which is similar in appearance to the field camera, was used by newspaper photographers until the 1950s. See **Figure 5-35**.

Linhof/HP Marketing Corp.

Figure 5-33. Rail-mounted view cameras like this one are used primarily in studio situations.

Jack Klasey/Goodheart-Willcox Publisher

Figure 5-34. The image on a view camera's ground glass is reversed both vertically and horizontally.

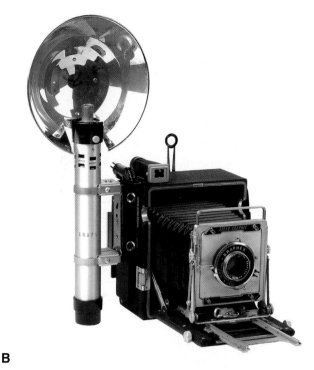

A

B

Figure 5-35. Portable view cameras. A—Flatbed field cameras are a more rugged and compact version of the studio view camera. B—This Graflex Pacemaker Speed Graphic press camera was designed to be handheld.

Portfolio Assignment

Shake It Up!

Camera shake can create some interesting and artistic images. For this assignment, you will purposely create some blurry pictures.

Experiment with different combinations of slow shutter speeds (such as 1/4 second, 1/2 second, and one second) and different motions (rapid panning, jiggling up and down, shaking, even jumping up and down). As shutter speeds decrease, you will get motion even when you try to hold still. Try shooting from a vehicle. **Example A**, the image of a city skyline at night, was a one-second exposure taken from the open top deck of a stopped tour bus. You could also make images from a playground swing or slide or seesaw.

Also try shooting with different focal lengths. As lenses become longer, even tiny movements are exaggerated. The portrait of a girl in a Paris café, **Example B**, was shot from across the street using a 400 mm telephoto with a 1/4 second exposure.

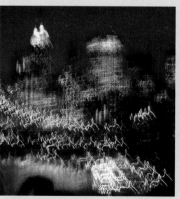

Jack Klasey/Goodheart-Willcox Publisher

Example A. A handheld one-second exposure created this interestingly blurred city skyline.

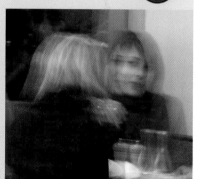

Jack Klasey/Goodheart-Willcox Publisher

Example B. Motion blur in this portrait of a girl in a café resulted from use of a long lens.

After reviewing your images, choose the one you feel is the most interesting and creative. Make a print for your portfolio. Attach a note to the back of the print with shutter speed, aperture, ISO, and focal length, as well as a brief description of how you achieved the results.

Check Your Photography IQ ➦

Now that you have finished this chapter, see what you learned by taking the chapter posttest.

www.g-wlearning.com/visualtechnology/

Review Questions ➦

Answer the following questions using the information provided in this chapter.

1. What are the three interactive systems of a camera?

2. The autofocus method that reads changing energy levels as the image is brought into focus is referred to as _____.

3. Film and digital cameras both use light rays passing through a lens to record an image. At what point in the picture-taking process do the two methods begin to differ?

4. A _____ camera does not have a viewing/focusing system.
 A. digital
 B. pinhole
 C. large format
 D. twin-lens reflex

5. Why is parallax a problem with cameras that have a viewfinder separate from the taking lens?

6. The _____ autofocus system uses a beam of infrared light to calculate the camera-to-subject distance.

7. To adjust the aperture on their view camera lenses, nineteenth century photographers used a set of _____.
 A. Windisch shutters
 B. aperture plates
 C. adjustable diaphragms
 D. Waterhouse stops

8. Depth of field _____ as the aperture becomes larger.

9. Describe the difference between focal plane shutters and between-the-lens shutters in terms of using electronic flash.

10. Film holders for large format cameras typically hold _____ sheet(s) of film.
 A. one
 B. two
 C. four
 D. six

11. Each frame of 35 mm film has _____ sprocket holes along its edges.

12. Single-lens reflex digital cameras may have full-frame, _____ size, or Four Thirds System sensors.
 A. CFC
 B. APS-C
 C. CTR
 D. ALS

13. The 110 and 126 cartridge film sizes were developed for use in Kodak's _____ snapshot cameras.

For Questions 14–19, match each of the camera types with the phrase that applies to it.

14. Medium format camera
15. Rangefinder camera
16. SLR camera
17. TLR camera
18. Field camera
19. Simple camera

A. Viewing lens above taking lens
B. Point-and-shoot operation
C. 120 film
D. Through-the-lens focusing
E. Separate viewfinder
F. Compact, folding view camera

20. List three advantages of the mirrorless camera compared to the single-lens reflex.

21. What is a *trilinear array*?

Suggested Activities

1. Survey 20 people—10 teens and 10 people over age 50. Ask them what type and make of camera (point-and-shoot, SLR, smartphone, etc.) they use most often. Also ask why they use that type of and whether they would choose a different type the next time they buy a camera. Compile your results for each of the two age groups in a table. Analyze the data and report your conclusions in a short paper.

2. Study the light control system on a 35 mm SLR film camera. Open the camera back and then look through the camera lens from the front side as you operate the shutter release. You should see a flash of light as the focal plane shutter opens and closes. Set the shutter speed to 1/8 second and watch the focal plane shutter from the back of the camera after you press the shutter release. You should be able to clearly see the operation of the shutter curtains. Experiment with longer and shorter shutter speeds to see the difference in curtain movement. Describe and demonstrate the shutter operation to another student.

Critical Thinking

1. In only about 20 years, the sensors in consumer-level digital cameras have grown from 1Mp to 16Mp or more, while professional large-format cameras have sensors in excess of 400Mp. Is it reasonable to expect this growth trend will continue until there is a camera with a greater-than-1Gp (gigapixel) sensor? Do the math before you decide on an answer.

2. A salesperson shows you two new camera models with comparable features. One has an active autofocus system and the other has a passive autofocus system. Which one would you be inclined to buy? Why?

Communicating about Photography

1. **Speaking.** Choose two major camera manufacturers and debate the topic of which produces the better products. Divide into two groups. Each group should gather information in support of either the *pro* argument (Brand A is better) or the *con* argument (Brand B is better). You will want to do further research to find expert opinions, costs associated with the camera models, and other relevant information.

2. **Listening.** As classmates deliver their presentations, listen carefully to their arguments. Take notes on important points and write down any questions that occur to you. Later, ask questions to obtain additional information or clarification from your classmates as necessary.

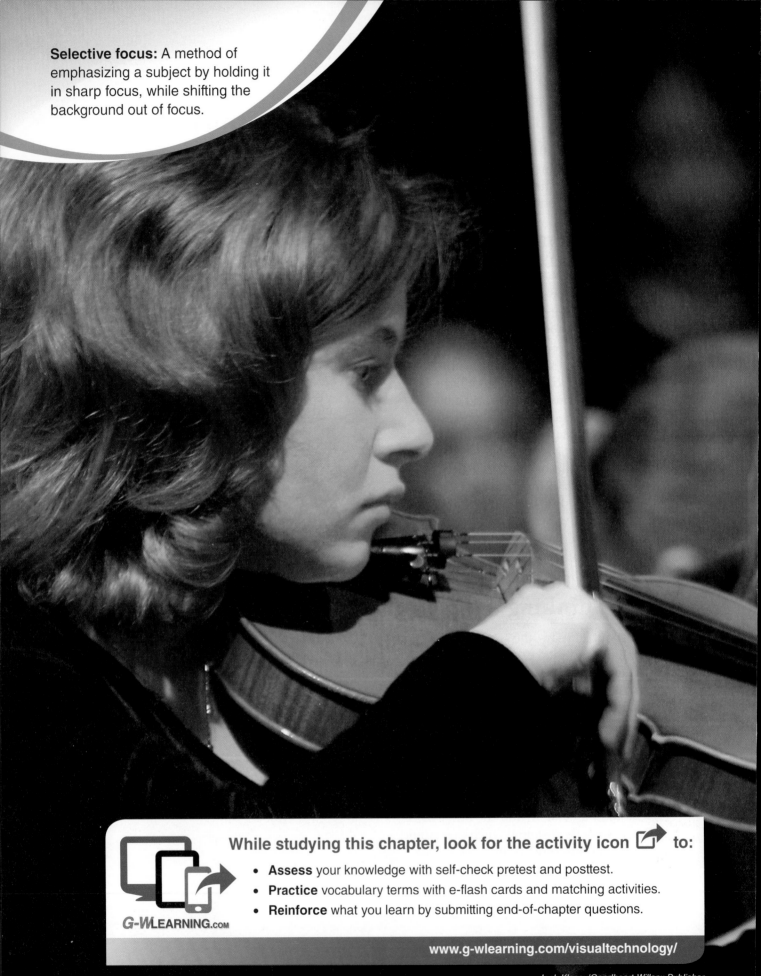

Selective focus: A method of emphasizing a subject by holding it in sharp focus, while shifting the background out of focus.

While studying this chapter, look for the activity icon ↗ **to:**

- **Assess** your knowledge with self-check pretest and posttest.
- **Practice** vocabulary terms with e-flash cards and matching activities.
- **Reinforce** what you learn by submitting end-of-chapter questions.

G-WLEARNING.com

www.g-wlearning.com/visualtechnology/

Lenses

Objectives

When you have finished reading this chapter, you will be able to:

- Describe the effects of the six types of lens aberrations.
- Explain how a lens focuses an image on film or a sensor.
- Describe the relationship of focal length to image size.
- Explain the multiplier effect on lenses used with most digital SLR cameras.
- Recall the characteristics of the various types of lenses.

Check Your Photography IQ

Before you read this chapter, assess your current understanding of the chapter content by taking the chapter pretest.

www.g-wlearning.com/visualtechnology/

Technical Terms

astigmatism
back focus
barrel distortion
chromatic aberration
coma
concave
converge
convex
creative effects lens
curvature of field
digital zoom
distortion
diverge
elements
fish-eye lenses

focal length
focal point
front-focusing
macro
meniscus lens
optical zoom
pincushion distortion
refraction
reproduction ratio
retrofocus
spherical aberration
superzooms
teleconverter
zoom range

As a device for making small objects appear larger or distant objects look closer, the lens has been in use for thousands of years. It was not until the late 1500s and early 1600s, however, that the magnifying power of lenses was put to practical scientific use with the invention of the microscope and the telescope.

Photographic applications of the lens began well before the first permanent photographic image was captured by Niépce in about 1826. William Hyde Wollaston, an English scientist and inventor, designed the *meniscus lens* in 1812 to improve the image projected by the camera obscura. As shown in **Figure 6-1**, the lens had one convex face and one concave face. By changing the shape of the lens, Wollaston was able to project a flatter, less distorted image than the previously used biconvex lens.

How a Lens Works

A lens bends light through a process called *refraction*. As shown in **Figure 6-2**, a light ray passing from air into glass changes direction. Because glass is denser than air, it slightly slows the speed of the light ray, causing its path to bend. When the light ray emerges from the other surface of the glass, it again changes speed, and thus direction.

Lens Shapes and Light

Lenses are curved shapes, so the rays of light entering them are bent to different angles by

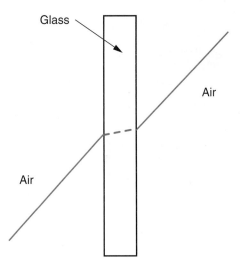

Goodheart-Willcox Publisher

Figure 6-2. Light rays are bent as they pass through materials of different densities, such as glass and air.

different parts of the curved surface. If the lens shape is *convex* (curved outward), the emerging light rays will *converge*, or be brought together. If the lens is *concave* (curved inward), the rays will *diverge*, or be spread apart. Rays that enter the lens at a 90° angle to its surface pass straight through and are not refracted.

Figure 6-3 shows how simple convex and concave lenses affect light. In the convex lens, light rays that enter different areas of the curved surface are bent to converge on a common point called the *focal point*. The convex lens produces a real image at its focal point. That image can be seen or captured on film or an electronic sensor.

The concave lens, on the other hand, causes light rays that pass through it to diverge. This lens also forms an image, but on the front side of the lens. This virtual image can be seen only by looking through the lens.

Lens Aberrations

Optical problems called *aberrations* can cause blurred, color-distorted, or shape-distorted images when a convex lens is used alone. In order to produce a sharper, more distortion-free image, lens designers have combined varying numbers of different-shaped lens *elements* (convex and concave lenses) to form compound lenses. See **Figure 6-4**. The designers also improved glass formulations and added special surface coatings.

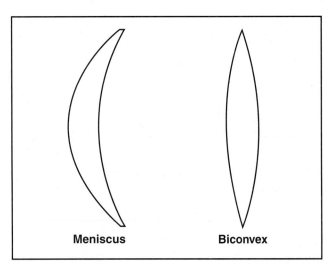

Goodheart-Willcox Publisher

Figure 6-1. A meniscus lens projects a less distorted image than a biconvex lens.

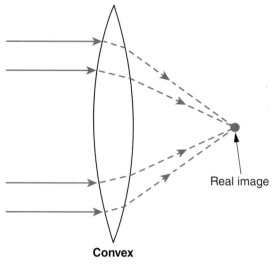

Convex

Real image

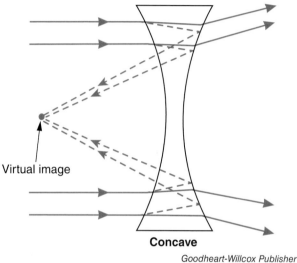

Virtual image

Concave

Goodheart-Willcox Publisher

Figure 6-3. Convex and concave lenses affect light rays differently.

Goodheart-Willcox Publisher

Figure 6-4. A compound lens combines elements to help correct some aberrations.

There are six major types of aberrations:

- *Spherical aberration* occurs in simple biconvex lenses, which bend the light rays entering the outer edges of the lens more sharply than those entering closer to the center, **Figure 6-5**. These outer rays come to a focus at a point closer to the lens, resulting is an overall softness of the image. An aplanatic lens corrects this by making the curvatures different on the two sides of the lens, bringing light rays to focus at a common point.

- *Chromatic aberration* is similar to spherical aberration but involves the different colors of light, which refract differently when passing through a lens. As shown in **Figure 6-6**, each

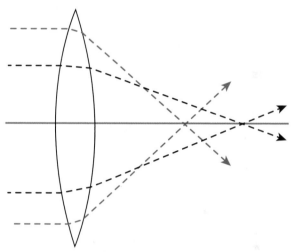

Goodheart-Willcox Publisher

Figure 6-5. In spherical aberration, light rays do not come to a common focal point.

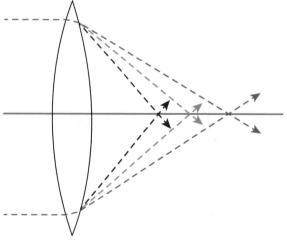

Goodheart-Willcox Publisher

Figure 6-6. The different wavelengths of light are refracted differently in chromatic aberration.

of these wavelengths focuses at a slightly different distance behind the lens. In the 1700s, a convex lens of crown glass and a concave lens made from flint glass were combined to bring the different colors of light to a common focus. An apochromatic lens is corrected to provide precise convergence of red, blue, and green wavelengths.

- *Curvature of field* is a failure of light rays to focus at a common point. The curved surface of the lens causes an image that would be in perfect focus on a matching spherical field. On a flat surface, however, only one portion of the image will be in focus, **Figure 6-7**. This problem is overcome by aspheric lenses (those with surfaces that are not a section of a sphere).

- *Astigmatism* is the inability of a lens to bring horizontal and vertical lines of the subject into sharp focus at the same time, **Figure 6-8**.

In the 1880s, the development of a new optical glass called *Jena glass* made possible the development of anastigmatic lenses to overcome this problem.

- *Coma* occurs when light rays that are not parallel to the lens axis create a series of overlapping circles of decreasing size, **Figure 6-9**. Lenses are corrected for coma by using elements with coma aberrations that cancel each other out.

- *Distortion* involves a change in the shape of a rectangular image projected by a lens. As shown in **Figure 6-10**, the distortion may take the form of outward-bulging sides (*barrel distortion*) or sides that are pushed inward (*pincushion distortion*). A symmetrical lens, which consists of two groups of lens elements with the lens diaphragm placed between them, corrects distortion.

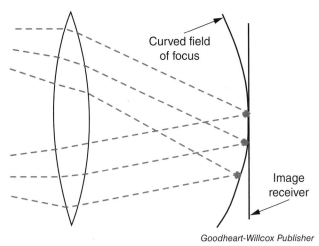

Goodheart-Willcox Publisher

Figure 6-7. When a lens exhibits curvature of field, only one part of the image is in focus.

Goodheart-Willcox Publisher

Figure 6-9. Points of light from the edge of an image are distorted into a teardrop (comet) shape in the coma aberration.

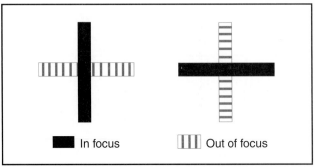

Goodheart-Willcox Publisher

Figure 6-8. Astigmatism makes it impossible to obtain sharp focus on both the horizontal and vertical lines of the subject.

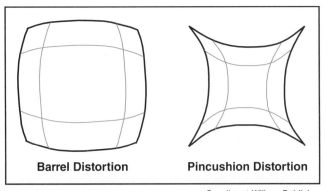

Goodheart-Willcox Publisher

Figure 6-10. Two different forms of distortion affecting a rectangular image.

Lens Coatings

In addition to refracting light, lenses also reflect some light from their surfaces. This reflection of light has two negative effects on lens performance. First, light reflected from the lens is lost and cannot be focused on the image receiver to help make an image. Second, light reflected off multiple surfaces of the lens elements can cause flare and ghost images. To lessen or eliminate these problems, manufacturers apply nonreflective coatings to lenses.

The loss of light from reflection can be severe. For example, a lens with six elements could have total light transmission cut by almost one-third (about 5% from each uncoated lens surface). This makes the lens slower because it has only about two-thirds the light-gathering power that it should provide.

Problems caused by ghost images and flare can degrade picture quality, **Figure 6-11**. If a bright light source shines directly into the lens, one or more ghost images (reflections of the pentaprism used in the viewfinder) may appear. Flare may be less immediately noticeable. It may be a mild effect, with colors or shadow values appearing less intense than expected, or it may create a severe washed-out appearance that mimics overexposure.

Coatings were initially applied as a single, extremely thin layer that reduced flare significantly and increased light transmission into the 90% range. Later, multiple coatings with as many as ten layers raised light transmission levels to as high as 99%.

Focal Length

With the lens focused at infinity, its *focal length* is the distance from the optical center of the lens to the point where the light rays converge on the plane of the image receiver. See **Figure 6-12**. Although focal lengths may be stated in inches or in millimeters, the general practice is to refer to a 50 mm lens rather than a 2-inch lens.

Not many years ago, a photographer typically carried a camera bag filled with as many as a half-dozen lenses in a variety of fixed focal lengths. Today's well-equipped photographer, film or digital, can cover a range of focal lengths from wide to telephoto with only two zoom (variable-focus) lenses. Zoom ranges continue to expand, with 28 mm–300 mm, 80 mm–400 mm, 50 mm–500 mm, 170 mm–500 mm, and even 300 mm–800 mm lenses offered by various manufacturers.

Advanced compact digital cameras include a subcategory referred to as *superzooms*. These small cameras have exceptionally wide zoom ranges, from as wide as 21 mm to as long as 1365 mm. The zoom range and light weight, compared to SLRs, has made superzooms a favorite with travelers.

For many years after they were introduced, zoom lenses were considered optically inferior to prime lenses, which are those with a fixed focal length. Advances in materials, manufacturing techniques, and design have made the best zoom lenses of today equivalent to comparable prime lenses.

Lenses with very short or very long focal lengths present problems. If built with the normal

Jack Klasey/Goodheart-Willcox Publisher

Figure 6-11. The sun causing this ghost image is just outside the frame on the upper-right corner.

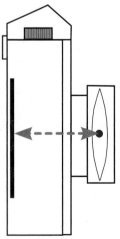

Goodheart-Willcox Publisher

Figure 6-12. Focal length is measured from the optical center of the lens to the plane of the image receiver.

construction, a very short-focus lens, such as a 20 mm, would leave no room for the camera mirror. At the other extreme, a conventional 1000 mm lens would be an unwieldy 39″ (one full meter) in length.

By arranging varying groups of convex and concave lenses, designers can shorten or lengthen the actual physical distance traveled by the rays. The physical size of a long-focus lens can also be changed by using mirrors to fold and shorten the light path, **Figure 6-13**.

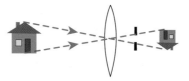

Short Focal Length Lens

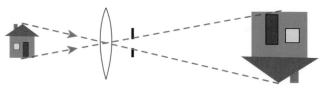

Long Focal Length Lens

Goodheart-Willcox Publisher

Figure 6-14. Image size at the receiver is directly affected by the focal length of the lens.

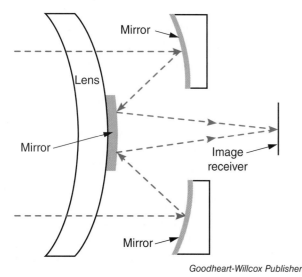

Goodheart-Willcox Publisher

Figure 6-13. Mirrors fold the light path of a long focal length lens to allow a physically shorter lens.

Focal Length and Image Size

The focal length of the lens directly affects the size of the image projected onto the image receiver, **Figure 6-14**. As the focal length becomes shorter, the light rays are bent at sharper angles, converging a short distance behind the lens and producing a small image. As the focal length becomes longer, the light rays are bent less sharply and converge a greater distance behind the lens, resulting in a larger image.

Directly related to the image size is the angle of view of the lens, **Figure 6-15**. The image

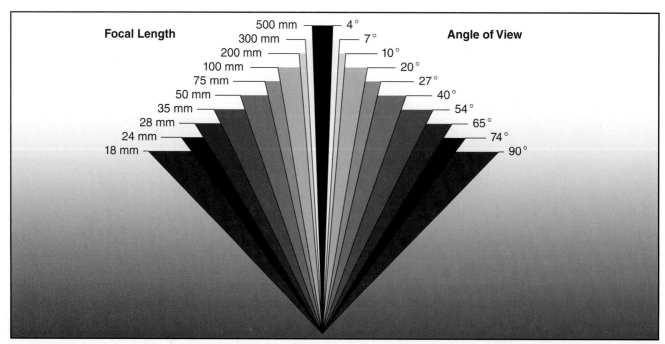

Goodheart-Willcox Publisher

Figure 6-15. This graphic shows the angle of view for a number of common lens focal lengths.

projected by a short focus lens covers a wide area, with objects in the scene relatively small in relation to the overall view. A 28 mm lens, for example, has an angle of view of 65°, compared to the 40° angle of view of a normal 50 mm lens. As the focal length increases, the angle of view becomes progressively narrower. A 100 mm lens has a 20° angle of view—half as wide as the 50 mm. **Figure 6-16** shows the relationship between angle of view and object size for different focal lengths.

Focal length also affects perspective, the relative size of objects in a scene and how they are aligned. A view made with a 50 mm lens presents near and far objects in a size relationship that is very close to what we are used to seeing in everyday life. A short-focus lens exaggerates depth and width, making objects look smaller and farther apart than they would to the naked eye. Long-focus lenses compress perspective, making distant objects appear larger and closer together, **Figure 6-17**.

Digital Multiplier Effect

Lenses used on most digital SLR cameras exhibit what is sometimes called a *multiplier effect*—the focal length appears to increase by approximately 1 1/2 times. Thus, a 100 mm lens behaves as if it were a 150 mm lens.

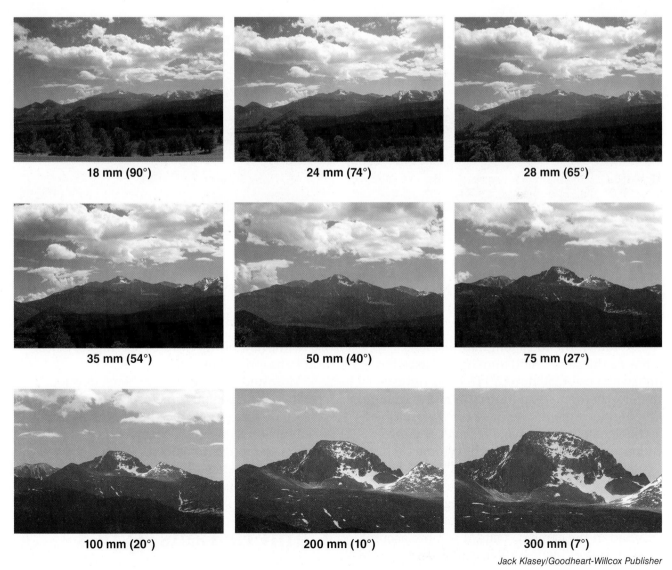

18 mm (90°) **24 mm (74°)** **28 mm (65°)**

35 mm (54°) **50 mm (40°)** **75 mm (27°)**

100 mm (20°) **200 mm (10°)** **300 mm (7°)**

Jack Klasey/Goodheart-Willcox Publisher

Figure 6-16. As the focal length of a lens increases, angle of view decreases. These nine views were taken using a tripod-mounted camera with only the focal length of the lens changed for each view.

28 mm

200 mm

400 mm

600 mm

Figure 6-17. Compressed perspective. Note how the background objects seem to be made larger and brought closer to the foreground objects.

Actually, the focal length of the lens remains the same. A 50 mm lens focuses the image at a point 50 mm (2″) from its optical center, whether it is mounted on a film camera or a digital camera. The image circle projected by the lens onto the image receiver is large enough to cover the 35 mm film frame or a full-size sensor. The smaller APS-C size sensor of most digital SLRs is able to capture only a smaller portion of the image circle. See **Figure 6-18**. In effect, the image is being cropped in the camera. Thus, it is more accurate to refer to the *cropping effect*, rather than multiplier effect. The cropping effect varies from Nikon's factor of 1.5 and Canon's 1.6 to the 2.0 factor (doubling) used by Olympus, Leica, and Panasonic cameras.

More and more lenses are being developed specifically for digital cameras. Designed to project an image circle matched to the APS-C sized sensor, these lenses are smaller and lighter than conventional lenses with equivalent wide-angle coverage. They are less expensive to manufacture, making them more affordable.

Camera Lens Types

Fixed-focal length lenses have traditionally been grouped based on their angle of view.

Figure 6-18. Multiplier effect of APS-C size sensors. A—Image circle coverage on a 35 mm film frame or full-size sensor. B—Image circle coverage for the same lens on a typical APS-C size sensor.

The three categories are normal, wide-angle, and telephoto. Zoom lenses cover ranges of focal lengths but can be broadly classified as wide-angle or telephoto.

Normal Lenses

The 50 mm lens is usually described as a normal lens because it provides an angle of view and a perspective close to that of the unaided human eye. Actually, the focal length that provides the most distortion-free normal view is one that is equal to the diagonal measurement of the image receiver. The diagonal of a 35 mm film frame, or a full-size sensor, is 43 mm, so in theory, 43 mm is the normal focal length.

The smaller APS-C size sensors used in most digital cameras have a diagonal measurement of 34 mm. Taking into account the digital multiplier factor of 1.5, a 24 mm lens would have a focal length of 36 mm ($24 \times 1.5 = 36$). On cameras with

these smaller sensors, the conventional 24 mm lens would be normal.

Since the definition of normal is based on the diagonal of the image receiver size, the focal length of the normal lens is different for medium format and large format cameras. **Figure 6-19** is a table showing equivalent focal lengths for various formats.

Wide-Angle Lenses

A lens with an angle of view from about 55° to as much as 180° is considered a wide-angle lens. In terms of focal length, wide-angle lenses are typically 28 mm or less. Some lenses with an angle of view greater than 100° show considerable barrel distortion. Vertical and horizontal lines are straight when near the center of the image, but bow outward when located near the image edges. Because of the round image they produce, **Figure 6-20**, such lenses are usually referred to as *fish-eye lenses*.

Equivalent Lens Focal Lengths						
	35 mm	**APS**	**6 cm × 6 cm**	**6 cm × 7 cm**	**4″ × 5″**	**8″ × 10″**
Wide	28 mm	18 mm	34 mm	60 mm	105 mm	210 mm
Normal	43 mm	28 mm	75 mm	85 mm	150 mm	300 mm
Tele	105 mm	65 mm	190 mm	210 mm	370 mm	740 mm

Figure 6-19. Equivalent lens focal lengths for various formats.

Other lenses with an angle of view of approximately 100° are referred to as *superwide lenses*. These lenses are rectilinear, which means they are corrected for barrel distortion. Straight lines are straight no matter where they fall in the image.

To allow room for the hinged mirror of an SLR camera, most wide-angle lenses are of the *retrofocus* type, **Figure 6-21**. In this inverted telephoto design, the front element group is composed of concave lens elements that cause light rays to spread or diverge. The rear elements are convex, causing the light rays to converge. The design stretches the light path within the lens to provide sufficient *back focus* (distance from the rear element of the lens to the image receiver) for mirror clearance, while maintaining the focal length of the lens.

Telephoto Lenses

A lens with a longer-than-normal focal length is commonly referred to as a *telephoto lens*.

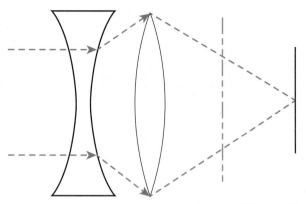

Goodheart-Willcox Publisher

Figure 6-21. A retrofocus lens design moves the point of measurement for focal length (the green dashed line) backward so it is located in midair behind the rear lens element.

Most of the longer lenses made today, especially zoom lenses, use a *front-focusing* design. See **Figure 6-22**. In this type of lens, the front element group has a converging design, and the rear elements have a diverging design.

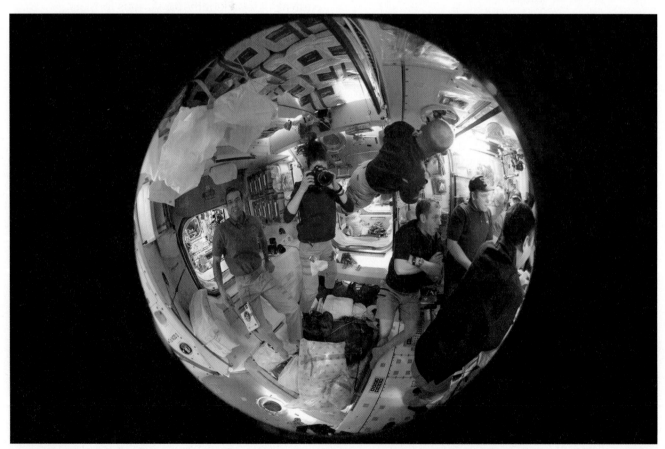

NASA

Figure 6-20. This photo taken aboard the International Space Station shows the 180° angle of view and distinctive round shape of an image shot with a fish-eye lens.

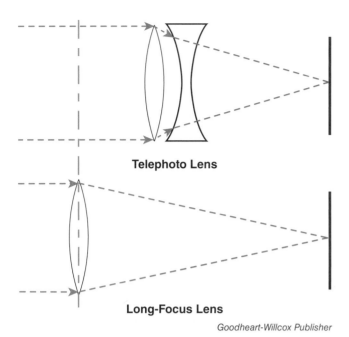

Telephoto Lens

Long-Focus Lens

Figure 6-22. The focal length point of measurement (the green dashed line) is shifted forward, out in front of the lens itself, in this front-focusing telephoto lens design.

This shortens the light path, making a larger image possible at the focal plane with less physical distance between the front lens element and the image receiver. The point from which the distance to the focal plane is measured has been moved forward into the space in front of the first lens element group.

Zoom Lens

The major attraction of the zoom lens is its variable focal length, allowing the photographer to change composition without physically changing lenses or position. The lens can be zoomed out for a broader view of the scene or zoomed in to focus on a detail, quickly and easily. See **Figure 6-23**.

The zoom lens operates on the principle of lens groups moving varying distances within the housing to provide the different focal lengths.

View at 100 mm Setting on a Zoom Lens

View at the 300 mm Setting on Same Lens

Figure 6-23. A zoom lens lets the photographer choose an overall view or extract a detail of the scene.

As shown in simplified form in **Figure 6-24**, a negative lens is placed between two positive lenses. As the negative lens moves forward, the focal length of the zoom lens is shortened; as it moves backward, the focal length becomes longer. A zoom lens uses groups of lens elements, with a number of the groups moving varying distances as the focal length is changed.

The *zoom range*, or ratio of shortest focal length to longest focal length, is expressed as a digit followed by a times sign (3× for example). Ranges may be as low as 2× (12 mm–24 mm) or as high as 16× (18 mm–300 mm), but most are 3× or 4×. Common zoom ranges for SLRs are 24 mm–70 mm, 28 mm–300 mm, 70 mm–200 mm, and 200 mm–400 mm.

Compact digital cameras have lenses with shorter focal lengths. Many models are available with zoom ranges between 5× and 8×. Some models have 10×, 16×, or 20× zooms, while a few offer 50× or 65×. When selecting a compact digital camera, it is important to distinguish between optical zoom and digital zoom. *Optical zoom* is achieved by moving the lens elements to change the angle of view without affecting the quality of the image. *Digital zoom* electronically crops the image to smaller dimensions, causing the image quality to deteriorate. As a photographer, you should disregard digital zoom specifications when purchasing or using a camera.

Zoom lenses often have different maximum apertures at the two extremes of the zoom range. A difference of 2/3 stop to one full stop is most common. A typical 70 mm–300 mm lens may have a wide-open aperture of f/4 at the 70 mm end and f/5.6 at the 300 mm end. Zoom lenses that feature a constant maximum aperture, often f/2.8 or f/4, are typically more expensive due to their greater complexity. These zoom lenses offer better light-gathering power, allowing the use of faster shutter speeds, especially under dim lighting conditions.

Specialty Lenses

Many photographers carry one or more special-purpose or specialty lenses for use in specific situations. They include teleconverters, macro lenses, tilt-shift lenses, creative effects lenses, and camera phone accessory lenses.

Teleconverter

The focal length of a telephoto lens can be increased by mounting an accessory lens called a *teleconverter* between the camera lens and the camera body. Teleconverters are usually available in two different degrees of magnification. A 2× extender doubles the focal length of the lens, and a 1.4× extender increases focal length by 1.4 times. See **Figure 6-25**.

General-purpose teleconverters are not designed for a specific lens. They are relatively inexpensive, but may cause a noticeable loss of sharpness and contrast, especially with a zoom lens. A multiple-element teleconverter made specifically for use with a given lens is more expensive but is designed to work together optically with the lens, maintaining image quality.

A

B

Goodheart-Willcox Publisher

Figure 6-24. Moving groups of lens elements provide the varying focal lengths in a zoom lens. A—Moving the negative element closer to the front positive element shortens the focal length. B—Moving the negative element toward the rear positive element lengthens the focal length.

Figure 6-25. Adding this teleconverter between the camera and lens will increase the focal length of the lens by 1.4 times.

Macro Lens

Photographing objects so they are larger than life is called *macrophotography*, or *close-up photography*. A **macro** lens can focus more closely than a typical lens of the same focal length, providing a larger image of an object on the image receiver. The relationship between the actual size of an object and the size that object is physically recorded is called the **reproduction ratio**, or magnification. In the ratio, the first number represents the object's size on the image receiver; the second number represents the actual size. For example, if the actual size of an object is 1/4" (6.3 mm) and the recorded image is only 1/8" (3.1 mm), the reproduction ratio is 1:2, or half life-size.

In the past, normal lenses typically only focused close enough to provide a 1:7 or 1:8 reproduction ratio. Today, macro capability built into a number of fixed focal length lenses often provides 1:1 reproduction ratios. Most zoom lenses allow macro focusing only at the long end of their zoom range and provide only a 1:4 reproduction ratio. Close-up photography is described in greater detail in Chapter 12, *Outdoor Photography*.

Tilt-Shift Lens

Photographing tall buildings often creates the problem of converging verticals—elements that seem to come together as they recede from the viewer. The convergence is particularly noticeable when the camera must be tilted upward to include the full height of a building.

Photographers using large format cameras correct convergence problems with tilt and swing controls. When shooting with digital or 35 mm film SLRs, there are two ways to control converging verticals. You can move far enough away from the subject to minimize the convergence, or you can use a special perspective control lens. Moving away or using a lens with a shorter focal length makes the subject smaller, so the camera does not have to be tilted upward. The perspective control or tilt-shift lens permits some of the same corrective adjustments used by large format photographers. See **Figure 6-26**.

Creative Effects Lens

A *creative effects lens* can achieve unusual focus effects, **Figure 6-27**. The lens element is housed on a swivel ball and focusing mechanism that can be used to vary the plane of focus,

Figure 6-26. A perspective control lens allows a 35 mm SLR to have some of the correction capabilities usually reserved for large format cameras equipped with tilts and other movements.

Courtesy of Lensbaby Photo by Ben Hutchison

Figure 6-27. A creative effects lens permits unusual effects, such as this image with a single sharp plane of focus.

somewhat like the more sophisticated tilt-shift lens, **Figure 6-28**. A variety of specialized lens elements can be mounted on the swivel mechanism for different optical effects.

Camera Phone Accessory Lenses

The rapid growth of camera phone photography has created demand for accessory devices to provide improved capabilities, especially extended wide-angle and telephoto ranges. Some devices designed to mount on a phone are fixed or adjustable lenses that fit over the existing camera lens. More sophisticated are the tiny lens-style cameras that mount on and electronically interface with the phone, **Figure 6-29**. These devices have their own built-in sensor and interchangeable lenses, but use the phone's screen as the viewfinder and its Wi-Fi capability for sharing images.

Courtesy of Lensbaby

Figure 6-28. Different lens elements can be mounted on the swivel ball of this creative effects lens system, which is designed to manipulate the plane of focus in an image.

Sony Electronics, Inc.

Figure 6-29. Lens-style camera devices extend the photographic capabilities of the camera phone. This device features a 20Mp sensor and a 30× optical zoom lens.

Portfolio Assignment

Extract a Detail

Use your telephoto lens to zoom into a scene and extract (pull out) a visually interesting detail. For example, you can shoot a nature scene, a street view or crowd, or a building. **Example A** shows a scene and the extracted detail.

Spend some time examining different scenes through your lens, looking for details you can extract. Shoot a number of possibilities, then choose and print the best detail image for your portfolio.

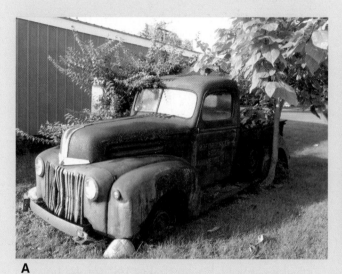

A

B

Jack Klasey/Goodheart-Willcox Publisher

Example A. Extracting a detail. A—Original scene. B—Detail extracted by zooming in.

Review Questions 📱

Answer the following questions using the information provided in this chapter.

1. Why does a lens refract (bend) light rays?

2. Light rays passing through a convex lens are bent at different angles and come together at a common _____.

3. The inability of a lens to bring horizontal and vertical lines of the subject into sharp focus at the same time is called _____.
 A. astigmatism
 B. coma
 C. spherical aberration
 D. distortion

4. Which of the following lens types was designed to correct the aberration known as *curvature of field*?
 A. Anastigmatic
 B. Aplanatic
 C. Aspheric
 D. Apochromatic

5. Coatings are applied to lenses to reduce flare and increase light _____.

6. Define the term *focal length*.

7. The longer the focal length of the lens, the _____ the size of the image projected onto the image receiver plane.

8. Assuming that you are using a 35 mm film SLR, which of the following lenses would you choose to provide an angle of view and a perspective most similar to unaided human vision?
 A. 28 mm
 B. 50 mm
 C. 80 mm
 D. 105 mm

9. When used with a digital camera that has an APS-C size sensor, the focal length of a lens appears _____ by approximately 1.5 times.

10. What problem is solved by applying retrofocus design to a wide angle lens?

11. A superwide lens corrected for barrel distortion is called a(n) _____ lens.

12. Most of the zoom lenses manufactured today use a(n) _____ design.

13. If you use a 1.4× teleconverter with your 135 mm lens, what is the focal length of the combination?

14. Your macro lens permits you to make close-ups at a reproduction ratio of 1:3. If you are making a close-up of a flower that is 3/8″ across, how wide will the flower's image be on film?

15. A tilt-shift lens can be used on a digital or 35 mm film SLR to correct the problem of _____.

Suggested Activities

1. The first scientific applications of lenses were the microscope and the telescope. Research the invention and development of either the microscope or the telescope and create a short illustrated report on your findings.

2. Because of their smaller physical size, the focal lengths of lenses used on compact digital cameras are much shorter than the familiar focal lengths of 35 mm camera lenses. To convert a digital camera focal length to its equivalent 35 mm focal length, multiply by 5.6. To convert 35 mm focal length to digital camera focal length, divide by 5.6. Construct a table showing the digital camera lens equivalents for the following 35 mm lenses—24 mm, 28 mm, 50 mm, 70 mm, 100 mm, 200 mm, 300 mm, 500 mm. Round the numbers up to the nearest tenth.

Critical Thinking

1. On a digital camera using an APS-C size sensor, a lens may exhibit a multiplier effect that increases its apparent focal approximately 1 1/2 times. For example, a 28 mm lens becomes a 42 mm lens, while a 200 mm lens becomes a 300 mm lens. What are the photographic advantages and disadvantages of this multiplier effect?

2. When purchasing a digital camera, should you consider *digital* zoom a desirable feature? Why or why not?

Communicating about Photography

1. **Speaking.** Choose one of the lens aberrations discussed in this chapter. In your own words, explain the aberration to the class. Talk about the cause and effect of the aberration.

2. **Speaking and Listening.** In small groups, discuss with your classmates—in basic, everyday language—your knowledge of the different types of lenses. Take notes on the observations expressed. Then review the points discussed, factoring in your new knowledge of lens types. Develop a summary of what you have learned about lens types and present it to the class. Use the terms that you have learned in this chapter.

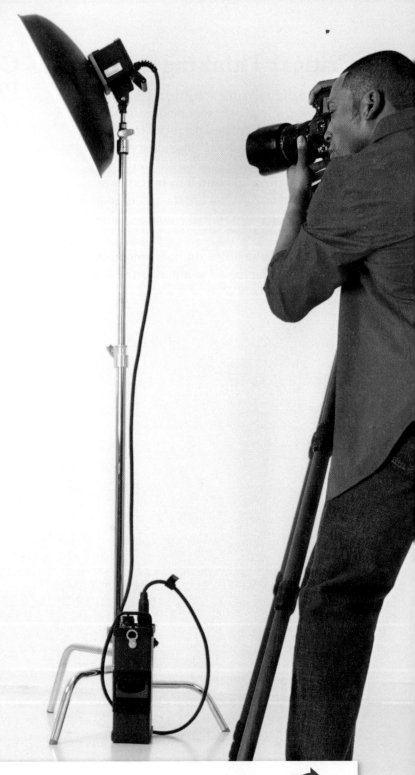

Metering: The process of using an in-camera or hand-held exposure meter to determine the amount of light being reflected from the subject.

While studying this chapter, look for the activity icon ↗ **to:**

- **Assess** your knowledge with self-check pretest and posttest.
- **Practice** vocabulary terms with e-flash cards and matching activities.
- **Reinforce** what you learn by submitting end-of-chapter questions.

G-WLEARNING.com

www.g-wlearning.com/visualtechnology/

iofoto

Light and Exposure

Objectives

When you have finished reading this chapter, you will be able to:

- Recall the basic characteristics of light.
- Select filters for different lighting conditions or special effects.
- Explain the importance of contrast filters for black-and-white photography.
- Describe how the f-stop system functions.
- Discuss how exposure is affected by the interrelationship of aperture, shutter speed, and ISO rating.
- Demonstrate proper light metering techniques.
- Describe the use of the Zone System.

> **Check Your Photography IQ** ↗
>
> Before you read this chapter, assess your current understanding of the chapter content by taking the chapter pretest.
>
> www.g-wlearning.com/visualtechnology/

Technical Terms ↗

additive color process
aperture
backlit
cadmium sulfide cell meter
color temperature
cooling filter
creative control
daylight-balanced
digital noise
exposure
frequency
f-stop
ISO rating
light
luminances

middle gray
nanometer
photographic daylight
polarizing filter
reciprocity law
shutter
specular reflections
subject brightness range (SBR)
subtractive color process
tungsten-balanced
visible spectrum
warming filter
wavelength
white light
Zone System

The word *photography* was coined in 1839 by English astronomer Sir John F. W. Herschel, who combined the Greek roots *photos* (light) and *graphos* (drawing). The description "drawing with light" is an appropriate one, since light rays entering the camera create a latent image on film by chemically changing its silver coating. In a digital camera, the entering light rays cause electrical changes on an array of electronic sensors. These "light drawings" then can be given permanent form and reproduced for viewing.

Basic Light Theory

Being aware of how light behaves can help you overcome problems and capture the scene as you visualized it. *Light* is a form of electromagnetic radiation, or radiant energy, which is visible to the human eye. The largest natural producer of this radiant energy is the sun. Artificial sources of radiant energy are lamps that produce light through discharge, fluorescent, incandescent, or electroluminescent means.

An electronic flash is an example of light emitted by discharge. The flash tube is filled with xenon gas that emits a short and very intense burst of light when a high-voltage electrical discharge takes place inside the tube.

In a fluorescent light source, a discharge of electrical energy causes a gas, usually mercury vapor, to emit ultraviolet radiation. This radiation, in turn, causes a coating inside the glass tube to glow and emit light.

Incandescent light sources consist of a metal element with high electrical resistance inside a sealed glass container or bulb. When an electric current is passed through the element, resistance causes it to heat rapidly to the point where it glows white-hot and emits light.

A light-emitting diode (LED) is an electroluminescent light source. The LED is a semiconductor device that emits light when a suitable voltage is applied to it.

Movement of Light

When light is emitted from a source, it radiates, or moves away, in straight lines in all directions. The light rays move in the form of a wave, vibrating at right angles to the direction of travel. The waves move away from the source at a speed of 186,000 miles per second. This is why a room appears to instantly fill with light when you press a wall switch.

Two characteristics of a light wave can be measured, as shown in **Figure 7-1**. The *wavelength* is the distance from the crest of one wave to the crest of the next. The unit of measure for wavelength is the *nanometer*, which is equal to one-billionth of a meter (0.000000001 m = 1 nm). *Frequency* is a measure of the number of waves (cycles) passing a point in a given amount of time. The unit of measure for frequency is the hertz (one cycle per second = 1 Hz).

Visible Spectrum

The tiny portion of the electromagnetic spectrum that can be seen by the human eye is referred to as the *visible spectrum*. It consists of waves with wavelengths ranging from about 400 nm to about 700 nm. Our eyes see different wavelengths of light as different colors, **Figure 7-2**. Although we may be able to distinguish as many as 100 different colors within the red-to-violet spectrum, the spectrum is traditionally divided into seven colors—red, orange, yellow, green, blue-green, blue, and violet.

The wavelengths for some distance on either side of the visible spectrum are not normally visible to the eye, but can be recorded on film. Infrared wavelengths are longer than 700 nm, so they are below red (infra means *below*) on the spectrum. Ultraviolet (beyond violet) wavelengths are shorter than 400 nm. Film can be made sensitive to infrared radiation with special dyes added in manufacture, and is normally quite sensitive to ultraviolet (UV) wavelengths. Digital camera sensors are infrared-sensitive and are typically covered by a factory-installed filter to balance that sensitivity.

Goodheart-Willcox Publisher

Figure 7-1. Wavelength is measured from one wave crest to the next wave crest. The number of waves passing a point in one second is the frequency.

The Visible Spectrum

Goodheart-Willcox Publisher

Figure 7-2. The wavelengths from approximately 400 nm to 700 nm make up the visible spectrum. The human eye perceives the different wavelengths as colors.

The Color of Light

White light is composed of red, green, and blue wavelengths in approximately equal proportions. Such a light is produced by the midday sun on a clear and cloudless day. Light has a specific *color temperature*, measured in kelvin (K) units. The light produced by the midday sun on a clear and cloudless day has a

color temperature of 5500 K and is referred to as *photographic daylight*. See **Figure 7-3**.

Although different types of artificial light have different colors, the human vision system adjusts to the differences and sees them as white light. Ordinary incandescent lightbulbs emit a light that is heavily balanced toward the red/orange/yellow end of the spectrum, while electronic flash tubes are balanced toward the spectrum's opposite blue/violet end.

In Kelvin scale measurements, lower temperatures are warmer and higher temperatures are colder. This is the opposite of the Fahrenheit and Celsius temperature scales, in which lower temperatures are colder and higher temperatures are warmer.

The color of light is an important factor in selecting a film type or the correct white balance for digital image capture. These topics are covered later in this chapter.

Absorption and Reflection of Light

To better understand what happens when light rays strike an object, **Figure 7-4**, visualize directing a stream of water from a garden hose at a brick wall. Some of the water soaks into the brick (is absorbed), but most of it bounces off (is reflected). If you direct the stream at a piece of wooden latticework, some of the water is absorbed and some is reflected. Most of it, though, it passes (is transmitted) through the diamond-shaped openings of the lattice.

Color Temperature	
Light source	**°Kelvin**
Candle	1800
100 W tungsten bulb	2900
250 W studio flood lamp	3400
Photographic daylight	5500
Electronic flash	6000
Sky light (overcast)	8000

Goodheart-Willcox Publisher

Figure 7-3. Color temperature of light is measured in degrees Kelvin.

Goodheart-Willcox Publisher

Figure 7-4. Light rays striking a material may be absorbed, transmitted, or reflected.

The amount of light that is absorbed, reflected, or transmitted depends on the material from which the object is made, the type of surface finish, and the object's color. Transparent or translucent (milky in color) material reflects very little light. Most of the light is either transmitted or absorbed. Opaque materials do not transmit light. They absorb or reflect light in different proportions, depending on their surface finish. A dull or rough surface absorbs a high percentage of light rays. The reflections from such a surface are diffuse (reflected in many directions).

A surface that is smooth and polished reflects a very high percentage of the light. This type of surface reflects rays as bright spots of light, which are referred to as *specular reflections*. Even materials that transmit most of the light that strikes them, such as glass or water, produce specular reflections from their smooth surfaces. White or light-colored objects reflect light rays readily, while black or dark-colored objects absorb most light rays.

Our perception of an object's color is based on the wavelengths of light that are reflected from that object. When white light (an equal mixture of red, green, and blue wavelengths) strikes the surface of a lime, the red and blue wavelengths are absorbed by the fruit's surface. The green wavelengths are reflected back to the viewer's eye, and the lime is seen as green. The yellow color of a lemon viewed under white light results from the blue wavelengths being absorbed and equal amounts of red and green wavelengths being reflected. See **Figure 7-5**.

Additive and Subtractive Color Processes

Visualize overlapping circles of red, green, and blue light thrown onto a screen by three separate slide projectors, **Figure 7-6**. The center

Jack Klasey/Goodheart-Willcox Publisher

Figure 7-5. Color perception. A—Red and blue wavelengths of white light are absorbed by the lime, while green wavelengths are reflected. The lime is seen as green. B—Blue light is absorbed by the lemon's skin, while red and green wavelengths are reflected, providing the yellow color.

Goodheart-Willcox Publisher

Figure 7-6. Additive color. Red, green, and blue can be combined in various ways to create any other color.

Goodheart-Willcox Publisher

Figure 7-7. On a sensor array, color filter decals are applied to pixels in a Bayer pattern (pixel size is greatly exaggerated).

area, where all three circles overlap, has no color, only the white of the screen. Where the red and the blue circles overlap, there is a wedge of magenta. Overlapping blue and green produce a wedge of cyan, while the overlap of green and red creates a yellow wedge.

This is a demonstration of the *additive color process*, in which the primary colors combine to create all other colors. You see this process every time you look at a television set, a computer monitor, or the LCD screen of a digital camera. Older television sets and monitors use cathode ray tube (CRT) screens. The inside surfaces of the screens are covered with rows of tiny phosphorescent dots that glow red, green, or blue when struck by an electron beam. The liquid crystal displays (LCDs) on digital cameras and newer TV sets and monitors have rows of liquid crystal pixels in red, blue, and green. These pixels light up when turned on by an electronic impulse. In both types of devices, the process results in a glowing full-color image.

Digital cameras capture images using red, blue, or green filters positioned over the individual pixels making up the sensor array. The filters are arranged in a Bayer pattern, **Figure 7-7**. This pattern has twice as many green filters as either red or blue filters, since human vision is most sensitive to light in the green portion of the visible spectrum.

Color film photography is based on the *subtractive color process*. Instead of colors

combining to create other colors, the subtractive process takes away some colors and allows others to be seen. On a color wheel, **Figure 7-8**, the subtractive primaries—cyan, magenta, and yellow—fall between the red, green, and blue additive primaries. Each of these subtractive primaries absorbs the light of its complementary color, which is the color positioned opposite it on the color wheel. The subtractive primary reflects or transmits the colors on either side of its position. For example, cyan absorbs red light and passes green and blue.

Goodheart-Willcox Publisher

Figure 7-8. On a color wheel, the subtractive primaries (C,M,Y) are located between the additive primaries (R,G,B).

Film Selection and White Balance Considerations

The human vision system automatically compensates for variation in the color temperature of light. However, films and digital sensors interpret color temperature literally—they do not adjust like the human eye to see a range of colors as white. For this reason, you should select a color film that is balanced for the type of light in which it will be used. Film that is *daylight-balanced* renders colors normally when exposed with natural light or electronic flash. *Tungsten-balanced* film reproduces colors realistically when the light is provided by incandescent bulbs.

Digital camera users can compensate for different color temperatures by using the camera's white balance control. The concept of white balance involves selecting a color temperature that renders a white object correctly, so all other colors in the image will be correct. Most cameras offer an automatic white balance setting and settings for specific lighting conditions, such as *Daylight*, *Cloudy*, and *Tungsten*. See **Figure 7-9**.

The color of light affects black-and-white films only slightly today, but this was not always the case. See **Figure 7-10**. The earliest films were blue-sensitive, responding only to wavelengths in the blue/violet/ultraviolet end of the spectrum. Modern black-and-white panchromatic films are sensitive to light in the blue, green, and red wavelengths.

Auto white balance (AWB) setting

Daylight setting

Shade setting

Cloudy setting

Fluorescent light setting

Tungsten light setting

Jack Klasey/Goodheart-Willcox Publisher

Figure 7-9. The effect of different white balance settings is shown in this series of photos of the US Capitol dome.

Film Sensitivity

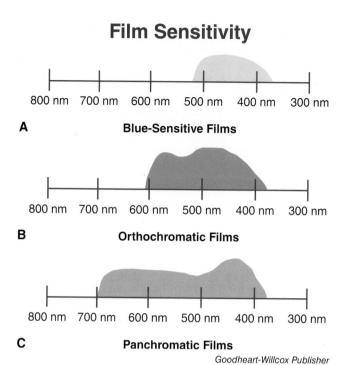

800 nm 700 nm 600 nm 500 nm 400 nm 300 nm

A **Blue-Sensitive Films**

800 nm 700 nm 600 nm 500 nm 400 nm 300 nm

B **Orthochromatic Films**

800 nm 700 nm 600 nm 500 nm 400 nm 300 nm

C **Panchromatic Films**

Goodheart-Willcox Publisher

Figure 7-10. Sensitivity of black-and-white films. A—The earliest film emulsions responded only to the shorter blue wavelengths. B—Orthochromatic films are "red-blind." They are sensitive to the blue and green wavelengths, but not to red. C—Modern panchromatic emulsions respond to almost the full 400 nm to 700 nm visible spectrum.

Even though panchromatic films respond to light across the entire visible spectrum, they do not see various colors in the same way that the human eye sees them. As shown in **Figure 7-11**, human vision is very sensitive to green wavelengths, and about equally sensitive to blue and red wavelengths. Panchromatic film, by contrast, is very sensitive to blue wavelengths and has approximately equal sensitivity to green and red.

This difference in sensitivity often results in colors that appear to our eyes as almost identical gray tones on black-and-white film. This is especially true for the colors red and green. To make

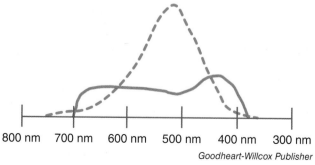

800 nm 700 nm 600 nm 500 nm 400 nm 300 nm

Goodheart-Willcox Publisher

Figure 7-11. The human eye (dashed line) is most sensitive to green light, while film (solid line) is most sensitive to blue.

the film emulsion render the colors as distinctly different, a contrast filter is needed. Contrast filters are described in the section *How Filters Work*.

Controlling Light with Filters

Except on rare occasions when the sun or another light source is included in a picture, all photographs are made with reflected light. Light rays from the source bounce off an object and pass through the camera lens to be focused on the image receiver. How the camera records those reflected rays of light can be controlled to a great extent with filters. Filters come in two basic forms— the round screw-in type that fits over the lens, and square type that is used in a special holder that attaches to the lens, **Figure 7-12**.

How Filters Work

Contrast filters are made in deep shades of red, green, and blue. Each transmits light of its own color, but absorbs light of the other two colors. These filters are used with black-and-white film or with digital cameras that offer a black-and-white shooting mode. If used with color film or a digital camera shooting color, a contrast filter would create an image with a very strong color cast.

Contrast filters help differentiate between colors when they are rendered as gray shades. The effect is to lighten objects of the same color as the filter and darken objects of other colors. Thus, a red filter lightens a red object and darkens green and blue objects, **Figure 7-13**. What about objects of other colors? Since colors are combinations of two or all three of the primary colors in different proportions, they are affected according to their makeup.

Jack Klasey/Goodheart-Willcox Publisher

Figure 7-12. Round and square filters.

Figure 7-13. Rendering red and green. A—Red flowers on green leaves, as the human eye would see them. B—Print from panchromatic film, with flowers and leaves rendered almost identical shades of gray. C—A contrast filter lightened the red flowers and darkened the green leaves to separate the two tones.

Digital images captured in color and converted to monochrome (black-and-white) may exhibit the same contrast problems as black-and-white film images. Image processing programs offer tools, such as the Channel Mixer in Photoshop, which can be used to mimic the effects of a contrast filter.

Using Filters for Emphasis

Creative use of filters can emphasize certain colors and deemphasize others. The most frequent use for filters in black-and-white film photography is darkening the sky. Because film is sensitive to the blue wavelengths, skies tend to photograph as white. Unless clouds are quite dark, they almost disappear. A yellow filter absorbs some of the blue light, darkening the sky and allowing clouds to stand out better. A deep yellow or orange filter darkens the sky even more, and a red filter gives the strongest effect. See **Figure 7-14**.

Figure 7-14. Using filters to darken the sky. A—No filter. The sky is white and clouds barely visible. B—Yellow filter. The sky is darkened, making clouds more visible. C—Orange filter. The sky is darkened even more, and clouds stand out more strongly. D—Red filter. The most dramatic contrast between dark sky and bright clouds.

When shooting color film, a photographer can correct color balance with filters. If a tungsten-balanced film must be used under daylight conditions or with an electronic flash, an 81B *warming filter* will avoid a cold blue cast. Exposing daylight-balanced film under indoor (tungsten) lighting results in a strong yellow cast, **Figure 7-15**, unless a blue (80A) filter is used. Fluorescent lighting may cause a green cast, especially when color transparency film is used, **Figure 7-16**. The green cast can be corrected with a magenta (FL) filter.

The automatic white balance setting on a digital camera usually provides well-balanced color results. If a color balance problem is detected while shooting, specific white balance settings can often be made to avoid the problem. Color cast problems can sometimes be corrected or minimized after capture with image-processing software.

Jack Klasey/Goodheart-Willcox Publisher

Figure 7-16. Fluorescent lighting often produces a green or blue coloration.

Using Filters to Control Reflection and Color Saturation

For both digital and film camera users, a *polarizing filter* is a valuable tool. It can deepen the color of a blue sky; improve the color saturation of natural objects by reducing glare; and reduce or eliminate reflections from glass, water, and similar surfaces.

Polarization occurs when light is reflected from a shiny surface at an angle of approximately 35°. Light becomes polarized when its waves all vibrate in the same plane, rather than vibrating in all directions perpendicular to the line of travel.

A polarizing filter consists of a material in which tiny crystals are all oriented in a single direction. Light striking the filter is either transmitted or blocked, **Figure 7-17**. If the light

Jack Klasey/Goodheart-Willcox Publisher

Figure 7-15. Daylight-balanced transparency film takes on an overall warm yellow cast when exposed with tungsten lighting.

Light blocked

Light transmitted

Goodheart-Willcox Publisher

Figure 7-17. Operation of a polarizing filter.

waves are oriented in the same direction as the crystals, the waves can pass through the filter. If the light waves are oriented at a right angle (90°) to the crystals, transmission is blocked.

Reflections off water, glass, painted finishes, smooth leaves, and similar surfaces can be reduced by a polarizing filter, **Figure 7-18**. As the polarizing filter is rotated to diminish or eliminate the reflection, the result can be seen through the camera's viewfinder, permitting you to judge the point of best effect. Light reflected off bright metal surfaces (specular reflection) is not polarized, so the polarizing filter has no effect.

Darkening of a blue sky is achieved with a polarizing filter because a large percentage of sky light is polarized. Bright light from the sky causes a glare from leaves and other surfaces that mutes or washes out their colors. Many photographers never notice this until they see the stronger, more saturated colors that become visible when using a polarizer to eliminate the glare. A polarizing filter is most effective on a blue sky when the sun is at a right angle to the axis of the camera lens, **Figure 7-19**.

When purchasing a polarizing filter, it is important to buy the type that is compatible with your camera. There are two types—the linear polarizer and the circular polarizer. A linear polarizer is commonly used with older manual film cameras. It cannot be used with autofocus cameras or with those that use a beam splitter as part of their exposure metering system. *Circular* refers to the way the crystals of the polarizing material are arranged, not to the shape of the filter. The circular polarizer is more expensive, but is

Without a Polarizing Filter

With a Polarizing Filter

Jack Klasey/Goodheart-Willcox Publisher

Figure 7-19. A polarizing filter darkens the blue of the sky and brings out cloud forms more strongly.

compatible with autofocus systems and with beam-splitter exposure meters. This means the circular polarizer can be used with any type of camera.

Without a Polarizing Filter

With a Polarizing Filter

Cokin Filters

Figure 7-18. Glare reflecting from the glass surface of an aquarium is filtered out with a polarizing filter.

Using Filters to Reduce Light

A neutral-density (ND) filter reduces the quantity of light reaching the image receiver without altering the light's color. An ND filter is most often used to compensate for bright lighting conditions that would cause overexposure with a fast film or the need to make a very long exposure.

ND filters are available in several strengths (densities) to allow different amounts of light reduction. With sufficient light reduction, it is possible to photograph a busy street scene with a long exposure to eliminate all the moving autos and pedestrians. The long exposure time means that any moving object will not be in the scene long enough to be recorded.

Filters with a density that graduates to a clear background are made in a square or rectangular shape. The graduated neutral-density filter, or ND grad, is used in landscape photography where there is often a large difference in brightness between the sky and the foreground. To balance the exposure of the scene, the filter is slid into its holder with the darker portion at the top. It can then be adjusted so the transition from dark to clear is positioned at the horizon. The camera is set to obtain proper exposure of the foreground area, and the ND filter reduces the sky exposure to avoid burning it out. See **Figure 7-20**.

Using Filters for Special Effects

Filters for achieving special effects are sold in both the round screw-in and square holder types. Special-effects filters can be used to change color in all or part of a scene, or to achieve many other creative variations.

Color-Changing Filters

The same yellow, orange, red, blue, and green filters used with black-and-white film to improve contrast or separate gray tones can be employed with color film to give a scene an overall color cast. For example, a desert scene might be exposed through an orange or dark yellow filter, or a seascape shot with a blue filter.

Graduated color, or color-grad, filters are available to add color to part of a scene. A popular color-grad filter is a yellow-orange color that enhances the sky hues when a sunrise or sunset is photographed. The same filter can be inverted to add warmth to a foreground, such as a beach scene, without affecting the color of the sky.

Exposed for the Foreground

Exposed for the Sky

Exposed for the Entire Scene with a Graduated Neutral-Density Filter

Jack Klasey/Goodheart-Willcox Publisher

Figure 7-20. Using a graduated neutral-density filter to properly balance exposure of the foreground and the sky.

A more subtle use of color filters is to warm or cool a scene. For example, if reflected skylight gives shadow areas a cold, blue appearance, you could put a warming filter, such as the yellowish 81B,

on your lens. The filter absorbs some of the blue light, warming up the scene. At the other extreme, you might wish to make the coloration of a campfire scene a bit less yellow. A *cooling filter*, such as the light blue 82A, will achieve the effect you want.

The white balance control of a digital camera can be used to achieve the same effects. To warm the blue tones of a bright, sunlit day, set the white balance to *Shade* or *Cloudy*. The yellow light from a campfire could be tamed with a daylight or electronic flash white balance setting.

Diffusion Filters

For portrait work or other applications, a slightly softened or diffused appearance is often desirable. A photo taken with a diffusion filter, **Figure 7-21**, appears as if it were shot through a light veiling of fog. The slight softening of the image smoothes out small wrinkles and skin defects. For years, photographers have created diffusion effects by such means as stretching a piece of sheer black nylon stocking material over the lens or applying a thin smear of petroleum jelly to a UV filter.

Image-Modifying Filters

In a strict sense, all filters are image modifiers, since their purpose is to change what appears on the image receiver. In this section, however, the term is being used to group filters that have a more pronounced effect on the image. Filter manufacturers offer many varieties, including the following commonly used filters:

- **Star filters.** These filters have a grid of finely etched lines called a *diffraction grating.*

The lines cause bright rays to extend from any small, intense light source in the picture. Different gratings will produce "stars" with four, eight, or sixteen rays. See **Figure 7-22**.

- **Multiple-image filters.** Anywhere from two to twenty-five repetitions of the image are displayed. Patterns in which the images are arranged vary with the number of repetitions.

- **Blur filters.** Different degrees and patterns of blurring are offered to provide such effects as motion blur, zoom, rotation, or fog.

- **Double-exposure filter.** This device is an opaque mask that can be rotated to cover half of the lens at a time. In use, the first exposure is made with the mask in position over half the lens area. The mask is then rotated to cover the area first exposed, and the second exposure is made without advancing the film. The result is two nonoverlapping exposures on the same film frame.

Filter Factors

Almost any filter placed on a lens reduces the amount of transmitted light. This loss is called a *filter factor*. The filter factor is important information when exposure must be calculated and set manually for large format and medium format cameras. With SLR cameras, no adjustments are necessary. The camera's built-in meter takes its reading through the already mounted filter, automatically including the additional exposure required by the filter.

Cokin Filters

Figure 7-21. A diffusion filter produces an overall softening of an image and is often used for portrait work.

Cokin Filters

Figure 7-22. Star filters add interest to photos that include bright points of light.

The filter factor is normally stated as a number by which normal exposure must be multiplied to correct for the light loss. Filter factors increase as the filter colors get darker. A UV filter, which is essentially clear glass, has a filter factor of 1. A yellow No. 8 filter has a factor of 2, and the dark red No. 25 filter has a factor of 8. Filter factors for daylight and for tungsten lighting often differ. **Figure 7-23** lists filter factors and exposure compensations for a number of contrast filters.

Controlling Exposure

Exposure is the amount of light reflected from a scene that reaches the camera's image receiver. Exposure is primarily determined by three interacting factors—aperture, shutter speed, and ISO rating.

Most cameras today offer totally automatic exposure control. The in-camera exposure meter reads the scene and sets the proper combination of aperture and shutter speed for the photo. In film cameras, the auto-exposure system also factors in the ISO rating (speed) of the film that is loaded in the camera. Digital cameras may alter the sensitivity of the sensor (and thus, the effective ISO), as well as the aperture and shutter speed.

Automatic exposure control is useful, but it is important to understand how the factors of aperture, shutter speed, and ISO rating can

be altered to affect image appearance. This is called *creative control*. By learning how changing the various factors affects exposure, you will be able to make good photographs in situations where automatic exposure control would produce poor results.

Aperture

The *aperture* is the hole through which light enters the camera to make an exposure. A mechanism called a *diaphragm*, which consists of overlapping plates of thin metal, makes the opening larger or smaller. Movement of the diaphragm can be controlled manually or automatically. Manual control of aperture size involves rotating a collar on the lens to one of a series of marked settings (f-stops). On digital cameras, a control on the camera body is used to change aperture size.

The F-Stop System

An *f-stop* is a unit of measure that represents the size of a specific aperture. The standard f-stop designations are 0.7, 1, 1.4, 2, 2.8, 4, 5.6, 8, 11, 16, 22, 32, 45, and 64. This system probably creates more confusion among beginners than any other aspect of photography. First, the mix of whole numbers and decimals is hard to remember. Second, as f-stop numbers become larger, the opening (aperture) that they represent becomes smaller.

Filter Factor Adjustments				
Filter	**Daylight Factor**	**Increase f-stop by:**	**Tungsten Factor**	**Increase f-stop by:**
#6 Light Yellow	1.5	2/3	1.5	2/3
#8 Yellow	2	1	1.5	2/3
#11 Yellow-Green	4	2	3	1 2/3
#15 Deep Yellow	2.5	1 1/3	1.5	2/3
#25 Red	8	3	5	2 1/3
#47 Blue	6	2 2/3	12	3 2/3
#58 Green	6	2 2/3	6	2 2/3

Goodheart-Willcox Publisher

Figure 7-23. Filter factors and f-stop compensation for contrast filters used with black-and-white film.

The f-numbers themselves are calculated by dividing the focal length of the lens by the diameter of the aperture. See **Figure 7-24**. For a 50 mm lens with an aperture of 25 mm, the f-number is 2. If the aperture is 4.5 mm, the f-number is 11. In the first example, the aperture is 1/2 the focal length; in the second, it is 1/11 the focal length. Thus, an f-stop can be thought of as a fraction— f/2 is an aperture 1/2 the focal length, f/11 is an aperture 1/11 the focal length, and so on.

Aperture Size and Light Transmission

More important than the method of calculating f-stops is the relationship of the stops to each other. In the standard series of f-stops, the area of the diaphragm opening is either halved or doubled from one f-stop to the next, depending on whether the number is larger or smaller. The effect of this, at the same shutter speed, is to allow either half as much or twice as much light to reach the image receiver.

Aperture sizes are the reverse of the f-stop numbers. As the numbers get larger, the area of the opening gets smaller, **Figure 7-25**. The opening at f/16 is half as large as the opening at f/11; f/22 is half as large as f/16. Moving in the opposite direction, the opening at f/16 is twice as large as at f/22, and f/11 is twice as large as at f/16.

Relative Aperture

The sequence of f-stop numbers is the same regardless of the focal length of the lens, but

Focal length ÷ Aperture = f/stop
50 mm ÷ 25 mm = f/2
f/2 = 1/2 focal length

Goodheart-Willcox Publisher

Figure 7-24. Calculating the f-number of a lens.

the size of opening that a given stop represents changes with the focal length. This is called *relative aperture* and is important in order to obtain consistent photographic results.

A lens with twice the focal length of another lens has an aperture twice as large for a given f-stop. If f/2 represents an aperture of 25 mm on a 50 mm lens (50 ÷ 25 = 2), then f/2 on a 100 mm lens would require an opening of 50 mm (100 ÷ 50 = 2). The difference in aperture compensates for the difference in the intensity of the light reaching the film because of the increased focal length. This is demonstrated in **Figure 7-26**, which shows that both the 50 mm and 100 mm lenses transmit the same amount of light reflected from the subject.

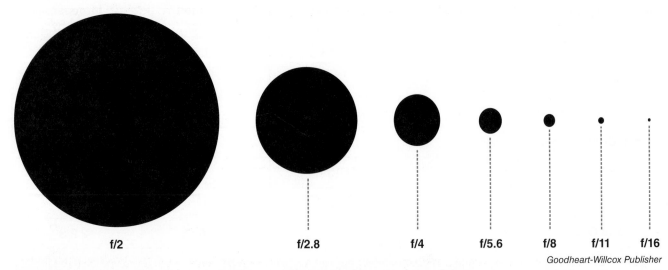

| f/2 | f/2.8 | f/4 | f/5.6 | f/8 | f/11 | f/16 |

Goodheart-Willcox Publisher

Figure 7-25. F-stop relationships are based on halving or doubling of the aperture area.

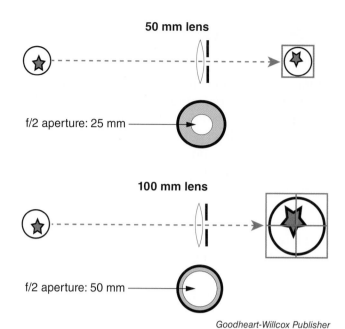

50 mm lens

f/2 aperture: 25 mm

100 mm lens

f/2 aperture: 50 mm

Goodheart-Willcox Publisher

Figure 7-26. Relative aperture. As focal length increases, the aperture also becomes larger for a given f-stop, and vice versa.

The image of the ball projected onto the film by the 100 mm lens is twice as large as the image of the ball from the 50 mm lens. The light reflected from the ball is spread over an area four times as large with the 100 mm lens. The aperture of the 100 mm lens at f/2 is twice the diameter (four times the area) of the same f-stop of the 50 mm lens, so the film receives the same exposure. The apertures are different physical sizes, but the same relative size.

Lens Speed

To shoot a speeding motorcycle at noon, you are unlikely to need a fast lens, but to photograph a tortoise at dusk, you probably will. A fast lens has a large maximum aperture, giving it great light-gathering power. A fast lens can be "opened up" to allow relatively short exposures in low-light conditions. With the speeding motorcycle at noon, plentiful light allows exposure at smaller apertures. The fading light at dusk, especially with a dark-colored subject like a tortoise, requires a large aperture.

The fastest lenses for SLRs are typically 50 mm lenses with maximum apertures greater than f/2. On many 50 mm lenses, a fractional stop such as 1.7 or 1.8 (one-third stop faster than f/2) is the maximum, but f/1.4, f/1.2, and even f/0.7 lenses are available.

Zoom lenses typically have a maximum aperture of f/3.5 or f/4 at their shortest focal length and f/4.5 or f/5.6 at the long-focus end. Longer lenses are slower than shorter-focus lenses because greater speed requires larger-diameter diaphragms than are practical for most users. The very large 1200 mm f/5.6 lenses used by professional sports photographers are almost 3′ in length and 8″ in diameter. See **Figure 7-27**.

Shutter Speed

The camera *shutter* opens to allow light to reach the image receiver and closes to prevent light from reaching the image receiver. How long the shutter remains open, in combination with the size of the aperture, determines how much light reaches the image receiver.

Depending on the type and age of the camera, the range of shutter speeds varies widely. The shutter speeds of older 35 mm film cameras generally range from 1/1000 second to 1 second in length. Newer cameras, both film and digital, are often fully electronic and stretch the range in

CanonUSA

Figure 7-27. Very long lenses, like this 1200 mm telephoto, are relatively slow because of the large aperture required to produce larger f-stops.

both directions. They offer exposures as long as 30 seconds and as short as 1/16,000 second. The fastest shutter speed of most models is 1/4000 second. Many also offer T and B settings for longer, manually controlled exposures. When the T setting is chosen, the shutter release must be operated once to open the shutter and again to close it. With the B setting, the shutter remains open as long as the shutter release is being pressed. Releasing the pressure closes the shutter.

Like the f-stops that are used to indicate aperture, shutter speeds have a constant relationship. At a given value (for example, 1/60 second) the shutter is open for half as long as the preceding speed (1/30 second) and twice as long as the following speed (1/125 second). This means that the adjoining speeds will admit twice as much or half as much light, respectively, just as adjoining f-stop values admit half as much or twice as much light.

Film Speed/ISO Rating

The sensitivity of an image receiver to light is measured by its film speed, more properly referred to as its *ISO rating*. The rating is an international standard that was originally developed to ensure consistency in films from different manufacturers. With the development of digital photography, the concept was applied to different levels of sensitivity that could be selected for a camera's sensor.

ISO ratings follow the same pattern as apertures and shutter speeds. Each is twice as sensitive to light as the preceding rating and half as sensitive as the one that follows. The number designations are typically whole numbers—25, 50, 100, 200, 400, 800, 1600—that double as they increase. Films are generally available with ISO ratings as high as 3200, but the most widely used are 100, 200, 400, and 800.

Digital cameras may offer a range of ISO equivalents as minimal as 100, 200, and 400 (mostly in the simplest compact models) or as wide as 50 to 6400 in SLRs. Top-level professional cameras offer equivalents as high as 51,600. Since the sensitivity of the sensor is changed electronically, a camera used in automatic mode may select an ISO anywhere in its full range (for instance, 179 or 3266). When the camera is used in other modes, the photographer selects the desired ISO equivalent from a menu.

Measuring Light

To properly expose a photograph, a means of measuring light is needed to help you make decisions on your camera settings. Virtually all cameras sold today have a built-in light meter that is used to determine and control exposure for automatic operation. The meter also indicates exposure when the camera is operated in the manual mode. Various types of handheld meters can also be used to determine proper exposure. Photographers working with medium format and large format cameras generally must rely on handheld meters for exposure determination.

How Exposure Meters Measure Light

A photoelectric light meter uses electrical changes caused by different light intensities to indicate various levels of illumination. These indications, in turn, can be used to determine the exposure needed for a scene. The electrical changes can be either a generated current or a change in resistance. The changes drive a pointer against a scale or provide an LCD (liquid crystal display) readout.

Photoelectric meters use either selenium cells or silicon cells. The silicon cell most widely used in meters is the cadmium sulfide (CdS) cell.

The selenium cell meter was once the most common type, but is used much less frequently today. It has a photoelectric cell that generates a tiny electrical current whenever it is struck by light. The strength of the current generated is directly proportional to the intensity of the light—the stronger the light, the larger the current, and vice versa. The current moves a pointer across a scale to indicate an exposure value. Selenium cell meters do not need a battery to operate.

A *cadmium sulfide cell meter* measures the electrical resistance caused by light striking the CdS cell. A battery generates a small electrical current through the meter circuit. The intensity of the light striking the cell causes a change in electrical resistance. The increase or decrease in resistance is directly reflected as a change in the current flowing through the circuit. The changing current is translated into exposure values indicated on a scale or a display. A CdS meter

provides a more precise reading than a selenium cell meter, especially under low-light conditions.

Meter Displays

Exposure values displayed by a meter may be either indirect or direct. Indirect-reading meters provide an index number that must be related to an f-stop/shutter speed combination, while direct-reading meters give a specific f-stop/shutter speed combination. Older handheld meters usually are the indirect type, with a needle moving over a scale. Newer meters typically provide a direct reading on an LCD. See **Figure 7-28**.

Through-the-lens (TTL) meters used in cameras are direct-reading, although the reading is presented in a number of different ways in the viewfinder. Some use blinking LEDs on a scale of shutter speeds or apertures. Others require matching two needles or indicators by changing aperture or shutter speed. Most newer models display both aperture and shutter speed in numerals. Digital compact cameras typically display the information on the LCD screen used to compose and review images. Because of the great variety of systems used, TTL meters will be covered only in general terms. For specific information, consult the owner's manual for your camera.

Types of Meter Readings

In-camera meters can only be used to read reflected light, or light that enters the lens after bouncing off the subject. Handheld meters typically make reflected light readings, but many can also be used to read incident light, which is the light that is falling on the subject.

Reflected light readings are made with the meter facing the subject, and are usually made from the camera position. To avoid having the meter influenced by adjacent brighter or darker areas, readings are sometimes made close to the most important part of the subject.

Since they measure light falling on the subject, incident light readings are taken from the subject's position, with the meter facing toward the light source. Meters used for incident light readings have a translucent cover over the light-sensitive cell to diffuse the light rays and help produce an average reading. Meters that can

Gossen; Manfrotto

Figure 7-28. Types of meter displays. A—Indirect reading. B—Direct reading.

be used for both types of readings typically have a translucent plastic dome that can be slid over the cell to read incident light, **Figure 7-29**.

Spot meters and flash meters are specialized instruments. A spot meter, **Figure 7-30**, can take reflected light readings from very tiny areas and distant subjects. It has an angle of view as narrow as 1°. A typical handheld light meter has an angle of view of 30° to 50°.

Newer cameras often allow selection of various metering patterns, including a spot meter mode. Whether done with a handheld meter or a camera, spot metering allows you to make precise readings to compare light reflected from different areas of the subject.

A flash meter is used to make an accurate reading of the short pulse of bright light produced by electronic flash equipment. Flash meters are used most often for studio photography or special field applications, such as weddings. Depending on the situation, a flash meter can be used to make either an incident or a reflected light reading.

Also available are multifunction handheld models that can be used as an incident meter, reflected light meter, flash meter, or spot meter with zoom capability. Readings are displayed on a large LCD panel, **Figure 7-31**.

Making a Light Reading

To obtain an accurate handheld meter reading, the meter first must be programmed with the ISO rating being used, **Figure 7-32**. If the film or ISO equivalent set in the camera is different from the rating in the meter, exposure will be incorrect. For example, if the meter is programmed for ISO 100, and the camera is set for ISO 400, the meter's recommended settings cause images to be overexposed by two full stops.

For built-in meters in most cameras, this problem does not occur. Film cameras read a bar code printed on the film cassette to ensure that the meter bases its readings on the speed of the film being used. A digital camera in automatic

Jack Klasey/Goodheart-Willcox Publisher

Figure 7-29. A translucent dome can be slid over the light-sensitive cell of a reflected light meter to make incident light readings.

Jack Klasey/Goodheart-Willcox Publisher

Figure 7-30. The spot meter can make reflected light readings from distant subjects or tiny areas of closer subjects.

Sekonic

Figure 7-31. Multifunction exposure meter.

Jack Klasey/Goodheart-Willcox Publisher

Figure 7-32. Programming a handheld meter with an ISO rating.

mode selects the appropriate ISO, shutter speed, and aperture. If the camera is being used in manual, shutter priority, or aperture priority mode, the exposure readings are based on the selected ISO equivalent.

Selecting the right areas to meter and the correct methods to obtain consistent and accurate readings are vital to taking well-exposed pictures. The following sections will concentrate on correct use of a handheld meter.

Making Averaged Readings

A reflective light reading, or averaged reading, is made by pointing the meter at the main subject, **Figure 7-33A**. Since a handheld meter has about the same angle of view as a normal lens, it is affected by light that is reflected from the same area that appears in the photo. The scene usually includes a range of tones, from those that reflect a great deal of light (highlights) to those that reflect little or no light (shadows). The meter reading falls somewhere in the middle, averaging out the reflected light. This reading allows the film to properly expose most of the tones present in the scene.

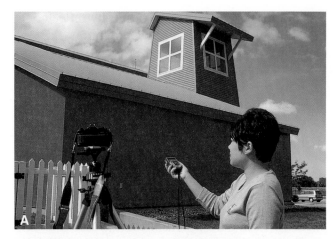

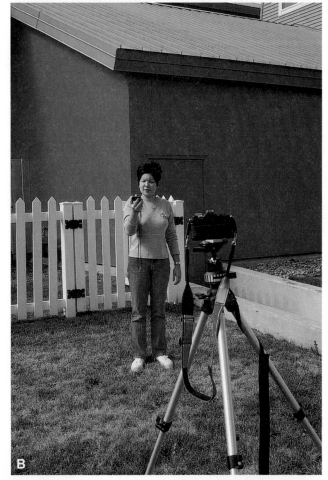

Jack Klasey/Goodheart-Willcox Publisher

Figure 7-33. Overall light readings. A—Pointing the meter at the main subject provides a reflected light reading. B—An incident reading measures the light falling on the subject.

An incident light reading accomplishes the same purpose for scenes with a wide range of tones. The incident meter is pointed at the light source from the subject's position to measure the light falling on the subject, **Figure 7-33B**.

The photograph is taken, of course, by reflected light. The average of that reflected light is equivalent to the incident light reading.

What averaged reflective readings and incident readings actually produce is an exposure value for *middle gray*, equivalent to a tone that reflects 18% of the light that falls on it. By properly exposing for the middle gray value, the darker and lighter tones in the scene generally reproduce properly.

When it is important to keep detail in specific shadow or highlight areas, a more precise technique involves the use of two meter readings. First, select the shadow area in which you want to preserve detail and take a meter reading from that area. Next, repeat the process with the selected highlight area, and then find the exposure midway between the two readings. For example, if the shadow reading indicated an exposure of f/4 at 1/60 second, and the highlight reading was f/16 at 1/60 second, the brightness range that you metered would be four stops (f/4, f/5.6, f/8, f/11, f/16), **Figure 7-34**. The midway point in that range is f/8. By using an exposure of f/8 at 1/60 second, you would likely keep the desired detail in the shadow and highlight areas you selected.

Metering Subjects That Are Not Average

When the object or portion of a scene that is metered is much darker or lighter than middle gray, problems can occur. The meter provides an exposure reading that results in a seriously overexposed or underexposed picture. As shown in **Figure 7-35**, exactly following the meter readings taken from the black or the white

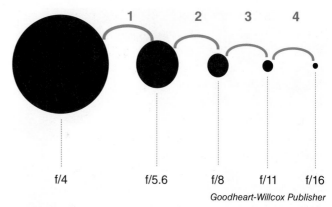

Goodheart-Willcox Publisher

Figure 7-34. A scene with a shadow reading of f/4 and a highlight reading of f/16 has a range of four stops.

squares results in pictures that are too dark or too light because the meter always makes a middle gray reading. If a large amount of light is being reflected (as from the white square), the meter adjusts the exposure reading downward to avoid the overexposure. As a result, the photo is underexposed. In the same way, the meter reacts to the small amount of light reflected from the black square by adjusting the exposure reading upward to prevent underexposure. In this case, the photo will be overexposed.

Compensating for the meter's behavior in such situations is a matter of experience. As a general rule, however, an adjustment of 1 to 1 1/2 stops usually provides a good exposure. For example, when photographing a winter snow scene, open up 1 1/2 stops from the meter's recommended exposure to reproduce the snow as white instead of gray. At the opposite extreme, to make a black cow appear black in a close-up photo, stop down 1 or 1 1/2 stops from the meter's reading.

Jack Klasey/Goodheart-Willcox Publisher

Figure 7-35. The exposure of this scene depends on where the meter reading was taken. A—Reading taken from the white square, underexposed. B—Reading taken from the black square, overexposed. C—Reading taken from the middle gray square, properly exposed.

If you are not careful about where you point the meter, it can produce an incorrect value even when making an overall reading of a scene. A typical situation is a scene in which the subject is *backlit* (has most of the light coming from behind it). As shown in **Figure 7-36**, a meter reading influenced by the bright light underexposes the subject, and may even create a silhouette. To prevent unplanned silhouettes, move in to take a reading directly from the subject, **Figure 7-37**. If a close-up reading cannot be made, increase your exposure by 1 1/2 stops over the meter reading.

Reading the Meter

Newer handheld meters and in-camera meters display the aperture and shutter speed combination directly on an LCD panel. Older handheld meters, however, typically use an index number that is manually translated into exposure recommendations by moving a dial.

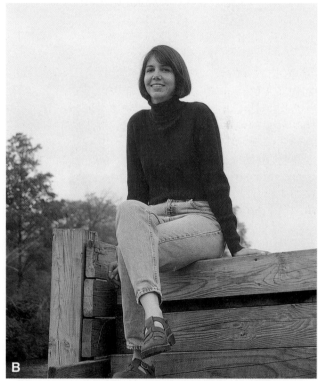

Jack Klasey/Goodheart-Willcox Publisher

Figure 7-37. Moving in close to the subject keeps the meter reading from being influenced by the strong backlight. A—Meter close to the subject. B—Move back to shoot the entire subject.

As shown in **Figure 7-38**, this type of meter is pointed at the desired subject and a button or switch is pressed to activate the metering circuit. A needle moves against a scale of index numbers to show the strength of the reflected light reaching the meter's photoelectric cell. A dial is then rotated to align an indicator mark with a number matching the index number indicated by the needle. This action provides recommended exposures by aligning an f-stop scale with a shutter-speed scale.

Jack Klasey/Goodheart-Willcox Publisher

Figure 7-36. Underexposure due to an overall meter reading made when a subject is backlit.

Figure 7-38. Using a handheld light meter. A—Making the light reading. B—Reading equivalent exposures directly from the f-stop and shutter speed scales.

The combinations presented by the paired f-stop and shutter-speed scales illustrate the *reciprocity law*, which describes the relationship of light intensity and time on exposure. For example, f/5.6 at 1/125 second, f/8 at 1/60, and f/11 at 1/30 result in the same amount of light reaching the image receiver. For this reason, they are known as *equivalent exposures*.

The reciprocity law has its limitations. When very long or very short exposures are made on film, the time/light intensity relationship does not remain constant—longer exposure times or larger apertures are needed. This is known as *reciprocity law failure* or *reciprocity failure*. The reciprocity law typically fails at 1 second and 1/1000 second. Film manufacturers provide information on the changes needed to compensate for reciprocity failure.

Digital camera sensors are not subject to reciprocity law failure. Very long or short exposure times do not require lengthening exposure times or increasing apertures. Very long exposures do, however, increase *digital noise*, tiny light-colored spots especially noticeable in shadow areas of an image.

The Zone System

The *Zone System* is a photographic method designed to produce consistent, predictable results through careful control of exposure, film development, and printing. This system, devised by Ansel Adams and Fred Archer in 1939, uses a 10-step scale of image values (tones) from pure black to pure white to allow precise description and control. Although its original use was with large format black-and-white sheet film, the Zone System can be applied to 35 mm film photography in both color and black-and-white.

The Ten-Step Scale of Values

Adams developed the Zone System to allow photographers to consistently produce a final print that matched their visualization of the scene. Sometimes that final print would be a literal rendering of the scene. At other times, the finished product would have a far different range of tones or contrasts from what the eye had seen. See **Figure 7-39**.

Any photograph can potentially have an almost infinite gradation of tones from absolute black to absolute white. Adams reduced the range to 11 specific tones numbered in Roman numerals. This provided for a progression of 10 steps from the darkest tone (0) to the lightest (X). See **Figure 7-40**.

Adams distinguished between the term *zone*, used to describe exposure, and the term *value*, used to describe the result of that exposure as seen on the negative and print. The zones are equivalent to f-stops and have the same halving and doubling relationship.

Three of the zones have particular importance. Zone V represents the middle of the exposure scale, equivalent to the gray card with its 18% reflectance. Zone III is an exposure that yields a dark (shadow) print value with texture

Jack Klasey/Goodheart-Willcox Publisher

Figure 7-39. Different visualizations. A—A scene that the photographer chose to render as seen. B—The same scene, visualized by the photographer as a much more dramatic, higher-contrast image.

0	I	II	III	IV	V	VI	VII	VIII	IX	X

Goodheart-Willcox Publisher

Figure 7-40. The Zone System provides ten steps (0 to I, I to II, etc.) of gradation from black to white.

and detail just visible. Zone VIII is an exposure that yields a light (highlight) print value in which texture and detail is just visible.

Unless you are photographing a gray card, any subject that you capture presents a variety of tones, or *luminances* (percentages of reflected light). The scene is made up of shadows (low-luminance areas), highlights (high-luminance areas), and middle tones (luminances between the extremes). As shown in **Figure 7-41**, these luminances in the subject are reproduced in a photographic print as values correlated with the exposure zones.

An average sunlit outdoor scene typically produces a range of luminances equivalent to nine stops, or Zones I to IX on the scale. This is known as the *dynamic range* or *subject brightness range (SBR)* of the scene. Some scenes may have a wider SBR, from Zone 0 to X and beyond, but most have a narrower range of three to seven stops. That range of stops may be located anywhere on the scale. A predominately dark-toned subject with a three-stop range might have values equivalent to Zones II, III, and IV. A light subject with the same range of three stops could have values equivalent to Zones VII, VIII, and IX.

Jack Klasey/Goodheart-Willcox Publisher

Figure 7-41. Values corresponding to the exposure zones can be identified in a photographic print. Each value represents the luminance of a specific area of the subject.

Placing an Exposure Value

Metered values may be shifted up or down the scale to provide an exposure that matches the photographer's visualization of the scene. A significant shadow area in a scene may be selected, for example, and a meter reading taken. The reading indicates the exposure required to yield a middle gray or Zone V value for that area. If the photographer visualizes that shadow area as dark enough so texture and detail will be just visible in the resulting print (Zone III), the exposure must be adjusted. By giving the scene two stops less exposure, the shadow area is exposed at Zone III instead of Zone V.

This adjustment is called *placing a value*. As a result of selecting the desired exposure, the shadow has been placed on Zone III. Other values in the scene will fall on the remaining Zones within the subject brightness range in relation to the Zone III placement. Thus, a light area that originally would have been a highlight (Zone VII) will now fall on Zone V, and thus be a middle tone. A shadow area that would have been Zone III (shadow with some visible detail) becomes Zone I (featureless black). See **Figure 7-42**.

Using a Simplified Zone System Exposure Method

Strict application of the Zone System to fully control the photographic process is a complex and time-consuming endeavor. Many beginning and intermediate photographers improve their work by applying a simplified form of the Zone System

that concentrates on better exposure control. It is most applicable to black-and-white photography, but can also be used to some benefit with color print film. The simplified method consists of three steps:

1. Metering significant shadow and highlight areas of the scene.
2. Adjusting the selected shadow reading to place it on the desired Zone.
3. Determining processing and paper grade adjustment for best rendition of highlights.

Metering Shadows and Highlights

To identify the subject brightness range of the scene, first meter the darkest shadow area in which you want to retain some detail and texture in the final print. Note the reading. Next, meter the lightest highlight in which you want to retain detail and texture in your print. Note that reading. Both readings should be for the same shutter speed, such as 1/60 second or 1/125 second.

Determine the SBR of the scene by counting the number of stops between the shadow reading and the highlight reading. For example, if the shadow reading is f/4 at 1/60 second and the highlight reading is f/22 at 1/60 second, you have a five-stop range of brightness (4 → 5.6 → 8 →11 → 16 → 22).

Placing a Zone Value

To achieve a print in which the significant shadow area shows just a trace of detail and texture, place that area on Zone III. Since your

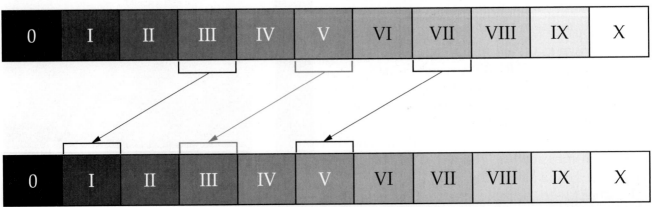

Goodheart-Willcox Publisher

Figure 7-42. When a value in a scene is placed on a specific Zone, all the remaining Zones shift as well.

meter reading of f/4 at 1/60 second would result in a Zone V value for the shadow, it is necessary to reduce exposure by two stops (and thus two Zones). An exposure of f/8 at 1/60 second would place the shadow area on Zone III.

Since you placed the shadow on Zone III, all other values would be two Zones lower. This means that your highlight value then falls on Zone VIII, exactly where it needs to be so it will show slight texture and detail. An exposure of f/8 at 1/60 second would result in a photo exposed properly to print on normal contrast paper.

Adjusting for Highlights

When the SBR is greater than seven stops, you usually can salvage what would otherwise be blank white highlights by adjusting film development to reduce contrast. If all the frames on a roll were taken under the same high-contrast (wide SBR) conditions, reducing the development time makes the highlight values (dark areas on the negative) less dense than they would be with normal-length development. The reduction in development time prevents the highlights from becoming so dense that no light comes through when making a print. The reduction time for a given situation is usually established by trial and error, but may be as great as 30%.

Digital Cameras and the Zone System

The simplified Zone System described in the preceding section can be applied to digital photography using the manual shooting mode. A handheld meter or the camera's built-in metering system can be used to determine exposure values. You would then make a trial exposure and examine the camera's histogram display, **Figure 7-43**. Based on the display, you would increase or decrease exposure as needed.

Jack Klasey/Goodheart-Willcox Publisher

Figure 7-43. A camera's histogram display shows the range of tones in the photograph.

Portfolio Assignment

Backlit Subject

Find or arrange a strongly backlit subject to practice metering for proper exposure. The subject should be a person or an object in front of a plain, bright background, such as a clear blue sky. The subject should be much less brightly illuminated than the background and should fill only about one-third of the frame. See **Example A**.

Expose the scene in different ways:

1. Meter the background.
2. Meter the overall scene.
3. Meter the subject close-up, then reframe.

Continue shooting and experimenting until you are satisfied with the subject exposure. Print that image and add it to your portfolio.

Jack Klasey/Goodheart-Willcox Publisher

Example A. A strongly backlit subject.

Check Your Photography IQ

Now that you have finished this chapter, see what you learned by taking the chapter posttest.

www.g-wlearning.com/visualtechnology/

Review Questions

Answer the following questions using the information provided in this chapter.

1. By what four means do artificial light sources produce radiant energy?

For Questions 2–6, match each of type of light with its wavelength.

2. Shorter than 400 nm
3. 400 nm–500 nm
4. 500 nm–600 nm
5. 600 nm–700 nm
6. Longer than 700 nm

A. Green light
B. Infrared radiation
C. Ultraviolet radiation
D. Red light
E. Blue light

7. Briefly explain why we perceive a blue object as blue.

8. The system in which three primary colors combine to create all other colors is called the _____ color process.
 A. synthesized
 B. subtractive
 C. additive
 D. analog

9. What does the term *panchromatic* mean when used to describe a black-and-white film?

10. The major use of the _____ filter is to differentiate between colors when they are rendered as gray tones in black-and-white images.

11. Which of the filters below brings out (emphasizes) clouds most strongly when black-and-white film is used?
 A. Light yellow
 B. Yellow
 C. Deep yellow
 D. Red

12. Autofocus cameras require the use of _____ polarizing filters for proper operation of the focusing system.

13. How does a neutral-density filter make it possible to eliminate all the cars from a photograph of a busy street?

14. The amount of additional exposure that must be calculated when most filters are used on a large-format camera is called the _____.

15. In this sequence of numbers—1, 1.4, 1.8, 2, 2.8, 4, 5.6—which does *not* represent an interval of a full f-stop from its neighbors?

16. Explain why the actual size of a given aperture (such as f/8) is larger for a 200 mm lens than it is for a 28 mm lens. Calculate the physical size of the aperture at f/8 for the two lenses.

17. Which of the following statements is *false*?
 A. F-numbers are calculated by dividing the focal length of the lens by the diameter of the aperture.
 B. As f-stop numbers become larger, the aperture they represent becomes smaller.
 C. In the standard series of f-stops, the area of the diaphragm opening is either halved or doubled from one f-stop to the next.
 D. A lens with twice the focal length of another lens has an aperture half as large for a given f-stop.

18. How does a selenium cell meter work differently from a cadmium sulfide cell meter?

19. Averaged reflective light meter readings produce an exposure value for _____.
20. To avoid silhouetting a backlit subject, the meter's exposure recommendation should be _____ by 1 1/2 stops.
21. In digital photography, _____ increases with higher ISOs or with long exposures.
22. In the Zone System, there are three zones with particular significance. List and describe them.

Suggested Activities

1. Explore the effects of a polarizing filter. Determine how its effectiveness is related to the location of the sun, and how it can be used to eliminate reflections in glass or water, deepen colors by removing glare, and bring out details in clouds. Use pairs of "before and after" pictures to illustrate a written report.
2. To better understand how changes in lighting affect exposure, choose a fairly large object (such as a statue, or the wall of a storage shed or garage) that will not change position. Set your camera to aperture priority and choose f/8 as the aperture. Meter the object and note the displayed shutter speed. Make readings from the same position at different times of day and under various weather conditions. Keep careful notes of the date, time, weather conditions, and meter reading. Continue for one week, making 3 to 5 readings each day. Compile your notes in the form of a table.

Critical Thinking

1. The Zone System was developed to produce consistent results using film cameras and making prints in a chemical darkroom. Do you think that studying the Zone System has any value for a photographer using a digital camera and making color inkjet prints?
2. Many photographers install an ultraviolet filter in front of their camera's lens. Can you think of reasons both for and against using this filter?

Communicating about Photography

1. **Speaking.** Pick a figure in this chapter, such as Figure 7-10 or 7-26. Working with a partner, tell and then retell the important information being conveyed by that figure. Through your collaboration, develop what you and your partner believe is the most interesting description of the importance of the chosen figure. Present your narration to the class.
2. **Writing and Speaking.** Working in a group, brainstorm ideas for creating classroom tools (posters, flash cards, and/or games, for example) that will help your classmates learn and remember the different types of filters. Choose the best idea(s), and then delegate responsibilities to group members for constructing the tools and presenting the final products to the class.

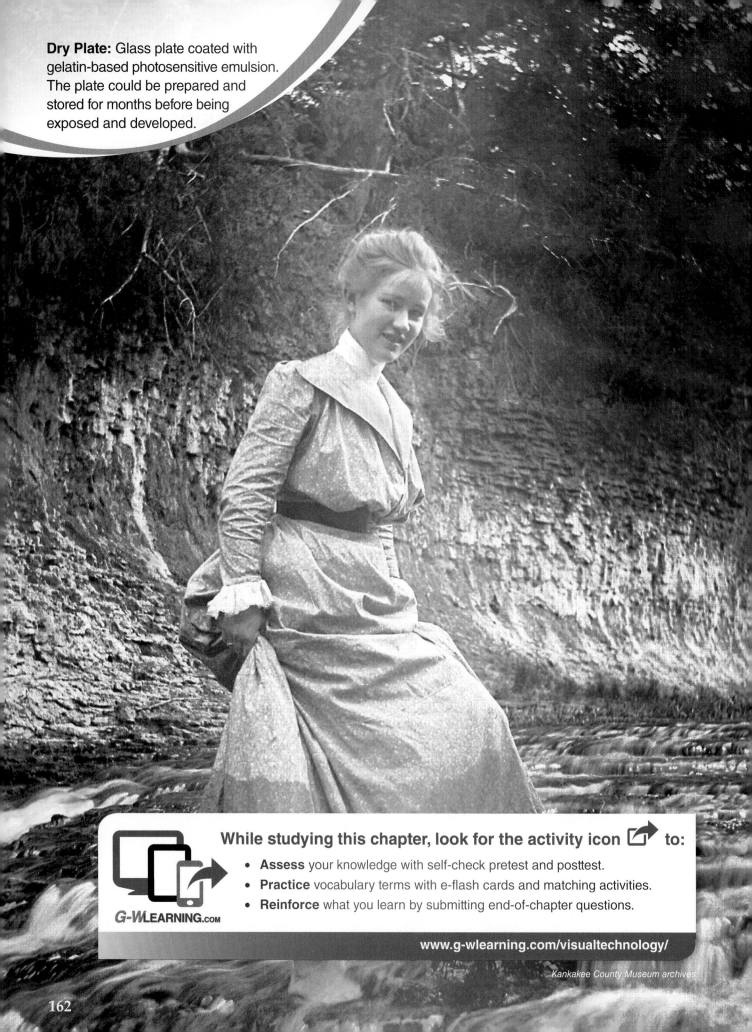

Dry Plate: Glass plate coated with gelatin-based photosensitive emulsion. The plate could be prepared and stored for months before being exposed and developed.

While studying this chapter, look for the activity icon 📲 **to:**

- **Assess** your knowledge with self-check pretest and posttest.
- **Practice** vocabulary terms with e-flash cards and matching activities.
- **Reinforce** what you learn by submitting end-of-chapter questions.

G-WLEARNING.com

www.g-wlearning.com/visualtechnology/

Kankakee County Museum archives

Image Capture Media

Objectives

When you have finished reading this chapter, you will be able to:

- Describe the differences between digital image capture and the traditional chemical method of image capture.
- Explain the operation of a sensor in capturing an image.
- Distinguish between the physical structures of black-and-white film and color film.
- Explain the method by which a latent image is formed.
- Describe the film speed rating system as a measure of sensitivity to light.
- Describe the various types and forms of film.
- Recall the advantages and disadvantages of color negative and color positive films.

> ### Check Your Photography IQ ↗
>
> Before you read this chapter, assess your current understanding of the chapter content by taking the chapter pretest.
>
> www.g-wlearning.com/visualtechnology/

Technical Terms ↗

analog signal	firmware
antihalation layer	full-frame
area array	gray levels
bit depth	image file
buffer	instant-print film
card speed	integral tri-pack film
characteristic curve	ions
charge-coupled devices (CCDs)	JPEG
collodion	memory card
complementary metal oxide semiconductors (CMOS)	negative/positive film
	RAW
compressed	reversal film
density	sensitivity specks
digital signal	solid-state
file formats	subbing layer
film loader	supercoat
film speed	TIFF
filter decals	

In 1900, a photographer capturing an image of children sledding on a snowy hill would have used a camera that recorded the scene on film, a strip of flexible material coated with an emulsion of light-sensitive silver halides.

A century later, the great-granddaughter of that photographer would have been more likely to record a similar scene using an electronic array called a *digital sensor*. Since digital imaging emerged in the late 1990s as a serious alternative to traditional chemical-based photography, it has almost completely captured the consumer market. Among professionals, digital cameras have replaced film equipment for photojournalism, product imaging, portraiture, and wedding photography.

Image Capture— Digital vs. Film

For more than 150 years, photography was an image-capture process that involved chemical changes in substances exposed to light. The light rays reflected from the subject passed through a lens and struck the light-sensitive film, imprinting a latent image. That image was made visible and permanent by chemical development and fixing.

The visible image could be a negative or a positive, depending on the type of film used. Positive (transparency) film resulted in a projectable image. Negative (print) film could be used to create positive prints on a paper or plastic surface that had been coated with a light-sensitive emulsion. Development and fixing with the appropriate chemicals resulted in a positive image of the scene originally photographed. The traditional chemical-based photographic process is diagrammed in **Figure 8-1**.

The similarities between traditional and digital image capture end at the camera's image receiver. In a traditional camera, light rays cause a latent image to form in the film emulsion. In a digital camera, the light rays strike image sensors containing millions of tiny photosites, or pixels (an abbreviation of the term *picture element*). The sensors may be ***charge-coupled devices*** (CCDs) or ***complementary metal oxide semiconductors*** (CMOS).

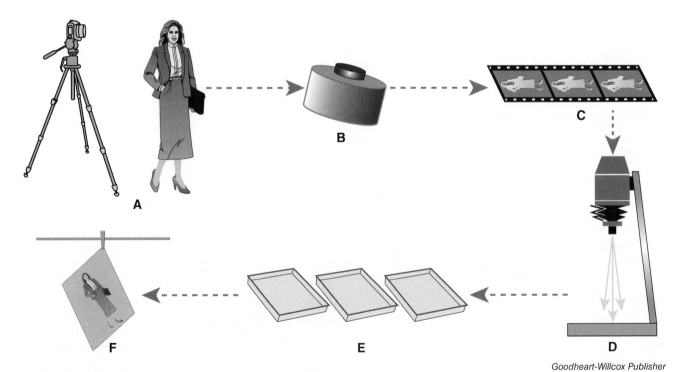

Goodheart-Willcox Publisher

Figure 8-1. The traditional, chemical-based process of capturing an image and creating a finished print has been used for more than 150 years. A—The film is exposed. B—The film negative is developed and fixed. C—The negative is washed and dried. D—The print is made by projection or contact method. E—The print is developed and fixed. F—The print is washed and dried.

Each type of sensor has its advantages. The CCD sensor is more sensitive, especially to lower light levels, and generates less digital noise than a comparable CMOS sensor. The CMOS sensor, on the other hand, is less expensive to manufacture, uses less power (thus draining the camera battery more slowly), and sends information to the camera's processing circuits faster.

Pixels are arranged in rows to form a grid or *area array*. A compact digital camera typically has 3200 rows with 5000 pixels per row, yielding a sensor with 16 million pixels. This camera would be referred to as a *16 megapixel camera*. See **Figure 8-2**. When light strikes an individual pixel, a tiny electrical charge is generated. The electrical charge from each pixel is passed on to a processor, or computer chip. The processor converts the charges into a digital image that is then stored as an individual *image file*, usually on a solid-state card. Image files can be displayed on the camera's LCD screen; sent to a smartphone, computer, or the Internet for viewing; projected onto a screen by a digital projector; or converted to a print on paper. The digital imaging process is diagrammed in **Figure 8-3**.

Panasonic

Figure 8-2. This Panasonic Lumix compact camera has a sensor with 16 million pixels.

The Digital Imaging Process

When light rays strike the camera's sensor, the electrical charges generated by each pixel vary in strength based on brightness of the light. These varying charges are then converted to an

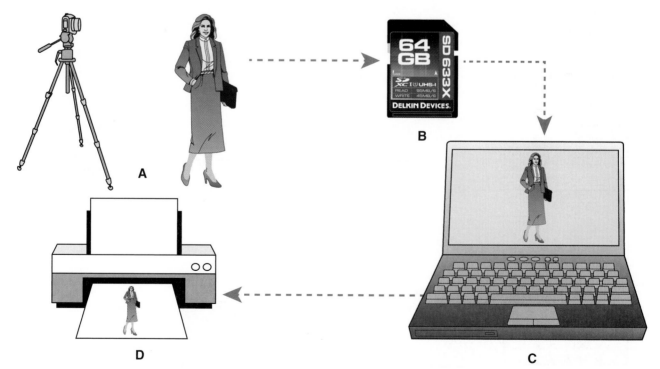

Goodheart-Willcox Publisher

Figure 8-3. The digital imaging workflow involves fewer steps than the film-based process shown in Figure 8-1. A—The image is captured by the camera's sensor and stored as a digital file. B—The file is transferred from camera's removable storage device to a computer. C—Software is used to process the image file in the computer. D—The image is sent to a printer to create a finished print.

analog signal (one composed of continuously varying values) for further processing. CCD and CMOS devices handle this step differently. See **Figure 8-4**.

In the charge-coupled device, the charges from individual pixels are moved, row-by-row, to a transfer register and converted to voltages. The voltages are passed to an amplifier and then to a converter that changes them from analog to digital values. The *digital signal*, which consists of only on/off values, is processed by the camera's built-in program or *firmware*.

Complementary metal oxide semiconductors handle the charges differently. Each pixel has its own circuitry for converting the charge to a voltage and amplifying it. The signal next goes to an analog-to-digital converter, and then is processed by the camera's firmware.

From Gray to Color

Firmware translates the signal from each pixel into a shade of gray. How many *gray levels*, or steps between pure white and pure black the camera sees, is determined by the pixel's *bit depth*.

Bit depth increases exponentially, as shown in **Figure 8-5**. A pixel with a bit depth of 1 distinguishes only white and black. A 2-bit pixel can distinguish four shades of gray; a 3-bit can distinguish eight shades, and so on.

Bit Depth	Exponent (Base of 2)	Shades of Gray
1	2^1	2
2	2^2	4
3	2^3	8
4	2^4	16
5	2^5	32
6	2^6	64
7	2^7	128
8	2^8	256

Goodheart-Willcox Publisher

Figure 8-5. Bit depth increases exponentially by powers of two.

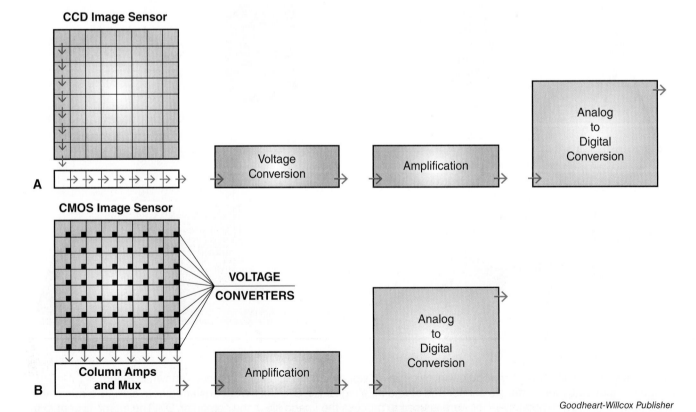

Goodheart-Willcox Publisher

Figure 8-4. CCD and CMOS sensors. A—CCD sensor processing. B—CMOS sensor processing.

A bit depth of 8 (256 shades of gray) is equivalent to the number of gray values in a black-and-white photographic print.

Color information is recorded by filtering the light striking the array to obtain three different grayscale channels. One channel is for green, one for red, and one for blue. Each channel typically has a bit depth of 8, so the resulting image has a bit depth of 24 (3 × 8). Up to 16.7 million different tones of color can be reproduced. See **Figure 8-6**. A 24-bit color depth is considered the minimum for good color reproduction.

The most common method of color filtering for area arrays uses *filter decals*. These red, blue, and green overlays are applied to individual pixels in a checkerboard arrangement called a *Bayer pattern*. See **Figure 8-7**. It has twice as many green filters as red or blue filters, since human vision is most sensitive to the light values in the green wavelengths.

A different approach is taken by the Foveon X3 sensor used in cameras made by Sigma. This sensor does away with the color filter decals. Instead, it is made up of three layers of pixels—each sensitive to blue, green, or red wavelengths. See **Figure 8-8**. According to the manufacturer, the layered pixel sensor design provides more accurate color, increased sharpness, and faster image processing in the camera.

Sensor Sizes

The sensor used in a digital camera may be *full-frame*, the same 24 mm × 36 mm dimensions as the traditional 35 mm film frame, or one of several smaller sizes. See **Figure 8-9**. The most common is the APS-C size, which is approximately 24 mm × 16 mm.

Bit Depth	Exponent (Base of 2)	Colors Displayed
8	2^8	256
16	2^{16}	64,000
24	2^{24}	16.7 million

Goodheart-Willcox Publisher

Figure 8-6. Bit depth for color images becomes much larger because of the three color channels involved.

Foveon, Inc.

Figure 8-8. The Foveon X3 sensor has three layers of pixels.

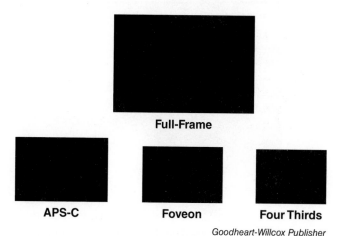

Goodheart-Willcox Publisher

Figure 8-9. Sensor size comparison.

R	G	R	G
G	B	G	B
R	G	R	G
G	B	G	B

Goodheart-Willcox Publisher

Figure 8-7. Filter decal arrangement for Bayer pattern sensors.

Many advanced compact and prosumer SLR cameras use this sensor. The Foveon sensor is somewhat smaller at 21 mm × 14 mm, and the Four Thirds system sensor used in Olympus and some other camera brands is smaller still at 17 mm × 13 mm. The Micro Four Thirds sensor, introduced in 2008, is the same size, but is used in mirrorless cameras.

A full-size sensor does not necessarily contain more pixels than an APS-size sensor. In fact, there are many compact cameras with a higher megapixel count than some professional full-size sensor models. The major difference is the size of the individual pixels. Full-frame pixels are approximately one-third larger than APS-size pixels. They gather more light and do not have to be amplified as much before processing, generating less digital noise.

Studio Cameras

Digital capture equipment used for studio work is typically medium format and large format cameras. These cameras may have an area array, usually in the form of a digital back, or a scanning back that functions much like the sensor array of a flatbed scanner.

Most common are medium format cameras capable of being used with either film or a digital back, **Figure 8-10**. A digital back is a capture device attached to the camera in place of a traditional film holder. It uses a large sensor, such as 54 mm × 40 mm, that produces an image file as large as 240 Mb. These cameras are also used for location shooting. They deliver large images of extremely high quality, **Figure 8-11**.

Phase One

Figure 8-10. A medium format camera equipped with a digital back.

Phase One photo by Alexander Flemming

Figure 8-11. Medium format and large format digital cameras, with their large arrays, capture very high quality images. This photo was taken by a camera with an 80Mp sensor.

Studio cameras with capture devices called *scanning backs*, **Figure 8-12**, make use of a trilinear array rather than an area array. The trilinear array is a bar containing three rows of sensors that is moved across the image capture area. Operation is much like the movement of the capture element in a flatbed scanner.

Resolutions achieved with scanning backs are very high, but the tradeoff is speed. Exposure times with a scanning back often are measured in minutes. The long exposures require a rock-solid camera mount, usually a heavy studio stand, and lighting that is constant in intensity and free from flicker. Digital studio cameras may be connected to a computer for framing and focusing—the computer screen becomes the ground glass. See **Figure 8-13**. This arrangement also makes use of the computer's hard drive for image storage.

Image Storage

The earliest digital cameras offered only internal (RAM) memory, but virtually every camera model today uses some form of removable memory device. Because of increases in camera resolution, and thus file size, a camera's internal memory would quickly fill up with image files without a removable device. Shooting would then have to stop until the files were transferred to a computer.

A storage card or **memory card** can be filled with image files and replaced in the camera with a fresh card so shooting can continue. The contents of the filled card can be transferred to a computer's hard drive, and the device formatted for use again.

Image File Sizes

The size of electronic files generated by a digital camera makes file storage and handling an important consideration. For example, a color image captured by a 16Mp camera and saved at the highest resolution (4068 × 3456 pixels), creates a file size of more than 47 Mb (megabytes). File size is computed by multiplying the dimensions in the pixel array (4068 × 3456 = 15,925,248). If the image is black-and-white, this would be its file size. A color image, however, is made up of three channels, each of which is 15,925,248 bytes in size. Adding together the red, green, and blue channel file sizes produces the actual file size of 47,775,744 bytes (47 Mb). See **Figure 8-14**.

Courtesy of Better Light

Figure 8-12. Scanning back being inserted in a studio camera.

Linhof/HP Marketing Corp.

Figure 8-13. Using a computer as the viewfinder for a studio digital camera.

Goodheart-Willcox Publisher

Figure 8-14. At the highest resolution, a digital camera produces a monochrome (black-and-white) image file that is the same as the resolution of the array. A color image file has three times the number of pixels in the array, since it consists of three channels (red, green, blue).

File Formats

Digital cameras allow files to be saved in a number of different modes or *file formats*. Some of these retain their original size and all the original pixel data. Files may also be *compressed* to a smaller size to take up less storage space or to speed up transfer time, but they may lose some image information in the process.

Digital cameras may offer the user one or two file formats, including RAW, JPEG, or TIFF. Each has its advantages and drawbacks:

- *RAW.* Available on all digital SLRs and some advanced compacts, RAW is technically not a file format like JPEG or TIFF. Instead, it is the basic image information captured by the sensor and saved with minimal processing by the camera's computer. With the proper software, a photographer can adjust many aspects of the RAW image, such as exposure or color temperature, without degrading the image quality. After adjustment, the file is converted to another format, such as TIFF, JPEG, or Adobe Photoshop's proprietary PSD. RAW is popular among professionals and advanced amateur photographers, but has

two negative aspects— its large file sizes and the need to perform extra operations on the file before it can be further processed with image manipulation software.

- *JPEG.* The JPEG format is the most common compressed file type and is the only compression choice offered on many cameras. The JPEG method of reducing file size is lossy, which means that some image information is discarded in the process of compressing the file. The amount of compression can be small or large. For example, a file from a 16Mp camera saved at the highest quality setting compresses to 3.6 megabytes. At the lowest quality (most compressed) setting, the file shrinks to 484 Kb (kilobytes). When the highest quality is selected, the loss is minimal, but more severe compression can seriously degrade image quality. Additional image information is lost every time a JPEG image is opened and resaved.

- *TIFF.* The Tagged Image File Format is not lossy. It retains all the image information through the processing steps performed by the camera's computer. Like RAW, file sizes are large. Unlike RAW, no additional steps are needed before using image manipulation software.

Removable Storage Devices

Removable storage devices are small memory cards that are slipped into a slot on a digital camera. Most are *solid-state;* they have no moving parts. The cards vary in physical size and capacity, **Figure 8-15.** Some can be used in many different makes and models of cameras, while others are usable in only a few brands of cameras. The following are examples of memory cards:

- CompactFlash (CF) cards are available in capacities from 512 Mb to 512 Gb (gigabytes). Once widely used, today they are most common in professional-level digital SLRs.

- Secure Digital (SD) cards are physically smaller and thinner than CompactFlash cards. They are available with capacities from 512 Mb to 256 Gb. Secure Digital cards are used for compact, advance compact, and a number of SLR models.

A B C

SanDisk; Lexar; Delkin Devices

Figure 8-15. Some removable storage devices. A—Compact-Flash card. B—Secure Digital card. C—MicroSD card and an adapter that allows it to be used in an SD card slot.

Other types of removable memory include the following:

- MicroSD cards, which are about the size of a postage stamp, are available in capacities of 4 Gb to 64 Gb. They are most commonly used for image storage in camera phones.

- Memory Stick cards are used primarily in Sony cameras. They are available in 512 Mb to 32 Gb capacities.

- Microdrive devices record information on a tiny hard disc the diameter of a US 25-cent coin. These removable drives are the size of a CompactFlash card and can store up to 8 Gb of files.

Solid-state removable storage devices can usually survive extreme conditions and rough handling. Unlike film, they are not affected by airport X-rays. However, they should not be exposed to strong magnetic fields.

Card Capacities

The most important factors in choosing a memory card capacity are the size of files you will be producing and how long you want to shoot before changing cards. For example, if you have a 10Mp camera and prefer to shoot RAW files, you would want a card larger than 512 Mb, otherwise you would be able to shoot only about 30 images before running out of space. See **Figure 8-16**. At the other extreme, you could shoot almost 1000 images before filling a 16 Gb card.

For most people, the right size card is somewhere in-between, especially if they use high-quality JPEG files, as do most nonprofessional photographers. A card size of 2 Gb or 4 Gb represents a good compromise between capacity and price. Cards larger than 2 Gb use a file system called FAT 32 that is readable only by newer cameras. Before purchasing a 4 Gb or larger card, check your camera manual to determine if the card and camera are compatible.

Some photographers buy the largest-capacity card they can afford so they can shoot without interruption for long periods. Others take a more cautious approach, preferring to use several smaller-capacity cards, minimizing any potential loss of images due to card failure.

Storage Card Image Capacities						
File Type	**512 Mb**	**1 Gb**	**2 Gb**	**4 Gb**	**8 Gb**	**16 Gb**
6Mp RAW	65	130	260	520	1040	2080
6Mp JPEG	140	280	560	1120	2240	4480
10Mp RAW	30	60	120	240	480	960
10Mp JPEG	80	160	320	640	1280	2560

Goodheart-Willcox Publisher

Figure 8-16. Approximate image capacities of different size removable storage cards.

The number of images that fit on a card, as indicated by charts found in most camera manuals, are only an approximation. The actual size of an image, measured in megabytes, varies depending on its content, especially with the JPEG file format. A simple scene with a limited number of tones and details produces a smaller file than a complex scene with a wide range of tones and many details. See **Figure 8-17**.

Card Speed

A confusing issue for many photographers new to digital is *card speed*. Unlike film speeds, memory card speeds have nothing to do with exposure. Instead, card speeds are a measure of how rapidly image files can be transferred from your camera to the memory card.

A fast card is an advantage in situations, such as sports or news coverage, where images are being recorded quickly with little pause between exposures. The camera has a *buffer* (internal memory) that functions as a holding tank for image information that has been processed but not yet transferred to the memory card. Fast-paced shooting may feed image information into the buffer faster than it can be output to the card. If the buffer fills up, the camera does not allow another exposure to be made until buffer space is available.

Card speeds are expressed in "×" terms, based on 1× being equal to a transfer rate of 150 Kb per second. Higher numbers such as 80× or 256× indicate higher transfer speeds, **Figure 8-18**. For example, a card rated at 1000× would be able to accept a 6 Mb image file from the buffer in 1/25 second.

Lexar

Figure 8-18. Card speed is a measure of the rate at which data can be transferred to the card from the camera.

A fast card is not an advantage if your camera cannot write (send) information to the card at a high speed. The owner's manual for your camera should provide write speed information on its specifications page.

Traditional (Film) Image Capture

As described in Chapter 4, "film" in the mid-nineteenth century was a coated plate of glass that required cumbersome preparation and immediate exposure. This wet-plate collodion process was then replaced by dry plate photography, which allowed the photographer to use already prepared plates and delay exposure until it was convenient.

Jack Klasey/Goodheart-Willcox Publisher

Figure 8-17. File sizes become larger as the subject becomes more detailed and complex. A—This simple subject has only a few tones. File size is 1.57 Mb. B—This complex subject includes a wide variety of tones. File size is 3.12 Mb.

In 1888, George Eastman developed roll film. A 100-exposure roll of the gelatin-emulsion film was packaged in a simple "point-and-shoot" box. See **Figure 8-19**. The camera could be sent back to the company for developing and printing.

The Physical Structure of Film

Early films consisted simply of a layer of emulsion on a support material or base, but modern film structure is much more complex. Black-and-white film typically consists of five layers of material, and color film can have nine or more.

The base material used to support the emulsion has evolved through the years from metal, paper, and glass to modern plastics. For roll film, a flexible base material was needed. In 1889, Eastman began producing roll film with the emulsion applied to a base of flexible and durable cellulose nitrate (dried collodion), which was highly flammable. Cellulose nitrate was replaced in the 1920s by cellulose acetate, which is not flammable.

Black-and-White Film

While the base provides support, the critical layer in any film is the emulsion, a thin coat of clear gelatin in which silver halide crystals are suspended. The silver halide crystals are like the seeds in a poppy seed cake. Just as the seeds are separated and held in place by the cake, the crystals are supported by the gelatin.

As shown in **Figure 8-20**, a typical black-and-white film has three additional layers. The layer between the base and emulsion is called the *subbing layer.* This very thin layer, usually

composed of pure gelatin without silver halide crystals, helps bond the emulsion to the base.

The layer on the bottom of the film balances the curling tendency of the emulsion so the film stays relatively flat. This layer also serves as an *antihalation layer.* It prevents light rays that have passed through the base from being reflected back through the base and emulsion to forming halos (halation) around bright objects in the photograph.

The primary purpose of the very thin topmost layer, referred to as the *supercoat*, is to protect the emulsion from abrasion during exposure and processing. This layer may contain a number of additives, such as hardeners, antistatic agents, preservatives, and antifogging chemicals. A wetting agent, or surfactant, may be incorporated in the coating to help ensure even development.

Color Film

A subtractive color film, often referred to as an *integral tri-pack film*, has three separate emulsion layers, **Figure 8-21**. One is sensitive to

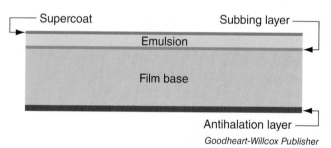

Goodheart-Willcox Publisher

Figure 8-20. Black-and-white film typically consists of five layers.

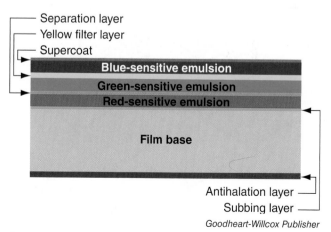

Goodheart-Willcox Publisher

Figure 8-21. Color film is more complex than black-and-white film.

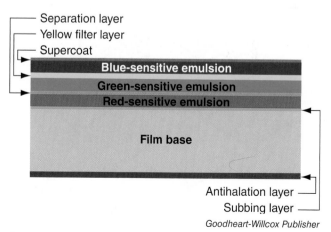

Eastman Kodak Company

Figure 8-19. The Kodak Brownie roll-film camera, introduced in 1888.

blue light, the second to green light, and the third to red light. A layer of yellow material separates the blue-sensitive and green-sensitive layers. This thin layer traps any blue light that has not been absorbed by the blue-sensitive emulsion. Sometimes, another thin layer of material separates the green-sensitive and red-sensitive emulsion layers.

An antihalation layer may be located on the bottom side of the film base or between the subbing layer and red-sensitive emulsion layer. In some film designs, antihalation material is used in both locations.

How Light Affects Film

As described in the preceding section, the film emulsion consists of light-sensitive silver halide crystals dispersed in a layer of gelatin. The effect of light on the crystals is determined by their shape and size and how densely they are packed in the gelatin layer.

Silver bromide is by far the largest halide used in photography. Crystals of silver bromide consist of pairs of silver and bromine atoms arranged in a lattice form, as shown in **Figure 8-22**. The silver and bromine atoms are *ions*, which means they carry an electrical charge. Each silver ion has one less orbiting electron than the number of protons in its nucleus, and thus has a positive

electrical charge. Each bromine atom has an extra electron, so it carries a negative charge. These opposing charges bond the pairs of ions together. In addition to the paired ions, a silver bromide crystal typically contains impurities referred to as *sensitivity specks*. These specks are believed to act as focal points, or sites, for the formation of the silver clumps making up the latent (undeveloped) photographic image.

Creation of a Latent Image

When a photon (particle of light), strikes one of the bromine ions in the silver bromide crystal, it increases the energy level of the extra electron in the ion. This allows that electron to break free. With the loss of one electron, the bromine atom becomes electrically neutral. This in turn creates a free silver ion, since there is no longer the positive-negative attraction holding the pair together. The sensitivity specks serve as gathering points for negatively charged electrons that have broken free of the bromine ions. These negatively charged electrons attract the positively charged free silver ions. As more light strikes the crystal, more electrons and silver ions are freed from the lattice to form clumps of silver metal on the sensitivity specks, **Figure 8-23**. These clumps make up the latent image, which becomes visible when developing chemicals are used to bring it out.

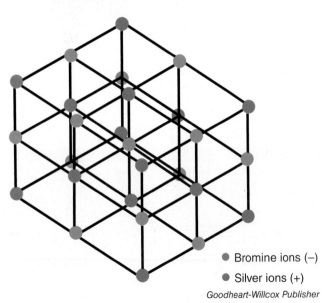

● Bromine ions (−)

● Silver ions (+)

Goodheart-Willcox Publisher

Figure 8-22. The opposite electrical charges of silver and bromine ions hold them together in pairs on the lattice of the silver bromide crystal.

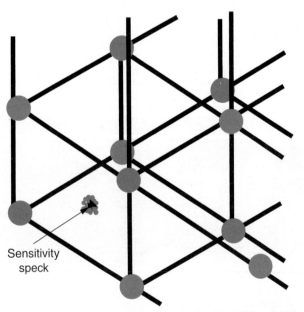

Sensitivity speck

Goodheart-Willcox Publisher

Figure 8-23. A latent image is formed by free silver ions gathering as clumps of silver around sensitivity specks.

Density Is Proportional to Light

Density is the darkness, or light-blocking ability, of the developed image. The density created on the film in any given area is proportional to the amount of light striking that area. For example, a deeply shadowed area of the subject will reflect only a small amount of light. When this tiny amount of light strikes the film, the latent image in that area consists of clumps of silver metal that are small and relatively far apart. In the developed negative, that area of the film exhibits very low density—it will be clear or very nearly so. The reverse is true of an area that has received light from a bright (highlight) part of the subject. That area of the negative will exhibit very high density, appearing black and opaque. Between these two extremes, varying densities are exhibited as different shades of gray. When the negative is printed, the values are reversed to reflect the actual scene. See **Figure 8-24**.

The Characteristic Curve

The buildup of density is not strictly proportional to the amount of light or exposure. If each increase in exposure generated a corresponding increase in density, the relationship shown on a graph would appear as a diagonal straight line. See **Figure 8-25A**.

In the real world of photography, however, exposure and density are not so neatly paired. The relationship between exposure and density increase is typically plotted in the S-shape shown in **Figure 8-25B**. This **characteristic curve** serves as a snapshot of a specific film's reaction to light. While the general shape of the curve remains the same, its details differ for each film.

The characteristic curve is traditionally divided into four major sections. The first section, *film base plus fog*, is short and horizontal. It represents the minimal amount of density resulting from the base material of the film plus a very small density increase caused by action of the developer.

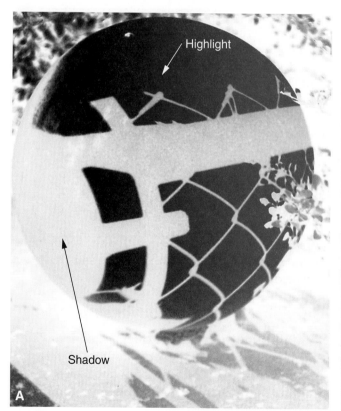
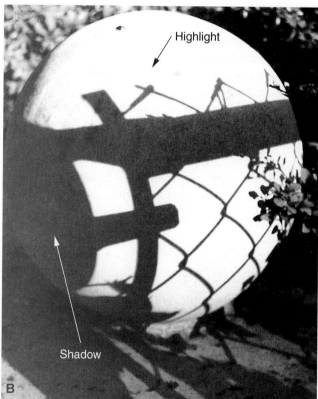

Jack Klasey/Goodheart-Willcox Publisher

Figure 8-24. Light and density. A—A small amount of light forms little silver, resulting in a virtually clear section of the negative, while a large amount of light creates a black area of high density. B—Low-density areas of the negative allow a large amount of light to pass, resulting in a dense black shadow area in the print. Very dense areas permit little or no light to pass, resulting in a white highlight area.

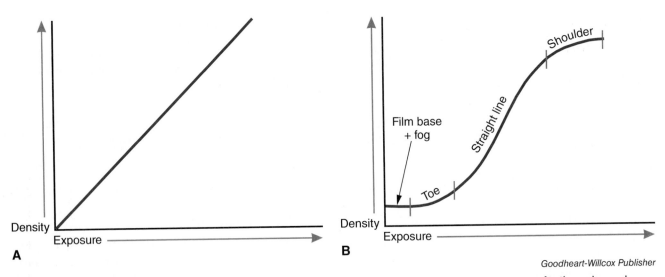

Goodheart-Willcox Publisher

Figure 8-25. Exposure/density relationship. A—If exposure increase and density increase were perfectly reciprocal, a straight-line graph could be plotted. B—The characteristic curve is a graphic representation of the exposure/density relationship for a specific film.

Typically, this is the density of the clear areas between frames on roll film.

In the *toe* section of the curve, the sharply curved line indicates that density is increasing at a faster rate than exposure. The toe is the low-density, or shadow, portion of the curve.

The density/exposure relationship is most nearly proportional in the *straight line,* or middle-density, section. In other words, each increase in exposure causes a corresponding and approximately equal increase in density. The steep slope shows that the contrast, or separation of tones, is greatest in this area— the steeper the slope, the higher the film's contrast.

In the *shoulder* portion of the curve, exposure changes make progressively less difference in density. This high-density portion of the curve represents the highlights of a scene.

Film Speed Ratings: A Measurement of Sensitivity

Film speed is a measure of sensitivity to light— the higher the number, the less light is needed to create a latent image. Thus, a 100-speed film is much less sensitive to light than a 3200-speed film.

A film's official speed rating is properly referred to by preceding the number with ISO, such as ISO 400. This indicates that the rating was established using standards set by the International Standards Organization.

Although the standard ISO film speeds are calculated in increments of 1/3 stop, **Figure 8-26,**

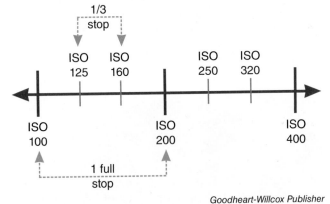

Goodheart-Willcox Publisher

Figure 8-26. ISO film speed relationships.

commonly available film speeds represent differences of one stop in exposure. Each of the popular film speeds—100, 200, 400, 800— represents a sensitivity to light that is double that of the next lower speed and half the sensitivity of the next higher speed.

Film Speed/Grain Relationship

Film emulsions can be categorized into four speed groups. Although some authors select different points for dividing the categories, the traditional divisions are as follows:

- **Low.** ISO 50 or below.
- **Medium.** ISO 64 to ISO 200.
- **High.** ISO 250 to ISO 640.
- **Very high.** ISO 800 and above.

As film speed increases, so does grain (the clumps of metallic silver visible on the film or print). Traditionally, low speed has implied fine, virtually invisible grain, while high speed meant grain that was distinctly noticeable. The speed/grain relationship results from the traditional method of increasing film speed by making the silver grain larger. A physically larger silver grain presents more surface area to be affected by light, and thus makes the emulsion more light-sensitive. When the film is developed, these larger grains also form bigger, more easily seen clumps of metallic silver than the finer grains of slow films.

Film size also affects the visibility of grain—the larger the film, the smaller the relative size of the grain. Although the clumps of silver metal are the same physical size on a 35 mm negative and on a 4″ × 5″ negative, the size of a silver clump relative to the film size is far different. This is most noticeable when the image on the film is enlarged, since the smaller negative must be magnified more than a large negative for a given size print. See **Figure 8-27**.

Film Types, Forms, and Sizes

The rapid growth of digital photography has greatly reduced the use of film. The largest segment of the film market continues to be 35 mm color negative film, and the smallest is large format sheet film.

All film can be classified as reversal (transparency), negative/positive (print), or instant-print. *Reversal film* produces a positive image on a transparent base. *Negative/positive film* produces a negative, or reversed, image on a transparent base. That negative can be used to create a positive image, usually in the form of a paper-based print. *Instant-print film*, as the name indicates, results in a print.

Reversal Film

The transparency produced by reversal film is an original, or first generation, image, **Figure 8-28**. If correctly developed, a transparency shows precisely the exposure selected by the photographer or automated camera system. This makes it valuable for assessing technique, since overexposure or underexposure by as little as 1/3 stop can be detected. Reversal films are available in both color and black-and-white, with color film accounting for the vast majority of sales.

Negative/Positive Films

Film that yields snapshots or positive prints that can be readily viewed and shared with others is negative/positive film, commonly called

8″ × 10″ 8″ × 10″

2X 8X

4″ × 5″ 35 mm (24 mm × 36 mm)

Goodheart-Willcox Publisher

Figure 8-27. To make an 8″ × 10″ print, a 4″ × 5″ negative must be enlarged only twice actual size, but a 35 mm negative must be magnified about eight times. Grain is enlarged proportionally.

Jack Klasey/Goodheart-Willcox Publisher

Figure 8-28. Reversal film provides a positive transparent image, or transparency.

"print film." The overwhelming majority of film manufactured worldwide is negative/positive film. It is popular for a number of reasons:

- Virtually universal availability.
- Wide range of film speeds in most formats.
- Acceptable exposure under most lighting conditions.
- Rapid and easily accessible processing.
- Ease of handling and displaying prints.
- Fast, simple, and relatively low-cost production of multiple copies.

Until the early 2000s, camera design and processing methods and equipment were optimized for the use of negative/positive color film. Today, digital photography is the dominant force in the consumer market. Most retail film processing locations now emphasize the making of prints from digital files. See **Figure 8-29**.

Print films produce a negative original that is then used to make a positive print. In a negative, light tones in the scene record as dark areas on the negative and vice versa. When a print is made from the negative, tones are reversed again, back to the relationship they had in the original scene. See **Figure 8-30**. Color negatives are harder to "read" directly than black-and-white negatives when making judgments on exposure, since they display subtractive primary colors and have an overall orange dye mask that is used to properly balance colors in printing. See **Figure 8-31**.

Jack Klasey/Goodheart-Willcox Publisher

Figure 8-30. In the negative/positive process, the original is a negative, which is used to produce a positive print.

Walgreen Company

Figure 8-29. One-hour processing labs for both film and digital images are located in many retail centers.

Jack Klasey/Goodheart-Willcox Publisher

Figure 8-31. A color film negative displays the subtractive primary colors (cyan, magenta, and yellow).

Instant-Print Films

This category of films was introduced in 1947 by Dr. Edwin H. Land, inventor of the Polaroid® process. In its original black-and-white form, Polaroid instant-print film provided a developed print in approximately one minute. In the 1960s, color print film was introduced.

Traditional Polaroid films fell victim to the growth of digital photography and were discontinued in 2008. Instant-print films manufactured by Fuji are available, however. In early 2015, Polaroid introduced a new digital instant-print camera, **Figure 8-32**. The camera includes a built-in printer that produces dye-based 2″ × 3″ color prints. Because it has the same Android™ operating system found in cell phones, the camera can also be used to send images to a remote printer or upload them to social media.

Forms of Film

Film is available in four basic forms—cassettes, drop-in cartridges, paper-backed rolls, and sheets. Coated glass plates are still made for specialized applications, such as astrophotography, that require an extremely stable base material.

Figure 8-32. The Polaroid Socialmatic digital camera can produce small color prints or send files to social media.

Film in Cassettes

The most popular film-packaging method is the cassette, a light-tight metal or plastic container holding a long strip of film. Typically, the film is pulled out of the cassette as it is exposed, one frame at a time, and then rewound into the cassette to protect it until it is processed.

Although the cassette form of packaging is used by both 35 mm and APS (Advanced Photo System) film, **Figure 8-33**, the digital camera has made APS virtually obsolete. A few APS cameras are still on the market, but film is available in limited speeds and types and is becoming difficult to find. APS and 35 mm cassettes are similar, but not interchangeable.

The 35 mm cassette, usually made of metal, is cylindrical in shape and holds a strip of film 35 mm wide by up to 5 1/2′ (36 frames plus leader) in length. The film is removed from the cassette for processing, and then cut into individual slides (reversal film) or short strips of several negatives for ease of storage. The empty cassette is typically discarded.

Cartridge Film

Drop-in cartridge film is almost obsolete. The 126-size film cartridge was introduced in 1963 for use in Kodak's Instamatic® line of cameras. Later, the smaller 110-size film cartridge was developed for use in small Pocket Instamatic cameras. Cartridges for the 126-size film are no longer sold in stores, while the 110-size cartridges are available only in a few color print films and a narrow range of film speeds.

Jack Klasey/Goodheart-Willcox Publisher

Figure 8-33. Cassettes for APS (left) and 35 mm film.

Roll Film

Paper-backed roll film is now sold almost exclusively in the 120 size for use in medium format cameras. This film is 2 1/4″ in width and approximately 2 1/2′ long. A paper backing is attached to the film for protection and economy (no film is wasted as exposed leader). See **Figure 8-34**.

Medium format cameras using 120 roll film yield one of four common negative sizes. A roll of film provides 15 exposures in the 6 cm × 4.5 cm format, 12 exposures in the square 6 cm × 6 cm (2 1/4″ × 2 1/4″) format, 10 exposures in the 6 cm × 7 cm format, or 8 exposures in the 6 cm × 9 cm format.

Sheet Film

Sheet film is on a somewhat heavier, stiffer base than roll or cassette films, since its larger area must remain flat during exposure. A number of film speeds and types are available. The most common sheet sizes are 4″ × 5″, 5″ × 7″, and 8″ × 10″. The selection becomes more restricted for smaller and larger size sheets. Packaging of sheet films is typically in boxes of 10, 25, 50, or 100, **Figure 8-35**.

Loading 35 mm Cassettes

Some photographers, especially those who process their own film, prefer to load their own film cassettes rather than buying factory-loaded film. The major advantage is flexibility—the photographer is not restricted to the standard 24 or 36 exposures per roll. Although as many frames as desired can be loaded, approximately 40 is a practical upper limit because of the physical size of the cassette. Many photographers like to load a number of short rolls containing from 5 to 15 frames for testing, experimenting, or use in situations where only a few exposures are needed. Another advantage is cost, since buying film in 50′ or 100′ bulk rolls and loading reusable cassettes can significantly reduce the cost per cassette.

Film loading does require time and some investment in equipment and supplies, however. You will need a *film loader*, a light-tight device that holds the roll of bulk film and allows a desired number of frames of film to be wound into a cassette, and a number of reusable cassettes. You will also need tape, scissors, labels, and a pen or marker. See **Figure 8-36**.

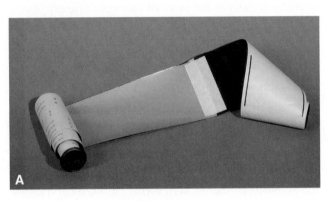

6 cm × 4.5 cm 6 cm × 7 cm

6 cm × 6 cm 6 cm × 9 cm

B

Jack Klasey/Goodheart-Willcox Publisher

Figure 8-34. Roll film. A—The strip of film is attached to a paper backing for protection and economy. B—Four common negative sizes used in medium format roll-film cameras.

Jack Klasey/Goodheart-Willcox Publisher

Figure 8-35. Sheet film.

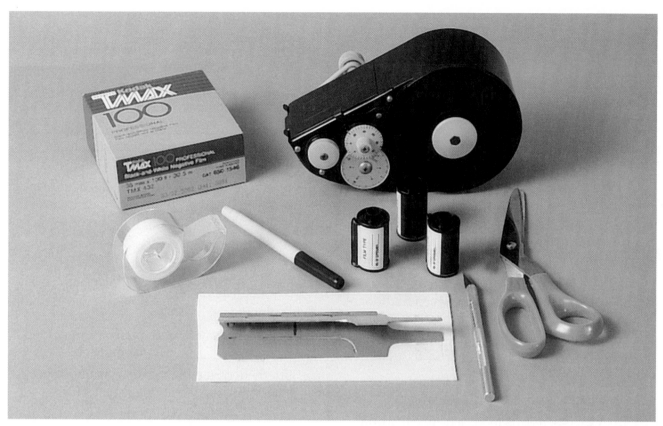

Figure 8-36. Loading your own film cassettes, using the tools and supplies shown, can be convenient and can reduce film costs somewhat.

Reusable cassettes should be discarded after being loaded three times to avoid the possibility of light leaks or scratches from foreign matter. Some people obtain emptied cassettes at no cost from one-hour film processors. The method the processor uses to unload the cassettes leaves a short stub of film extending through the light trap. Bulk film can be taped to this stub and wound into the cassette in the same way as reusable cassettes. These cassettes are discarded after a single use.

Check Your Photography IQ

Now that you have finished this chapter, see what you learned by taking the chapter posttest.

www.g-wlearning.com/visualtechnology/

Review Questions

Answer the following questions using the information provided in this chapter.

1. Where do the similarities between traditional and digital image capture end?

2. Which of the following statements about image sensors is *false*?

 A. A CMOS sensor is more expensive to manufacture than a CCD sensor.

 B. A CCD sensor is more sensitive to lower light levels than a CMOS sensor.

 C. A CMOS sensor drains the camera battery more quickly than a CCD sensor.

 D. A CCD sensor generates less digital noise than a CMOS sensor.

3. An 8-bit pixel can distinguish _____ shades of gray.

4. Human vision is most sensitive to the _____ wavelengths of light.

 A. blue

 B. red

 C. yellow

 D. green

5. An APS-C size sensor in a digital camera is approximately _____ in size.

 A. 24 mm × 16 mm

 B. 24 mm × 20 mm

 C. 30 mm × 17 mm

 D. 36 mm × 24 mm

6. The higher the resolution setting of a digital camera, the _____ the image file size will be.

7. The _____ file format is used to compress files to a smaller size.

8. _____ memory cards are used in compact, advanced compact, and some SLR cameras.

9. Photography first achieved wide acceptance when the _____ camera was introduced, providing ease of use.

10. Which of the following prevents light from being reflected back through the film base and emulsion?

 A. Subbing layer

 B. Emulsion

 C. Antihalation layer

 D. Supercoat

11. Color film may have as many as nine layers, including _____ separate emulsion layers.

12. Briefly describe the role of sensitivity specks in forming the latent image on film.

13. The _____ of any part of the image on the film is proportional to the amount of light striking that area at the time of exposure.

14. The _____ portion of the characteristic curve represents the low-density, or shadow, values.

 A. film base plus fog

 B. toe

 C. straight line

 D. shoulder

15. A film's rated speed is a measure of its _____ to light.

16. Film rated at ISO 800 is _____ times faster than a film rated at ISO 100.

 A. two

 B. four

 C. six

 D. eight

17. Why is grain likely to be less noticeable in enlargements made from a 4″ × 5″ negative than one made from a 35 mm negative?

18. Which type of film is the best choice to make exposure tests? Why?

19. Which of the following is *not* an advantage of the negative/positive system?

 A. Ease of "reading" negatives to assess exposure.

 B. Ability to rapidly produce multiple prints.

 C. First-generation sharpness and contrast.

 D. Widely available, fast processing.

20. The strip of 35 mm film in 36-exposure cassette is approximately _____' in length.

21. Medium format cameras producing the popular 6 cm × 4.5 cm format can make _____ exposures on a roll of 120 size film.

 A. 8

 B. 10

 C. 12

 D. 15

Suggested Activities

1. Visit at least three different types of stores in your area that sell color print film. Make a chart showing of the film speeds (ISOs) offered at each store. If the store sells more than one brand of color print film, list the film speeds available for each brand.

2. On a sheet of poster board, draw a cross-section view showing the different layers of color film. Use Figure 8-21 for reference. In an oral presentation to the class, describe the function of each of the layers.

Critical Thinking

1. If you were developing a new camera model intended for first-time camera users, would you use a CCD sensor or a CMOS sensor? Why?

2. You are buying storage media for a two-week vacation to photograph African wildlife. Would you buy several very-high-capacity cards or a number of smaller-capacity cards that would provide the same total amount of storage? Explain your reasoning.

Communicating about Photography

1. **Speaking and Listening.** Divide into groups of four or five students. Each group should choose one of the following topics: file formats, image sensors, removal storage devices, or film types. Using your textbook as a starting point, research your topic and prepare a report on the different capabilities of the items within the topic. As a group, deliver your presentation to the rest of the class. Take notes while other students give their reports. Ask questions about any details that you would like clarified.

2. **Speaking and Writing.** Prepare a written or oral report comparing and contrasting the different types of file formats.

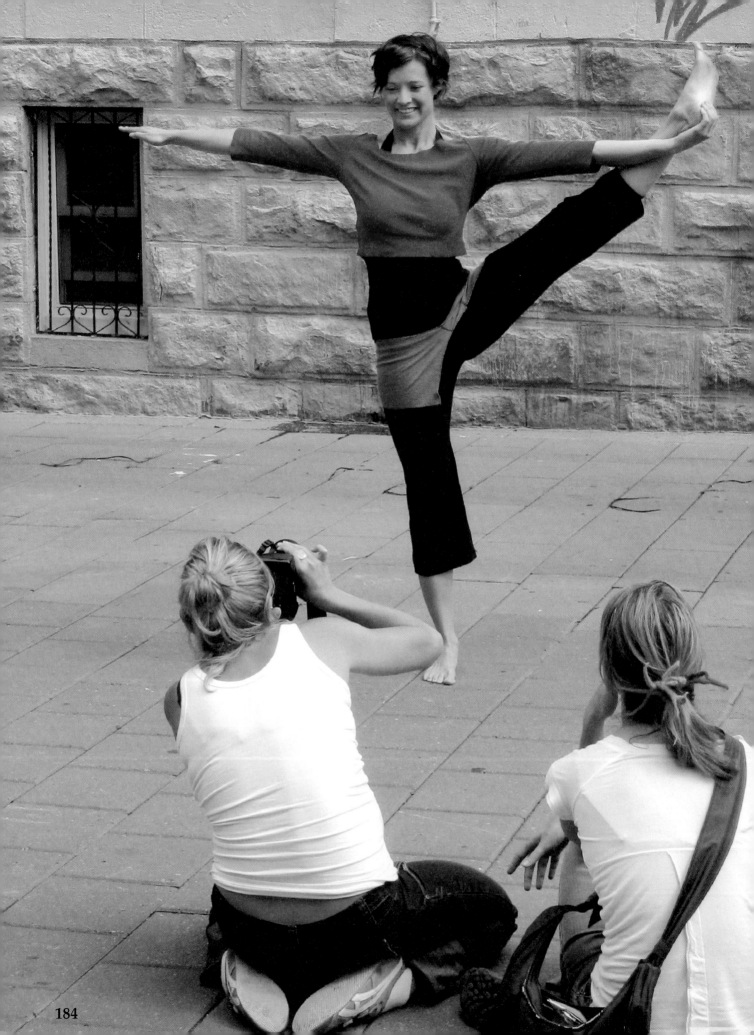

Section 2

Shooting

Chapter 9 Making a Picture

Chapter 10 Making Exposure Decisions

Chapter 11 Action and Event Photography

Chapter 12 Outdoor Photography

Chapter 13 Travel Photography

Chapter 14 Portrait and Studio Photography

Jack Klasey/Goodheart-Willcox Publisher

Camera angle: Point of view (such as a high or low angle) chosen for its effect on a picture's composition and visual impact.

While studying this chapter, look for the activity icon ➦ **to:**

- **Assess** your knowledge with self-check pretest and posttest.
- **Practice** vocabulary terms with e-flash cards and matching activities.
- **Reinforce** what you learn by submitting end-of-chapter questions.

G-WLEARNING.com

www.g-wlearning.com/visualtechnology/

Jack Klasey/Goodheart-Willcox Publisher

Making a Picture

Objectives

When you have finished reading this chapter, you will be able to:

- Understand the difference between "taking a picture" and "making a picture."
- Recall the six basic elements of composition.
- Use compositional techniques to focus viewer attention.
- Explain how the rule of thirds is used in composing a photograph.
- Describe techniques that can be used while shooting to create interesting visual effects in photographs.

Check Your Photography IQ 📲

Before you read this chapter, assess your current understanding of the chapter content by taking the chapter pretest.

www.g-wlearning.com/visualtechnology/

Technical Terms 📲

camera angle	leading lines
center of interest	line
compositional elements	negative space
contrast	panning
convergence	pattern
depth-of-field preview	point
emphasis	portrait mode
exclusion	rhythm
extracting	rule of thirds
formal balance	selective focus
frame	shape
inclusion	viewpoint
informal balance	visualization
landscape mode	zooming

For a visual artist, especially a photographer, being said to have "a good eye" is high praise. Such a person looks at a scene or a subject in a way quite different from a nonartist. Being aware of the relationship of masses and colors, the emotional content of the scene, the interplay of light and shadow, the meaning that goes beyond the obvious and readily apparent, are among the many elements of seeing photographically.

Subjects are all around us. Which ones we select to photograph depends on many factors, but the first is personal interest. We must recognize the person, place, or thing as a possible subject, and then decide that we want to photograph it.

"Taking" a Picture vs. "Making" a Picture

The commonly used term for photographic activity is *taking a picture*. This implies a simple recording of what is in front of the camera. The vast majority of all photographs that are taken are casual snapshots. These images are simple record shots of places visited, children's activities, and family events.

More serious photographers often use the term *making a picture*, which implies conscious control of the process and the final result. Instead of merely recording what appears in the viewfinder, these photographers make choices, applying the elements and principles of art to affect what the viewer of the final image sees. For example, a photographer visiting the local farmer's market might first envision a photo of shoppers examining fresh cantaloupes. Looking a bit more closely at the subject, the photographer might decide to make an image depicting the melons' shape and texture instead. See **Figure 9-1**.

To control how the finished image appears to the viewer, the photographer must first see the desired final result in his or her own mind. A formal term for this

Jack Klasey/Goodheart-Willcox Publisher

Figure 9-1. Taking a picture versus making a picture. A—This photo of shoppers at a farmer's market, taken from standing eye level, is a competent but unexciting shot. B—To make a more interesting image, the photographer moved in closer to fill the frame, selected a different angle, and carefully exposed to bring out texture and shadow detail.

process is *visualization*. As Ansel Adams described it in his book, *The Camera*: "To visualize an image … is to see it clearly in the mind prior to exposure, a continuous projection from composing the image through the final print."

Selecting the Viewpoint

To capture a visualized image, a photographer must make a series of choices. The most basic decision is selecting the subject and determining how you want to portray it. For example, an abandoned building, such as an old factory, farm structure, church, or rural schoolhouse, could be shown in many different ways.

In **Figure 9-2**, each of the old church images involves a different *viewpoint*—the distance and angle from which the camera (and eventually, the viewer) sees the subject. **Figure 9-2A** and **Figure 9-2B** are basically eye-level exterior views from some distance away. These images show the entire structure. The pattern shot, **Figure 9-2C**, could be made from almost any distance, depending on the lens used, but includes only

Jack Klasey/Goodheart-Willcox Publisher

Figure 9-2. An abandoned building, such as this old brick church, can be portrayed in many different ways. A—A traditional three-quarters architectural view. B—In this wider environmental view, the church ruin is a focal point. C—Repetitive arch shapes form a pattern. D—Worn brick, weathered remnants of plaster, and encroaching plants provide rich texture to an interior wall. E—The church interior, open to the elements, is a portrait of abandonment.

part of the building. Texture studies are often close-up views that show an even smaller part of the subject, **Figure 9-2D**. **Figure 9-2E** is an interior view portraying the roofless, abandoned nature of the building. The interior could be shown from a number of viewpoints—wide-angle, normal, or telephoto; eye-level, low angle, or high angle.

Often a picture is taken from the first possible viewpoint the photographer encounters, typically resulting in an eye-level shot that may be competent, but probably is not very exciting. Photographers who want to make a picture, instead of merely taking one, move around the subject to see it from as many sides and distances as practical. They also try to visualize the result of shooting from a high-angle or low-angle.

Two other factors that affect the choice of viewpoint are the light and the background. The strength and direction of light can make a major difference in the impact of an image. In **Figure 9-3**,

the interplay of the angled shadows with the opposing diagonal lines of the fire escape provide a dramatic statement that would be absent on a cloudy day. The viewpoint—looking upward at an angle—also creates a much different composition from a straight-on shot.

What appears in your photo behind and around the subject must be taken into account. If you want to show a young couple pitching their tent in a peaceful natural setting, the viewpoint should not include a nearby line of electrical transmission towers or a factory smokestack. On the other hand, a portrait of a successful young architect might be quite effective when shot against the busy background of a construction site.

Composition Considerations

The way that you compose your photograph—how you arrange, or lay out, the relative positions and sizes of the different elements—strongly influences the message the viewer will receive. Assume that you have a half-dozen identically sized balls and want to convey to the viewer that one of these is more important than the other five. **Figure 9-4** illustrates four compositional techniques that achieve this objective:

- Place one of the balls nearer the camera, so it appears larger.
- Sharply focus on one ball and leave the others in soft focus.
- Paint one of the balls a strongly contrasting color.
- Isolate one ball from the others.

These are only a few of the many compositional techniques that experienced photographers use regularly. All techniques for composing photographs make use of a limited number of *compositional elements*. As visual artists, both painters and photographers make use of these same elements. Painters can freely add, subtract, and rearrange the elements within the picture. Photographers, however, are bound by physical limitations of the scene. They must use careful framing, changes of angle, selective focus, and other techniques to achieve the desired composition, or layout, of the final photograph.

Jack Klasey/Goodheart-Willcox Publisher

Figure 9-3. Directional light and shooting upward at an angle strengthen this composition.

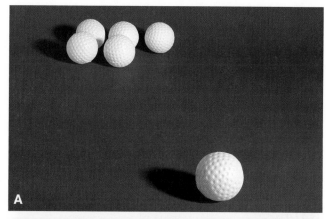
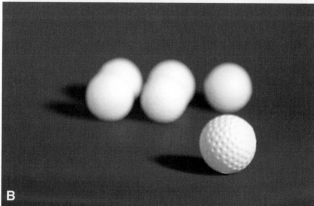
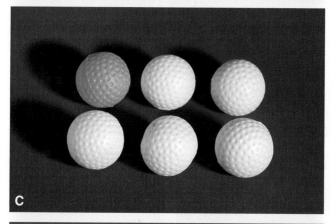

Figure 9-4. Compositional techniques. A—Apparent size. B—Focus. C—Color. D—Isolation.

Elements of Composition

Various sources list different numbers of and names for the basic elements of composition. These six include the important topics:

- Point
- Line
- Shape or pattern
- Balance
- Emphasis
- Contrast

Point

A ***point*** is a single object, typically small in size that attracts the eye. It may serve as the center of interest in a composition, or it may be a distraction that pulls the eye away from a more important object. See **Figure 9-5**.

Figure 9-5. Point as a compositional element. A—In this photo, the small bright spot (the baseball) is the center of interest, drawing the viewer's eye to the desired area of the photograph. B—The small bright area in this photo, a discarded soda can, draws the eye away from the intended center of interest.

Line

A *line* is a "stretched point." It typically draws the viewer's eye along its length, making it a useful tool for directing attention. The orientation and shape of a line can convey certain impressions. Straight horizontal or vertical lines are static, whereas diagonal lines imply motion. Gently curved lines are considered placid and restful, while sharply curved or bent lines, as well as broken lines, convey energy or strong movement. See **Figure 9-6**.

Shape or Pattern

The *shape* of an individual object and the *pattern* made by multiple objects are strong compositional elements. A shape may appear to be flat and two-dimensional, exhibiting only the properties of length and width. Light falling on an object creates shadows or tonal variations, adding a third dimension, the property of depth. See **Figure 9-7**. A pattern may consist of repetition of identical shapes or may have elements alternating or varying in shape, size, or color. Repeated shapes or lines establish a *rhythm* that moves the eye through the frame, **Figure 9-8**.

Balance

Overall arrangement of elements within the frame determines the compositional balance.

Jack Klasey/Goodheart-Willcox Publisher

Figure 9-6. Lines as compositional elements. A—Vertical lines, like those of this war memorial sculpture, are static. B—Horizontal lines are stable and restful. C—Diagonal lines, such as these bridge girders, give a sense of action and movement. D—Gentle curves, like the *S* shape of this shoreline, are placid and restful-feeling. E—Sharply curved or broken lines are energetic and have a strong feeling of movement.

Jack Klasey/Goodheart-Willcox Publisher

Figure 9-7. Shape as a compositional element. A—The silhouetted church spires are two-dimensional shapes. B—Light falling on the spires creates a three-dimensional appearance through tonal variation (light and shadow).

Jack Klasey/Goodheart-Willcox Publisher

Figure 9-8. Rhythm as a compositional device is established when a repeated shape or line leads the eye through the frame. A—Repeated arches and statues. B—Curving rows of theater seating.

Figure 9-9. Balance as a compositional element. A—Formal balance. B—Informal balance.

The balance may be symmetrical (formal), or asymmetrical (informal), **Figure 9-9**. A composition that exhibits *formal balance* consists of matched halves—dividing the frame vertically or horizontally in the middle produces two mirror images. A common metaphor for formal balance is a seesaw with riders of equal weight at equal distances from the center balance point. *Informal balance* provides a feeling of visual balance without the mirror image effect. Using the seesaw example again, informal balance involves riders of different weights, with the larger of the two positioned closer to the balance point and the smaller rider farther from the balance point. In a photograph, informal balance may be achieved by the relative positions of two objects of different sizes or by using a smaller, brightly-colored object to balance a larger

dark object. Sometimes, a single large object may be balanced by several smaller objects.

Emphasis

Emphasis is used to make some element of a picture stand out and capture the viewer's attention. By emphasizing a single element of the photo, you are making that element dominant and creating a *center of interest* to which all the other elements of the picture relate. Without a center of interest, or with more than one emphasized element, the photo does not send a clear message to the viewer. An old design maxim, "all emphasis is no emphasis," is illustrated in **Figure 9-10**. When every element of the photo is given equal weight, nothing stands out because the viewer receives no guidance.

Figure 9-10. Emphasis. A—With all objects equally emphasized, the viewer does not know where to look. B—Emphasizing one element provides a center of interest to guide the viewer.

Contrast

Although it is a compositional element in itself, **contrast** is often employed to provide emphasis. Contrast is a noticeable difference between adjacent elements of a composition, **Figure 9-11**. These include light and shadow, large and small size, dark and light (or saturated and muted) colors, smooth and rough textures, curved and straight-edged shapes, and sharp and unsharp (soft) focus.

Inclusion and Exclusion in Composition

Inclusion and *exclusion* are important concepts in composition. By selective framing, you decide what to keep in the frame (inclusion) and what to keep out (exclusion). Sometimes referred to as *cropping in the camera*, selective framing produces the picture you visualized, without any extraneous elements. Depending on the situation, this may be accomplished through choice of lens (focal length), by changing angle of view, or by moving toward or away from the subject. Frequently, all three techniques may be necessary to frame the photo as you desire.

Moving in closer usually helps you make a better picture. Think of the boring vacation photos you have seen, like the one in which Aunt Mavis—that tiny speck in the center of the frame—is shown at the rim of the Grand Canyon. Now think of the improved photo that would have resulted if Uncle Fred had moved in close enough so you could see Aunt Mavis's features and make out some of the details of the canyon behind her.

As you compose your picture, check all the edges of the frame for distracting or unwanted elements, **Figure 9-12**. It is easy to focus your attention on placement of the main subject or the

Jack Klasey/Goodheart-Willcox Publisher

Figure 9-11. This image illustrates two types of contrast—shape and color. It is also an example of formal balance.

Jack Klasey/Goodheart-Willcox Publisher

Figure 9-12. The table legs in the upper-right corner draw attention away from the main subject. Eliminate them by recomposing the shot before pressing the shutter.

major elements of the composition and overlook something that is at the edge of the frame. Make it a habit, before pressing the shutter release, to check the frame edges. If you find a problem, remove the distracting item if possible, or recompose to avoid it.

Also check for the problem of *convergence*, where parts of the image come together in an undesirable way. A classic example of convergence is the flagpole or tree that appears to be growing out of your subject's head. Other objects can create sometimes humorous results, **Figure 9-13**.

Seeing Pictures within the Picture

Images often contain a few, or even many, other potential images. Learning to see these pictures within a picture, **Figure 9-14**, helps you make better-composed and more interesting photographs. With practice, you will look at a given scene and immediately begin to identify portions of that scene that could stand alone as individual shots.

Photosebia

Figure 9-13. Convergence can be unintentionally funny, but most often it merely ruins the photo.

Identifying and *extracting* (pulling out) individual images from a larger scene is most easily done with the aid of a zoom lens. While remaining in one spot, you can frame a possible image and then make necessary adjustments for good composition. If you are using a camera with a fixed focal length lens, you can still extract images from a larger scene by using the "two-legged zoom"—walking toward the subject until it is satisfactorily framed.

Choosing Vertical or Horizontal Framing

Unless you are using a medium format film camera that produces 2 1/4″ × 2 1/4 ″ (6 cm × 6 cm) square negatives, or displaying your photos in the square format required by Instagram, your images will be either horizontal rectangles (*landscape mode*) or vertical rectangles (*portrait mode*). The frame ratio for 35 mm film cameras and many digital cameras is 2:3 (in landscape mode, two units high by three wide). Some digital cameras also offer an image in a 3:4 ratio. The difference in ratios affects print proportions. A 2:3 ratio produces a standard 4″ × 6″ print using the full frame, while a 3:4 ratio yields a 4 1/2″ × 6″ image.

Certain subjects are obviously suited to either horizontal or vertical rectangular shapes, **Figure 9-15**. Common subjects for the horizontal rectangle are street scenes, houses or industrial buildings, and group pictures. Vertical rectangles work well with such subjects as individual people, tall buildings, isolated flowers or trees, church steeples, and statues.

When framing your subject, explore the possibilities by viewing both horizontal and vertical formats, possibly changing focal lengths as well to achieve a particular composition. See **Figure 9-16**. Professionals shooting for magazines strive to capture at least one striking vertical composition, since that format is required for selection as a cover image.

Using the Rule of Thirds

Good composition should be almost instinctive, since we live in a society that surrounds us with well-composed images. Unconsciously, we are disturbed by a poorly-composed image and pleased by a well-composed one.

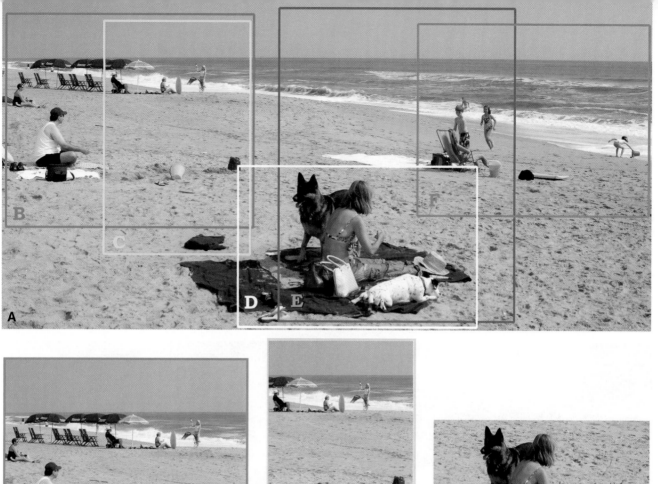

Figure 9-14. Finding pictures within a picture. A—This beach scene contains many possible compositions that could be extracted. Five have been identified. B—Horizontal framing with near and distant subjects relaxing on the beach. C—A vertical scene with a family in background and colorful foreground objects. D—A sunbather and her dogs isolated as a horizontal composition. E—The sunbather as foreground with children playing in the background. F—A horizontal view featuring the children.

Jack Klasey/Goodheart-Willcox Publisher

Figure 9-15. Horizontal and vertical framing. A—The horizontal format was a natural choice for this Quebec City scene. B—The vertical format is ideal for portraying this food vendor at a street fair.

Jack Klasey/Goodheart-Willcox Publisher

Figure 9-16. Different formats. A—Horizontal composition. B—The same subject composed as a vertical.

The basis of any photographic composition is the *frame*. Like a painter's canvas, the frame is the working space within which the picture is composed. All the compositional elements are employed in relation to the frame.

For example, a center of interest can be placed anywhere within the frame, but some locations are more effective than others. As a general practice, placing the center of interest in the physical center of the frame is considered rather static and boring, while placement elsewhere in the frame is usually more interesting visually.

A well-known compositional device is the *rule of thirds*, a tic-tac-toe grid that divides the frame into thirds, **Figure 9-17**. The intersections created by the crossing lines are considered the most effective spots to position the center of interest. By mentally imposing these lines in your camera viewfinder, you can see the effects of different placement.

The compositional tool known as *negative space* is the area within the frame surrounding the subject. Properly used, negative space isolates and emphasizes the subject. The simplest example of negative space is a silhouetted subject, like the one shown in **Figure 9-7A**, but negative space may be any subdued background, such as the brick sidewalk in **Figure 9-17**, that helps the subject stand out.

The rule of thirds is a useful guide when your photo includes the horizon or another dominant horizontal or vertical line (such as a desert roadway or a lighthouse). Placing the horizon on or close to the top or bottom

Jack Klasey/Goodheart-Willcox Publisher

Figure 9-17. Placing your center of interest at or near one of the four points where grid lines cross will make a more interesting composition than centering the subject.

guidelines of the grid will make for a much more interesting photo than positioning it across the middle of the frame. See **Figure 9-18**.

High Horizon

Low Horizon

Jack Klasey/Goodheart-Willcox Publisher

Figure 9-18. Placing the horizon on or near one of the grid lines will result in a more effective photo.

Focusing Viewer Attention

Many different means can be used to direct the viewer's attention within a photograph. Various forms of emphasis have already been covered. You can also focus the attention of the viewer by using leading lines, different camera angles, or the elements of color, shape, and size.

Using Leading Lines

A commonly used method of directing attention is the use of *leading lines*. These pictorial elements draw the viewer's eye from one area of the photo to another, **Figure 9-19**. In an outdoor scene, a leading line might be a fence, a road, a railroad track, or even a fallen tree. In a portrait, the line of the subject's arm, **Figure 9-20**, a shadowed fold in clothing, or an object in the environment surrounding the

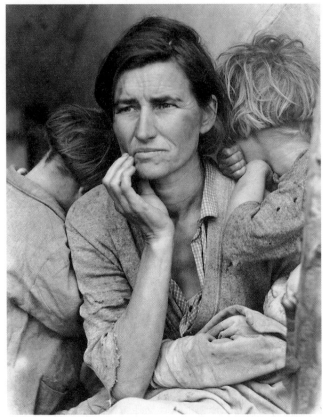

Courtesy of the Library of Congress

Figure 9-20. The woman's arm leads the eye to her face in this classic portrait titled *Migrant Mother*, taken by Dorothea Lange in 1936. It was one of a series of photos depicting the plight of migrant farm families during the Great Depression.

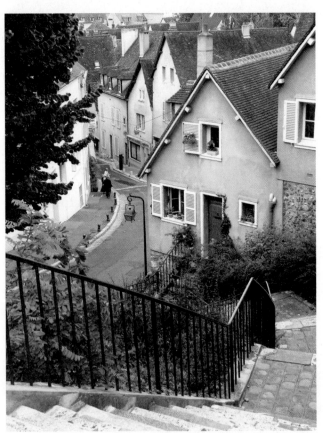

Jack Klasey/Goodheart-Willcox Publisher

Figure 9-19. Leading lines direct the viewer's attention. The railing of the stairway leads the eye to the house and then to the curving street in the quaint village of Chartres, France.

person can serve to lead the eye as intended by the photographer.

Try to avoid compositions that direct the viewer's attention out of the frame. This is most often a problem when photographing people or moving objects. If possible, provide some additional room on the side of the frame toward which the subject is looking or moving, **Figure 9-21**. This keeps the viewer's attention within the frame.

You can also have a "frame within the frame" by using a foreground object or shape to partly or fully surround your main subject. This technique directs attention into the frame, focusing it in the main subject and gives the picture a sense of depth. Although the use of an overhanging tree branch or a building archway as a frame has become a visual cliché, the concept of the frame is still valid and useful. See **Figure 9-22**.

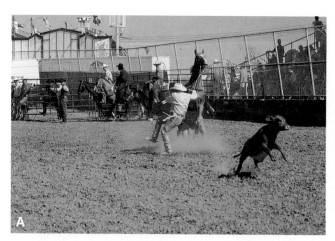

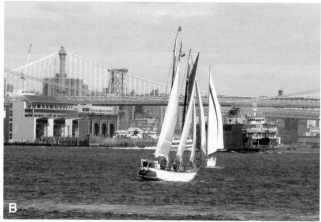

Jack Klasey/Goodheart-Willcox Publisher

Figure 9-21. Controlling viewer attention. A—A moving object can lead the eye out of the picture. B—Provide some space between the object(s) and the frame edge to hold attention within the frame.

Jack Klasey/Goodheart-Willcox Publisher

Figure 9-22. A statue depicting George Washington meeting the Seneca Chief Guyasota frames a view of the Allegheny River bridges in downtown Pittsburgh.

Using Camera Angles

Changing your *camera angle*, or point of view, can have a dramatic effect on the picture's composition and visual impact. See **Figure 9-23**. An innovative way of photographing a field of flowers, for example, is to lie on your back and shoot upward through blossoms that are backlighted by the sky.

Jack Klasey/Goodheart-Willcox Publisher

Figure 9-23. Using camera angle to focus the viewer's attention. A—A high-angle shot taken from the first platform of the Eiffel tower. B—This low-angle view emphasizes the movement of these bicycle racers.

Alternatively, you could stand on a chair or ladder for a high-angle approach, or even shoot from a second-story window or the roof of a building. Photographing from a high angle is a good way to show patterns or to avoid a visual obstacle, such as a foreground fence. When photographing a landscape, a high angle permits you to tilt down and eliminate an uninteresting expanse of cloudless sky.

When working with children or animals, the opposite is true. Getting down to their eye level often results in a better picture than the birds-eye view of shooting downward from an adult viewpoint. See **Figure 9-24**.

Using Color, Shape, or Size

The viewer's eye is drawn to the brightest element in a picture. That brightest element is often white or a light color, but it also can be the most strongly saturated color visible. Shape and relative size are other tools you can use to focus viewer attention. See **Figure 9-25**.

Jack Klasey/Goodheart-Willcox Publisher

Figure 9-24. Suit the camera angle to the subject. A—Photograph children or animals from their own eye level. B—Adult viewpoint diminishes shorter subjects.

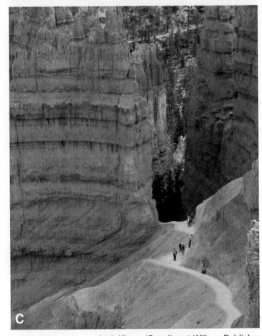

Jack Klasey/Goodheart-Willcox Publisher

Figure 9-25. Focusing viewer attention. A—Color. B—Shape. C—Relative size.

Creating Visual Effects While Shooting

A number of techniques can be used to achieve visual effects that make your pictures more interesting or help to convey your intended meaning. Most of these effects work with both color and black-and-white images.

Motion Blur

While blurring as a result of camera shake is seldom desirable, motion blur due to movement of the subject can be used creatively. Manipulating a zoom lens during exposure can produce motion effects.

A technique called *panning* conveys speed when you are shooting moving vehicles, such as bicycles and racing cars. Practice and experimentation are needed to obtain acceptable results, but the concept is simple. See **Figure 9-26**. With the camera prefocused for the proper distance, frame the vehicle as it approaches, then pan (move the camera laterally) to keep the vehicle properly framed as it crosses in front of you. At the desired point, make your exposure without stopping the panning movement. Continuing to pan after pressing the shutter release is an important part of this technique. The result is a vehicle that is sharply focused against a background that is blurred and streaked horizontally to show movement.

Zooming is moving the camera's zoom lens in or out during the exposure, usually done to impart a sense of motion to a photo of a stationary subject.

Striking motion effects can be achieved by using a relatively slow shutter speed and zooming out or zooming in during the exposure. Mount the camera on a tripod to hold the desired framing on the subject during the zooming action. See **Figure 9-27**. Each exposure made with this technique results in a different effect because the zooming rate and smoothness of the motion is different each time. Zooming in produces a different effect from zooming out. Lenses with different ranges of focal lengths can be used to create different effects.

Soft Focus

This technique is used primarily in portrait photography, since it is flattering and helps to mask minor blemishes and wrinkles. The effect, **Figure 9-28**, is subtle and is different in quality from the unsharpness caused by imprecise focusing. To achieve the soft-focus effect, stretch a single thickness of sheer black stocking fabric across the lens, or smear a thin coat of petroleum jelly on a clear (UV) filter. Special soft-focus filters are also available in several degrees of softness.

Selective Focus

Sharp definition of objects from the near foreground to the distant background is desirable in some photographs but less desirable in others. **Figure 9-29** shows two versions of a flower portrait. A depth of field that renders the busy background sharp enough to be recognizable distracts the eye from the main subject. A shallower depth of field that throws the background far out of focus draws attention to the main subject.

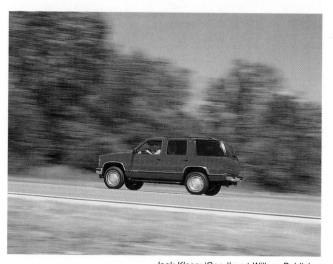

Jack Klasey/Goodheart-Willcox Publisher

Figure 9-26. Panning the camera along with the motion of the subject.

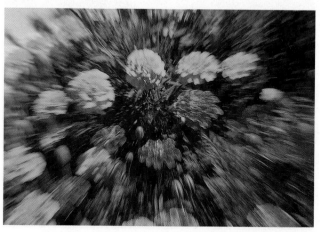

Jack Klasey/Goodheart-Willcox Publisher

Figure 9-27. Zooming creates an interesting, almost abstract effect and a strong feeling of motion.

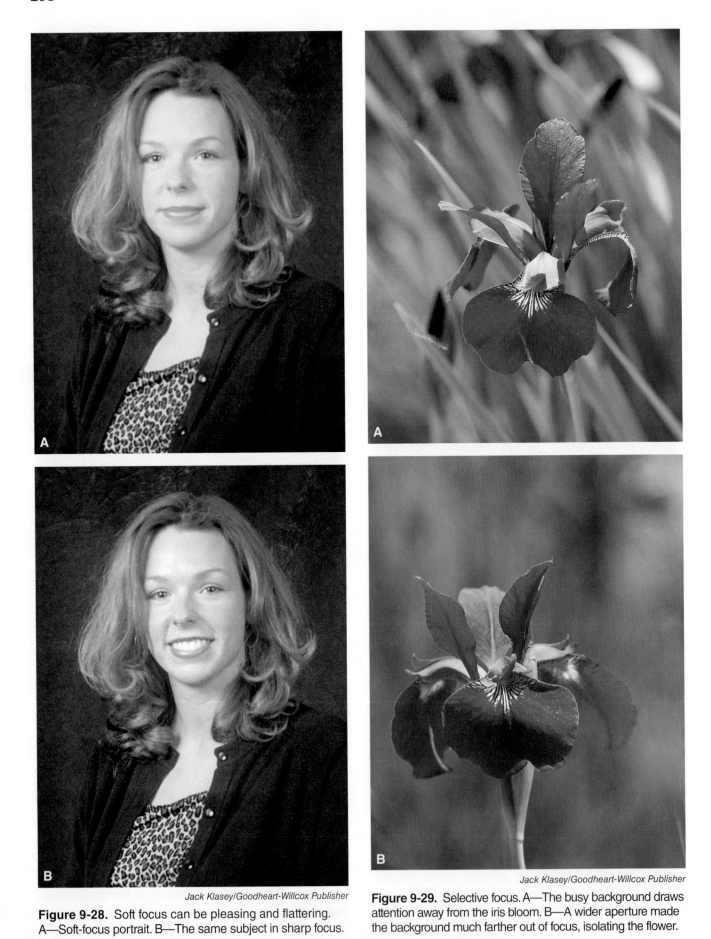

Jack Klasey/Goodheart-Willcox Publisher

Figure 9-28. Soft focus can be pleasing and flattering. A—Soft-focus portrait. B—The same subject in sharp focus.

Jack Klasey/Goodheart-Willcox Publisher

Figure 9-29. Selective focus. A—The busy background draws attention away from the iris bloom. B—A wider aperture made the background much farther out of focus, isolating the flower.

This *selective focus* technique is used extensively in photographing flowers and small animals, especially in natural settings. In the studio, it is often used for both product photos and portraits.

Depth-of-field preview is a desirable camera feature. It allows you to view the degree to which the background is out of focus or one subject is emphasized and another is de-emphasized. The preview feature permits viewing the scene at the desired aperture so the photographer can see the actual depth of field. The degree to which the background is out of focus can be judged and adjusted by shifting the plane of focus or changing to a higher or lower f-stop. Without depth-of-field preview, selective focus is more difficult to achieve. However, a depth-of-field chart or the depth-of-field scale found on some lenses can be used.

Intentional Double Exposure

Unintended double exposures were once a common occurrence. See **Figure 9-30**. Older cameras had separate mechanisms for advancing the film and cocking the shutter for the next exposure. If the photographer forgot to advance to the next frame after making an exposure, it was easy to cock the shutter and make an unplanned second exposure on the same frame.

Most of today's film cameras, especially the SLRs, make it almost impossible to double-expose a frame by mistake. In fact, it is often difficult to do so intentionally! With most digital cameras, a double exposure is impossible. The method for making two or more exposures on a single film frame for artistic reasons depends on the type and age of your camera. Some models permit the shutter to be recocked without advancing the film. Older cameras with mechanical film advance lock the shutter release until the advance lever is operated. To make a double exposure, you must take up any film slack with the rewind crank, then press the rewind release button (usually on the bottom of the camera). This permits you to operate the film advance lever and recock the shutter without actually advancing the film.

Planning a Double-Exposure Photo

To create an effective double (or triple, quadruple, etc.) exposure on film, you need to plan for both the composition and the exposure.

Jack Klasey/Goodheart-Willcox Publisher

Figure 9-30. This unplanned double exposure combines vertical and horizontal scenes of children skating on a neighborhood pond.

Multiple-exposure photographs may contain separate images or overlapping images. A different technique is used for each type.

To plan a photo where the images do not overlap, such as **Figure 9-31**, first identify the individual elements and their relative sizes and positions within the frame. Some photographers make a rough sketch to be used as a guide, while others just visualize the completed picture. Since the images will be made with a dark background and will not overlap, each can be normally metered and exposed. The dark background results in little or no exposure of the film. The resulting clear area on the negative lets the other image(s) expose the paper when making the final print. One or more of the images may be deliberately underexposed to emphasize the importance of the image or images that were normally exposed.

Figure 9-31. A multiple-exposure photo with images that are not overlapped.

Determining Exposure for Overlapped Images

A photo in which images overlap may be as simple as a ghostly figure appearing in a scene or as complex as a montage of several layered images. Because the images overlap, some areas of the frame receive more exposure than others and could become seriously overexposed. Careful planning is needed to produce an effective and attractive multiple-exposure photo.

The rule of thumb is that the proper exposure for the scene should be divided by the number of images that are placed on the film frame. In other words, if there are four images, each should be given one-fourth the exposure needed for a single-image photograph. Begin by metering the subject that occupies the largest portion of the frame, as if it were the only image you are photographing. Assume that your meter reading is 1/60 second at f/8. If you are planning to use a total of two images, the proper exposure for

each image is one-half that reading. You would thus expose each of the images at 1/60 second at f/11. Since you are stopping down by one stop for each image, the total exposure will add up to 1/60 second at f/8. Calculating exposure for two images is relatively easy, but larger numbers of images become more complicated to figure. The table in **Figure 9-32** allows you to directly read the exposure decrease in f-stops needed for each image when combining various numbers of exposures in one frame.

If your camera allows setting of an ISO rating for the film, you can merely multiply the ISO rating of the film (for example, ISO 64) by the number of images to be combined. For a four-image multiple exposure, your new ISO setting would be 256 (64 × 4 = 256). The nearest ISO rating to 256 is 250 (1/3 stop faster than ISO 200). With the film speed reset to ISO 250, you can meter each image normally and expose it based on the meter reading. The exposures for the images in **Figure 9-33** were determined by this method.

Digital Multiple Exposure

Unlike film, which allows you to build up multiple images on the same frame, the sensor in most digital cameras is wiped clean after each exposure. For digital camera users, multiple exposures must be created using a computer and image manipulation software to combine individual files.

Exposure Adjustment for Multiple Images	
Total # of Images	**# of Stops Decrease**
2	1
3	1 1/2
4	2
6	2 1/2
8	3
12	3 1/2
16	4

Figure 9-32. Exposure adjustments for combining multiple overlapping images.

Technically, any image created in the computer by combining individual files is termed a *composite* rather than a multiple exposure, although the visual effect is the same. The multiple exposure photos shown in **Figure 9-31** and **Figure 9-33** could be created from digital files, without the need for exposure calculations or shooting all components in the same session. Like a multiple exposure on film, a digital composite requires planning. You should visualize the desired result, make a rough sketch if necessary, and then shoot the needed images. The techniques for creating composites are covered in Chapter 17, *Advanced Digital Darkroom Techniques.*

Portfolio Assignment

Extracting Images

Without using a camera, practice the technique of "seeing pictures within the picture." Look at a scene and find parts of that scene you could extract as separate images. Refer to **Figure 9-14**. Once you are comfortable with the technique, try it with your camera. Frame and shoot the overall scene, then use your zoom lens to compose and record the separate images. Find several different scenes that interest you and extract at least two separate images from each scene.

Select your best work and make prints of both the overall scene and the images you extracted from it. Place them in your portfolio.

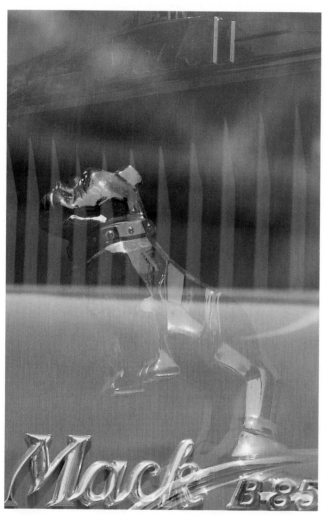

Jack Klasey/Goodheart-Willcox Publisher

Figure 9-33. A three-image multiple exposure made using the film-speed method.

Check Your Photography IQ ⬈

Now that you have finished this chapter, see what you learned by taking the chapter posttest.

www.g-wlearning.com/visualtechnology/

Review Questions ⬈

Answer the following questions using the information provided in this chapter.

1. How is "making a picture" different from "taking a picture"?

2. The process of seeing the final picture in your mind, before pressing the shutter release, is called _____.

3. When selecting a(n) _____ for your photograph, the background and the light must be taken into account.

4. How you compose a photograph involves how you arrange, or _____, the relative positions and sizes of the different elements.

5. Which of the following is *not* one of the six basic elements of composition?

 A. Line

 B. Color

 C. Shape

 D. Balance

6. Light falling on an object creates tonal variations or _____ that add the property of depth to the image.

7. The dominant element in a photo is called the _____.

8. Define *convergence* and give an example.

9. _____ is the practice of identifying and capturing individual images within a larger scene.

10. Which of the following is the frame ratio for 35 mm film?

 A. 2:3

 B. 3:4

 C. 4:5

 D. 9:16

11. What is the *rule of thirds* and how is it used?

12. _____ is the area within the image frame surrounding the subject.

13. Pictorial elements that draw the viewer's eye from one part of the photograph to another are called _____.

14. The brightest element in a photograph or the one with the most _____ color will first attract the viewer's eye.

15. Describe the result of photographing a moving vehicle using the panning technique.

16. Why is soft focus a technique commonly used in portrait photography?

17. The technique of making part of the picture sharp and the rest soft is called _____.

18. Describe how to use film speed (ISO rating) to calculate exposure for a multiple-exposure photo in which exposures overlap.

19. Explain the key difference between making a multiple exposure on film and making a digital composite.

Suggested Activities

1. In small groups, examine the images in your portfolio and those belonging to the other members of your group. Discuss, analyze, and critique the visual aspects of each image. Each student should then choose three images from the portfolios and write a report. In the report, list the design elements noted and describe how those elements make the images more interesting or convey intended meaning.

2. Study the works of famous photographers. Print one image from each of three different photographers and prepare a written or oral report that discusses the composition of these images. Comment on the color, design, shape, shadow, negative space, and background shown in the images.

Critical Thinking

1. You compose an image of a single colorful wildflower in the foreground, occupying about one-fourth of the frame. The space surrounding the flower is varying shades of green foliage. Do you think the space surrounding the flower can be described as negative space?

2. The rule of thirds is actually a useful technique rather than a rule. Many successful photographs have been created that do not conform to this rule. Think of some types of images that could be considered well-composed without conforming to the rule of thirds.

3. How can shadows be used in a photo to add contrast and drama to the image? Think of several different examples.

Communicating about Photography

1. **Speaking.** Choose one of the elements of composition (such as rhythm or balance) discussed in this chapter. Prepare a visual display of three images that include this element. Explain to the class how the compositional element is used in each image.

2. **Writing and Speaking.** Working in a group, brainstorm ideas for creating classroom tools (posters, flash cards, and/or games, for example) that will help your classmates learn and remember the elements of composition. Choose the best idea(s), and then delegate responsibilities to group members for constructing the tools and presenting the final products to the class.

3. **Speaking.** In small groups, discuss the principles of design in photographic work with a focus on color. Discuss how color can be used to create contrast and focus viewer attention.

Diffused light: Light that is reflected in many directions and has a soft, almost shadowless, unfocused quality.

While studying this chapter, look for the activity icon ⬀ **to:**

- **Assess** your knowledge with self-check pretest and posttest.
- **Practice** vocabulary terms with e-flash cards and matching activities.
- **Reinforce** what you learn by submitting end-of-chapter questions.

G-WLEARNING.com

www.g-wlearning.com/visualtechnology/

Jack Klasey/Goodheart-Willcox Publisher

CHAPTER 10

Making Exposure Decisions

Objectives

When you have finished reading this chapter, you will be able to:

- Determine proper exposure using your camera's built-in light meter.
- Make appropriate corrections to resolve exposure problems.
- Select appropriate aperture/shutter speed combinations for different situations.
- Describe the effects of exposure compensation.
- Identify the types of artificial lighting used in photography.

Check Your Photography IQ ➨

Before you read this chapter, assess your current understanding of the chapter content by taking the chapter pretest.

www.g-wlearning.com/visualtechnology/

Technical Terms ➨

ambient lighting
blocked shadows
burned-out highlights
center-weighted averaging
circles of confusion
clipping
depth of field
diffusing
equivalent exposures
evaluative metering
exposure bracketing
exposure compensation
fill flash

film grain
focusing mark
high key
hyperfocal distance
low key
metering modes
permissible circle of confusion
partial metering
plane of focus
proper exposure
sidelighted
spot metering
white balance bracketing

If you want to move beyond *taking* pictures and begin *making* pictures, you will be faced with many decisions. While the preceding chapter discussed composition and other artistic considerations, this chapter concentrates on the technical decisions needed to achieve a proper exposure. In the automatic mode, your camera makes all the exposure decisions. In the manual, shutter priority, aperture priority, and program AE modes, you must make those decisions.

Proper Exposure

What is a *proper exposure*? It could be described as one that is not too dark or too light, but just right. That description is subjective—what is too dark for one photographer might be just right for another. Also, some scenes are *high key* (mostly white or light shades), while others are *low key* (mostly dark values).

Some characteristics of exposure are objective rather than subjective. A properly exposed photo does not display featureless white *burned-out highlights* or equally featureless black areas of *blocked shadows*. See **Figure 10-1**. Except in the case of high-key or low-key subjects, photographs should display a full range of tonal values from shadows through midtones to highlights, **Figure 10-2**.

Jack Klasey/Goodheart-Willcox Publisher

Figure 10-2. A wide tonal range, from deep black shadows to brilliant white highlights. A full palette of middle tones is evident.

Jack Klasey/Goodheart-Willcox Publisher

Figure 10-1. Exposure defects. A—Highlight areas are blank, with no texture or detail. B—Blocked shadow areas are totally black, without detail or texture.

For many photographers, choosing the right combination of shutter speed and aperture to make a proper exposure is a difficult decision. To complicate matters, the exposure situation keeps changing. The speed and f-stop combination suitable for one scene is often incorrect for another scene.

To find out whether their exposure choices were correct, film camera users must wait to check transparencies or prints. Digital shooters, however, can assess image exposure immediately by using the camera's histogram. It displays all the tonal values of the image in the form of a bar graph.

There is no perfect or ideal shape for a histogram, but it should display the following, as shown in **Figure 10-3**:

- A good range of tones, spreading across most of the space on the graph.

- No *clipping* (loss) of shadows or highlights, which are indicated by tall vertical lines at the extreme left and/or right ends of the graph.

- No obvious gaps (spaces) that indicate missing groups of tones.

The left and right ends of the histogram are the areas where problems usually appear. A graph that is weighted heavily toward the left end indicates an underexposed image. A graph that is "bunched" at the right end shows overexposure. See **Figure 10-4**.

A

B

Jack Klasey/Goodheart-Willcox Publisher

Figure 10-4. Exposure defects shown on a histogram. A—Underexposure. B—Overexposure.

Jack Klasey/Goodheart-Willcox Publisher

Figure 10-3. A histogram displaying proper exposure, with no clipping of highlights or shadows.

Exposing for Highlights or Shadows

Experienced photographers using print film often slightly overexpose to capture detail in shadow areas. Slide shooters may slightly underexpose (typically by 1/3 stop) to avoid burning out the highlights.

Digital photographers are often advised to underexpose by 1/3 or 1/2 stop to retain highlight detail. While this approach is sometimes worthwhile, it should not be standard practice. Try to make as perfect an exposure as you can, then check the histogram and increase or decrease exposure based on what it shows.

Digital cameras may offer a highlight overexposure warning as an aid to assessing exposure. When an image is being reviewed, this

feature causes any overexposed areas to blink on and off, **Figure 10-5**. If the situation permits, exposure adjustments can be made and the scene exposed again.

Determining Exposure

In the early days of photography, a proper exposure often depended on the ability to judge the particular combination of shutter speed and aperture required by a given scene. A sunny day meant a small aperture and (relatively) fast shutter speed. A dark day indicated a wider aperture and slower shutter. Today, photographers generally rely on their camera's built-in meter to determine exposure.

Using Built-in Meters

Meters built into cameras measure light reflected from a subject and use this information to determine exposure. In the automatic, shutter priority, and aperture priority shooting modes, metering information is used to set shutter speed, aperture, or both. In the manual mode, the reading indicates whether chosen settings will underexpose or overexpose the image. This allows the photographer to adjust shutter and aperture settings as needed.

For use in different situations, in-camera meters offer two or more *metering modes*. See **Figure 10-6**. Advanced camera models allow the photographer to select the metering mode.

Evaluative metering is the most common mode. Light reflected from the scene is read and analyzed using a number of points spread across the field of view. The shadows,

A

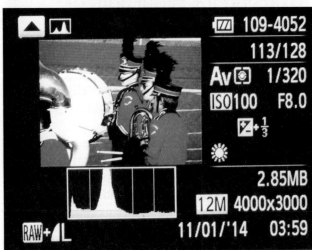

B

Jack Klasey/Goodheart-Willcox Publisher

Figure 10-5. Highlight overexposure warning. A—Blink on. B—Blink off.

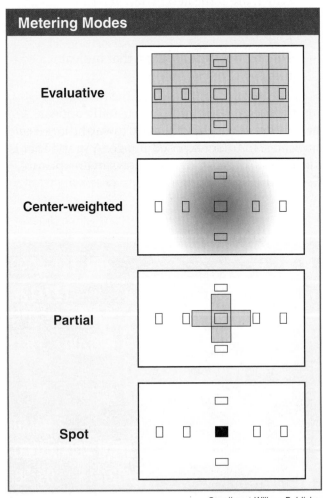

Goodheart-Willcox Publisher

Figure 10-6. Metering modes used by in-camera exposure meters.

highlights, and midtones are evaluated to produce an averaged reading that usually results in an acceptable exposure.

Center-weighted averaging gives greater importance (weight) to information from the center of the frame than to information from the edges. An average reading is then developed for the scene.

Partial metering and spot metering make exposure readings from only part of the scene, which is a particular advantage when photographing backlit subjects. *Partial metering* reads information from a small area (usually about 10%) in the center of the frame. *Spot metering* reads an even smaller area—as little as 1% in some cameras.

Meter readings produce an exposure value for middle gray, equivalent to a tone that reflects 18% of the light that falls on it. When a scene is properly exposed for its middle gray value, the darker and lighter tones in the scene will generally reproduce correctly.

Large areas of very bright or very dark subject matter create a metering problem. These areas fool the meter and result in readings that produce an underexposed or overexposed image. When the subject is very bright, such as a field of fresh snow, the meter senses too much light and returns a middle gray value to prevent overexposure. For a very dark subject, the meter does not sense enough light and returns a middle gray value to prevent underexposure.

For a very bright subject, more exposure is needed. Opening up (increasing aperture size) by 1 to 1 1/2 stops will result in snow that is white, not gray. See **Figure 10-7**. A very dark subject

needs less exposure. Stopping down (decreasing aperture size) by 1 to 1 1/2 stops renders black as truly black.

Correcting Exposure Problems

To correct underexposure or overexposure, increase or decrease (respectively) the amount of light falling on the film or the camera's sensor. This can be done in various ways:

- In manual shooting mode, change either the aperture or the shutter speed for a single adjustment. Alternatively, bracket the metered exposure with increased or decreased exposures.

- In program AE, shutter priority, or aperture priority mode, use the camera's exposure compensation feature to increase or decrease exposure. As in manual mode, this can be done as a single exposure adjustment or as bracketed exposures.

Exposure Bracketing

Many film camera photographers use exposure bracketing, especially under tricky lighting conditions, such as changes in sunlight intensity caused by moving clouds. *Exposure bracketing* involves shooting the scene three times—once at the exposure indicated by the meter, once at a decreased exposure value, and once at an increased exposure value. A change of one full

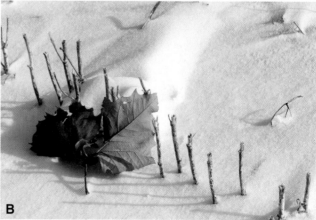

Jack Klasey/Goodheart-Willcox Publisher

Figure 10-7. Exposing for bright subjects. A—The metered exposure rendered the snow as gray. B—Opening up one stop renders the snow as white and presents other colors accurately.

stop in each direction often is used, especially when shooting print film. Transparency (slide) film has less exposure latitude, so bracketing is typically done in increments of 1/3 stop.

Some digital cameras offer automatic exposure bracketing. The camera's AEB control can be set to decrease or increase exposure, usually in 1/3 stop increments, by up to two stops. Most cameras make the metered exposure first, then the decreased exposure, and finally the increased exposure. See **Figure 10-8**.

Exposure Compensation

You may need to increase or decrease the metered exposure in special lighting situations. If you are using the camera's manual settings, you can adjust either the aperture or shutter speed to make a proper exposure. If you are shooting in shutter priority or aperture priority mode, though, you cannot override the meter reading. If you change one setting, the camera adjusts the other to allow the same amount of light to reach the sensor.

The *exposure compensation* feature on SLRs and some advanced compact cameras allows you to increase or decrease exposure while using the shutter priority or aperture priority modes. You can select an increase or decrease of as much as three stops, typically in 1/3 stop increments. See **Figure 10-9**.

Jack Klasey/Goodheart-Willcox Publisher

Figure 10-8. Exposure bracketing. A—Metered exposure (1/500 second at f/5.6). B—Underexposure (1/1000 second at f/5.6). C—Overexposure (1/250 second at f/5.6).

Jack Klasey/Goodheart-Willcox Publisher

Figure 10-9. Exposure compensation. A—Scale is set to +1 stop. B—Setting of +1 changed exposure time from 1/2 second to one second, lightening the image.

A plus setting lightens the image, and a minus setting darkens it.

Equivalent Exposures

Many different combinations of aperture and shutter speed can be used to allow the same amount of light to reach the image receiver. For example, the pairs 1/60 at f/8 and 1/250 at f/4 result in identical exposure. Such pairs are called *equivalent exposures*. In the shutter priority, aperture priority, or program AE modes, the camera calculates and sets an equivalent exposure if you change either the shutter speed or the aperture.

Remember that a one-stop change in aperture either doubles the amount of light reaching the image receiver or cuts it in half. The same relationships apply to changing shutter speeds. To quickly calculate equivalent exposures, count stops or shutter speed units in opposite directions. As shown in **Figure 10-10**, if you make your aperture smaller by two stops, you move two shutter speed units in the opposite direction so the shutter is open longer. Memorizing the sequence of f-stops and shutter speeds found on your cameras and lenses allows you to easily determine equivalent exposures.

Equivalent Exposures			
f/2	1/2	f/2	1/2
f/2.8	1/4	f/2.8	1/4
f/4	1/8	f/4	1/8
f/5.6	1/15	f/5.6	1/15
f/8	1/30	f/8	1/30
f/11	1/60	f/11	1/60
f/16	1/125	f/16	1/125
f/22	1/250	f/22	1/250
f/32	1/500	f/32	1/500
f/45	1/1000	f/45	1/1000
Stop Down		**Open Up**	

Goodheart-Willcox Publisher

Figure 10-10. Equivalent exposure examples. The metered exposure is f/11 @ 1/60. Left—Stopping down by two stops, from f/11 to f/22, moves the shutter speed two steps in the opposite direction. Right—Opening up by four stops.

Shutter Speed vs. Aperture Tradeoffs

To achieve specific effects, you can select different shutter speed/aperture combinations. Fast shutter speeds and the resulting large apertures are typically chosen to capture action. Small apertures and the resulting slow shutter speeds achieve greater *depth of field* (the distance between the nearest and farthest objects that are in acceptably sharp focus) with stationary subjects. When capturing action, choose shutter priority; for situations where depth of field is important, select aperture priority. Some photographers favor these modes over full manual shooting, since only one variable (shutter speed or aperture) must be selected.

Using Higher Shutter Speeds to Capture Action

Selecting a shutter speed to stop the movement of a subject involves three factors:

- Speed of the subject's motion.
- Direction of the subject's movement in relation to the camera.
- Distance of the subject from the camera.

The rate at which your subject is moving affects the choice of shutter speed. Arresting the motion of a motorcyclist, for example, requires a faster shutter speed than stopping the movement of a pedestrian.

The direction of the subject's movement in relation to the camera has a major effect on motion-stopping capability. See **Figure 10-11**. When the subject is moving directly toward or away from the camera, movement may be stopped by a relatively low shutter speed. A subject moving at an angle across the camera's field of view requires a somewhat faster shutter speed. The highest shutter speeds are needed to stop motion of subjects moving directly across the field of view.

A subject that is close to the camera crosses the field of view more rapidly than a subject that is far away, so a faster shutter speed is needed. A distant subject that is moving slowly toward or away from the camera is easily stopped with a relatively slow shutter speed. However, a very high speed would be needed for a subject that is

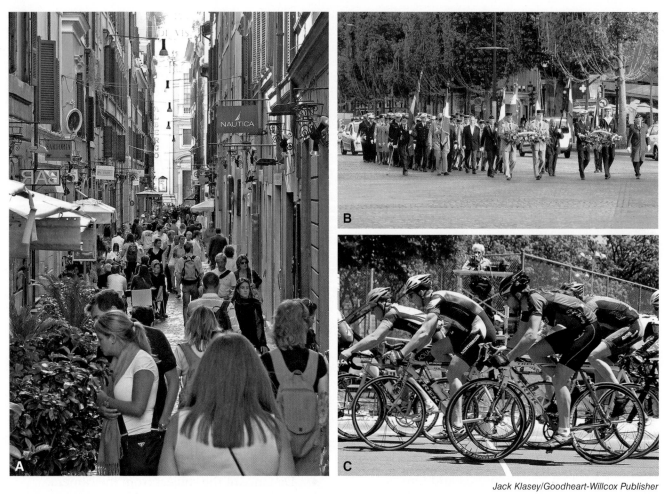

Jack Klasey/Goodheart-Willcox Publisher

Figure 10-11. Apparent motion. A—Moving directly toward or away from the camera. B—Diagonal movement. C—Moving across the field of view.

close to the camera and moving rapidly across the field of view. See **Figure 10-12**.

The tradeoff of using a high shutter speed to stop action is usually a shallow zone of sharp focus. The shallow depth of field results from the need to use large apertures to provide the proper exposure. This may be relieved by using a faster film or higher ISO setting. Each step upward in ISO gains one stop at a given shutter speed.

Using Smaller Apertures to Maximize Depth of Field

If motion is not a factor, aperture becomes more important than shutter speed. The size of the lens opening is the major element in controlling depth of field, or how much of the scene will be in focus. In mountain landscape photography, depth of field may be measured in

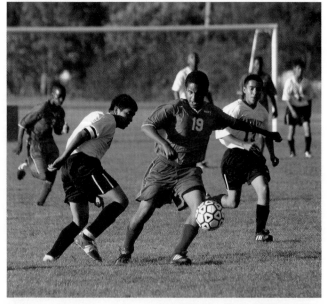

Jack Klasey/Goodheart-Willcox Publisher

Figure 10-12. Rapid movement and nearness to the camera require a high shutter speed to stop motion.

miles, while in close-up flower photography, it may be in fractions of an inch. As the aperture becomes larger, depth of field decreases; as the aperture becomes smaller, depth of field increases. See **Figure 10-13**.

Technically, only a single "slice" of a scene, the *plane of focus*, can be in sharp focus. Parts of the scene closer to or further from the camera will be progressively softer or out of focus, **Figure 10-14**. The limited resolving power of the human eye finds focus to be apparently sharp in a zone extending some distance in front of and behind the plane of focus. That is why the term "appears to be in sharp focus" was used when defining depth of field.

Sharpness of focus results from the way that light rays reflected from the subject are refracted by the lens and projected onto the image receiver plane. As shown in **Figure 10-15**, each point of light reflected from the subject has a corresponding point on the plane of the image receiver. Points from the plane of focus are represented as points on the image receiver, but points in front of or behind the plane of focus appear as small circles called *circles of confusion*. The size of these circles determines sharpness of the image on the receiver. Up to a certain diameter, a circle is seen as a point, and thus appears to be sharp. Depending on individual eyesight and other factors, the size of the *permissible circle of confusion* varies. It is generally defined as a circle 1/100″ in diameter on a 6″ × 8″ print when viewed from a distance of 10″.

Factors Controlling Depth of Field

How much or how little depth of field you can obtain in a specific photographic situation is governed by three factors—the distance of the subject from the camera, the f-stop used, and the focal length of the lens. You often can alter one, two, or all three factors, allowing considerable control.

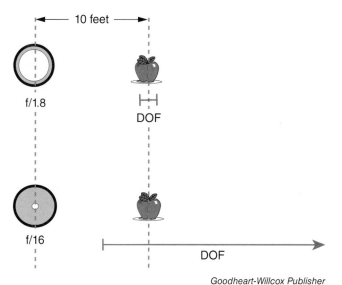

Goodheart-Willcox Publisher

Figure 10-13. With a 50 mm lens focused on an object 10′ away, depth of field at f/1.8 is measured in inches. At f/16, depth of field extends from approximately 6′ to almost 30′.

Goodheart-Willcox Publisher

Figure 10-14. The zone of acceptable sharpness is usually considered to be one-third in front of the plane of focus and two-thirds behind it.

Goodheart-Willcox Publisher

Figure 10-15. Circles of confusion. A—Light rays from an object farther away than the plane of focus. B—Light rays from an object at plane of focus. C—Light rays from an object nearer than the plane of focus.

The ways in which these factors can be altered are as follows:

- **Subject distance.** The farther the subject is from the camera, the greater the depth of field, and vice versa. As shown in **Figure 10-16**, if you focus on a subject 5′ away from the camera, the depth of field might be from about 4′ to 7′. When you take a few steps backward so the subject is 10′ away and then refocus, you increase depth of field by four times. Objects in the scene now will be in acceptable focus from about 6.5′ to almost 18′ away.

- **F-stop.** This is the control factor most often used to alter depth of field. The relationship of f-stops to depth of field is the same as their relationship to exposure, but in reverse. Stopping down increases depth of field; opening up decreases depth of field. By adjusting shutter speed to compensate, you can adjust depth of field while maintaining correct exposure. See **Figure 10-17**.

- **Focal length.** The choice of lens has a considerable effect on depth of field. Changing from a 50 mm lens to a 100 mm lens while maintaining the same f-stop and

subject distance cuts depth of field in half; moving from the 50 mm to a 24 mm doubles depth of field. If the camera is moved to keep the image the same size with each of the lenses, however, depth of field will be exactly the same.

To maximize depth of field, use all three control factors. Focus on a subject that is reasonably distant from the camera, use the smallest practical f-stop, and select a wide-angle lens.

Determining Depth of Field

Most older lenses include depth-of-field scales to permit direct reading of the distances in acceptable focus. The scale has markings for the lens apertures on either side of the *focusing mark*, **Figure 10-18A**. After focusing on the subject, you can determine the distance from the camera by noting the number on the distance scales that is aligned with the focusing mark. Distances appearing above the markings for the selected f-stop will be the nearest point in focus (left-hand mark) and the most distant point in focus (right-hand mark). Some newer lenses show depth of field on a small LCD display, **Figure 10-18B**.

Figure 10-16. The distance of the subject from the camera is a factor in depth of field.

Jack Klasey/Goodheart-Willcox Publisher

Figure 10-17. Stopping down increases depth of field. A—Aperture at f/5.6. B—Aperture at f/11. C—Aperture at f/32.

For lenses without scales, a depth-of-field table must be used. Data sheets packed with a new lens and various reference books provide such tables.

Hyperfocal Distance

To obtain the greatest possible depth of field for a given lens at a specific aperture, set the lens at its *hyperfocal distance*, which is the nearest point that is in sharp focus when the lens is focused on infinity. Focus then will be sharp from one-half that distance to infinity. The distance is different for each f-stop and each focal length.

To find the hyperfocal distance of a lens without a depth-of-field scale, a chart must be used. Finding the hyperfocal distance on a lens with a depth-of-field scale, **Figure 10-19**, is simple.

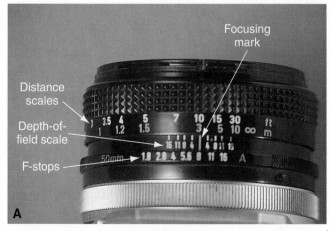

Jack Klasey/Goodheart-Willcox Publisher; Courtesy of Nikon, Inc., Melville, New York

Figure 10-18. Depth-of-field dcalies. A—Physical scale used on older lens. In this example, depth of field at f/8 will be from about 8 feet to almost 15 feet. B—Newer lens with an LCD display.

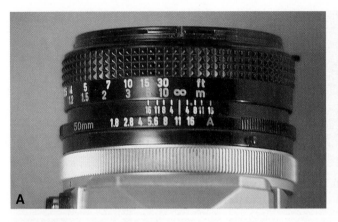

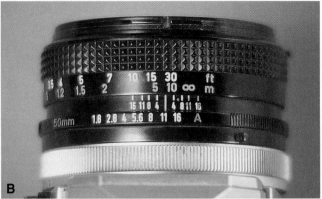

Figure 10-19. Hyperfocal focusing. A—Aligning the infinity symbol on the focusing mark. B—Aligning the hyperfocal distance with the focusing mark.

PROCEDURE
Finding the Hyperfocal Distance

1. Align the infinity symbol (∞) on the focusing mark.
2. On the left-hand scale, note the distance (in feet or meters) shown above the mark for the appropriate f-stop. This is the hyperfocal distance.
3. Rotate the focusing ring until the hyperfocal distance found in Step 2 is aligned with the focusing mark.
4. Find the distance figure above the appropriate f-stop on the left-hand scale. It will be one-half the hyperfocal distance. Everything from that point to infinity will be in focus.

The hyperfocal method is useful in landscape and nature photography, as well as in street photography or similar situations where you wish to be unobtrusive. It is also helpful in sports or action photography where focusing on a rapidly changing scene would be difficult.

Effect of ISO Settings on Exposure

You can use the range of ISO ratings, in combination with aperture and shutter speed settings, to capture usable images under a wide variety of conditions. Increasing the camera's ISO setting or using a higher-rated film is especially helpful under low-light conditions where the indicated shutter speed is too low for a successful handheld exposure. For each increase in ISO rating (such as from 100 to 200), you can gain one full step in shutter speed. Instead of 1/30 second, for example, you could shoot at 1/60 second and properly expose the photo.

The danger of using higher ratings, especially above ISO 400, is increased digital noise or film grain in the image. Digital noise is specks of various colors that are most noticeable in shadows or areas of smooth color, such as clear skies, **Figure 10-20**.

Figure 10-20. Digital noise.

Film grain takes the form of larger clumps of metallic silver in the developed emulsion. It can give the image a mottled appearance, almost like grains of sand.

Capturing the Light

How long an exposure is needed to take a photo of a black cat in a coal mine at midnight? What if the subject were a white rabbit, instead of the cat? Since the description "in a coal mine at midnight" indicates a condition of total darkness, you would not get a picture in either case, no matter how long you exposed the film. Without light, you cannot capture a photographic image.

Under the described conditions, you must supply the necessary light to obtain a photograph. The amount of light needed can be amazingly small—with a long-enough time exposure, a tiny birthday candle would allow you to capture a picture of that black cat. See **Figure 10-21**.

Types of Lighting

Light necessary to make a photographic exposure can be natural, artificial, or a combination of the two. Outdoor photography usually involves working with natural light, while indoor photography is mostly done by artificial light. Natural light may be supplemented with artificial light when working outdoors, and vice versa when shooting indoors.

Natural Light

The intensity, color, and direction of natural light are all highly variable. At the beginning and end of the day, sunlight has a warm red-orange hue and a horizontal direction due to the rising or setting sun. During the rest of the day, sunlight is colder and bluer. At midday sunlight is hardest and most intense, **Figure 10-22**. Light intensity and color are further modified by the presence

Jack Klasey/Goodheart-Willcox Publisher

Figure 10-22. Natural light. A—Warm, soft light from a setting sun. B—Harsh, bright midday light.

Jack Klasey/Goodheart-Willcox Publisher

Figure 10-21. A toy black cat photographed with light from a small birthday candle. Exposure was 1/30 second at f/8, with ISO set at 100.

of clouds. A thin layer of clouds softens, diffuses, and slightly warms the light of the midday sun. Broken clouds present a photographic challenge, since the intensity and color of the sunlight can change rapidly and unpredictably.

The direction of light striking the subject must also be taken into account. A subject that is *sidelighted* (lighted from one side) often exhibits strong contrast between the lighted and shadowed sides, providing a dramatic effect. See **Figure 10-23**. However, sidelighting can also result in an image with burned-out highlights or blocked and featureless shadows.

Backlighting can render a subject as a dramatic silhouette, or with more exposure, as a recognizable person or object against a bright background. Certain subjects exhibit a brightly glowing halo effect when backlit. See **Figure 10-24**.

Modifying Natural Light

Strong sunlight on a subject often produces an extreme range of contrast—highlights are too bright and shadows are too dark. As a result, both lose detail. To remedy this problem, modify the light by reducing its intensity or by exposing for the highlights and adding light to the shadow areas.

Diffusing (reducing the intensity of) the light striking the subject decreases the range of contrast to retain detail in both shadow and highlight areas. The light can be diffused by

Jack Klasey/Goodheart-Willcox Publisher

Figure 10-24. A spider and web backlit by the sun.

placing a translucent material, such as tracing paper or white nylon fabric, between the light source and the subject. See **Figure 10-25**. The translucent material permits only a portion of the light to reach the subject. The image receiver can then capture detail in both highlights and shadows. Since less light is falling on the subject, an exposure adjustment is almost always necessary.

To reveal detail in the shadowed area of a sidelighted subject, additional light is needed. The simplest way to add light is to use a reflective material to bounce back some of the daylight, **Figure 10-26**. Some photographers use a simple white card, while others prefer silver or gold metallic reflectors. Silver material produces a somewhat harder light, while gold reflections are softer and warmer.

Adding artificial light to the shadowed area is also a possibility. Often, the added light is in the form of *fill flash*, light of reduced intensity used to soften shadows and reveal details. Some cameras have a fill-flash setting, while others allow you to use a separate flash at a fraction of its normal power. Some photographers leave the flash at full power setting but reduce and soften its light output by covering it with one or more layers of a white handkerchief.

Artificial Light

Photographers use three basic types of artificial lighting— ambient (room) lighting, portable (usually electronic flash) lighting, and studio lighting. Each has advantages and drawbacks, especially in terms of controllability.

Jack Klasey/Goodheart-Willcox Publisher

Figure 10-23. Sidelighting from the sun at about a 45° angle to the horizon.

Figure 10-25. A diffuser in use. A—Translucent material taped to a cardboard window mat makes a usable diffuser. B—No diffusion. The flower image is very contrasty, with lost highlight and shadow detail. C—Using a diffuser tames the extreme contrast.

Figure 10-26. A silver reflector bounces light onto the shadowed side of a subject. The photographer is using a remote shutter release cord, allowing her to move away from the camera to better aim the reflector.

Ambient lighting is the least controllable; studio lighting the most easily controlled.

Ambient Lighting

The lighting that already exists in a scene or space, without any additions, is *ambient lighting*. Indoors, this lighting can be natural (daylight from a window or skylight), artificial (electric lamps, candles, firelight), or a mixture. See **Figure 10-27**.

Figure 10-27. Ambient light from the windows and small table lamps were used to capture this interior scene.

The primary advantage of ambient lighting is that you do not need to provide any additional light to expose the film. It also can give a feeling or mood to an image that would be almost impossible to duplicate with portable flash or studio light sources, **Figure 10-28**. Using only ambient lighting also permits you to make photographs unobtrusively, an advantage at religious ceremonies or other settings where use of a flash would be objectionable.

Possible disadvantages of ambient lighting can be brightness, direction, and color. The light falling on your subject may be too strong, causing harsh shadows and washing out highlight details. On the other hand, the light could be too weak, providing low contrast and requiring long exposure at a wide aperture. Light direction can also be a problem. For example, bright overhead lighting can create unflattering deep pools of shadow in eye sockets or under the nose and chin, **Figure 10-29**.

Jack Klasey/Goodheart-Willcox Publisher

Figure 10-29. A strong overhead light source is very unflattering and should be avoided whenever possible.

Mixed Artificial and Natural Lighting

Some photographic situations involve a mixture of artificial and natural lighting. Most often, the supplementary light source is fill flash used to add light to shadowed areas. Fill flash also brightens colors and helps separate the shapes of objects. See **Figure 10-30**. In some cases, the artificial source serves as the main light and the natural light as the secondary, or fill, source. Using artificial light as fill is more common, however.

Compensating for Mixed Lighting

Mixed types of lighting can create problems, especially when color transparency film is exposed. When dealing with two different types of light, first determine which light source is dominant, then select the film balanced for that source or use a correction filter. An alternative solution is to use color negative (print) film in mixed-light situations, since considerable correction can be done when making prints.

For digital photographers, automatic white balance frequently does a good job of balancing different light sources. If the situation allows,

Photodisc

Figure 10-28. It would be difficult, if not impossible, to duplicate this photo with studio or portable flash lighting.

Figure 10-30. Using fill flash. A—Only ambient light was used. B—Fill-flash light added depth and richness.

make a second exposure with white balance set to the dominant source (such as daylight or tungsten). Some cameras also offer *white balance bracketing*. The camera makes one exposure with the selected white balance and two others—one with a warmer color temperature and one with a cooler color temperature.

The most precise method of compensating for mixed lighting, however, is to create a custom white balance. This feature, typically offered by advanced compact and SLR models, involves photographing a white object under the actual lighting conditions. The image is then stored and used by the camera to adjust subsequent shots under those lighting conditions. See **Figure 10-31**.

Figure 10-31. Shoot a white card in mixed lighting situations to create a custom white balance.

Portfolio Assignment

Minus and Plus

Choose a well-lighted subject with a good range of tones (see **Figure 10-2** for an example). Mount your camera on a tripod and select aperture priority mode. Set the ISO to 100, and then adjust the aperture to a value in the middle of the available range (probably f/8 or f/11).

Shoot the scene five times, using exposure compensation in this sequence: −2, −1, 0, +1, +2. Review the shots on the LCD, noting how the shutter speed selected by the camera becomes longer (slower) in regular steps as you move from −2 to +2.

Make a straight print (no adjustments) of each of your five exposures, and label each image with the shutter speed, aperture, and exposure compensation. Compare the prints to observe the effects of exposure compensation. Place the prints in your portfolio.

Check Your Photography IQ

Now that you have finished this chapter, see what you learned by taking the chapter posttest.

www.g-wlearning.com/visualtechnology/

Review Questions

Answer the following questions using the information provided in this chapter.

1. In a photo that is properly exposed, the highlights are not _____ and the shadows are not _____.

2. What is *clipping* and how is it shown on a histogram?

3. _____ metering gives greater importance to the middle of the frame when determining exposure.

4. Middle gray is equivalent to a tone that reflects _____% of the light that strikes it.
 A. 10
 B. 18
 C. 50
 D. 68

5. Some cameras offer *exposure bracketing*. What is it?

6. When you are shooting in the aperture priority mode, you can use _____ to lighten or darken the image.

7. The metered exposure for a scene is f/8 @ 1/60. To stop motion, you change the shutter speed to 1/250. For an equivalent exposure, you must reset the aperture to _____.
 A. f/32
 B. f/16
 C. f/8
 D. f/4

8. A(n) _____-stop change in aperture either doubles or halves the amount of light reaching the image receiver.

9. What are the three factors controlling the depth of field exhibited in a photograph?

10. The sharpness of the image at the image receiver is determined by the size of the _____.
 A. circles of confusion
 B. silver molecules in the emulsion
 C. points of parallax
 D. lens element groups

11. The nearest point that is in sharp focus when a lens is focused on infinity is called the _____.

12. Film grain or digital noise begins to increase noticeably at ISO ratings higher than _____.
 A. 100
 B. 200
 C. 400
 D. 800

13. To reduce the range of contrast in a photo taken in strong sunlight, you can _____ the light by using translucent material between the light source and the subject.

14. The lighting technique used to lighten shadow areas and reduce contrast when photographing outdoors is called _____.
 A. indirect flash
 B. fill flash
 C. open flash
 D. bounce flash

15. _____ light is the lighting that already exists in a scene or space, without additions.

16. In digital photography, _____ is the most precise method of compensating for mixed lighting.

Suggested Activities

1. Explore the effects of different white balance settings on a photographed scene. Choose an outdoor scene that is fairly brightly lit and exhibits a good range of colors. Make one exposure with the Auto White Balance setting, and then make exposures of the same scene using each of the white balance settings offered by your camera. Make a 4″ × 6″ straight (uncorrected) print of each image. Mount your prints on a poster board, labeling each with the white balance setting used. Which setting most closely matched the Auto White Balance image? Display the board in your classroom.

2. Can looking directly at the sun through your SLR's viewfinder cause damage to your vision? Research the subject on the Internet and write a report. If you find that viewing the sun this way is dangerous, describe the possible effects and proper precautions. Alternatively, create a safety poster on the subject.

Critical Thinking

1. You are photographing a desert scene and wish to keep everything from the foreground cactus to the distant mountains in sharp focus. Your camera, with a wide-angle lens, is mounted on a tripod. What camera setting adjustment would you make to obtain the greatest possible depth of field?

2. Think of locations in or near your community where you could photograph a high key or a low key image. If none come to mind, consider other places where you could make such images. Identify at least one high key possibility and one low key possibility.

Communicating about Photography

1. **Writing and Speaking.** Create an informational pamphlet about the camera model of your choice. Research the camera's features, controls, and cost. Include images in your pamphlet. Present your pamphlet to the class and answer any questions the other students may have.

2. **Listening and Speaking.** Search online for photography instruction videos. Watch two or three of the videos and listen for terms that you have learned from this textbook. Write a short summary of each video, including the important terms mentioned. Be prepared to present your report to the class.

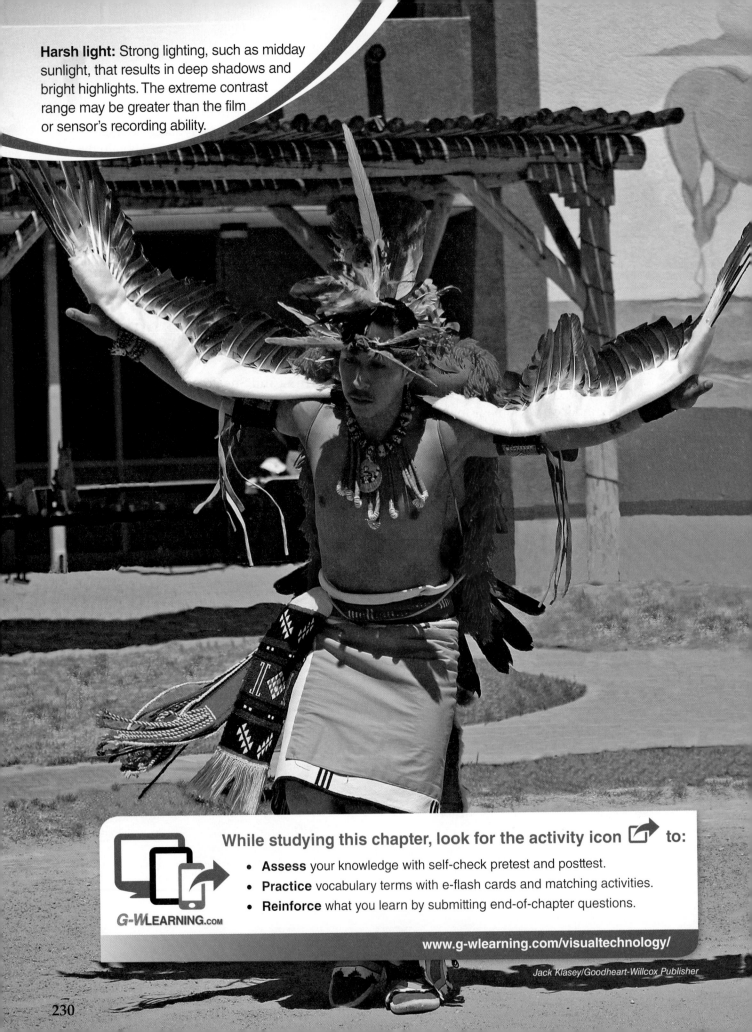

Harsh light: Strong lighting, such as midday sunlight, that results in deep shadows and bright highlights. The extreme contrast range may be greater than the film or sensor's recording ability.

While studying this chapter, look for the activity icon 📲 **to:**

- **Assess** your knowledge with self-check pretest and posttest.
- **Practice** vocabulary terms with e-flash cards and matching activities.
- **Reinforce** what you learn by submitting end-of-chapter questions.

G-WLEARNING.com

www.g-wlearning.com/visualtechnology/

Jack Klasey/Goodheart-Willcox Publisher

CHAPTER 11

Action and Event Photography

Objectives

When you have finished reading this chapter, you will be able to:

- Recall the major categories of action and event photography.
- Identify the techniques used to stop action.
- Describe the different focus techniques used in action photography.
- Contrast hard news and feature (soft news) photography.
- Recall the advantages and disadvantages of using a camera's built-in flash.

Check Your Photography IQ ↗

Before you read this chapter, assess your current understanding of the chapter content by taking the chapter pretest.

www.g-wlearning.com/visualtechnology/

Technical Terms ↗

bounce flash
built-in flash
capacitor
dedicated flash units
direct flash
follow focus
guide number
hard news
high-voltage power pack
hot shoe
lens collar
off-camera flash
open flash

painting with light
peak of action
photojournalism
picture story
prefocusing
rear-curtain synchronization
recycle
red eye
relative motion
self-contained flash units
slave units
soft news
zone focusing

Virtually any picture that portrays people involved in activities—from children playing a game to the hustle and bustle of a city street—can be classified as action and event photography. Most assignments covered by photojournalists, whether they are shooting fires, the effects of weather, or the doings of public officials, fall into this classification as well.

Major categories of action and event photography include the following:

- **Sports.** Portraying athletics at any level from Little League to professional.

- **Street shooting.** Capturing candid views of people and their activities, often in an urban setting.

- **Photojournalism.** Recording breaking news events of all kinds, plus feature photos to accompany articles and those shot strictly for their visual interest.

- **Performances.** Photographing all types of entertainment activities, such as concerts, stage productions, festivals, and parades.

Action and event photographs often fall in the category of *record shots* ("I was there and this is what I saw."), **Figure 11-1**. At times, the photos convey a strong emotional or artistic impact. News photographs frequently convey emotional content, while performance photos can have an abstract artistic appearance, **Figure 11-2**.

To be successful as an action and event photographer, you must be able to respond quickly to changing conditions and often to rapidly moving subjects. You have to be completely familiar with your camera's capabilities and controls, so you can make needed adjustments instinctively. You need to make technique decisions, such as freezing motion vs. motion blur, without hesitation and apply them immediately.

Alfred Eisenstaedt, a renowned photojournalist, once described his approach as "f/8 and be there." In other words, be in the right place at the right time and use the proper camera settings to capture the scene.

Jack Klasey/Goodheart-Willcox Publisher

Figure 11-1. A record shot showing Times Square in New York City.

Figure 11-2. The color, costumes, and motion of the dancers in a performance often provide photographs that approach the abstract.

Although using the camera's full automatic setting is often considered an amateur's technique, professional photojournalists frequently leave their cameras set on *auto*. They do so to anticipate situations where a quick "grab shot" may be their only opportunity to capture the action. If time allows, they can then make necessary setting adjustments and keep shooting.

Stopping Motion

In many photographic situations, an important objective is a crisp, well-focused shot of the subject. If the subject is moving, this objective can be achieved only by stopping that subject's motion.

When you seek to fully stop the movement of a subject, *relative motion* must be considered. This means not only the speed at which the subject is moving, but the direction of movement in relation to the camera.

Effects of Relative Motion

A subject moving directly toward the camera, whether quickly or slowly, can be stopped by a relatively slow shutter speed. See **Figure 11-3**. A subject moving at an angle to the lens's axis, either toward or away from the camera, requires a higher shutter speed. If the movement is crossing your field of view, a still faster shutter speed is needed, **Figure 11-4**.

Figure 11-3. Motion toward the camera shot at 1/125 second.

Figure 11-4. Movement across the camera's field of view shot at 1/500 second.

Under identical conditions, shutter speeds need to be twice as fast for each directional change. See **Figure 11-5**. For example, if 1/125 second stops movement toward or away from the camera, 1/250 second would be required to freeze a diagonal movement. Motion across the field of view would need 1/500 second. Another factor is the distance of the subject from the camera. The closer the subject, the faster it will move across the lens's field of view and the faster the shutter speed needed to stop its motion.

The focal length of the lens you use may also require a change of shutter speed. As the focal length increases, the field of view narrows proportionately. If both a 100 mm lens and a 200 mm lens are focused on a bicycle rider 100′ away, the bicyclist would cross the field of view of the 200 mm lens twice as fast because the field of view of that lens is only half as wide. See **Figure 11-6**. The shutter speed is doubled for each doubling of the focal length. If you choose

a shutter speed of 1/125 second to stop motion with the 100 mm lens, you would need a speed of 1/250 second with the 200 mm lens to achieve the same effect.

Even though today's professional SLR cameras offer shutter speeds as brief as 1/8000 second, some action cannot be stopped by shutter speed alone. The movement may be too rapid even for a very fast shutter speed. Also, low light levels might require slower shutter speeds (even with large apertures) for proper exposure. The solution is to use electronic flash. The extremely short duration (1/10,000 second–1/50,000 second) of the light burst from the flash tube freezes the subject into stillness.

Using flash to stop motion is most effective with low levels of ambient light, since the subject is isolated against a dark background. When the level of ambient light is fairly high, *ghost images* can result.

Object in motion (or type of action)	Approximate speed		Distance from camera		Type of movement		
	(mph)	(kph)	(feet)	(meters)	Toward/ away	Diagonal	Across
• People walking	5	8	10–12 25 50 100	4 8 16 33	1/125 1/60 1/30 1/15	1/250 1/125 1/60 1/30	1/500 1/250 1/125 1/60
• People jogging, skating, or bicycling • Children in active play	10	16	10–12 25 50 100	4 8 16 33	1/250 1/125 1/60 1/30	1/500 1/250 1/125 1/60	1/1000 1/500 1/250 1/125
• Active sports • Animals (large) running • Vehicles on city streets	25	40	10–12 25 50 100	4 8 16 33	1/500 1/250 1/125 1/60	1/1000 1/500 1/250 1/125	1/2000 1/1000 1/500 1/250
• Vehicles on highway	50	80	25 50 100 200	8 16 33 66	1/500 1/250 1/125 1/60	1/1000 1/500 1/250 1/125	1/2000 1/1000 1/500 1/250
• Racing vehicles • Other fast-moving subjects	100	160	25 50 100 200	8 16 33 66	1/1000 1/500 1/250 1/125	1/2000 1/1000 1/500 1/250	1/4000 1/2000 1/1000 1/500

Goodheart-Willcox Publisher

Figure 11-5. The effects of distance and direction of movement on shutter speeds for some typical subjects. Shutter speeds listed are for 35 mm cameras, based on use of a normal (50 mm) lens.

Jack Klasey/Goodheart-Willcox Publisher

Figure 11-6. Focal length and field of view. A—100 mm. B—200 mm.

With older cameras, the blurred ambient light (ghost) image is in front of the subject. This occurs because the flash exposure is made the instant the shutter opens. The subject continues to move, and is recorded on the film by ambient light until the shutter closes. Many newer SLR cameras offer *rear-curtain synchronization* that delays the firing of the flash until the instant before the second curtain of the focal plane shutter begins to close. This places the ghost image behind the moving subject for a more natural appearance. See **Figure 11-7**.

Capturing the Peak of Action

Experienced action photographers, especially those covering sporting events, are often able to capture dramatic stop-action photos without the use of flash or extremely high shutter speeds. They catch their subject at the *peak of action*, the instant when motion slows to almost a stop. A familiar example of the peak of action is the pole vaulter or high jumper who seems to hang in midair just above the bar, **Figure 11-8**. At that instant, the upward momentum of the athlete is briefly balanced with the pull of gravity. He or she has stopped moving upward, but has not yet begun moving downward.

The key to using this technique effectively is knowing the sport, and sometimes the individual participant, well enough to anticipate when action will reach a peak. Some sports, such as the high jump or basketball, have fairly regular and predictable action peaks. Others, such as lacrosse

Jack Klasey/Goodheart-Willcox Publisher

Figure 11-7. Ghost image with rear-curtain flash synchronization.

Jack Klasey/Goodheart-Willcox Publisher

Figure 11-8. This high jumper has been caught at the peak of action.

or soccer, feature more random and unpredictable motion, making it more difficult to anticipate the peak of action. See **Figure 11-9**. Good timing is vital—the shutter must be released an instant before the peak of action takes place. If you wait to see the peak of action in your viewfinder, you will miss the shot. It takes practice plus knowledge of the sport to perfect your timing.

With older digital cameras and some current compact models, capturing the peak of action is made more difficult by *shutter lag*. This noticeable delay between the time the shutter release is pressed and the actual opening of the shutter is caused by slow operation of the camera's autofocus system. The problem often can be

overcome by pressing and holding the shutter release halfway down to prefocus. To make the exposure, press the release the rest of the way.

The likelihood of capturing the peak of action can be increased by careful use of the motor drive (burst mode) feature found on most SLR cameras. On a film camera, the battery-operated drive keeps making exposures as long as the shutter release is pressed. With good timing and by making exposures in short bursts of 3–4 frames, a photographer can often get the desired shot, **Figure 11-10**.

Focus Techniques

Cameras with predictive autofocus and similar sophisticated focusing systems have made life simpler for sports and wildlife photographers. Besides improving the percentage of well-focused shots, autofocus allows more attention to be paid to composition, timing, and other matters. There are a number of manual focusing techniques, however, that continue to be valuable photographic tools.

Follow Focus

Because some autofocus systems react too slowly for action photography, a photographer skilled in manual focusing can do the job faster and more effectively. When a moving object must be kept in focus to allow the shutter to be pressed at any time, manual focus is preferable to slow autofocus.

Follow focus is a technique that requires making constant small focus adjustments to keep the subject sharp. This method permits the photographer to select the exact instant to release the shutter. The photographer usually judges the sharpness of the image on the viewfinder's ground glass rather than using the split-image or microprism portions of the finder. Determining the amount of lens barrel rotation needed to keep the focus sharp requires practice.

If you are using a film camera, much of the follow-focus practice can be done without actually exposing film, since the object is to develop proper coordination and motor skills. Shooting an occasional practice roll of film allows you to assess your technique. Digital cameras, of course, allow you to make a shot and immediately judge the effectiveness of your follow-focus technique.

Jack Klasey/Goodheart-Willcox Publisher

Figure 11-9. In some sports, such as soccer, excellent timing is vital to capture the peak of action.

Jack Klasey/Goodheart-Willcox Publisher

Figure 11-10. A camera's motor drive or burst mode allows the photographer to capture a sequence of action. A—Windup. B—Delivery. C—Follow-through.

Prefocusing

A useful technique when the action follows a regular pattern or route, as it does in baseball and most types of racing, is *prefocusing* on a specific spot. Select a particular location (for example, first base or the finish line of the track), sharply focus the camera there, and wait for your subject to reach that point, **Figure 11-11**. This method works best when it is possible to use a smaller f-stop for increased depth of field.

Zone Focusing

Zone focusing can be used to cover a wider area and is a good choice for less predictable activities such as football, basketball, or soccer. First, determine the pair of distances between which you wish to be able to capture action, such as 10′ and 30′. Since the area of acceptable sharpness is approximately one-third in front of and two-thirds behind the actual point of focus, your point of focus should be at approximately 17′. This is one-third the distance between 10′ and 30′. Stop the lens down to an aperture that provides acceptable sharpness from 10′ to 30′. Any action within that zone will be acceptably sharp, **Figure 11-12**.

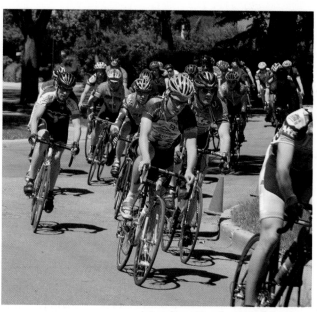

Jack Klasey/Goodheart-Willcox Publisher

Figure 11-11. In this bicycle race shot, the prefocus spot was the orange traffic cone at right.

Figure 11-12. The players fighting for the rebound are in the chosen focus zone.

Figure 11-13. The shutter speed was fast enough to preserve the rodeo rider "biting the dust," but allowed some blurring of the bucking bronco's hooves and tail.

Figure 11-14. A slow shutter speed was used to blur the lights of these cars in downtown Chicago into colorful streaks that show movement.

Blurring for Visual Interest

Completely stopping a subject's motion is not always desirable. Some degree of motion blur in a photograph conveys a sense of movement.

Depending on the desired effect, the amount of blur may be very slight or almost total. As shown in **Figure 11-13**, selecting a shutter speed fast enough to stop the most important motion still allows some degree of blur to convey movement. **Figure 11-14** shows the opposite effect. A strong sense of motion is conveyed by using a shutter speed slow enough to capture streaks of colored light from moving vehicles on a city street at night.

Panning and Zooming

Blurring due to movement of the camera is usually considered undesirable. However, two types of blur induced by camera motion—panning and zooming—often are used to create visual interest.

In panning, the camera is moved in an arc as the subject passes, and the shutter release is pressed at the desired point. The panning movement must continue past the point where the shutter is released. The result is a sharply focused subject, such as a runner or a vehicle, moving across a blurred background, strongly conveying the idea of rapid movement, **Figure 11-15**. A background close to the moving subject will streak more interestingly than a distant background. A tripod-mounted camera provides smoother movement than can be

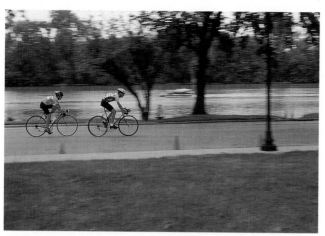

Figure 11-15. Panning the camera along with the motion of the subject.

Figure 11-16. Zooming creates an interesting, almost abstract effect and a strong feeling of motion.

obtained by hand-holding, especially when a long lens is used.

Zooming is usually done to impart motion to a photo of a stationary subject. The subject is centered in the viewfinder and sharply focused, and the camera's zoom lens is moved in or out during the exposure. Tripod-mounting of the camera is vital, since a fairly long exposure time is necessary to allow zooming. A zoomed photo has a center area that is in focus and streaking that extends outward from the center to the edges of the print. See **Figure 11-16**.

Photojournalism

In a strict sense, every photograph is an act of communication, conveying information, an idea, or an emotion. *Photojournalism* involves a specific kind of communication—telling a story. The story may be communicated in a single image or in a series of images called a *photo story*. Ideally, the photograph itself should be able to convey the story to the viewer. Most often, though, a writing or publishing application is used to add a caption that provides needed information. See **Figure 11-17**.

● On the Local Scene

Springfield's 47th Flowerfest Gets Underway

With the Springfield High marching band leading the way, the Flowerfest Parade stepped off along Main Avenue Friday afternoon to open the community's annual celebration honoring its commercial flower production industry.

Grand Marshal for the parade was Mary Johnson, Citizen of the Year and popular host of theWSPC-TV "Morning with Mary" program.

Highlights of this year's weekend-long event will be the pet parade, antique auto exhibit, the Garden Club Flower Show, a local talent showcase

Citizen of the Year Mary Johnson served as Grand Marshal of the 47th Springfield Flowerfest Parade on Friday afternoon. The annual event wraps up with fireworks at 8 p.m. Sunday in Hubbard Park.

on Saturday evening in the High School gymnasium, a huge flea market, and the closing fireworks show scheduled to be held at 8 p.m. on Sunday in Hubbard Park.

The Menard Bros. Carnival returns again this year. To form the carnival's Midway, Sheldon Parkway has been blocked off between Main and Forrest Avenues. Rides will operate from 10 a.m. to 11 p.m. Saturday and noon to 10 p.m. on Sunday. Tickets and all-ride wristbands will be sold on the Midway.

Figure 11-17. The photo itself provides some information, but the caption adds necessary details.

Types of Photojournalism

Photojournalism can be categorized in many different ways. The following four types include almost every relevant application:

- News/feature photography.
- Picture stories.
- Yearbook/school event/newsletter.
- Other event photography.

The categories overlap to some extent. In this section, they will be considered separately for ease of discussion.

News and Feature Photography

Most photojournalists work for newspapers, magazines, or electronic media and handle a variety of photo responsibilities. On any given day, a photojournalist may have both *hard news* assignments, such as fires, accident or crime coverage, and *soft news* feature assignments. Examples of soft news features are seasonal pictures, fashion or food shots, and human interest photos. Mastery of technical skills is particularly important on the hard news assignments, where there may be no opportunity for additional shots.

Hard News Photography

Besides photographic knowledge, important skills for photojournalists are the ability to make decisions and act quickly, the determination to carry out the assignment despite obstacles, and the physical stamina to work in unpleasant and sometimes dangerous conditions. See **Figure 11-18**.

In addition, photojournalists must be able to work with people of all kinds, from political figures and government officials to distraught crime victims and antagonistic individuals. Especially in smaller news organizations, they may be on call for breaking news at any hour of the day or night and often work long or irregular hours.

Photojournalists were among the first professionals to use digital cameras because of the speed with which images could be taken, delivered, and processed. Except in the largest news organizations, the photographer is likely to shoot the photo and then use image editing software to prepare the image files for publication. The photographer does not usually select the image to be used. A member of the editorial staff typically reviews the possible images and chooses one or more to be published.

In smaller communities, photojournalists and reporters are well-known to police officers and firefighters, and therefore seldom have a problem gaining access to sites where a news event is occurring. Larger municipalities, in order to control access to the scene, typically issue press credentials to news people. See **Figure 11-19**. Depending on local regulations, independent (freelance) photojournalists may also obtain credentials.

Photojournalists are also called on to shoot a variety of civic, business, and community events. Typical assignments are groundbreaking ceremonies for new buildings, **Figure 11-20**, civic meetings, school ceremonies, and award luncheons.

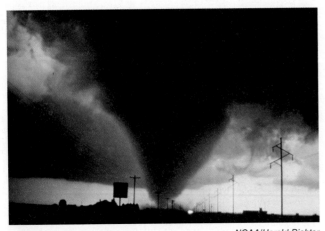

NOAA/Harald Richter

Figure 11-18. A photojournalist sometimes must work in dangerous situations, such as shooting this approaching tornado.

Jack Klasey/Goodheart-Willcox Publisher

Figure 11-19. The author's Chicago press card from his early days as a print journalist.

Photo by Larry Morris

Figure 11-20. Civic events are common assignments for photojournalists.

Assignments in which the subjects shake hands and smile for the camera are often referred to as "grip and grin" events. The challenge in such assignments is to avoid the tired photographic cliché and find a fresh approach that results in a visually interesting photo that tells a story.

Large city newspapers and television stations may have staff members who specialize in sports photography. Photographers at smaller publications handle sports assignments as well as regular news and feature pictures. Almost all outdoor sporting events take place on large fields, requiring use of a long telephoto lens to fill the frame with dramatic action, **Figure 11-21.**

Jack Klasey/Goodheart-Willcox Publisher

Figure 11-21. At outdoor sporting events, long telephoto lenses are necessary to capture action across the large playing field.

Because of their weight and physical size, such long lenses are impossible to handhold. Instead of a bulky tripod, sports photographers typically use a monopod for support, **Figure 11-22.** The monopod is easily repositioned and steady enough for sharp images.

Medium and long telephoto lenses are attached to a monopod or tripod with a *lens collar* rather than the tripod mounting screw on the camera body. See **Figure 11-23.** This attachment method prevents strain on the lens mount from the weight of the lens, as well as providing better balance for the camera/lens unit.

Indoor sporting events usually involve a smaller playing area, so photographers are closer to the action. Offsetting the shorter distances, however, is the generally lower light level of indoor venues. A sports photographer often must supplement ambient light with a portable flash. In addition to providing enough light for proper exposure, flash may also freeze motion for

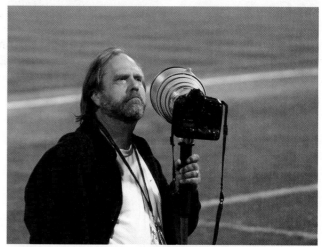

Jack Klasey/Goodheart-Willcox Publisher

Figure 11-22. This sports photographer is using a telephoto lens on a monopod to shoot a baseball game.

Courtesy of Nikon, Inc., Melville, New York

Figure 11-23. An 800 mm lens with an integral lens collar for tripod mounting.

dramatic effect. An example is the water droplets around the swimmer in **Figure 11-24**. Sports officials may sometimes restrict the use of flash for the safety of the athletes or in situations where the flash could adversely affect competition.

Soft News Photography

Newspapers frequently carry human interest stories about the activities of individuals or groups. An example is a feature on a person with an interesting leisure activity, such as rock climbing, **Figure 11-25**. Photo illustrations for human interest stories usually include an informal portrait of the subject, and possibly one or more illustrations of the person involved in the activity.

Different techniques are used for the various types of illustrations. The informal portrait may be taken indoors with flash or studio-type lighting or outdoors with ambient light and fill flash to open up dark shadows. Depending on the location and lighting, photos of the subject involved in an activity can be shot with available light, possibly supplemented by flash or a reflector. If the subject is a collector, photos of the collectibles vary considerably in their requirements. Small or intricate items obviously require different lighting and shooting techniques from antique autos, **Figure 11-26**.

Jack Klasey/Goodheart-Willcox Publisher

Figure 11-24. Due to the low light level, a flash was necessary for this shot at a high school swim meet.

Jack Klasey/Goodheart-Willcox Publisher

Figure 11-25. This image was made to illustrate a feature story on the subject's rock-climbing hobby.

Jack Klasey/Goodheart-Willcox Publisher

Figure 11-26. Illustrations for stories on collectors require different approaches. A—Souvenirs from the 1893 Columbian Exposition. B—An antique auto displayed at an outdoor car show.

Sometimes, a photojournalist shooting a soft news assignment might be asked to keep certain information confidential. For example, a collector might show the photographer a particularly rare or valuable item, but ask him or her to avoid mentioning or picturing it in the story because of concerns about theft. Such ethical questions more often occur in hard news coverage, however.

Seasonal photos are a staple item for most publications. These may be scenic shots of trees blazing with fall color or a garden displaying spring flowers in bloom. Shoppers at the local farmers' market are a popular subject, **Figure 11-27**. Holidays provide colorful and high-interest photo opportunities, such as decorated houses, children on an Easter egg hunt, or Independence Day fireworks, **Figure 11-28**.

Picture Stories

A *picture story* consists of feature-type photos that carry out a theme. In purest form, a picture story, sometimes called a *photo essay*, relies on the photos and their accompanying captions to "tell the tale." While there may be an introductory paragraph or two, the emphasis is on the pictures. The heyday of the pure picture story was the mid-twentieth century, when several large format magazines were devoted to that form, **Figure 11-29**. Today, magazines use photos primarily as illustrations for written articles.

Jack Klasey/Goodheart-Willcox Publisher

Figure 11-28. Fireworks are a seasonal favorite for both photojournalists and amateur photographers.

Jack Klasey/Goodheart-Willcox Publisher

Figure 11-29. Pictorial magazines filled each issue with picture stories. This 1950s spread shows shipwreck survivors being rescued.

School Event and Yearbook

For a student, photojournalism opportunities usually involve shooting for the school newspaper, yearbook, website, or Facebook page. The newspaper and yearbook may be a specific class in the English or the Fine Arts department or an extracurricular activity relying on volunteers.

Jack Klasey/Goodheart-Willcox Publisher

Figure 11-27. The interaction of buyers and sellers at a local farmer's market.

Activities such as assemblies or concerts provide a wealth of subject matter. For such events, a good strategy is to shoot a variety of types of shots. Examples include wide-angle overall views of the activity, medium shots of groups within the larger activity, and close-up shots of individuals taking part, **Figure 11-30**.

Yearbook photography often involves group portraits of various clubs or classes. When shooting posed groups, a tripod is recommended. This allows you to set up the shot and frame it, then make any needed adjustments before shooting. Using a tripod also permits you to make a number of exposures under identical conditions. This is useful to get the best expressions on the faces of the subjects (nobody with eyes closed, for example), as well as allowing exposure bracketing and white balance bracketing.

Figure 11-30. A variety of shot types help tell the story of an event, such as a school band concert. A—A wide shot showing the overall activity. B—One section of the band. C—A solo performer.

Covering school sports is usually an important part of student photojournalism. Although a good sports photo is worth using no matter whom it features, try to concentrate on members of your school's team, **Figure 11-31**. Since you are unlikely to have a very long telephoto lens, find a location close to where the action is most likely to take place—the soccer goal, the home team basket, first base, near the football sideline, at the volleyball net, or by the track finish line. Do not neglect high-angle and low-angle viewpoints to provide visual variety. Lie on the ground and shoot upward to isolate hurdlers or high jumpers against the sky or climb up in the stands for a bird's-eye view of the action, **Figure 11-32**.

Do not just shoot the action on the field or court. Look for photo opportunities like those shown in **Figure 11-33**. The yearbook or newspaper editor will appreciate the extra shots you take.

Other Event Photography

Our lives are filled with events that are worth photographing, from community activities to family celebrations. Shooting such events can be considered a form of photojournalism, since you are recording activities for future reference or for the enjoyment of others who will view your prints or see your images on social media.

Be particularly careful to avoid violating the privacy of your subjects when posting images to social media or otherwise displaying your photos. Be sensitive to the content of your photos—

Jack Klasey/Goodheart-Willcox Publisher

Figure 11-32. Try for different viewpoints when shooting events.

avoid depicting racial or gender stereotypes, showing people in embarrassing situations, or emphasizing physical defects.

Community Events

Most communities have one or more public celebrations each year. These may be a commemoration of a historic event, an ethnic festival, or an activity related to a major competitive event, such as a balloon rally or an auto race. An important event in rural areas is the annual county fair, which includes agricultural displays and competitions, contests of various kinds, concerts, and carnival rides, **Figure 11-34**.

These events provide opportunities to perfect your photographic skills under a variety of conditions. Parades lend themselves to various ways of recording the activity, **Figure 11-35**.

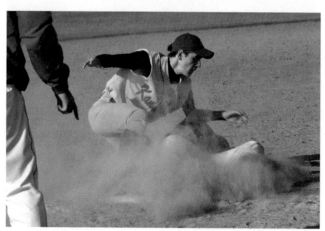

Jack Klasey/Goodheart-Willcox Publisher

Figure 11-31. When covering school sports, try to feature players from your school.

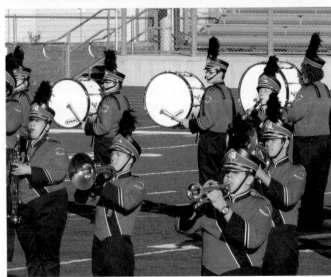

Figure 11-33. Besides action on the field or court, sporting events provide many "photo ops" for a student photojournalist.

Jack Klasey/Goodheart-Willcox Publisher

Figure 11-34. When photographing a carnival scene at twilight, meter the sky near the horizon as a starting point, then bracket exposures. A 1 1/2 second exposure blurred moving rides and some of the people on the midway.

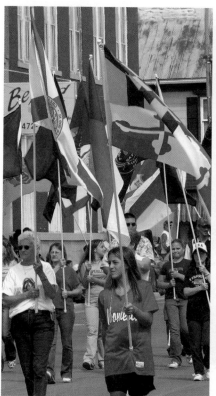

Jack Klasey/Goodheart-Willcox Publisher

Figure 11-35. A parade can be covered photographically in many different ways.

Flea markets or swap meets are good places to practice candid street photography, **Figure 11-36**.

Competitions such as auto and boat races, kite flying, cycling, and rodeo riding are colorful and allow you to perfect action-shooting techniques, **Figure 11-37**. Indoor events under stage lighting, such as dance performances and concerts, require good timing, a steady hand, and the ability to shoot using only available light, **Figure 11-38**.

Figure 11-38. The stage lighting at this concert was sufficient to capture a close-up portrait of a violinist deep in concentration on her music.

Family Milestones

Events such as weddings, birthday parties, and the birth of a child are usually photographed by one or more family members "for the record."

Figure 11-36. Customers examine merchandise at a community sale.

Figure 11-37. Photographing competitions, like hydroplane racing, requires good timing and composition skills.

If the event is indoors, flash is almost always necessary to obtain proper exposure. If flash is not permitted, shoot at the widest available aperture and lowest ISO that permits a shutter speed fast enough to avoid camera shake.

When photographing a new mother and her baby, move in to fill the frame with the subjects, since hospital backgrounds are typically cluttered and distracting. If possible, capture the infant with his or her eyes open (the flash will not cause any harm). See **Figure 11-39**. Today's more sophisticated digital cameras automatically adjust the duration of the flash. This results in a more natural and correctly exposed subject.

For birthdays and similar celebrations, you will likely take the traditional shots, such as blowing out the candles. You should also include as many photos as possible of friends and relatives interacting with the person being honored.

Jack Klasey/Goodheart-Willcox Publisher

Figure 11-40. Try to find a vantage point for your shot that does not interfere with the professional hired to shoot the wedding.

At weddings, **Figure 11-40**, a professional photographer is usually present to record the ceremony and its accompanying activities. Since the photographer was hired to produce professional results, attendees with cameras should avoid interfering with the pro. Some professionals are disturbed when wedding guests shadow them, copying each setup shot; others consider it to be a minor annoyance. Be courteous to the photographer and to the bride and groom—do not act like a member of a paparazzi pack closing in on a celebrity. If you want to photograph the same scenes as the professional, such as the couple cutting the wedding cake, take your shot after she or he has captured the image.

Street Photography

Life on the streets of a community, showing people engaging in various activities, has long been a favorite subject for photographers. Performers, **Figure 11-41**, are colorful additions to an urban street scene, but even a quiet view of

Jack Klasey/Goodheart-Willcox Publisher

Figure 11-39. Catching the baby with eyes open adds to the quality of this photo.

Figure 11-41. This mime, in traditional whiteface, performs on a street in Paris' Montmartre neighborhood.

Figure 11-42. This tranquil view of a man relaxing in front of a barbershop was shot from the window of a passing vehicle.

a man seated in front of a barbershop tells a story about city life, **Figure 11-42**.

Street photographers use a variety of techniques to capture unposed shots of their subjects. Some work from a distance, using a telephoto lens. Others use shorter lenses while walking along the street or standing at a convenient vantage point, such as a traffic island or building doorway, **Figure 11-43**. Digital cameras with pivoting LCD viewfinders can be held at waist level to be less obtrusive or to provide a different angle.

Interesting shots can be made from a moving vehicle. However, for safety reasons, never use a camera while driving.

If possible, open the window and set a shutter speed high enough to compensate for the vehicle's movement. Do not support the camera by resting it or your arms on the door or windowsill of the vehicle, because vibration transmitted from the street or the engine can cause camera movement and blur.

Figure 11-43. A painter touches up a doorway, unaware of the photographer shooting from across the street.

If you cannot open the window, hold the camera's lens as close as possible to the glass without touching it to prevent capturing reflections. This position also helps the camera's autofocus system avoid focusing on the window rather than the scene you are photographing. See **Figure 11-44**.

Working with Flash

Action and event photography often requires the use of a portable light source, or electronic flash unit. Flash units are the primary source of portable artificial light for most photography. They provide ease of use, greater light output, and rapid repeatability.

Electronic flash units are based on a simple circuit, **Figure 11-45**. A strong electrical charge is built up in a storage device called a *capacitor*. When the camera's shutter release is pressed, a trigger

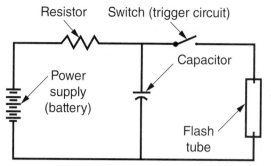
Goodheart-Willcox Publisher

Figure 11-45. Electronic flash circuit.

circuit causes the accumulated electrical charge in the capacitor to discharge. An electrical pulse is released into a gas-filled flash tube, producing a burst of bright light synchronized with the opening of the camera shutter. The flash unit will then *recycle* (rebuild the capacitor's electrical charge).

Types of Flash Units

Built-in flash is found in most compact digital cameras, camera phones, and many consumer-level SLR cameras, **Figure 11-46**. While they are convenient for snapshots, they are limited in capability for serious artificial light photography.

Self-contained flash units can be divided into two broad categories:

- Small units designed for mounting on a camera's hot shoe.

- Larger, more powerful units attached to the camera with a removable bracket.

Jack Klasey/Goodheart-Willcox Publisher

Figure 11-44. Shooting through glass. A—Placing the lens very close to the glass of a train window eliminates reflections and allows the autofocus system to function properly. B—Moving the lens away from the window allows reflections to appear, partly obscuring the scene outside.

Courtesy of Nikon, Inc., Melville, New York

Figure 11-46. Built-in pop-up flash on a compact camera.

The first type is widely used by amateur and professional photographers alike. The second type is primarily a professional tool.

Shoe-Mount Flash Units

To synchronize the shutter release and flash trigger circuit of a separate flash, a *hot shoe* is usually provided on top of the camera. Electrical contacts on the hot shoe mate with those on the flash unit, triggering the flash when the shutter release is pressed.

Shoe-mount flashes, **Figure 11-47**, are available from camera manufacturers and from third-party equipment makers (those whose units can be used with various camera brands). These flashes vary in light output, physical size, mechanical design, and degree of automated operation.

Light output is measured scientifically in beam candlepower-seconds (BCPS), but from a practical photographic standpoint, the *guide number* is generally used. The guide number is determined by the flash manufacturer and relates the light output to the ISO rating being used. For manual flash operation, the proper flash exposure is calculated by dividing the guide number by the flash-to-subject distance to yield the proper f-stop.

On some shoe-mount flash units, the flash head is fixed at a right angle to the body. On others, the flash head can be pivoted to point upward at an angle or even straight up, **Figure 11-48**. The pivoting head provides greater flexibility, allowing the photographer to soften the light by bouncing it off the ceiling or another surface.

A variation is the ringlight flash, which is used for close-up and macrophotography. The flashtube encircles the front of the lens to provide even, shadowless light. The flash body containing the electronic circuitry mounts on the hot shoe and is connected with a flexible cable to the flashtube.

Today's shoe-mount electronic flash units are highly sophisticated, with many automated features. The most fully-featured products are the *dedicated flash units* designed for use with specific camera models or a range of models from one manufacturer. These units fully automate the process of flash photography, setting the proper aperture and shutter speed and adjusting the duration of the flash by measuring the light reaching the image receiver. Because of their metering method, such dedicated units are often referred to as through-the-lens (TTL) flash systems, **Figure 11-49**.

Vivitar

Figure 11-48. Many shoe-mounted flash units are designed with a pivoting head that can point straight forward, straight up, or at one or more angles in between.

Courtesy of Nikon, Inc., Melville, New York

Figure 11-47. Small flash units are designed for mounting on a camera's hot shoe or similar camera-top locations.

Dedicated flash units offer many other features, such as automatic fill flash and compensation for different zoom lens focal lengths. Most third-party flash makers offer special modules that provide dedicated operation for some of their flash units.

Handle-Mount Flash Units

Professional photographers who require high light output, durability, and the ability to use different types of power usually select a larger handle-mount flash unit, **Figure 11-50**. These units are physically much larger than shoe-mount types and are connected to the camera with a sync cord.

Wedding photographers and photojournalists need power sources that can provide numerous full-power flashes and permit fast recycling of the capacitor. Handle-mount flash units typically can be used with a number of power sources, ranging from multiple AA batteries to household current. Many photographers consider a belt-mounted *high-voltage power pack* that uses special rechargeable batteries to be most practical. Spare charged batteries can be quickly substituted as needed.

Metz

Figure 11-50. Many professionals use powerful handle-mount flash units like this one. The high light output permits photography under low-illumination conditions.

Flash Techniques

Many amateur photographers aim the flash straight at the subject from a position directly over or right next to the lens. This *direct flash* method almost guarantees an unflattering photograph.

Direct flash creates a number of problems in an image:

- Harsh, flat lighting.
- Unattractive shadows.
- Burned-out foreground details.
- Red eye.

The only advantage of direct flash is ease and convenience of use—wherever the camera is pointed, the light goes as well. For people interested primarily in taking snapshots of friends, family, pets, or vacation activities, the quality of the lighting may not be an issue. From observing results of their own and friends' photography, they expect flash pictures to look that way, **Figure 11-51**.

Direct flash commonly results in a *red eye* appearance caused by light reflecting back from the retina of the subject. See **Figure 11-52**. Many cameras offer a red-eye reduction feature for built-in flash units. A series of short, low-power flashes occur while the camera is autofocusing in order

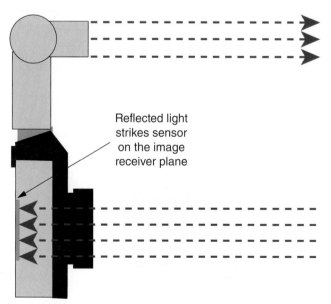

Reflected light strikes sensor on the image receiver plane

Goodheart-Willcox Publisher

Figure 11-49. For precise control of flash exposure, TTL flash units evaluate the amount of reflected light reaching the camera's film plane. Once sufficient light has fallen on the image receiver plane sensor, the flash is cut off.

Jack Klasey/Goodheart-Willcox Publisher

Figure 11-51. Direct flash can produce harsh light and distracting shadows.

to make the subject's pupils contract before the main flash is triggered. Since the pupil opening is smaller, less red light is reflected back. This method reduces red eye but does not eliminate it.

Shoe-mount flash units can be used in a way that not only eliminates red eye, but

overcomes the other problems of direct flash. The simplest method for improving results with an on-camera flash is to diffuse or soften the light it produces. Diffusion is accomplished by placing a translucent material, such as a white handkerchief or frosted plastic, over the flashtube, **Figure 11-53**. This causes the light rays to scatter, eliminating the harshness of the light. The diffusion material lowers the light output, making an exposure adjustment necessary with manual flash.

A second method is to remove the flash unit from the hot shoe and position it more effectively. By using a coiled sync cord, the photographer can move the flash a foot or more to one side of the camera or raise it. Some photographers hold the flash in one hand and operate the camera with the other, while others prefer to use an L-shaped bracket, **Figure 11-54**. The *off-camera flash* method eliminates not only red eye but troublesome flash reflections from eyeglasses, mirrors, and metal surfaces. The higher positioning of the light also throws shadows downward behind the subject and out of sight.

Bounce Flash

A softer and more pleasing lighting effect is made possible with *bounce flash*. In this technique, the light reaches the subject only after being bounced off something else. For example, the light can be directed at a light-colored ceiling and reflected to the subject, becoming much more diffused and even. See **Figure 11-55**.

Two important considerations in using bounce flash are the flash-to-subject distance and the color of

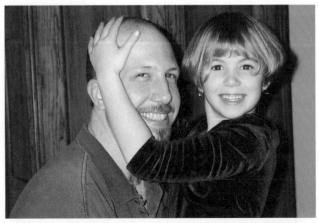

Jack Klasey/Goodheart-Willcox Publisher

Figure 11-52. Red eye is caused by flash located directly above the lens.

Jack Klasey/Goodheart-Willcox Publisher

Figure 11-53. A light diffuser mounted on the flash unit.

Vivitar

Figure 11-54. Moving the light source to one side of the camera will eliminate most of the problems encountered with direct on-camera flash.

the reflecting surface. Dedicated or automatic flashes compensate for the greater distance the bounced light travels, but users of manual flash units must take that factor into account. In addition to calculating the f-stop based on the increased distance, you must open up one or two stops to account for the loss of light due to scattering from the reflecting surface. To be safe, bracket exposures when using this technique.

Beware of reflecting a color cast onto your subject from a strongly colored reflecting surface. Also, avoid very dark surfaces that absorb rather than reflect much of the light.

When a suitable reflective surface is not available, you can provide your own, **Figure 11-56**. If an assistant or some form of stand is available, a piece of stiff white card several feet square can serve as a reflector. The flash unit is reversed so it points at the reflective surface rather than the subject.

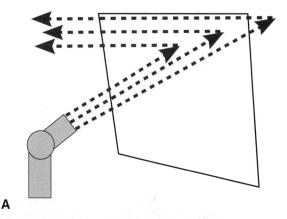

A

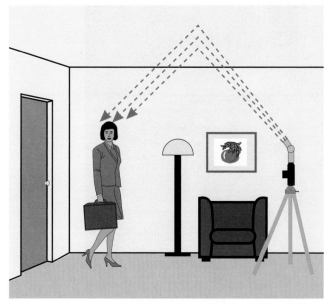

Goodheart-Willcox Publisher

Figure 11-55. Bounce flash can help light your subject evenly and avoid harsh shadows.

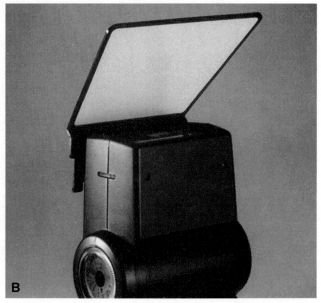

B

Porter's Camera Store

Figure 11-56. Alternate methods of bouncing light. A—A large square of white card can reflect light onto the subject. B—A bounce card directs most of the flash unit's light output toward the subject.

A device that is simple to make is a bounce card. A small piece of white card stock is fastened to the flash head. The head is pointed straight up, and the card bent to extend over it at about a 45° angle. When the flash is triggered, most of the light bounces off the card in the direction of the subject. A rigid plastic version of the bounce card is available commercially.

Open Flash

Most flash techniques rely on synchronization to make sure the flash is triggered while the shutter is fully open. *Open flash* requires no synchronization, since the shutter is held wide open and the flash triggered manually one or more times. This method is most effective when there is little or no ambient light to cause additional exposure.

For effect, flash and ambient light exposures may be combined. An example is a faintly moonlit scene in which a single feature, such as a plant or person, is given prominence by the use of flash exposure. See **Figure 11-57.**

Painting with light is an open flash technique typically used in large, dimly lighted spaces, such as church interiors. The basic procedure is to lock open the camera lens, and then illuminate the subject with a series of flashes. Care must be taken to avoid overlapping the different light bursts to prevent localized overexposure and to avoid silhouetting the person holding the light against the illuminated background.

Multiple Flash

Lighting a large or complex subject can also be accomplished with multiple flash units.

Figure 11-57. The shutter was left open long enough for the overall scene to be exposed by ambient light, then a single burst of light gave the blooming yucca plants prominence.

Two or more flash units can be physically connected with sync cords to fire simultaneously. However, *slave units* are a more reliable and flexible method of control.

A slave unit may be a small flash specifically designed for such use or an adapter connected to a conventional electronic flash, **Figure 11-58**. In either case, the actuating device is a photoelectric cell that responds to the bright burst of light from the master flash that is connected to the camera. The photoelectric cell causes the slave unit flash to fire instantaneously.

For more complex multiple flash situations, radio slaves are often used. These consist of a transmitter mounted on the camera and receivers used to trigger the flash units. See **Figure 11-59**.

LPA Design photo by Zachary Gauthier

Figure 11-59. A radio slave transceiver that can be used as either a transmitter or a receiver attached to remote flash units.

Vivitar

Figure 11-58. A small flash slave unit.

Portfolio Assignment

Stop It!

Depending on the season, choose an outdoor sport and practice shooting subjects in motion, such as a baseball pitcher, tennis player, or runner. Set your camera to shutter priority mode and experiment with shutter speeds to produce varying amounts of motion blur and to completely stop motion. Select two of your best images—one with motion blur and one with stopped motion. Print the images and label each with the shutter speed you used. Add them to your portfolio.

Review Questions

Answer the following questions using the information provided in this chapter.

1. List the four categories of action and event photography.
2. What did Alfred Eisenstaedt mean when he described his approach to photography as "f/8 and be there"?
3. In action photography, the point at which motion slows almost to a stop is called the _____.
 A. decisive moment
 B. sweet spot
 C. action key
 D. peak of action
4. A manual technique used to track a moving object is known as _____ focus.
5. When shooting a sport with unpredictable movement, such as soccer, _____ focusing is a useful technique for capturing the action.
6. To capture a moving subject in sharp focus while blurring the background, you would use a technique called _____.
 A. following
 B. panning
 C. zooming
 D. shifting
7. Most photojournalists are photographers who work for _____.
8. List three important skills for a photojournalist besides photographic knowledge.

9. Which of the following is *not* an example of a hard news assignment?
 A. A fire in an apartment building
 B. A car accident
 C. A fashion show
 D. The scene of a crime
10. Describe the challenge that faces a photojournalist when shooting routine events, such as civic luncheons or award ceremonies.
11. Why would a professional photographer use a monopod when shooting a sporting event?
12. What is the best photographic strategy for covering a school activity, such as an assembly, for the yearbook?
13. For a student photographer, what is the advantage of shooting at community events, such as parades, festivals, sports competitions, fairs, or carnivals?
14. Why are self-contained portable electronic flash units preferable to built-in flash?
15. _____ shoe-mount flash units are designed for use with specific camera models or range of models from one manufacturer.
16. To calculate proper exposure for manual flash, the guide number is divided by _____.
17. Flash units that adjust flash duration by reading reflected light at the film plane are called _____ systems.
18. For a softer and more pleasing lighting effect, many photographers use _____ flash instead of direct flash.
 A. bounce
 B. remote
 C. reduced power
 D. indirect

Suggested Activities

1. Organize and conduct a meeting of students interested in starting a newspaper at your school. At the meeting, set up committees to plan various aspects of the project.

2. As a small group project, plan and create a photo story entitled "One Day at Our School." Make prints and arrange them on a timeline displayed in a school hallway.

3. Dr. Harold Edgerton was a professor of Electrical Engineering at the Massachusetts Institute of Technology. What was his important contribution to photography? Do research to find out, and share your findings in an oral report to your photo class.

Critical Thinking

1. While reviewing photos you shot at an event for inclusion in the school yearbook, what types of sensitive content should you watch for that may make a photo unsuitable to print in the yearbook?

2. Observe a fast-moving sport, such as basketball or hockey, and think about how you would create a single image that captures the essence of the game. What viewpoint would you choose? Would you employ motion blur or freeze the action?

Communicating about Photography

1. **Speaking and Writing.** Research the National Press Photographer's Association Code of Ethics. In an oral or written report, use your own words to explain the contents of the code to the class.

2. **Speaking and Art.** Using pictures from magazines and newspapers, create a collage that helps you remember the difference between hard news and soft news photography. Show and discuss your collage in a group of four to five classmates. Are the other members of your group able to determine the difference between the two types of photography that you tried to represent?

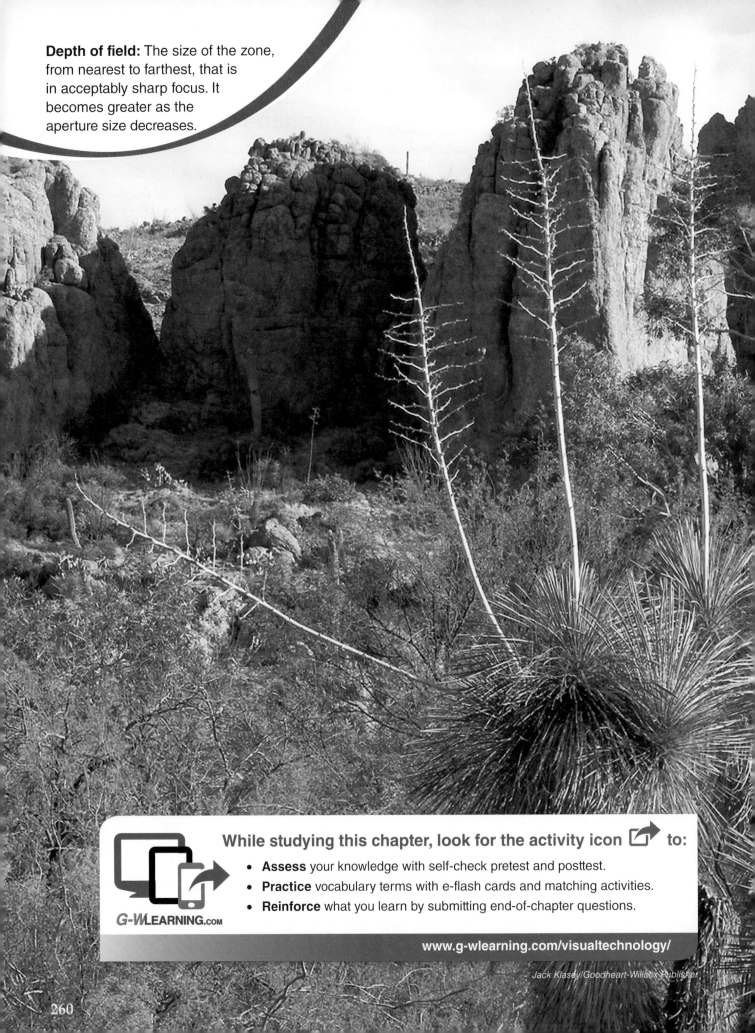

Depth of field: The size of the zone, from nearest to farthest, that is in acceptably sharp focus. It becomes greater as the aperture size decreases.

While studying this chapter, look for the activity icon ↗ **to:**

- **Assess** your knowledge with self-check pretest and posttest.
- **Practice** vocabulary terms with e-flash cards and matching activities.
- **Reinforce** what you learn by submitting end-of-chapter questions.

*G-W*LEARNING.COM

www.g-wlearning.com/visualtechnology/

CHAPTER 12

Outdoor Photography

Objectives

When you have finished reading this chapter, you will be able to:

- Identify the types of subjects covered by the term *outdoor photography.*
- Describe the importance to photographers of the lighting conditions surrounding sunrise and sunset.
- Understand the reasons for using a tripod when photographing landscapes.
- Explain why manual exposure, focus, and white balance controls should be used when shooting a panorama with a digital camera.
- Describe the environmental precautions to be observed when photographing plants and animals.
- Compare the effects of different shutter speeds on the appearance of water in motion.
- Compare the various types of close-up equipment and identify the most suitable use for each type.

Check Your Photography IQ ➦

Before you read this chapter, assess your current understanding of the chapter content by taking the chapter pretest.

www.g-wlearning.com/visualtechnology/

Technical Terms ➦

catchlight
close-up range
flare
focusing rail
landscape photography
macro photo range
magnification rate
mirror image

nature photography
nodal point
outdoor photography
panorama
photomicrography
reversing ring
windbreak

For most photographers, the term *outdoor photography* covers two broad areas—landscapes and wildlife. For this reason, it also is often referred to as *nature photography*, since it deals with all aspects of the natural world.

Landscape Photography

When you hear the term *landscape photography*, what picture comes to mind? You probably visualize a grand vista, such as a mountain range or a river with whitewater cascading through masses of rocks, **Figure 12-1.** But what about smaller, more intimate views, such as a single windswept tree clinging to a cliff face or a pattern of bright-colored lichen on a boulder? These, too, are examples of *landscape photography*, which is defined as recorded views of the natural world in any of its aspects. While most landscape views feature the vegetable and mineral kingdoms (rocks and plants), the animal kingdom also may be represented as a part of a scene. For example, a view of peaks in the Swiss Alps that includes a mountain goat in the middle ground would be considered a landscape. If the mountain goat was the main subject, however, the image would be considered an animal or wildlife photo. Animal photography is covered later in this chapter.

Grand Vistas

Before digital technology made it possible to review an exposure on the camera's LCD screen, many photographers were disappointed when their landscape photos came back from the film processor. Their pictures seemed flat and dull, not at all like the stunning views they remembered from the scenic overlook.

The problem was most likely the focal length of the lens used to take the photo. When attempting to record a large scene, the natural tendency is to choose a wide angle lens to "get it all in." The wide angle captures a broad, distant scene like the wind-eroded rocks of Bryce Canyon National Park, but emphasizes the foreground rather than the more distant formations, **Figure 12-2A.** The human eye and brain process the scene differently, minimizing the bland foreground.

The solution to this wide-angle lens problem is to include an interesting foreground object that

Jack Klasey/Goodheart-Willcox Publisher

Figure 12-1. This impressive expanse of whitewater and rugged rocky outcrops on the Potomac River is only a few miles upstream from Washington, DC.

Figure 12-2. Foreground improvement. A—The wide angle lens used to record this scene emphasized the uninteresting foreground, instead of the colorful rock formations. B—Including a sharply focused, visually interesting object in the foreground improves the photo by giving it a greater sense of depth.

will give the photo increased depth and visual interest, **Figure 12-2B**. With a small aperture and careful focusing, the wide angle lens allows you to have both the foreground object and the distant subject in acceptable focus.

Another possibility is to use a longer focal length to bring the distant subject closer, and then shoot several overlapping horizontal shots to form a panoramic view. This can be done with film, but is far simpler with digital images that can be merged in the computer.

Panoramic Views

A *panorama* is an extremely wide view of a scene, typically a landscape. The term, derived from ancient Greek roots, means *to see all*. Panoramic prints have been made from film for over 100 years.

Film Technique

The simplest way to create a panoramic view with a film camera is to shoot the desired scene with a wide-angle lens, then crop the resulting print to a long, narrow form, **Figure 12-3**. If the original is shot on 35 mm film, however, the size of the resulting print will be limited. For very large prints, a medium format or large format negative will give better results.

An old technique used to create negatives in panoramic form employed a rotating lens and a slit-type shutter to "paint" the exposure across a long strip of film. Special cameras using this method are still available, **Figure 12-4**.

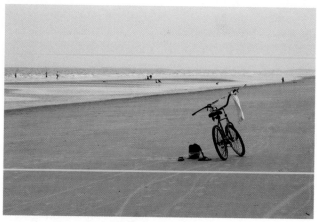

Figure 12-3. Cropping to panoramic form.

Figure 12-4. A modern panoramic film camera.

Digital Technique

Digital panoramas are created from individual files merged together in sequence to create the finished image. See **Figure 12-5**.

Figure 12-5. A panoramic view shot in Rocky Mountain National Park. A–G—The seven individual exposures that were stitched together. The camera was mounted on a tripod and carefully leveled, and then each shot was overlapped by about one-quarter of its width. The overlapping helps the merge software achieve a smooth, seamless look. H—The resulting panorama covers a vista many miles in width.

Most image manipulation software includes a panorama-making feature, and separate stitching programs are also available. A panorama may be horizontal or vertical. The image can be taken with a lens of any focal length and can cover a scene distance measured in inches (flower close-ups) to miles (a mountain vista).

Distant scenery panoramas are easier to create successfully than close-up views because of distortion problems. A camera's tripod socket is typically located directly below the image receiver plane. As the camera is rotated to capture the individual shots, the distance to the subject varies slightly. The extreme ends will be farther away than the center shots. The result is an alignment problem—adjacent image edges will not line up precisely. When the subject is reasonably far away, the alignment problem usually is slight. In a close-up, however, the minor difference in edge matching will stand out. To avoid this problem, the camera must be mounted so its center of rotation is beneath the ***nodal point***, or optical center, of the lens. This is the point, inside the lens barrel, where the incoming light rays converge and turn the image upside down. Specially designed tripod mounts, **Figure 12-6**, permit positioning the center of rotation beneath the nodal point.

When shooting panoramas, follow these basic guidelines:

- Choose a subject and a composition with distinct starting and ending points and interesting subject matter in between.

- Carefully level the tripod and camera. Some tripod heads include bubble levels. A level that mounts on the camera's hot shoe also is useful. Level the setup with the camera pointed at the center of the composition, and then slowly move it through the arc that you will use when shooting. Watch the level and make any necessary adjustments.

- Select a focal length ranging from a moderate wide angle to a long normal lens (between 28 mm and 75 mm is best). Wider lenses may introduce distortion, and longer lenses are more subject to sharpness-robbing vibration.

- Use your camera's autoexposure lock function to keep exposure consistent throughout the panorama. Instead, you may wish to turn off autoexposure and set exposure manually.

- Avoid automatic white balance (AWB) because it can shift color temperature from frame to frame. Instead, choose an appropriate white balance preset or use a custom white balance.

- Use manual focus instead of autofocus. Focus carefully for the first image, and then check focus on each succeeding image. Make minor adjustments as needed.

- Prevent an unintended shift in focal length when using a zoom lens. Use a piece of tape to lock the lens barrel.

- Overlap adjoining images between 20% and 50% so the stitching software can merge them.

If you are shooting similar material before or after your panorama, include marker frames. These blank frames make it easier to find the sequence of images. Before your first panorama shot, cover your lens and shoot a blank frame. Repeat the process after your last panorama shot. When you transfer the images to your computer for processing, it will be easy to tell which images make up the panorama.

SUNWAYFOTO

Figure 12-6. A tripod mount for panoramic photography.

Landscape Shooting Tips

For a landscape photographer, the angle and intensity of the light striking the subject can make the difference between a successful photograph and an unsuccessful one. The dramatic difference light direction can make is shown in **Figure 12-7.**

The color of the light can also be a strong factor in the success of your photo. On a sunny day, midday light is harsh, creating extreme contrast and adding a strong blue cast to shadows. Most photographers prefer the light of early morning and late afternoon, **Figure 12-8.** Often referred to as "the magic hour," the half hour before and after either sunrise or sunset provides a warm light that makes subjects almost glow.

Subjects reflecting the sun's light can be metered normally, but a different technique is necessary when the sun will be in the photo. If the sunrise or sunset itself is the subject, meter a clear area of sky near the sun, but do not include the sun in the frame. Lock in that exposure, set it manually, then reframe to include the sun.

One danger of including the sun in the frame, or positioning it just outside the field of view, is *flare.* When the sun's rays strike the front element of a lens, reflections off internal elements of the lens result. These reflections are typically visible as ghost images or bright spots obscuring parts of the picture, **Figure 12-9.** Even when ghost images are not visible, flare causes an overexposed, washed-out appearance in the photo. To prevent flare, use a lens hood or shade the lens with a hand, hat, or other object.

To more dramatically render the sky during daylight hours, you can use a polarizing filter

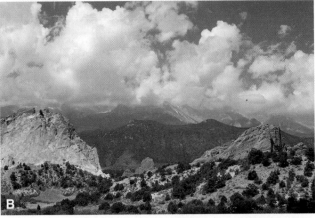

Jack Klasey/Goodheart-Willcox Publisher

Figure 12-7. Colorado's Garden of the Gods Park. A—Early afternoon sunlight placed the foreground rocks in shadow. B—Midmorning sunlight falling on the gateway rocks brings out their full, vibrant color.

to darken the blue of the sky and increase the contrast of clouds. The filter also can improve the color saturation of foliage and other shiny surfaces by eliminating light reflections.

Jack Klasey/Goodheart-Willcox Publisher; Larry Morris

Figure 12-8. Photography in the magic hour. A—Soft, warm light bathes a stand of pine trees shortly after dawn. B—Sunset and sunrise photos require careful metering to avoid overexposure.

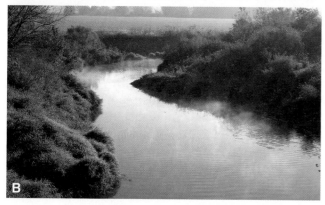

Jack Klasey/Goodheart-Willcox Publisher

Figure 12-9. Eliminating flare. A—Flare can give a scene a washed-out appearance and create ghost images. B—Shading the lens eliminates flare.

Whenever you shoot a scene showing the horizon, be sure that the horizon line is level in the viewfinder. When the horizon in a photo is tilted, **Figure 12-10**, the viewer is disoriented and made uneasy. Image-editing software can be used to make the horizon straight, but the best practice is to be sure it appears level before pressing the shutter release.

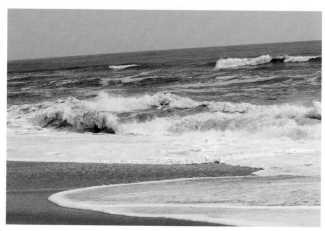

Jack Klasey/Goodheart-Willcox Publisher

Figure 12-10. With a tilted horizon line, the ocean surf appears to be flowing downhill.

Horizon placement in a photograph determines whether the foreground or the background is dominant. As shown in **Figure 12-11**, the horizon or other obvious dividing line may be placed high to emphasize the foreground, low to make the background more prominent, or in the center to provide a neutral, though static, appearance.

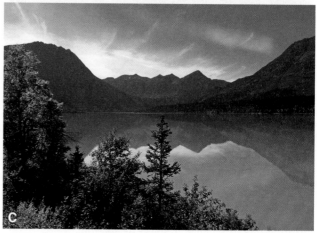

Suzanne M. Silagi

Figure 12-11. Horizon placement. A—High horizon line. B—Low horizon line. C—Centered horizon line.

Shooting with a telephoto zoom lens allows you to locate and fine-tune a smaller composition from within a larger scene, **Figure 12-12**. When using the longer end of the telephoto zoom (for example, 300 mm), a shutter speed of at least 1/500 second is required to avoid camera shake. Whenever possible, use a tripod, even with a high shutter speed. Your chances of a sharp image greatly improve.

Smaller-Scale Subjects

Smaller-scale landscape subjects are easily accessible, whether you are in an exotic location or your own neighborhood. The size of your subject often allows you to walk around it to find a viewpoint with the best composition and lighting, **Figure 12-13**. Some photographers do this search with the naked eye, while others find it easier to do preliminary framing through the viewfinder of a handheld camera. Once a viewpoint is established, the camera can be mounted on a tripod and the composition further refined.

Smaller-area subjects can usually be photographed with zoom lenses in the middle of the focal length range, typically 35 mm to 150 mm. This focal length allows you to fill your frame with a cascading woodland stream or to select a tighter view emphasizing water streaming around a boulder, **Figure 12-14**.

While grand vistas are usually shot as horizontal frames, smaller-scale subjects often lend themselves to being photographed in

Jack Klasey/Goodheart-Willcox Publisher

Figure 12-12. Selective framing. A—A small water reservoir in the Arizona desert makes a pleasant composition. B—Zooming in and reframing provides a vertical composition with the tree as its focal point.

Jack Klasey/Goodheart-Willcox Publisher

Figure 12-13. A smaller-scale nature study of plants growing in an old, decayed tree stump. The photographer tried several different compositions and angles before settling on this one.

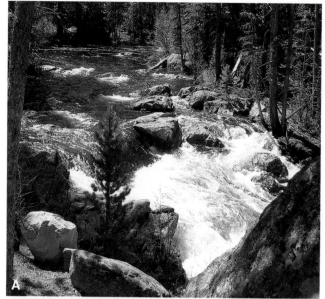

Figure 12-14. Different compositions from the same viewpoint. A—Wide view. B—Zoomed-in composition.

either horizontal or vertical formats. It is often worthwhile to shoot a subject both ways.

Flower Photography

A popular subdivision of landscape photography is shooting pictures of wildflowers and cultivated plants. Flowering plants appeal to the eye because of color, texture, shape, and structure. Another reason for their popularity as a subject is availability. Flowering plants can be found just about anywhere—from the desert to alpine tundra; in abandoned farm fields, prairie remnants, or even roadsides; and of course, in gardens both formal and informal, **Figure 12-15**.

Figure 12-15. Flowers can be photographed in many settings. A—An informal garden. B—Columbines in a forest setting. C—Lilies peeking through a picket fence. D—A formal English-style garden.

Flower photography requires careful control of both exposure and focus. Bright sunlight can result in extreme contrast, with the danger of overexposing lighter areas. White flowers can be particularly difficult to shoot, even with diffused light or in a shaded area. Since the tonal variations in a white flower are very subtle, even slight overexposure loses the texture of the lightest areas, **Figure 12-16**. Bracketing in 1/3 stop increments is usually sufficient, although sometimes decreasing exposure by one stop or more may be necessary.

Controlling focus is critical to photographic success. Your camera's autofocus system can sometimes be fooled, locking on to something other than the subject you want to be in sharp focus, **Figure 12-17**. On a digital camera, you can confirm the correct focus using the LCD. Most cameras allow you to zoom in and pan to check the captured image.

Selective focus is a useful tool when photographing flowers. By choosing a large aperture, such as f/2.8, you can create a very shallow depth of field that emphasizes a single flower or even a portion of a flower. The background may be extremely out of focus, or just soft enough to be recognizable as other blossoms but not visually competitive with the sharply focused subject. See **Figure 12-18**.

Strong emphasis is achieved when a subject is isolated from its background by lighting contrast. See **Figure 12-19**. Color can

Jack Klasey/Goodheart-Willcox Publisher

Figure 12-16. Keeping detail in light-colored and white flowers. A—The metered exposure provided good detail in the green foreground leaf and the more-shaded petals, but burned out the center and more brightly lit petals of the water lily. B—Decreasing the exposure brings out detail and texture.

Jack Klasey/Goodheart-Willcox Publisher

Figure 12-17. Autofocus systems sometimes select a focus point different from the one you want. In this case, the background evergreens were selected instead of the flowers.

Jack Klasey/Goodheart-Willcox Publisher

Figure 12-18. Two approaches to selective focus. A—The flower in the center is sharp, while the brick wall is soft, but recognizable. B—The very soft background, along with color contrast, adds to the impact of this crisply focused flower.

Jack Klasey/Goodheart-Willcox Publisher

Figure 12-19. Lighting contrast. A—The sunlit yellow desert flower stands out from the shadowed background of thorny stems. B—Backlighting creates a glow in the strands of milkweed seeds.

also provide visual emphasis, with a bright or warm-colored subject standing out against a surrounding of cooler, more-muted colors, **Figure 12-20**.

Still another form of emphasis can be provided by physical isolation. See **Figure 12-21** and **Figure 12-22**. Repetition, the opposite of isolation, can sometimes be used to make an interesting photo. Repeated forms or plant elements create a pattern, as shown in **Figure 12-23**.

Jack Klasey/Goodheart-Willcox Publisher

Figure 12-22. Shooting from below isolates these blossoms of Queen Anne's Lace against the sky.

Jack Klasey/Goodheart-Willcox Publisher

Figure 12-20. Color emphasis.

Jack Klasey/Goodheart-Willcox Publisher

Figure 12-21. Distant, misty hills form a soft backdrop to isolate the flowers and stems in the foreground.

Subject motion caused by the wind can be a problem, especially with close-ups. While some flower photography uses motion blur to good effect, close-ups are usually expected to be tack-sharp. The use of a flash can stop motion, but wildflower photographers normally prefer natural light, sometimes with a reflector for fill. If the light level is high enough, a faster shutter speed, such as 1/250 second or 1/500 second, can stop the subject's movement.

With conditions requiring lower shutter speeds, two strategies are possible—waiting for a lull or blocking the breeze. Wind seldom blows steadily for more than a few seconds. By using a tripod and waiting patiently, a photographer can make an exposure during a lull when the subject briefly remains still. A more efficient method is to block the wind. If an assistant is available, he or she can hold a sheet of poster board or similar material upwind of the subject and just outside camera range. If you are working alone, a *windbreak* that creates a zone of stillness around the subject often can be improvised from a collapsible reflector, plastic sheeting, a trash bag, or even an article of clothing.

Jack Klasey/Goodheart-Willcox Publisher

Figure 12-23. Repeated shapes form visually interesting patterns.

Insects and Flowers

Flowers and some insects have a close working relationship. Two common flower visitors (and thus, the most likely photo subjects) are butterflies and bees, **Figure 12-24**. Most often, you would use a telephoto zoom lens to take shots of insects on flowers, since moving in too close threatens them and causes them to leave. Since insects move quickly and erratically from flower to flower, mount the camera on a monopod to provide both support and easy movement to the best vantage point. Use aperture priority to gain the desired depth of field and manual focus for the greatest possible sharpness.

Figure 12-24. Insects and flowers. A—A colorful butterfly stands out against green leaves. B—Honeybees are vital to pollination of many plants.

Follow these environmental guidelines when photographing flowers and other plants:

- Step, kneel, or lie down carefully when composing your shot. Do not damage other plants while you are capturing your image.

- Do not uproot, prune, or break plants to improve your field of view. If necessary, use string to tie back intruding foliage, or hold it out of camera range with your free hand while releasing the shutter.

- Do not leave behind evidence of your visit. Return a site to the state in which you found it by removing all your debris.

Infrared Photography

Striking landscape photos in which sunlit grass and tree leaves appear as bright, ghostly white objects can be produced by capturing infrared light. See **Figure 12-25**. Infrared wavelengths of light are not visible to the human eye. They can, however, be recorded on a digital sensor or on film that has the proper sensitivity.

In a well-exposed and printed black-and-white infrared photograph, the leaves of green plants are bright white and appear to glow. Chlorophyll in the grass and leaves absorbs most of the visible light that strikes it, but reflects most of the infrared wavelengths. As a result, the leaves and grass blades are bright reflective objects and appear white.

Figure 12-25. Grass and leaves reflect almost all the infrared wavelengths, so they are recorded on film as strongly lighted objects—in black-and-white prints, they glow brilliant white.

To obtain the desired recording of infrared wavelengths, a filter is needed to absorb unwanted blue and violet wavelengths. The strongest infrared effects are obtained with the visually opaque Wratten 87, 87C, or 88A filters. Focusing cannot be done with the filter in place, so you must first focus and then mount the filter over the lens. More practical is the deep red Wratten 25 filter. Although it darkens the finder image considerably, focusing through the filter is still possible. The red filter absorbs blue and ultraviolet wavelengths. See **Figure 12-26**.

Figure 12-26. The photo at left was taken with panchromatic film; the one at right, with infrared film. Compare the way each film "sees" the different elements of the scene.

A further difficulty is the slight difference between the point of visible-light focus and the point of infrared focus. Some older lenses indicate the infrared focus position with a red dot, **Figure 12-27**. The image is focused normally, and the barrel is then rotated slightly to align the focused distance with the red dot.

Because infrared film is sensitive to such a wide spectrum, it must be handled in complete darkness from the time its packaging is opened until it has been developed and fixed. To avoid possible light fogging, keep a camera loaded with infrared film out of direct sunlight as much as practical.

Most digital cameras cannot be used for infrared photography because the manufacturer has installed an infrared-blocking filter in front of the image sensor. Cameras can be modified by having the blocking filter removed, but the conversion is costly and must be done by a trained technician.

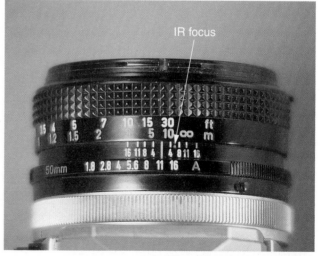

Figure 12-27. A red dot marked on the barrel of older manual-focus lenses is used to correct focus for infrared film.

To determine whether your camera can recognize and record infrared light, you can do a simple test using your television remote control, which emits a beam of infrared light to control the TV set. Point the remote at the camera, press one of the channel-changing buttons, and make an exposure. If the photo shows a bright light from the remote, your camera can detect infrared. If the light is dim or not visible at all, the camera has a blocking filter.

Water Photography

Water may be a part of a landscape photo, **Figure 12-28**, or it may be the primary subject of the picture. Moving water—surf, streams, or waterfalls—is a favorite subject for many photographers. A mirror-like lake surface or other form of still water also can result in a memorable photo.

Another aspect of water as a subject is weather. A rainstorm can be captured dramatically by shooting a downpour at a relatively slow shutter speed, usually 1/60 second or less. The resulting streaks of rain convey the feeling of a storm, **Figure 12-29**. Patterns made by raindrops falling on a pond are also a good subject, as are the glistening drops remaining on surfaces after the rainstorm has passed, **Figure 12-30**.

Jack Klasey/Goodheart-Willcox Publisher

Figure 12-29. This summer rainstorm was captured using a shutter speed of 1/30 second.

Jack Klasey/Goodheart-Willcox Publisher

Figure 12-28. A small stream meanders in an S-curve across a mountain meadow, drawing the viewer's eye into the landscape.

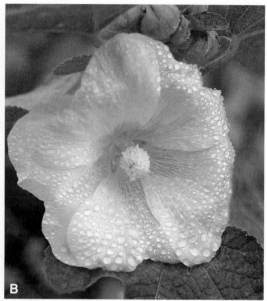

Figure 12-30. Rain effects. A—Ripples from scattered raindrops form a pattern of interlocking rings on the surface of a pond. B—A blossom is beaded with raindrops, like hundreds of tiny jewels.

Water droplets suspended in air (fog) lend a dream-like quality, especially when photographed in early-morning light, **Figure 12-31**. In cold-weather areas, photos of water in solid form, ice or snow, can be dramatic and often colorful, **Figure 12-32**. Exposure must usually be increased by 1 1/2 to 2 stops from the metered value to avoid underexposure.

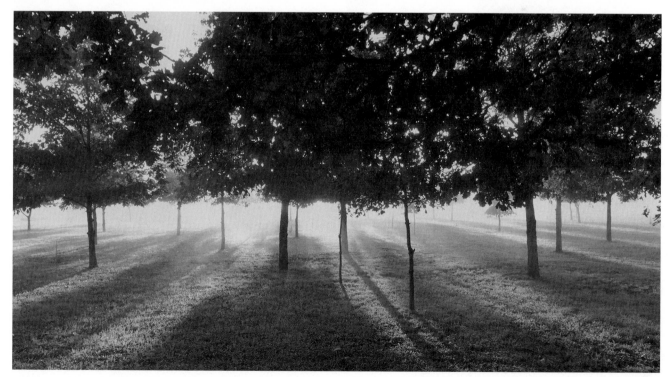

Figure 12-31. Fog and early morning light combine for a dramatic silhouetted view of an orchard. The image was captured with a camera phone.

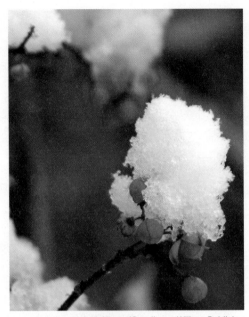

Jack Klasey/Goodheart-Willcox Publisher

Figure 12-32. White snow contrasts with the vivid red of dried bittersweet berries.

Water in Motion

Moving water holds a fascination for most people and poses a challenge to photographers, who must determine how best to capture the movement. Possibilities include sharply focused "stop-motion" streams and droplets, a strong-textured flow with some motion blur, and a soft, almost creamy flow. Each approach gives an image a different character. The degree of blurring is controlled by the choice of shutter speed. See **Figure 12-33**. Waterfalls lend themselves to wide shots, both horizontal and vertical, that convey the scope and power of the moving water. See **Figure 12-34**. A human figure can be included in the scene to provide a sense of scale, **Figure 12-35**.

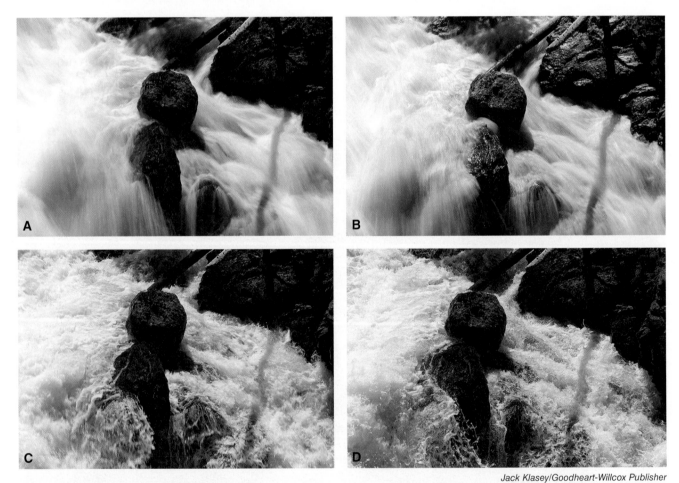

Jack Klasey/Goodheart-Willcox Publisher

Figure 12-33. Shutter speed changes the appearance of fast-moving water. A—A very slow shutter speed (1/5 second) blurs the water into a soft, creamy flow. B—At 1/8 second, streaks of flowing water are more well defined, but the overall effect is still soft. C—The water's texture is much more sharply defined at 1/100 second. D—At 1/320 second, the water is "frozen," and individual drops can be seen. In all four shots, apertures were adjusted to provide equivalent exposures.

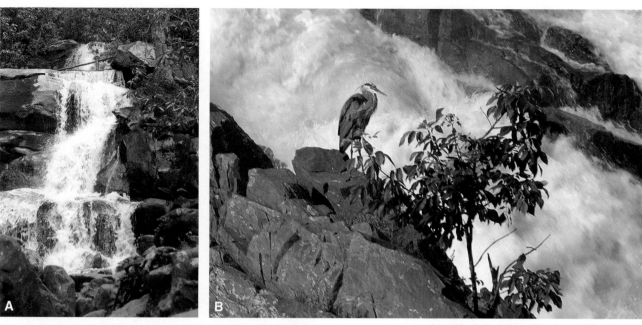

Larry Morris; Jack Klasey/Goodheart-Willcox Publisher

Figure 12-34. Vary format to suit the subject. A—This waterfall is a natural for a vertical format. B—The diagonal movement of water across this horizontal image is balanced by the still figure of a great blue heron.

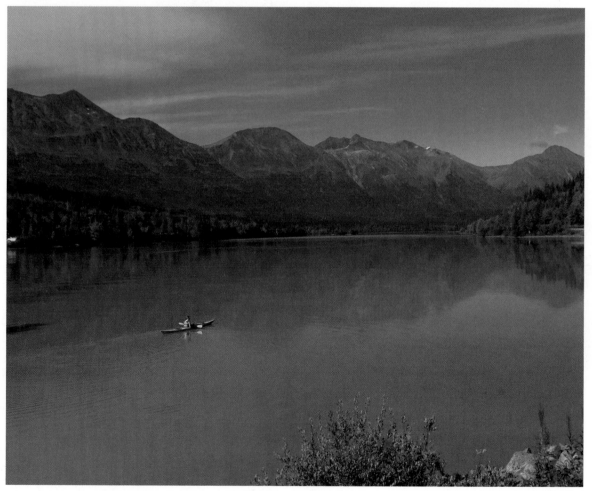

Suzanne M. Silagi

Figure 12-35. The tiny figure in the kayak provides a scale reference for this Alaskan scene.

Falling water is broken into tiny droplets, forming a mist that can generate a rainbow, **Figure 12-36**.

When water is still, its surface often reflects its surroundings. The most common approach to photographing reflections in water is the *mirror image*, which is an almost exact reproduction of the scene in reverse. See **Figure 12-37**. Color reflections can be captured from surfaces with only a film of water, such as beach sand, and even from moving water when the light source itself is being reflected, **Figure 12-38**.

At times, you may prefer to eliminate reflections in the water to remove distractions from the main subject. A polarizing filter both eliminates reflections and improves color saturation by reducing glare, **Figure 12-39**. Objects underwater that were obscured by reflections can be revealed, as well.

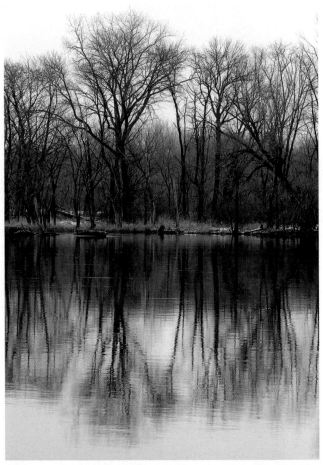

Jack Klasey/Goodheart-Willcox Publisher

Figure 12-37. On a late autumn day, a river's surface provides a mirror-image reflection of bare trees.

Animal Photography

While some animal photography involves groups, the most striking and memorable shots are usually of an individual. In many respects, animal photography is a form of portraiture, capturing the likeness and personality of a subject. Like portraits of human subjects, animal portraits should be composed, focused, and lighted with care. See **Figure 12-40**. Since you will usually be working with ambient light, try to choose a time of day and angle to the sun that provides the most effective lighting on your subject.

Compositionally, an animal's pose may be human-like—a photographer might position a person the same way for a portrait. A key element in all types of portraiture is the subject's eyes. If visible, they must be in sharp focus and should contain a small bright reflection, called a *catchlight*, to add sparkle and liveliness.

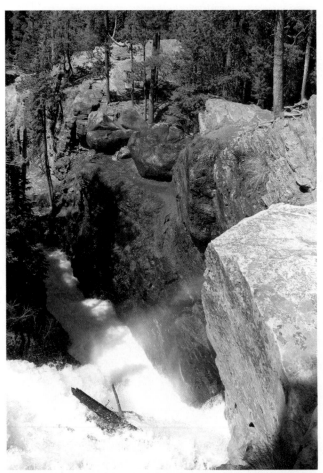

Glory Klasey

Figure 12-36. Sunlight refracted from water droplets in a churning stream forms a persistent rainbow.

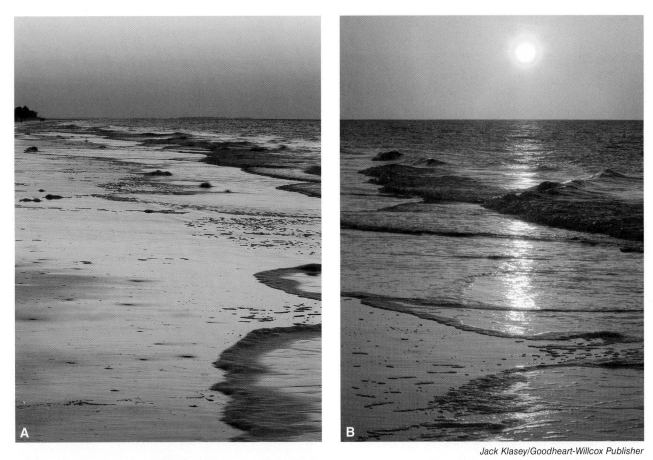

Figure 12-38. Seashore reflections. A—The colors of the predawn sky are mirrored in the film of water. B—Moving water reflects the rising sun.

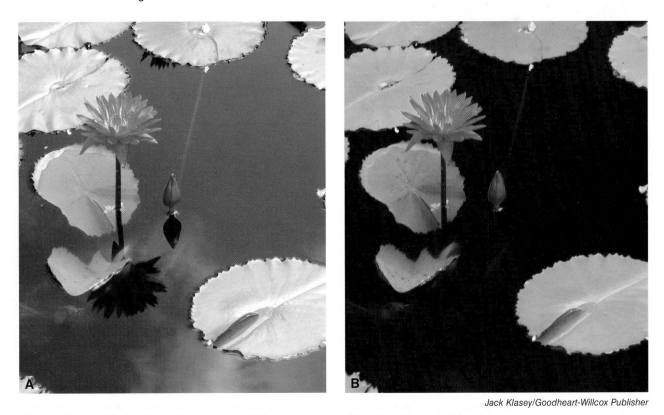

Figure 12-39. Eliminating reflections. A—Without polarizing filter. B—With polarizing filter.

Figure 12-40. This portrait of a mandrill at a Phoenix zoo would have been less striking visually with flat frontal lighting.

Pet Photography

Your dog, cat, or other pet animal can be a great photographic subject and is easily accessible for practicing animal photography techniques. An advantage in photographing your own pet is your knowledge of his or her moods, habits, and favorite activities. There are three basic ways to photograph a pet:

- A portrait, either in a formal close-up or a wider environmental context.

- An action shot of the animal engaged in a favorite or typical activity.

- A picture of the pet interacting with another animal or a human being.

While many of your pet photos will be spur-of-the moment shots, **Figure 12-41**, you should devote some time to making a planned photo shoot. If possible, select a location with good lighting and a minimum of background clutter, such as a floor area with ample light coming through a window or patio door. The location must be one that the pet frequents or will remain in long enough for you to get your shots.

Like children, pets are best photographed from their own level. Kneel or even lie down on the floor. If someone is available to act as an assistant, he or she can help draw the animal's attention to a certain direction or introduce the toy or other activity. This frees you to concentrate on getting the shots you want.

Figure 12-41. Informal pet portrait of a kitten.

Photographing in the Wild

Some photographers are fortunate to be able to travel to exotic locales, capturing dramatic photos of African lions, penguins in Antarctica, or moose in Alaska, **Figure 12-42**.

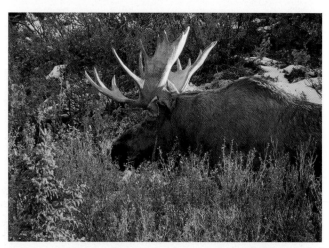

Figure 12-42. A moose browsing along a roadway in Denali National Park in Alaska.

However, wildlife opportunities abound close to home, such as birds of many types, small animals of field and forest, **Figure 12-43**, and the denizens of swamps or deserts.

An acceptable wildlife photo may result from being in the right place at the right time and being prepared to shoot when a subject unexpectedly appears. See **Figure 12-44**. Wildlife photographers who are consistently successful, however, carefully study the animals they wish to photograph. They learn about the locations where they can be found, how they behave, when they are active, and how common or rare they are. With this knowledge, the photographer can plan when and where to go, what equipment to bring, and how much time to devote to the project.

The time required to obtain a desired image is often measured in days. The photographer may erect a portable blind near the site where the animal is usually found, **Figure 12-45**. He or she must enter the blind when the animal is not around, and then spend many hours of patient observation before doing any shooting. Vehicles can serve as blinds, since animals do not consider them a cause for alarm. A car or truck can be an effective form of concealment when photographing birds, **Figure 12-46**.

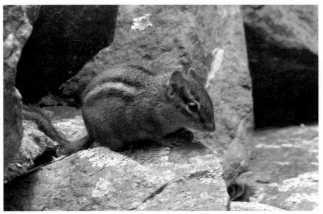

Jack Klasey/Goodheart-Willcox Publisher

Figure 12-43. Small wildlife subjects, such as this ground squirrel, usually can be found in locations close to your home (even in a city).

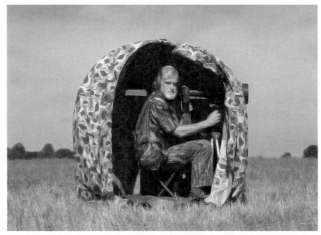

Leonard Rue Enterprises

Figure 12-45. Noted wildlife photographer Leonard Lee Rue demonstrates one type of portable shooting blind.

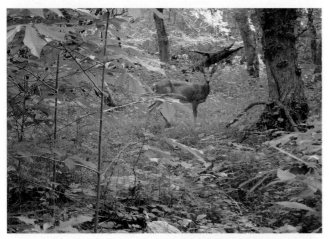

Jack Klasey/Goodheart-Willcox Publisher

Figure 12-44. This deer suddenly appeared in a clearing while the photographer was walking along a path in the woods. A wide-angle lens (35 mm), large aperture (f/5.6), and high ISO (800) resulted in a usable handheld image despite a slow (1/20 second) shutter speed.

Jack Klasey/Goodheart-Willcox Publisher

Figure 12-46. The photographer got close to these birds while using a car as a blind. A road bordered the shallow area of the river where they were wading, allowing the photographer to approach closely enough to use a 300 mm lens.

Most wildlife photographers consider a 500 mm lens to be the practical minimum for good animal and bird close-ups. A long lens is not as necessary, however, when the birds come to you. Providing food often attracts birds to within a reasonable distance, making them easy to photograph. See **Figure 12-47**. When birds are closer, a telephoto lens permits you to make a "head and shoulders" portrait, **Figure 12-48**.

When photographing in the wild, avoid stressing animals, especially nesting birds. Approaching too closely or making sudden movements or loud noises may cause harm to the animal, which is not worth any photograph. Be careful to avoid attracting the attention of possible predators to a nest location.

Photographing in Captive Environments

Though an African safari or a trek through the jungles of South America may not be feasible, you can still photograph exotic species. You can

Jack Klasey/Goodheart-Willcox Publisher

Figure 12-48. A tight close-up of a small bird made with a 300 mm lens. Note that the eye is in sharp focus and shows a small catchlight.

visit a nearby zoo, a wildlife park, or a captive animal compound, **Figure 12-49**.

Zoo photography presents a number of photographic challenges. These include cluttered or unnatural backgrounds; view-blocking fences, screens, or bars; and crowds of visitors that make it difficult to find a good shooting position, **Figure 12-50**. Overcoming these obstacles, however, can result in an outstanding animal photo, **Figure 12-51**.

Jack Klasey/Goodheart-Willcox Publisher

Figure 12-47. Gulls flocking behind a ferryboat to snatch food from the outstretched hands of passengers. Food will attract birds closer to your camera.

Suzanne M. Silagi

Figure 12-49. Intimate portraits of creatures, such as this wolf, can be captured at a wildlife park.

Figure 12-50. A crowd at a popular zoo exhibit can make it difficult to establish a good position for photography.

Ed Cayot

Figure 12-51. Waiting for the right conditions and the right behavior paid off in this appealing portrait of a baby gorilla.

Photograph zoo animals early or late in the day when they are most active, especially in warmer months. Morning or early evening photography has other advantages, such as better light than midday and smaller crowds around the exhibits.

Getting a good shot requires patience and keen observation skills. Watch the animal for some time to see how it behaves and what areas of the exhibit it favors. Then, set up your camera and tripod, **Figure 12-52**, and wait patiently for the action you want to capture, **Figure 12-53**.

Glory Klasey

Figure 12-52. A tripod will help produce more crisply focused, shake-free photos of zoo subjects.

Jack Klasey/Goodheart-Willcox Publisher

Figure 12-53. This shot of a bear enjoying an afternoon snack was the best of a dozen exposures made from the same position.

Sometimes, the behavior you will illustrate is quite passive. For example, tigers, lions, and other big cats spend a great deal of time sleeping in the sunlight. With fairly natural-looking surroundings and careful composition, even a dozing animal can make a good photo, **Figure 12-54**.

Zoos vary considerably in the amount of natural-looking outdoor habitat they provide. In most cases, you can find shooting angles that avoid unnatural-appearing backgrounds, **Figure 12-55**. Often, you can select an aperture that throws the background out of focus. At other times, shifting position will be necessary to find an acceptable view.

Photos of large animals in action, such as a running cheetah, are typically shot under controlled conditions on captive animal ranches or compounds. These animals can be "put through their paces," for a fee, by photographers shooting primarily for advertising agencies. Similar businesses

Figure 12-54. A sleeping tiger, a small waterfall, and the interplay of sunlight and shadow combine to make a pleasing image of repose.

offer amateur photographers opportunities to photograph herds of horses, western cattle drives, or big game animals.

Figure 12-55. Avoiding a "zoo" appearance. A—This giraffe is obviously in a captive environment. B—A far more natural appearance results from photographing a young giraffe against the mother's flank, using a 300 mm lens to throw the background out of focus.

Close-Up Photography

A close-up photographer is able to open the door to a strange and often beautiful world in which intricate shapes and structures emerge from everyday objects, and common insects take on the menacing appearance of prehistoric monsters. This world is conveniently located—close-up photographers can find an almost endless supply of subjects in their own backyards.

How Close Is Close?

For greater precision when discussing close-up photography, the terms *reproduction ratio* and *magnification* are commonly used. Although they present the information in different forms, both methods state the size relationship between the actual object and its recorded image.

Some people find the size relationship easiest to understand when stated as a reproduction ratio, such as 1:4. The numeral before the colon represents the reproduction size, the size of the recorded object on film or in the digital file. The second numeral represents the size of the actual object. A 1:4 ratio means that the actual object is four times larger than its representation. If the recorded image is 1″ long, then the actual object is 4″ in length.

Figure 12-56 shows examples of reproduction ratio. If a ladybug is 1/4″ long, and the recorded image is also 1/4″ long, the reproduction ratio is 1:1. The recorded image is said to be same size or life-size. If the image measures only 1/8″, the reproduction ratio is 1:2, or half life-size. The recorded image also may be larger than the real object. If the ladybug image measures 1/2″, it is twice as big as the real insect, so the reproduction ratio is stated as 2:1.

The *magnification rate* provides the same information as the reproduction ratio, but in a different form. Instead of describing the size relationship as 2:1, for example, it is stated as 2×, or "two times life-size." Reproduction at less than life-size is represented by fractional magnification rates, such as 1/2× or 1/10×. Fractional rates can also be expressed in decimal form, such as 0.5× or 0.10×.

The meaning of the term *close-up* is subjective. However, three ranges of magnification can be used to help answer the question, "How close is close?" The lowest magnification range extends from about 1/20× to 1×, or 1/20 life-size to actual life size. This degree of magnification, which can be referred to as the *close-up range*, is achieved by the use of normal-focus or close-focusing lenses alone, without employing special techniques or accessory equipment. A close-focusing lens is often referred to as a *macro* lens. The term comes from the Greek word *makros*, which means "large".

1:1 1:2 2:1

Figure 12-56. Reproduction ratio.

A reproduction ratio of 1:1 (life-size, or a magnification rate of 1×) is generally considered the borderline between the close-up range and the *macro photo range*. In the macro range, various types of accessories are used to increase the magnifying power of the camera's lens.

At approximately 25×, another borderline is passed, moving into the third range of magnification. This is the highly specialized realm of *photomicrography*, in which a microscope is used to achieve extremely high magnifications.

Ways of Getting Close

In the close-up range (up to life-size), macro lenses provide the advantage of simplicity and ease of use. These lenses also are versatile, since they can be used for normal photography as well as close-focusing situations.

For magnifications greater than life-size, other devices must be used in combination with the camera lens. The devices and methods used to obtain greater magnification include the following:

- **Close-up diopters.** These magnifying devices screw onto the front of the camera lens. In effect, they shorten the focal length of the lens and thus increase the image size on the film. Usually sold in sets of three, they can be used singly or in combination. See **Figure 12-57**. These simple single-element lenses can degrade optical quality. The optically superior two-element diopters made by several camera manufacturers provide much sharper images. They can be used with any brand of lens with the appropriate filter size.

- **Extension tubes.** Much higher magnifications can be achieved by inserting an extension tube to move the lens farther away from the film plane. Unlike the close-up lenses that put additional optical elements in the light path, the tubes add only distance. The tubes come in various lengths and are sometimes sold in sets, **Figure 12-58**. Tubes of different lengths can be coupled together to achieve the desired extension. To determine the extension needed for a desired magnification, multiply the focal length of the lens by the magnification. With the lens focused at infinity, adding an amount of extension equal to the focal length will produce a 1:1 reproduction ratio. Thus, to achieve a 3:1 ratio (3× magnification, or three times life-size) with a 50 mm lens, couple together tubes for a total extension of 150 mm, or about 6″.

- **Bellows.** In effect, the bellows is a variable-length extension tube, with the camera attached to one end and a lens to the other. Due to its bulk and the fragility of the folding bellows material, this device is more commonly used in studio work than in field photography.

- **Reversed lens.** Mounting a lens backward, using an accessory called a *reversing ring*, is one of the most effective methods of gaining higher magnifications. See **Figure 12-59**.

Porter's Camera Store

Figure 12-58. Extension tubes increase magnification, but do not degrade the image.

Goodheart-Willcox Publisher

Figure 12-57. A set of close-up diopters.

Reversing ring

Jack Klasey/Goodheart-Willcox Publisher

Figure 12-59. A lens mounted in the reversed position on a bellows, using a reversing ring.

The ring has filter-mounting threads on one side to attach the reversed lens. A lens mount on the other side connects it to the camera body, extension tubes, or a bellows. The advantages of reverse-mounting are 1× or higher magnification and increased working distance.

Exposure and Other Problems

When a bellows, extension tubes, or coupled lenses are used for close-up work, the distance that light rays must travel from the lens to the image sensor is increased. This means that less light will reach the film or sensor surface due to light falloff, making an exposure increase necessary. If you are using a modern camera with a built-in through-the-lens (TTL) meter, no compensation is needed. The meter reading automatically adjusts for the decreased light level.

If your camera does not have a TTL meter, a corrected exposure must be calculated. To determine the exposure change, you need three items of information—the focal length of the lens, the extension, and the exposure (f-stop) metered for the subject. Multiply the f-stop by the focal length, and then divide the result by the extension. As an example, using the information from **Figure 12-60**, *f-stop* (16) × *focal length* (100) = 1,600 ÷ *extension* (150) = 10.66. Identify the nearest f-stop to this value (10.66); in this case, f/11. The corrected exposure is a one-stop increase (from f/16 to f/11).

Compensation is usually done by changing exposure time rather than aperture, because opening up to change exposure would seriously decrease depth of field. Thus, the corrected exposure would be f/16 @ 1/15 second, a one-stop increase from the metered f/16 @ 1/30 second.

Depth of Field

As you increase magnification, the portion of the subject that is in acceptably sharp focus at a given f-stop decreases. The depth of field can shrink to a fraction of an inch or a few millimeters. For example, when photographing an object at twice life-size (2×), the distance from nearest to farthest sharp focus at f/8 is only 0.4 mm or 16/1000". To increase the depth of field, stop down as you would in normal photographic situations. By using smaller apertures such as f/16, f/22, or f/32 (depending on the capability of your lens), you will obtain the greatest depth of field possible under the circumstances.

150 mm
Extension

100 mm
Focal length

Metered exposure: f/16 @ 1/30

Goodheart-Willcox Publisher

Figure 12-60. Information needed to calculate the exposure change necessary to compensate for lens extension.

When working with a depth of field measured in units as small as tenths of a millimeter or thousandths of an inch, critical focusing and a sturdy tripod are essential. To eliminate camera movement from vibration, use a cable release and mirror lock-up, if possible. Manual focusing is almost always necessary to get the desired fineness of focus.

A *focusing rail*, **Figure 12-61**, permits the camera to be moved toward or away from the subject in tiny increments to achieve precise focus. It can be locked into position after focus is set. The base of the rail unit mounts to the tripod, while the camera is attached to the movable top slide.

A different technique can be employed if you are using lower magnification under conditions that permit hand-holding. For example, if you are photographing flowers or insects at a 0.25× (1:4) magnification and using flash or bright sunlight as illumination, your depth of field at f/16 would be just over 3/4″. In this situation, many nature photographers would focus on the desired area of the subject, and then use small body movements to adjust placement of the plane of focus, **Figure 12-62**.

Working Distance

Working distance is the amount of space between the front of the lens and the subject. A working distance that is too short can block natural light, placing the subject in shadow and making it virtually impossible to use artificial light. Also, animals and insects have a comfort zone—moving closer than the invisible border of that zone will cause them to flee.

Jack Klasey/Goodheart-Willcox Publisher

Figure 12-62. To capture this close-up of a bumblebee, the photographer was able to shift the plane of focus by using body movement.

The key to working distance is the focal length of the lens. The longer the focal length, the farther you can be from the subject while retaining the same magnification. The distances are proportional, **Figure 12-63**. If you fill the frame with your subject using a 50 mm lens at a lens-to-subject distance of 6″, switching to a 100 mm lens allows you to double that distance to 12″ while keeping the same image size. If the image size is kept the same and the same f-stop is used, no change in depth of field

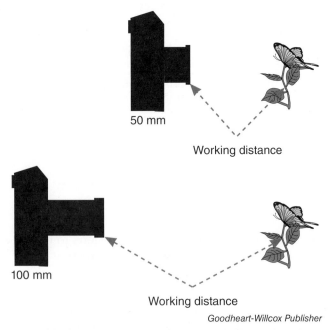

Goodheart-Willcox Publisher

Figure 12-63. A longer focal length permits you to gain working distance while keeping the subject image the same size.

Kirk Enterprises

Figure 12-61. Focusing rail.

occurs when focal length is increased to gain working distance. If the same working distance is retained, but a longer focal length lens is substituted to increase image size, the depth of field changes in inverse proportion. Doubling the focal length reduces the depth of field by one-half.

Lighting

Increased working distance makes it easier to light the subject for proper exposure. In some situations, natural light is sufficient, but more commonly, electronic flash must be used to freeze subject movement.

The use of flash illumination allows hand-holding of the camera when small animals or insects are photographed. The mobility of the subjects and the photographer's need to quickly change positions for the best composition make hand-holding a virtual necessity. While a tripod is desirable in many close-up situations, it is far too slow and cumbersome for capturing active insects or small animals. The use of flash allows the photographer to "freeze" the subject as well as achieve a good exposure.

The built-in flash found on point-and-shoot and many SLR cameras is not suitable for close-up work. Shooting natural subjects in the field is usually done with small self-contained flash units placed on an adjustable bracket rather than the camera's hot shoe. Some photographers prefer to use a single flash positioned several inches above and just behind the front of the lens. Others employ two flashes mounted on adjustable arms positioned several inches to either side and just above the level of the lens, **Figure 12-64**. One flash serves as the main light and the other as the fill light.

Portfolio Assignment

Photographer's Choice

Choose one or more of the following projects for your portfolio:

- **Create a panorama.** Look for a suitable subject (horizontal or vertical). Shoot at least four overlapping images and assemble the finished panorama using image-editing software.
- **Freeze some water** (photographically, that is). Shoot moving water, such as a waterfall, rainstorm, or even a lawn sprinkler. Use different shutter speeds to observe the effect on motion. Choose the image you like best, noting the exposure information.
- **Capture an animal.** Use your smartphone or tablet to photograph a pet or other animal involved in a typical activity. If the "activity" is a nap, try for an interesting or unusual angle.

Stroboframe

Figure 12-64. Butterfly and insect photographers often use an adjustable double flash bracket.

Review Questions

Answer the following questions using the information provided in this chapter.

1. Outdoor photography is often called *nature photography*, since the subject matter includes the broad areas of _____ and _____.

2. When shooting images for a digital panorama, you should overlap adjacent shots by _____%.
 A. 10–15
 B. 20–30
 C. 20–50
 D. 40–70

3. What is the *magic hour*, and why is this period desirable for outdoor photography?

4. List several reasons for using a tripod in outdoor photography.

5. When shooting a panorama, how should you use manual focus?

6. What environmentally sound methods can be used to keep intruding foliage out of your field of view when photographing in the field?

7. Since _____ films are extremely blue-sensitive, they must be loaded and unloaded in total darkness.

8. Why do green plants appear bright white in prints made from black-and-white infrared film?

9. When moving water is the subject, what camera control can be used to regulate the amount of motion blur? Describe the effect in general terms.

10. A still-water reflection that exactly reproduces the reflected subject is referred to as a(n) _____.

11. What is the advantage of shooting from a vehicle when photographing animals?

12. Why should you avoid approaching animal subjects too closely, moving suddenly, or making loud noises?

13. When a reproduction ratio such as 1:3 is given, the number before the colon represents the _____.

14. What are the advantages of using a reversed lens for close-up photography?

15. If your camera does not have a TTL meter, a(n) _____ change must be calculated to compensate for lens extension.

16. In close-up photography, the amount of space between the front element of the lens and the subject is called _____.

Suggested Activities

1. Shoot three "head and shoulders" animal portraits of a dog or cat. The portraits may be of the same animal or different animals. Choose the image in which the animal looks most appealing and use it as the basis for a poster promoting a local animal shelter's pet adoption program. You may want to show the poster to the shelter and see if they would like to use it.

2. As a class project, create a calendar with nature photographs (landscapes or wildlife images). Ask each student to submit one or two images for a total of at least 24 images. Select 12 final images by voting. Use a computer program or an on-line or retail photo processor to produce the calendar.

Critical Thinking

1. While photographing in a botanical garden, you find a perfect blossom that would make a spectacular photo. Unfortunately, to properly frame the shot, you would need to cut away some parts of the plant. Should you do so?

2. You are capturing a four- or five-shot panorama on a partly cloudy day when the light keeps changing from sunny to cloudy. Would you expect to get better results by setting your camera's white balance to automatic, or by changing it for each shot to match the lighting? Why?

Communicating about Photography

1. **Speaking.** Select a figure in this chapter, such as Figure 12-33 or Figure 12-63. Working with a partner, tell and then retell the important information being conveyed by that figure and its caption. Through your collaboration, develop what you and your partner believe is the most interesting description of the importance of the chosen figure. Present your narration to the class.

2. **Speaking and Listening.** Divide into groups of four or five students. Each group should choose one of these topics—water photography, animal photography, flower photography, or infrared photography. Using your textbook as a starting point, research your topic and prepare a report on techniques for obtaining good photos. As a group, deliver your presentation to the rest of the class. Take notes while the other students give their reports. Ask questions about any details that you would like clarified.

Portrait mode: Term describing an image composed as a vertical rectangle. Photographs intended as magazine or book covers are captured in portrait mode.

While studying this chapter, look for the activity icon ↗ to:

- **Assess** your knowledge with self-check pretest and posttest.
- **Practice** vocabulary terms with e-flash cards and matching activities.
- **Reinforce** what you learn by submitting end-of-chapter questions.

G-WLEARNING.com

www.g-wlearning.com/visualtechnology/

Travel Photography

Objectives

When you have finished reading this chapter, you will be able to:

- List some of the potential uses for travel photographs taken by professional and amateur photographers.
- Describe methods of research used by photographers to prepare for both long and short trips.
- Explain the importance of using a portable storage device for digital images when traveling.
- Describe various ways that buildings can be photographed to emphasize different qualities or points of view.
- Discuss the different strategies a photographer can use to cope with unfavorable weather or lighting conditions.
- Demonstrate methods of supporting a camera at slow shutter speeds when a tripod cannot be used.

Check Your Photography IQ ↗

Before you read this chapter, assess your current understanding of the chapter content by taking the chapter pretest.

www.g-wlearning.com/visualtechnology/

Technical Terms ↗

backup copy
candid photos
recreational travel

search engine
travel guides
travel photography

Recreational travel is hugely popular, and few travelers fail to bring along a camera to capture memories of the places they have visited. In addition to landscapes and other nature subjects, *travel photography* pays considerable attention to the human-made aspects of our world and to the people who inhabit it, **Figure 13-1**. While it is mostly an outdoor activity, travel photography can include a significant number of indoor locations.

Traveling with a Camera

Professionals often write magazine or newspaper travel articles illustrated by their photos. They also shoot photos for use in books and for stock photography agencies. Amateurs most often shoot vacation snapshots to share with friends and family after the trip, **Figure 13-2**. Some advanced amateurs produce high-quality travel photos rivaling those of the professionals.

They may use their photos to illustrate a travel story in a local or regional publication, enter them in photo contests, sell prints at local galleries or art shows, deliver audiovisual travel programs to various audiences, or simply display them on their home or office walls. An increasing number of photographers, both amateur and professional, post their photos on websites and social media such as Facebook or Instagram.

Researching in Advance

Whether you are planning a journey to a foreign locale, a family vacation, or a day trip, advance research helps you take more interesting pictures.

The Internet is a great travel research tool. Use a *search engine* to locate sources of information on your destination, **Figure 13-3**. These resources help you locate points of interest, special events, hours of operation and admission fees for attractions, and directions for arriving by various means of transportation.

Jack Klasey/Goodheart-Willcox Publisher

Figure 13-1. Photographing places and people. A—Chicago's reflective Cloud Gate sculpture (nicknamed "The Bean") is a popular photo subject for tourists. B—Young visitors shooting their reflections in the sculpture.

Caroline Klasey

Figure 13-2. Friends on a visit to Venice captured this snapshot with a cell phone.

Books and travel guides are excellent planning tools, **Figure 13-4**. Libraries have a selection of illustrated travel books on major destinations. They also are likely to have copies of *travel guides* for countries or specific cities. Such guides are useful to take along on your trip, so you may wish to purchase the current edition of a guide at a bookstore or online. Organizations such as the American Automobile Association (AAA) offer their members maps

Jack Klasey/Goodheart-Willcox Publisher

Figure 13-4. Travel guides are available for most major destinations.

Arizona Office of Tourism

Figure 13-3. The Internet can help you quickly research a location or attraction in preparation for a trip.

and guidebooks with information on attractions, hotels, and restaurants for North American destinations.

For some heavily-photographed areas, there are guides created specifically for photographers, **Figure 13-5**. An Internet search for *photography location guide books* will help you find them. You may also want to seek information from other photographers who have shot in that area.

What Equipment Will You Need?

How much camera gear you take on your trip will vary considerably, depending on your budget, personal preferences, transportation plans, and other factors. Because of the flexibility it provides, many travel photographers prefer a camera with interchangeable lenses (SLR or rangefinder). With two zooms—a wide-angle to short telephoto and a short-to-long telephoto— most photographic situations can be covered. Those who favor smaller, lighter equipment often choose one of the superzoom compact cameras. These cameras, typically with 16Mp sensors, provide optical zoom ranges as high as 60× (22 mm to 1200 mm)

Professionals typically carry a backup camera in case the main camera gets damaged or malfunctions while traveling. This may be a second SLR camera body, or an advanced compact camera.

The development of digital cameras has made the photographer's life easier in some respects, and more difficult in others. The greatest advantage of digital photography, of course, is the ability to immediately review your photos, instead of waiting until film is developed. If necessary, you can often capture the scene again. While you do not have to carry numerous rolls of film, you will need spare batteries and a charger, a supply of memory cards, and usually some type of portable storage device.

Memory Cards

Since memory cards are fairly inexpensive, some travel photographers carry enough high-capacity (64Gb or more) cards to last for the entire trip. Using high-capacity cards minimizes the need to reload the camera.

Others prefer to use a lower capacity card (such as 4Gb or 8Gb), downloading it at the end of each day to a portable hard drive, USB flash drive, or a laptop computer, **Figure 13-6**. Cards may then be reformatted to use again. This method avoids the danger of losing a large number of images if a card fails.

Jack Klasey/Goodheart-Willcox Publisher

Figure 13-5. Guides developed specifically for photographers provide helpful information, such as locations and viewpoints along specific routes.

Jack Klasey/Goodheart-Willcox Publisher

Figure 13-6. A laptop or other portable storage device allows you to download images from memory cards and then reformat the cards for continued shooting.

No matter which memory card approach they use, careful photographers make a ***backup copy*** to guard against possible loss of their images. Very high capacity cards should be backed up to a portable storage device at the end of each day. If lower-capacity cards are being reused, they should be copied twice for safety. For example, copy to both a laptop and flash drive, to a laptop and portable hard drive, or to portable hard drive and flash drive.

Transporting Camera Equipment

While a compact camera, a spare set of batteries, and extra memory cards often can be carried in a pocket or small pouch, a sturdy camera bag is the preferred method for organizing and transporting equipment with interchangeable lenses. See **Figure 13-7**. Camera bags have compartments and dividers to hold and protect camera bodies, lenses, and other equipment and accessories.

If you travel by air, your camera bag should be treated as a carry-on, not as checked baggage, to protect it from the rough handling typical of airline baggage systems, **Figure 13-8**. You also can better protect expensive equipment from theft if you keep it in your control. Pack a tripod in one of your suitcases, if it will fit. Otherwise, place it in a sturdy tube or similar container and check it as baggage.

Jack Klasey/Goodheart-Willcox Publisher

Figure 13-8. Airline baggage is often is handled roughly. To guard against damage, loss, or theft, camera bags should be treated as carry-on luggage.

Memory cards are not affected by the X-rays used to examine checked baggage, but film (especially 800 ISO and higher) can be fogged. Do not place film—unexposed or exposed—in your checked baggage. Instead, put it in a clear plastic bag and store the bag in a piece of carry-on luggage. The lower-dosage X-ray equipment used at passenger security checkpoints should not cause fogging, but to be perfectly safe, you can request a hand inspection of the film. This is your right under law in US airports, but security personnel at foreign airports may not honor requests for hand inspection.

What Will You Shoot?

The answer to this question depends on your personal interests or, if you are a professional, your assignment. Professionals often work from a detailed list of photos to be taken (shot list) and must meet strict client delivery deadlines. Some photographers concentrate on landscapes or buildings, while others focus on people and their activities, **Figure 13-9**. Most will shoot a mix of places and people.

Manfrotto/Kata

Figure 13-7. Camera bags are available in various sizes.

Suzanne M. Silagi; Jack Klasey/Goodheart-Willcox Publisher

Figure 13-9. Travel photo subjects. A—Railroads provide access to some of Alaska's most scenic areas. B—Street artists at work are a common sight in European cities.

The urban scene is typically varied, busy, and visually exciting, whereas the countryside often provides slower-paced and more restful photographic possibilities. Many of the same techniques described in Chapter 12, *Outdoor Photography*, also apply to shooting city scenes—careful composition, proper exposure, attention to focus and depth of field issues, and taking advantage of the best light.

Photographing Buildings

When you are shooting buildings and architectural details in a city, concentrate on those aspects of the scene that are unique to the locale. A fast-food restaurant or chain store in Phoenix, Arizona, probably looks almost exactly the same as one in Toronto, Canada. Some cities have landmarks that are instantly recognizable. See **Figure 13-10**.

Buildings can be photographed in many different ways to emphasize various qualities or points of view. For example, shooting upward greatly exaggerates a tall building's height, while an elevated viewpoint can show the surrounding environment. See **Figure 13-11**.

Jack Klasey/Goodheart-Willcox Publisher

Figure 13-10. Recognizable landmarks. A—Rome's Coliseum. B—The Eiffel Tower in Paris. C—The Statue of Liberty in New York Harbor.

Jack Klasey/Goodheart-Willcox Publisher

Figure 13-11. Various approaches to building photography. A—Shooting upward to convey height. B—Framing a historic building with another structure. C—A high angle shot shows the building's surroundings. D—The glass wall of a downtown building reflects its neighbors.

A building and its surroundings can be presented very differently when photographed from the same spot with wide-angle and telephoto lenses, **Figure 13-12**.

Doors, windows, carvings, textures, paint colors, shadow patterns, ornamental objects, and other details also make graphically interesting photos. See **Figure 13-13**. Some photographers have done photo essays on a single subject, such as front doors in a city or a particular neighborhood.

Photographing People

People and their activities account for a significant percentage of travel and vacation photos. Snapshots of family members, **Figure 13-14**, are a way of saying "we were there and saw this." If the photographer does not pay careful attention to the background, such photos can sometimes have unfortunate outcomes, **Figure 13-15**.

City sidewalks, parks, shopping areas, and other areas where people gather provide numerous opportunities for *candid photos*, which are informal and unposed pictures.

Jack Klasey/Goodheart-Willcox Publisher

Figure 13-12. The two views of the United States Capitol building were shot moments apart from the corner of Fifteenth Street and Pennsylvania Avenue in Washington, DC. A—Wide-angle view down Pennsylvania Avenue. B—Telephoto view from the same position.

Jack Klasey/Goodheart-Willcox Publisher

Figure 13-13. Concentrating on architectural details can produce graphically strong images.

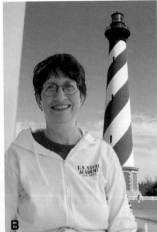

Jack Klasey/Goodheart-Willcox Publisher

Figure 13-15. Avoid unintended photographic results. A—The lighthouse appears to be sprouting from the woman's shoulders. B—A better approach, with the woman moved to the left and placed in the shade of an open porch to eliminate the harsh shadows on her face.

Katie Gorham

Figure 13-14. A family vacation snapshot recording a day at the beach.

See **Figure 13-16**. Recreational activities, such as community festivals, concerts, or fairs and carnivals, are especially rich in possible subjects.

Historical sites with costumed interpreters who bring history to life also provide many photo opportunities. See **Figure 13-17**.

Jack Klasey/Goodheart-Willcox Publisher

Figure 13-16. People, on the street or in other settings, represent an endless series of photographic possibilities.

Figure 13-17. Colorful period dress and visually interesting activities, such as blacksmithing, make a living history museum a rewarding photographic experience.

When Will You Shoot?

As noted in Chapter 12, *Outdoor Photography*, most photographers prefer the warm light of the magic hour surrounding sunrise and sunset. The difference in mood of the same scene photographed under varied lighting conditions can be dramatic. See **Figure 13-18**.

Hand-holding the camera to shoot scenes after dark can be tricky, since long exposure times can result in blur and streaked lights from camera shake, **Figure 13-19**. Finding a means of support to steady the camera will often give acceptable results, **Figure 13-20**. Even at night, ambient light may be sufficient to allow handheld photography. See **Figure 13-21**.

Jack Klasey/Goodheart-Willcox Publisher

Figure 13-18. Lighting strongly influences the mood of a photo. A—The Seattle skyline by day. B—Late afternoon light bathes the building with a warm glow. C—At dusk, the darkening sky sets off buildings illuminated by sunset's afterglow and their own lights.

Jack Klasey/Goodheart-Willcox Publisher

Figure 13-19. Handholding a camera for a night shot almost always results in camera shake.

Jack Klasey/Goodheart-Willcox Publisher

Figure 13-20. The photographer steadied the camera by pressing it against a traffic light pole to take this night shot of Chicago's historic Water Tower. Because of the 1/4 second shutter speed, pedestrians and moving vehicles are motion-blurred, but the Water Tower is sufficiently sharp.

Coping with Unfavorable Conditions

Traveling with your family or with a group often can make it difficult to photograph in the best light. Your time available at a given location may be limited to a few midday hours. Another problem may be unfavorable weather conditions that cause cancellation of an event or make photography difficult.

A resourceful photographer copes with unfavorable conditions by changing strategies. Work around the strong, contrasty light of midday by seeking subjects sheltered from the sun. Shade from trees may be solid or dappled, **Figure 13-22**, providing different lighting effects.

Figure 13-21. Using ambient light. A—This baseball field was lit brightly enough to permit a shutter speed of 1/50 second, so that the running players were captured without motion blur. B—Lighting at this carnival booth was bright enough for an exposure of 1/15 second, with the camera steadied against a trash can.

Figure 13-22. Using shade to limit contrast. A—Open shade (solid but bright) provides a soft, even light for this scene. B—Dappled (broken) shade can soften light enough to avoid harsh contrast in important subject areas.

Photographing your subject on an open porch provides attractive, diffused light while retaining a good sunlit background. See **Figure 13-23**.

Strong, high-contrast light is actually good for certain subjects, helping to convey the feeling of heat and bright sun in a desert scene. See **Figure 13-24**. It also can be useful for spotlighting a subject against a shadowy background, **Figure 13-25**.

On a cloudy day with a flat uninteresting sky, abandon the plan for broad landscape views or a sunlit beach party scene. Instead, take advantage of the softly diffused light to capture rich, saturated colors in smaller-scale views, **Figure 13-26**. Since the sky has no color or detail, you would generally choose an angle and composition to exclude it from your shot. For example, concentrate on a portion or detail of a building instead of the whole structure. See **Figure 13-27**.

Jack Klasey/Goodheart-Willcox Publisher

Figure 13-24. Strong, midday sunlight casts deep shadows beneath the rock ledges and across this saguaro cactus.

Jack Klasey/Goodheart-Willcox Publisher

Figure 13-23. This softly lighted bridesmaid was photographed in the shade of an open porch.

Jack Klasey/Goodheart-Willcox Publisher

Figure 13-25. Natural spotlighting on the performer provides excellent separation from the background.

Figure 13-26. Diffused light. A—Soft, even lighting brings out the rich blues and greens of a blooming hydrangea. B—Misty weather at midmorning attractively lights a carpenter's toolbox on the windowsill of an old mill undergoing restoration.

Figure 13-27. Excluding a flat sky. A—The solid gray sky on a misty day adds little to this view of Thomas Jefferson's home, Monticello. B—Changing camera angle and distance eliminates the sky while retaining the character of the building.

If stormy weather prevents you from carrying out plans for a sunny afternoon of photography, use the unfavorable conditions as your subject. **Figure 13-28** shows some examples of bad weather scenes.

Moving Indoors to Shoot

To avoid unfavorable weather conditions, you can, of course, move indoors. Museums, historic structures, public buildings, and some natural attractions allow you to photograph regardless of the weather outside. Caves such as Virginia's Luray Caverns, **Figure 13-29**, offer visitors guided tours along paved paths to view dramatic stone formations. The lighting level in such caves is low enough that you usually need to select a high ISO and provide some form of support or stabilization to avoid camera shake. Since you are part of a tour group, using a tripod is not practical. However, a monopod can provide the needed support without tripping your fellow tourists.

Jack Klasey/Goodheart-Willcox Publisher

Figure 13-29. Fantastic shapes of stalactites and stalagmites at Luray Caverns.

Jack Klasey/Goodheart-Willcox Publisher

Figure 13-28. Adverse weather can be a good subject.

Tripods are almost always banned in museums because of the crowds of visitors, **Figure 13-30**. Since flash photography is usually prohibited to prevent fading of the artwork, museum shooting requires a fairly high ISO and a means of steadying the camera during longer exposures. In dimly lit church interiors, you can steady the camera on a railing or the back of a pew, **Figure 13-31**.

Period rooms in historic houses are usually dimly lit, sometimes only by natural window light. Steadying the camera on a door frame will normally provide sufficient sharpness without use of a flash, **Figure 13-32**.

Jack Klasey/Goodheart-Willcox Publisher

Figure 13-31. The interior of St. Peter's Basilica in Rome, captured with an exposure of 1/25 second at f/2.7 with an ISO of 400.

Jack Klasey/Goodheart-Willcox Publisher

Figure 13-30. Visitors gathered in front of the Mona Lisa at Paris' Louvre Museum; some ignore the "no flash" rule.

Jack Klasey/Goodheart-Willcox Publisher

Figure 13-32. This eighteenth century period room was dimly lighted by windows on two sides. Bracing the camera on a door frame allowed a shake-free exposure of 1/6 second.

One area where flash usually is permitted, and is almost a necessity, is aquarium photography. To avoid reflections, position the camera so it is almost touching the glass. The bright burst of light from the flash will penetrate the dim light in a large tank, bringing out the bright colors of the fish and vegetation, **Figure 13-33**.

Even on days with favorable outdoor weather, interesting photos can be made shooting exterior scenes from indoors, using building elements to frame the shots. See **Figure 13-34**.

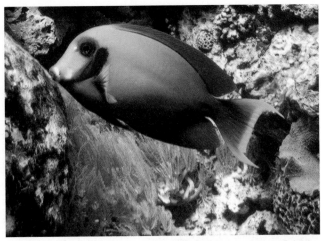

Jack Klasey/Goodheart-Willcox Publisher

Figure 13-33. Use flash to capture the vivid colors in an aquarium.

Portfolio Assignment

Brace Yourself!

Find a subject that would normally require the use of a tripod to capture without camera shake. Possible subjects include a lighted street scene at night or a dimly-lit interior space.

Set your camera for aperture-priority mode. Select the widest available f-stop, and set the ISO to 100. Meter the scene. If the shutter speed is one second or longer, increase the ISO rating to 200 and meter again. If necessary, repeat until the shutter speed is less than one second.

Find a suitable support to brace your camera against and make an exposure. Check your image for blurring due to camera shake (moving subjects will blur, but stationary objects should be sharp). This shooting technique takes some practice to avoid moving the camera as you press the shutter. Make a number of exposures until you get the desired results. Print the best image for your portfolio, noting the shutter speed, f-stop, and ISO you used.

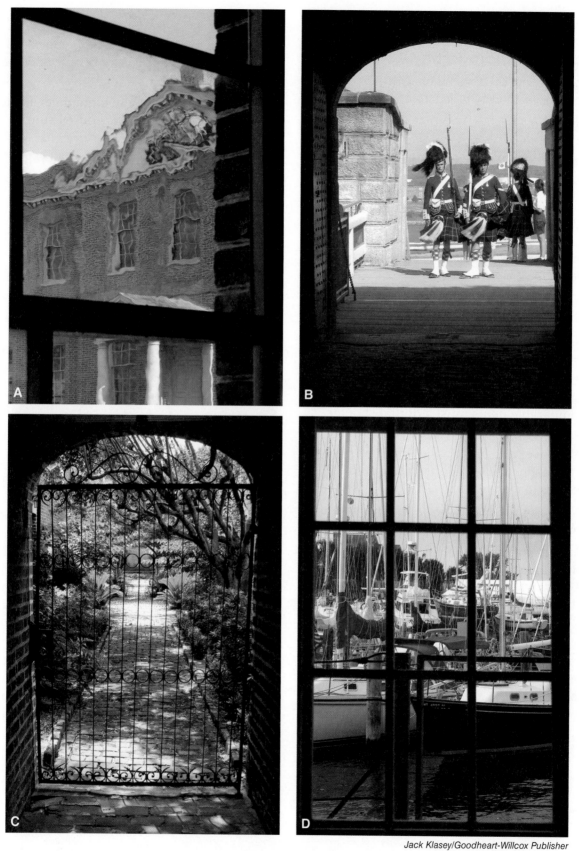

Jack Klasey/Goodheart-Willcox Publisher

Figure 13-34. Shooting from indoors. A—The uneven, rippled quality of old window glass distorts the façade of an eighteenth century building. B—Sentries in period uniform framed by the arched entry of a restored fortress. C—A hidden garden seen through the gate at the end of a covered passageway. D—Colorful boats in a marina framed by a restaurant window.

Check Your Photography IQ 📲

Now that you have finished this chapter, see what you learned by taking the chapter posttest.

www.g-wlearning.com/visualtechnology/

Review Questions 📲

Answer the following questions using the information provided in this chapter.

1. What markets do professional travel photographers find for their pictures?

2. Name at least four resources you can use to research travel destinations in advance.

3. Traveling film shooters must carry a supply of film and spare batteries. What comparable items must a digital shooter take along?

4. When working on an assignment for a client, a travel photographer often must produce images to match a detailed _____.

5. Why is a portable storage device needed for longer trips with a digital camera?

6. For general travel photography, many photographers carry two zoom lenses to cover a wide range of focal lengths. Most photographic situations can be covered with what two types of telephoto lenses?

7. To cope with equipment damage or a malfunction, professional photographers carry a backup SLR _____ or a second camera.

8. When traveling by air, why should you treat your camera bag as a carry-on rather than checked luggage?

9. Why should you avoid placing your film supply (or exposed film) in your checked baggage?

10. List several different ways of shooting a building or urban scene.

11. Name some locations where you could obtain candid photos of people and their activities.

12. What is the reason photographers like to shoot during the magic hour at sunrise and sunset?

13. What are some reasons why you might not be able to photograph a scene with the best light during your family vacation trip?

14. Describe some strategies for photographing on an overcast day with a flat, uninteresting, gray sky.

15. Why do art museums ban the use of tripods and flash photography?

16. How would you photograph a dimly lighted museum display or period room in a historic house without the aid of a tripod or monopod?

Suggested Activities

1. Work with three other students on a "Photography Rocks!" project. Each person should choose one letter (R, O, C, or K) and shoot at least six different examples of a close-up view of the letter (on a store sign, scratched in beach sand, on an alphabet block, etc.) Select four examples of each letter, and make 4" × 6" prints. Assemble four variations of the word ROCK on a poster board with the heading "Photography Rocks!" and display it in the classroom or school hallway.

2. Research tourist attractions in the capital city of your state or province to find photographic possibilities. List five specific locations where you would shoot on a sunny day and five where you would shoot on a day with rainy or otherwise unfavorable weather. If possible, use your list on a trip to that city.

Critical Thinking

1. After returning from a vacation trip to Alaska, you have been asked to present a short audiovisual program to two audiences—a first-grade class and a local senior citizens' club. How could you tailor your program to the interests and needs of these very different audiences?

2. Some photographers concentrate on landscapes or buildings, while others focus on people and their activities. Which would appeal more to you? Why?

Communicating about Photography

1. **Reading and Speaking.** Choose a foreign country that you would like to visit. Research the culture, history, and notable features of this country. Give a short oral report to the class on the types of photos you would take to visually express the character of the country.

2. **Reading and Writing.** Partnering with another classmate, read a travel guide or photographer's guide. Make a list of the types of information found in the guide.

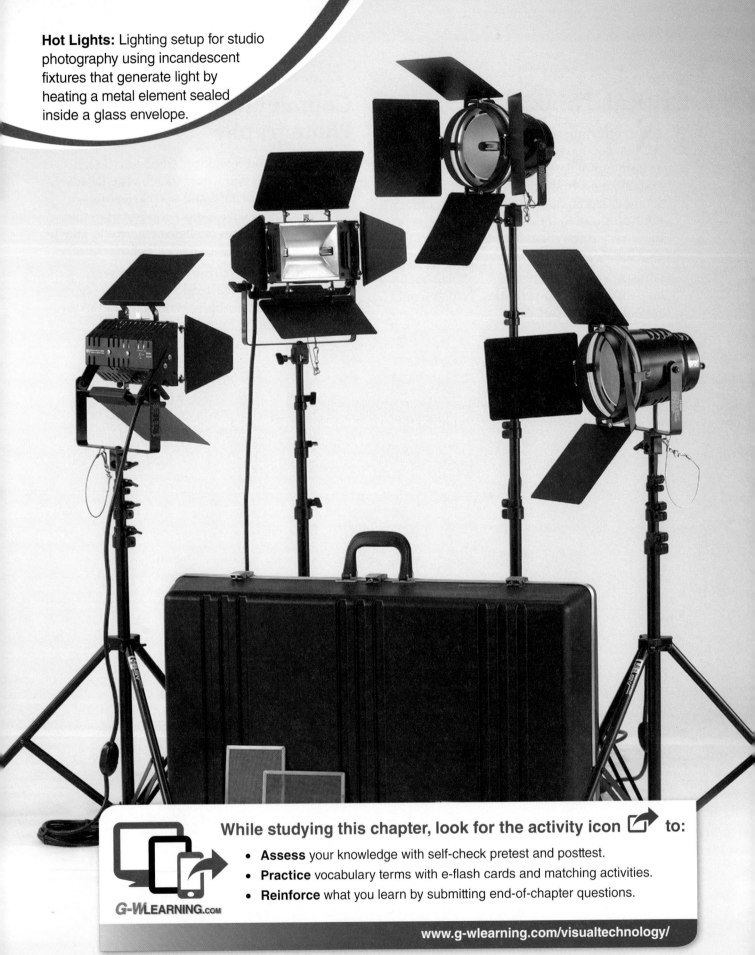

Hot Lights: Lighting setup for studio photography using incandescent fixtures that generate light by heating a metal element sealed inside a glass envelope.

While studying this chapter, look for the activity icon ⬀ **to:**

- **Assess** your knowledge with self-check pretest and posttest.
- **Practice** vocabulary terms with e-flash cards and matching activities.
- **Reinforce** what you learn by submitting end-of-chapter questions.

G-WLEARNING.com

www.g-wlearning.com/visualtechnology/

Smith-Victor Corporation

CHAPTER 14

Portrait and Studio Photography

Objectives

When you have finished reading this chapter, you will be able to:

- Describe the various types of portrait and studio photography.
- Demonstrate the use of white balance settings to provide a warming or cooling effect on light being recorded by a digital camera.
- Identify situations in which fill flash should be used.
- Discuss the techniques for controlling light in the studio.
- Apply the basic techniques of studio lighting for both portrait and product photography.

Check Your Photography IQ ⟶

Before you read this chapter, assess your current understanding of the chapter content by taking the chapter pretest.

www.g-wlearning.com/visualtechnology/

Technical Terms ⟶

3-point lighting
accent light
barn doors
continuous lights
electronic studio flash
environmental portraits
feathering
fill light
flags
formal studio portrait
gobo
grid
hair light
hard light

inverse-square law
key light
lighting ratio
monolight
pack-and-head system
photoflood
rim light
self-contained system
snoot
soft light
softbox
tenting
theatrical gel
tungsten-halogen bulb

"What type of photography is done in a studio?" In answer to this question, the great majority of people would reply "portraits." The association of the two is natural, since photo studios often display sample portraits in their windows, and many people have been in a studio to sit for individual or family portraits.

Portraits are the primary activity for most community-based photographers, but they are not the only kind of photographs made in a studio. Some studios, especially in larger cities, specialize in shooting objects rather than people. These studios concentrate on product photography for use in advertising and catalogs. While some product shots, such as clothing, involve people, the human beings are essentially props needed to display the merchandise.

Product photographers often must practice client confidentiality, since the products they are photographing may not be publicly announced for weeks or months. They must protect their client's information in a highly competitive business world.

Types of Portrait Photography

The *formal studio portrait* has been popular since the mid-1800s, when the slow tintype method forced subjects to hold uncomfortably stiff poses for long periods, **Figure 14-1**. Although improved technology has made portrait sessions less physically demanding, most studio portraits of adults remain fairly formal. This is especially true of executive portraits made for use in publications such as annual reports, **Figure 14-2**.

Studio portraits of children, on the other hand, are more spontaneous and are designed to capture the joy of childhood, **Figure 14-3**. Many parents schedule annual portraits to record their child's "growing up" years.

Goodheart-Willcox Publisher

Figure 14-1. Early photographic methods required long exposure times. As a result, most portrait subjects appear stiff and uncomfortable.

Image Group Photography, LLC

Figure 14-2. Studio portraits of adults, especially business people or civic leaders, are quite formal.

Amy Stroo Photography

Figure 14-3. A child's portrait session often captures delightful moments.

A more informal type of portrait, made outside the studio setting, has become popular. Often called *environmental portraits*, these images show the subject in natural surroundings or in a setting meaningful to them. Subjects typically wear casual clothing and are posed in a much more relaxed manner than in formal studio portraits, **Figure 14-4**.

For many studios, creating environmental portraits of high school seniors is an important source of business income. To develop a reputation that will attract continuing business in a competitive local market, the photographer must carefully schedule portrait sessions and post-production work. Good production scheduling is necessary to be able to deliver the finished product when promised.

Working with Ambient Light

Environmental portraits are typically made with ambient light. Outdoors, this would be sunlight or skylight. Indoor ambient light might be room lighting or a combination of room light and natural light coming through a window or door.

Ambient light often must be modified because it can be too bright, too dim, too contrasty, or too flat. The intensity of the light can be changed by strategies such as moving your subject out of harsh sunlight into open shade or using diffusion material to soften the light. You can reduce the contrast range by using a reflector to bounce light back onto the shadowed areas or a portable flash to provide fill light.

Larry Morris; Jack Klasey/Goodheart-Willcox Publisher

Figure 14-4. Portraits made outside the studio, often in natural surroundings, have become increasingly popular.

Fill Flash

In the fill flash technique, the flash unit's output is balanced with the ambient light. Generally, the flash is set to provide approximately one-half the light that is needed for proper flash exposure. With fill flash, the lighting of the subject appears natural rather than giving the appearance of a flash picture.

Many photographers use fill flash for portraits and other outdoor situations involving people or animals. When the subject is strongly sidelighted or even partially backlit, the flash projects enough light into the shadowed areas to soften them and reveal detail, **Figure 14-5**. When subjects are evenly and softly lighted (for example, in open shade), fill flash adds a hint of directional light to better model their features.

White Balance

With a digital camera, you can affect the color of the light by changing the white balance. The camera's automatic white balance (AWB) setting usually provides good results but may render the subject too cool or too warm for your liking. By using the appropriate white balance preset (*Daylight*, *Shade*, *Cloudy*, *Flash*, etc.), you can achieve the desired mood.

For example, a photo taken in open shade may have a rather cool blue cast because of reflected skylight. Using the camera's *Cloudy* setting will compensate for the skylight and give the photo a warmer appearance. See **Figure 14-6**. If a photo taken in late afternoon appears too warm, it can be cooled down by using the *Daylight* or *Flash* settings.

Ed Cayot

Figure 14-5. Using fill flash to balance light. A—Strong sunlight on the subject's face is too harsh and contrasty. B—Fill flash opens up the shadows for a more balanced lighting effect.

Automatic White Balance

Cloudy Preset White Balance

Jack Klasey/Goodheart-Willcox Publisher

Figure 14-6. Light color can be altered by changing white balance settings.

Digital cameras capable of producing RAW files provide another option. RAW files are image captures with minimal in-camera processing. These files must be converted with computer software into a format such as JPEG or TIFF. As part of that processing, the photographer can preview the image with different white balance settings and choose the best appearance.

In mixed-lighting situations, such as a portrait involving both natural light and artificial light, the photographer can create a custom white balance. An image of a white card in the actual light falling on the scene is captured, and then used as a reference by the camera for other images taken in that lighting situation. For detailed discussions of the modification of light color with white balance controls, refer to Chapters 7 and 10.

Working with Studio Lighting

The greatest amount of control over lighting can be exercised in the studio. Lighting units can be added, removed, and repositioned until the desired effect is achieved. Accessories can help control light intensity, direction, and coverage.

Always be aware of safety in the photo studio. Switch off and discharge monolights before plugging or unplugging lights or power. Use properly grounded extension cords of the appropriate length and rating. Avoid touching bulbs. Wear heat-resistant gloves when necessary to prevent burns from hot lights. It is a good idea to keep a fire extinguisher handy.

Light sources for studio use are typically either continuous (remain lit) or flash, although some photographers also make use of natural light from a skylight or window in the studio. *Continuous lights* may be incandescent (often referred to as *hot lights* because of their heat output), fluorescent, or a light-emitting diode (LED) array. The least expensive form of incandescent studio light is the *photoflood*, a glass bulb constructed for high light output.

These bulbs are normally mounted in metal reflectors to direct and concentrate the light output, **Figure 14-7.**

The second form of incandescent light is the *tungsten-halogen bulb,* **Figure 14-8.** These small, bright bulbs have both a higher light output (typically 600 watts) and a longer life than photoflood bulbs. Tungsten-halogen lights are very bright and extremely hot. With any type of incandescent light, be careful to prevent contact with skin or flammable materials.

Smith-Victor Corporation

Figure 14-7. Metal reflectors are typically used with photoflood bulbs.

In recent years, fluorescent light banks and LED light arrays have become available for studio use. These types of continuous lights overcome the problem of heat posed by incandescent lights. Continuous lights enable the photographer to directly observe the light falling on the subject.

A popular form of lighting, especially in studios doing product photography, is the *softbox,* **Figure 14-9.** This large source of diffused light consists of several lamps (usually fluorescent) or electronic flash units mounted inside a reflective housing. A sheet of translucent material covers the side of the housing that faces the subject. A large softbox provides a directionless light that seems to wrap around the subject.

Electronic studio flash units are the primary source of portable artificial light for photography. A strong electrical charge is built up in a storage device called a *capacitor,* then released into a gas-filled flash tube, producing a burst of bright light synchronized with the opening of the camera shutter.

Electronic studio flash units eliminate heat, the major drawback of incandescent lights. Additional advantages of electronic flash are a very short burst of light (measured in thousandths of a second) that helps freeze any slight subject movement, compatibility with 5500K daylight-balanced film, and a steady light output that does not change as the unit ages. Many electronic units include incandescent modeling lights to help the photographer assess lighting effects.

Bulb

Jack Klasey/Goodheart-Willcox Publisher

Figure 14-8. Tungsten-halogen bulbs produce brilliant light but also generate considerable heat.

Sinar Bron Imaging

Figure 14-9. A softbox produces a very diffuse, directionless light that is ideal for product photography.

There are two types of studio flash systems on the market—pack-and-head and self-contained, **Figure 14-10**. The *pack-and-head system* consists of a power pack that plugs into a wall outlet and separate flash heads connected to the power pack by individual cables. The pack contains the capacitors and output controls, and the head contains only the flash tube.

Advantages of the pack-and-head system are as follows:

- Heads are less heavy than monolights.
- The output of all the heads is controlled in one place.
- Each head has only one cord.

Disadvantages of the pack-and-head system are as follows:

- If the pack malfunctions, all of the lights are affected.
- The heads are not interchangeable among different brands of packs.

The *self-contained system*, often called a *monolight*, is a combination flash head and power supply. The flash tube, controls, and capacitors are combined into a single housing. Each unit plugs into a wall outlet.

Advantages of monolights are as follows:

- If one unit fails, the others will continue to work.
- You can use monolights from multiple companies.

Disadvantages of monolights are as follows:

- Monolights are heavier than flash heads.
- Output control is done at each unit.
- A control cord and a power cord are required for each unit.

Lighting Methods

Studio lighting can be as simple as a single light, or as complex as a setup involving three, four, or even more light sources. The important consideration is what effect you wish to achieve, not the number of lights you use. Studio photographs, from portraits to still-life arrangements, often are made with a single light or just a light and a reflector, **Figure 14-11**.

The lighting unit that provides the primary illumination of the subject is called the *main light* or *key light*. This light may be positioned to the left or right of the camera, at an angle of a few

A

B

Sinar Bron Imaging; Paul C. Buff, Inc.

Figure 14-10. Studio flash systems. A—A pack-and-head system uses a central power pack to which a number of separate flash heads can be connected. B—Monolights combine the flash head and power pack in a single housing.

Jack Klasey/Goodheart-Willcox Publisher

Figure 14-11. A single key light was located to the left of the camera and raised to simulate conventional skylight coming through a kitchen window.

degrees to more than 90° to the axis of the camera lens. See **Figure 14-12**. Since we are conditioned to outdoor (sky) lighting in which the light strikes the subject from a high angle, the key light is usually raised to simulate that lighting. The light should strike the subject from an angle of 40°–65° above the horizontal.

Supplementary illumination of the subject can be provided by a *fill light*. This light softens dark shadows, decreases the contrast range of the light reflected from the subject, and helps to reveal detail in shadow areas. As shown in **Figure 14-13**, a fill light is typically positioned on the opposite side of the camera from the key light. The fill light is usually placed close to the axis of the lens and set at approximately the same height as the camera.

When using fill lighting, be sure to avoid conflicting shadows that show light coming from two directions (an unnatural situation). Alter the location or intensity of the fill light to prevent such shadows.

To provide sufficient visual separation between the subject and the background, a separate light is often used. The background should be lighted so it is slightly less bright than the subject, **Figure 14-14**. Usually, the light is placed low and behind the subject so it is hidden and gives the background a gradually shaded illumination. Sometimes, a colored *theatrical gel*

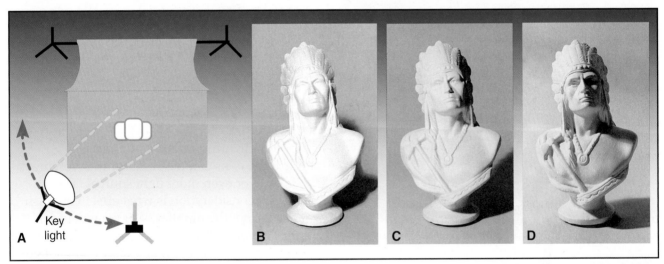

Jack Klasey/Goodheart-Willcox Publisher

Figure 14-12. The key light is the primary source of illumination falling on the subject. A—The key light may be located anywhere on the horizontal arc shown and is usually directed downward onto the subject. B—Positioning the key light just slightly off the camera lens axis provides flat frontal lighting. C—Moving the key light to strike the subject at a 45° angle to the lens axis casts shadows that provide a greater degree of modeling of the features. D—With the light at an angle of 90°, a much more dramatic appearance results because one-half of the subject's face is strongly shadowed.

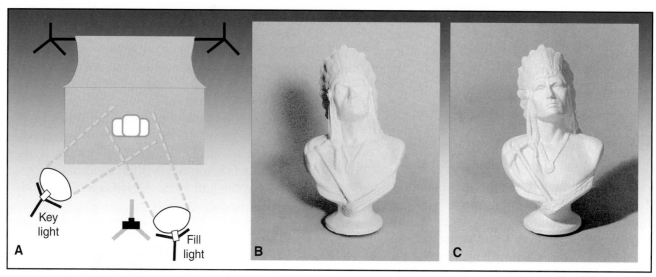

Jack Klasey/Goodheart-Willcox Publisher

Figure 14-13. The fill light supplements the key light. A—The fill light is usually located at the same height as the camera, on the side opposite the key light. B—The fill light intensity must be sufficient to soften dark shadows cast by the key light but not strong enough to create conflicting shadows. C—The combined effects of key and fill lights help to define the subject's features and avoid excessive contrast.

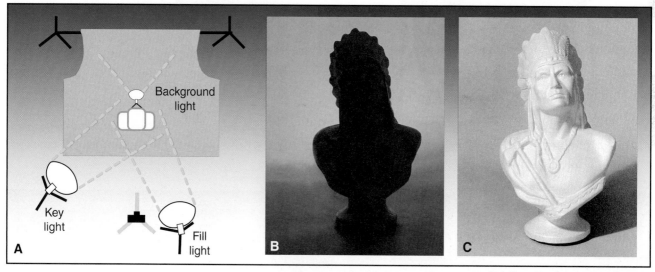

Jack Klasey/Goodheart-Willcox Publisher

Figure 14-14. A background light helps to separate a subject from its background. A—The light is pointed upward at the background. B—Placing the background light low and behind the subject hides the source from the camera. C—Lighting the background so it is somewhat less bright helps separate it from the subject.

is placed over the light to tint the background. A patterned translucent material or an opaque cutout may be placed in front of the light to project textures or shadows.

Sometimes, additional lighting is needed for emphasis, dramatic effect, or other reasons. For example, in a catalog shoot, one of the products in a grouping may need to be highlighted to emphasize it. Use a small spotlight to place a tightly concentrated beam of light on that product. The difference in lighting intensity will make the product stand out.

In portrait photography, an *accent light*, also called a *rim light* or *hair light*, is often used both for dramatic effect and to help separate a dark-haired subject from a dark background.

This light is positioned behind and to one side of the subject to provide backlighting. **Figure 14-15** shows placement of such a light. A lighting arrangement involving use of a main light, fill light, and accent light is referred to as *3-point lighting*.

Controlling Light

There are a number of ways to vary the intensity, or brightness, of the light falling on the subject. Two basic methods are changing the output of the light unit and changing the distance of the light from the subject. Many electronic studio flash units can be adjusted to change the light output over a range equivalent to several f-stops. See **Figure 14-16**.

This allows light output to be varied while leaving the lighting unit in one spot. The most practical way to adjust the intensity of continuous lights is to move the lighting unit closer to, or farther from, the subject.

The light's intensity may also be controlled by using devices, such as snoots or grids, or a technique called *feathering*. A *snoot*, **Figure 14-17**, is a tube placed on the front of a light to narrow its beam, producing a small spot of intense light. In portrait work, a snoot is often used to direct the beam of the hair light. A *grid* is a frame with

Paul C. Buff, Inc.

Figure 14-16. Controls on many electronic studio flash units allow light output to be increased or decreased.

Norman Enterprises, Inc. Division of Photo Control Corporation

Figure 14-17. A snoot created a small, intense spot of light.

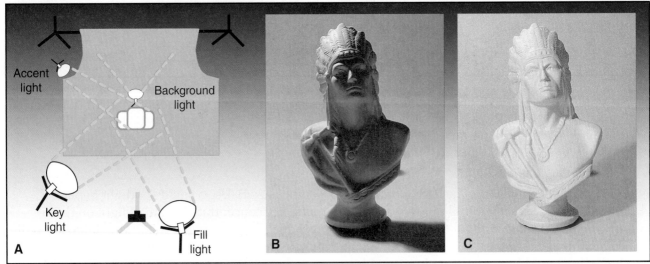

Jack Klasey/Goodheart-Willcox Publisher

Figure 14-15. Accent lighting can be used to emphasize certain features or parts of subjects. A—An accent light (also called *rim light* or *hair light*) is placed behind the subject to provide backlighting. B—The rim light emphasizes the edges of the subject. C—Combined with other lights.

square or hexagonal openings that align the rays of light so they are more ordered and parallel. See **Figure 14-18**. This type of light adds sparkle to a scene through increased contrast.

When a cone of light is projected from a lighting unit, the intensity is greatest at the center and falls off toward the edges. In *feathering*,

Norman Enterprises, Inc. Division of Photo Control Corporation

Figure 14-18. The square or hexagonal openings in a grid align the light rays and make them more parallel.

the light is adjusted so the less intense outer edges of the light cone illuminate the subject. See **Figure 14-19**.

The quality of light can be termed *hard* or *soft* based on the type of shadows that are produced. Light from a small, bright source is specular, or made up of parallel rays. Light from a large source is diffused, or made up of rays scattered at various angles. The light cast on a subject directly from a small source results in dark, well-defined shadows. This light is called **hard light**. When a translucent material is placed between the light and the subject, a large light source is created, resulting in shadows that are lighter and less defined. The light is then called **soft light**. See **Figure 14-20**.

Soft light also may be obtained by the indirect or bounced light method. A reflective material, such as a matte white panel or a photographic umbrella, produces a soft, diffused light. Materials with a silver finish produce a slightly harder but still diffused light.

Reflectors can be placed opposite the key light, on the other side of the subject, to add illumination to the shadowed area. When used like this, the reflector gives results similar to a fill light. Alternatively, a piece of flat black card stock can be positioned like a reflector, but with the opposite effect—elimination of an unwanted reflection of light into shadow areas. This method is valuable when the objective is to achieve a dramatic, high-contrast photo with dense black shadows.

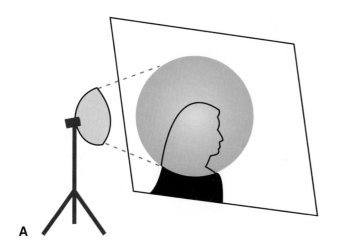
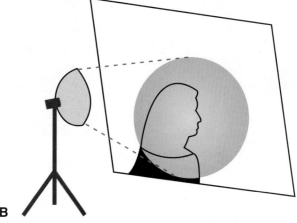

Goodheart-Willcox Publisher

Figure 14-19. Feathering light. A—The cone of light cast by a lamp is most intense in the center and decreased in intensity toward the edges. B—Intensity of light on the subject can be varied by moving the light so illumination comes from the edge of the cone.

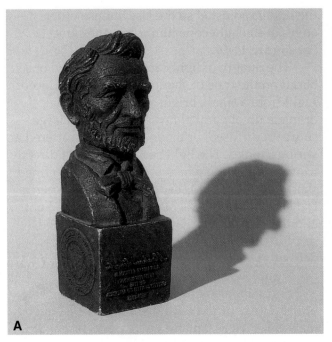

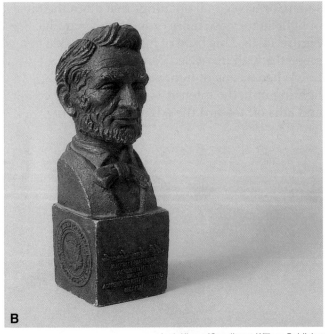

<div style="text-align:right;">*Jack Klasey/Goodheart-Willcox Publisher*</div>

Figure 14-20. Hard light vs. soft light. A—Specular hard light from a small source creates dense, well-defined shadows. B—Diffused soft light from a large source lightens shadows and makes them less defined.

Light-control devices called barn doors and flags prevent light from falling in areas where it is not wanted. *Barn doors* are hinged rectangular flaps of black-painted metal attached to the front of a lighting unit. See **Figure 14-21**. The flaps can

be adjusted, for example, to prevent light from spilling beyond the subject onto a background.

Flags are usually smaller than barn doors. They may be almost any shape and are usually cut from black posterboard or stiff black paper. A flag is often used to shade the camera lens and prevent flare from a lighting unit that is pointed toward the camera, such as when a subject is backlit.

A similar light control device is the *gobo*, a generic term for anything that goes between the light and the area where the light is intended to fall, **Figure 14-22**. A widely used type of gobo is a cutout that places on the background a shadow representing a multipaned window.

Measuring Light in the Studio

Careful measurement of the light falling on the subject is important not only for establishing correct overall exposure but also for determining the relative intensities of the key and fill lights. The method used to measure studio lighting depends on the type of lighting units involved. Light from continuous sources can be metered by using a camera's built-in meter or a handheld meter. For overall exposure, place a gray card in front of the subject and take a reflective meter reading. An incident-light meter reading, if preferred, can be

<div style="text-align:center;">*Norman Enterprises, Inc. Division of Photo Control Corporation*</div>

Figure 14-21. Barn doors are metal flaps that can be adjusted to prevent light from falling in certain areas.

Smith-Victor Corporation

Figure 14-22. A frame like this one can be used to hold a theatrical gel or other form of gobo in front of a light source.

made by holding the meter with its diffusing dome just in front of the subject. See **Figure 14-23**.

The brief burst of light from studio electronic flash units cannot be measured with conventional handheld or in-camera meters. A special handheld flash meter allows the photographer to trigger the flash units and make an incident light reading from the subject's position. Separate flash meters are available, but the trend in recent

years has been to combine the flash-reading function with the traditional reflected-light and incident-light capabilities of a handheld meter to create an all-in-one instrument.

Inverse-Square Law

The farther the subject is from the light source, the less brightly it is illuminated. This principle is referred to as *light falloff*.

The amount of light falloff is described scientifically using the ***inverse-square law***, which states that the illumination provided by a point source of light varies inversely as the square of the distance from the source. In other words, as light moves further away from its source, it spreads out to cover a larger area and thus provides weaker illumination. See **Figure 14-24**.

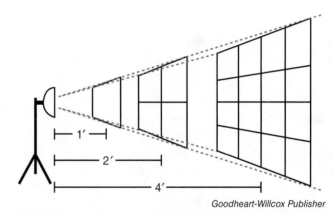

Goodheart-Willcox Publisher

Figure 14-24. Light intensity decreases as the distance from the source increases, since the light covers a larger area. As shown, a given amount of light falling on 1 ft² area at a distance of 1′ from the source spreads out to cover an area of 4 ft² at a distance of 2′ from the source. At a distance of 4′ from the source, the same amount of light covers an area of 16 ft².

Jack Klasey/Goodheart-Willcox Publisher

Figure 14-23. Light readings for incandescent sources. A—Reflected-light reading. B—Incident-light reading.

Since the amount of light reaching the image receiver after reflecting from the subject is the vital factor in determining exposure, the practical importance of the inverse square law is obvious. For example, the amount of light output by portable flash governs how distant the subject can be in order to remain properly illuminated.

Establishing the Lighting Ratio

Achieving an effective balance among the various lighting elements is important in all types of studio photography. However, the concept of *lighting ratio* is most often discussed in the context of portrait photography. That ratio is a numeric expression of the relationship between the illumination of highlight and shadow areas of the subject's face. Put another way, the lighting ratio expresses the relative intensities of the key and fill lighting.

A ratio of 1:1 means that the key light and the fill light are of equal intensity when measured at the subject position. Thinking in terms of f-stops, a 2:1 ratio indicates that the key light is one stop brighter than the fill light (i.e., twice as bright). A 4:1 ratio is a two-stop difference, an 8:1 ratio, three stops, and so on.

Traditionally, the lighting ratio for portrait work is 3:1—the highlight areas are three times (1.5 stops) brighter than the shadow areas. Low-contrast lighting ratios of 2:1 or 3:1 are preferred for portraits of women because they produce pleasing skin tones and minimize wrinkles and blemishes. Men are often photographed with a somewhat higher ratio of 4:1 or 5:1, while more dramatically lighted portraits may use ratios of 16:1 or even higher. **Figure 14-25** shows the effects of different lighting ratios on a single subject.

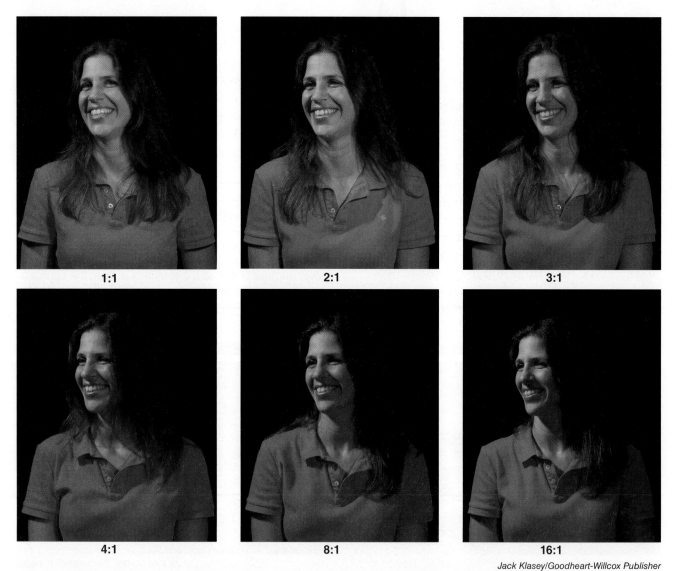

Jack Klasey/Goodheart-Willcox Publisher

Figure 14-25. Typical lighting ratios for portraiture. As ratios become higher, the lighting becomes more dramatic.

The method used to establish lighting ratios differs slightly, depending on whether a reflective meter or incident meter is being used. The following basic techniques can be employed with a normal handheld meter and incandescent lights or with a flash meter and electronic flash:

- **Reflective-reading method.** Hold a gray card at the subject's position, pointed midway between the key light and the camera. Take a reading from the card and note the exposure reading (f-stop). Shift the card so it points directly at the camera. Make a fill-light-only reading by shading the card so no illumination from the key light strikes its surface. Note this reading, and then determine the number of stops between the two readings. Refer to the table in **Figure 14-26** to convert the difference in stops to a lighting ratio.

- **Incident-reading method.** Hold the incident meter at the subject's position, aiming it directly at the key light. Note the exposure reading. Next, aim the meter at the camera.

Shade the meter to prevent any key light from falling on it so you obtain a reading from just the fill light. Note the second exposure reading, determine the number of stops difference, and use the table to find the lighting ratio.

Typical Lighting Situations

Lighting methods for portrait subjects and for products have many common elements, but also may differ in details. The following sections describe typical portrait and product lighting situations.

Portrait Photography

Basic portrait lighting can be done with a single light source, with a one light plus reflector arrangement, or with two lights (key and fill). When using only one light, avoid straight-on lighting that flattens out the subject's features. Raise the light source above the subject's head level and tilt it downward at an angle of 40°–65°. To provide some measure of sidelighting, shift the light somewhat away from the axis of the lens, as shown in **Figure 14-27**. The sidelighting casts shadows that give the face a more rounded, three-dimensional appearance. Unless a dramatic, contrasty look is desired, diffuse the light source to soften the shadows.

Lighting Ratios	
If the difference in f-stops is:	**Then the lighting ratio is:**
2/3	1.5:1
1	2:1
1 1/3	2.5:1
1 2/3	3:1
2	4:1
2 1/3	5:1
2 2/3	6:1
3	8:1
3 1/3	10:1
3 2/3	13:1
4	16:1

Goodheart-Willcox Publisher

Figure 14-26. This chart converts f-stop differences to lighting ratios.

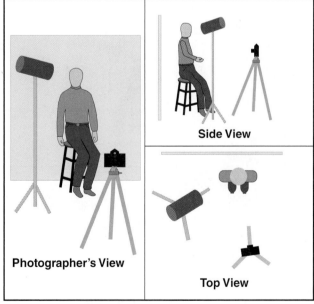

Goodheart-Willcox Publisher

Figure 14-27. In a single-light portrait setup, raise the light so it shines downward at an angle of 40°–65°. Often, the light is diffused to avoid casting dense shadows.

If the key light must be placed in a position that deeply shadows one side of the face, a second light or reflector is needed to lighten the shadows, lower the overall contrast, and reveal shadow detail. **Figure 14-28** shows how a reflector can be positioned in relation to the key light.

A two-light arrangement is extensively used for portraits, since it offers considerable flexibility in creating different effects and lighting ratios. The key light is typically positioned in the same way as in the single-light method and may or may not be diffused, depending on whether hard or soft lighting is desired. The fill light is located close to the camera position, and is usually lower than the key light, **Figure 14-29**. Normally, the fill light is diffused to provide a softer light.

The lighting ratio is established by changing the amount of fill light reaching the subject. As noted earlier, light intensity is changed by moving the light closer to or farther from the subject or by adjusting lighting unit controls to deliver a greater or smaller amount of light.

Sometimes, you need a multiple light arrangement. Adding a background light or a hair light can increase the impact of a traditional portrait. See **Figure 14-30**.

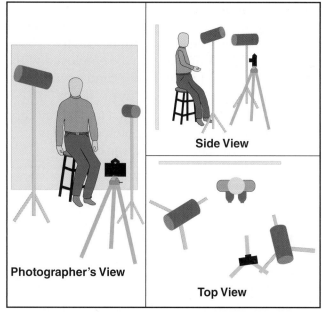

Goodheart-Willcox Publisher

Figure 14-29. The two-light arrangement is popular because of its ease of use and the flexibility it provides.

Jack Klasey/Goodheart-Willcox Publisher

Figure 14-30. To light this portrait, the photographer used three light sources. The key light was to the left of the camera and raised to direct light downward at about a 45° angle. The fill light was at head level and positioned to provide a 3:1 lighting ratio. A small spotlight provided rim lighting on the hair.

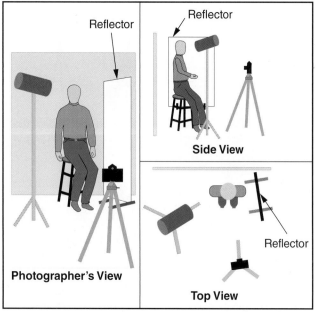

Goodheart-Willcox Publisher

Figure 14-28. A reflector can be used with a single-light setup to bounce additional illumination into shadowed areas.

Product Photography

For product photography, the key light may be a softbox or similar large diffused source to provide a soft overall lighting effect. Additional accent lights and reflectors are then positioned as necessary to create shadows and highlights. See **Figure 14-31**.

Glassware, polished metal, and other reflective objects can be difficult to light, since they act as mirrors showing the light source and surrounding objects. See **Figure 14-32**. If desired, it is possible to eliminate reflections entirely by methods such as *tenting* the subject. This is done by constructing a cone or shell of white translucent paper or plastic, with a small hole cut in one side for the camera lens. Light thrown on the cone from the outside results in a very diffuse illumination of the subject. Although this lighting approach eliminates reflections, it tends to flatten the object. Surface texture and curvature are not conveyed very well.

Another approach, which is often used for photographing glass, is indirect or transmitted lighting. Light is bounced off the background and passes through the glass objects to the camera lens. Since no frontal light is striking the reflective glass surface, there are no reflections. Colored backgrounds, or color gels on the lights, can be used to good effect. See **Figure 14-33**.

Jack Klasey/Goodheart-Willcox Publisher

Figure 14-32. Polished metal surfaces act as a mirror, showing undesirable reflections from the light source and objects in the studio. Note the reflection of the camera and photographer in these silver service pieces.

The key to successfully portraying most reflective subjects is controlling the reflections. Controlled reflections help to define the three-dimensional nature of the subject, convey its texture, and provide highlights that add visual interest. Reflection control involves a combination of light sources, reflectors, and black materials.

Small, bright light sources will create small specular reflections, while large, diffused light sources will result in broader and less intense reflections. To make the reflection pattern in the shiny surface more interesting, pieces of black

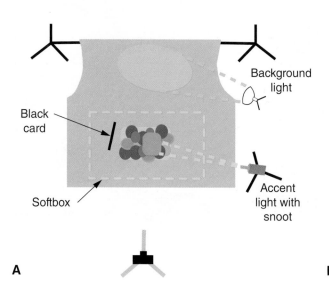

A

B

Jack Klasey/Goodheart-Willcox Publisher

Figure 14-31. A product shot using multiple light sources. A—The large softbox above the setup provided virtually directionless overall illumination. The product was given emphasis by lighting it with a small spotlight with a snoot. Positioning a black card opposite the accent light prevented lightening of the shadow areas due to reflection. A background light was placed low and directed through a colored gel. B—The final effect of the lighting setup.

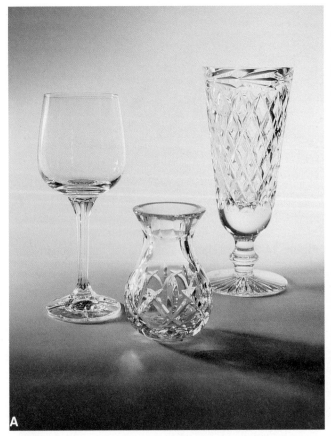

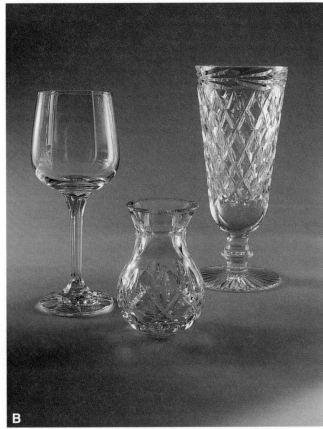

Jack Klasey/Goodheart-Willcox Publisher

Figure 14-33. Transmitted light can eliminate undesirable reflections when photographing glassware. A—Bouncing light off the seamless background material. B—Using a color background or adding color theatrical gels to the lights.

paper or card stock may be strategically placed between the diffused light source and the object. This will break up the reflection into dark and bright areas.

Entire books have been written about the complex subject of studio lighting. Such books can provide a good grounding in the subject and many examples of different lighting treatments. However, the best way to learn lighting technique is practice and experimentation, **Figure 14-34**.

Use a systematic approach—start with a single key light and try various angles and distances or intensities until you are satisfied. Next, add a reflector and see the differences that result from changing angles and distances. Replace the reflector with a fill light. Turn off the key light and experiment with various fill light placements. Turn the key light on again and make any additional adjustments to the fill light. Use a meter to determine lighting ratio and experiment with different ratios by making changes to the fill light. As you make exposures with various

Jack Klasey/Goodheart-Willcox Publisher

Figure 14-34. Experimenting with different lighting setups builds skills in the use of studio lighting.

lighting setups, keep careful notes. Include a rough sketch of the light placement (with dimensions) and the frame or image number.

If you are shooting film, you can check your notes to see the effects of the different arrangements after the film is developed and printed (or slides are processed). If you are using a digital camera, the LCD screen gives you a quick general view of the lighting effect. For a more accurate assessment, however, view the images on your computer screen, **Figure 14-35**. However, do not perform any adjustments on the digital files. You want to see exactly the lighting effects your sensor is recording. Experimenting with lighting and critically studying the images allows you to learn successful techniques and discard those that do not provide the desired results.

Portfolio Assignment

Finding the Right Ratio

Experiment with lighting ratios to produce a pleasing portrait. Use two continuous light sources, if available, or one light and a reflector. Working with a model, try various key light-to-fill ratios. Make exposures of at least three different ratios. You may want to make several exposures at each ratio to get a good expression as well as a proper exposure.

Choose the best portrait and print it for your portfolio. Indicate the lighting ratio and exposure information.

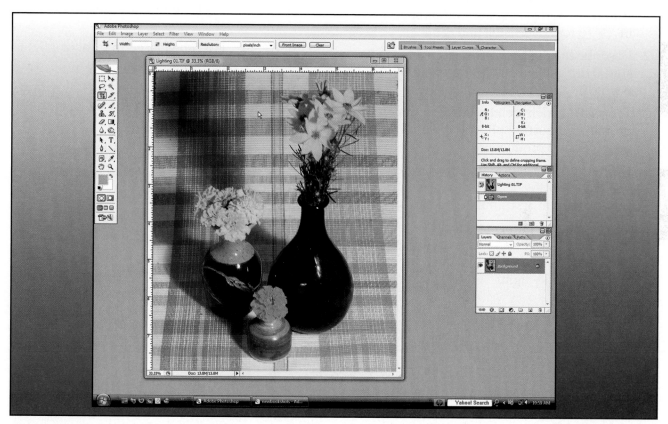

Goodheart-Willcox Publisher

Figure 14-35. Lighting experiment images shot with a digital camera should be viewed on the computer screen to closely examine shadow details and lighting effects.

Check Your Photography IQ

Now that you have finished this chapter, see what you learned by taking the chapter posttest.

www.g-wlearning.com/visualtechnology/

Review Questions

Answer the following questions using the information provided in this chapter.

1. While most of the photographs made in a studio are portraits, some studios specialize in _____ for advertising and catalogs.

2. Describe the differences between a formal studio portrait and an environmental portrait.

3. To be able to deliver a finished product when promised, a portrait photographer must practice good production _____.

4. Fill flash is a form of supplementary lighting used to lower the _____ range of a subject in bright sunlight and similar situations.

5. When photographing a subject in open shade, which white balance setting would you choose to overcome the cool blue cast caused by reflected sky light?
 A. *Auto*
 B. *Daylight*
 C. *Cloudy*
 D. *Fluorescent*

6. How would you set a proper white balance for a mixed lighting situation involving both natural and artificial light?

7. Photofloods and tungsten-halogen units are the two forms of _____ lighting, and are often referred to as *hot lights*.

8. Studios specializing in product photography often use a source of diffused light known as a(n) _____.

9. Which of the following statements about a pack-and-head system is *false*?
 A. Each head has only one cord.
 B. Flash heads are heavier than monolights.
 C. If the pack malfunctions, all of the lights are affected.
 D. The output of all the heads is controlled in one place.

10. In studio photography, the light that provides the strongest illumination is called the _____ light.

11. A supplementary light, called the _____ light, is often used to soften shadows and reveal detail.

12. Why is a background light often used in studio work?

13. A(n) _____ is a tube placed in front of a light source to narrow and direct its beam.

14. When making an incident-light reading in the studio, the meter is placed _____.
 A. at the camera's position
 B. at a 45° angle to the left of the camera
 C. at a 45° angle to the right of the camera
 D. at the subject's position

15. What is meant by the term *lighting ratio*? What lighting ratio is traditionally used for portrait photography?

16. When photographing a polished metal object, would you use a small light source placed far from the object or a large diffused source located close to the object? Why?

Suggested Activities

1. Research the tintype photographic process popular in the late nineteenth century. Use what you learn to create a small advertisement for a tintype portrait studio that might have appeared in an 1890 newspaper.

2. In teams of two, find good locations in your school to take a portrait of a fellow student. List three locations and describe why they would be suitable for shooting a portrait of that person. Include information about the available lighting in each location.

Critical Thinking

1. You work after school in a photo studio and were present when a client's new product, a radically new type of skateboard, was photographed for a catalog that will be released next month. Your best friend is an avid skateboarder and blogger on skateboarding topics. What are the potential consequences of telling him or her about the new product?

2. Examine a newspaper advertising insert for a large general retail store and one for a home improvement store. Some of the photos they contain show just the product and others contain a person. Is the balance between "product only" and "people with product" similar, or different? Why are people used in some of the photos?

Communicating about Photography

1. **Writing and Speaking.** Working in groups of two or three students, create flash cards for the technical terms in this chapter. On the front of the card, write the term. On the back of the card, write a brief definition. Use your textbook and a dictionary for guidance. Then take turns quizzing one another on the definitions of the key terms.

2. **Reading and Speaking.** Many portrait studio websites include tips for clients regarding how to prepare for their sitting. Read through several of these lists of tips and compile your own list of top 10 tips. With another student, role-play a situation in which you are a portrait photographer advising the client on how to prepare for the sitting. Then switch roles.

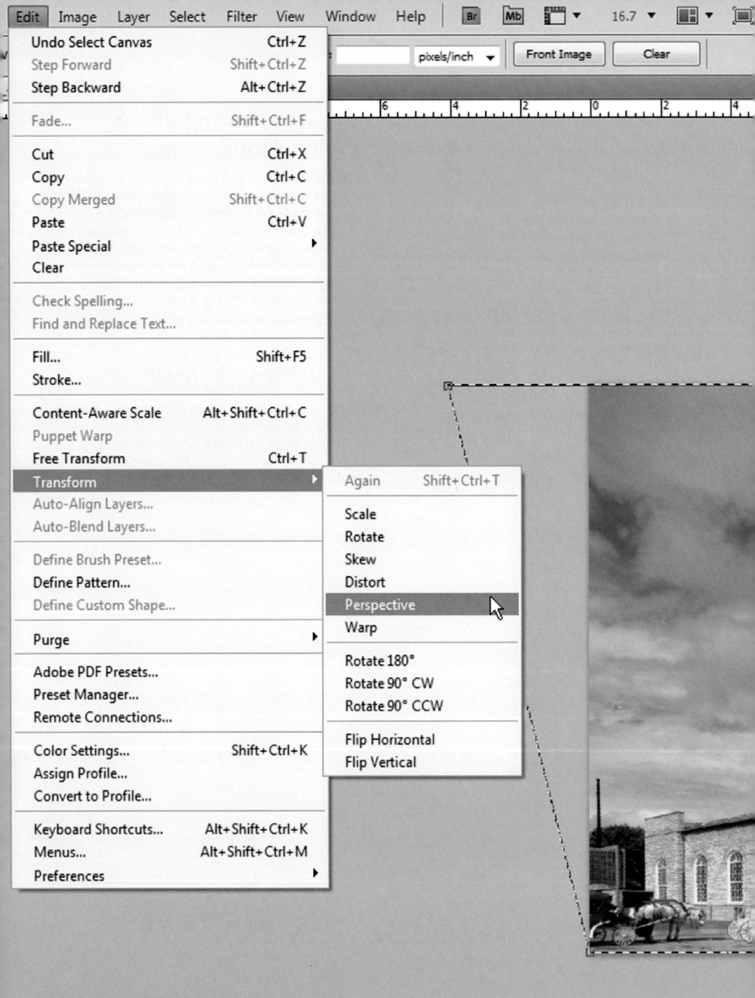

Section 3

Postprocessing

Chapter 15 Image Input and Scanning

Chapter 16 Digital Darkroom Basics

Chapter 17 Advanced Digital Darkroom Techniques

Chapter 18 Image Output and Presentation

Chapter 19 Film and Print Processing

Jack Klasey/Goodheart-Willcox Publisher

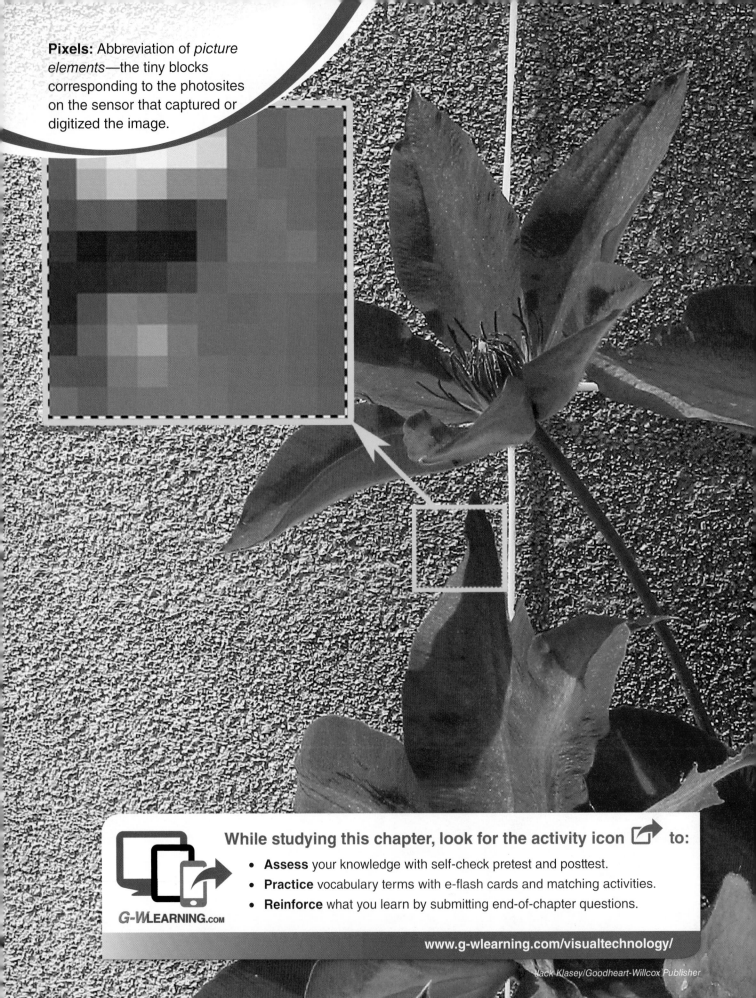

Pixels: Abbreviation of *picture elements*—the tiny blocks corresponding to the photosites on the sensor that captured or digitized the image.

While studying this chapter, look for the activity icon ↱ **to:**

- **Assess** your knowledge with self-check pretest and posttest.
- **Practice** vocabulary terms with e-flash cards and matching activities.
- **Reinforce** what you learn by submitting end-of-chapter questions.

G-WLEARNING.COM

www.g-wlearning.com/visualtechnology/

CHAPTER 15

Image Input and Scanning

Objectives

When you have finished reading this chapter, you will be able to:

- Describe the ways files are input from a digital camera.
- Apply the basic techniques of digital image capture with a camera or scanner.
- Describe the major types of scanners and the advantages of each.
- Explain the process of copying with a digital camera as an alternative to scanning.
- Discuss and apply copyright laws.
- Identify the various types of Internet-based image sources.
- Describe the use of keywords for image cataloging in database programs.

Check Your Photography IQ

Before you read this chapter, assess your current understanding of the chapter content by taking the chapter pretest.

www.g-wlearning.com/visualtechnology/

Technical Terms

archival-quality disc
attribution
black point
browsing
card reader
cataloging programs
copyright
copystand
database program
digital resolution
download
dynamic range
EXIF (Exchangeable Image File Format)
first generation
image management
infringement

keyword
metadata
online photofinishing sites
optical resolution
photo-sharing sites
preview image
public domain
rights-managed images
royalty
royalty-free images
scanners
thumbnails
upload
watermarking
white point

After capturing images with your camera, you must take one or more additional steps to convert them to a form that can be used for display or shared with others. If you are shooting with a film camera, the next step is processing to produce slides or negatives and prints. With a digital camera, you must transfer the image files to another device for processing and printing. This chapter concentrates on working with digital images. Film development and printing is covered in Chapter 19, *Film and Print Processing.*

Types of Input from a Camera

Inputting files from a digital camera involves sending or taking the files to a commercial processor, downloading them to a computer for processing and subsequent printing, copying to a portable storage device, or printing directly from a memory card. From a smartphone or a Wi-Fi-capable camera, images can be sent electronically directly to a printer.

Commercial Processing

Commercial processors are most commonly used to produce prints. A major factor in the tremendous growth of digital camera use among consumers was the introduction of digital file processing by mass-market retailers. Customers can drop off a memory card or *upload* (send) files via the Internet and then pick up finished prints in less than an hour. Unlike the all-or-nothing approach of film developing, customers can choose which files they want to print.

Many retail photofinishing locations offer kiosks that provide quick and relatively inexpensive printing and enlargement of photos, **Figure 15-1**. The machines typically accept originals in print, negative, slide, or digital form, including images from camera phones, tablets, and Facebook. They also offer tools for cropping and editing images. In addition to prints, the kiosks can produce photo posters, calendars, and similar products. Images files can be assembled and burned to a disc.

Online photofinishing sites, **Figure 15-2**, typically offer low-cost printing of images that you upload from cameras, phones, or tablets.

©2015 Kodak Alaris. TM: licensed from Eastman Kodak: Kodak and Kodak trade dress.

Figure 15-1. Picture kiosks are available at many photofinishing locations.

©2015 Shutterfly, Inc. Reproduced by permission of Shutterfly, Inc.

Figure 15-2. Online photofinishing. A—In addition to prints, these businesses offer customers the ability to use their images in photo books, calendars, and other products. B—Directions for uploading from your camera, computer, or other image sources are provided.

Images can also be forwarded from social networking sites like Facebook and Instagram. Large collections of images for printing can be physically sent on a DVD or a USB drive.

Photo-sharing sites on the Internet, such as Flickr or Smugmug, **Figure 15-3**, allow photographers to post albums of their pictures for viewing by family members and friends. To protect against unauthorized use of photos, the photographer can restrict access to the album by requiring a password. Physical prints can be ordered for delivery by mail.

Professional photographers have traditionally used specialized photo processors, usually referred to as *labs.* Wedding photographers use the labs to produce packages for their clients, and fine art photographers use them for individual or limited-edition prints. Advanced amateurs frequently send files to labs to obtain high-quality prints in sizes larger than they can produce on their own equipment.

Downloading to a Computer

Photographers who want greater control of their prints typically do their own processing and printing. They *download* the images (copy the image files from their camera or memory card

to their computer), perform desired adjustments using image editing software such as Adobe Photoshop, and then make prints of the selected images on their own printer.

To download images, a digital camera can be connected directly to one of the computer's *USB (Universal Serial Bus)* ports with a special cable. A more convenient method is the use of a *card reader*, which transfers the contents of a memory card to a computer. See **Figure 15-4**. Card readers are relatively inexpensive and use the computer's power to operate. Many newer computers and printers have built-in card readers.

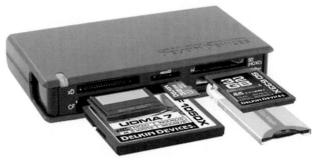

Delkin Devices

Figure 15-4. A card reader allows the photographer to download images from memory cards. This reader can be used with most types of available memory cards.

Smugmug

Figure 15-3. Photo-sharing sites on the Internet are popular for displaying albums of photographs that can be viewed by family and friends.

Travelers or photographers on lengthy location assignments can download memory cards to a laptop, a portable hard drive, or a USB drive, and then format the cards for reuse. At the end of the trip or assignment, the photographer transfers the stored files to a computer for processing.

Wireless Transfer

Camera phone users can upload pictures electronically to their computer or printer, a social networking site, or another cell phone. With wireless networking technology, such as Wi-Fi, photos can be transferred directly from a specially equipped digital camera, **Figure 15-5**, to a computer or printer located as far as 150′ away. File transfer over longer distances is possible by connecting the camera to a cellular telephone network.

Other Image Input Methods

In addition to transfers from a digital camera or cell phone, there are a number of other methods of acquiring digital images. These include using a scanner to create digital files from transparencies, negatives, or prints; having prints or slides scanned and placed on a disc, and downloading digital images from the Internet.

Scanners

Scanners are mechanical/optical devices used to convert transparencies, negatives, or prints into digital form. The three basic types are flatbed scanners, film (transparency and negative) scanners, and drum scanners.

Flatbed Scanners

The most common scanner type is the flatbed, **Figure 15-6**, which can be used to scan artwork, printed material, some three-dimensional objects, and photos. Some flatbeds can scan transparencies, while others can do so with a special adapter.

Multipurpose devices that incorporate flatbed scanner, photocopier, and printer functions are available. The advantages of these all-in-one units are convenience and saving of desktop space.

Most flatbed scanners for home or small business use can handle originals up to 8.5″ × 11″; some scan an area as large as 8.5″ × 14″. More expensive units intended for professional use accept originals up to 12″ × 17″ in size.

Resolution

The quality of an image produced by a scanner, like the output of a digital camera, is directly related to resolution. The higher the resolution, the more detailed the image is. Resolution is measured in pixels per inch (ppi) and is usually stated in a form such as 1200 × 2400. The first number is the number of sensors (pixels) per inch on the scanner's

Figure 15-5. This compact digital camera has Wi-Fi capability built in.

Figure 15-6. An inexpensive flatbed scanner is a popular tool for capturing digital images.

trilinear array. The second is the number of distinct "steps" per inch that that are made as the array moves the down the length of the scanned material. See **Figure 15-7**. Typically, only the first number is used to describe a scanner's resolution (for example, a 1200 ppi scanner).

Scanner resolution may be optical or digital, and it is important to distinguish between the two. *Optical resolution* is the actual pixels per inch count—600, 1200, 2400, and so on. *Digital resolution* is the measurement stated by some manufacturers for advertising purpose and is achieved by using software to insert additional pixels around those actually scanned. The digital resolution figure is misleading, since the resulting scan is actually lower in quality than one scanned at the comparable optical resolution.

Other Scanner Considerations

In addition to resolution, the quality of a scanned image is affected by color (bit) depth and dynamic range. Bit depth is a measure of the number of shades of gray that a pixel can display. *Dynamic range* is the ability of a scanner to reproduce detail at the extremes of highlight and shadow.

A scanner records color information by filtering the three rows of sensors on the array to obtain three different grayscale channels—one for green, one for red, and one for blue. Each channel typically has a bit depth of 8 and thus can contain 256 levels of gray. The resulting image has a bit depth of 24 and can reproduce up to 16.7 million different tones ($256 \times 256 \times 256$). Software translates the shades of gray into color values for display.

The dynamic range of a scanner is measured on a scale with a maximum value of 4.0. A dynamic range of 3.0 is considered minimum. Most moderately priced scanners are in the 3.2 or 3.3 range, while more expensive models might have a dynamic range of 3.4.

The speed at which a machine scans an image and sends it to the computer may be measured in minutes, especially with large originals and higher resolutions. The speed of the connection between the scanner and computer is also a factor. Common connection types from slowest to fastest are parallel, USB, and FireWire. For the photographer scanning a few images, speed is not usually a major consideration. For larger volumes of scanning, scan and data transfer speeds become more important.

Scanning transparent images requires the use of transmitted light, rather than the reflected light used to scan prints and other opaque originals. A few scanner models have a built-in source of transmitted light, **Figure 15-8**.

Trilinear array

1200 pixels per inch

2400 steps per inch

Scanning direction

Goodheart-Willcox Publisher

Figure 15-7. The trilinear array of a flatbed scanner is parallel to the short side of the scanning area. Thus, a 1200 ppi array would have 10,200 sensors for an 8.5″ wide scanning area (1200 × 8.5). A stepper motor moves the array down the length of the scanning area, making 2400 stops per inch, or a total of 26,400 for the full 11″ scanning area.

Epson Perfection V 550 Photo Color Scanner

Figure 15-8. A light source in the lid of some flatbed scanners allows them to be used for scanning slides and larger transparencies.

Most flatbed scanners, however, must be used with a transparency adapter, **Figure 15-9**. A transparency adapter provides the best results from medium-format or large-format transparencies. For the smaller areas presented by 35 mm slides or negatives, the higher resolution of a film scanner provides better scans.

Scanning Software

To preview and adjust the characteristics of the image before the actual scan is made, specialized software is used. Scanner makers provide software with their equipment, and scanning programs also are available from software developers. Such third-party programs offer more control than the manufacturer's software. These programs are typically used by professionals who deal with a large scanning volume.

Generating a *preview image*, **Figure 15-10**, is the first step in scanning. The preview is used to identify what cropping, contrast adjustment, and color correction should be done before scanning.

To crop the preview image, the cursor is used to adjust the dashed line frame as needed. As a visual reference, the area outside the crop lines is slightly darkened. See **Figure 15-11**.

Microtek

Figure 15-9. A transparency adapter shines light through the transparent original onto the CCD sensors.

The histogram, a graphic display of the number and distribution of tones in the image, is a useful tool. **Figure 15-12A** is the histogram for a black-and-white photograph. The histogram display consists of 256 columns, representing the possible shades of gray in the 8-bit image. The peaks and valleys are representations of the actual number of pixels of each shade, from 0 (pure black) at left to 255 (pure white) at right. **Figure 15-12B** shows the histogram for a color image. A histogram can be viewed as a single composite, or as a separate display for each of the three color channels.

Goodheart-Willcox Publisher

Figure 15-10. Scanning software allows you to preview the image and make adjustments before scanning. The preview screen typically displays image resolution and size information, as well as tools for cropping and adjusting the image.

Figure 15-11. Cropping on the preview display is done by dragging the dashed line frame with the cursor.

Figure 15-12. The histogram displays the tonal distribution of pixels in the image. A—The black-and-white histogram. B—The color histogram.

A histogram displaying empty areas at either end indicates there are no pixels at the lowest or highest values. The image can be adjusted to use the full tonal range by positioning small triangular indicators, called *sliders*, below the lowest and highest values shown on the histogram, **Figure 15-13**. The values of the pixels at each end are then reassigned, so the darkest value becomes 0 and the lightest, 255. All the remaining pixel values are redistributed to provide a full tonal range. The effects of such changes can be viewed in the preview image.

The **Eyedropper** tool is another means of adjusting the tonal range of an image before scanning, **Figure 15-14**. The dark eyedropper is used to sample the darkest desired tone in the image, setting its value as the *black point* (0). The light eyedropper is used in the same way to select the lightest desired tone, which becomes the *white point* (255).

The **Curves** tool adjusts the contrast and color of an image before scanning, **Figure 15-15**. As initially displayed, it consists of a diagonal line

Goodheart-Willcox Publisher

Figure 15-13. Adjusting the sliders to the first pixels at either end of the histogram expands the tonal range of the image.

Goodheart-Willcox Publisher

Figure 15-14. The **Eyedropper** tool is used to set the black point and white point of an image, thus achieving full tonal range. The black point has already been set; the light eyedropper is about to select the white point.

across a grid with the 0 point at lower left and the 255 point at upper right. **Figure 15-15A** shows the initial display for a black-and-white image. In **Figure 15-15B**, the curve has been adjusted into an *S* shape. This increases contrast in the image by redistributing pixel values to darken the shadows and lighten the highlights. Mastering the use of curves takes more practice than working with the histogram but provides precise control.

Once all image adjustment and cropping is done, the image can be scanned and the digitized file transferred to the computer's hard drive. The file can then be opened and manipulated, as needed, with an image-editing program such as Adobe Photoshop.

Film Scanners

Higher resolution, a greater dynamic range, and the ability to work from *first generation* (original) materials are the primary reasons for using a film scanner, **Figure 15-16**. These small desktop units

Courtesy of Nikon, Inc., Melville, New York

Figure 15-16. An important feature of this 35 mm film scanner is built-in software that automatically cleans up dust spots and scratches on the film.

Goodheart-Willcox Publisher

Figure 15-15. The **Curves** tool. A—The initial straight line display. B—The curve adjusted to increase image contrast.

range from scanners that can handle only 35 mm materials to those capable of scanning medium- or even large-format transparencies or negatives.

Film scanner resolutions start at about 2400 ppi (double the typical flatbed resolution) and range upward to 4000 ppi. Dynamic range of these scanners is typically 3.4 to 3.6.

Working with first-generation materials—transparencies and negatives—helps to achieve higher quality. Second-generation materials, such as prints made from a negative, inevitably suffer some quality loss. Many scanners have software that eliminates dust spots and scratches during the scan. This feature can save considerable time that would otherwise have to be spent electronically eliminating such small defects.

Film scanners, as a group, are more expensive than flatbeds, but provide far superior results from 35 mm materials. Where space and budget permit, many photographers have both types—a flatbed for prints and large transparencies, and a film scanner for smaller format originals.

Drum Scanners

When scan quality is the major consideration, such as a fine art reproduction or an image that will be enlarged drastically for use on a mural, a drum scanner is called for. Drum scanners, **Figure 15-17**, are typically found in prepress departments of large printing companies. These complex machines are also found in service bureaus that are used by publishing companies, advertising agencies, and commercial photographers. Drum scanners can be used to scan transparent or reflective materials of almost any size, as long as they can be mounted on the scanning drum. Books, mounted photos, or similar rigid materials cannot be scanned on a drum scanner.

Images on Disc

If you are not ready to invest time and money to do your own scanning, you can still have your film images converted to digital form. When you have a roll of film developed and printed by a commercial processor, you can have the images scanned and placed on a Compact Disc (CD) as well. Simple software provided with the CD or more sophisticated image-editing programs

Heidelberg

Figure 15-17. Drum scanners produce scans of the highest quality. Skilled operators are needed to run the equipment.

allow you to use your computer to crop, change contrast, adjust color, or combine images.

A number of online photo labs offer scanning of prints, 35 mm negatives or slides, and larger format images, **Figure 15-18**. The materials are sent to the lab by mail or other delivery services and returned along with a CD or DVD. Prints are typically scanned at 300 dpi, while slide and film negative scans are offered at a choice of resolutions (usually 2000, 3000, or 4000 dpi). Prices for scanning services vary by type of original, quantity, and the selected resolution.

DigMyPics.com

Figure 15-18. Online labs can scan prints and slides to produce digital image files.

Copying

If a scanner is not available, you can create digital files from a small number of prints or slides by copying them with your digital camera. This method is also useful when copying a print or document that is too large to fit on a flatbed scanner. In the same way, a film camera can be used to produce copies of slides, or to convert prints or documents to slide form.

Flatwork

The traditional method of copying flatwork—photographic prints, documents, and similar two-dimensional items— is to use a copystand. As shown in **Figure 15-19**, a *copystand* consists of a vertical column with an adjustable mount for the camera, a flat stage on which the print or other item is placed, and arms holding lighting units. The lights are typically arranged at a 45° vertical angle to the stage to provide even illumination and eliminate reflections.

If a copystand is not available, or if the original is too large to fit on its stage, a tripod and a pair of floodlights can be used. The original is fastened to a wall, evenly lighted, and then copied with a tripod-mounted camera.

When copying flatwork, use the lowest practical ISO and a white balance matching the type of lighting. If accuracy in color reproduction is critical, create a custom white balance by shooting a white card in the light falling on the subject. To avoid camera shake, use an electronic shutter release or a two-second time delay.

Slides

Photographers who enter competitions are reluctant to send out their original slides, which could become damaged or lost. Instead, they send high-quality duplicate slides, typically referred to as *dupes*. The easiest, but most costly, method of obtaining quality dupes is to have them made at a professional laboratory.

For greater control and flexibility, some photographers prefer to make their own dupes. Several types of slide-duplicating devices are available. Straight 1:1 copying of the slide is the only option with the least expensive models, while better units permit cropping and enlarging portions of the image.

Most slide-duplicating devices are in the form of a tube that attaches to the camera's lens. At the end of the tube is a slide holder covered with a light diffuser. See **Figure 15-20**. An electronic flash, photoflood, or even natural light can be used to provide the necessary illumination.

Since slides usually gain contrast when copied, special low-contrast slide duplicating films are normally used. To create an electronic file from a slide, you can use a digital camera.

IFF Repro-System/Bogen Photo Corp.

Figure 15-19. A copystand is a convenient tool for duplicating photographic prints or other documents.

Porter's Camera Store

Figure 15-20. A slide duplicator attaches to the camera in place of the lens and can be used to make an exact copy of the original slide.

If a slide duplicator is not available, you can copy a slide that is projected on a piece of white posterboard or similar matte surface and focused for maximum sharpness. This method results in a somewhat lower-quality duplicate, however.

Downloading from the Internet

Many photographers set up a website to display their work or post their images in online galleries maintained by organizations or individuals. For a beginning photographer, the Internet provides opportunities to see a wide variety of work by others as part of the learning process.

One negative aspect of posting on the Internet is the relative ease of downloading images, which can result in copyright law violations. An example is a photographer who downloads several images from galleries or web pages and uses them to develop a line of greeting cards for sale in local gift shops. Unless the photographer received permission to use the images, she has violated the owners' copyrights and has, in effect, committed theft. A method used by some photographers to help protect digital images is *watermarking*. Electronic watermarking embeds copyright information and the owner's identity in the digital file, providing a basis for identifying and prosecuting copyright violators. The various aspects of copyright as related to photography are discussed in the following section.

Copyright and the Photographer

Copyright is a law that gives the copyright owner the exclusive right to use and distribute a photograph or other item of intellectual property (such as a novel, song, or computer program) for a specific period of time. This means that no one else can make copies or otherwise use that photograph without the copyright owner's permission.

To obtain copyright for your photograph, all you have to do is press the shutter release on your camera. From the instant the image is created, it is covered by US copyright law. The law continues to provide protection for that image for your lifetime plus 70 years. Although a copyright notice, such as "© 2017 John Smith," can be used when the photo is printed or displayed on electronic media, it is not required by law. Displaying the notice may help discourage unauthorized copying of the image, however.

As described in Chapter 3, *Commercial Photography*, a photographer can license rights for use of a photograph in specific situations. A fee is usually charged. For example, a photograph might be licensed for use in a book or magazine, on a website or billboard, or even on a T-shirt. Licenses can be limited to use in a particular geographic area or for a specific period of time.

If someone uses your photograph without obtaining permission, they are committing an *infringement* (violation) of your copyright. The infringement may appear to be an innocent error. For example, the user may have been unaware that the photo was protected by copyright. In this case, you may just demand that they stop using it. If the infringement seems deliberate, you can seek a court order to stop usage of the image and possibly sue for a financial penalty.

Fair Use

Under certain circumstances, copyrighted material can be used without seeking permission. The *fair use* provision of the copyright law allows limited use of an intellectual property by critics and reviewers, scholars and researchers, and classroom teachers.

There are no specific rules to determine whether a particular instance is fair use or an infringement, but the law provides four factors that must be considered:

- The purpose and character of the use. Is it a nonprofit educational use, or a commercial (for profit) use?
- The nature of the work. What type of intellectual property is involved?
- The amount of the portion used in relation to the whole work.
- The effect of the usage on the value or potential market for the work.

An example of fair use would be a photography teacher downloading an image from a website to make copies for class discussion of compositional techniques. However, downloading of the same image for reproduction on a poster that is sold on the Internet would likely be considered copyright infringement.

Derivative Works

A work may be used without infringing copyright if it serves as the basis of a new creation.

This is called a *derivative work*. However, the original must be substantially adapted or modified to produce what is a new and different work. For example, a photograph of a leaping ballet dancer is changed considerably by the addition of butterfly wings, cropping to a different format, and compositing with various foreground and background images.

The legal and ethical considerations of combining images from different sources, as well as manipulating those images, is discussed in Chapter 17, *Advanced Digital Darkroom Techniques*.

Sources of Free and Fee-Based Images

Certain websites allow images to be downloaded legally, either free or for a fee. Free images are available primarily from government websites or for promotional purposes from some corporate sites. Images available for a fee are found on stock photo websites and in collections of royalty-free images sold on CD or DVD.

Free Image Sources

The largest and most accessible source of free images that can be downloaded from the Internet is the United States government. Since these images are in the ***public domain*** (not copyrighted), they are not subject to royalties or usage fees. The military services, the National Oceanic and Atmospheric Administration (NOAA), the National Aeronautics and Space Administration (NASA), and the Department of Agriculture all maintain huge libraries of images relating to their areas of interest.

The largest archive of images, and the most-often used, is maintained by the Library of Congress. The library's website, **Figure 15-21**, offers an incredible variety of pictures from many areas of both historic and contemporary America. A number of the historic photos used in this book were downloaded from the Library of Congress website.

Some photo-sharing websites, such as Flickr, offer many images at no cost under Creative Commons licensing. Some images have usage restrictions, but most can be used freely with ***attribution*** (giving proper credit to the person who

Library of Congress

Figure 15-21. The Library of Congress website offers thousands of photographs, many in high resolution, that can be downloaded free.

created the image). Creative Commons licensing is described in greater detail in Chapter 18, *Image Output and Presentation*.

With certain restrictions on use, free images are also available from organization and company websites. Associations that promote a specific occupational area, industry, business, or charitable activity may offer images related to their area of interest. Many large companies have libraries of images showing their products or services.

Since company images are intended to be used for publicity purposes, they are usually located in a section of the website identified as *Media* or *Press*. Some sites allow access and downloading of images without registration. Others require you to provide your name and organization to obtain a password for access (some refuse access to nonjournalists). Frequently, you must agree to abide by certain restrictions on the use of the images, such as not using them in a negative or demeaning context.

Fee-Based Image Sources

Images are also available for a wide range of fees. The most expensive images are those held in massive stock photo libraries such as Corbis. Known as *rights-managed images*, these photos are used extensively in advertising, magazine work, and book publishing. Users pay a fee for each use of an image—a single advertisement, for example, or one edition of a book. The stock agency pays a *royalty* (percentage of the fee) to the photographer or other copyright holder. Many professional photographers "shoot for stock" to supply images to such agencies. Those whose images are popular make a significant income.

Major stock photo agencies also offer a wide selection of *royalty-free images*. These photos are available for a one-time fee and can be used as often as the buyer wishes. Just like rights-managed images, the photographer or copyright holder receives a fee for each sale of the image.

A less expensive source of royalty-free images is a collection of photos offered on CD or DVD. These collections often are devoted to a specific topic, such as nature, travel, or transportation. Per-image costs are relatively low, but choices are limited by the size of the collection. Companies compiling such collections typically purchase the rights from photographers for a flat fee—royalties are not paid on each sale.

A lower-cost option has emerged in recent years with the development of smaller stock

agencies specializing in inexpensive royalty-free images. These agencies typically use a prepayment system in which customers purchase a quantity of credits, then spend them as they select images to purchase. Such agencies rely on a large number of mostly amateur or semiprofessional photographers who supply images and receive a small payment each time an image is sold. While this type of stock photography is unlikely to provide a full-time living for a photographer, it can generate a useful supplemental income.

Image Management

The more photos you shoot, the more important it becomes to develop a method of *image management*. This is a filing method, or cataloging system, that allows you to quickly locate a desired image. Ideally, you should develop and begin using a system before you accumulate a large number of images. If you already have a large body of work tucked away in shoeboxes or on your hard drive, the best method is to start cataloging current projects, and then gradually work backward through existing material as time allows.

Filing/Cataloging Methods

Depending on your needs, a cataloging system can be simple or complex. If you shoot only weddings, for example, a basic system might be to file by name and date:

Martin/Dubravec: July 16, 2015.

Two simple lists or card files—alphabetical and year/month—make it easy to locate a particular event. For film-based materials, the list entry references the storage location (binder, box, or file drawer). Digital image locations (CD/DVD or hard drive) are noted in the same way, along with the title of the electronic file folder containing the images. For example, if files are stored on a large hard drive, the basic file folder structure could be organized by year, then by month within that year. If several weddings were shot in a given month, each would have its own folder, **Figure 15-22**.

Such a system works well for anyone who simply needs to locate a particular group of photos, but it is not adequate for finding a specific individual photo or similar images taken at different times and places. Travel photos filed by the group method can lead you to the 2015 Grand Canyon trip or the Florida Keys journey of 2011, but do not help

Goodheart-Willcox Publisher

Figure 15-22. A simple image filing system that might be used by a wedding photographer consists of folders for each month and a subfolder for each wedding within that month.

you find images of a Cooper's hawk photographed on visits to five different locations in as many years.

Database Programs

Numerous image database programs, ranging from basic to extremely complex, are on the market. A *database program* is software that allows a collection of files (one file for each catalogued image) to be sorted in various ways to locate desired information. The most basic programs offer a *browsing* function that allows the user to view a number of small images (*thumbnails*) on the screen at one time, **Figure 15-23.** Related images can be grouped in a labeled album or collection. Most basic programs also allow some form of ranking (for example, assigning one or more stars) for image quality or impact. Groups of images

Goodheart-Willcox Publisher

Figure 15-23. Basic image database programs present stored images in thumbnail form for easy review and comparison.

can then be sorted and displayed based on the star rankings, **Figure 15-24.**

A browsing system with ranking capability is suitable for an image collection that is relatively small and limited to such topics as family photos and vacation shots. These programs are usually designed to work strictly with images that are stored on a computer's hard drive.

Keywords

The most sophisticated and useful method of locating individual images, or groups of images on a particular topic, is the *keyword* technique used by advanced image database programs. These *cataloging programs* allow users to assign specific descriptive words to each image so those words can be entered to search for that image in the database.

A

B

Goodheart-Willcox Publisher

Figure 15-24. Grouping photos. A—Related images can be grouped into named collections. B—Favorite shots within a collection can be identified and labeled with one or more stars for sorting.

The cataloging software reads the image files from a folder on a hard drive or from a CD or DVD and generates and stores both a small thumbnail image and a larger preview image for each file. Once the image files have been read, the photographer can assign keywords that describe the content of the image. Keywords can be added or deleted at any time using the program's edit function, **Figure 15-25**.

Well-chosen keywords are important in finding a desired image or images among the thousands in the database. The program's search function permits the user to be quite specific by using several keywords in combination. In the example shown in **Figure 15-26**, the first keyword is *flower*, and the second is *yellow*. Note that the first term is modified by the word *contains*, which would find files with either *flower* or *flowers* as a keyword. The keyword yellow is tightly specified—only files that exactly match that word (not *yellows* or *yellowing*, for example) will be accepted.

As shown in **Figure 15-27**, 79 images out of more than 16,000 in the database meet the criteria by containing both the keywords *flower* (or *flowers*) and yellow. Some image cataloging programs have a print feature that allows the image thumbnails to be printed out as an index print or "digital contact sheet." The photographer can scroll through the thumbnails displayed on the screen to locate the desired image or images and click on a thumbnail to examine a specific image more closely. See **Figure 15-28**.

Goodheart-Willcox Publisher

Figure 15-27. A portion of the search results for *flower* and *yellow*. The search returned some images with other flower colors visible in addition to yellow, because those images included *yellow* among their keywords.

Goodheart-Willcox Publisher

Figure 15-25. Assigning specific keywords allows identification of a given image.

Goodheart-Willcox Publisher

Figure 15-26. Combining keywords in a search allows very specific results.

Goodheart-Willcox Publisher

Figure 15-28. Clicking on the thumbnail view expands the image to a full-screen preview to allow closer examination.

Metadata

Cataloging programs can display a wealth of information about any image that was made using a digital camera. This information is called *metadata* (loosely translated as "data about data") and is contained in a file recorded by the camera at the time of exposure. The *EXIF (Exchangeable Image File Format)* file contains many image properties, including the shutter speed, aperture, ISO, and lens focal length. See **Figure 15-29**.

Once a desired image file has been identified, it can be accessed for use in an image editing program. The method for accessing the actual image file depends on its physical location as identified by the cataloging program. A file on the computer's hard drive can be opened immediately by the image editing software. A file that is located on a separate storage medium, such as a CD or DVD, must be imported by placing the disc in the computer's CD/DVD drive and copying the file to the hard drive.

Photographers who shoot large numbers of images often store the original files (sometimes called *digital negatives*) on CD or DVD, importing files to the computer as needed for processing. Since any storage device can fail, always make a separate backup copy of each CD or DVD on an *archival-quality disc*, **Figure 15-30**. Such discs are designed to preserve the files for literally hundreds of years.

Large-capacity hard drives have become more affordable, making storage of large numbers of image files in the computer possible. The advantage is immediate access to files without importing them from separate storage media. Backup copies of files are stored on a second or even third hard drive (often an external unit connected via USB or FireWire cable for rapid data transfer).

Delkin Devices

Figure 15-30. An archival quality disc is manufactured to more rigid standards and contains higher-quality materials than standard discs.

Goodheart-Willcox Publisher

Figure 15-29. The database also includes EXIF data about each image, providing the photographer with useful information for making comparisons of similar shots, or analyzing exposure.

Portfolio Assignment

Scan It!

Select a snapshot taken on a family vacation or other occasion. The subject can be people, scenery, a pet, or whatever you consider interesting. Using a flatbed scanner, display a preview image. Make a scan of the print without any cropping or adjustments, then save the file, naming it *original*.

Next, check the histogram of the preview image and adjust for a full tonal range. You can either use the sliders or the eyedroppers. If necessary, use the **Curves** control to improve the contrast of the image. Scan your adjusted image and save the file with the name *adjusted*.

Make prints of the two image scans, label them *original image scan* and *adjusted image scan*. Place the prints in your portfolio.

Check Your Photography IQ ↱

Now that you have finished this chapter, see what you learned by taking the chapter posttest.

www.g-wlearning.com/visualtechnology/

Review Questions ↱

Answer the following questions using the information provided in this chapter.

1. List several ways that images can be sent to photofinishing sites.

2. Photographers can restrict access to their photo albums on photo-sharing sites by using a(n) _____.

3. Images can be transferred from a camera to a computer without connecting cables through the use of _____ networking technology.

4. When flatbed scanner resolution is given in the form 1200 × 2400, what do the two numbers mean?

5. Scanning software usually displays a(n) _____ that shows the number and distribution of tones in the image.

6. What can the **Curves** tool be used for when preparing to scan an image?

7. What are three primary reasons to use a film scanner?

8. Online photo labs usually scan prints at a resolution of _____ dpi.

9. How does electronic watermarking help protect an image from copyright violation?

10. Describe two methods for using a digital camera to create image files from 35 mm slides.

11. Copyright protection for a photograph you create will be in effect for your lifetime plus _____.

12. The copyright law provision that allows copyrighted material to be used under certain circumstances without seeking permission is known as _____.
 A. exclusion
 B. limited use
 C. infringement
 D. fair use

13. What is the largest and most available Internet source for free images?

14. A photo reproduced under a Creative Commons license typically requires _____.

15. The category of stock photos or art requiring payment of a fee for each use is known as _____.

16. _____ is the process of developing a system for identifying and locating stored images.

17. Software that allows a collection of files to be sorted in various ways to locate the desired information, such as an image, is called a(n) _____.

18. Keywords are a feature of advanced image database programs. What are *keywords*?

Suggested Activities

1. Divide the class into two groups. One group should discuss the concept that photographs and other intellectual property posted on the Internet should be freely available for use without charge. The other group should discuss the idea that creators of intellectual property should have their rights protected under the copyright law. After the discussion, each group should select a spokesperson to present its view before the class.

2. On the US Copyright Office website, select "Copyright Law of the United States," then open Chapter 1. Locate and copy definitions for these terms—audiovisual works; computer program; copies; copyright owner; digital transmission; financial gain; pictorial, graphic, and sculptural works; work of visual art. Be prepared to explain one of the terms in your own words in class.

3. The basis of the copyright law is found in Article 1, Section 8 of the U.S. Constitution. Read that Section and identify the paragraph that gives the US Congress the power to protect the rights to intellectual property. Report to the class how you identified the proper paragraph.

4. Browse the Library of Congress website and find a photograph you like. Download the highest-available resolution of the image to your computer. Make an inkjet print on 8.5″ × 11″ photo paper. Post the print in your classroom, along with information about the image.

Critical Thinking

1. You find an old photograph showing your high school's 1940 football team. It has a stamp on the back stating "Copyright 1940 Powell Studio." Can you reproduce the photo without infringing copyright? Why or why not?

2. A friend brings you a photo taken at his senior prom by a professional photographer. He says that he would like you to copy it and make ten prints, because he does not want to pay what the photographer would charge for copies. What should you do, and why?

3. Think about the photos you have stored on your smartphone. How can you organize them to make it easier to find specific images?

Communicating about Photography

1. **Speaking and Listening.** Compare and contrast the different types of scanners discussed in this chapter. In what situations would the use of one type be preferable to the other? Record the key points of your discussion. In a class discussion, compare your responses to those of your classmates.

2. **Speaking and Writing.** Select two different images from a student portfolio. Imagine that you are going to put these images into an image database program. Divide into groups of two or three students and, working together, develop keywords that would help locate each image in a database.

Layer mask: An image manipulation tool used to protect a portion of an image from change or to permit a lower layer to show through the topmost layer.

While studying this chapter, look for the activity icon **to:**

- **Assess** your knowledge with self-check pretest and posttest.
- **Practice** vocabulary terms with e-flash cards and matching activities.
- **Reinforce** what you learn by submitting end-of-chapter questions.

*G-W*LEARNING.com

www.g-wlearning.com/visualtechnology/

Jack Klasey/Goodheart-Willcox Publisher

CHAPTER 16

Digital Darkroom Basics

Objectives

When you have finished reading this chapter, you will be able to:

- Distinguish between digital image processing and digital image manipulation.
- Understand the general procedure for using image-editing software.
- Describe digital darkroom techniques to adjust the size, contrast, and overall color balance of an image.
- Describe different methods of converting a color image to monochrome.
- Explain how and why unsharp masking is used on digital images.

Check Your Photography IQ ⤻

Before you read this chapter, assess your current understanding of the chapter content by taking the chapter pretest.

www.g-wlearning.com/visualtechnology/

Technical Terms ⤻

active layer
adjustment layers
burning in
dodging
downsampling
graphics tablet
grayscale mode
image editor
image manipulation

image processing
interpolation
monochrome
oversharpening
RAW converter
sharpening
shortcut keys
upsampling

In this age of digital imaging, it is possible to shoot a photo, process the image, and print a color enlargement in a matter of minutes. A number of sports and event photographers use such capabilities to their business advantage. See **Figure 16-1**.

Digital vs. Conventional Darkroom

For most photographers, the advantages of working digitally are creative control, convenience, and time savings. Compared to a conventional darkroom, the space required by a computer, scanner, and printer is minimal. The digital darkroom requires little setup time, and there is no need to set aside several hours to complete the work of printing, developing, fixing, washing, and drying prints.

Digital imaging also offers a great amount of flexibility. Work on a digital image can be halted, the results saved, and efforts resumed at the photographer's convenience, whereas conventional darkroom operations typically must be carried through to completion in a single session. Conventional darkroom work usually means hours of standing in a darkened room; digital darkroom activities are carried out in a lighted room from the comfort of a desk chair. For the photographer with allergies or chemical sensitivities, the advantage of a digital darkroom is obvious.

Image Processing or Image Manipulation?

Some photographers make a distinction between image processing and image manipulation. They consider *image processing* to be the electronic equivalent of the work typically done in the conventional darkroom. This work includes adjustment of exposure, color, and contrast; cropping the image; dodging; and burning in. More extreme changes to the image are considered *image manipulation*. These changes include distortion, removal of elements from the photo, combination of elements from

Jack Klasey/Goodheart-Willcox Publisher

Figure 16-1. Only moments after the winning power boat crosses the finish line, a print will emerge from the photographer's printer.

one or more other sources, and radical changes of color and tone.

Using that distinction, processing activities could be classified as working in the digital *darkroom*, while manipulation could be characterized as working in the digital *studio*.

How much manipulation of an image is permissible depends on its intended use and the photographer's ethical standards. Most print and electronic news media maintain strict control over photo content. The photographer or other staff member can make basic processing adjustments but cannot manipulate the photo by adding or removing content.

Some changes, such as removing a distracting person in the background, might seem harmless and an improvement to the image. However, news ethics do not permit such manipulations. The reasoning is that permitting even such minor "improvements" could lead to manipulation of photo content that would distort the meaning of the image and mislead readers or viewers.

Photographic artists are not necessarily bound by such considerations. They may use a variety of manipulation techniques to create works that distort reality to a greater or lesser extent, much like the work of impressionist or cubist painters. See **Figure 16-2**. The artist's intent is not to mislead the viewer but to convey his or her individual viewpoint. The work might be intended to convey a specific emotion, an idea, or a sense of altered reality.

Many photographers prefer to do what they refer to as *straight photography*, using little or no manipulation. These photographers produce prints that reflect, as accurately as possible, what they saw through the camera's viewfinder or on its LCD screen.

Image-Editing Software

An indispensable tool for either image processing or image manipulation is an ***image editor*** or editing program. These software applications range from very simple ones that can be used for basic tasks to highly complex applications with an array of specialized features. See **Figure 16-3**.

A

B

Goodheart-Willcox Publisher

Figure 16-3. Image-editing programs. A—Basic image editors typically use buttons to display a number of preset functions and effects. B—Full-featured image-editing programs, such as Adobe Photoshop®, are more complex and require time and effort to learn.

Goodheart-Willcox Publisher

Figure 16-2. Image manipulation techniques can produce images that distort reality.

PROCEDURE
Using Image-Editing Software

The procedure for using image-editing software, in general terms, includes the following:

1. Open an image for editing. The image may be stored on the computer's hard drive, imported from a CD, or the output of a scanner.
2. Perform basic processing actions, such as cropping or contrast adjustment.
3. Save the altered image file to preserve the changes.
4. Output the image to a printer or to social media.

Step 2 of the image-editing procedure may involve only a broad change or two, such as cropping the image or altering its overall brightness. Smaller adjustments may also be made, such as lightening the color of a subject's eyes.

Many different tools are available for performing actions on the image, **Figure 16-4**. Tools are typically selected and applied by using a standard computer mouse, although some users prefer a *graphics tablet* and pen. See **Figure 16-5**. The tablet and pen allow more precise control, especially when used to draw or retouch fine details.

Adobe Photoshop and similar full-featured programs allow the use of *shortcut keys* as an efficient alternative to employing a mouse and menu to perform many operations. A shortcut key may be an individual key or a combination of the Ctrl or Alt key (Command or Option key on an Apple® computer) with a letter, numeral, or punctuation mark.

The image-editing window, **Figure 16-6**, varies in appearance somewhat from program to program but almost always includes these features:

- A menu bar with drop-down menus across the top of the screen.
- An options bar for configuring a chosen tool.
- A toolbox displaying the available tools.
- A workspace or editing area where the image is displayed.
- One or more panels used for specific displays, such as color choices or brush sizes.

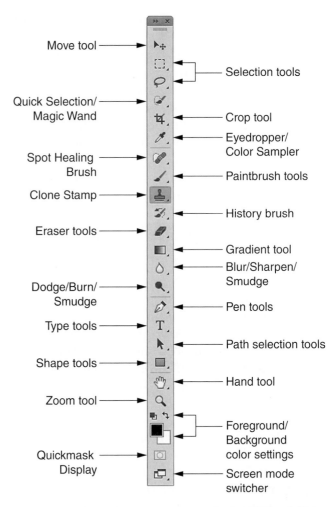

Goodheart-Willcox Publisher

Figure 16-4. Tools available for various image-editing functions are shown as icons on the toolbox.

Wacom

Figure 16-5. A graphics tablet allows precise control when working on images.

Figure 16-6. The basic parts of an image-editing program screen. A—Menu bar. B—Options bar (tool-specific). C—Toolbox. D—Workspace or editing area. E—Panels for specific displays. F—Displayed image.

Working in the Digital Darkroom

The descriptions of the tools, commands, and screen representations in this chapter are from Adobe Photoshop. Although they may differ in name or appearance, the corresponding tools and commands of other image editing programs accomplish similar results.

Creating a Working Copy

Always preserve an original image file without changes. Create a duplicate file, or working file, for processing. This allows you to go back to the original and make a fresh copy at any time.

Preparing a working copy often involves a change of file type. If the original image file is a compressed JPEG (.jpg) file, the duplicate should be changed to a Tagged Image File Format (.tif) or the Photoshop file format (.psd). As described in Chapter 8, .jpg files are lossy—they lose quality each time they are opened and resaved. The .tif and .psd file types are not lossy. Also, both .tif and .psd files support the use of layers, an important image processing feature that is covered later in this chapter.

RAW Conversion

RAW is a file type but not a file format like .jpg or .tif. Essentially, a RAW file is unprocessed image information—the camera's processor does not make any adjustments to the image as it does for .jpg files. Many digital photographers prefer to shoot RAW because it allows them more precise control of their images.

Image-editing programs cannot work directly on RAW files. These files must be changed to a file format that the program can handle. This is done with a *RAW converter*, software that allows the photographer to make a number of adjustments to the file data before saving the image as a .tif or .psd file. Photoshop and most other full-featured image-processing programs include a RAW converter. Camera manufacturers typically provide a RAW converter with their cameras, as well.

The major areas of adjustment are exposure, white balance, and contrast. See **Figure 16-7**.

Cropping and Resizing Images

To bring out the best in an image, cropping is often necessary. The **Rectangular Marquee** tool can be used to crop an image, **Figure 16-8**.

Goodheart-Willcox Publisher

Figure 16-7. RAW converter software allows the user to alter the white balance of the image to correct color casts or to simulate the effects of warming or cooling filters.

Goodheart-Willcox Publisher

Figure 16-8. Clicking and dragging create a frame to specify the desired crop.

Highlight the tool on the toolbox with a mouse click, and then click on one of the intended corners of the area to be cropped. Hold down the mouse button and drag the cursor to the diagonally opposite corner, and then release the button. A rectangular frame of dashed lines will be visible. Move the frame, if necessary, by

clicking inside it and dragging in the desired direction. It cannot be changed in size, however. If a different-size crop is needed, click outside the frame to delete it, then click-and-drag again to create a new frame. To perform the actual crop, select **Crop** from the **Image** drop-down menu.

A more flexible method is to use the **Crop** tool. Grouped with the selection marquees on the toolbox, this tool is applied in the same way (click-and-drag), but can be adjusted in both size and orientation. Once the mouse button is released, the frame can be resized by selecting and dragging any of the four sides or corners, **Figure 16-9**. The image also can be rotated by clicking outside one of the corners and dragging the mouse in the desired direction. This is especially useful for correcting a crooked scan or an image where the camera was tilted. The change is previewed on screen, making it easy to determine when the proper amount of rotation has been achieved. To perform the crop, you can double-click inside the frame or merely press the ENTER key.

Sometimes an image looks better if it is reversed left-to-right or even top-to-bottom. In the digital darkroom, this reversal can be done with a single mouse click, **Figure 16-10**. In addition to the **Flip Canvas Horizontal** and **Flip Canvas Vertical** choices, it is possible to rotate the entire frame in 90° increments.

Goodheart-Willcox Publisher

Figure 16-9. The **Crop** tool allows both resizing and rotation of the frame. For easier visualization, the area outside the cropping frame is dimmed.

Changing Image Size and Resolution

Image processing software allows you to change the size of your digital image, the resolution, or both. The physical size of your image and its resolution depends on the type of camera and the settings programmed into it by you or the camera manufacturer.

If the camera's file is output at 72 ppi, as many are, the physical dimensions could be quite large. For a 16Mp camera, such a file measures 64″ × 48″. In its original state, the file is not of much use,

since the dimensions are far too large for full-size display on a computer monitor, and the resolution is far too low for acceptable print quality. For a file output at 300 ppi, the dimensions are much more manageable at approximately 16″ × 12″.

In Photoshop, you can change the size or resolution with the **Image Size** dialog (other programs have similar controls). See **Figure 16-11**. The dialog has three key areas:

- **Image Size/Dimensions**
- **Width/Height/Resolution**
- **Resample**

Goodheart-Willcox Publisher

Figure 16-11. The **Image Size** dialog provides information on the current file size, image dimensions, and resolution.

A

B

Goodheart-Willcox Publisher

Figure 16-10. Flipping an image. A—An image can be flipped vertically or horizontally. B—The reversed image.

The top portion of the dialog shows the file size in kilobytes (K) or megabytes (M), and the width and height dimensions in pixels. A drop-down menu allows changing dimensions to other measurement units.

The document's width, height, and resolution are shown in the center section. You can display width and height in various measurement units. Clicking on the down arrow at the right opens a drop-down menu showing the choices, **Figure 16-12**. The **Resolution** drop-down lists two choices—**pixels/inch** and **pixels/cm**.

At the bottom of the dialog, **Resample** is checked by default. A drop-down menu displays *Automatic* but shows other resampling methods when the down arrow is clicked, **Figure 16-13**. The default **Automatic** choice is effective for most size changes. When size changes are 50% or more, some photographers prefer using **Bicubic Smoother** when increasing size or **Bicubic Sharper**

when decreasing size. For extreme enlargements of 100% or more, **Preserve Details** may be selected to upscale the image in multiple steps. The **Nearest Neighbor** and **Bilinear** settings are seldom used.

The **Resample** checkbox has a different effect on image size and resolution changes, depending on whether it is checked or unchecked. When the **Resample** box is checked (turned on), the following effects occur:

- A change in image dimensions does not increase or decrease the resolution.

- A change in the resolution does not increase or decrease the image dimensions.

If you decrease the image dimensions, the software selects and discards enough pixels to match the new size at the specified resolution, **Figure 16-14**. The same process, called *downsampling*, is followed if you decrease resolution while keeping the dimensions the same. Downsampling generally has less effect on image quality than *upsampling*, which occurs when image size or resolution is increased with the **Resample** box checked.

Goodheart-Willcox Publisher

Figure 16-12. A drop-down menu offers a number of choices for measurement unit displays. Pixels, inches, millimeters, or centimeters are most commonly used.

A

Goodheart-Willcox Publisher

Figure 16-13. The resampling method to be used when making image size changes can be selected from a drop-down menu.

B

Goodheart-Willcox Publisher

Figure 16-14. The **Resample** box checked. A—Clicking the lock button links dimensions so they change proportionally. B—Downsampling reduces both the image size and dimensions.

When you increase the dimensions, the size of the pixels remains the same (300 per inch), but the number of pixels has to increase to fill the added space. The image processing software creates new pixels to fill the gaps, a process called *interpolation*.

In **Figure 16-14**, note that the width and height dimensions are linked. Any change in width is accompanied by a corresponding change in height and vice versa. This avoids any distortion of the image when it is enlarged or reduced. If you uncheck the **Constrain Proportions** lock button (chain-link symbol), you can stretch or squeeze the image by changing the dimensions independently. This capability is useful for making small adjustments in one dimension.

When the **Resample** box is unchecked (turned off), the following effects occur:

- A change in image dimensions either increases or decreases the resolution.

- A change in the resolution either increases or decreases the image dimensions.

As shown in **Figure 16-15**, if your original file is at a resolution of 180 ppi and you change the resolution setting to 300 ppi, the dimensions shrink by 40%. The number of pixels remains unchanged—you are just packing more of them into each inch by making them physically smaller. The result is a higher-quality image that reproduces better when printed. This is a major reason why you should shoot images at the highest quality setting available on your camera. The larger the file, the more information is captured, giving you greater capabilities for image editing and manipulation.

Changing Canvas Size

If you want to increase the size of the space around your image, open the **Canvas Size** dialog by clicking **Image>Canvas Size**. See **Figure 16-16**.

The uppermost section shows the current size of the image, while the center section has **Width** and **Height** boxes, a **Relative** checkbox, and a grid labeled **Anchor**.

There are two ways to specify the amount of extension:

- With the **Relative** box checked, the amount of increase (in inches or other units) can be specified for both height and width, **Figure 16-17**.

- With the **Relative** box unchecked, the desired final width and height dimensions must be entered.

A

B

Figure 16-15. The resample box unchecked. A—Width, height and resolution are linked. B—Changing the resolution changes height and width, but not image size or dimensions.

Figure 16-16. Think of the canvas as the base on which your image rests. You can use the **Canvas Size** dialog to increase the space around your image.

Figure 16-17. To increase the canvas size by a specific amount, check the **Relative** box, and then enter the desired increase in width and height.

If the **Anchor** grid is left in its default state (with the black dot in the center square), the canvas is extended as specified on all four sides of the image. Moving the square with the dot to one of the outside spaces distributes the canvas extension in other ways. See **Figure 16-18**.

You can select the color of the extended canvas at the bottom of the dialog. The default is the **Background** color shown in the **Toolbox** (which is normally set to white). A drop-down menu allows you to select the **Foreground** color, white, black, gray, or a custom color.

Working with Layers

One of the most attractive features of full-featured image-editing programs is the ability to create *image layers*. These layers can be thought of as separate transparent sheets attached to the base image. Different elements of the image can be placed on separate layers so they can be worked on independently without changing the rest of the image. Material on a layer can totally block out the corresponding image area on layers below it or may be decreased in opacity to allow the underlying material to show through to some degree. Layers can be blended together for various effects, including overall darkening or lightening of the image.

A

B

C

Figure 16-18. Effects of using different anchor grid locations. A—With the dot square in the center position, the desired 1″ amount of canvas extension is split, adding 1/2″ on all four sides. B—When the dot square is moved to the left side, the canvas is extended 1/2″ on top and bottom and 1″ on the right side. C—Moving the dot square to the lower-right corner adds 1″ on the top and 1″ on the left side.

When an image is first opened in the editing program, it is on a single layer called the **Background Layer**. If only basic digital darkroom tasks are to be performed on the image, the single background layer may be sufficient. As noted earlier, you should make changes on a copy of the image, preserving the original in its unchanged state for possible future use.

The background layer and any layers that you add as you work on the image appear on the **Layers** panel, **Figure 16-19**. Each layer is a separate item on the panel. An individual layer can be displayed on the monitor by itself or in combination with other layers. The visibility of each layer is indicated by an eye icon to the far left of the item. Clicking on the icon turns layer visibility on and off. Changes can be made only to the *active layer*, which is indicated by highlighting, **Figure 16-20**.

Layers can be added, deleted, or moved to a different position within the stack of items shown on the **Layers** panel. As new layers are added, they are placed on top of the stack. You can delete a layer by dragging the item to the trashcan shown at the bottom of the panel. To move a layer, drag it upward or downward in the stack. A layer also can be relocated using the **Arrange** commands from the **Layer** menu.

Goodheart-Willcox Publisher

Figure 16-20. The blue highlighting shows that **Background Copy Layer** is currently active. Any changes to the image are made on that layer; other layers are not affected.

Creating New Layers

New layers can be created in a number of ways. To open a new blank layer, click on the **Create New Layer** icon at the bottom of the **Layers** panel, or select **New Layer** from the **Layer** drop-down menu.

Goodheart-Willcox Publisher

Figure 16-19. All layers created for an image are shown as items on the **Layers** panel.

When you have selected part of an image (selection tools are covered in detail in Chapter 17) and wish to place the selected material on a separate layer, choose **New Layer** from the **Layer** drop-down menu. The menu choices include **Layer via Cut** and **Layer via Copy**. Either one copies the selection to a new layer, but they differ greatly in their effect on the original image layer, **Figure 16-21**. **Layer via Cut** leaves a blank area behind when the new layer is created. On a background layer, the "hole" is white. On other layers, the opening is transparent. **Layer via Copy** copies the selection onto the new layer, but the original remains intact.

You can also place a selection on a new layer in a different image, a technique commonly used to create a composite (composite creation is covered in Chapter 17). There are two different methods for moving a selection to a different image—cut-and-paste and dragging.

Cut-and-paste. Click on the selection, then select **Cut** or **Copy** from the **Edit** menu. You can also use shortcut keys—Ctrl+X and Ctrl+C, respectively. Open the destination image, and then click on **Paste** from the **Edit** menu or use the shortcut, Ctrl+V. The selection is placed in the destination image as a new layer.

Dragging. Both the original and destination images must be open on the monitor. Click on the **Move** tool in the toolbox, then click on the selection and drag it to the destination image.

The selection is placed on a new layer in the destination image. See **Figure 16-22**. Existing layers can also be copied from one image to another by dragging. Again, both images must be open on the monitor. Click on the original image to make it active, and then click on the desired layer thumbnail on the **Layers** panel. Drag the layer to the destination image, releasing the mouse button when a black border appears around the destination image window.

Adjustment Layers

Adjustment layers allow you to make changes to an image's appearance without permanently altering the original image pixels. These special purpose layers permit you to experiment with different effects or values while observing the changes on the display. When using a **Hue/Saturation** adjustment layer, for example, you can increase or decrease the saturation of colors in the image or change the colors themselves. See **Figure 16-23**. The use of adjustment layers is explored in greater detail in Chapter 17.

Adjusting Overall Exposure

Most images, even those that are generally well-exposed, require some adjustment for best appearance. The most basic image refinement is expanding the tonal range with the **Levels** adjustment command. While the **Levels** command can be used on the **Background** layer, it is preferable

Goodheart-Willcox Publisher

Figure 16-21. A selection can be placed on a new layer by either cutting or copying. A—The **Layer via Cut** command leaves a "hole" on the original layer. B—The **Layer via Copy** command leaves the original layer unchanged.

Goodheart-Willcox Publisher

Figure 16-22. Copying a selection from one image to another with the **Move** tool. The cut-and-paste or copy-and-paste techniques can also be used.

Goodheart-Willcox Publisher

Figure 16-23. Using a **Hue/Saturation** adjustment layer to emphasize the bright colors of the pumpkins and store awning.

to make changes using an adjustment layer. To create a **Levels** adjustment layer, click on the **Levels** icon in the **Adjustments** panel. The **Levels** histogram appears, and a new layer (**Levels 1**) is shown on the **Layers** panel. See **Figure 16-24**.

The histogram is a graphic display of the number and distribution of tones in an image.

The peaks and valleys represent the actual number of pixels of each shade, from 0 (pure black) at left to 255 (pure white) at right. The histogram for an image with a full range of tones shows smaller numbers of pixels at the extremes and a large number distributed through the middle tones.

A

B

Goodheart-Willcox Publisher

Figure 16-24. Using the **Adjustments** panel. A—Click on the **Levels** icon to create a new adjustment layer. B—A **Levels 1** adjustment layer is shown on the **Layers** panel, and a histogram appears. The empty area at the right side of the histogram indicates that the image is dark and underexposed.

A histogram that displays empty areas at either end indicates no pixels at the lowest or highest values. You can adjust the image's black point and white point to distribute tones over the full tonal range by moving the small triangular sliders below either end of the histogram. Position the sliders beneath the lowest and highest values shown, **Figure 16-25**. This reassigns the values of the pixels so the darkest value becomes 0 and the lightest 255. All pixel values in the image are redistributed to provide a full tonal range.

To lighten or darken the midtones of an image, use the slider located below the center of the histogram. Moving the slider to the left lightens, while moving it to the right darkens. You can view the effects of the changes in the preview image.

Another command used to adjust the overall lightness or darkness of an image is **Brightness/Contrast**. Unlike the **Levels** command, it does not expand the tonal range—it merely shifts the histogram to the right (lighter) or to the left (darker).

An image can also be lightened or darkened overall by using **Duplicate Layer** and one of the blending modes. As shown in **Figure 16-26**, the duplicate layer appears above the **Background** layer in the **Layers** panel. To lighten the image, choose the **Screen** blending mode from the blending modes list and adjust the opacity slider until the desired degree of lightening is achieved. This is a useful method for salvaging an image that has been overexposed. To darken an underexposed image, follow the same procedure, but choose the **Multiply** blending mode.

Sometimes, using the **Levels** adjustment improves the overall brightness of the image but does not lighten the shadow areas. The **Shadows/Highlights** command, accessed by clicking **Image**>**Adjustments**>**Shadows/Highlights**, lightens the darker (shadow) areas of the image without affecting the lighter (highlight) areas. See **Figure 16-27**. The amount of shadow lightening is adjustable using a slider control. The default setting is 50%, but many photographers feel this is too light. Highlight areas can be darkened (but not lightened) using a separate slider. The **Shadows/Highlights** command cannot be used as an adjustment layer; however, it can be applied to a new duplicate background layer. By positioning the duplicate layer between the **Levels** adjustment layer and the **Background** layer, both the levels and the shadow and highlight changes are visible.

Goodheart-Willcox Publisher

Figure 16-25. Moving the slider below the right side of the histogram adjusts the white point, distributing image tones over the full tonal range. Compare the histogram and the brightness of the image in this illustration with the histogram and image in Figure 16-24B.

A

B

Goodheart-Willcox Publisher

Figure 16-26. Using blending modes. A—This image is somewhat dark. B—Adding a duplicate layer and changing the **Blending** mode to **Screen** lightens the image.

A

B

Figure 16-27. Shadow/Highlight command. A—This high-contrast scene was exposed to avoid burning out the highlights. B—The **Shadows** slider has been moved to 30% to lighten the shadow areas, revealing detail without affecting the highlight exposure.

Adjusting Local Exposure (Burning In and Dodging)

Those who have worked in a conventional darkroom are familiar with the processes of ***burning in*** (increasing exposure) and ***dodging*** (decreasing exposure) in specific print areas. In the digital darkroom, the toolbox contains a **Burn** tool and **Dodge** tool that serve the same purposes. Both tools offer the option of being applied to shadows, midtones, or highlights. Exposure can be controlled on the options bar by typing in a value from 1 to 100 or using a slider. See **Figure 16-28**.

Once the **Dodge** tool or **Burn** tool is selected, the tool size can be chosen from the **Brushes** panel. Typically, a soft-edged brush is used to help blend the effect with surrounding image areas. Brush size depends on the size of the area being dodged or burned in. For those who use a pen and graphics tablet, the options bar has an icon to specify whether pen pressure affects the size of the brush being used.

Burning in and dodging cannot create texture and detail where none is available. If highlight areas are "blown out" to pure white by overexposure, burning in creates a featureless and unattractive gray tone. Similarly, dense black underexposed shadow areas can be lightened, but will also be without any detail or texture.

Altering Contrast

Altering the relationship of shadow and highlight, or contrast, within a photo is a basic

Figure 16-28. The **Burn** tool is being used at a low (7%) value to slightly darken the midtones of the yellow leaf.

operation, since a straight print, or unaltered image, is seldom totally satisfactory. The tonal range may be too narrow, resulting in a flat and dull image, or too wide, producing a harsh and too-contrasty print.

The digital darkroom permits use of an infinite range of contrast alterations. There are two basic methods for changing contrast—the **Brightness/Contrast** command and the **Curves** command. Both are available as adjustment

layers, allowing them to be applied without affecting the pixels of the original image.

Brightness/Contrast is simple to use—sliders allow adjustment of contrast from 0 to 100 (increase) or 0 to –100 (decrease). Control is not precise, however, since sliders are difficult to adjust in small increments.

Curves, **Figure 16-29**, is more versatile. Its tone graph is initially presented as a straight diagonal line, representing the gradation from darkest value (at lower left) to brightest value (at upper right). Using the mouse, a graph curve can be constructed that is reflected by value changes in the image. If the **Preview** box is checked (the usual configuration), changes can be observed on the monitor as adjustments are made.

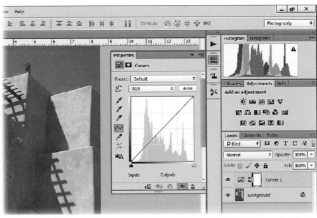

Goodheart-Willcox Publisher

Figure 16-29. The **Curves** adjustment layer.

PROCEDURE
Using Curves to Alter Contrast

1. With the image open, click on the **Curves** icon in the **Adjustments** panel.

2. Click on the midpoint of the diagonal line to anchor it at that point. A small black dot will appear at the center of the graph line.

3. Click on the line at a point midway between the center and the lower-left corner, then drag it a small distance diagonally down and to the right. Note that the line is now a curve from the midpoint to the lower-left corner. The line from the midpoint to the upper-right corner has assumed a matching (but opposite) curved shape, **Figure 16-30**.

4. The image now has more contrast, with the tonal range extended. The degree of contrast change depends on the distance the point was moved. The farther the line curves away from the diagonal, the greater the change.

5. To decrease contrast, move the curve in the opposite direction, curving upward from the lower-left corner to the midpoint and downward from the midpoint to the upper-right corner. The tonal range is decreased, flattening the image.

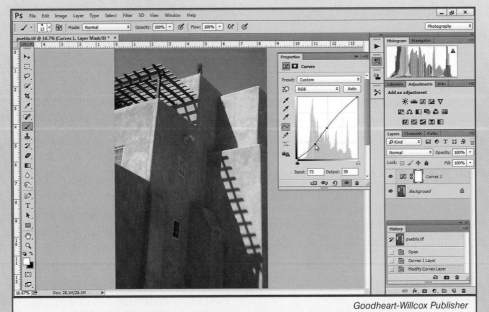

Goodheart-Willcox Publisher

Figure 16-30. This mildly S-curved line represents a moderate increase in the contrast of the image.

For greater control when working with a color image, you can individually adjust contrast of the red, green, and blue color channels. Use the **Channel** box above the tone graph to select the desired channel. **RGB** is the default—when it is displayed, contrast adjustments are applied to all three channels simultaneously.

Contrast also can be adjusted in a selected area of the image. Such a local change might be made to bring up detail in the somewhat dark foreground of a landscape. First, make a selection, then the contrast adjustment. The change will affect only the selected area.

Correcting and Adjusting Color

Working with color images, as compared to black and white, can be considered three or four times as complicated, since color images consist of either three channels (red, blue, and green) or four (cyan, magenta, yellow, and black). The images displayed on your computer screen are RGB images—all the colors you see are combinations of varying amounts of red, blue, and green light. Tiny phosphor dots of red, blue, and green glow when struck by a beam of electrons, transmitting the color. Light emitting diode displays (LEDs) and liquid crystal displays (LCDs) operate on different principles but have the same visual effect. Red, green, and blue are referred to as the *additive primaries*, since their light is added together to make a color.

Images that are printed on paper or another opaque base material convey colors to the eye using reflected light instead of transmitted light. Printed images make use of a different set of colors—cyan, magenta, and yellow. Each color blocks, or subtracts, a specific color and reflects others. Yellow absorbs the blue wavelengths of light but reflects red and green, magenta absorbs green but reflects red and blue, while cyan absorbs red and reflects blue and green. For this reason, these colors are called the *subtractive primaries*.

On the standard color wheel, **Figure 16-31**, the additive and subtractive primaries alternate and thus are paired on opposite sides—red is opposite cyan, blue is opposite yellow, and green is opposite magenta. The colors in each pair are known as *complementary colors*.

Color Correction

Being familiar with complementary color pairs is important when correcting color images using a **Curves** adjustment layer. With this method, adjustments can be made to the composite (RGB) curve, which affects all colors in the image, or to the individual color channels.

Figure 16-31. A standard color wheel.

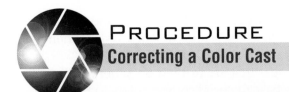

PROCEDURE
Correcting a Color Cast

Photos taken under industrial fluorescent or mercury vapor lighting often have an overall green color cast. To correct such a color cast, follow these steps:

1. Create a **Curves** adjustment layer and switch to the green channel (since green is the problem color).

2. Click on the **Target Adjustment** tool button located to the left of the channel indicator. Move the cursor (eyedropper tool) to an area where the color cast is most noticeable. A small circle appears on the diagonal line of the tone graph. The circle indicates the graph location for the pixel values being sampled.

3. Click the mouse button, and the cursor will change to the **Target Adjustment** tool (a hand and double-headed arrow). Drag the tool downward to reduce green and increase its complementary color, magenta, **Figure 16-32**. If you drag too far, the image takes on a distinct magenta cast.

4. The curve changes may cause the image to darken somewhat. To lighten the entire image, switch to the composite (RGB) curve and pull diagonally up to the left on the midpoint of the curve, **Figure 16-33**.

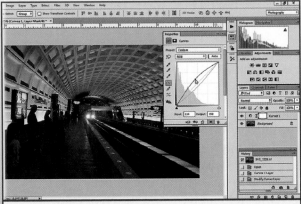

Goodheart-Willcox Publisher

Figure 16-33. To brighten the image, the composite curve is pulled slightly upward.

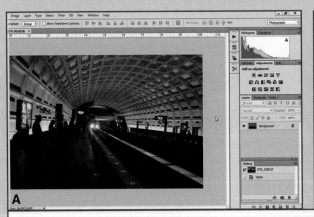
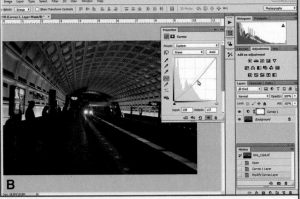

Goodheart-Willcox Publisher

Figure 16-32. Correcting a color cast. A—Fluorescent lighting has given this photo of a subway station a strong green cast. B—Using a **Curves** adjustment layer, the green channel can be adjusted to correct the color.

The **Color Balance** adjustment layer is less precise but easier to use than the **Curves** adjustment layer. It presents the three pairs of complementary colors, with a slider control for each pair. To make a color correction, the appropriate slider is moved toward the color that is to be increased, **Figure 16-34**. If desired, color balance can be adjusted differently in the image's shadows, midtones, and highlights.

Color Adjustment

The **Hue/Saturation** adjustment layer can be used to fine-tune colors in an image. You can select any of the six primary colors in the image (red,

A **B**

Figure 16-34. Using **Color Balance**. A—This photo, taken with incandescent light on daylight-balanced film, is much too yellow. B—Using a slider to add blue and decrease yellow.

green, blue, cyan, magenta, yellow) and adjust the hue, saturation, and brightness of the chosen color.

As shown in **Figure 16-35**, the **Hue** slider can shift a given color through shades of all the other primary colors. For example, moving the slider to the left can change a red bird's plumage to blue, while sliding to the right can make it yellow. The **Saturation** slider changes the intensity (strength) of the color, while the **Lightness** slider alters the overall brightness.

Similar changes can be made with the **Replace Color** command or the **Color Replacement** tool. The **Replace Color** command's dialog box, **Figure 16-36**, has a preview window that shows (in white) the color selected for replacement. You make a selection by using an eyedropper to sample the desired area of the image.

Figure 16-36. **Replace Color** is being used to change color of a running shoe from deep pink to yellow. The area selected for change is shown in a preview window.

A **B** **C**

Figure 16-35. Shifting color with the **Hue** slider. A—Original image of a red macaw. B—Sliding the control to the left shifts the color to a deep blue. C—Sliding the control to the right shifts the hue towards yellow.

Move the **Fuzziness** slider in the dialog box to expand or contract the selection in the preview window. To replace the selected color, use the **Hue**, **Saturation**, and **Lightness** sliders.

The **Color Replacement** tool is selected from the toolbox (right click on the **Brush** tool to see it). Once you have selected the **Color Replacement** tool, click on the foreground color in the toolbox to open a color picker. Select the desired replacement color by clicking **OK**. The **Color Replacement** tool brush appears as a circle with a crosshair in the center. Placing the crosshair over the color to be replaced and then clicking changes the color under the brush circle, **Figure 16-37**. You can change brush size and sensitivity (tolerance) on the **Options** bar.

Converting Color to Monochrome

For dramatic effect or other reasons, it may be desirable to change a color image to one that is *monochrome*, or single-color (typically black and white). There are several ways to do so:

- Convert the mode to grayscale.
- Choose one of the color channels as the grayscale source.
- Remove color (desaturate).
- Use the **Channel Mixer** command.
- Create a **Black & White** adjustment layer.

When an image is converted from a color mode to *grayscale mode*, all the color information is discarded. The red, green, and blue color channels are merged into a single grayscale channel. The resulting image is often flat and lacking in contrast (especially local contrast in adjoining areas of the image). This problem occurs because quite different colors, such as some shades of red and green, have very similar brightness values. When converted

Goodheart-Willcox Publisher

Figure 16-37. The **Color Replacement** tool brush paints a new color over an object while retaining the original surface texture.

from color to a shade of gray, similar brightness values make it difficult to distinguish a red flower from its background of green leaves. To improve the contrast of the converted image, adjust it using **Levels** or **Curves**.

A conversion method that often gives better contrast is to review the individual color channels, which are displayed in grayscale, and select the one that looks best. The grayscale conversion will be made using the brightness values of that channel. **Figure 16-38** compares the results of the two conversion methods.

When the **Desaturate** command is used, color is removed from the image, and gray values are displayed. The image remains in the color mode, with the three color channels still intact. In this mode, possibilities for image

Goodheart-Willcox Publisher

Figure 16-38. Converting from color to grayscale. A—The original color image. B—A straight conversion to the grayscale mode. C—Selecting the best color channel and converting it to grayscale.

manipulation are increased. Areas of color can be added or some parts of the image can be restored to their original color values (see the Using the History Brush section in Chapter 17).

To desaturate part of an image so some areas are gray and others are in color, two techniques are available. The **Desaturate** command can be applied after a selection is made to isolate the desired part of the image. Desaturation also can be done directly with the **Sponge** tool. This tool, located with the **Dodge** and **Burn** tools on the toolbox, is applied like a paintbrush to the desired area. Opacity can be set to 100% to remove all color or to a lower value that leaves a tint of the color. See **Figure 16-39**.

The **Channel Mixer** command provides a great deal of control when converting a color image to monochrome. With the Monochrome box checked, you can select different percentages from each of the color channels (red, green, blue) while observing, in monochrome, the effects of the changes. See **Figure 16-40**.

A drawback to using any of the preceding methods for monochrome conversion is that they are destructive—once the image has been saved, the change cannot be reversed. A better choice is to use the **Black & White** adjustment layer. Adjustment layers are nondestructive. This means the images can be saved and closed, then opened again, and the changes removed to bring the image back to its original state.

Goodheart-Willcox Publisher

Figure 16-39. Desaturation. A—The left side of this image was desaturated, while the original color was retained on the right side. B—The sponge tool can "wipe away" color in selected areas for effect.

Goodheart-Willcox Publisher

Figure 16-40. Using the **Channel Mixer** command, a scene can be given a different interpretation by varying the percentages of the three channels.

Like **Channel Mixer**, the **Black & White** adjustment layer allows you to adjust color sliders and try different combinations to find the best monochrome conversion. Instead of the three color sliders in the **Channel Mixer**, however, the

Black & White adjustment layer has five sliders. An alternate method to the color sliders is the **Target Adjustment** tool, as described earlier in this chapter. Once you are satisfied with the conversion, close and save the image.

PROCEDURE
Converting to Monochrome with a Black & White Adjustment Layer

1. Open the image you wish to convert.
2. Click on the **Black & White** icon on the **Adjustments** panel.
3. Try different combinations of the channel sliders while observing the effect on the monochrome image. Alternatively use the **Target Adjustment** tool as shown in **Figure 16-41**.
4. When you are satisfied with the changes, save and close the image.
5. If you later wish to try a different set of adjustments, reopen the file, and then click on the **Black & White** adjustment layer on the **Layers** panel.
6. Make your changes, and then resave and close the file.

Goodheart-Willcox Publisher

Figure 16-41. Using the **Black & White** adjustment layer's **Target Adjustment** tool to make a monochrome conversion.

Cleaning Up the Image

Careful cleaning of scanned materials is necessary to minimize the need for *spotting* (removing small dust spots on the image). When scanning from prints, inspect the glass of the flatbed scanner and clean it if necessary. Dust negatives and slides with a soft antistatic brush before inserting them in a film scanner.

Spotting may also be necessary on images captured with a digital SLR camera. When the camera body is opened to change lenses, dust and lint particles can enter and settle on the cover plate of the sensor. The particles show up as dark spots when the image is displayed. The spots are especially noticeable in areas of light, continuous tone such as the sky or an expanse of snow or sand.

Spotting is done with the **Clone Stamp** tool. It is used to copy (clone) a small area of the image and place it over the dust spot. Set the working size of the **Clone Stamp** tool by choosing a brush size from the **Brushes** panel. For spotting work, a fairly small, soft-edged brush is normally used.

Figure 16-42 shows a scanned antique image that requires spotting. All spotting work should be done with the image displayed at the full size (100%) setting. This allows you to see what the image will look like when printed so even tiny defects can be identified and corrected. Spotting should be done systematically, beginning at one of the image corners and proceeding in steps until the entire image has been displayed and processed. The Page Up and Page Down keys allow you to step through the image vertically; combined with the Ctrl key, they allow horizontal stepping.

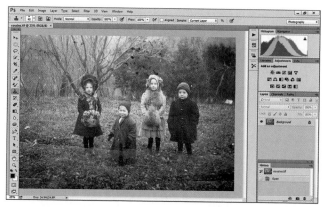

Goodheart-Willcox Publisher

Figure 16-42. This antique image has numerous spots (both black and white) that must be cleaned up. Spotting should be done with the image displayed at 100% to make even small defects visible.

PROCEDURE
Eliminating a Spot Using the Clone Stamp Tool

1. Position the cursor (brush-size circle) on an area near the spot to be removed. See **Figure 16-43**. The area should be as close as possible in appearance to the spot's immediate surroundings. This will make the correction less obvious.

2. Hold down the Alt key (Option on a Mac) and click with the left mouse key to select the image pixels that will be copied. Release the Alt key.

3. Reposition the cursor over the spot and press the left mouse key. The spot will be covered with the image information (pixels) you selected in step 2. If the spot is larger than the brush size, move the cursor and press the left mouse key again. Continue moving and clicking until the spot is eliminated.

4. Larger areas can be covered by clicking and dragging (using the tool as a paintbrush), but the results are often an unsatisfactory patterned appearance. Move and click to cover the defect with a series of smaller cloned spots for better results.

Brush circle

Goodheart-Willcox Publisher

Figure 16-43. After selecting an area from which to clone image information, the brush circle is placed over the spot. A mouse click copies the selected image over the white spot. Note that the image is displayed at 100%. At that size, only a portion of it can be displayed on the screen.

When cleaning up defects on human subjects, the **Spot Healing** brush tool is particularly useful. See **Figure 16-44**. Select a brush size, and then place it over the defect to be removed to blend the repair with the color and texture of the area surrounding the defect. This tool works well for removing small skin defects in portraits, since the blending makes the repair virtually invisible.

Eliminating Dust Spots and Scratches

Many scanners offer a feature that automatically cleans up dust spots and scratches during the scanning process. This can be a real timesaver, especially if the original is in poor condition from improper storage.

Image-editing programs offer a tool that automatically cleans up scans from images that exhibit a large number of such defects. In Photoshop, the tool is called the **Dust & Scratches** filter, **Figure 16-45**. This filter works by blurring pixels in small bright areas (which are usually dust spots or scratches), but it can cause an undesirable softening of the entire image.

Two settings in the dialog box for the **Dust & Scratches** filter allow you to select the degree of change. The *radius* setting determines the width of the defect that the program will identify as a spot or scratch. The larger the number, the more blurred the image will be. The *Threshold* setting sets the filter's sensitivity—how much the color

Figure 16-44. The **Spot Healing** brush is ideal for repairing small skin defects on portrait subjects.

of the spot must differ from its surroundings to be considered a defect. If the setting is 1, the filter considers everything a defect and blurs the whole image. A value of 255 has the opposite effect—no defects are recognized and nothing is changed. Checking the **Preview** box allows you to see the amount of blurring and spot elimination done at various settings. Because of its effect on image quality, use this filter only for images that show a very large number of defects. Although it can be tedious, cleaning up spots and scratches with the **Clone Stamp** tool is a better choice for preserving image quality.

A

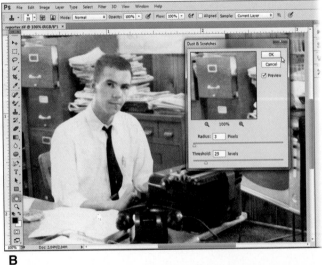

B

Figure 16-45. The **Dust & Scratches** filter in use. A—This image was scanned from an old Polaroid print. Note the many small white spots on the file cabinet at left and on the screen of the television set. B—Applying the **Dust & Scratches** filter at the settings shown minimized the white spots but seriously softened the image.

Sharpening the Image

Sharpening involves enhancing edge contrast to make an image appear more sharply focused. While it cannot correct an image that is badly out of focus, it may improve one that is slightly soft. The most common use for the sharpening technique, however, is overcoming the slight blurring that can occur when an image is resized, rotated, or otherwise processed digitally.

Sharpening is actually an optical illusion. It does not restore lost detail but increases the difference in the color of adjacent pixels, especially along edges. This tricks the eye into seeing the image as more detailed and sharp. Use this technique with care because *oversharpening* can give the image an unattractive, harsh, blotchy appearance. See **Figure 16-46**.

Sharpening Filters

An image-editing program may offer several sharpening tools or filters. Photoshop, for example, lists six choices—**Shake Reduction**, **Sharpen**, **Sharpen Edges**, **Sharpen More**, **Smart Sharpen**, and **Unsharp Mask**. The **Unsharp Mask** tool is most often used because of the control it offers. Three of the remaining choices are all-or-nothing in their approach, providing a set amount of sharpening. The amount of sharpening is minimal in the case of **Sharpen** and **Sharpen Edges** and considerably greater in **Sharpen More**. The fifth choice, **Smart Sharpen**, has the same control advantage as **Unsharp Mask**, plus some additional features that make it more difficult to use. **Shake Reduction** is a complex sharpening tool that is designed to eliminate or greatly reduce the blurring caused by slight camera movement.

The **Unsharp Mask** filter creates a slightly blurred copy of the image and uses it as a mask (hence, the term unsharp) to determine which areas will be sharpened. When using this filter, you can control and preview the degree of sharpening. The chosen degree of sharpening

Jack Klasey/Goodheart-Willcox Publisher

Figure 16-46. Oversharpening can seriously degrade image quality. A—A properly sharpened image. B—The same image that has been badly oversharpened.

is displayed on both a small detail view and the full-size screen image, **Figure 16-47**. For accurate judgment of the sharpening effect, the displayed image should be at 100%. By checking and unchecking the **Preview** box or by clicking on the detail view, you can compare the image before sharpening and with sharpening applied.

Three sliders control the effect of the filter. The amount can be adjusted from 1% to 500%, but most often it is set somewhere between 100% and 200%. Higher values are typically used with larger images that will be reproduced on inkjet or dye sublimation printers. Lower values are used for smaller images, especially if they will be reproduced by the halftone printing process (for example, in a magazine).

Radius settings can be varied from 0.1 pixels to 250 pixels. At the lower values, sharpening is confined mainly to edges within the image. Settings of 5 pixels or lower are typical. The *Threshold* setting identifies how different two pixels must be in brightness level before

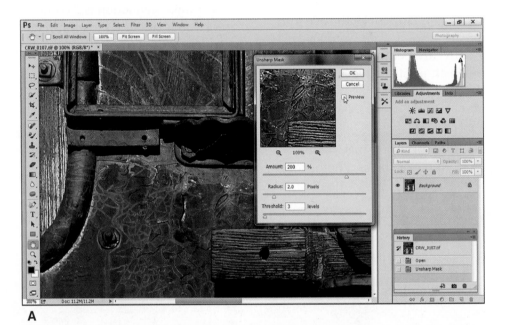

A

B

Goodheart-Willcox Publisher

Figure 16-47. Unsharp masking. A—A portion of an image with various textures, before applying sharpening. B—With sharpening applied, texture details are more visible.

sharpening will be applied. The adjustment range is 1 to 255, with the number of pixels affected decreasing as the setting increases. A typical starting point for *Threshold* settings is 3 to 4.

Sharpening should be done as the final step before printing, after all other adjustments have been made to the file. If sharpening is applied earlier in the process, additional image changes could exaggerate its effects. For example, increasing file dimensions after sharpening could make the edges of objects appear to be oversharpened.

Sharpening Layered Images

If an image has more than one layer, the layers must be sharpened individually (or the image flattened to a single layer before sharpening). Only "content" layers can be sharpened, however. Sharpening has no visible effect when applied to an adjustment layer, since it has no pixel content.

Figure 16-48 shows a file with three "content" layers. Sharpening this image is a three-step process—each layer is selected and sharpened individually. An advantage of this method is the ability to independently sharpen layers or even selected portions of layers. Depending on the image content and artistic intent, different amounts of sharpening could be applied.

Portfolio Assignment

Monochrome Conversion

Choose one of your images (or shoot a new one) that you feel would make an effective black-and-white print. Using a **Black & White** Adjustment Layer, experiment with different conversions. Use the **Target Adjustment** tool or move the color bar sliders to set various combinations of percentages. When you are satisfied with the appearance of the image, make a print for your portfolio.

Goodheart-Willcox Publisher

Figure 16-48. Sharpening an image with several layers must be done on a layer-by-layer basis. As indicated by the highlight in the **Layers** panel, the sharpening is being applied to the **Background Layer**, which is the active layer.

Check Your Photography IQ

Now that you have finished this chapter, see what you learned by taking the chapter posttest.

www.g-wlearning.com/visualtechnology/

Review Questions

Answer the following questions using the information provided in this chapter.

1. List at least two advantages of the digital darkroom compared to a conventional darkroom.

2. How does image manipulation differ from image processing? Give examples of each.

3. The software used to alter and refine digital images is called a(n) _____.
 A. scanning program
 B. digitizer
 C. image editor
 D. graphic processor

4. For more efficient image-editing program operation, you can use _____ instead of a mouse and menu choices.

5. Why is it important to make a working copy of an image file for processing?

6. Name the two tools used to crop photos. Which is more useful, and why?

7. If the **Resample** box in the **Image Size** dialog is unchecked, how will an increase in resolution affect the image dimensions?

8. What is the advantage of placing different elements of an image on separate layers?

9. How would you copy a selection from one image to another?

10. How is a histogram used to adjust the tonal range (darkness or lightness) of an image?

11. What are the **Burn** and **Dodge** tools used for in the digital darkroom?

12. The most precise way of controlling contrast in an image is to use the _____ command.

13. When correcting a green color cast in an image, you would increase its _____ color, which is magenta.

14. Which of the following is *not* a technique for converting a color image to a grayscale image?
 A. Straight mode conversion
 B. Mode conversion using a color channel
 C. Desaturation
 D. Color stripping

15. Describe the process that is used to remove small defects, such as dust spots, from a digital image.

16. Why is the statement *sharpening restores lost detail to an image* incorrect?

17. When the **Unsharp Mask** tool is used, a value of 3 to 4 is normally the starting point for the _____ setting.

Suggested Activities

1. Find a news photograph that includes elements that distract the viewer from the main subject. If you had captured the image and were not bound by the photojournalist's "no manipulation" rule, how would you improve the photograph? Make a copy of the image and mark it to show areas where you would make changes, such as deleting a distracting object. Discuss the final result with your instructor.

2. Select one of your images, adjust its overall exposure, and then make a full-frame print. Set the print aside, then view the image on-screen again. In what ways could you crop the image to make it more visually interesting? Create different cropped versions, saving each under a different file name. Make a print of each image. Choose the one you believe is most effective. Ask several friends to look at the full-frame print and the cropped images and select the one they think is the best photo. Do their choices match yours?

3. Shoot two identical exposures of a scene with quite a bit of detail, such as a bed of flowers or a crowd scene. Open the first image in Photoshop or a similar image editor. Make sure **Resample** is checked in the image size dialog. Check the resolution and reset it if necessary to 72 ppi. Next, change the width of the image to 10″ and close the image size dialog. Save the image with the name *Example 72* and make a print. Open the second image and bring up the image size dialog. If necessary, uncheck **Resample**, and then change the resolution to 300 ppi. Note that the width and height dimensions change. Turn on **Resample**, then change the width to 10″ and close the image size dialog. Save this image as *Example 300* and make a print. Compare the two prints. Which one looks better, especially in areas with fine detail?

Critical Thinking

1. One of your photos has won first place for originality in a local photo contest. The idea for your image occurred to you when a friend showed you a similar photo she had taken. Should you give credit to your friend publicly when you accept the award, should you thank her personally at a later time, or should you do nothing?

2. Photography clubs and other organizations that sponsor competitions often require manipulated images and straight images to be judged in separate categories. What arguments can you think of in favor of permitting the two categories of images to compete in a single category? Alternatively, what reasons would you cite for keeping the categories separate?

Communicating about Photography

1. **Speaking.** Research the photo-editing apps that are available for iPhones and Android phones. Print promotional materials for a variety of apps. Analyze the data in these materials and make inferences about the apps and recommend the best ones to the class.

2. **Speaking and Listening.** In small groups, discuss with your classmates—in basic, everyday language—the types of changes that can be made to an image in an image-editing program. Then discuss the tools in an image-editing program that can be used to effect these changes. Summarize your discussion for the class, using the terms that you have learned in this chapter.

Compositing: The process of creating digital images by combining part or all of other images. Further manipulation may be done on the combined image.

While studying this chapter, look for the activity icon ↗ **to:**

- **Assess** your knowledge with self-check pretest and posttest.
- **Practice** vocabulary terms with e-flash cards and matching activities.
- **Reinforce** what you learn by submitting end-of-chapter questions.

G-WLEARNING.com

www.g-wlearning.com/visualtechnology/

William V. Porter

Advanced Digital Darkroom Techniques

Objectives

When you have finished reading this chapter, you will be able to:

- Describe the various types of selection tools and their uses.
- Use **Quick Mask** and the **Eraser** tools to refine selections.
- Understand the importance of using adjustment layers when altering images.
- Apply layer masks to control the effects of adjustment layers.
- Identify the types of special effects filters available in image-editing programs.
- Describe the process of digital photo restoration.

> **Check Your Photography IQ** ➦
>
> Before you read this chapter, assess your current understanding of the chapter content by taking the chapter pretest.
> www.g-wlearning.com/visualtechnology/

Technical Terms ➦

anchor points	handles
clipping mask	layer mask
composites	path
elliptical marquee	rectangular marquee
filters	selection tools

Moving beyond the basic adjustments and techniques of the digital darkroom, you enter the realm of image manipulation. The basic areas of manipulation include removing or adding picture elements; altering the shape, color, texture, or other visible attribute of the subject; changing the relationship of elements in the picture; and combining elements from two or more pictures into a single image.

Ethical Conduct and Image Manipulation

While image manipulation opens many creative possibilities for the photographer, it also can create situations that raise ethical and legal questions. For example, some publications have been criticized for altering their cover photos to make the subject either more attractive or less attractive. During political campaigns, photographs have been manipulated to discredit candidates by showing them in situations contradicting their stated beliefs. Even if they are created with humorous intent, manipulated images often reinforce racial, gender, and other forms of stereotyping.

Sometimes even an unmanipulated image can be used in a manner that invades a person's privacy, damaging his or her reputation or self-esteem. Many unflattering or embarrassing photos or videos have been posted on social media without the subject's permission. Before posting an image, keep in mind the importance of cultural sensitivity and image appropriateness.

The wide availability of images on the Internet and the relative ease of altering or combining those images can result in failure to respect intellectual property rights. As noted in earlier chapters, the person who creates an image has the exclusive right to duplicate and distribute that image. If you publish that image without permission, you are violating the creator's copyright. Although an idea cannot be copyrighted, you should always acknowledge the source of an inspiration that resulted in an image you produced.

Selecting Parts of Images

A basic skill for manipulating images is mastering the tools used to select one element of an image. Once selected, that element can be manipulated (rotated, changed in color, etc.) without affecting other portions of the image. The selected element can be copied, changed in size or shape, repositioned within the image, or moved to another image.

Selection Tools

Selection tools include the marquee tools, the **Lasso** tool, **Pen** tool, **Magic Wand** tool, and **Quick Selection** tool. See **Figure 17-1**. Selections can also

Goodheart-Willcox Publisher

Figure 17-1. Image editing software typically offers a choice of several selection tools.

be made using the **Color Range** command, one of the choices in the **Select** drop-down menu.

Marquee Tools

The marquee tools are quick and easy to use when the area being selected is a simple rectangular or elliptical shape. All are used by clicking with the mouse at the point of origin, then dragging to the final size and shape. To constrain the *rectangular marquee* to a square selection, or the *elliptical marquee* to a circle, hold down the Shift key while selecting. Holding down the Alt (Option on a Mac) key radiates the selection outward from a center point.

The rectangular marquee can be used to crop an image, but the elliptical marquee cannot do so directly. However, an elliptical marquee selection can be used for cropping by clicking **Layer** on the menu bar, then **New** and **Layer via Copy** or **Layer via Cut**. **New Layer via Cut** creates a new layer with the selection, leaving a corresponding "hole" in the **Background** layer (original file), **Figure 17-2**. The **Background** layer can then be deleted.

If you need to keep the original file intact, use **New Layer via Copy**. You can then save the image with a new name (using **Save As**), and delete the background layer from the new file.

Lasso Tool

This tool allows you to select irregular shapes by drawing around the desired outline with the mouse or a pen and graphics tablet. There are three lasso tools, each using a slightly different selection technique.

The basic **Lasso** tool, **Figure 17-3**, is a freehand drawing tool used to trace around the desired outline. After the initial click, the mouse button is held down until tracing is completed. When the button is released back at the point of origin, the selection outline appears. This tool is often used to make a loose selection that is then refined using the **Quick Mask** overlay or one of the eraser tools, which are described later in this chapter.

The **Magnetic Lasso** tool works in a similar fashion but does not require holding down the mouse button after the initial click. This tool works best when selecting shapes with well-defined edges, since it distinguishes differences in color or brightness, **Figure 17-4**.

A

B **C**

Goodheart-Willcox Publisher

Figure 17-2. Creating a circular crop. A—After making the selection, choose **New Layer via Cut**. B—The cropped image is extracted from the **Background** layer and displayed on a new layer. C—The **Background** layer can then be deleted.

Goodheart-Willcox Publisher

Figure 17-3. A loose selection made with the **Lasso** tool.

Anchor points Cursor

Goodheart-Willcox Publisher

Figure 17-4. A **Magnetic Lasso** selection "clings" to the edge as you move the cursor, setting anchor points as it moves.

As you trace the shape, the **Magnetic Lasso** sets fastening points to anchor the selection. If the selection strays from the edge you are trying to select, you can make a correction by moving the cursor back over the selection while pressing the Delete or Backspace key. Once back on the correct line, you can set additional fastening points by left-clicking the mouse as you move the cursor.

The **Polygon Lasso** tool is useful for making selections that have straight edges. It is used by clicking the origin, then stretching the visible line (rubberbanding) to the point where the edge changes direction. Clicking sets a point to lock the first line segment in place, and then the line is then stretched to the next direction change and a point placed. The process continues until the entire shape has been defined. Curved portions of a selection can be defined with many short straight-line segments, but such shapes are better selected using the **Pen** tool.

Pen Tool

The most precise of the selection tools, the pen is used to define a *path* that can be edited and altered as necessary. Like the **Polygon Lasso** tool, the **Pen** tool uses a "connect the dots" technique. The difference is in the nature of the points set by clicking the mouse. Single clicks set *anchor points* connected by straight lines, while holding down the mouse button and dragging

sets anchor points with *handles* that can be used to curve the line segment between them. The handles allow you to select curved shapes, **Figure 17-5**.

Some people find the **Freeform Pen** tool easier to use—you click to set an origin point and then move the mouse around the desired outline. Clicking again on the origin point defines the completed path. If you check the **Magnetic** box on the **Options** bar, the **Freeform Pen** tool behaves like the **Magnetic Lasso** tool. Clicking on the down arrow on the **Options** bar opens a drop-down menu, **Figure 17-6**. The higher the value entered in the **Curve Fit** box (between 0.5 and 10), the closer together anchor points are set, resulting in a smoother curve.

Once a path has been adjusted to its final contour, it can be turned into a selection. The simplest way to do so is to right-click anywhere

Handle

Goodheart-Willcox Publisher

Figure 17-5. Handles on the points set by the **Pen** tool can be used to fit the line to curved shapes.

Goodheart-Willcox Publisher

Figure 17-6. The **Curve Fit** box lets you specify how close together anchor points are set along a curved path.

on the image and select Make selection from the resulting menu, **Figure 17-7**.

Quick Selection and Magic Wand Tools

Making selections based on color and tone can be done with either the **Quick Selection** tool or the **Magic Wand** tool, which are somewhat similar in operation. Both allow you to quickly select areas of similar color by clicking on them. The **Magic Wand** is somewhat more complex to use than the newer **Quick Selection** tool. For example, **Quick Mask** requires use of the Ctrl key and additional clicks to add to a selection, while **Quick Selection** uses a simpler click-and-drag method.

Goodheart-Willcox Publisher

Figure 17-7. Converting a path to a selection.

PROCEDURE
Using the Quick Selection Tool

1. Click on the **Quick Selection** tool icon on the toolbar.
2. Place the cursor in the image area you wish to select, then click and drag.
3. As you drag the cursor, the selection outline is displayed, **Figure 17-8**.
4. A selection may be expanded, or additional selections made, by using the same click-and-drag method.

5. To subtract an area from a selection, press the Alt key, place the cursor, and then click and drag.
6. To better visualize the selected area, press the Q key. This displays a red overlay, or **Quick Mask**, that covers everything outside the selection, **Figure 17-9**. (**Quick Mask** is described in detail later in this chapter.)
7. Press Q again to return to the selection.
8. Refine the selection by continuing to add or subtract.

Goodheart-Willcox Publisher

Figure 17-8. The **Quick Selection** tool is dragged across an area, such as this semi-silhouetted building, to make a selection.

Goodheart-Willcox Publisher

Figure 17-9. The **Quick Mask** overlay covers areas outside the selection.

Color Range

You might find the **Color Range** command easier to use than the **Quick Selection** or **Magic Wand** tools because the selections are simpler to visualize. **Color Range** is on the **Select** drop-down menu, **Figure 17-10**. It opens a dialog box with an eyedropper cursor that is used to sample a color in the image. The sampled color is shown as white or a shade of gray in the preview window, **Figure 17-11**. Expand or contract the range of shades in the sampled color with the **Fuzziness** slider—sliding right expands the range; sliding left contracts the range. The two eyedropper symbols

with plus (+) and minus (–) signs are used to add or subtract sampled colors from the selection. Once you are finished sampling, click **OK** in the dialog box. The selection outline appears on the image, **Figure 17-12**.

Refining Selections

Even the most careful selection often needs some touch-up work along the edges. The **Quick Mask** mode is most commonly used to add to or delete areas from a selection. In **Quick Mask**, you use the **Brush** tool to apply or erase a semitransparent color overlay on the image. The edges of the color overlay define the selection.

Using Quick Mask

Once you have made your selection, click on the **Quick Mask** icon at the bottom of the toolbar. This generates a translucent (50% opacity) red mask over the image, **Figure 17-13**. The red color covers all the area outside the selection. If preferred, the overlay can be reversed, or inverted, to cover the selection instead.

By selecting a brush size and setting black as the foreground color, you can paint new areas onto the mask to refine the selection. Switching to

Goodheart-Willcox Publisher

Figure 17-10. The **Color Range** command is accessed from the **Select** drop-down menu.

Goodheart-Willcox Publisher

Figure 17-11. A preview window in **Color Range** displays the sampled color as white against a black background.

Goodheart-Willcox Publisher

Figure 17-12. The selected area is outlined on the image.

Goodheart-Willcox Publisher

Figure 17-13. The translucent red overlay covers the area outside the selection.

Goodheart-Willcox Publisher

Figure 17-14. Erasing part of the mask using a small brush at high magnification.

the background color (white) allows you to use the brush to erase the red mask in chosen areas. For precise work, use a small brush and zoom in to 200%, 300%, or more. See **Figure 17-14**. To check the effect of mask changes on the actual selection, you can toggle (switch) back and forth between the **Quick Mask** and the selection outline by pressing the letter Q on the keyboard.

Using Eraser Tools

You can selectively delete portions of an image with one of the eraser tools in the toolbox. These tools are especially useful for cleaning up stray pixels and small areas along edges of a selection when a background is removed or after a selected portion of the image is moved to a new layer. Photoshop has three different erasers:

- **Eraser** tool
- **Background Eraser** tool
- **Magic Eraser** tool

The **Eraser** tool removes pixels much like the **Brush** tool applies color. The size and hardness of the **Eraser** tool can be changed using the **Options** bar. On the **Background** layer, the opaque (usually white) background color shows through after erasing. Other layers erase to a transparent background. See **Figure 17-15**.

A **B**

Goodheart-Willcox Publisher

Figure 17-15. Using the **Eraser** tool. A—On the **Background** layer. B—On other layers.

Like most image-editing tools, the **Eraser** tool has a number of options. It can be used like a paintbrush, with any of the hard-edged or soft-edged brush sizes; like a pencil, with only hard-edged sizes; or like an airbrush, for very soft edge transitions. Also available is a square block eraser, which is selected by clicking on the **Mode** drop-down menu on the **Options** bar. With the image zoomed to its maximum (3200%), the block eraser can erase one pixel at a time, **Figure 17-16**. Erasers can be varied in opacity, allowing partial erasure of pixels. This can be useful for fading effects or for blending overlapping images.

The **Background Eraser** tool has a cursor with centered crosshairs (+) that is used for sampling. When you click, the sampled color within the brush diameter is erased, **Figure 17-17**. The **Background Eraser** tool has a tolerance setting that determines how many closely related colors are selected. You can also choose whether **Contiguous** (touching) or **Discontiguous** (separated) pixels of the sampled color are erased. A third option, **Find Edges**, works well when the foreground object has a clearly defined edge. See **Figure 17-18**.

The **Magic Eraser** is similar in function to the **Magic Wand** tool, but it both selects and erases pixels instead of merely selecting them. It has the same controls in the **Options** bar as the **Magic Wand** but also offers an **Opacity** slider. The slider

Figure 17-17. The **Background** eraser removes sampled colors within the brush diameter.

Figure 17-18. Using **Find Edges**.

allows you to leave a hint (from faint to strong) of the background instead of erasing it completely.

The **Erase to History** checkbox on the **Eraser Options** bar will allow you to restore pixels that have been erased. The **Background Eraser** and the **Magic Eraser** options bars do not have an **Erase to History** checkbox, but the feature can be accessed by switching to the **Eraser** tool, **Figure 17-19**.

Depending on the settings you use, eraser tools may miss or only partly erase some pixels in the background. These scrap pixels should be cleaned up so they do not appear in the finished image.

Figure 17-16. The block eraser can be used to remove single pixels.

Goodheart-Willcox Publisher

Figure 17-19. Using **Erase to History** to restore the missing pixels on a flower petal.

PROCEDURE

Making Scrap Pixels More Visible to Simplify Cleanup

1. From the **Layer** menu, select **New Fill Layer**, then choose **Solid Color**. This will create a new layer. When the **Color Picker** appears, select a bright yellow or similar light color.
2. Move the new layer so it is beneath the layer with the erased background.
3. Zoom in and look for scrap pixels, which should show up well against the bright color of the **Fill** layer, **Figure 17-20**.
4. Make the layer with the erased background the active layer.
5. Use the **Eraser** tool to systematically clean up all the scrap pixels.
6. When finished, delete the **Fill** layer.

Goodheart-Willcox Publisher

Figure 17-20. A bright-colored temporary fill layer will make obvious any scrap pixels that were missed in erasing.

Combining Images

The ability to select part of one image and make it part of another is the key to creating combined images (*composites*). Sometimes these combinations are strictly utilitarian, **Figure 17-21**. Composites often are created for an artistic purpose, resulting in images ranging from the clearly fantastic to what have been called *believable lies*—scenes that might have been captured with a camera. See **Figure 17-22**.

Artistic composites may involve extensive editing and various types of manipulation. One technique is *morphing*, in which images may be merged or distorted to transform an object's appearance. An example is an age progression portrait, which depicts a child as he or she would look in adulthood.

Goodheart-Willcox Publisher

Figure 17-21. Left—A dull gray sky weakened the visual impact of this colorfully painted building in a seashore community. Right—The sky area was selected, erased, and replaced with a brighter, more visually interesting sky.

Jack Klasey/Goodheart-Willcox Publisher

Figure 17-22. The fireworks and the Civil War soldier statue were photographed miles apart in distance and months apart in time. Eleven layers were used to construct this image.

Using Layers

To create a composite, you will make extensive use of layers. As described in Chapter 16, layers function like a series of sheets that can be stacked one atop another. Portions of these layers are transparent, permitting image material from lower layers to show through. The characteristics of a layer, such as its opacity, can be altered by applying blending modes and masks. These tools are described later in this section.

Adding Layers

Layers can be added to an image in various ways:

- To add a new, blank layer, click on **Layer > New**, then choose **Layer...** from the drop-down menu, or click the **New Layer** icon at the bottom of the **Layers** panel, **Figure 17-23**.

- To create a copy of the **Background** layer (or any other active layer), choose **Duplicate Layer...** from the **Layer** drop-down.

- To add an **Adjustment** layer, click on the desired icon on the **Adjustments** panel.

Goodheart-Willcox Publisher

Figure 17-23. Adding a new blank layer to an image using the **Layer** drop-down menu.

- To make a selection from an existing layer and save it as a new layer, use **Layer > New > Layer via Copy** or **Layer via Cut**.

- To add a selection from a different image to the original image as a new layer, use the **Move** tool or the **Cut** and **Paste** commands.

When you are copying or moving material from one image to another, the two images must have the same resolution, or the size relationship changes. As shown in **Figure 17-24**, when you

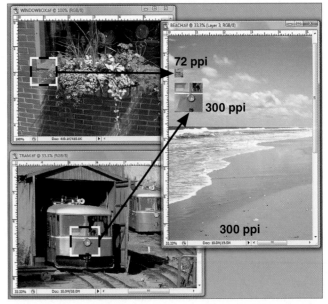

Goodheart-Willcox Publisher

Figure 17-24. When constructing a composite, be sure that the resolutions match.

make a 1″ × 1″ selection from one 300 ppi image and move it to another 300 ppi document, it remains 1″ × 1″. However, when you make a 1″ × 1″ selection from a 72 ppi image and move it to a 300 ppi document, the selected material is only about 1/4″ × 1/4″.

As new layers are added, they appear at the top of the layer stack, **Figure 17-25**. New layers are created with a transparent background. If an image is later placed on that layer, only the image area obscures the layer below. The transparent background allows the rest to be visible. See **Figure 17-26**.

When creating a composite, the order of the image layers is important, since each layer obscures some or all of the layers below it. You can change the ordering of layers by dragging with the cursor or by using the commands listed under **Layers > Arrange**, **Figure 17-27**.

Figure 17-27. Commands for changing layer order are on the **Layers > Arrange** menu.

The **Bring Forward** and **Send Backward** commands move the active layer up or down in the stack by one place. The **Bring to Front** and **Send to Back** commands move the active layer to the top or bottom of the stack (if there is a **Background** layer, the moved layer will be positioned just above it).

At times, it is desirable to have the image on a lower layer show through the image on the layer

Figure 17-25. New layers are added to the top of the stack on the **Layers** panel.

Figure 17-26. In a composite, an image will obscure areas on the layer below it. A—The top layer. B—The background layer. C—The two-layer composite.

above it. The upper layer image can be made more or less transparent by changing its opacity. You can use a slider control on the **Layers** panel to change the opacity of the upper layer image, making it more or less transparent. See **Figure 17-28**.

Using Adjustment Layers

Whenever possible, make changes to the working file by using one or more adjustment layers. An adjustment layer is a special-purpose layer that allows you to make changes to the appearance of

an image without permanently altering the original image pixels. To add an adjustment layer to an open working file, click on the icon for the desired type of layer on the **Adjustments** panel, **Figure 17-29**. The type of adjustment layer an icon represents is displayed at the top of the panel when the cursor is placed on the icon.

When you alter a "regular" image layer by using one of the tools from the **Image** menu, the change becomes permanent when you save and close the image. You have made alterations

A

B

Figure 17-28. The amount of show-through from the lower layer was varied by changing the opacity of the upper layer to produce two different versions of this "ghost" in a Colonial-era graveyard. A—An opacity of 75%. B—An opacity of 45%.

Figure 17-29. An adjustment layer can be added to an image by clicking on the icon of the desired type in the **Adjustments** panel.

to the image pixels themselves and you cannot restore the image to exactly what it was before the change. If you change your mind before you close the image, however, you can undo the change. The **History** panel records each change as it is made, allowing you to undo one or more changes with a single mouse click, **Figure 17-30**.

By using an adjustment layer, you can close an image and then later open it and make additional changes. For example, assume that you used a **Curves** adjustment layer to increase contrast of the image. After making a print from the image file, you decide that it is too contrasty. You can then reopen the file, select the **Curves 1** layer in the **Layers** panel, and adjust the curve to decrease contrast while observing the effect of the adjustment on the image. See **Figure 17-31**.

Layer Masks

Changes made using an adjustment layer can be applied to the entire image or just to a portion of it. A *layer mask* limits the effect of

Goodheart-Willcox Publisher

Figure 17-31. An adjustment layer can be reopened to make changes to an image.

the adjustment layer. A mask is typically used to protect part of the image from change.

Assume you have an image of flowers, **Figure 17-32**, and want to make one of the blossoms stand out. You can use the **Brush** tool to create a layer mask for that blossom and protect it from change as you alter the rest of the image.

Goodheart-Willcox Publisher

Figure 17-30. Changes to an image are listed on the **History** panel.

Goodheart-Willcox Publisher

Figure 17-32. A layer mask helps make one blossom stand out from this colorful bed of red-orange daylilies.

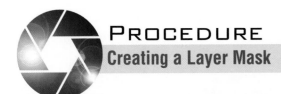

PROCEDURE
Creating a Layer Mask

1. Add a **Hue/Saturation** adjustment layer, and then click **OK** to close the dialog box without making any changes.

2. With the adjustment layer active, double-click the white rectangle (layer mask thumbnail) in the **Layers** panel. This opens the **Layer Mask Display Options** dialog box.

3. By default, the box displays black as the mask color and 50% as the opacity for the mask. To change the masking color for better visibility, click on the color sample to open the color picker. After selecting a new color, you might also want to change the opacity. The masking color used in **Figure 17-33** is blue at 80%.

4. Click on the **Layer Mask** thumbnail again while holding down the Shift and Alt keys. This allows you to view the mask as you paint it.

5. Select a brush size and hardness, and then begin painting. Zoom in to see detail if necessary. If you paint outside the area you wish to mask, press X on the keyboard to swap foreground and background colors. Paint over the error using the background color, which acts like an eraser, rather than appearing as a color.

6. When you have completed the mask, hide it by pressing Shift+Alt while clicking on the **Layer Mask** thumbnail. This allows you to better see the changes you make with the adjustment layer.

7. Click on the **Layer** thumbnail (displayed to the left of the **Layer Mask** thumbnail). This reopens the **Hue/Saturation** dialog box.

8. Moving the **Saturation** slider all the way to the left changes the entire image, except the masked blossom, to monochrome. See **Figure 17-34**. If you prefer to leave some color in the image, slowly move the slider to the right until you get the look you want.

Layer mask thumbnail

Goodheart-Willcox Publisher

Figure 17-33. Painting a mask on the portion of the image protects it from change. Note that the mask is also displayed in the small black-and-white layer mask thumbnail as you paint it.

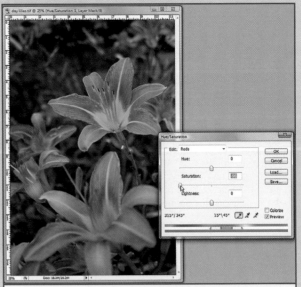

Goodheart-Willcox Publisher

Figure 17-34. Using the **Saturation** slider to remove color from the area not protected by the mask.

Blending Modes

When an image has two or more layers, the pixels of those layers can be blended in various ways to create different effects. This is done by selecting a blending mode from a menu in the **Layers** panel, **Figure 17-36**. The colors in the topmost layer are blended with the colors in all the lower layers, changing the overall appearance.

A common reason for blending layers is to lighten or darken an image. In **Figure 17-37**, a too dark image is lightened by creating a duplicate layer and then applying the **Screen** blending mode. The amount of lightening is adjusted by using the **Opacity** slider in the **Layers** panel. To darken a light image, use the **Multiply** mode. Experiment with various blending modes, as well as different opacities, to observe the different effects on the image's appearance.

9. To make additional changes, convert the mask to a selection. Right-click on the **Layer Mask** thumbnail, and then click on **Add Layer Mask to Selection**. A selection border appears around the masked area.

10. To preserve the original pixels, create a copy of the **Background** layer to work on. Make the **Background** layer active, right-click on it, and then click **Layer > Duplicate Layer**.

11. With the **Background Copy** layer active, select **Filter > Blur > Gaussian Blur**. Move the **Radius** slider to the right until you see the desired amount of blur, then click **OK**. See **Figure 17-35**. To hide or reveal the selection border, press Ctrl+H.

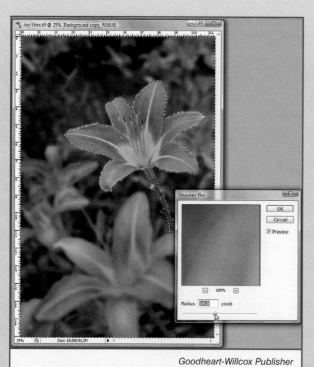

Goodheart-Willcox Publisher

Figure 17-35. The black-and-white portion of the image can be blurred to further emphasize the colored blossom. For safety, do the blurring on a copy of the **Background** layer.

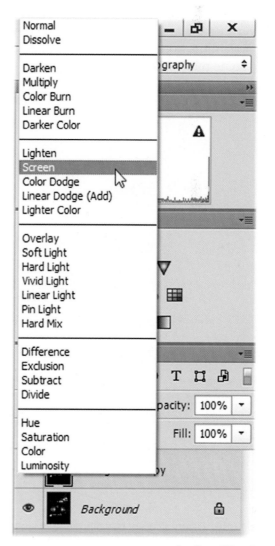

Goodheart-Willcox Publisher

Figure 17-36. Selecting a blending mode.

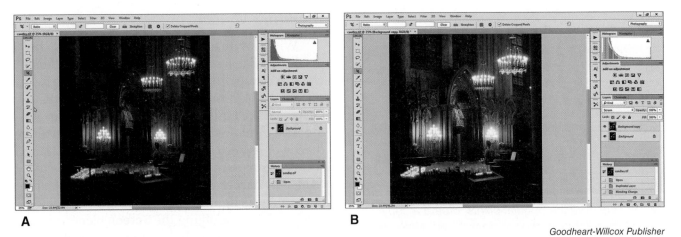

A **B**

Figure 17-37. Using a blending mode. A—The original is too dark. B—Using the **Screen** blending mode lightens the image and reveals more detail of the church interior.

A different use of blending modes is with painting tools. These modes blend the foreground color with the color of the object or area being painted over. To protect the pixels of the original, paint on a new, blank layer—click on the **New Layer** icon at the bottom of the **Layers** panel.

In some modes (**Darken**, **Multiply**, **Color Burn**, **Linear Burn**), the result of the blending is a darker color. In other modes (**Lighten**, **Screen**,

Color Dodge), the blended colors are lighter. See **Figure 17-38**. The **Hue** blending mode preserves shadow and highlight detail while changing the color of the object being painted over. The intensity of the color being painted over is strengthened when the **Saturation** blending mode is used. The **Color** blending mode darkens, and the **Luminosity** mode lightens.

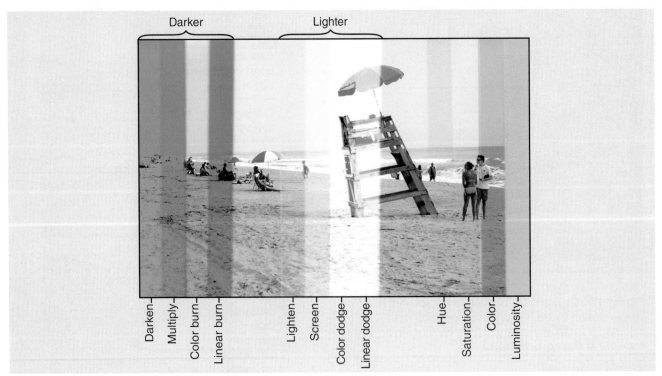

Figure 17-38. Using different blending modes when applying colors with painting tools produces darker or lighter hues, depending on the selected mode. This beach scene was painted with strokes of green at 100%. The effect of the different blending modes on the color can be compared. A different color would produce a different appearance, but the effect (darkening or lightening of the blend) would be the same.

Adding a Border

A border may be added to an image for practical or artistic reasons. Image borders can be created easily with several techniques.

For a narrow black border, **Figure 17-39,** press Ctrl+A to select the entire image. Next, click on **Edit > Stroke**. In the dialog box, fill in a pixel width for the stroke (a width of 6 to 10 pixels is often used for an 8″ × 10″ image). Select *inside* for the location. If the color shown in the **Color** box is not black, click on it to open the **Color Picker** and reset the color. Finally, click **OK** to add the border.

Goodheart-Willcox Publisher

Figure 17-39. A narrow black border helps separate the image from its mounting board.

PROCEDURE
Creating Irregular Borders

1. Make a duplicate of the **Background** layer, and then use a marquee or other selection tool to define the area that you wish to make the border.
2. Enter the **Quick Mask** mode by pressing Q. See **Figure 17-40**. You will modify the mask to make your border.
3. Click on **Filter > Filter Gallery, Figure 17-41.** Try different effects from the **Filter** menu to see how they affect the softened (blurred) inner edges of your border. Experiment with filters in the **Texture, Distort,** and **Brush Strokes** categories in particular. You can click on the **New Effect Layer** button at the bottom right to "stack" the effects of the filters.
4. Once you have found a satisfactory effect, change the mask to an active selection by pressing Q.
5. Click on **Select > Inverse.**

Goodheart-Willcox Publisher

Figure 17-41. In the **Filter Gallery,** a large black-and-white preview image shows the changes as you add and modify the filters.

6. Create a new **Fill** layer and select a color for the border. Click **OK** to create the border, **Figure 17-42.**

Goodheart-Willcox Publisher

Figure 17-40. The selection outline displayed as a **Quick Mask.**

Goodheart-Willcox Publisher

Figure 17-42. The completed border was created by using a brown **Fill** layer to complement the color of the sand and stones.

A similar technique can create the oval vignette often used for portraits. Make a selection of the desired size with the **Elliptical Marquee** tool, then invert the selection and apply a wide feather (40–50 pixels) to produce a soft edge. Create a new **Fill** layer and choose a color. While white is most common, the fill layer may be any color, **Figure 17-43**.

Portrait courtesy of Image Group Photography, LLC

Figure 17-43. The soft inner edge of this oval vignette was created by applying a 70-pixel feather to the selection.

PROCEDURE
Creating a Clipping Mask That Fills Type with an Image

1. Open the image that you wish to have showing through the letters. Note the dimensions of the image.
2. Set the background color in the toolbar to the desired hue (the color that will surround the type in your final image).
3. Open a new, blank image with the same dimensions and resolution as the first image. Select **Background Color** in the dialog box.
3. Make your photo image the active image again, and then select the **Horizontal Type** tool from the toolbar.
4. From the typeface drop-down menu, select the desired type. The type should have thick, bold letter strokes. Choose a point size appropriate to the size of your image and set the text color to white.

5. Click an insertion point (the spot where you want the first letter to appear) on the image, then key in the desired letters, **Figure 17-44A**. When all letters have been keyed in, press Ctrl+Enter.
6. The type is now on its own layer. The type can be moved using the **Move** tool or manipulated using a transformation (such as **Scale**) from the **Edit** menu. Position the type and resize it, if necessary, **Figure 17-44B**.
7. Convert the **Background** layer to a regular layer so it can be moved. To do so, double-click the **Background** layer in the **Layers** panel, then click **OK** in the **New Layer** dialog box, **Figure 17-45**. The layer is now named **Layer 0**.

Goodheart-Willcox Publisher

Figure 17-44. Create the **Type** layer. A—Select the desired typeface and size, and then key in the letters. B—Scale and move the type to fill the frame.

Combining Type with Photos

You can overlay type on a photo or arrange type so a photo shows through the letters. In the first case, the type is added to the image as a layer. It can be treated like any other layer, with the color, opacity, and other characteristics changed as necessary. With white or light-colored type, you can adjust the opacity of the type layer to allow the underlying image to show through to a greater or lesser degree.

To fill type with a background image, various methods may be used. One that works well is creating a *clipping mask*, which results in letters that are on a transparent background and filled with the desired image. The filled letters can then be moved as a layer to a new document that will provide a solid color or other background.

Goodheart-Willcox Publisher

Figure 17-45. Convert the **Background** layer using the **Layers** panel.

Goodheart-Willcox Publisher

Figure 17-46. The clipping mask fills the type with the image on a transparent background.

8. Drag **Layer 0** upward in the **Layers** panel so it is above the **Type** layer.

9. With **Layer 0** as the active layer, click on **Layer > Create Clipping Mask**. The result is image-filled type on a transparent background, **Figure 17-46**.

10. Link the two layers of the image so they can be moved together. Press Ctrl and click on the **Type** layer to select both layers, and then click on the **Link** (chain) icon at the bottom of the **Layers** panel.

11. Click on the type image you have created and drag it to the open image with the color background, **Figure 17-47**. If necessary, use the **Move** tool to position it, then click on **Layer > Flatten Image**.

Goodheart-Willcox Publisher

Figure 17-47. The final, combined image.

Applying Transformations and Filters

The **Edit** drop-down menu provides access to a number of tools for changing the size, shape, and orientation of an image or a selection. The **Transform** section of that menu offers tools for scaling the image to a larger or smaller size, rotating it a specified amount, skewing or distorting it in different directions, or altering its perspective.

Transformations

A transformation can be applied only to a selection made on a layer (usually the entire layer). To select an entire layer or the entire image, press Ctrl+A. One often-used type of transformation is a slight rotation to correct a tilted horizon. See **Figure 17-48**.

PROCEDURE
Correcting a Tilted Horizon

1. Select the entire image and adjust the window so you can see the edges of the image.
2. Click on **Edit > Transform > Rotate**. Move the cursor outside the image at one of the corners. The cursor becomes a curved, double-headed arrow.
3. Move the cursor to rotate the image until the horizon is level. Press Enter to complete the transformation.
4. After rotating the image, you usually have to crop to restore the rectangular format. You can use the **Rectangular Marquee** tool, but the **Crop** tool is easier to adjust. (Since the **Crop** tool can also rotate an image, some photographers prefer to use it for both the rotation and cropping steps.)

Alternatively, you can correct a tilted horizon with the **Ruler** tool. This method has the advantage of straightening and cropping in a single step.
1. Click on the **Eyedropper** in the toolbox and select the **Ruler** tool from the flyout menu.
2. Click and drag from one end of the horizon to the other.
3. Release the mouse button.
4. In the **Options** bar for the Ruler, click the **Straighten** button.

Another commonly used transformation is the correction of converging lines (perspective). Select the entire image, and then click on **Edit > Transform > Perspective**. As shown

A

B

C

Goodheart-Willcox Publisher

Figure 17-48. Correcting horizon tilt. A—The entire frame is selected with Ctrl+A. B—Rotating the image counterclockwise corrects the tilt. C—Cropping restores the rectangular format.

in **Figure 17-49**, dragging one of the corner handles outward adjusts both sides of the image, correcting the convergence. Perspective correction and cropping also can be done with the **Perspective Crop** tool. This tool can be selected from the flyout menu that appears when you click on the **Crop** tool in the toolbox.

Filters

Changes ranging from mild to wild are achieved by using *filters*, which are special effects that can be applied to all or part of an image. See **Figure 17-50**.

Goodheart-Willcox Publisher

Figure 17-49. Perspective correction. A—The tall columns of this war memorial sculpture appear to be tilting inward. B—Moving the **Perspective** tool outward returns the columns to the perpendicular.

Goodheart-Willcox Publisher

Figure 17-50. A sampling of filter effects. A—The original image before filtering. B—**Motion blur** was applied to just the foot, leg, and pedal. C—**Rough Pastels** filter. D—**Mosaic** filter. E—**Graphic Pen** filter. F—**Emboss** filter. G—**Find Edges** filter. H—**Texturizer (burlap)** filter. I—**Neon Glow** filter.

The more dramatic filters, which radically alter image appearance, often are best applied to an entire image to serve as a background. Applying them to only part of an image, however, can make a strong visual statement, **Figure 17-51**.

Warming, cooling, and color filters are accessed by clicking **Image > Adjustment > Photo Filter**. The strength of the filter effect can be previewed while adjusting it with the **Density** slider. **Figure 17-52** shows use of a warming filter.

The **Lens Blur** filter can simulate the effect of a shallow depth of field. To create this effect, choose a suitable image (one with a fairly prominent foreground object works well). See **Figure 17-53**.

Figure 17-51. The neon cowboy image was created by selecting the rodeo rider and horse and applying the **Glowing Edges** filter. The rest of the scene was shifted in hue and lowered in saturation to further emphasize the cowboy.

Figure 17-53. This image of a bed of poppies currently has good depth of field.

A

B

Figure 17-52. Warming filter. A—This beach scene was taken just after sunrise. Despite the color of the sky, the overall light is cool and blue in tone. B—Applying a warming filter at 60% provides a much warmer appearance.

PROCEDURE
Using the Lens Blur Filter to Reduce Depth of Field

1. Click on the **Channels** tab in the **Layers** panel, then click on the **Create New Channel** icon at the bottom of the panel.

2. A channel named **Alpha 1** is created and appears as a black fill obscuring your image.

3. Select the **Gradient** tool in the toolbox and choose the black-to-white gradient in the options bar. The foreground color should be set to black and the background color to white.

4. Click at the bottom of the image and drag the cursor straight upward to the top to create the gradient, **Figure 17-54**.

5. Click on the **RGB Channel** to make it active, and then click on the **Layers** tab.

6. Click on **Filter > Blur > Lens Blur**. In the dialog box, **Alpha 1** should be shown in the **Depth Map Source** box. If not, click and select it from the drop-down menu.

7. On the large preview image, click on the point you wish to display as the plane of sharpest focus. Note that areas in front of and behind that plane are increasingly blurred the farther they are from it. See **Figure 17-55**. If desired, set a different focal plane by clicking on a different point in the preview image.

8. To alter the degree of blur, experiment with the **Radius** slider in the **Iris** section of the dialog box. You may also want to see the effect of trying different iris shapes.

9. When you are satisfied with the effect, click **OK**.

Goodheart-Willcox Publisher

Figure 17-54. Creating a black-to-white gradient to serve as a mask on the **Alpha 1** channel.

Goodheart-Willcox Publisher

Figure 17-55. Compare the blurred foreground and background in this image with the original in Figure 17-53.

Adding Color to a Monochrome Image

A black-and-white image, while striking by itself, can sometimes be made even more dramatic by the addition of color. The process of hand-coloring black-and-white conventional prints with oils or pencils, popular in the days before color films, achieved a distinctive look that can be duplicated with digital techniques. Another approach makes use of a strategically placed spot or two of vivid color in a monochrome image.

To create either effect digitally, the image must be in a color mode. If the original is a grayscale image, convert it to RGB mode. An image that is already in color can be desaturated to display grayscale values while remaining in a color mode.

If you want to achieve the appearance of a hand-colored photograph, avoid highly saturated colors and apply your hues at low opacity settings, as shown in **Figure 17-56**. The most effective coloration of this type is closer to tinting than applying solid color. The details of the photograph show through the color.

Photoshop's **History Brush** tool is another method for adding color to a desaturated (monochrome) image. This tool allows you to "paint in" details from the full-color version of an image, resulting in a grayscale image with areas or spots of the original color. See **Figure 17-57**. To use this technique most dramatically, select a single element—preferably with a strong color—to which you want to draw the viewer's attention.

Applying an overall color (toning) can make an image stronger or help it communicate a period feeling. Digital toning can be done quite easily with a **Hue/Saturation** adjustment layer. Click on the **Colorize** check box and then use the **Hue** slider to cycle through the entire color wheel to find the desired color. Use the **Saturation** and **Lightness** sliders to refine the appearance of the image on the monitor. **Figure 17-58** shows examples of images that have been colorized.

Kankakee County Museum archives

Figure 17-56. Applying color to a black-and-white image at a low opacity provides a soft tinting effect that lets the image details show through.

Jack Klasey/Goodheart-Willcox Publisher

Figure 17-57. After converting this playground image to monochrome, the **History Brush** was used to "paint in" the child from the original color image.

Figure 17-58. Applying overall color to a monochrome image. A—A sepia tone is appropriate for this image of a girl taken over a century ago. B—A deep blue tone was chosen to convey the cold, stark nature of this mountain scene.

Restoring Damaged Photos

Old, faded, damaged images can be restored to like-new condition with digital imaging techniques. **Figure 17-59** shows an old, yellowed portrait with multiple emulsion cracks, dirt spots, and discolorations.

Figure 17-59. This badly yellowed portrait of three children, taken over a century ago, has been subjected to rough handling that caused numerous cracks in the emulsion.

When restoring an image, the first and most important step is to make a copy of the original. Do all your work on the copy, preserving the original image in case it is necessary to start over with a fresh copy.

Restoration is a multistep process. First, correct any fading and yellowing. Next, make large repairs, such as fixing major emulsion cracks. Follow that step by making small or critical repairs, such as cracks or scratches across the subject's face. Repair or replace any material that was damaged by emulsion cracks or blemishes. Examine the image carefully to find and eliminate spots and small stains. Finally, adjust overall and local contrast as necessary,

inspect the entire image again for any missed defects, and sharpen as needed.

Correct Fading and Yellowing

Convert the image to grayscale using one of the methods described in Chapter 16. For a conversion method that permits precise control, add a **Black & White Adjustment Layer**. The default settings provide a good starting point for removing the yellowing. By using the **Target adjustment** tool, **Figure 17-60**, you can fine-tune the conversion and correct fading to some extent.

Make Large Repairs

The **Clone Stamp** is the most commonly used tool for eliminating the emulsion cracks and cleaning up blotchy areas such as the picture border, **Figure 17-61**. The image shows a great deal of improvement once the large repairs are completed, **Figure 17-62**. The major task remaining is to repair cracks and eliminate other defects on the subjects' faces.

A

B

Goodheart-Willcox Publisher

Figure 17-61. Making large repairs. A—Repairing major emulsion cracks with the **Clone Stamp** tool. B—The tool was also used to eliminate stains, dirt spots, and cracks on the image borders.

Goodheart-Willcox Publisher

Figure 17-60. Conversion to grayscale was done using a **Black & White Adjustment Layer** and fine-tuned with the **Target adjustment** tool (the hand icon on the boy's shirt).

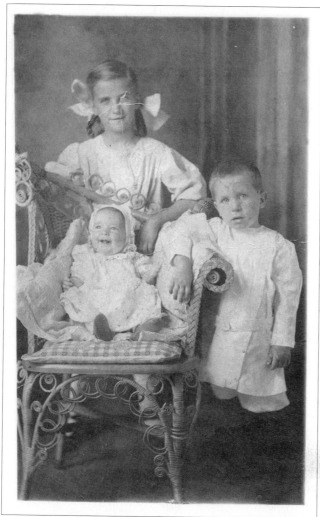

Figure 17-62. The image with large repairs completed, but work on such critical areas such as the girl's face still must be done.

Make Critical Repairs

Slow and careful use of the **Spot Healing Brush** tool is needed to smoothly repair the cracks crossing a subject's face, **Figure 17-63**. The work should be done at high magnification, such as 400% or 500%, for the greatest visibility and control. After eliminating the cracks on the girl's face, an important remaining task is to repair the damage to her left eye. This was done by making a selection around the undamaged right eye, using **New Layer via Copy**. The selection was flipped (**Edit > Transform > Flip Horizontal**), and properly oriented using the **Move** and **Rotate** tools. See **Figure 17-64**.

Figure 17-63. The **Spot Healing Brush** is used to blend skin tone while making repairs to the girl's face.

Figure 17-64. Repairing the damaged left eye. A—The girl's right eye is selected, copied, and flipped. B—Using transformation tools, the selection is moved, rotated, and adjusted, then placed over the damaged area.

Once critical repairs have been completed, the entire image is closely examined at the full size (100%) setting and small defects are cloned out.

Adjust Contrast and Sharpen

The final adjustment to the restored image is made with the **Curves** tool to increase contrast and brighten the image, **Figure 17-65**. The **Unsharp Mask** filter was applied with an **Amount** setting of 200. **Figure 17-66** shows the final result of the restoration work.

Restoration of older color prints involves many of the same tools and techniques. Because of the color shifts and fading common to prints made decades ago, working with color originals is more complex than black-and-white restoration work. When you work on an old color print, the **Color Balance** tool and the **Hue/Saturation** tool come into considerable use. Experimentation and practice will permit you to become proficient in color photo restoration.

Portfolio Assignment

Fix It!

Find an old, damaged black-and-white snapshot from a family album or other source, such as a flea market or antique shop. Scan the image as a color original to preserve any yellowing or other discoloration. Set the resolution for 300 dpi.

Make a print of the image in its original condition to display in your portfolio for comparison with the final image you create with your restoration work. Using image editing software, convert the image to monochrome to correct yellowing, then make repairs by applying the techniques described in this chapter.

When you are satisfied with the work you have done on the image, make a print and place it in your portfolio.

Goodheart-Willcox Publisher

Figure 17-65. Increasing contrast with the **Curves** tool.

Figure 17-66. Compare the finished image on the right with the battered and yellowed original.

Check Your Photography IQ

Now that you have finished this chapter, see what you learned by taking the chapter posttest.

www.g-wlearning.com/visualtechnology/

Review Questions

Answer the following questions using the information provided in this chapter.

1. Posting an embarrassing or unflattering image of a person to the Internet is an invasion of his or her _____.

2. Describe how you would make a circular selection and use it to crop an image.

3. Which two tools can be used to make selections based on color and tone?

4. Which of the following is the best tool for making a selection that includes both straight-line and curved elements?

 A. **Elliptical/Circular Marquee** tool

 B. **Polygon Lasso** tool

 C. **Pen** tool

 D. **Magic Wand** tool

5. Sensitivity of the **Background Eraser** tool (which image pixels the tool will select) is determined by the _____ setting.

6. To toggle between the **Quick Mask** and selection outline while refining a selection, you can press the _____ key.

 A. R

 B. Q

 C. T

 D. S

7. When using one of the eraser tools, how can you restore pixels erased by mistake?

8. _____ is the term used to describe a combination of two or more images.

9. An age-progression portrait, which depicts a child as he or she would look in adulthood, makes use of a manipulation technique called _____.

10. Material on one layer normally hides material directly beneath it on a lower layer. To allow the lower layer material to show through, you must decrease the _____ of the upper layer.

11. What is the advantage to using an adjustment layer to make changes to the appearance of an image?

12. To protect a portion of an image from changes applied using an adjustment layer, you can create a(n) _____.

13. Describe how you would use a blending mode to lighten an underexposed (too-dark) image.

14. How do you convert a background layer to a regular layer?

15. To create a soft border for an oval vignette, make a selection with the **Elliptical Marquee** tool, invert the selection, and apply a wide _____.

16. How would you correct the exaggerated perspective (convergence) resulting from shooting upward to include all of a tall building?

17. A shallow depth of field can be simulated with a(n) _____ filter.

18. If you desaturate a color image and reduce it to shades of gray, what tool can you use to restore some areas to their original color?

19. What is the first and most important step to take when restoring an image?

20. What is the **Clone Stamp** tool used for in photo restoration?

Suggested Activities

1. Using the techniques described in this chapter, make a composite combining a word of up to six letters (your name, a hobby, the name of a color, etc.) with an appropriate photo. The photo should show through the letters of the word. Make a print of your composite image and place it in your portfolio.

2. Select one of your images and apply different filters to it, one at a time. Choose the six most interesting filter effects and make 4″ × 6″ prints of your image, each with a different filter applied. Mount the prints on a sheet of poster board, add the title "Filter Effects," and display it in your classroom.

3. Download or scan a copy of artist Grant Wood's *American Gothic* painting. Working with two other students, brainstorm ways that you could manipulate this image and combine it with one or more other images to create a derivative work (a new work of art that is based on an existing work). Create and display your derivative work. Be sure to acknowledge that it is "based on a painting by Grant Wood."

Critical Thinking

1. You are browsing the Internet and find one of your images displayed on a gallery website but identified as the work of the website's owner. What course of action would you take?

2. After converting an image to grayscale mode and saving it, you decide to recover the color in a foreground clump of flowers. Since you have already saved the image as grayscale, you cannot use the **History Brush** tool. What options do you have to obtain the color effect you visualize?

Communicating about Photography

1. **Speaking.** Working in a group, brainstorm ideas for creating classroom tools (posters, flash cards, and/or games, for example) that will help your classmates learn and remember the different tools in Adobe Photoshop. Choose the best idea(s), and then delegate responsibilities to group members for constructing the tools and presenting the final products to the class.

2. **Writing and Speaking.** Create an informational pamphlet on restoring damaged photos. Include your original photo and restored photo from the Portfolio Assignment in this chapter. List the steps you used to restore the photo. Present your pamphlet to the class.

Window mat: A sheet of mat board with a hole or window cut in it to display and help protect a print. The mat is hinged to the mounting board.

While studying this chapter, look for the activity icon **to:**

- **Assess** your knowledge with self-check pretest and posttest.
- **Practice** vocabulary terms with e-flash cards and matching activities.
- **Reinforce** what you learn by submitting end-of-chapter questions.

www.g-wlearning.com/visualtechnology/

Image Output and Presentation

Objectives

When you have finished reading this chapter, you will be able to:

- Describe alternatives for digital image output.
- Compare the types of printers used for digital images.
- Explain the differences between inkjet printer types.
- Describe methods used for monitor calibration.
- Select appropriate mounting materials.
- Identify the most suitable mounting method for a print.
- Mount a print using various mounting methods.
- Understand the reasons for using different types of overmat.

Technical Terms ↗

archival quality
buffered
calibrate
coated papers
colorimeter
conservation board
Creative Commons license
dry mounting
dye sublimation printers
edge-mounting
flush mounts
foam board
giclée
inkjet printer

large-format inkjet printers
mat board
metamerism
museum board
online gallery
pH
pigment-based inks
pressure-sensitive adhesive material
print positioner
printer
profile
quad-tone ink set
release paper
sublimate

Once you have captured digital images, it is natural to want to share those images with others. Sharing methods include posting the images on a website, displaying them on a computer monitor or smartphone screen, and making physical prints.

Electronic Display

Once an image has been captured or scanned into digital form, it can be displayed in a number of electronic venues. Many photographers use a favorite image as the wallpaper on their smartphone, tablet, or computer monitor, **Figure 18-1**, or display a series of images as the screen saver.

Pictures can be posted on a number of online sites, such as Facebook, Flickr, Instagram, or SmugMug, for the enjoyment of friends, family, and others, **Figure 18-2**. A similar approach, aimed at more serious photographers, is the *online gallery*. These sites are maintained by schools or organizations such as photo clubs,

Figure 18-3, and access may be restricted to members of the organization. Others are available for public viewing. Many amateur and professional photographers maintain personal websites to display their work. These range from simple, single-page sites to elaborate, professionally developed sites displaying numerous images with accompanying information and biographical/personal data about the photographer.

Creative Commons Licensing

Under copyright law, a photographer owns all rights to his or her image and can choose to allow others to use that image under certain circumstances, such as printing for use as a greeting card. For commercial uses, such as the greeting card, the copyright owner typically charges a fee.

Some photographers, especially those who post images on photo-sharing sites, may choose to allow others to use their images (for example, by posting on a personal website) without charge.

Goodheart-Willcox Publisher

Figure 18-1. A digital image displayed as the wallpaper on a computer desktop.

Figure 18-2. Using a smartphone to post a photo to Facebook. A—Choose and display the image you wish to post. B—Select Facebook as the destination. C—Key any comment or information you wish to post along with the photo. D—Press *Post*.

Figure 18-3. A member's gallery on a photo club website.

Figure 18-4. Photographer Justus Hayes posted this striking photo to a photo sharing site. He chose to make it available to others under a Creative Commons license requiring only attribution.

They do so by assigning certain rights using a *Creative Commons license*. These licenses permit the copyright owner to make some or all usage rights to an image available without charge. See **Figure 18-4**.

A number of different licenses are available to grant or restrict different rights. Common to all the licenses is attribution, meaning that the copyright owner must be given credit for creating the image. One type of license restricts image use to noncommercial applications. For example,

a photo can be shown on a charity's website but cannot be used by a company printing and selling calendars. Another type of license, called a *nonderivative license*, forbids alteration of the image, such as incorporating part of it in a composite. A share alike license permits the user to make changes to the image or make it the basis for a new work. The new work must be attributed

to the copyright owner and licensed under the same terms as the original image.

Licenses can be combined in various ways to meet the needs of the copyright owner. A combination of attribution, noncommercial, and nonderivative licenses makes up about one-third of all Creative Commons licenses.

Display Devices

Digital photo frames, **Figure 18-5**, were developed in response to the rapid growth in digital photography. These devices, available in a number of sizes, can display a changing series of images.

An LCD projector is the electronic equivalent of the traditional slide projector. When connected to a computer, the device can be used to display digital images on a large screen for group viewing. See **Figure 18-6**. Due to their cost, most of these devices are currently owned by businesses, schools, or organizations.

Making Prints

The most common form of image output is the photographic print. Each year, millions of snapshots are printed to allow photographers to share experiences and events with others. Many retail locations offer fast and relatively inexpensive printing from digital image files.

Epson Pro Cinema 4030 2D/3D 1080p 3LCD Projector

Figure 18-6. An LCD projector can be used to present digital images to an audience.

Customers bring image files into the store on a memory card or CD or transmit them to a processor via the Internet. Larger-size prints may be made at do-it-yourself print kiosks at retail locations. These kiosks allow cropping and some control of print color and other characteristics. See **Figure 18-7**.

©2015 Kodak Alaris. TM: licensed from Eastman Kodak: Kodak and Kodak trade dress.

Figure 18-7. Photo kiosks are available at many retail locations.

Eastman Kodak Company

Figure 18-5. A digital photo frame is an LCD display small enough to fit on a desktop or bookshelf.

Prints and enlargements can also be obtained by uploading files to an online photofinishing site, which returns the finished prints by mail. Some of these sites have a gallery or album feature that allows the photographer's friends or family members to view the images and order their own prints.

Many photographers print their digital images on a desktop *printer,* an electromechanical device that translates digital data into tiny dots of color to simulate the appearance of a continuous tone photographic print. There are at least five different types of color printers on the market, but only two—the inkjet printer and the dye sublimation printer—are used for serious photographic output.

Inkjet Printers

The *inkjet printer* was originally intended to provide color printing capability to home computers for such applications as word processing and simple art programs. Thus, it was well-established by the time consumer-level digital cameras came on the scene. Even earlier, photographers and graphic designers had begun experimenting with the inkjet as an output device. In the early 1990s, the French term *giclée* (meaning spray or squirt) was adopted among fine art photographers to characterize the prints they were producing on high-quality commercial inkjet printers.

Several printer manufacturers identified the emerging consumer market for photo-quality reproduction and began producing inkjet printing papers that would provide the look and feel of photographic papers, **Figure 18-8.** An inkjet image is formed by very small droplets of liquid ink that are sprayed onto the paper. On an uncoated paper, the ink droplets soak into the surface. This ink spread produces a soft image with flat color. *Coated papers* resist the spread of ink droplets; the drops retain their shape and color brilliance as they bond to the paper surface. The high gloss of the paper reinforces the photo-like appearance. Photo-quality inkjet papers are offered in glossy, semi-glossy (luster or pearl), and matte finishes. Sizes range from 4″ × 6″ to 13″ × 19″. Some papers are also available in long rolls and various widths.

Figure 18-8. Coated papers for photo reproduction allow inkjet printers to produce output that rivals traditional photographic prints.

Printer Sizes

The two basic formats of desktop inkjet printers are letter-size and wide-format. A letter-size printer accepts standard 8 1/2″ × 11″ paper. Although veteran photographers still refer to the output as an "eight by ten," most photo papers for inkjet printing are the standard letter-size.

Wide-format printers accept paper up to 13″ in width, allowing the photographer to make larger prints. Most of these printers also accept paper in rolls, which may be used for making multiple prints (usually snapshot-size) or panoramic prints up to several feet long. See **Figure 18-9.**

Epson Stylus R3000

Figure 18-9. Wide-format printers are popular with photographers who want to produce larger prints. Most wide-format printers accept paper 13″ in width.

Large-format inkjet printers, normally operated by commercial printing houses or service bureaus, are used to produce large fine art prints, posters, banners, billboard sheets, and similar products. These units accept paper and other media as much as 6′ in width with virtually no length restriction. See **Figure 18-10**.

Ink Colors

Originally, all inkjet printers used a four-ink set—the traditional CMYK, or cyan, magenta, yellow, black. As color photo printing became more popular, however, manufacturers introduced ink sets consisting of eight or more inks, **Figure 18-11**. In addition to the basic CMYK inks, these ink sets typically include at least two different black inks—one for matte photo paper and one for glossy papers. Other inks that may

Epson SureColor S70675

Figure 18-10. Large-format inkjet printers produce big images, such as banners and posters.

Goodheart-Willcox Publisher

Figure 18-11. This wide-format inkjet printer uses eight ink cartridges.

be included are light magenta and light cyan, red and blue, red and green, or shades of gray. A clear gloss enhancer may be included to produce a very high-gloss coating on a print.

Ink Types

All inkjet printers originally used inks based on liquid color dyes. These dye-based inks provided rich, vivid colors on photographic paper, but tended to fade and show color shifts when exposed to ultraviolet light sources (especially sunlight) and high humidity.

The print fading problem led to the development of ***pigment-based inks***. These consist of solid color pigments ground into extremely fine particles and suspended in a liquid. Pigment-based inks resist fading much better than the early dye-based inks. When used with compatible papers, they produce prints capable of lasting for 100 years or more without fading.

Archival Quality

The question of print permanence, or ***archival quality***, has long been a concern of photographers using inkjet printers. In addition to concern about their work being preserved for future generations, these photographers are motivated by an ethical concern. They maintain that a museum or individual purchasing one of their works has a right to expect it will not deteriorate in a reasonable period of time and thus lose both its artistic and monetary value. The availability of printers using pigment-based inks and improvements in dye-based inks has greatly eased the concerns about print permanence.

Monochrome Printing

Photographers who work in black-and-white (or convert color digital images to monochrome for printing) face the challenge of producing a true neutral gray. When printed with the standard four ink colors, images often exhibit a slightly green or magenta cast. See **Figure 18-12**. This problem can be solved by dedicating a printer to monochrome work and using a special ***quad-tone ink set***. These specialty ink sets consist of black and three grays rather than CMYK. Those who choose to stay with CMYK can often find an acceptable combination of inks, paper,

Figure 18-12. Standard color inks can produce a color cast when used to make a monochrome print. A—Neutral gray monochrome print. B—Monochrome print with a magenta color cast.

and printer setting through experimentation. This is especially true when using the newer printers with ink sets that include two or more black inks.

Dye Sublimation Printers

Archival quality and brilliant color have always been a selling point for *dye sublimation printers*. The drawback has been the high cost for models capable of printing sizes up to 8″ × 10″. In recent years, however, small dye sublimation printers for making snapshot-sized prints have become popular. See **Figure 18-13**.

These printers typically produce a 4″ × 6″ print in 30 seconds or less. The printers are stand-alone units that do not have to be connected to a computer and are small enough to be easily portable. Some models can run on battery power, and a few are equipped to receive and print images sent wirelessly from a Wi-Fi–equipped camera or a cell phone.

At least one manufacturer offers snapshot-type cameras with a built-in printer producing 2″ × 3″ prints, **Figure 18-14**. The developing process makes use of paper with embedded dye crystals that are activated by heat.

Dye sublimation printers work on a thermal principle. A print head with thousands of tiny precisely controlled heating elements works in conjunction with a wide plastic transfer ribbon carrying solid CMYK dyes. The print head causes

Epson PictureMate MP-400

Figure 18-13. Small dye sublimation printers are popular for making quick, high-quality, snapshot-size prints.

Polaroid Corporation

Figure 18-14. Small photo prints can be produced directly from this camera.

the dyes to *sublimate* (change state from a solid to a vapor) and deposit tiny color spots on a specially coated paper. The vapor deposits blend to produce an extremely smooth image without visible dot structure, very similar to a continuous tone photographic print. Dye sublimation images are not subject to fading.

Making Quality Prints

The most difficult aspect of printing—especially when using an inkjet printer—is making a print that reflects exactly the image displayed on your computer monitor. It is possible through trial and error to develop a method that provides acceptable results for a specific paper and ink combination. However, this approach requires making numerous test prints to find the right settings.

The best way to achieve consistent and predictable prints is to *calibrate* your monitor and use the appropriate profile for your printer and paper. A calibrated monitor displays colors accurately and consistently. The two calibration methods are software only and software/hardware combination. Software-only methods rely on the user's judgment in evaluating a series of test patterns on the screen. Results will vary from person to person, but software-only calibration is better than no calibration.

Software/hardware systems use a *colorimeter*, **Figure 18-15**. This device reads color values from the monitor screen so the accompanying software can make the necessary adjustments. The calibrated monitor accurately displays the color values in an image file. This allows the photographer to see the effect of changes made with image-editing software and to determine how the final print will appear.

A *profile* is a program that tells a printer how to handle a particular paper so the final print accurately reproduces the color values of the image file. When a monitor is calibrated and the correct profile is used, the print should be a close match to the monitor image. The two never match precisely because a print is a reflected-light image while the monitor image is seen by transmitted light.

The software installed with the printer includes a set of profiles for the papers offered by the printer manufacturer. Profiles for other papers, such as fine art papers from a number of companies, can often be downloaded from the paper company's website and installed on a computer.

When preparing to print, the type of paper being used is selected from a drop-down menu, **Figure 18-16**. This tells the printer which profile to apply when printing. Depending on the printer make and model, you also may be prompted to choose a quality level for the print. The quality levels represent changes in the resolution (dots per inch, or dpi) of the finished print. The higher the resolution, the finer the detail exhibited by the

Goodheart-Willcox Publisher

Figure 18-15. A colorimeter is used with appropriate software to calibrate a monitor.

Goodheart-Willcox Publisher

Figure 18-16. Selecting the desired paper type from a drop-down menu will tell the printer which profile to apply.

print. For inkjet prints, a resolution of 300 or 350 dpi is typically used. Lower resolutions, such as the 72 dpi or 96 dpi normally used for website or other electronic displays, would produce a much lower quality, less detailed print. The price for higher quality, however, is a longer printing time. Print size also affects printing time. A 4″ × 6″ print will be completed more quickly than an 8″ × 10″.

Prints made with modern inks and papers also have a lesser tendency to exhibit *metamerism*. This term refers to a color shift that is noticeable when the print is viewed under different lighting conditions, such as tungsten and daylight. This problem was most common with prints made by printers using the early pigment-based ink formulations.

Print Mounting and Matting

Something interesting happens when a photographic print is mounted, overmatted, and framed—it becomes *art*. Whether or not a critic might agree to that label, the viewer's perception of a photo is different when it is presented in unmounted and mounted forms. See **Figure 18-17.** The wide border formed by the mounting board or overmat eliminates distracting surroundings, helping the viewer concentrate on the photo itself.

Preparation for Mounting

Two basic decisions must be made before starting the mounting process. You must select the surface (substrate) and determine which mounting method is appropriate to the situation. Photographers usually do not make these decisions each time they mount prints but settle on a basic substrate and method and use it for most work. Changes in substrate or method are then made as necessary.

Selecting a Mounting Surface

The vast majority of mounted photographic prints are placed on *board*, the general term for a stiff, paper-faced material that supports the print and keeps it flat for display. The two basic types are **mat board**, composed of two or more

Jack Klasey/Goodheart-Willcox Publisher

Figure 18-17. Compare the unmounted print, left, with the same print that has been mounted, overmatted, and framed.

layers of cellulose fiber, and *foam board*, which has a paper facing on a rigid core of plastic foam. See **Figure 18-18**.

When selecting a mat board for mounting a photograph, consider the following:

- Composition
- Weight/thickness
- Color
- Size

Composition

Composition is the material from which the board is made. Board composition is important when permanence is a consideration. Common mat boards, made with cellulose fibers derived from wood pulp, are slightly acidic. Over time, the acids can combine with airborne moisture and attack the photograph, causing it to yellow and deteriorate. When archival-quality prints are being produced, *museum board* or *conservation board* should be used. These boards are made using acid-free fibers. **Conservation board** is made with fibers derived from specially processed wood pulp and is typically less expensive than **museum board**, which is made with fibers from cotton. An acid-free board has a neutral *pH* (a scale that is used to determine acid/alkaline balance).

Conservation boards and some museum boards are **buffered** (made slightly alkaline) to counter the long-term effects of weak airborne acids.

The choice of buffered or nonbuffered board depends on the material being mounted.

Black-and-white prints should be mounted on a buffered board to take advantage of the additional protection offered. Color prints, especially dye-based inkjet prints, should be placed on nonbuffered board because the prints themselves contain acidic dyes. The dyes could react with the alkaline buffering and cause a color shift.

Foam board typically has an acid-free, buffered-paper facing on both sides. The core material is a chemically inert polystyrene foam.

Thickness

The weight or thickness of mat board is measured in the number of layers or plies that have been glued together. Boards are available with 1-, 2-, 4-, or 8-ply construction. For prints up to 8″ × 10″, a 2-ply board is stiff enough to stand alone for display; 4-ply should be used for larger items. If an overmat (window mat) will be used, a common combination is 2-ply for mounting and 4-ply for the mat, **Figure 18-19**.

Foam board is available in various thicknesses from 1/8″ to 1/2″ or more. It combines very high rigidity with light weight and often is used for mounting mural-sized prints for such applications as trade show displays.

Color

Selecting the most appropriate mat color is somewhat a matter of personal taste, although there are traditional choices. Photographers working in black-and-white usually mount

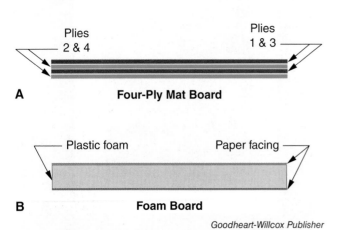

Goodheart-Willcox Publisher

Figure 18-18. Board for mounting. A—Mat board is made up of two or more layers, called plies, of cellulose fiber. B—Foam board has a core of rigid plastic foam with paper facing on each side.

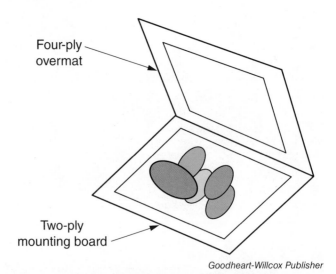

Goodheart-Willcox Publisher

Figure 18-19. Mounting on a two-ply board with a four-ply overmat will provide sufficient rigidity and protection for the print.

their work on a white mat. An overmat, if used, is normally white or black, depending on the photo. A high-key photo with its predominately white or light gray tones would be set off most dramatically by a black overmat. A dark, low-key photo might benefit from a white overmat. See **Figure 18-20**.

Jack Klasey/Goodheart-Willcox Publisher

Figure 18-20. Selecting overmat colors. A—Light-toned image with black. B—Dark-toned image with white.

For framed display in a home or office, a colored overmat may be selected. The mat color for a black-and-white print may be selected to match or complement a room's color scheme. If a color print is being displayed, mat color is often selected to emphasize or contrast with the dominant color in the photo, **Figure 18-21**.

Size

One of the most important reasons for mounting and matting a print is to provide visual isolation, which removes distractions and allows the viewer to focus on the photo. To achieve this isolation, a relatively wide border is needed on all sides of the print.

The rule of thumb is to make the mat size for a given print equal to the next-larger print size. Thus, an 8″ × 10″ print would be mounted on an 11″ × 14″ mat, an 11″ × 14″ print on a 16″ × 20″ mat, and so on. For dramatic effect, proportionally larger mats may be used. Avoid proportionally smaller mats because a too-narrow border around the print is cramped-looking and fails to provide the desired visual isolation. Prints with atypical proportions may be mounted on standard-size mats or effectively displayed on mats proportioned to their dimensions. See **Figure 18-22**.

Other Substrates

In addition to the traditional boards, photos may be mounted for display on a wide variety of other substrates, such as composition board, wood,

Jack Klasey/Goodheart-Willcox Publisher

Figure 18-21. Overmatting in a color to emphasize a key hue in the image.

Goodheart-Willcox Publisher

Figure 18-22. A photo with nonstandard proportions, such as 4″ × 11″, can be effectively displayed with a standard 11″ × 14″ mat, or with a more proportional 8″ × 15″ mat.

metal, glass, or plastic. Most of these provide a hard, smooth finish and good dimensional stability (they do not expand or shrink excessively). However, they may not provide the permanence available from mounting on archival, acid-free boards.

Selecting a Mounting Method

Factors influencing the selection of a mounting method include permanence, convenience, time and cost, and the availability of needed materials and equipment. Mounting methods can be grouped into three categories:

- Edge or "loose" mounting
- Cold-adhesive mounting
- Heated-adhesive (dry) mounting

Edge Mounting

Museum curators and others concerned with maximum archival preservation of photos favor this approach. *Edge mounting* is a loose-mounting method in which the photographic print is held by its corners or by hinges made from easily removed acid-free paper tape.

Corners are available from commercial sources in polyester or paper form. They also can be easily formed from strips of acid-free paper. As shown in **Figure 18-23**, the corners are positioned and fastened to the mat, and then the print is slipped into place. Corners are used when the print has a sufficiently wide border so the corners can be concealed by the overmat. The loose mounting allows the print to be removed and rematted if necessary.

There are two types of hinges formed from acid-free tape and used for archival mounting, **Figure 18-24**. The hinging material can be removed, if necessary, without damaging the print.

A T hinge is formed by adhering a piece of tape to the back of the print with half its width extending above the edge. The print is then positioned on the mat and a second piece of tape is adhered to the extended part of the first piece and to the mat. This hinge is used when the edges of the print will be covered by an overmat.

If the edges will be exposed, a V hinge must be formed. The first piece of tape is positioned in the same way as the T hinge, but the part of the tape extending above the print edge is then bent downward. Viewed from the end of the print, the tape forms an inverted *V*, with the point just below the print's top edge. The print is positioned on the mat, and then rotated or flipped along its top edge.

Goodheart-Willcox Publisher

Figure 18-23. Corners of acid-free material hold a print firmly in position on the mat, but allow it to be removed when necessary. An overmat will cover the corners.

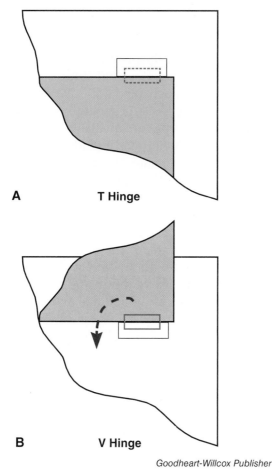

Figure 18-24. Hinging methods. A—The T hinge. B—The V hinge.

Goodheart-Willcox Publisher

The bent-over portions of the hinge are dampened and adhered to the mat. For additional security, a second piece of tape is adhered to the mat over the first piece. The print is then folded down into position, hiding the hinges.

The major disadvantage of loose-mounting methods is that they leave the print free to expand or contract with changing humidity levels. This often results in some degree of curling or rippling.

Cold-Adhesive Mounting

Adhesive mounting methods bind the print tightly to the substrate, and are generally considered permanent. The greatest advantage of the cold methods, as compared to heated-adhesive mounting (dry mounting) is convenience, particularly when only one or a few photos need to be mounted. There is no need to set up or prepare equipment, and the mounting usually can be done in a more limited amount of space.

There are two methods of mounting with cold adhesive. Pressure-sensitive adhesives may be supplied in sheet form or already applied to a substrate. Alternatively, an adhesive can be applied to the print or the mount by spraying, brushing, or applying with a roll-on applicator.

Pressure-sensitive adhesive material is widely used and can be purchased in sheets or rolls. See **Figure 18-25**. The material is positioned

Goodheart-Willcox Publisher

Figure 18-25. Mounting with pressure-sensitive adhesive material requires a knife or scissors and a burnisher.

between the print and substrate, and pressure is applied with a burnisher or roller. This activates the adhesive, forming a permanent bond. An advantage of this material is the ability to reposition the print, if necessary, before applying pressure to activate the adhesive.

Foam board with an already-applied adhesive can be purchased and used for *flush mounts* (those where the photo extends to the edge of the mount, with no border). See **Figure 18-26**. To mount a photo, a sheet of protective paper is peeled away from the adhesive and the print is carefully aligned with the mount edges. The print is then burnished to assure a good bond.

Applied cold adhesives are not as popular as they once were. The oldest form of brush-on adhesive, rubber cement, is no longer recommended because the solvent in the cement often causes discoloration of the mounted material. A water-based acrylic adhesive that allows repositioning and alignment of the print is a more acceptable form of brush-on material. The print is not bonded to the substrate until pressure is applied with a roller or burnisher.

A spray-on adhesive can be applied quickly but is messy to use. Adjacent areas must be protected from overspray, and good ventilation must be provided.

Several types of roll-on adhesive applicators are marketed. The liquid adhesive forms a pressure-sensitive bond, allowing the photo to be repositioned until burnished down.

Heated-Adhesive Mounting

Dry mounting, a process that uses heat and pressure to bond the print to the substrate, is most widely used by professional studios and framing shops. The heat-activated adhesive material, called *mounting tissue*, is generally sold in sheet form. Various types are available for different applications. One type is intended strictly for use with porous materials, such as fiber-base photo paper. Another is used for either porous or nonporous materials. Both of these form permanent bonds. A special archival mounting tissue allows reversal of the bonding action— reheating a mounted print allows it to be removed from the mount without damage.

Heated-adhesive mounting is done using a dry-mount press, which has an electrically heated platen that is clamped down to apply both heat and pressure, **Figure 18-27**. Dry-mount presses range in size from home units capable of mounting an 11″ × 14″ print to large commercial presses able to handle material up to 52″ in width.

Positioning the Print

No matter which mounting method you select, you must position your print carefully and accurately on the substrate to show it to best advantage. A basic rule of print positioning is that the print's long axis should be parallel with the long axis of the mat board. For example, if you have an 8″ × 10″ print, the 10″ side should be parallel with the 14″ side of the 11″ × 14″ board. This is true whether you have a horizontal or a vertical print, **Figure 18-28**.

Goodheart-Willcox Publisher

Figure 18-26. This print has been flush-mounted on a piece of foam board with an already-applied adhesive.

Seal/Bienfang

Figure 18-27. A dry-mount press for heated-adhesive mounting.

Figure 18-28. Orient the print so its long side is parallel to the long side of the substrate.

There are two slightly different ways of positioning the print on the board, depending on whether or not you plan to use a precut overmat. When the print will be displayed without an overmat or with a custom-cut overmat, the preferred mounting method places the print at the optical center of the board. This means that the print has equal amounts of space on either side, but unequal amounts above and below. Since the space below the print is somewhat greater than the space above, the center of the print will be slightly higher than the center of the mounting board. If you are mounting a horizontal 8″ × 10″ print on an 11″ × 14″ board, the margins at each side would be 2″, the bottom margin would be 1 3/4″, and the top margin would be 1 1/4″. See **Figure 18-29**.

If you are using a precut window mat like those available from art supply stores, the print position must match the window. This generally requires the print to be centered on the mounting board at top and bottom as well as from side to side. In this case, the side margins are 2″, but both bottom and top margins are 1 1/2″, **Figure 18-30**. The opening in the precut mat is slightly smaller than 8″ × 10″ so the edges of the mounted print will be hidden.

Mounting a Print

The two most common methods of attaching a print to a substrate are cold-adhesive (pressure-sensitive) mounting and dry mounting using a heat-activated adhesive. Both methods will be described briefly in the following sections.

To avoid possible print contamination by skin oils, many photographers wear lint-free white cotton gloves whenever they handle photographic prints. Others find the gloves cumbersome and minimize skin contact through handling prints by the edges.

The workspace for print mounting should be a table or counter with an area that holds the mounting equipment and still leaves a clear surface area large enough for the biggest mat board that will be used. A hard, easily cleaned surface such as a plastic laminate is preferred.

Figure 18-29. Positioning the print at the optical center of the substrate.

Figure 18-30. Positioning the print at the actual (mathematical) center of the substrate.

Procedure
Cold-Adhesive Mounting

This mounting method requires a clean work surface and mounting adhesive material (sheet or roll), protective ***release paper*** (silicone-coated material that prevents mounting tissue from sticking to it), an artist's knife, and a burnishing tool. Trim the print to the desired size, removing the white borders, before mounting work begins.

1. Place the print, face up, on the exposed adhesive surface of the mounting material. Press down lightly with fingers to hold it in place, then cut carefully through the mounting material along each edge of the print. See **Figure 18-31**.

Goodheart-Willcox Publisher

Figure 18-31. Trimming the mounting material.

2. Lay the print face down on a sheet of release paper. With firm pressure, slide the burnishing tool in overlapping strokes across the entire back of the print to bond the adhesive to the print. See **Figure 18-32**.

Goodheart-Willcox Publisher

Figure 18-32. Burnishing to adhere the adhesive sheet to the print.

3. Peel the protective paper away from the back of the print to expose the adhesive layer, **Figure 18-33**.

Goodheart-Willcox Publisher

Figure 18-33. Peeling the protective paper from the print.

4. Place the print face up on the mounting board. Do not apply pressure. Adjust the print position as necessary so it is properly centered and parallel to the board edges, **Figure 18-34**. This may be done using a ruler or a print positioner (described in the next section). Experienced photographers often can position the print visually.

Goodheart-Willcox Publisher

Figure 18-34. Positioning the print on the mounting board.

5. Place the release paper over the print and board, and then burnish thoroughly to bond the materials. See **Figure 18-35**.

Goodheart-Willcox Publisher

Figure 18-35. Bonding the print to the mounting board.

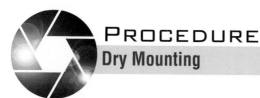

PROCEDURE
Dry Mounting

This mounting method requires a mounting press, a tacking iron, mounting tissue, release paper, an art knife or rotary trimmer, a steel straightedge, and clean kraft paper for use in the press. The work surface must be near an electrical power source to heat the mounting press and tacking iron.

Tack Mounting Tissue to the Print

To hold the materials in the proper alignment with each other for subsequent mounting steps, tack (adhere) a sheet of mounting tissue to the print.

1. Lay the print face down on the work surface and align a single sheet of mounting tissue with the print.
2. Place a small piece of release paper over the area where you will use the heated tacking iron. Touch the iron's tip lightly to the release paper for a few seconds, moving it in a small circle, **Figure 18-36**.

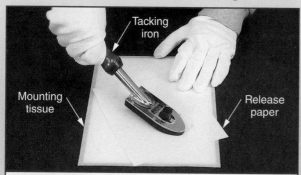

Goodheart-Willcox Publisher

Figure 18-36. Using the tacking iron to bond the mounting tissue to the print.

Trim the Print

Before mounting, trim the print to remove the white borders and excess mounting tissue. Use a steel straightedge with a sharp knife or a rotary cutter.

1. Place the print face up on a cutting mat or piece of scrap board and align the straightedge for the first side to be trimmed.
2. In one smooth, nonstop motion, make the first cut, **Figure 18-37**. Reposition the print to make subsequent cuts. Be sure all corners are square (form a 90° angle).

Position the Print

The trimmed print must be aligned so it is properly centered and its edges are parallel to the mat-board edges. A *print positioner* can be used to place the print in the optical center of the board.

1. Align the print, face up, with the upper-right corner of the mat board. Lay the positioner on the left side of the mat board, with its "T" head extending over the top edge of the board.

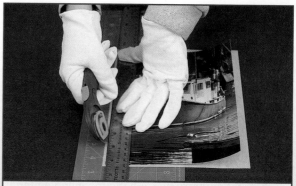

Goodheart-Willcox Publisher

Figure 18-37. Trimming the print with a rotary cutter and straightedge.

2. The scale on the "T" head is a centering rule. To establish the side margins, move the positioner left or right until there are equal distances shown from the print edge to the zero mark and the left edge of the board to the zero mark. See **Figure 18-38**.

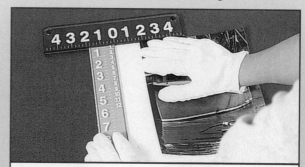

Goodheart-Willcox Publisher

Figure 18-38. Establishing side margins with the centering scale.

3. Holding the positioner firmly in place, move the print from the upper-right corner to the lower edge of the mat board, **Figure 18-39**.

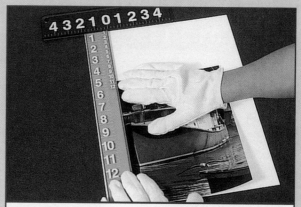

Goodheart-Willcox Publisher

Figure 18-39. Moving the print to the bottom edge of the mat board.

(Continued)

PROCEDURE
Dry Mounting *(Continued)*

4. The positioner body has two number scales—small and large. Look at the top edge of the print and determine where it aligns with the large number scale, **Figure 18-40A**.

5. Slide the print upward until its top edge aligns with the matching point on the small number scale, **Figure 18-40B**. The print is now properly positioned at the mat board's optical center.

Tack the Print to the Board

This is a critical step, since any shift in photo alignment at this point will be difficult or impossible to correct.

1. With one hand holding the print firmly so it does not shift, use the other to lift up one corner of the photo. Slip a small piece of release paper between the print and the mounting tissue, **Figure 18-41**.

2. Carefully insert the tacking iron on top of the release paper to bond a small area of the mounting tissue to the mat board. Be extremely careful not to shift or buckle the mounting tissue when moving the iron.

Insert the Board in the Press

Temperature and time in the dry-mount press varies depending on the substrate, mounting tissue, and size of the material being mounted.

1. Check to be sure the press temperature is correct for mounting, and then open the press. Place clean brown kraft paper on the top and bottom of the mat board, **Figure 18-42**.

2. Insert the material in the press and close the cover. At the end of the time recommended for the mounting tissue used, open the press and remove the mounted print.

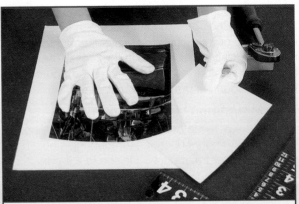

Goodheart-Willcox Publisher

Figure 18-41. Release paper must be used between the tacking iron and the mounting tissue to prevent transfer of adhesive to the iron.

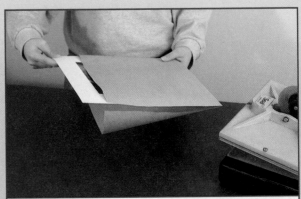

Goodheart-Willcox Publisher

Figure 18-42. Using clean kraft paper or special cover sheets will protect the photo and substrate from foreign matter while in the press.

Goodheart-Willcox Publisher

Figure 18-40. Establishing the top-margin distance. A—Identify where the top of the print aligns with the large scale. B—Move the print upward until its top aligns with the same number or mark on the small scale.

Overmatting a Print

An overmat with a window cut into it to allow the print to show through has two primary functions—appearance and protection. The color (and sometimes texture and pattern) of the mat can help to show the photo to best advantage. Protection, however, is equally important. When a mounted photo is framed and displayed behind glass or plastic, the mat provides spacing to prevent the photo from touching the glazing material. If a mat is not used, moisture in the air may discolor and warp the print or cause the emulsion to stick to the glazing material.

Overmat Types

The most common form of overmat is one with a beveled-edge opening that slightly overlaps the print borders. Multiple-opening mats are widely used for displaying a collection of school or family-member portraits. Double- or even triple-layer window mats are available in most framing and art supply stores. Special die cut shapes are also popular. Framers often create mats to meet customer desires by adhering various fabrics, papers, or other coverings to mat board.

A less common form of window mat is cut with an opening somewhat larger than the print. Sometimes referred to as a *reveal mat*, this larger version is most popular among fine-art photographers and museum curators. Curators like this style of mat for its archival preservation quality—it protects the print like a standard window mat, but does not actually touch the print (minimizing sources of possible contamination or chemical reaction).

Fine art photographers also like the fact that a reveal mat does not overlap the edges of the print, so the entire photo is revealed to the viewer. A reveal mat, if cut sufficiently oversize, also allows room for the copyright date, photographer's signature, and edition numbering. See **Figure 18-43**.

Cutting an Overmat

Although precut mats are commercially available in standard print sizes, many photographers prefer to cut their own. The major benefit of doing so is creative flexibility—there is no limit on size and position of the window or windows. It also permits pairing archival-quality mounting boards with window mats of the same material (precut mats are not necessarily acid-free).

Goodheart-Willcox Publisher

Figure 18-43. The reveal mat allows room for the photographer's signature and other information.

Cutting an overmat with a rectangular window is fairly simple and becomes even easier with practice. The basic tool is a handheld cutter with replaceable blades, **Figure 18-44**. The cutting depth and blade angle should be adjustable. Additional tools include a straightedge, a pair of large spring clamps to hold the straightedge in position, an artist's knife or single-edge razor blade, a ruler, and a pencil.

Before cutting a mat, several preparatory steps are needed. The board for the overmat should be cut to the same outside dimensions as the board on which the photo is mounted. A fresh blade should be installed in the cutter, if necessary, and the angle and depth adjusted. Windows are typically cut at a bevel of 45°; the blade depth should be set to cut through the mat board and lightly into the surface of the underlying cardboard or cutting mat. A too-shallow cut does not free the window from the surrounding board, while cutting too deep produces a ragged or wavy cut as the blade digs into the underlying surface. Test the cutting depth on a mat scrap of the appropriate thickness.

Goodheart-Willcox Publisher

Figure 18-44. A handheld mat cutter like this one is suitable for use with a straightedge when cutting small numbers of mats.

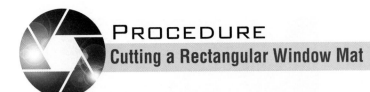

PROCEDURE
Cutting a Rectangular Window Mat

1. Measure and note the distance from each mat edge to the corresponding photo edge.

2. Transfer these dimensions to the backside of the overmat (since windows are cut from the back). Use the straightedge and pencil to lightly draw a rectangle showing the size and position of the photo.

3. For a mat that will overlap the print, draw a rectangle 1/8″ or 3/16″ smaller than the print on all sides. Make the adjusted rectangle with darker lines so it can be readily identified while cutting, **Figure 18-45**.

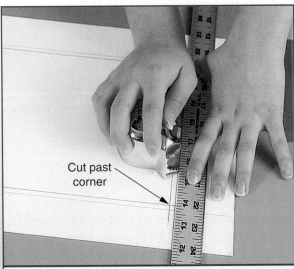

Cut past corner

Goodheart-Willcox Publisher

Figure 18-46. Cut each side of the window with one continuous motion.

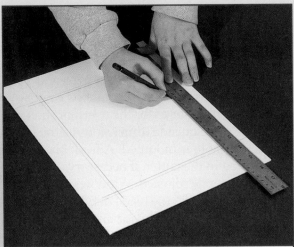

Goodheart-Willcox Publisher

Figure 18-45. Make the lines you will cut on darker so they stand out.

4. Set up the straightedge for the first cut. Begin the cut just outside the corner of your cutting line rectangle. Continue cutting in one smooth motion until the blade goes just past the other corner, **Figure 18-46**.

5. Make your cuts on the other three sides, then remove the straightedge and carefully lift one edge of the mat. If the window was perfectly cut, it will remain on the cutting surface. Often, however, at least one corner will not be cut through completely.

8. Supporting the window piece to avoid tearing the mat surface, turn the mat face up. Insert an art knife or razor blade between the window piece and mat, and carefully cut through the material to the corner, matching the 45° bevel. See **Figure 18-47**.

9. Lay the window mat over the mounted photo to check alignment. If it fits properly, hinge the overmat to the mount at the top with acid-free tape. See **Figure 18-48**.

The same basic procedure can be used to cut multiple openings in a mat or to cut slightly larger or smaller windows for double-matting. Oval and circular masks can be cut with the aid of a special swiveling cutter, **Figure 18-49**.

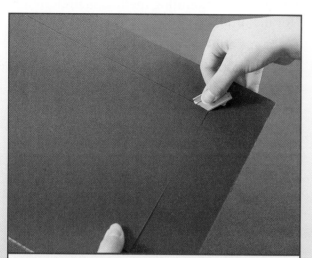

Goodheart-Willcox Publisher

Figure 18-47. If a corner is not cut all the way through, finish it with a sharp blade. Match the bevel and cut carefully.

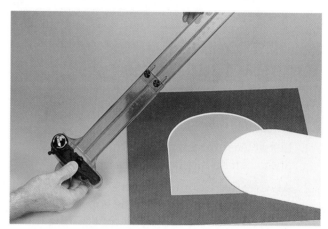

Porter's Camera Store

Figure 18-49. Devices are available that allow you to cut oval or circular windows in overmats. This mat combines a semicircular cut with straight cuts.

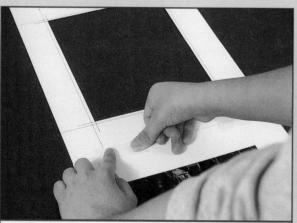

Goodheart-Willcox Publisher

Figure 18-48. The overmat should be hinged to the mount with a length of acid-free tape. This will hold the two in proper alignment.

Check Your Photography IQ

Now that you have finished this chapter, see what you learned by taking the chapter posttest.

www.g-wlearning.com/visualtechnology/

Review Questions

Answer the following questions using the information provided in this chapter.

1. List at least three ways in which a digital photo can be displayed electronically.

2. All Creative Commons licenses require _____, which means that the copyright owner must be given credit for creating the image.

3. Fine-art photographers use the French term _____ to describe high-quality inkjet prints.

4. Name the two types of desktop inkjet printers.

5. Inkjet printers may use either _____-based or _____-based inks.

6. What ethical issue regarding inkjet prints is a continuing concern for photographers?

7. _____ printers are used by consumers for making quick, snapshot-sized prints.

8. To accurately display color values in image files, a monitor should be _____.

9. What is the purpose of a printer profile?

10. Define the term *metamerism*.

11. Describe the basic difference between museum board and conservation board.

12. Buffering is a process that is used to make mat board more _____.
 A. acid
 B. corrosive
 C. neutral
 D. alkaline

13. For a high-key photo, _____ is a good color choice for the overmat.

14. An 11″ × 14″ print should normally be mounted on a mat that is at least _____ in size.

15. Which print mounting method is preferred for maximum archival protection of photos?
 A. Spray adhesive
 B. Edge mounting
 C. Cold-adhesive
 D. Dry mounting

16. Why is rubber cement *not* recommended for mounting prints?

17. One advantage of using pressure-sensitive adhesives is the ability to _____ prints before they are burnished down.

18. Which type of adhesive material used in dry mounting permits reversal of the bonding action?
 A. Tissue for porous materials
 B. Tissue for nonporous materials
 C. Archival tissue
 D. Biodegradable tissue

19. A photo that is optically centered on the substrate has equal margins on the sides, but _____ space above than below.

20. Why should an overmat be used when a photo is to be framed and covered with glass or rigid plastic?

Suggested Activities

1. Go to the Creative Commons website and explore the differences between distributing your work under the Creative Commons Attribution license and placing it in the Public Domain. Present your findings as a written report.

2. Compare the results of printing an image on different types of paper. Choose a color image with a good range of tones and make a 5″ × 7″ print on plain white copier paper. Next, make a print of the same image on glossy photo paper. If matte finish and semigloss (luster) papers are available, make prints on them as well. Mount the prints side by side and label each type of paper. Compare the prints and decide which type of paper produced the best results.

3. Make a print on 8.5″ × 11″ photo paper and mount it on an 11″ × 14″ board. Use the cold adhesive mounting method. Position the print so you can use an overmat with an 8″ × 10″ precut window. Choose a suitable color overmat, and hinge it to the mounting board. If desired, frame your mounted and matted print for display.

Critical Thinking

1. Creative Commons licensing is described in this chapter. How would you find images on the Internet that are available for use under this method of licensing?

2. You have made a dramatic print of an image with deep black shadows and brilliant white highlights. How would you mount, overmat, and frame the print to display it on your wall most effectively?

Communicating about Photography

1. **Speaking and Writing.** Working in pairs, create flash cards for the technical terms that you find challenging in this chapter. Each student should choose six technical terms and make flash cards for those terms. Using your textbook and a dictionary, write the term on the front of the card and the pronunciation and definition on the back. Quiz each other on the pronunciations and definitions of the terms.

2. **Listening and Speaking.** Survey several people you know about how they display their photos online and electronically. Report your findings to the class, giving reasons why you would or would not want to display your own photos in those ways.

Wet side: The area of a darkroom that includes the processing sink, chemical storage, and solution mixing equipment.

While studying this chapter, look for the activity icon ⬀ **to:**

- **Assess** your knowledge with self-check pretest and posttest.
- **Practice** vocabulary terms with e-flash cards and matching activities.
- **Reinforce** what you learn by submitting end-of-chapter questions.

G-WLEARNING.com

www.g-wlearning.com/visualtechnology/

Jack Klasey/Goodheart-Willcox Publisher

Objectives

When you have finished reading this chapter, you will be able to:

- Develop black-and-white film.
- Safely handle and properly store photographic chemicals.
- Recall the steps involved in making an enlargement.
- Adjust exposure and contrast locally with dodging and burning in.
- Explain the importance of archival processing of prints.
- Correct minor print defects.

Check Your Photography IQ ↪

Before you read this chapter, assess your current understanding of the chapter content by taking the chapter pretest.

www.g-wlearning.com/visualtechnology/

Technical Terms ↪

acid stop bath
agitation
archival processing
condenser enlarger
contact print
countdown timers
developer
dichroic filter head
diffusion enlarger
dry side
fiber-base (FB) papers
fixer
grain focuser
inversion tanks
light trap
noninversion tanks

oxidation
paper safe
printing easel
projection print
pull processing
push processing
replenisher
resin-coated (RC) papers
ringaround
safelight
solutions
spotting
stock solution
surge marks
variable contrast paper
wet side

Most serious photographers who develop their own film do so for reasons of creative control and quality. For the same reasons, they usually prefer to make their own prints. In this chapter, you will learn how to develop and make prints from 35 mm black-and-white film. Also covered are darkroom equipment and materials, chemical safety, and archival print processing.

Film-Developing Requirements

All light must be excluded from the space needed to remove exposed film from a 35 mm cassette, thread it onto a developing reel, and enclose that reel in a light-tight tank. The film loading operation can be performed in any space that can be made light-tight, such as a closet or a windowless bathroom. The space should be as clean and dust-free as possible and should have a shelf, table, or counter.

You also can use a bag or tent of tightly woven fabric made for this purpose. The film cassette, developing reel and tank, and a pair of scissors are placed inside the bag. You perform the loading operation by inserting your arms through elastic cuffs that maintain light-tightness.

Equipment

Basic film developing equipment consists of a developing tank and reel, an opener for 35 mm film cassettes, a pair of scissors, a watch or timer, and clips for hanging the film to dry. Processing chemicals, a measuring cup or pitcher, a thermometer, and appropriate containers are also required.

The tank and reel may be made of stainless steel or plastic. See **Figure 19-1**. The most common tank can hold two rolls of 35 mm film. A *light trap* in the tank lid allows processing chemicals to be added or drained without exposing the film to light.

There are two types of developing tanks. *Inversion tanks* have spillproof caps, allowing them to be physically turned upside down at intervals to agitate the chemicals. *Noninversion tanks* are intended to remain upright. In some, a thermometer or other device is inserted into the hub of the developing reel and rotated. Others are

Jack Klasey/Goodheart-Willcox Publisher

Figure 19-1. Developing tanks and reels are made of either stainless steel or plastic. Normally, plastic reels are used with plastic tanks, and stainless steel reels with stainless steel tanks.

agitated by sliding the tank in an arc on a smooth surface.

The most popular type of plastic developing reel allows film to be threaded onto it with a ratcheting action. Stainless steel reels require some practice to load properly and easily, but have the advantage of allowing loading even when damp. Moisture on plastic reels causes the film to stick and bind.

A bottle opener is often used to pry open 35 mm film cassettes. The tightly rolled film can be slipped out to thread onto the developing reel.

Scissors are used to trim the beginning section (leader) of the film for threading onto the developing reel. Once the film is on the reel, the end attached to the cassette hub is cut off. After developing, the strip of film is hung up to dry using clothespins or clips.

Chemicals

Developing chemicals, **Figure 19-2**, consist of a *developer* for turning the latent image into a metallic silver visible image, a *fixer* or *acid stop bath* to make the image permanent, and water to stop development action. To wash residual chemicals out of the emulsion, a washing aid may be used. A final rinse with a solution containing a wetting agent prevents water spots from forming on the developed film as it dries.

Measured amounts of processing chemicals and water usually must be mixed before use. A measuring cup, beaker, or pitcher large enough to hold the required amount of material is needed. Mixing can be done with a stirring paddle or rod, or even the thermometer that is used to measure developer temperature for accurate calculation of developing time. To hold and store the mixed solutions, use airtight containers of the proper volume. See **Figure 19-3**.

Jack Klasey/Goodheart-Willcox Publisher

Figure 19-3. Equipment used for measuring, mixing and storing processing chemicals. Unbreakable plastic containers are usually preferred to those made from glass.

Mixing Chemicals

Darkroom *solutions* (liquid or powdered materials dissolved in water) must be mixed in the proper proportions and often at a specified temperature. See **Figure 19-4**. Liquids are normally mixed at approximately room temperature, 68°F (20°C). For dissolving powdered chemicals, a temperature of approximately 100°F (38°C) is usually specified. Generally, the mixed solution then must cool to room temperature before use.

The developer can be made ineffective if contaminated with stop bath or fixer. To avoid contamination, reserve specific pieces of measuring and mixing equipment strictly for developer or thoroughly rinse and clean equipment to eliminate any residue.

Jack Klasey/Goodheart-Willcox Publisher

Figure 19-2. Film processing chemicals must be mixed with water in the proper proportions.

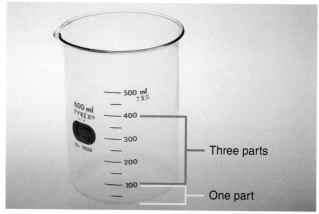

Jack Klasey/Goodheart-Willcox Publisher

Figure 19-4. In a mixing ratio, the first number is typically the chemical and the second is the diluting agent. If 100 ml of chemical is used, 300 ml of water is added to make 400 ml of solution at a 1:3 ratio.

Implement workplace safety rules and regulations in the photography lab or darkroom. When working with photographic chemicals, follow proper chemical handling procedures and wear appropriate protective equipment, **Figure 19-5**. When mixing any acid (such as the acetic acid used for stop bath) with water to make a dilute solution, always pour acid into water; never pour water into acid. This eliminates the possibility of a violent reaction that could splatter acid onto your skin or into your eyes.

If a photographic chemical is splashed in your eyes, immediately flush your eyes with clean, lukewarm tap water. Continue flushing for at least 20 minutes. *Do not* rub your eyes. If you wear contact lenses, they may be flushed out by

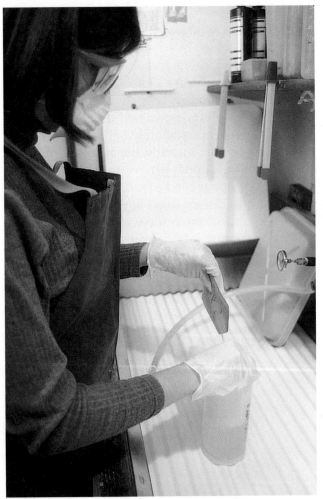

Jack Klasey/Goodheart-Willcox Publisher

Figure 19-5. Safety glasses with side shields protect against solution splashes, a dust mask prevents inhalation of chemical powder, latex gloves prevent skin contact with chemicals, and an apron protects clothing from splashed chemicals.

the water. If not, remove them. Then, thoroughly wash and rinse your hands to remove any chemical residue. Seek medical attention as soon as possible after flushing your eyes. Tell medical personnel the name of the chemical or bring the chemical container with you.

Storing Chemicals

For safety and to prevent mix-ups, clearly label all chemical containers. Containers must prevent oxygen and light from causing the chemical to degrade. In areas that may be exposed to light for lengthy periods, store chemicals in dark-colored or opaque containers.

Oxidation, a chemical change from exposure to oxygen in the air, causes developer to lose its effectiveness. To minimize oxygen contact, there should be little or no air space at the top of the container. See **Figure 19-6**.

The shelf life (length of time effectiveness is retained) of a chemical depends on its state. Powdered chemicals in sealed packages or liquids in unopened bottles have a shelf life measured in months. Once the bottle is opened or the powdered chemical is mixed with water to form a concentrated *stock solution*, shelf life becomes considerably shorter. Diluting the stock solution to form a working solution results in a useful life of usually 24 hours or less.

Chemicals have a specific capacity, or amount of material that they can be used to process before becoming exhausted. The capacity of many commonly used developers is 16 rolls per gallon. However, developer loses strength with each roll that is processed. Keep track of the number of rolls developed and progressively increase developing time at stated intervals. See **Figure 19-7**. Alternatively, use a *replenisher* solution to maintain normal developer strength (and thus, developing times).

Fixer capacity is considerably greater than developer capacity. However, since inadequately fixed film can discolor and deteriorate over time, discard fixer well before it becomes exhausted.

Disposing of Chemicals

Large-scale users of photographic chemicals, such as commercial developing labs, must dispose of chemical wastes under

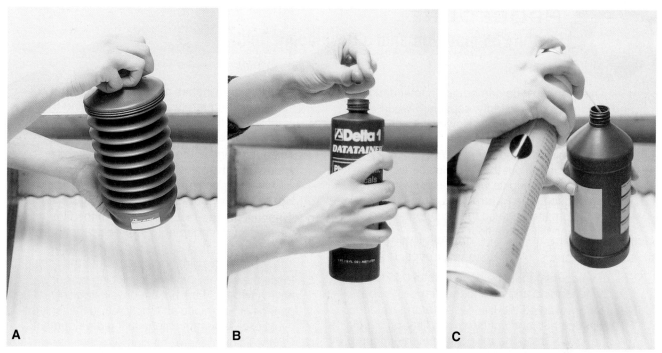

Jack Klasey/Goodheart-Willcox Publisher

Figure 19-6. Methods of excluding oxygen contact with stored chemicals. A—Collapsible bottles. B—Glass marbles. C—Inert gas.

Environmental Protection Agency regulations. Home darkrooms are not subject to these regulations, but local governments often have regulations that apply to any material being discharged into the sewer system.

The key to proper disposal of home darkroom chemicals is dilution. Most photographic solutions are nontoxic in the concentrations normally used, and further diluting them with plenty of water makes them even less likely to cause harm. Once all the solution has been poured out and the container rinsed, let the water continue to flow for a minute or so to clear any residue out of the sink trap.

Developing 35 mm Film

The developing process begins with loading the film onto a reel and enclosing it in a light-tight tank, moves on to a series of chemical steps (developing, stopping, fixing), then ends with washing to remove fixer residues and drying.

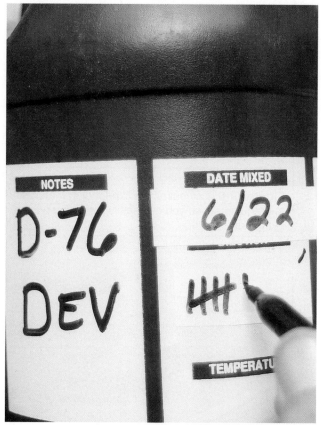

Jack Klasey/Goodheart-Willcox Publisher

Figure 19-7. Record the number of rolls processed in a batch of developer so necessary developing time adjustments can be made.

PROCEDURE
Loading 35 mm Film onto a Developing Reel

This step must be carried out in total darkness and requires some dexterity, especially when loading stainless steel reels. However, once the process is mastered, it can be performed in a matter of a minute or so per roll.

Before turning out the lights, place all equipment and materials within easy reach on the working surface. See **Figure 19-8**. Keep all items well back from the edge so they cannot be easily dislodged and fall on the floor.

1. Turn off the lights and make sure no light of any kind is leaking into your work area. Film development must be done in total darkness to avoid fogging and ruining the film.
2. Pry one end off the film cassette and slide the cassette hub and tightly wound film roll out of the shell. Grasp the roll of film between thumb and forefinger to keep it from unrolling.

3. Unroll several inches of the film leader and cut the film end squarely across, just behind the point where the leader is trimmed to narrower width, **Figure 19-9**.
4. Thread the end of the film onto the reel and feed the film into the spiral track. The method you use will differ, depending on whether you are working with a plastic reel or a steel reel. See **Figure 19-10**.
5. When all but the last few inches of the film have been threaded onto the reel, cut off the end of the film that is taped to the cassette hub. Thread the film completely onto the reel.
6. Place the full reel into the developing tank. If you have a two-reel tank but are developing only one roll of film, place an empty reel in the tank to avoid excessive movement during development.
7. Put the lid on the tank, making sure that it seats firmly. If you are using an inversion-type tank, the cap over the pouring opening should be in place.
8. The remaining film processing steps can be carried out in room light.

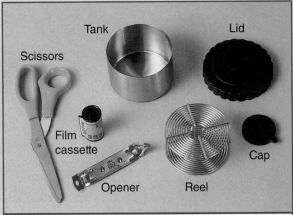

Jack Klasey/Goodheart-Willcox Publisher

Figure 19-8. Lay out all the film-loading materials and equipment so you can easily locate everything in the dark.

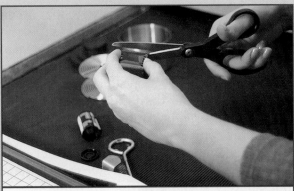

Jack Klasey/Goodheart-Willcox Publisher

Figure 19-9. Trimming the film end squarely makes it easier to load onto the developing reel.

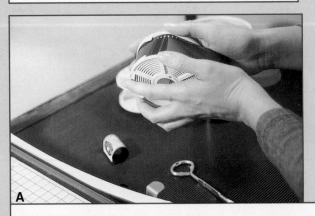

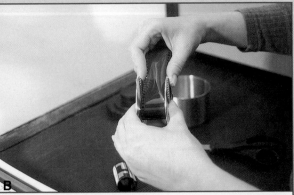

Jack Klasey/Goodheart-Willcox Publisher

Figure 19-10. Film loading methods. A—Plastic reels allow the film to be loaded with a ratcheting action. B—Film must be bowed slightly with finger pressure while loading a stainless steel reel.

Determining Development Time

For any combination of film and developer, the length of time for normal development is determined by the developer temperature. For most developers, the recommended normal temperature is 68°F (20°C).

To find the proper development time for your specific combination of film and developer, first determine the developer temperature. Then, check the development table in a darkroom guide or the technical data sheets available from the developer's manufacturer. The tables show time and temperature combinations for specific film brands and speeds for both full-strength developer and various dilutions.

To achieve the desired consistent temperature, you may have to cool or warm the developer and other solutions. Adjust the supply faucet to provide water of the desired temperature, and then fill a developing tray to serve as a tempering bath. A slow, steady flow of water to the tray holds the temperature at the desired level, **Figure 19-11**. Solutions inside the containers gradually stabilize at the temperature of the water.

A more rapid method of raising or lowering solution temperature is to place ice cubes (or hot water) in a plastic bag that has a zip closure. Squeeze most of the air out of the bag and then submerge it in the beaker of solution to bring it to the desired temperature.

Developing Steps

Before starting development, make sure all needed equipment and materials are at hand.

Measure the necessary amounts of developer, fixer, and washing aid into containers for easy pouring. A timing device should be easily visible to monitor the amount of time needed for each step. Film development can be broken down into an eight-step process with an elapsed time of less than 30 minutes.

Prewetting (1 minute–optional)

Fill the tank with water and agitate for one minute. Soaking the film in water supposedly swells and softens the gelatin emulsion, making it easier for the developer to be absorbed consistently.

Developing (5–15 minutes)

If prewetting is used, empty the water and pour the developer into the tank, **Figure 19-12**. Start the timer when you begin to pour in the developing solution. When the tank is full, replace the cap on the light trap or insert the agitator in the reel hub.

Proper *agitation* (movement of developer inside the tank) keeps fresh solution always in contact with the film. If there is no movement of the solution, the developer that is against the film surface becomes exhausted in a short time, and development stops.

Inversion tanks are agitated by being turned upside down, then right side up again. Each inversion should be completed in about one second. Use continuous motion for the first full minute, then 5 seconds of agitation at 30-second intervals for the remainder of the developing time.

Jack Klasey/Goodheart-Willcox Publisher

Figure 19-11. A tempering bath can bring solutions to the desired temperature before development begins.

Jack Klasey/Goodheart-Willcox Publisher

Figure 19-12. Timing of a processing step should start at the same time tank filling begins.

For tanks that cannot be inverted, the agitation method depends on the tank design. In one type, **Figure 19-13A**, an agitator inserted in the reel hub is twirled back and forth between thumb and forefinger, causing the reel to rotate. A noninversion tank without an agitator, **Figure 19-13B**, can be slid back and forth in a short arc on a smooth surface to create solution movement. The agitation cycle should be completed in about one second.

Too little agitation can cause incomplete or uneven development. Too much agitation, however, can create *surge marks*—streaks resulting from developer flowing back and forth through the sprocket holes of the film.

When the timer shows 10 seconds left, begin pouring the developer out of the tank. With practice, you will be able to finish pouring just as the timer ends its cycle. Even after the solution has been poured out of the tank, the residue of developer on the film continues to work until it is stopped.

Stop Bath (30 seconds)

You can stop film development with an acid stop bath or plain water. The acid stop works quickly by neutralizing the alkaline developer. Water dilutes the developer sufficiently to stop developing action almost as quickly. For a water stop, fill and empty the tank three times. For an acid stop, continuously agitate and pour out after 30 seconds.

Fixer (2–4 minutes)

The developer acts on the latent image on the film, forming molecules of metallic silver to make the image visible. Silver halides in areas of the film that have not been exposed to sufficient light to form a latent image are not affected by the developer. Fixing dissolves these unexposed silver halides, which would otherwise darken on exposure to light. It allows them to be washed away, while leaving the metallic silver (visible image) intact.

Before beginning development, find the proper fixing time by placing a small piece of exposed but undeveloped film in a beaker of fixer, **Figure 19-14**. Measure the time it takes to turn the film from opaque to clear (clearing time). Fixing time should be twice this clearing time.

Rinse (30 seconds)

A water rinse stops the action of the fixer and dilutes any residue. Fill and empty the tank three times.

Washing Aid (2 minutes)

Use a washing aid to save time and water. A two-minute immersion of the film in a washing aid cuts the washing time from about 30 minutes to 10 minutes or less.

Washing (10 minutes)

Film that has not had fixer residues thoroughly washed out can eventually discolor and deteriorate. A running water wash is recommended. Many photographers merely fill and empty the tank several times until the recommended time has elapsed.

Jack Klasey/Goodheart-Willcox Publisher

Figure 19-13. Noninversion tank agitation. A—Rotating the agitator to move the reel inside the tank. B—Moving the tank in a short arc to provide agitation.

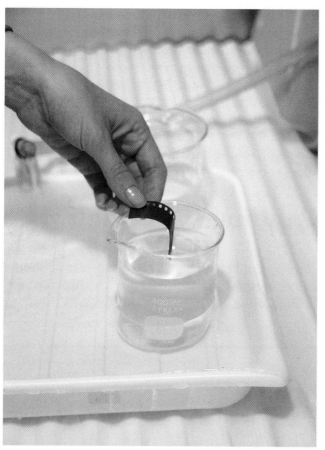

Jack Klasey/Goodheart-Willcox Publisher

Figure 19-14. Immersing a small piece of exposed film in fixer will establish its clearing time.

Wetting Agent (30 seconds)

After washing, immerse the film for 30 seconds in a wetting agent solution to prevent the formation of water spots during drying. Many careful darkroom workers also remove excess water with a sponge or a set of squeegee tongs, **Figure 19-15**.

Drying Film

A dust-free atmosphere for film drying is essential, since a dust particle that becomes embedded in the emulsion is difficult or impossible to remove without visible damage. Film may be hung in the open or inside a drying cabinet.

Once the film has dried, it must be placed in a protective covering to prevent damage from foreign matter or handling. A common method is to cut the film into short strips (usually five frames for 35 mm film) and place them in a plastic storage page, **Figure 19-16**. Wear thin cotton gloves to avoid scratching the negatives and prevent fingerprints on the film surface.

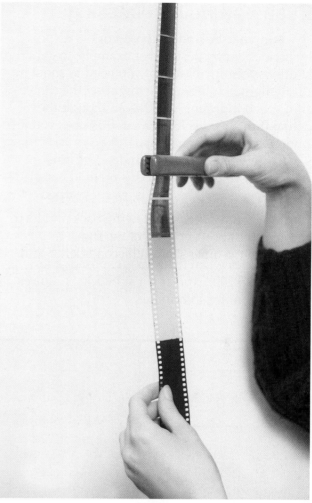

Jack Klasey/Goodheart-Willcox Publisher

Figure 19-15. Avoid spots on film by carefully using squeegee tongs to remove excess water.

Jack Klasey/Goodheart-Willcox Publisher

Figure 19-16. Wear cotton gloves to avoid fingerprints and scratches on negatives when storing them in plastic pages.

Push and Pull Processing

Film may be underexposed or overexposed by accident or by design. For example, to gain the shutter speed increase that you need to shoot in a dimly-lighted interior, you might set the camera's film speed indicator to 400, even though the actual film speed is ISO 200. In this case, you are underexposing by one stop.

To compensate for the underexposure, increase developing time. This method is called *push processing*. The film is overdeveloped with a resulting increase in grain and contrast. The rule of thumb is to increase development time 50% for a one-stop push. If the developing time is 10 minutes when the film is exposed at its normal ISO 200, exposing it at ISO 400 requires development for 15 minutes.

The opposite of push processing is *pull processing*, or intentional underdevelopment of the film. This method is used when film has been overexposed by one or more stops or in extreme contrast situations, such as a night shot of a brightly lit scene. A typical starting point for a one-stop pull is a 30% reduction in developing time. One danger of pull processing is uneven development due to too-short developing times. Avoid development times shorter than five minutes.

Reading the Negative

The interrelated effects of exposure and development on a negative are easiest to see and understand when the variations are displayed in a *ringaround*. As shown in **Figure 19-17**, this is

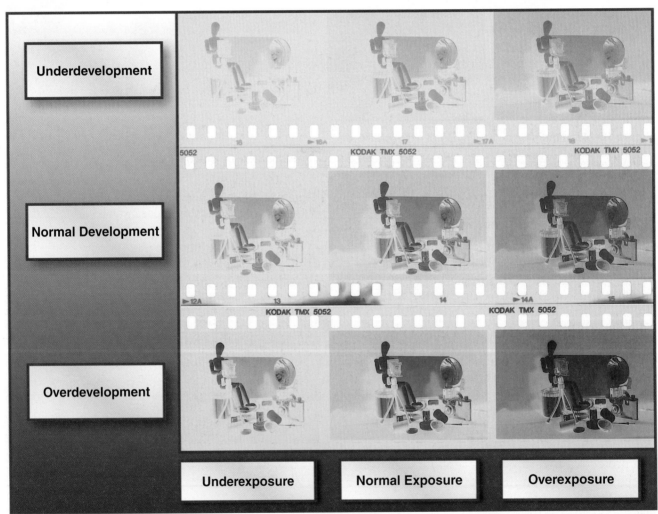

Figure 19-17. A ringaround allows you to compare negatives side-by-side to see the effects of different exposure and development combinations. For example, the negative in the upper-left corner shows the effects of a combination of underdevelopment and underexposure.

a panel of nine developed negatives of the same subject that shows all possible combinations of exposure and development. Careful examination of the negatives, and the matching set of prints in **Figure 19-18**, will help you learn how to read your negatives as an aid to making good prints.

When examining a negative, first look at the overall density. Is it thin and light gray in appearance (underexposed) or dense and dark overall (overexposed)? A properly exposed and developed negative of a subject with a full-range of tones exhibits a matching range of tones, although they will be reversed in value for the scene. The highlights, which appear darkest on the negative, should exhibit detail in all but the most dense areas. The shadows (light on the negative) should show detail or texture in all areas except those that print pure black.

The details of the scene, when examined under magnification, should be sharply focused.

An object or detail that appears soft in the negative will be much more obviously soft in an enlarged print. When examining negatives, watch for the following physical faults:

- Scratches, pinholes, or dust embedded in the emulsion. Dust spots appear as white areas on the print, while scratches or holes in the emulsion print black.

- Clear or opaque patches on the film are caused by adjacent areas of film touching on the developing reel, preventing the developer from reaching the emulsion. Dark round spots or mottling on the film can be caused by air bells (bubbles) that cling to the film surface, interfering with development. Dark, arc-shaped marks indicate that the film was bent sharply, or kinked, during loading on the reel.

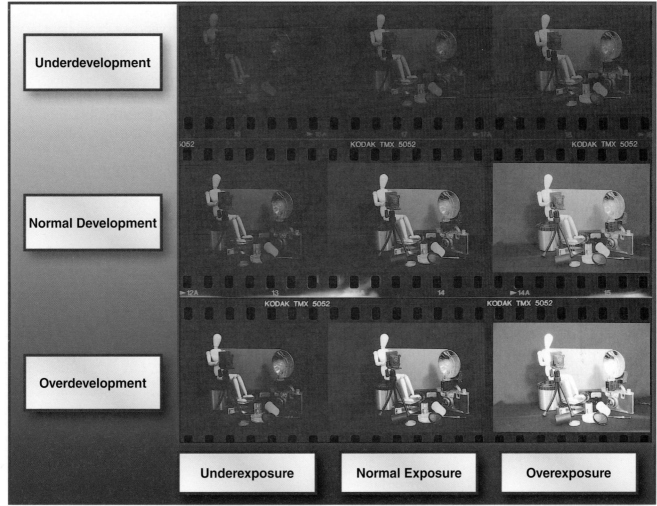

Goodheart-Willcox Publisher

Figure 19-18. Prints showing the result of each negative condition depicted in Figure 19-17.

- If the negative is clear except for the manufacturer's edge printing (name and numbers), the developed film was never exposed. Clear film without edge printing was exposed to processing chemicals in the wrong order—fixer before developer. If the film is completely black, or has large black areas, it was fogged by exposure to light.

- Overlapping images can indicate a faulty film transport mechanism in the camera or an exposed roll that was inadvertently loaded and exposed again.

- Uneven development (one edge of the film lighter than the other) is a sign of insufficient developer in the tank. Solutions must completely cover the film during development.

The Darkroom

To make prints from your developed film, you need access to a darkroom with sufficient sink room and counter space to handle the largest desired print, storage space for materials and equipment, and excellent ventilation.

A darkroom is traditionally divided into a wet side and a dry side, **Figure 19-19**. The *wet side* consists of the processing sink and areas for washing prints, viewing wet prints, and print drying. Chemical storage containers and mixing equipment are also normally kept on the wet side. The *dry side* contains the enlarger, counter space for such equipment as a paper trimmer, and storage for photographic paper and other materials

and tools that must be kept dry. If the darkroom is small, finishing and print mounting are usually done in a separate workspace.

Enlargers

There are two basic types of photographic enlargers—condenser and diffusion. In a *condenser enlarger*, light is passed through a condensing lens or lenses to make it directional and focus it on the plane where the negative is held, **Figure 19-20**. This bright, focused beam of light allows for relatively short exposure times and provides a sharp, somewhat contrasty image.

A *diffusion enlarger* produces a soft, unfocused light for enlarging. The light from an incandescent or fluorescent source is softened and made nondirectional by passing it through a frosted diffusing panel, **Figure 19-21**, or by reflecting it repeatedly off the walls of a mixing chamber. Compared to a condenser enlarger, a diffusion enlarger requires longer exposure times and produces a print that is somewhat softer in contrast.

Some diffusion enlargers use a cold-light head, in which a grid of fluorescent tubes emits a soft nondirectional light. The light is usually further diffused before passing through the negative.

An enlarger equipped with a *dichroic filter head*, **Figure 19-22**, permits the photographer to dial in the desired values of yellow and magenta filtration when printing with variable contrast black-and-white paper.

Goodheart-Willcox Publisher

Figure 19-19. A typical darkroom layout. The arrangement completely separates the wet side and dry side, and permits efficient processing without wasted steps.

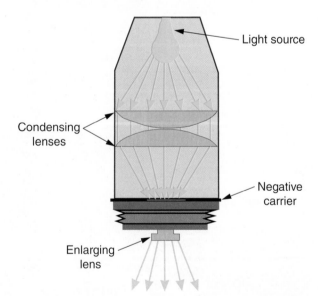

Goodheart-Willcox Publisher

Figure 19-20. Light from an incandescent source is focused and made more directional, then passes through the negative and the enlarging lens and is projected onto the paper.

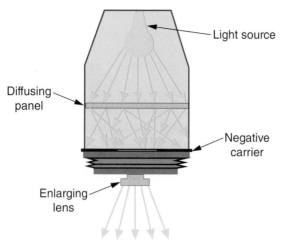

Goodheart-Willcox Publisher

Figure 19-21. In a diffusion enlarger, the light from the source passes through the negative and the enlarging lens to print a projected image on the paper.

Different values are set on the filter head controls, substituting for the sheet-type variable contrast filters used with other enlargers.

Enlargers range from small and inexpensive units for 35 mm negatives to huge pieces of equipment capable of handling 8″ × 10″ negatives. Enlargers made for 35 mm and medium format (120-size film) negatives are most common in home and educational darkrooms. See **Figure 19-23**.

The size of the largest print that can be made on the enlarger's baseboard is governed by the combination of negative size, enlarging lens focal length, and height of the enlarger column. Typically, for a 35 mm negative and the standard 50 mm enlarging lens, an enlarger can produce an 11″ × 14″ print with the head raised to the top of the column.

Jack Klasey/Goodheart-Willcox Publisher

Figure 19-22. A dichroic filter head enlarger permits the photographer to dial in the desired filtration for printing.

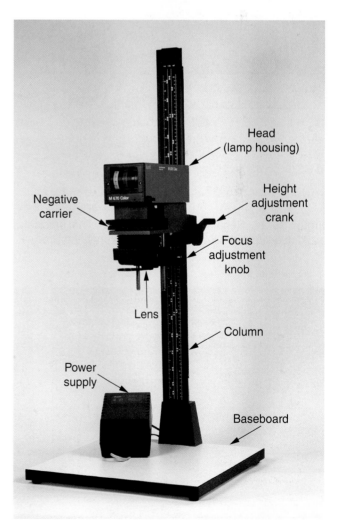

Jobo Fototechnic, Inc.

Figure 19-23. Parts of a typical enlarger used with 35 mm negatives.

Enlarger Equipment and Accessories

A negative carrier is usually a hinged two-piece design with an opening sized for a specific negative format, **Figure 19-24**, Most photographers have a separate carrier for each film format they print.

An enlarging lens for use with 35 mm negatives has a focal length of 50 mm. To ensure proper covering power (the circular area that is "seen" by the lens), a different focal length lens is usually needed for each film format.

Lensboards hold lenses so they can be easily mounted or dismounted when the film format is changed, **Figure 19-25**. Lenses are usually held

in place on the lensboard with a retaining ring called a *jam nut*.

Variable Contrast Filter Set

A set of variable contrast (VC) filters gives the photographer the equivalent of a dozen different paper contrast grades. Grade numbering differs from one manufacturer to another.

A highly desirable feature in an enlarger is a filter drawer positioned between the light source and the negative, **Figure 19-26**. The drawer allows the use of acetate or gelatin filters for variable contrast printing. Placing the filters above the negative modifies the light without optically degrading the projected image. If the enlarger does not have a drawer, filters usually must be positioned between the enlarging lens and the paper. Such filters must be handled carefully to avoid fingerprints or scratches.

Jack Klasey/Goodheart-Willcox Publisher

Figure 19-24. Negative carriers are made with a precisely sized opening that allows light to pass through the film.

Jack Klasey/Goodheart-Willcox Publisher

Figure 19-25. An enlarger lens mounted in a lensboard can be easily inserted or removed.

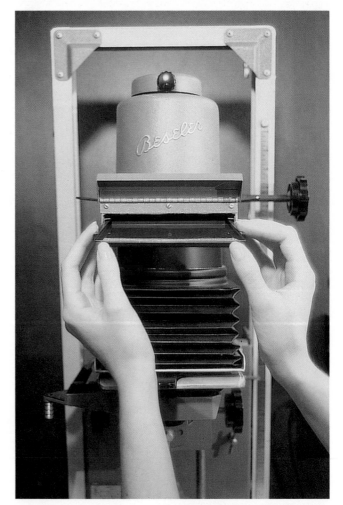

Jack Klasey/Goodheart-Willcox Publisher

Figure 19-26. A filter drawer positioned above the negative allows use of sheet-type VC filters.

Timer

To accurately time exposures, a timing device that switches the enlarger bulb on and off is needed. Dial timers are calibrated in full seconds, while digital electronic timers may be set in increments of 1/10 second. Some electronic timers are programmable to permit a sequence of timed events.

Safelight

Black-and-white printing can be done under safelight illumination, while color printing must be done in total darkness. The *safelight* used for darkroom work with most black-and-white papers, an amber color designated *OC*, provides enough illumination to work comfortably.

To prevent fogging of photographic paper during exposure and processing, the safelight should be at least 4′ from any point where paper might be exposed to its illumination. Avoid leaving unprocessed paper in the open for more than a few seconds.

Printing Easel

A *printing easel* holds the printing paper flat and in the desired position during exposure. Easels are made in several sizes and types, **Figure 19-27**.

Single-size easels are handy for someone who normally prints on a particular size of paper. These easels are made for common paper sizes up to 11″ × 14″.

A two-blade easel can handle paper of different sizes, and the blades can be moved to change the proportions of the print. Two-blade easels are made in sizes to accommodate paper up to 16″ × 20″.

Most serious photographic printers choose the four-blade easel. It has independently adjustable spring-steel blades, allowing almost infinite variation of print size and proportion. Sizes up to 20″ × 24″ are available.

Focusing Aid

To ensure maximum sharpness, careful printers use a focusing aid. The *grain focuser* is most common. It is placed on the enlarging easel after the projected image has already been adjusted for size and focused as well as possible by eye. A small section of the image is reflected from the focuser's mirror to a magnifying eyepiece. The enlarger's focus control is adjusted until the image is as sharp as possible.

Goodheart-Willcox Publisher; Charles Beseler Company

Figure 19-27. Printing easels. A—Single-size easel. B—Two-blade easel. C— Four-blade easel.

Paper Storage

Unexposed photographic paper can be stored in any light-tight container that is easily opened and closed. The simplest type of *paper safe* is a hinged plastic box with a latch to help prevent accidental opening. Unlatching and opening the lid, then extracting a sheet of paper is an easy,

one-handed operation. Larger paper safes have several shelves for different sizes and types of paper and typically have a spring-loaded door on the front.

Negative Cleaning Equipment

A soft brush and a jet of compressed air can be used to remove stray bits of lint or dust from negatives before printing. This prevents disfiguring white marks on the print.

Print Processing Equipment

Basic print developing equipment consists of a set of four trays—one each for developer, stop bath, fixer, and water. See **Figure 19-28**. The water tray may serve as a holding area for prints until they are placed in a separate print washer, or the prints may be washed in the tray itself.

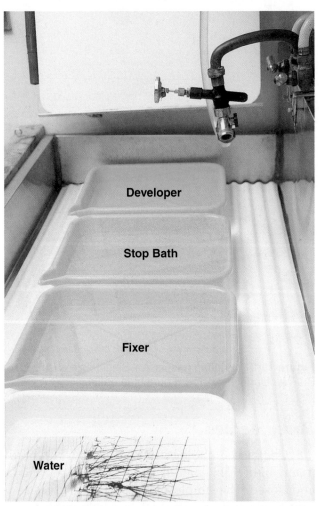

Figure 19-28. Four print trays are commonly used in this left-to-right arrangement.

Tongs or Gloves

Since contact with darkroom chemicals can cause skin irritation, the use of print tongs or gloves is strongly recommended. Thin latex surgical-type gloves are preferred because they provide a more positive grip on prints.

Print tongs are usually more practical. Tongs are made from stainless steel, plastic, or bamboo with rubber nonslip tips, **Figure 19-29**. Separate tongs for each of the three solutions are often used.

Clock or Timer

Print processing steps can be timed by a number of devices, ranging from a clock or wristwatch with a second hand to a separate timer for each step. Electromechanical or digital *countdown timers* can be set for the total period, then count down to zero and sound an alarm.

Print Washer

The simplest form of print washer is a tray that is filled with water and manually emptied a number of times to remove fixer residues from prints. Almost as simple is the tray siphon, which clips to a tray to provide a continuous, steady flow of fresh water, **Figure 19-30**.

Archival print washers have vertical compartments to hold a single print or two prints placed back-to-back with emulsion out. This design permits free flow of water around the prints and virtually total removal of fixer residues to help ensure long print life.

Figure 19-29. Types of print tongs. The set of bamboo tongs is color-coded for easy identification.

Porter's Camera Store

Figure 19-30. A tray siphon mounts on the edge of a holding tray and provides a continuous flow of water into and out of the tray.

Drying Equipment

Once prints are sufficiently washed, they must be dried for display or storage. The drying method should produce a print that is reasonably flat and has a pleasingly smooth surface. Drying methods vary depending on the type of paper.

Resin-coated (RC) papers dry quickly and remain flat when suspended over the sink from a line with clips. Fiberglass window screen material, stretched onto a frame, can also be used as a drying support for RC prints, **Figure 19-31**.

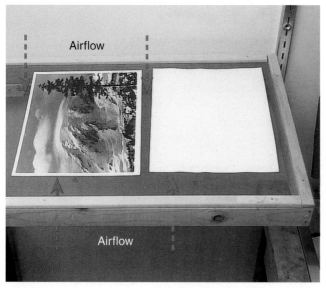

Airflow

Airflow

Jack Klasey/Goodheart-Willcox Publisher

Figure 19-31. Both RC and FB papers can be dried on fiberglass screens, which permit free airflow to both sides of the prints.

Fiber-base (FB) paper placed with the emulsion side down on the screen material dries relatively flat, although the process takes considerably longer. A chemical print-flattening agent for FB papers can be used after washing.

Processing Chemicals and Storage Containers

Three basic chemical solutions—developer, stop bath, and fixer—are used to process black-and-white prints. The developer must be designed for use with paper, not film. Stop bath and fixer are the same solutions used for film processing, although fixer is sometimes diluted more for paper.

In addition to developer, stop bath, and fixer, washing aids or wetting agents may be used. The quantity of the chemical to be stored determines the choice of container. Larger darkrooms have two-gallon, five-gallon, and even larger tanks. See **Figure 19-32**.

Working in the Darkroom

Many variables affect the look of a print. These include process variables (exposure time and contrast selection) and variations in materials (choices of paper and developer).

Beginning darkroom workers are usually advised to choose one combination of paper and developer and explore it thoroughly before moving on to other possibilities. The best way to select between alternatives is to have only one variable involved. For example, if you are trying to determine whether a 10-second or a 13-second

Regal/Arkay

Figure 19-32. Large darkrooms, such as those in schools or custom labs, use storage tanks of two-gallon or greater capacity for photographic chemicals.

exposure is best for a print, all other elements—the enlarging lens aperture, contrast filter, paper, and developing time—should be held constant. If two variables (such as exposure time and contrast) are changed at the same time, it will be impossible to determine whether the result is due to the exposure change, the contrast change, or both.

Selecting a Developer

General-purpose paper developers for black-and-white printing, sometimes referred to as *universal paper developers*, are used in most darkrooms. See **Figure 19-33**. Like film developers, paper developers are offered in either powder or liquid concentrate form. Liquid concentrates offer convenience, since they can be easily mixed with water to form a working-strength solution.

Selecting a Printing Paper

Printing paper choices include fiber-base vs. resin-coated; variable contrast vs. contrast-graded; cold-tone/neutral vs. warm-tone; and glossy, satin, or matte finish.

Fiber-Base vs. Resin-Coated

Technically, all black-and-white photographic papers are *fiber-base (FB) papers*, since the emulsion layer is coated onto a paper substrate (support). In *resin-coated (RC) papers*, however, a layer of plastic material is applied on both sides of the paper substrate. An antistatic backing prevents a buildup of static electricity on the plastic bottom layer. See **Figure 19-34**.

An advantage of the resin coating is shortened washing and drying times. Since the paper absorbs only small amounts of processing solutions and water, RC prints must be washed for only a fraction of the time required by FB papers. Fiber-base prints require several hours of air drying, while prints on resin-coated paper are dry enough to handle in as little as 10 minutes.

FB papers are the choice of fine-art photographers, who are concerned with both the appearance and the permanence of their prints. These photographers maintain that a given print will have a better appearance on FB paper than on the equivalent RC paper. Permanence is a greater issue,

Jack Klasey/Goodheart-Willcox Publisher

Figure 19-33. Either a liquid concentrate or powder developer can be used for paper. Liquid concentrates are easier to use.

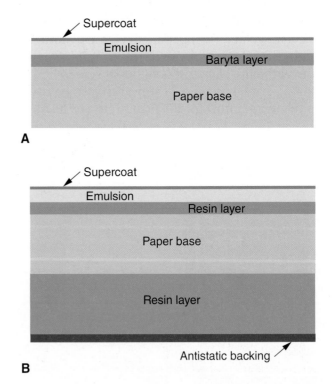

Goodheart-Willcox Publisher

Figure 19-34. Paper structure. A—FB papers consists of four layers. The baryta (barium sulfate) layer provides a smooth, very white, reflective base for the emulsion. The supercoat protects the emulsion from scuffs and scratches during processing. B—RC papers have a waterproof resin (plastic) layer on each side of the paper.

especially for photographers who sell their prints to museums and collectors. Fiber-base prints can be archivally processed with the expectation that they will remain unchanged for a century or more.

Variable Contrast vs. Contrast-Graded Paper

For many years, the list of basic materials for a black-and-white darkroom included separate boxes of paper in up to five different contrast grades. *Variable contrast paper*, used with a set of VC filters, provides all the grades in one box.

A two-part emulsion is used for variable contrast papers. One part is sensitive to blue light and governs the paper's high-contrast response. The other part is sensitive to green light and is responsible for low-contrast response. Contrast of the final print is governed by the proportions of green and blue light reaching the paper.

VC filters range in color from a pale yellow to a deep magenta tone, **Figure 19-35**. The yellow filters block varying amounts of blue light, while the magenta filters do the same with green light. By selecting a VC filter, you are altering the blue/green light ratio and thus the response of the paper. With a low-numbered yellow filter, the light exposing the paper has a higher proportion of green, producing a print with soft, or low, contrast. A high-numbered magenta filter has the opposite effect—a higher proportion of blue in the light and a print with hard, or high, contrast.

Paper Weight and Finish

Papers are available in different thicknesses and surface finishes. FB papers are offered in a thin single-weight and a heavier double-weight. RC papers are usually described as medium-weight. Thicker papers are easier to handle during processing, especially when larger prints are being made.

Printing papers have glossy, matte, or semimatte finishes. Glossy paper provides the richest appearance, displaying the full range of tones available in the photo. This type of paper is especially valuable in conveying strong, deep black tones. Matte (sometimes called *satin*) paper has a flatter appearance that is suited to subjects conveying a subtler, narrower range of tones. Semimatte paper falls between the other two and is favored by some printers as a good compromise. Semimatte is also described as a *pearl* or *luster* finish by some manufacturers.

Types of Prints

Prints made on photographic paper from negatives are produced by either contact or projection methods. The major distinction is size of the print in relation to the size of the negative. A *contact print*, made by exposing a negative that is physically laid on top of the photographic paper, is always the same size as the negative. A *projection print*, however, is an enlarged version of the negative. It is produced by passing a beam of light through the negative and a lens and projecting it onto the photographic paper.

Procedures for making both contact and projection prints are described in the Appendix, *Making Prints*.

Evaluating and Improving Prints

Your first print from a negative is most likely to be a proof that you can evaluate for improvement. You can make this initial evaluation from a still-wet print. Allow the water to drain off and then place the print in a clean spare tray so it can be viewed under normal room illumination rather than safelight. This may be done in the darkroom using the normal white light or a separate inspection light. Before turning on the white light, safely store all paper and other light-sensitive materials. You can also carry the print out of the darkroom to an adjacent lighted area.

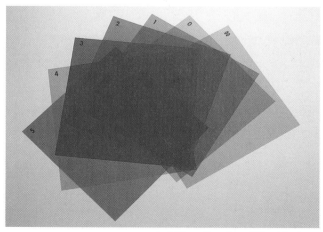

Jack Klasey/Goodheart-Willcox Publisher

Figure 19-35. A set of variable contrast filters.

First, examine the print as a whole. It should exhibit the full range of tones seen in the negative or on the contact sheet. The print should not give an overall impression of being too dark or too light, **Figure 19-36**.

The most critical areas for judging proper exposure are the highlights. On a print, highlight areas may range from light gray to pure (paper) white. Unless the highlight is a specular reflection or an actual light source such as the sun or a light-bulb, it should not print as paper white. It should show at least a hint of texture or a slight shading of gray.

If the significant highlight areas are too light, more exposure is needed. If they are too dark, less exposure should be given. Think in terms of a percent increase or decrease in exposure. If you need to bring out a bit more texture in the highlight, try a 10% change. For example, if your original exposure time was 17 seconds, a 10% change is 1.7 seconds. Round the time to

2 seconds, making your exposure time 19 seconds (17 + 2 = 19). Any exposure change to alter the highlights affects the midtones and shadows to the same degree. However, a change of even 20% usually does not make the rest of the print unacceptably light or dark.

Once a satisfactory exposure time has been established and a new print made, you can evaluate the print's contrast and adjust it as necessary. See **Figure 19-37**. A flat print has a generally gray appearance with no areas of strong black or bright white. An overly contrasty print has strong blacks and bright whites, but few gradations of tone in between.

Carefully examine the shadow areas of the print. Very deep shadows may be totally black and show no detail, but shadows that are less deep should include at least a hint of texture and detail. In general, if the shadow areas seem too light or weak-looking, change to a higher-contrast grade paper or filter. If the

Figure 19-36. Overall exposure evaluation. A—Printed too light, exposure too short. B—Printed with full range of tones, exposure about right. C—Printed too dark, exposure too long.

Figure 19-37. Overall contrast evaluation. A—Flat, gray appearance, contrast too low. B—Average contrast, showing full range of tones. C—Chalk and soot appearance, contrast too high.

shadows are too dark and featureless when they should be showing detail, decrease the contrast grade. To show the differences in appearance that result from increasing and decreasing contrast, **Figure 19-38** displays six prints made from the same negative.

Filtration can affect the exposure times for prints. For example, Ilford, the major manufacturer of black-and-white paper and chemicals, specifies doubling exposure times with filters #4 and above. Less drastic adjustments of a few seconds may be necessary when changing from one grade to another (such as #2 to #1).

Local Exposure Control

Since adjustments in exposure time and contrast affect the entire print, there are limitations to what can be done in straight printing. Almost every print can be improved to some extent by using local adjustment of exposure and contrast. Some shadow areas may need decreased exposure to reveal the detail they contain. At the opposite extreme, some highlight areas may require extra exposure to prevent printing as blank white paper.

The process of giving less exposure to a limited area of the print is called *dodging*. The opposite technique, providing additional exposure to part of the print, is called *burning in*. Dodging and burning in are usually done using simple tools that are either purchased or homemade. See **Figure 19-39**.

Jack Klasey/Goodheart-Willcox Publisher

Figure 19-39. Tools for dodging and burning in can easily be made in a variety of sizes and shapes to suit specific needs.

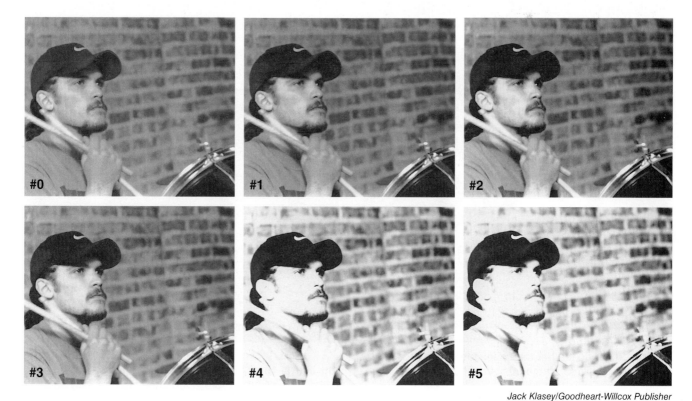

Jack Klasey/Goodheart-Willcox Publisher

Figure 19-38. The range of contrast differences attainable using variable contrast paper and filtration from very low (#0) to very high (#5). The negative used exhibited a full range of tones when printed with normal-contrast filtration.

Dodging is slightly more difficult to master, since it must be done during the basic print exposure. A tool of the approximate shape of the area to be dodged is placed in the light path to shade the selected area of the paper during part of the exposure, **Figure 19-40**. The tool must be kept in slight but constant horizontal motion to prevent a noticeable edge between the dodged area and the rest of the print. The critical factor in dodging is time. Too much leaves the dodged area unnaturally light, **Figure 19-41**, while not enough leaves the area too dark to reveal the desired detail. Skill in dodging develops with practice.

Burning in is done by making one or more additional exposures of selected areas after the basic print exposure has been made. The tool for burning in is a card large enough to shadow the whole print, with a hole in it to direct light onto the desired area. Using white card stock thick enough to block light makes the projected image easy to see so the spot of light can be positioned more accurately, **Figure 19-42**.

Moving the card closer to the lens or farther away changes the size of the light spot projected onto the paper. A single large spot may be used for an "all-at-once" exposure, or a smaller spot may be used to "paint" light onto the paper in

Jack Klasey/Goodheart-Willcox Publisher

Figure 19-41. Dodging one area of a photo, such as this prickly pear cactus, for too long will make it unnaturally light and ruin the print.

Jack Klasey/Goodheart-Willcox Publisher

Figure 19-40. To feather the edges of the dodged area and blend the different amounts of exposure, keep the dodging tool in constant motion.

Hole in card

Spot of light on print

Jack Klasey/Goodheart-Willcox Publisher

Figure 19-42. A burning-in tool made from an opaque white card allows the projected image to be easily seen.

a series of exposures. To avoid a hard edge on a burned-in area, the spot must be kept in constant slight motion. As with dodging, burning-in skills improve with practice.

Archival Processing for Image Permanence

Archival processing ensures that a photographic print will last for hundreds of years without deteriorating. This method is especially important for prints that will be displayed in museums or sold to collectors. During fixing, by-products are formed that are difficult to dissolve. If these by-products are not removed by sufficient washing, the print will sooner or later exhibit stains or overall discoloration. See **Figure 19-43**.

Archival processing is typically used for prints made on FB paper. A washing aid can be used to shorten the long washing times for FB to a period of from 10 to 30 minutes.

Selenium protective toning is most often part of the washing-aid step. The toner is mixed with the washing aid in a 1:20 or even greater dilution. The very dilute selenium chemically changes the silver in the image to a more stable compound, silver selenide. It causes little or no color change in most papers.

Washing can be done with running water in a tray. The flow rate should be sufficient for a complete change of water every five minutes. The preferred method is a washer design that provides a separate slot for each print, **Figure 19-44**. This design permits adequate water flow to both surfaces to carry away residual fixer.

Prints that have been archivally processed should be mounted, stored under archival conditions, or both. Storage boxes, mounting boards, and any other materials in contact with the prints must be acid-free.

Finishing Prints

Before a print can be mounted, it must be dried and have any minor visual defects repaired. These operations are collectively termed *finishing*. Proper finishing—especially the elimination of small white or dark spots—is vital to the appearance of the mounted print.

Author's collection

Figure 19-43. Prints that are not archivally processed eventually deteriorate from residual fixer in the paper. This view of the original 1893 Ferris wheel is badly faded and shows both yellowing and brown stains.

Jack Klasey/Goodheart-Willcox Publisher

Figure 19-44. The individual slots of this archival washer help to ensure thorough washing of prints.

It is best to avoid visual defects in the first place. Regular cleaning of the darkroom and careful handling of negatives at every stage helps avoid dust, scratches, and fingerprints.

Even with the utmost care, however, a few white or black defects may appear on dried prints. Specks of dust that settled on the negative after it was already in the enlarger show up as white spots, **Figure 19-45**. Damage to the negative in the form of a pinhole in the emulsion or a scratch is revealed as a dark mark.

Repairing Light-Colored Defects

The traditional method of darkening light-colored defects to match their surroundings, called *spotting*, is tedious but not difficult to master. Diluted dye is carefully applied to the spot with a fine-tipped brush to gradually darken it and match the surrounding print tone. **Figure 19-46** shows the full set of spotting tools. Spotting dyes are made in a number of different shades or tones to better match the tone of the printing paper.

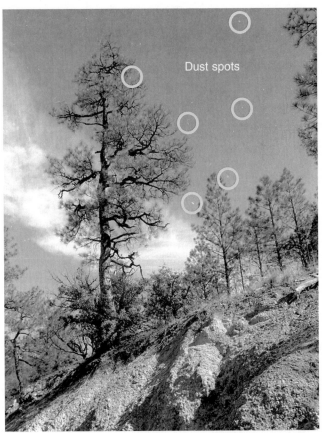

Jack Klasey/Goodheart-Willcox Publisher

Figure 19-45. Small white spots on the print are usually caused by dust particles on the negative.

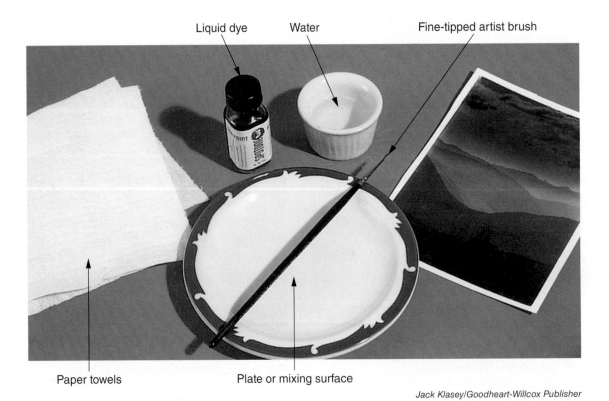

Jack Klasey/Goodheart-Willcox Publisher

Figure 19-46. Tools for print spotting.

PROCEDURE
Spotting a Print

1. Mix a drop of wetting solution (such as Photo-Flo™) with a tablespoon or so of lukewarm water in a small container. The wetting solution helps the dye penetrate into the emulsion.
2. Using the brush, place a drop or two of the spotting dye on the plate.
3. Dip the brush in the water, and then wipe it dry on the paper towel.
4. Select a spot on the print to be treated.
5. Dip the brush in the water to pick up a small amount of liquid.
6. Deposit the drop of liquid on the plate next to one of the spots of dye.
7. Blend a little water with some of the dye to make a very light gray solution, **Figure 19-47**.
8. Dry the brush on a paper towel. Draw the brush across the paper so the fine point is maintained at the tip.

9. Touch the brush to the light gray solution on the plate to pick up only a small amount of liquid.
10. Holding the brush perpendicular to the print surface, touch the tip very lightly to the spot, **Figure 19-48**. A tiny amount of dye will be deposited.
11. Lightly blot the spot with a clean paper towel.
12. Examine the spot. It may be a bit darker, or it may show no perceptible change after the first application.
13. Continue to add dye to the spot (repeat steps 9–11) until the tone matches its surroundings.
14. Follow the same procedure for each of the light spots on the print. Often, you can work on several spots at the same time, speeding up the overall process.
15. When all spots have been repaired, set the print aside to dry.

Jack Klasey/Goodheart-Willcox Publisher

Figure 19-47. Small amounts of water and dye are blended to make the spotting solution.

Jack Klasey/Goodheart-Willcox Publisher

Figure 19-48. Use just the tip of the brush to deposit a small amount of dye. The procedure must usually be repeated several times to achieve the desired darkening of the spot.

Removing Dark Defects

Getting rid of a black spot or line is more complicated and slower than eliminating white spots, since it is a two-stage process. First, you must turn the dark spot into a white spot, and then darken the white spot to match its surroundings.

The traditional method of removing a black spot, called *knifing*, involves mechanically scraping away the emulsion layer down to the baryta layer that lies below it. A very sharp blade and a steady hand are required to achieve good results. If scraping goes through the baryta layer to the actual paper, the dye application will be hard to control. The exposed paper surface absorbs dye differently from the emulsion or the baryta layer, making it difficult to match both the color and the luster of the surrounding area.

A chemical method can be used to eliminate the black marks without causing a mechanical change in the surface. Bleach solution is applied to the spot with a fine brush to dissolve the exposed silver grains. The result is a clear spot in the print emulsion that shows the underlying white baryta layer. The reducing action is stopped, or chemically neutralized, by a fixer. After the black blemish has been eliminated, dye must be carefully applied to gradually build up the tone to the desired level.

Check Your Photography IQ

Now that you have finished this chapter, see what you learned by taking the chapter posttest.

www.g-wlearning.com/visualtechnology/

Review Questions

Answer the following questions using the information provided in this chapter.

1. Once film has been placed in a(n) _____ tank, the developing process can be carried out in normal room lighting.

2. When mixing acid with water, you should always pour the acid into the water. Why?

3. You are using a liquid developer concentrate and want to make a liter (1000 ml) of working solution. The directions tell you to mix concentrate and water in a 1:4 ratio. How much concentrate and how much water will you use?

4. If a chemical is splashed in your eyes, flush the eyes with clean, lukewarm water for at least _____ minutes.

5. When mixing photographic chemicals, always clean equipment thoroughly to avoid _____.

6. Disposal of photographic chemicals by commercial film laboratories is regulated by the _____.

7. _____ is the key to safe disposal of used photographic chemicals.

8. The length of time for normal development is determined by the _____.

9. Deliberately overdeveloping film to compensate for underexposure is called _____.

10. The darkroom is typically divided into a(n) _____ side and a(n) _____ side.

11. What are the two basic types of enlargers?

12. Why do digital timers provide more precise control than conventional dial timers?

13. Paper manufacturers recommend that the darkroom safelight be located at least _____′ away from any paper to prevent fogging.

14. For minimum optical distortion, variable contrast filters should be placed _____ the negative in the enlarger.

15. Why should gloves or print tongs be used while processing prints in the darkroom?

16. _____ print washers are designed to remove virtually all fixer residues to greatly lengthen the life of the photographic print.

17. To keep fiber-base printing paper relatively flat when drying it on fiberglass screen material, should it be placed with the emulsion side up or down?

18. Explain the importance of having only one variable when making a comparison (choosing between alternatives).

19. What is the primary advantage of RC papers compared to FB papers?

20. In a variable contrast paper, the green-sensitive part of the emulsion controls the _____-contrast response.

21. A(n) _____ print is always the same size as the negative from which it was made.

22. What is meant when a black-and-white print is described as *flat*?

23. Providing extra exposure to a part of the print to darken it or bring out detail is called _____.
 A. spotting
 B. burning in
 C. dodging
 D. toning

24. The use of _____ toner in a highly dilute solution is an important step in archivally processing a fiber-base print.

25. When spotting prints, why is it better to gradually build up a tone to match its surroundings than to try matching in a single dye application?

26. What must be done to eliminate a black spot on a print?

Suggested Activities

1. Identify a space in your home that could be converted to a photographic darkroom. Make measurements and draw a plan for the darkroom.

2. Create a series of images illustrating the steps needed to develop a roll of film, and narrate a slide show for your class. If possible, use a digital projector. If one is not available, display the images on a laptop computer.

3. Working with a partner, make lists of the equipment and chemicals you would need to set up a home darkroom, based on what you have read in this chapter. Research the Internet to find sources and identify the costs of the needed equipment and chemicals. Prepare a report of your findings and share it with the class.

Critical Thinking

1. If you need to process several rolls of film one after the other, would you use a plastic or a stainless steel reel? Why?

2. Evaluating a print you just made, you note that the middle tones look good, but some important shadow and highlight areas lack detail. What steps could you take to improve the print?

Communicating about Photography

1. **Writing and Speaking.** Create an informational pamphlet on general safety rules for the darkroom. Refer to this chapter and research the Internet for information. Include images and illustrations in your pamphlet. Present your pamphlet to the class.

2. **Reading and Speaking.** Choose three main topics in the chapter that you would like to understand better and reread the section on each topic. Write a three to four sentence summary of what you just read. When writing your summary, paraphrase and use your own words.

Making Prints

Making contact prints and projection prints require the same basic operations—testing to determine proper exposure time, using that time to expose the paper, and then processing the print. When projection printing, however, the image must be sized and focused on an easel before making the final exposure.

Contact Printing

The most common form of contact print is called a *contact sheet*, or *contact*. These sheets contain same-size prints of an entire roll of film negatives, **Figure A-1**. A well-made contact sheet allows the photographer to assess each frame and decide which to print.

An enlarger usually is the light source for making contact sheets. An empty negative carrier placed in the enlarger provides a rectangle of light on the baseboard. The enlarger is turned on and the head is raised until the

lighted area is approximately 11″ × 14″ in size. This provides adequate coverage for the typical contact sheet.

If the negatives are stored in clear plastic pages, the entire page can be laid atop the sheet of photographic paper to make the print. A sheet of glass is placed over the negative sheet/paper sandwich to press it tightly together, **Figure A-2**.

Jack Klasey/Goodheart-Willcox Publisher

Figure A-2. The negative storage page and photographic paper are pressed tightly together for contact printing by a sheet of glass. Cloth tape has been applied to the glass edges to prevent cuts.

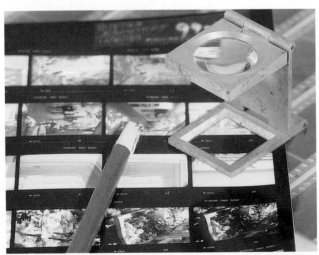

Jack Klasey/Goodheart-Willcox Publisher

Figure A-1. The contact sheet is useful for determining which negatives should be selected for printing.

PROCEDURE
Determining the Proper Exposure for a Contact Sheet

1. Set the enlarger lens aperture to f/5.6 or f/8. Remove any VC filters from the filter drawer or set the dichroic filter controls to zero.

2. Turn off the darkroom white light and turn on the safelight.

3. Take a sheet of VC paper out of the package or paper safe and place it on the enlarger baseboard with the emulsion side facing up.

4. Lay the negative storage page, emulsion side down, on top of the paper. The negatives are properly oriented if the film-edge numbers and words can be read normally (are not reversed).

5. Carefully lay a clean sheet of glass on top of the negative sheet and paper.

6. Set the enlarging timer for 15 seconds.

7. Lay a sheet of black card stock on the glass so it covers all but a strip approximately 1/5 the width of the negative storage page. See **Figure A-3**.

8. Start the timer, which turns on the enlarger light source. After 3 seconds (at the 12-second mark on a countdown timer), move the card to expose another 1/5 of the negative page width.

Jack Klasey/Goodheart-Willcox Publisher

Figure A-3. Black card stock is used as a mask to expose strips for different lengths of time.

9. Repeat the card movement at 3-second intervals. The result will be a contact sheet exposed in steps of 15, 12, 9, 6, and 3 seconds.

10. Develop the contact sheet as described later in the appendix.

11. Turn on the white light and examine the developed contact sheet. It should show a series of strips ranging from lightest (3-second exposure) to darkest (15-second exposure), **Figure A-4**.

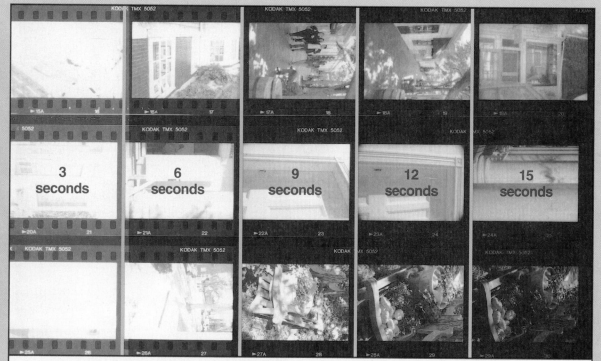

Goodheart-Willcox Publisher

Figure A-4. Test exposures are cumulative, showing regular steps from lightest to darkest.

(Continued)

PROCEDURE

Determining the Proper Exposure for a Contact Sheet *(Continued)*

12. To find the correct exposure time, look closely at the edges of the strips of film on the print. Working from the lightest exposure strip toward the darkest, compare the sprocket holes to the film edge surrounding them. The first strip where the sprocket holes disappear (are the same black as surrounding film edge) represents the correct exposure time for contact sheets. See **Figure A-5**.

13. If the first contact sheet does not produce a dark enough exposure to make the sprocket holes disappear, make a second sheet using longer exposure times (still at 3-second intervals).

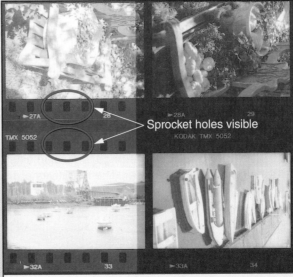

Goodheart-Willcox Publisher

Figure A-5. A correctly exposed contact sheet strip shows no distinct sprocket holes.

You can use the aperture and exposure time established with this test procedure each time you make a contact sheet. The print that results will show clearly whether a frame is overexposed, normally exposed, or underexposed. This is valuable for improving your photographic technique and provides needed information for making projection prints.

Projection Printing

Examine the contact sheet and select a negative to print. If necessary, use a magnifier to choose a frame that has a wide range of tones and is sharply focused.

Remove the strip of film containing the negative from the storage page. Place it in the enlarger's negative carrier, with the desired frame centered in the carrier opening, **Figure A-6**. Position the negative with the emulsion side down, and then close the carrier to firmly hold it in place.

Clean the negative to remove any dust or lint, **Figure A-7**. Cleaning is done from below the carrier to avoid redepositing loosened dust or lint.

Jack Klasey/Goodheart-Willcox Publisher

Figure A-6. When placing a negative in the carrier, wear gloves or handle the film by the edge to avoid fingerprints.

Jack Klasey/Goodheart-Willcox Publisher

Figure A-7. Using compressed air to clean the negative.

After cleaning one side of the negative, turn the carrier over and clean the second side.

Install the negative carrier in the enlarger and place your printing easel on the baseboard. If an adjustable easel is used, set its blades for the desired print size. To make framing and focusing easier, place a sheet of processed photographic paper, such as the back of a discarded print, in the easel.

Shut off the white light and turn on the enlarger's light source. Raise or lower the enlarger head until the rectangle of light projected onto the printing easel is the desired size. The proportion of the 35 mm film frame is different from the proportions of standard paper sizes. As shown in **Figure A-8**, a full-frame print on an 8″ × 10″ sheet from a 35 mm negative results in an image approximately 6 1/2″ × 9 1/2″. Printing to the full 7 1/2″ width of the paper, allowing for borders, means the loss of approximately 1 1/4″ of the projected image's length.

Once the print size is established, focus the image for maximum sharpness. To focus, turn the knob or handwheel that moves the lensboard up or down.

Goodheart-Willcox Publisher

Figure A-8. The 35 mm frame has a 2:3 proportion (1″ × 1 1/2″), while 8″× 10″ paper has a 4:5 proportion. A—The full-frame print is narrower than the paper. B—Printing the full width of the paper loses some image at one or both ends. C—Greater enlargement can be used to print only part of the 35 mm frame.

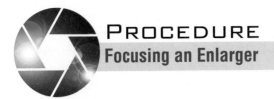

PROCEDURE
Focusing an Enlarger

1. Open the enlarging lens to its maximum aperture to obtain a bright image for focusing.
2. Rotate the focus knob or handwheel until the image on the easel appears to be as sharp as possible.
3. If focusing has caused the image size on the easel to become too large or too small, adjust the enlarger head height as necessary, then refocus.
4. Use a grain focuser for fine focus adjustment, **Figure A-9**. Move the control until the image just passes the point of sharp focus, and then adjust in the opposite direction until the sharpest focus is achieved. Several back-and-forth movements may be needed for critical focusing.

Jack Klasey/Goodheart-Willcox Publisher

Figure A-9. For critical sharpness, adjust the focus control of the enlarger while looking through the grain focuser eyepiece.

After focusing, stop down the enlarging lens to the aperture needed for printing. Most lenses are considered to be sharpest two or three stops down from wide open. Thus, an enlarging lens with a maximum aperture of f/4 is usually set to f/8 or f/11.

Insert the normal contrast filter in the filter drawer or filter holder. If you are printing with a dichroic filter head, set the yellow and/or magenta values for a normal contrast print as suggested by the paper manufacturer.

Determining Exposure Time

There are several methods for determining the preferred exposure time for a print. All rely on the photographer's judgment and personal preference. Some photographers prefer to print with a darker range of tones, while others prefer a lighter look.

When making a straight, or normally exposed, print, most people try to find an exposure that reproduces the full range of tones in the original scene. The exposure should preserve some detail in the shadows while conveying some texture and detail in the brightest highlights.

The most common method of determining exposure times is a test strip. As when making a contact print, a black card is moved across the paper surface in timed steps. However, in this case a projection print is being made and the exposure uses normal-contrast filtration.

Use the red filter on your enlarger to project an image that does not expose printing paper. While viewing the image on the easel, you can put your test strip paper in place. Turn off the enlarger, move the red filter out of the light path, and make a series of timed exposures. Do not move the strip of photo paper while shifting the card between exposures. With a well-exposed negative, a good starting point is to make five exposures in 5-second increments at an aperture of f/8. This provides a strip with exposures of 25, 20, 15, 10, and 5 seconds, as shown in **Figure A-10**.

Since not all negatives are well-exposed, the entire test strip may be too light or too dark. Changing the aperture usually allows you to make a usable test strip. Opening up from f/8 to f/5.6 doubles the amount of light reaching the paper at each exposure increment. Stopping down from f/8 to f/11 has the opposite effect.

Figure A-10. This test strip from a medium-contrast negative was made with 5-second exposure increments.

Processing Prints

Like film developing, print processing consists of six steps—development, stopping development, fixing the image, treatment in a washing aid, washing, and drying. As a general rule, all of the processing steps are shorter for RC papers than for FB papers.

Developing

Ilford, the major manufacturer of black-and-white paper and chemicals, recommends a range of 1 minute to 1 1/2 minutes for RC papers. Times for FB papers are longer—1 1/2 minutes to 5 minutes. In both cases, the variations are due to different developers or developer dilutions.

To help ensure even development, slip the exposed print smoothly into the developer so the surface is quickly covered by solution. Begin timing immediately. The image usually begins to appear in as little as 30 seconds. Resist the temptation to pull the print out of the developer early. Prints that are not allowed to develop for the full time often have a washed-out or muddy appearance.

During development, follow a regular cycle of slightly lifting one corner of the tray, then lowering it, to set up an ebb and flow of solution over the print. This ensures even development by constantly exposing the emulsion to fresh solution. Approximately 10 seconds before the end of the development time, lift the print out of the developer by one corner, **Figure A-11**. Allow excess solution to drain back into the tray.

Next, slip the print into the stop bath tray. Do not dip the tongs into the stop. If stop bath

Figure A-11. Allow approximately 10 seconds of draining time for developer to run off the print.

does get on the tongs, rinse it off with water immediately to prevent contaminating the developer with stop bath when you handle the next print. One pair of tongs should be used only with developer. A second pair can be used in both stop bath and fixer, if desired.

The acidic stop bath chemically neutralizes the alkaline developer to halt development almost instantly. The stop bath also helps to extend the life of the fixer. A stop bath time of approximately 15 seconds is sufficient for both RC and FB papers. Indicator stop bath includes a chemical that turns the solution from yellow to purple when its capacity is near exhaustion, **Figure A-12**.

Figure A-12. A color change shows the indicator stop bath has reached its useful capacity.

Fixing

If they were not processed in fixer, developed prints would begin to discolor and darken when exposed to light. This occurs because the residual silver halides in the emulsion react with the light. Fixer is a solvent that removes unexposed silver halides from the emulsion.

Sodium thiosulfate fixer is typically diluted 1:3 for film and 1:7 for prints. An alternate is ammonium thiosulfate rapid fixer, which is diluted 1:3 for both film and prints. This dilution is used in the rapid fixing method (30 seconds for RC, 1 minute for FB) advocated by Ilford. The theory is that the short fixing times allow a sufficient interval for the fixer to do its work but little time for the solution to soak into the paper.

Fixer can be checked for exhaustion with a test solution, **Figure A-13**. A few drops of solution are added to a sample of the fixer. If a precipitate forms, the fixer should be replaced.

Prints must be properly agitated to keep a fresh supply of fixer in contact with the emulsion. Agitate continuously for at least the first 15–30 seconds, then periodically during the remainder of the fixing time. For short fixing times, agitate for the entire time the print is in the tray.

Washing

Fixer and its by-products must be thoroughly removed from prints by washing. If not, the prints eventually exhibit stains and yellowing.

Resin-coated papers have short wash times—Ilford recommends 2 minutes. Fiber-base is a different story—the typical washing time for double-weight FB paper is 60 minutes in running water. By placing the print in a tray of washing aid for a few minutes, washing time can be shortened to 10 minutes.

Drying

There are a number of drying methods, ranging from blotters to electrically heated devices. Most commonly, RC prints are air-dried by hanging them from clips on a line over the darkroom sink or placing them on fiberglass screen frames. A print on RC paper can be squeegeed to remove excess water and then dried with a hair dryer in a matter of minutes, **Figure A-14**.

Special Printing Techniques

Many approaches to printing can be taken with technique, materials, or both. A sampling of these will be discussed in the following section.

Jack Klasey/Goodheart-Willcox Publisher

Figure A-13. Testing fixer to determine whether the solution has reached its capacity.

Jack Klasey/Goodheart-Willcox Publisher

Figure A-14. A print made on RC paper can be dried quickly with a hair dryer used on a warm setting.

Multiple-Image Printing

Multiple-image printing combines two or more subjects to create a new photograph. Some multiple-image prints have images that are totally separate from each other on a dark background. Others overlap slightly, usually on a light background.

To make a multiple-image print, place the first negative in the enlarger. Size, position, and focus the negative. Determine correct exposure and expose the first image. Mark the top edge on the back of the print for correct orientation later, and then store the exposed sheet in a light-tight box.

Place a sheet of plain white paper in the easel and project the first negative onto it. Trace the outlines of the image on the paper to help position later images, **Figure A-15**. For prints in which the images will be separate, this tracing can also be used to make a mask for subsequent printing.

Place the second negative in the enlarger and project the image on the easel containing the traced outline. After size, position, and focus are adjusted for the second negative, trace that image onto the paper. Remove the tracing from the easel. Make a test print to determine proper exposure for the second image.

The technique used for printing the second image depends on the final appearance desired for the multiple print. If the images are to be separate, use the tracing to create a mask that blocks out the first image. Place the previously exposed and stored

sheet of photo paper in the easel with the top edge oriented properly and the mask aligned with the paper. As the second image is being exposed onto the paper, move the mask up and down very slightly to "feather" the junction of the first image and the dark background. With careful planning, a similar masking procedure can be used to print a number of separate images on one piece of photo paper.

If the images are supposed to partly overlap, use the tracing as a basis for creating an opening in a large opaque card. The opening should be approximately the shape of the second image and is used in the same way as a burning-in card. Project the image through the hole in the card onto the paper while keeping the card in limited up-and-down or horizontal motion to blend the image edges with the background. This technique works best if the first image printed includes a large blank area, such as a cloudless sky, so the second image only partly overlaps the first. Interesting effects also can be achieved when overprinting areas of distinct clouds, **Figure A-16**.

Jack Klasey/Goodheart-Willcox Publisher

Figure A-15. Tracing the image of a projected negative onto plain white paper.

Jack Klasey/Goodheart-Willcox Publisher

Figure A-16. Printing onto a patterned area, like these clouds, can create interesting multiple-image effects.

Sabattier Prints

A *Sabattier print* displays a partial reversal of tones, producing effects that can be dramatic. The effect, named for a French photographer who first produced such prints in the 1860s, occurs when a print is briefly exposed to light partway through the developing process. See **Figure A-17**. The degree of tone reversal varies from print to print.

Typically, the re-exposure of the print is done with a somewhat dim (such as 25W) bulb for a second or two about halfway through the development process. Position the bulb 12″–18″ above the developer tray. Cease agitation and allow the developer/paper movement to stop before turning on the bulb. Experiment with varying re-exposure times, distances of the bulb above the tray, and the proportion of development time before and after the re-exposure.

Vignetting

The *vignetting* printing technique gives the central image a soft-edged shape that gradually shades to either white or black, **Figure A-18**. To make an image vignetted out of a white background, cut an opening of the desired size and shape in an opaque card to make a mask. To obtain the soft, gradual shading into the white background, move the card up and down slightly during the exposure.

For a vignette out of a black background, first expose the print for a white background. To expose for the black background, use a piece of opaque card to make a second mask the same size and shape as the opening in the first mask. Tape this mask to a piece of stiff wire about 6″ in length.

Using the enlarger's red filter for viewing the projected image, position the second mask to cover the area printed in the first exposure. Remove the negative from the enlarger, move the red filter out of

Jack Klasey/Goodheart-Willcox Publisher

Figure A-17. The Sabattier effect. A—A normally exposed and developed print. B—This print was exposed to light for about 1/2 second halfway through the development process. Note the thin bright lines (Mackie lines) along some edges of the subject in the upper-left quarter of the print. These lines dramatically enhance the contours of the subject.

Figure A-18. Vignetting. A—A vignette with a white surround. B—The same image with a black surround.

the light path, and make the second exposure. This exposure should be long enough to provide a strong black surrounding the vignetted area. To avoid a white or gray line from the wire used to hold the mask, keep the wire in constant slight motion during the exposure, just as you would a dodging tool.

Bleaching

Selective bleaching chemically alters prints. A dilute solution of a reducing agent is applied to areas of the print, lightening them for emphasis or for better balancing of tones. See **Figure A-19**.

Figure A-19. Bleaching selected areas of a print. A—Original print. B—Print after bleaching to brighten the breaking wave and bring out highlights in the large rock.

Usually, a 1:10 dilution (1 part of solution and 10 parts of water) provides good control of the bleaching action.

Bleaching must be done on a damp print. Have a tray of water for rinsing and a tray of fixer within reach to halt the bleaching action. Apply the bleach to the print in small quantities, being careful to avoid drips and runs into areas that you do not want lightened, **Figure A-20**. Watch closely as you apply the solution, since the bleaching action can be quite rapid. When the degree of lightening is just short of what you want, place the print in the rinse. Some bleaching continues until the print is placed in the fixer. Fix and wash the print according to directions for your paper and fixer.

Toning

Toning is a chemical process that changes or intensifies the color of a black-and-white print. Most common toning colors are a yellowish-tan to brown color called *sepia*, blue, and the slightly purple tone that results from selenium toner.

Color toning is most effective when it fits the subject matter or mood of the photograph, **Figure A-21**. Blue toning imparts a rather cold feeling, while sepia toning conveys an old-fashioned or antique appearance.

Toning can be selectively applied to only certain areas of a print by using rubber cement or artist's liquid frisket to create a mask. When the

Jack Klasey/Goodheart-Willcox Publisher

Figure A-21. Color toning. A—The coldness of this snow scene is strengthened by the blue tone. B—Sepia toner or brown toning works well with weathered wood.

Jack Klasey/Goodheart-Willcox Publisher

Figure A-20. Carefully applying small amounts of the bleach helps to control the process.

print is immersed in the toner, the mask prevents the solution from acting on the areas it covers. After washing and drying the toned print, strip off the masking material to reveal the untoned areas, **Figure A-22**.

Jack Klasey/Goodheart-Willcox Publisher

Figure A-22. Careful masking permits toning just a portion of a print. The toner changes the print color in all the unmasked parts of the image.

When performing toning work, pay special attention to ventilation and to avoiding contact with the solutions. Many toning chemicals produce gases with unpleasant odors; these gases are potentially dangerous in a confined space without sufficient ventilation. Some toning materials, especially selenium, can be toxic if absorbed through the skin. Always wear rubber gloves or use tongs to handle prints while toning. Wear goggles or safety glasses with side shields to protect the eyes against splashes. Since toning solutions stain clothing, a plastic or rubber apron is recommended.

Technical Vocabulary

A

abstractionism: A school of photographic thought that places strong emphasis on forms and their relationships. (1)

accent light: A light positioned behind and to one side of a portrait subject for dramatic effect or to help separate a dark-haired subject from the background. Also called *rim light* or *hair light*. (14)

acid stop bath: Acidic solution that neutralizes and halts the action of a film or paper developer. (19)

active autofocus: Focusing system in which a beam of infrared light is emitted to bounce off the subject. The system times the interval between the departing and returning burst of light, calculates the distance, and focuses the camera to that distance. (5)

active layer: The layer to which changes are made. (16)

additive color process: Color-reproduction method used with transmitted light, such as on television screens or computer monitors. Red, blue, and green wavelengths of light interact to create all other colors. (7)

adjustment layers: Special-purpose layers that allow changes to be made to an image's appearance without permanently altering the original image pixels. (16)

Adobe RGB: Color space developed by the manufacturer of Photoshop and other graphics software. (2)

advanced compact digital cameras: Cameras with many of the same features as SLR cameras, except for interchangeable lenses. Cameras in this category have extended zoom ranges and often include image stabilization to counteract camera shake.

agitation: Regular cycle of movement of a processing tray or developing tank to set up an ebb and flow of solution over the print or film. (19)

ambient lighting: Lighting that already exists in a scene or space, without any additions being made. It can be from natural sources, artificial sources, or a mixture of the two. (10)

ambrotype: A glass negative placed over a black backing material that changed the appearance of the negative into a positive so it resembled a daguerreotype. (4)

analog signal: A continuous signal in which the electrical charges vary in strength. (8)

anchor points: Control points set by clicking the mouse while making a selection using the **Pen** tool. (17)

antihalation layer: The bottommost layer of film, located on the back side of the base. This layer prevents light rays from being reflected back through the base and emulsion. (8)

aperture: The size of the opening through which light passes to expose the film inside the camera. (7)

aperture priority: Exposure mode in which the photographer selects the aperture setting, and the camera sets a shutter speed based on its meter reading. (2)

APS-C size sensor: Image receiver approximately 24 mm × 16 mm in size, widely used in digital cameras. (5)

archival processing: Fixing and washing procedures typically used for photographic prints on FB paper to ensure that the print will last for hundreds of years without deteriorating. (19)

archival quality: Term applied to photographic prints that are processed with the intent of achieving very long life. (18)

archival-quality disc: A CD or DVD made with materials designed to preserve image files for literally hundreds of years. (15)

area array: A grid made up of rows and columns of electronic sensors. (8)

astigmatism: The inability of a lens to bring horizontal and vertical lines in the subject into sharp focus at the same time. (6)

attribution: Providing proper credit to the person who created an image. (15)

Autochrome process: The first practical form of color photography, introduced in 1907. Fine grains of colored potato starch were applied to a plate, and then the plate was coated with an emulsion. After exposure and development, it produced a viewable color image. (4)

B

back focus: The distance from the rear element of the lens to the image receiver. (6)

backlit: Descriptive term for a subject that has most of the light coming from behind it. (7)

backup copy: A duplicate set of image files placed on a CD, DVD, USB drive, or portable hard drive to guard against possible loss of the originals. (13)

ball head: Tripod head that uses a single control to lock the camera in position. (2)

barn doors: Hinged rectangular flaps, attached to the front of a lighting unit, that can be adjusted to physically block a portion of the light being emitted. (14)

barrel distortion: An optical distortion in which a rectangular image has outward-bulging sides. (6)

between-the-lens shutter: Light-control device that is part of the lens assembly. (5)

bit depth: A numeric expression of the number of shades of gray a pixel is capable of displaying. (8)

black point: In scanning, the tone selected as the desired darkest value (0) for the image. (15)

blocked shadows: Underexposed, featureless areas of an image. (10)

bounce flash: A method of softening and diffusing flash light reaching the subject by first bouncing it off a wall, a ceiling, or a piece of white plastic or card stock. (11)

browsing: A function of database programs that allows the user to view a number of small images (thumbnails) on the screen at one time. (15)

buffer: Internal memory in a camera that functions as a holding tank for image information already processed but not yet transferred to the memory card. (8)

buffered: Descriptive term for mounting boards that are made slightly alkaline to counter the long-term effects of weak airborne acids. (18)

built-in flash: Small artificial-light source found in most point-and-shoot and many consumer-level SLR cameras. (11)

burned-out highlights: Overexposed, featureless areas of an image. (10)

burning in: Application of additional exposure to a selected area of an image. This technique is primarily used to darken and bring out detail in midtone and highlight areas. (16)

burst mode: Continuous shooting mode in which the number of possible exposures ranges from two to eight or more per second. (2)

business plan: A document that describes your proposed business in detail and lays out a roadmap for its growth over a period of up to five years. (3)

C

cadmium sulfide cell meter: Light meter using a cell that changes its electrical resistance based on the intensity of light striking it. The increase or decrease changes current flow, which is translated into exposure values shown on a scale or a display. (7)

calibrate: To adjust a device, usually a monitor, so it displays colors accurately and consistently. (18)

calotype: An early version of the negative/positive system that used treated paper as the negative material. (4)

camera: A light-tight box with a closable hole at one side and a light-receptive material on the opposite inside surface. (5)

camera angle: Any of the different points of view that can be used to vary a picture's composition and visual impact. (9)

camera lucida: A tracing aid consisting of a prism mounted on a stand that projects a scene at a right angle onto a piece of paper. (4)

camera obscura: Literally meaning "dark chamber," the camera obscura was an enclosed space with a pinhole opening (later a lens) on one side that projected an image of the scene outside onto a movable screen or wall, where it could be traced onto paper or canvas. (4)

camera phones: Cell phones that include a photographic device. (4)

camera shake: The involuntary movement of the camera during exposure, causing a blurred picture. (5)

candid photos: Informal, unposed photographs, usually with people as the main subjects. (13)

capacitor: The element of an electronic flash that is capable of storing an electrical charge. (11)

card reader: A device used to transfer the contents of a memory card to a computer. (15)

card speed: A measure of how rapidly image files can be transferred from the camera to the memory card. (8)

cataloging programs: Advanced image database programs that allow the use of keywords for locating files by subject, date, or other criteria. (15)

catchlight: A small, bright reflection in a photo subject's eyes, used to add sparkle and liveliness. (12)

cellulose nitrate: An early plastic used as the clear base for early roll films. It was highly flammable and was replaced by the more stable cellulose acetate. Also called *celluloid*. (4)

center of interest: A single element of the photo to which all the other elements of the picture relate and which sends a clear message to the viewer. (9)

center-weighted averaging: Exposure-metering method that gives greater importance (weight) to information from the center of the frame than to information from the edges, and then develops an average reading for the scene. (10)

characteristic curve: An S-shaped graph that serves as a "snapshot" of a given film's reaction to light. It shows the relationship between exposure and density increase. (8)

charge-coupled devices (CCDs): Electronic sensors widely used in the image capture arrays of digital cameras. (8)

chromatic aberration: An optical problem in which different wavelengths (colors) of light focus at slightly different distances behind the lens. (6)

cinematographers: People who record moving images on film. (1)

circles of confusion: Points in front of or behind the plane of focus that appear as small circles on the film and become larger as the distance of the originating point from the plane of focus increases. Size of the circles determines sharpness of the image on the film. (10)

clipping: Loss of shadows or highlights in a digital file, indicated by tall vertical lines at the extreme left or right ends of the histogram. (10)

clipping mask: A blocking method that allows some of the content of a lower layer to be masked out by the upper layer. Often used to create type that is filled by a photographic subject. (17)

close-up range: The lowest range of magnification, from about 1/20 life-size to actual life-size, achieved by the use of lenses alone. (12)

coated papers: Papers used in inkjet printers to produce photographic prints. The coating material resists the spread of ink droplets and enhances the brilliance of the colors. (18)

collodion: A basic emulsion ingredient of the wet-plate process, consisting of cellulose nitrate dissolved in ether and alcohol. A halogen salt such as potassium iodide also is dissolved in the mixture. (4)

color temperature: A measurement of the color of light, expressed in units called degrees Kelvin (K). (7)

colorimeter: Device that reads color values from the monitor screen so the accompanying calibration software can make the necessary adjustments. (18)

coma: A lens aberration that occurs when light rays not parallel to the lens axis create a series of overlapping circles of decreasing size. (6)

commercial photographers: Professional photographers who make all or most of their living from photographic work. (1)

compact digital cameras: Image capture devices small enough to carry in a pocket, usually with zoom lenses and built-in flash. The most common "point-and-shoot" class of digital cameras. (5)

complementary metal oxide semiconductors (CMOS): Electronic sensors used in the image-capture arrays of a growing number of digital cameras. They are less costly to make and consume less power than the more widely used CCD sensors. (8)

composite: An image created by combining part or all of other images. (17)

composition: The arrangement of visual elements, such as shapes, colors, and textures, within the photographic image. (1)

compositional elements: The basic components used for effectively composing photographs. The traditional compositional elements consist of point, line, shape or pattern, balance, emphasis, and contrast. (9)

compressed: Term describing an electronic file that has been "squeezed" to reduce its size. (8)

concave: A lens shape that is curved inward. (6)

condenser enlarger: Photographic enlarger that passes light through a condensing lens to make it directional and focus it on the plane where the negative is held. (19)

conservation board: Type of mat board made with fibers derived from specially processed wood pulp. (18)

contact print: A same-size print made by exposing a negative that is physically laid on top of the photographic paper. (19)

continuous lights: Incandescent, LED, or fluorescent photographic light sources that remain lit, as opposed to the brief burst of light emitted by electronic flash units. (14)

contract: Legal document that specifies the responsibilities of both the photographer and client and spells out every detail of the arrangement. (3)

contrast: The relationship of shadow and highlight within a photo. Also, a noticeable difference between adjacent elements of a composition. (9)

converge: To come together, as in light rays passing through a convex lens. (6)

convergence: A compositional problem in which parts of the image come together in an undesirable way. (9)

convex: A lens shape that is curved outward. (6)

cooling filter: A light blue filter used to make the coloration of a scene a bit less yellow. (7)

copyright: A law that gives the creator of a photograph or other item of intellectual property the exclusive right to use and distribute that property for a specific period of time. (15)

copystand: A device consisting of a vertical column with an adjustable mount for the camera, a flat stage on which the item to be copied is placed, and usually two arms holding lighting units. (15)

corporation: A business in which investors or shareholders purchase ownership in the form of shares of common stock. A board of directors appoints or hires the people who operate the corporation. (3)

countdown timer: Darkroom timing device that is set for the total period, and then counts down to zero. (19)

Creative Commons license: A license that permits the copyright owner to make some or all usage rights to an image available without charge. (18)

creative control: The ability to affect image appearance through choice of shutter speed, aperture, white balance, and other camera settings. (7)

creative effects lens: An accessory lens that permits manipulation of the area of sharp focus in an image. (6)

curvature of field: A failure of light rays to focus at a common point. The projected image is either in focus at the center and out-of-focus at the edges, or vice versa, depending on which focal point is chosen. (6)

D

daguerreotype: The first widely available form of permanent photograph, in which the image was recorded on a silver plate. Each picture was one of a kind—a direct positive image. (4)

database program: Computer software that allows a collection of files (one file for each catalogued image) to be sorted in various ways to locate desired information. (15)

daylight-balanced: The amount of light reflected from a scene that reaches a camera's image receiver. (7)

dedicated flash units: Flashes manufactured for use with a specific camera model or a range of models from one manufacturer. (11)

density: The darkness, or light-blocking ability, of a developed photographic image. (8)

depth of field: The size of the zone of acceptably sharp focus. (10)

depth-of-field preview: A camera feature that allows the photographer to see the scene at the desired aperture and assess the actual depth of field. (9)

developer: A powerful reducing agent that converts silver halides to metallic silver in order to turn a latent image into a visible image. (19)

developing-out paper: A photographic paper that requires the use of a developer to bring out the latent image. (4)

diaphragm: A variable-aperture device (also called an *iris*) that consists of an assembly of thin, overlapping metal blades. (5)

dichroic filter head: A color-printing head for an enlarger that permits the photographer to dial in the desired values of yellow, magenta, and cyan filtration. It also can be used for printing with variable contrast black-and-white paper. (19)

diffusing: Softening the light falling on a subject by placing a translucent material between the light source and the subject. (10)

diffusion enlarger: A type of enlarger that produces a soft, unfocused, nondirectional light by passing it through a frosted diffusing panel or by reflecting it repeatedly off the walls of a mixing chamber. (19)

digital backs: Digital capture devices that can be attached to medium-format or large-format cameras, replacing the film back. (4)

digital noise: Tiny light-colored spots especially noticeable in shadow areas of an image. (7)

digital photography: Image capture method in which the information is recorded electronically as a series of numerical values. (4)

digital resolution: A means of expressing scanner resolution used by some manufacturers for advertising purposes. It is achieved by using software to insert additional pixels around those actually scanned. (15)

digital signal: Image information that is encoded as a series of on/off states (usually represented by 1 and 0) rather than varying continuously. (8)

digital zoom: A camera feature that electronically crops the image to smaller dimensions, making it appear larger but causing the image quality to deteriorate. (6)

direct flash: Aiming the flash "straight on" at the subject from a position directly over or right next to the lens. (11)

distortion: A change in the shape of a rectangular image projected by a lens. (6)

diverge: To be spread apart, as in light rays passing through a concave lens. (6)

documentation: Photography that simply records what the photographer saw—a scene, event, person, or object. (1)

dodging: A technique that involves applying additional processing to a selected area of an image. It is primarily used to lighten and bring out detail. (16)

download: Move files from the original source (camera or memory card) to a computer for storage and processing. (15)

downsampling: Decreasing the dimensions or resolution of an image with the **Resample** box checked. (16)

dry mounting: A process that uses heat and pressure to bond a print to the substrate. (18)

dry plate process: A method of producing a glass plate with a gelatin-based photosensitive emulsion. Unlike the wet-plate collodion process, dry plates could be prepared and stored for months before being exposed, and development could be delayed until convenient. (4)

dry side: Darkroom area that contains the enlarger, counter space for equipment such as the paper trimmer, and storage for photographic paper and other materials and tools that must be kept dry. (19)

dye sublimation printer: Printer containing a print head with many tiny, precisely controlled heating elements. The print head works in conjunction with a wide plastic transfer ribbon carrying solid CMYK dyes. The print head causes the dyes to vaporize (sublimate) and deposit as tiny color spots on specially coated paper. (18)

dynamic range: The ability of a scanner to reproduce detail at the extremes of highlight and shadow (the darkest and brightest areas of the picture). (15)

E

e-commerce capability: Feature of a website that allows clients to view images and order products. (3)

edge mounting: A loose mounting approach in which the photographic print is held by its corners or by hinges made from easily removed acid-free paper tape. (18)

electronic studio flash: The primary source of portable artificial light for photography. A strong electrical charge is built up in a storage device called a capacitor, then released into a gas-filled flash tube, producing a burst of bright light synchronized with the opening of the camera shutter. (14)

electronic viewfinder: Small LCD that shows the image from the camera's sensor. (5)

elements: Convex and concave lenses that are combined to form compound lenses. (6)

elliptical marquee: An image editing tool that allows the user to make a circular or oval selection. (17)

emphasis: A compositional tool used to make some element of a picture stand out and capture the viewer's attention. (9)

entrepreneurship: Starting and operating one's own business. (3)

environmental portraits: Informal portraits made outside the studio setting, usually designed to show the subject in natural surroundings. (14)

equivalent exposures: Different combinations of shutter speed and aperture that are equal in exposure value. (10)

evaluative metering: Metering mode in which light reflected from the scene is read and analyzed using a number of points spread across the field of view. The shadows, highlights, and midtones are evaluated to produce an averaged reading. (10)

exclusion: Selectively framing to eliminate unwanted elements in the photo, sometimes referred to as *cropping in the camera*. (9)

EXIF (Exchangeable Image File Format): A file recorded by the camera at the time of exposure. The file contains the shutter speed, aperture, ISO, lens focal length, and many other properties of the image. (15)

exposure: The amount of light reflected from a scene that reaches the camera's image receiver. (7)

exposure bracketing: Method of exposure in which the scene is shot three times—once at the exposure indicated by the meter, once at a decreased exposure value, and once at an increased exposure value. (10)

exposure compensation: A feature on SLRs and some advanced compact cameras that allows you to increase or decrease exposure while using the shutter priority or aperture priority modes. (10)

extracting: Identifying and pulling out individual images from a larger scene. (9)

F

feathering: Adjusting the light source so the less intense outer edges of the light cone illuminate the subject. (14)

ferrotype: Formal name for the tintype process, in which a wet collodion emulsion was applied to a thin iron plate that had been painted with a black or brown enamel. (4)

fiber-base (FB) papers: Photographic printing papers with the emulsion supported by a cellulose-fiber (paper) sheet. (19)

file formats: Different modes of saving image data, such as JPEG or TIFF. (8)

fill flash: Technique in which the flash unit's output is balanced with the ambient light in order to make the lighting of the subject appear natural. (10)

fill light: Studio light used to place supplementary illumination on the subject to soften dark shadows, decreasing the contrast range of the light reflected from the subject. (14)

film grain: Clumps of metallic silver visible on the film or print. (10)

film holder: A light-tight device that rigidly supports the film sheet. It is inserted in a large format camera and opened to permit an exposure to be made. (5)

film loader: A light-tight device that holds a roll of bulk film and allows a desired number of frames of film to be wound into a cassette. (8)

film speed: A film's sensitivity to light. (8)

filter decals: Method of color filtering for area arrays in which transparent color overlays are applied in a checkerboard pattern over individual sensors in a CCD or CMOS array. (8)

filters: Special features that can be applied to images to change aspects of their appearance. Some make only minor alterations; others perform radical change. (17)

firmware: The built-in program found in a digital camera or similar device. (8)

first generation: Original film images (negatives or transparencies). (15)

fish-eye lens: A lens with an angle of view greater than 180°, which produces a round image with considerable spherical distortion. (6)

fixer: A powerful silver solvent. It dissolves the unexposed silver halide particles and allows them to be washed away, making the developed image permanent. (19)

fixing: The chemical process of treating a developed photographic image to prevent further darkening of the silver by exposure to light. (4)

flags: Shapes cut from black poster board or stiff black paper and attached to light stands or other fixtures to block light (for example, to shade the camera lens). (14)

flare: The effect of stray light bouncing around inside the lens housing, causing decreased contrast or even a severe washed out appearance that mimics overexposure. (12)

flush mount: Type of mount in which the photo extends to the edge of the mount, with no border. (18)

foam board: Mounting material made with a paper facing on a rigid core of plastic foam. (18)

focal length: The distance from the optical center of a lens to the point where the light rays converge (the image receiver plane) when the lens is focused at infinity. (6)

focal plane shutter: Light-control device located in the camera body, just in front of the film. (5)

focal point: The common point at which converging light rays meet. (6)

focusing mark: A short line or a dot on a manual focus lens that is used to determine the distance from the camera to the subject. Numbers on a distance scale align with the mark to show the distance to the subject being focused on. (10)

focusing rail: A tripod-mounted accessory that permits the camera to be moved toward or away from the subject in tiny increments with a fine-toothed rack-and-pinion gearing set. (12)

follow focus: A technique in which the photographer makes continuous small adjustments to keep a moving object sharp so the shutter can be pressed at any time. (11)

formal balance: A composition that consists of matched halves. (9)

formal studio portrait: The traditional style of individual or family portrait, made in a studio setting. (14)

frame: The working space within which the picture is composed. (9)

freelancers: Self-employed photographers, especially those without a physical studio, who actively seek business from many sources and take on various types of photographic assignments. (1)

frequency: A measure of the number of electromagnetic waves (cycles) passing a given point in one second. (7)

front-focusing: A telephoto lens design in which the point where the distance to the focal plane is measured has been moved forward into the space in front of the first lens element group. (6)

f-stop: The number (5.6, 8, 11, 16, and so on) used to designate a lens aperture. An f-stop can be thought of as a fraction: f/8 is an aperture 1/8 the focal length of the lens. (7)

full-frame: Term describing digital camera sensors that are 24 mm × 36 mm, corresponding to the 35 mm film frame. (8)

G

giclée: A French term (meaning spray or squirt) adopted in the early 1990s by fine-art photographers to characterize the prints they were producing on high-quality commercial inkjet printers. (18)

gobo: A generic term for any light-control device or material (such as textured glass or a colored gel) that "goes between" the light and the area where the light is intended to fall. (14)

grain focuser: A critical focusing device placed on the enlarging easel. A small section of the image is reflected from the focuser's mirror to a magnifying eyepiece. (19)

graphics tablet: A pointing and selection device used with a pen. It is capable of more precise control than a mouse when drawing or when retouching fine details. (16)

gray levels: The distinct steps between pure white and pure black. (8)

grayscale mode: A mode in which all picture information is conveyed by up to 256 shades of gray. (16)

grid: Light modifier with square or hexagonal openings that align the rays of light so they are more ordered and parallel. The grid adds sparkle to a scene through increased contrast. (14)

guide number: A manufacturer-supplied number based on the light output of the flash and the ISO rating of the film, used to manually determine lens aperture for proper exposure. (11)

H

hair light: In portrait photography, a light positioned behind and to one side of the subject for dramatic effect or to help separate a dark-haired subject from the background. Also called *rim light* or *accent light*. (14)

handles: Control points on the **Pen** tool that can be used to curve the line segment, allowing the selection of curved shapes. (17)

hard light: Light cast on the subject directly from a small source, resulting in dark, well-defined shadows. (14)

hard news: Photojournalistic assignments such as fires, auto or industrial accidents, or public event coverage. (11)

high key: Term describing a photograph in which shades of white or light tones predominate. (10)

high-voltage power pack: Belt-mounted power supply for flash units that uses special rechargeable batteries. Such units are used by event photographers who shoot large numbers of flash exposures. (11)

histogram: Bar graph showing all of the tonal values of an image. (2)

hot shoe: Flash mounting terminal often located on top of an SLR. Its electrical contacts mate with those on the flash unit, triggering the flash when the shutter release is pressed. (11)

hyperfocal distance: The nearest point that will be in sharp focus when the lens is focused on infinity. This distance is different for each f-stop and each focal length. If the lens is set to the hyperfocal distance, focus will be sharp from one-half that distance to infinity. (10)

I

image editor: A software application considered the indispensable tool for either image processing or image manipulation. (16)

image file: An individual digital image that can be stored, transferred, or manipulated. (8)

image management: The process of using a filing method or cataloging system that allows a user to quickly locate a desired image. (15)

image manipulation: Changes to an image that are more extreme than those done in image processing. These changes include distortion, removal of particular elements from the photo, combining of elements from one or more other sources, or radical changes of color and tone. (16)

image processing: Changes to images such as adjustment of exposure, color and contrast, cropping the image, and dodging and burning. (16)

image receiver system: Camera component designed to place a light-sensitive medium at the point where light rays converge after passing through the lens. Depending on the camera type, it consists of either film and the means to hold it in place or a digital sensor and related electronic circuits. (5)

inclusion: Deciding what to include in the frame. (9)

informal balance: A compositional method that provides a feeling of visual balance, but not the mirror image effect of formal balance. (9)

infringement: Violation of the copyright law by using or distributing a work without permission of the copyright owner. (15)

inkjet printer: Output device that produces documents ranging from letters to photo-quality images by depositing a fine spray of tiny ink dots on paper. (18)

instant-print film: Film containing chemicals that develop it immediately after it is exposed. (8)

integral tri-pack film: The common form of subtractive color film, consisting of three separate emulsion layers. One is sensitive to blue light, another to red light, and the third to green light. (8)

intellectual property: A one-of-a-kind work, such as an artistic or musical work, that is protected by law. (3)

internship: Working in a business as part of an educational program for academic credit. (3)

interpolation: In scanning or image-editing applications, the creation of new image pixels by averaging the values of the surrounding existing pixels. (16)

inverse-square law: Scientific formula for calculating the amount of light falloff that states that the illumination provided by a point source of light varies inversely as the square of the distance from the source. (14)

inversion tanks: Film processing containers that are physically turned upside down at intervals to agitate the chemicals. (19)

ions: Atoms carrying a positive or negative electrical charge. (8)

ISO rating: A numerical designation indicating the light sensitivity of film, with higher numbers indicating greater sensitivity. The system has been adapted for use with digital cameras. (7)

J

JPEG: The most common compressed file format, developed by the Joint Photographic Experts Group. It can be used to reduce file size by a small or large amount. (8)

K

key light: In studio photography, the unit that provides the primary illumination of the subject. Also called the *main light*. (14)

keyword: Specific descriptive word assigned to an image in a database that allows a user to search for that image. (15)

L

landscape mode: Image format that is wider than it is tall—a horizontal rectangle. (9)

landscape photography: Views of the natural world in any of its aspects. Most views feature the vegetable and mineral kingdoms (plants and rocks), but the animal kingdom also may be represented as a part of a scene. (12)

large format cameras: Cameras used to expose individual sheets of film, most commonly in 4″ × 5″ or 8″ × 10″ sizes. (5)

large-format inkjet printers: Devices used to print images for murals, banners, and other large displays. (18)

latent image: A photographic image that does not become visible until developing chemicals are used to bring it out and make it permanent. (4)

layer mask: A method used to protect a portion of the image from change, often used with adjustment layers. (17)

LCD (liquid crystal display) screen: A small viewing screen on the back side of a digital camera that allows review of each image immediately after it is exposed. (2)

leading lines: Pictorial elements that draw the viewer's eye from one area of the photo to another. (9)

lens collar: A support method used on long telephoto lenses to prevent strain on the lens mount. (11)

light: A form of electromagnetic radiation, or radiant energy, that is visible to the human eye. (7)

lighting ratio: A numeric expression of the relationship between the illumination of highlight and shadow areas of the subject's face. It expresses the relative intensities of the key and fill lighting. (14)

light trap: Baffled opening that allows processing chemicals to be poured into and out of the developing tank without exposing the film to light. (19)

line: Compositional element that typically draws the viewer's eye along its length, making it a useful tool for directing attention. (9)

low key: Term describing a photograph containing mostly dark tones. (10)

luminances: Percentages of reflected light. (7)

M

macro: Shortened form of macro-focusing lens, usually applied to a lens that can focus more closely than a typical lens of the same focal length. (6)

macro photo range: Term used to describe photography in which the film image is as large or larger (even much larger) than the actual object. (12)

magnification rate: A method of expressing the size relationship between the actual object and its recorded image. An example is 2×, or "two times life size."

manual exposure: Exposure mode that provides the greatest degree of control. The photographer chooses the aperture, shutter speed, and ISO. (2)

marketing: Everything a business person does to acquire customers and establish an ongoing relationship with them. (3)

mat board: Mounting material composed of two or more layers of cellulose fiber. (18)

medium format cameras: Descriptive term for a type of camera that uses 2 1/4″ wide (120-size) roll film. Medium format cameras produce negatives in one or more of four different formats: 6 cm × 4.5 cm, 6 cm × 6 cm, 6 cm × 7 cm, or 6 cm × 9 cm. (5)

medium format digital cameras: Digital cameras equipped with sensors similar in size to the frame of 120-size film. (5)

memory card: A digital storage device used in cameras. (8)

meniscus lens: The first lens developed specifically as a camera lens. It eliminated much of the distortion that was a problem with the biconvex lens. (6)

metadata: Information on exposure and camera controls recorded at the time an image is exposed. (15)

metamerism: A color shift that is noticeable when a print is viewed under different lighting conditions, such as tungsten and daylight. (18)

metering modes: Different methods, such as evaluative or center-weighted, used by a camera to automatically calculate exposure. (10)

middle gray: An exposure value equivalent to a tone that reflects 18% of the light that falls on it. (7)

mirror image: A reflection in water that is an almost exact reproduction, in reverse, of a scene. (12)

mirrorless cameras: Interchangeable-lens cameras that are smaller and lighter than traditional SLR interchangeable lens cameras, since they do away with the mirror assembly and pentaprism. (5)

monochrome: Single-color, usually black-and-white. (16)

monolights: Independent studio flash units that combine the flash head and power supply. (14)

monopod: A one-legged device that combines improved camera support with good mobility, especially when using telephoto lenses. (2)

museum board: Acid-free archival mounting board made with fibers from cotton. (18)

N

nanometer: The unit of measure for wavelength, which is equal to one-billionth of a meter (0.000000001 m = 1 nm). (7)

nature photography: Photography that encompasses both landscape and wildlife photographs. Also called *outdoor photography*. (12)

negative space: The area within the frame surrounding the subject. This area can isolate and emphasize the subject. (9)

negative/positive film: A popular form of film that produces a negative original. The negative is then used to make a positive print. (8)

negative/positive system: The basis of chemical-based photographic printing, in which the original is a negative (reversed) image that can be used to print any number of duplicate positive images. (4)

nodal point: The optical center of a lens. This is the point inside the lens barrel where the incoming light rays converge and turn the image upside down. (12)

noninversion tanks: Film processing containers that are intended to remain upright. Most are agitated by inserting a thermometer or other device into the hub of the developing reel and rotating it. (19)

O

off-camera flash: Removing the flash unit from the hot shoe and positioning it above and to one side of the camera to eliminate red eye, eyeglass reflections, and some shadow problems. (11)

online gallery: Internet site for photo display, often maintained by organizations or schools. (18)

online photofinishing sites: Internet sites that offer low-cost printing from uploaded digital files. Prints from those files are returned by mail. (15)

open flash: Technique in which the camera's shutter is held wide open and the flash triggered manually one or more times. (11)

optical resolution: The actual pixels per inch resolution provided by a scanner. (15)

optical zoom: System that moves the lens elements to change the angle of view, and thus, image size, without affecting the quality of the image. (6)

outdoor photography: Photography that encompasses both landscape and wildlife photographs. Also called *nature photography*. (12)

oversharpening: Applying a sharpening filter at too high an intensity, giving the image an unattractive, harsh, blotchy appearance. (16)

oxidation: A chemical change in a solution as a result of exposure to oxygen in the air. (19)

P

pack-and-head system: Traditional studio flash system with a central power pack connected to separate flash heads. (14)

painting with light: A flash technique used in large, dimly lighted spaces or for exterior photos taken at night. The camera shutter is held open, and the flash is moved around to illuminate different sections of the subject. (11)

panning: Moving the camera along with an object crossing the field of view, conveying speed and movement by streaking the background behind a sharply focused moving subject. (9)

panorama: A horizontal or vertical image composed from a number of overlapping individual images. Specialized stitching software seamlessly blends the images. (12)

paper safe: A light-tight box used for storage of unexposed photo paper in a darkroom. (19)

parallax error: A mismatch in what the photographer sees through the viewfinder and what the camera's taking lens sees. The slight difference can result in cutting off part of a subject. (5)

partial metering: A metering mode that reads information from a small area (usually about 10%) in the center of the frame. (10)

partnership: Two or more individuals who have joined together to operate a business. (3)

passive autofocus: A focusing system that evaluates incoming light and makes focusing adjustments automatically. (5)

path: A line or closed figure, defined with the image editor's **Pen** tool, which can then be edited and altered as necessary. A closed figure can be converted to a selection. (17)

pattern: A compositional element made by multiple objects, consisting of repetition of identical shapes or elements alternating or varying in either shape or size. (9)

peak of action: The instant when motion dramatically slows almost to a stop. (11)

permissible circle of confusion: The largest diameter circle that is seen as a point and thus appears to be sharp at normal print-viewing distance. (10)

pH: A scale that is used to determine acid/alkaline balance. (18)

photoflood: A bulb similar in appearance to standard bulbs but constructed for high light output. (14)

photogram: A stencil-like photographic image created by placing opaque objects on treated paper that is then exposed to light. (4)

photographic assistant: Person who aids a photographer with a variety of tasks in the studio and on location. (3)

photographic daylight: Light produced by the midday sun on a clear and cloudless day, with a color temperature of 5500 K. (7)

photojournalism: Specialized field of photography devoted to capturing images of news events and similar subjects for use in newspapers, magazines, or other print and electronic media. (11)

photojournalists: Photographers who produce still pictures or video for use in newspapers, magazines, and electronic media. (1)

photomicrography: A highly specialized field in which a microscope is used to achieve extremely high magnifications. (12)

photo-sharing sites: Internet sites that allow a photographer to post albums of pictures for viewing by family members and friends. (15)

picture story: A group of feature-type photos that carry out a theme. In purest form, the photos and their accompanying captions "tell the tale."

pigment-based inks: A medium used in inkjet printers that is composed of very fine particles of solid color pigment suspended in a liquid vehicle. (18)

pincushion distortion: An optical distortion in which a rectangular image has sides that are pushed inward. (6)

pixel: Abbreviation of the term picture element. Digital cameras are often classified by the number of picture elements contained in their CCD array. (5)

plane of focus: The single plane of a scene that technically can be in sharp focus. Parts of the scene closer to or further from the camera are progressively more out of focus. (10)

point: Compositional element that is a single object, typically small in size, that attracts the eye. It may serve as the center of interest or focal point or it may be a distraction. (9)

polarizing filter: A photographic filter used to deepen the color of a blue sky, improve the color saturation of natural objects by reducing glare, and reduce or eliminate reflections from glass, water, and similar surfaces. (7)

Polaroid process: Process that developed a picture one minute after exposure by incorporating a small packet of chemicals in each sheet of film. After exposure, the sheet passed through a set of rollers while being ejected from the camera. Roller pressure broke open the packet of chemicals and spread the mixture evenly over the film surface. After the photo developed, a cover sheet was peeled off the film to reveal the finished photograph. (4)

portfolio: A book or binder displaying a photographer's best work; used to display the photographer's skills and abilities to potential clients or employers. (1)

portrait mode: Image format that is taller than it is wide—a vertical rectangle. (9)

portraiture: Photographs of individuals or groups. (1)

prefocusing: Focusing on a specific spot and waiting for the subject to reach that point. (11)

pressure-sensitive adhesive material: Sheets or rolls coated with a sticky material that is activated by applying pressure with a squeegee or roller. (18)

preview image: Display that shows an image as it would be scanned. It allows the user to determine any changes needed, such as cropping, contrast adjustment, and color correction. (15)

print positioner: T-shaped guide used to position a print in the optical center of a mounting board. (18)

printer: An electromechanical device that translates digital data into tiny dots of color to simulate the appearance of a continuous-tone photographic print. (18)

printing easel: Device used to hold the printing paper flat and in the desired position during exposure. (19)

printing-out paper: A photographic paper on which the image appears without the use of a developer. (4)

printing-out process: Photographic method in which the image appears on the paper without the use of a developer. (19)

profile: A program that tells a printer how to handle a particular paper so the final print accurately reproduces the color values of the image file. (18)

profit: The amount of money left after paying all the expenses. (3)

Program AE: Exposure mode in which the camera's processor selects exposure settings based on the meter reading, but the photographer can change either the shutter speed or aperture. (2)

projection print: Enlarged version of a photographic negative, made by projecting the image through an enlarger lens onto the photographic paper. (19)

proper exposure: Exposure that results in a photo that displays a full range of tonal values from shadows through midtones to highlights without featureless burned-out highlights or blocked shadows. (10)

prosumer: Marketing term used to identify cameras that bridge the gap between amateur and professional equipment. (4)

public domain: Term used to describe images that are not covered by copyright and are thus available for free use by anyone. (15)

pull processing: Intentional underdevelopment of film, usually done in situations where the film has been overexposed by one or more stops. (19)

push processing: Rating a film at a higher speed to permit shooting in low-light conditions, then adjusting development to compensate for the underexposure. (19)

Q

quad-tone ink set: A set of inks used with a dedicated inkjet printer for black-and-white reproduction. These ink sets consist of black and three grays rather than CMYK. (18)

R

RAW: File that contains the basic image information captured by the camera's sensor and is saved with minimal processing. (8)

RAW converter: Software that allows the photographer to make a number of adjustments to the file data before saving the image as a .tif or .psd file. (16)

rear-curtain synchronization: A camera feature that delays the firing of the flash until the instant before the second curtain of the focal plane shutter begins to close. This places the "ghost image" behind the moving subject for a more natural appearance. (11)

reciprocity law: A description of the relationship of light intensity and time on exposure. (7)

recreational travel: Journeys made for leisure, rather than business. (13)

rectangular marquee: In an image-editing program, a selection tool that is often used to crop an image. (17)

recycle: Process of rebuilding the electrical charge in a flash unit's capacitor. (11)

red eye: Problem that is caused by the light of the flash reflecting back from the retina of the subject's eye. (11)

refraction: The bending of light rays that takes place in a lens because of the differing densities of glass and air. (6)

relative motion: A combination of the speed at which a subject is moving and the direction of movement in relation to the camera. (11)

release paper: A silicone-coated material to which adhesive does not bond, preventing mounting tissue from sticking to a tacking iron. (18)

replenisher: Concentrated solution periodically added to a prepared developer to maintain normal strength (and thus, developing times). (19)

reproduction ratio: A numeric expression of size relationships, such as 1:4. The numeral before the colon represents the reproduction size, or the size on film. The number after the colon represents the size of the actual object. (6)

resin-coated (RC) papers: Photographic printing papers to which a thin layer of plastic material is applied on both sides of the paper substrate, permitting shorter washing and drying times. (19)

retrofocus: A type of wide-angle lens design that combines negative and positive lens elements to "stretch" the light path within the lens. This provides sufficient back focus for mirror clearance while maintaining the focal length of the lens. (6)

reversal film: A color film that results in a reversed or positive final image (transparency or slide). (8)

reversing ring: An accessory with filter-mounting threads on one side and a lens mount on the other, allowing a lens to be mounted backward for greater magnification. (12)

rhythm: A compositional element that consists of repeated shapes or lines that move the eye through the frame. (9)

rights-managed images: Stock photos for which a fee is charged for each use, such as different editions of a book or different packaging for a family of products. (15)

rim light: In portrait photography, a light positioned behind and to one side of the subject for dramatic effect or to help separate a dark-haired subject from the background. Also called *accent light* or *hair light*. (14)

ringaround: Panel of nine developed negatives or prints of the same subject showing all possible combinations of exposure and development. (19)

royalty: A percentage of the sale price paid to the author of a book, photograph, or other intellectual property by the publisher or stock photo agency. (15)

royalty-free image collections: Groups of photos based on specific themes (business, medicine, etc.) that are packaged on CDs and sold outright to the end-user. (15)

rule of thirds: A compositional device that divides the frame into thirds, both horizontally and vertically. The four intersections created by the crossing lines are considered the most effective spots to position the center of interest. (9)

S

safelight: Dim amber-colored darkroom light that does not expose and fog black-and-white photographic paper. (19)

scanners: Mechanical/optical devices used to convert transparencies, negatives, or prints into digital form. (15)

search engine: Program used to locate information or specific sites on the Internet. (13)

selection tools: In an image editing program, various methods that can be used to choose one element or portion of an image. Once selected, that element is isolated so it can be manipulated. (17)

selective focus: A technique that uses a shallow depth of field to throw the background out of focus, drawing attention to the main subject. (9)

self-contained flash units: Flash units available in a variety of sizes and types, either for mounting on the camera's hot shoe or on a separate bracket. (11)

self-contained system: A studio flash, often called a *monolight*, which consists of a flash tube and power supply combined into a single housing. (14)

sensitivity specks: Impurities believed to play the important role of focal points or sites for the formation of the silver clumps making up the latent (undeveloped) photographic image. (8)

sensor: An array of light-sensitive picture elements that serves as the image receiver in digital cameras. (5)

separate viewfinder: A viewing window used on simple cameras, rangefinder models, and twin-lens reflex (TLR) cameras, that does not present a "through the lens" view of the subject. (5)

shape: An individual object that is a strong compositional element. (9)

sharpening: In image editing, use of a built-in filter that enhances edge contrast to make an image appear more sharply focused. Intensity of the effect is adjustable. (16)

shortcut keys: Individual keys or combination of keys used to perform an operation as an alternative to a mouse and menu. (16)

shutter: Device that opens and closes to control the flow of light to the film. (7)

shutter lag: A delay between pressing the shutter button and the actual opening of the shutter. (2)

shutter priority: Exposure mode in which the photographer selects the shutter speed, and the camera chooses an aperture based on its meter reading. (2)

sidelighted: Description of a subject lighted strongly from one side. Such lighting often exhibits strong contrast between the lighted and shadowed side. (10)

slave units: Flash units containing a photoelectric cell that responds to the bright burst of light from a master flash that is connected to the camera. The burst of light causes the flash to fire instantaneously. (11)

small format cameras: Cameras that use films in 35 mm size or smaller. (5)

snoot: A tubular light modifier attached to a light source to direct a spot of intense light at the desired area of the subject. (14)

soft light: Light cast on the subject from a large, diffused light source, resulting in shadows that are light and less well-defined. (14)

soft news: Feature-type photo assignments, such as seasonal pictures, fashion shots, food shots, and human interest photos. (11)

softbox: A large source of diffused light that consists of several lamps or electronic flash units mounted inside a reflective housing and covered with translucent material. (14)

sole proprietor: A person who owns an unincorporated business by himself or herself. (3)

solid-state: Term describing a device, such as a memory card, that has no moving parts. (8)

solutions: Liquid or powdered chemicals dissolved in water. (19)

specular reflections: Bright points of light bounced back from smooth polished surfaces. The rays are reflected in an orderly and concentrated manner. (7)

spherical aberration: Optical problem in which the light rays entering the outer edges of a lens are bent more sharply than those entering closer to the center. The result is an overall softness of focus or fuzziness of the image. (6)

spot metering: A metering mode that reads information from a small area of the frame. (10)

spotting: In conventional darkroom work, the process of repairing small white dust spots or scratches on a print using dye solutions and a very fine-pointed brush. (19)

sRGB: Color space (standard Red, Green, Blue) that was defined by the computer industry for consistent display of colors on monitors. (2)

stabilizing systems: Methods used to control "camera shake" that causes blurry photos. Some stabilizing systems are specific to camera bodies, others to interchangeable lenses. (2)

stock solution: Concentrated chemical prepared by mixing a powder or liquid with water. It is further diluted to form a working solution. (19)

subbing layer: A very thin coating of pure gelatin that helps bond the emulsion to the base in black-and-white film. (8)

subject blur: Out-of-focus condition that occurs when a subject is moving too fast for the selected shutter speed to stop its motion. (5)

subject brightness range (SBR): Luminances present in the scene, from brightest to darkest, expressed in stops. (7)

sublimate: Change state from solid to gas without an intermediate liquid state. (18)

subtractive color process: Color reproduction method used with reflected light, in which the subtractive primaries (cyan, magenta, and yellow) subtract or block specific colors from the white light that is used to view the image. Cyan absorbs red light and passes blue and green; magenta absorbs green and passes blue and red; yellow absorbs blue and passes red and green. (7)

supercoat: The very thin, tough topmost layer of black-and-white film. Its primary purpose is to protect the emulsion from abrasion during exposure and processing. (8)

superzooms: Advanced compact cameras with zoom ranges from very wide angle to very long telephoto. Ranges are as high as 65×. (6)

surge marks: Streaks of uneven development resulting from developer flowing back and forth through the sprocket holes of the film due to excessive agitation. (19)

T

targeted marketing: Marketing aimed at a specific group. (3)

teleconverter: A diverging (negative) lens that is mounted between the camera body and a telephoto lens to increase focal length by 1.4× or 2×. (6)

tenting: A lighting method in which the subject is surrounded by a cone or shell of white translucent paper or plastic, with a small hole cut in one side for the camera lens. Lighting is done from outside the cone, resulting in a very diffuse illumination and elimination of unwanted reflections. (14)

theatrical gel: A thin, transparent sheet of material used to add color to studio lighting. (14)

through-the-lens viewing system: Composing and focusing method in which the viewfinder image is the scene viewed through the camera's taking lens. (5)

thumbnails: Small images displayed in database programs to help the photographer locate a desired file for image-editing. (15)

TIFF: Tagged Image File Format. This file format retains all the image information through the processing steps performed by the camera's computer. (8)

tintype: Process in which a wet collodion emulsion was applied to a thin iron plate that had been painted with a black or brown enamel. Also called *ferrotype*. (4)

travel guides: Books or electronic publications that provide travelers with needed information about places they plan to visit. Some are specifically designed for photographers. (13)

travel photography: A specialization focused on interesting places to visit. (13)

trilinear array: A bar containing three rows of sensors that is moved across the image receiver area, permitting image capture in a single pass. (5)

tripod: Camera support with each leg's length independently adjustable, allowing it to be firmly set in place on almost any kind of terrain. (2)

tungsten-balanced: A film emulsion optimized for the warmer (red/yellow) color temperatures of incandescent lighting. (7)

tungsten-halogen bulb: Small, extremely bright bulb with a higher light output and a longer life than a photoflood bulb. They are sometimes called *quartz lights* because the outer envelope of the bulb is made from quartz rather than glass. (14)

U

ultraviolet (UV) filter: Virtually clear filter that is screwed into place on the front of the lens to protect the front lens element from dust, salt spray, and bumps against hard objects. (2)

upload: Send image files to the Internet. (15)

upsampling: Increasing the dimensions or resolution of an image with the **Resample** box checked. (16)

V

variable contrast paper: Black-and-white printing paper that uses enlarger filters to obtain different degrees of contrast. (19)

videographers: Photographers who record moving images using electronic capture methods. (1)

view camera: A camera that accepts individual sheets of film, uses a ground-glass back for composition and focusing, and offers a variety of mechanical adjustments for control of perspective and depth of field. The camera can be fitted with a scanning back for digital image capture. (5)

viewpoint: Descriptive term for the distance and angle from which the camera (and eventually, the viewer) sees the subject. (9)

visible spectrum: The portion of the electromagnetic spectrum that can be seen by the human eye. It consists of waves with wavelengths ranging from about 400 nm to about 700 nm. (7)

visualization: A technique in which the photographer controls how the final product will appear to the viewer by first seeing that desired final result in his or her own mind. (9)

W

warming filter: A yellowish filter that will absorb some of the blue light, warming the scene. (7)

Waterhouse stops: An aperture-control method, used on some early cameras, that consisted of brass plates, each containing one precisely sized hole. The selected plate was slipped into a slit cut in the lens barrel. (5)

watermarking: Electronic method of embedding copyright information and the owner's identity in a digital file, providing a basis for identifying and prosecuting copyright violators. (15)

wavelength: The distance from the crest of one light wave to the crest of the next. (7)

wet-plate collodion process: Photographic system, introduced in the mid-nineteenth century, in which a glass plate was coated with a liquid emulsion. Exposure and development had to be done while the emulsion was still wet. (4)

wet side: Area of a darkroom that includes the processing sink, chemical storage, and solution mixing equipment. (19)

white balance: A method of adjusting how the camera sees a white object. By making a white object appear white under specific light conditions, all the other colors seen under that lighting will be accurately portrayed. (2)

white balance bracketing: A camera setting that makes one exposure with the selected white balance, one with a warmer color temperature, and one with a cooler color temperature. (10)

white light: Light composed of red, green, and blue wavelengths in approximately equal proportions. (7)

white point: In scanning or image editing, the tone selected as the desired lightest value in the image. (15)

windbreak: A blocking device, such as a piece of cardboard, used by nature photographers to keep a flower or similar subject from being moved by a breeze. (12)

Z

zone focusing: A method of prefocusing on an area, making use of depth of field to provide acceptable sharpness for action within that area. (11)

Zone System: A photographic method designed to produce consistent, predictable results through careful control of exposure, development, and printing. A 10-step scale of image values (tones) from pure black to pure white is used to allow precise description and control. (7)

zooming: Moving the camera's zoom lens in or out during the exposure, usually done to impart a sense of motion to a photo of a stationary subject. (9)

zoom range: Classification of a variable focus lens by the spread from its shortest focal length to its longest focal length, such as 100 mm–300 mm. (6)

Index

35 mm film, developing, 451–456
35 mm film, loading onto developing reel, 452
3-point lighting, 326

A

abstractionism, 10
accent light, 325–326
acid stop bath, 449, 454, 479
action and event photography, 232–257
 blurring for visual interest, 238–239
 categories, 232
 focus techniques, 236–237
 peak of action, 235–236
 photojournalism, 239–251
 stopping motion, 233–235
 working with flash, 251–257
active autofocus, 100–101
active layer, 371
additive color process, 86, 138–139
additive primaries, 377
adjustment layers, 372, 402–403
Adobe RGB, 33–34
advanced compact digital cameras, 109–110
advertising photography, 6
AE lock, 29
AEB control, 216
agitation, 453–454
ambient light, 225–226
 working with, 319–321
ambrotype, 83
American Photographic Artists (APA), 74
American Society of Media Photographers
 (ASMP), 74
analog signal, 166
anchor points, 394
angle of view, 122–123
animal photography, 280–291
 in captive environments, 284–286
 in the wild, 282–284
 pets, 282
antihalation layer, 173–174
aperture, 101, 147–149
 and depth of field, 102, 218
 methods of varying, 102
 relative, 148–149
 size and light transmission, 148

aperture priority, 25
aplanatic lens, 119
apochromatic lens, 120
APS-C size sensor, 107, 167–168
aquarium photography, 312
archival processing, 469
archival quality, 428
archival-quality disc, 357
area array, 165
art, 10
artificial light, 224–227
 mixed with natural light, 226, 321
aspheric lens, 120
astigmatism, 120
attribution, 353–354
Autochrome process, 86
autofocus systems, 28, 100–101
automatic exposure bracketing, 216
automatic white balance, 143, 320
averaged reading, 153–154
AWB. *See* automatic white balance

B

back focus, 126
Background Eraser tool, 397–398
Background layer, 371, 393, 397, 408
backlighting, 224
backlit, 155
backpack, 38–39
backup copy, 299
balance, 15, 192, 194
ball head, 48
barn doors, 328
barrel distortion, 120
Bayer pattern, 167
beanbags, 45
bellows, 288
between-the-lens shutters, 103
bit depth, 166–167
black-and-white film, physical structure, 173
black-and-white prints
 evaluating and improving, 465–469
 finishing, 469–471
 processing, 474–480
Black & White adjustment layer, 381–382, 416
black point, 348

bleaching, 483–484

blending modes, 405–406

blocked shadows, 212

blur, 104, 203, 238–239

blur filter, 146

board. *See* mat board

border, 407–408

bounce card, 256

bounce flash, 254–255

Brightness/Contrast command, 374–376

browsing, 355

buffer, 172

buffered, 432

buildings, photographing, 300, 302

built-in flash, 32–33, 251

built-in meters, 214–215

burning in, 375, 467–469

burned-out highlights, 212

burst mode, 29, 236

business

 building, 64–65

 financing, 63

 finding a niche, 62–63

 full-time, 63

 funding, 63–64

 leading a team, 69–70

 marketing, 64–68

 meeting with clients, 68–69

 operating, 70–73

 paperwork, 72–73

 part-time, 63

 setting up, 59–64

 skills, 12–13

 staffing, 64

 types, 59–61

business plan, 64

C

cadmium sulfide cell meter, 150–151

calibrate, 430

calotype, 82

camera

 body cleaning and maintenance, 36–38

 carrying methods, 39–40

 common controls and features, 24–29

 definition, 98

 dust protection, 35–36

 hand-holding, 40–43

 simple, 108–110

 storage and transportation, 38–39

 support methods, 40–50

 varieties, 108–112

 wet-weather protection, 34–35

camera angle, 201–202

camera body, cleaning and maintenance, 36–38

camera lucida, 80

camera obscura, 80

camera phone, 90

 accessory lenses, 130

camera shake, 104

camera system, 98–112

candid photos, 302

canvas size, 369–370

capacitor, 251

card reader, 343

card speed, 172

careers, 10–13. *See also* business

 preparation, 57

 professional growth, 75

 requirements, 12–13

cartridge film, 106, 179

cassettes, 179

cataloging

 programs, 355–356

 system, 354

catchlight, 280

CCD sensor, 164–166

CD, 350, 354, 357

cellulose nitrate, 85, 173

center of interest, 194, 199

center-weighted averaging, 215

Channel Mixer command, 381–382

characteristic curve, 175–176

charge-coupled devices (CCDs), 164–166

chemicals, 450–451

 mixing, 449–451

 processing, 463

 storing, 450

chromatic aberration, 119–120

cinematographers, 9

circles of confusion, 219

clamping devices, 44–45

clients, working with, 68–69

clipping, 213

clipping mask, 408–409

Clone Stamp tool, 383, 416

close-up diopter, 288

close-up photography, 287–291

close-up range, 287

CMOS sensor, 164–166

coated papers, 427

cold-adhesive mounting, 435–436, 438

collodion, 82–83

color, 377

 adding to monochrome image, 414

 adjusting, 378–380

 correcting, 377–378

Color Balance adjustment layer, 378
color film, physical structure, 173–174
colorimeter, 430
color photography, history of, 86
Color Range command, 396
Color Replacement tool, 379–380
color space, 33–34
color temperature, 137
color wheel, 139
coma, 120
combining images, 399–409
commercial photographers, 10–13
commercial photography, 10–13, 56
	building a business, 65–68
	entering the field, 57–59
	operating a business, 70–73
	setting up a business, 59–64
	working with clients, employees, and
		independent contractors, 68–70
commercial processing, 342–343
compact digital cameras, 108–109
compact disc, 350, 354, 357
CompactFlash (CF) card, 170
complementary colors, 377
complementary metal oxide semiconductors
	(CMOS), 164–166
composite, 207, 399
	creating, 400–406
composition, 15
	considerations, 190–202
	elements of, 191–195
	focusing viewer attention, 200–202
	rule of thirds, 196, 199
compositional elements, 190
compressed file, 170
compression, 32
concave, 118
condenser enlarger, 458
conservation board, 432
contact print, 465
contact printing, 475–476
contact sheet, 474–476
	determining proper exposure, 475–476
continuing education, 73–75
continuous lights, 321
contract, 72
contrast, 195
	altering, 375–377
contrast filters, 141–142
converge, 118
convergence, 196
convex, 118
cooling filter, 146

copying
	flatwork, 351
	slides, 351–352
copyright, 70, 352–353
copystand, 352
corners, 434
corporation, 60–61
countdown timer, 462
Creative Commons licensing, 353–354, 424–426
creative control, 147
creative effects lens, 129–130
cropping, 195, 365–366
Crop tool, 366
curvature of field, 120
Curves adjustment layer, 376–378
Curves tool, 348–349, 375–376, 418
custom white balance, 227

D

Daguerre, Louis Jacques Mandé, 81
daguerreotype, 80–81
damaged photos, restoring, 415–418
darkroom, 458–463
	working in, 463–465
database program, 355–357
daylight-balanced, 140
dedicated flash units, 252–253
density, 175
density/exposure relationship, 176
depth of field, 217, 289–290
	and aperture, 102
	determining, 220–221
	factors controlling, 219–220
	maximizing, 218–219
	reducing with **Lens Blur** filter, 413
depth-of-field preview, 29, 205
derivative work, 352–353
Desaturate command, 380–381
design principles, 15
developer, 449, 464, 479
developing-out paper, 82
diaphragm, 102, 147
dichroic filter head, 458–459
diffused light, 308
diffusing, 224
diffusion, 254
diffusion enlarger, 458
diffusion filter, 146
digital back, 88, 168
digital darkroom, 362–363
	advanced techniques, 391–418
	basics, 361–387
digital imaging process, 165–172

digital noise, 156, 222
digital photography, 87
 history of, 87–90
digital resolution, 345
digital sensor, 106–108
digital signal, 166
digital zoom, 128
direct flash, 253–254
display devices, 426
distortion, 120
diverge, 118
documentation, 7–8
dodging, 375, 467–469
double-exposure filter, 146
double-exposure photo, 205–206
download, 343
downsampling, 368
drum scanners, 350
dry mounting, 436, 439–440
dry-mount press, 436, 440
dry plate process, 84
dry side, 458
dupes, 351
dust protection, 35–36
dust spots, eliminating, 384, 470
DVD, 354, 357
dye sublimation printers, 429–430
dynamic range, 157, 345

E

Eastman, George, 84–85, 173
e-commerce capability, 66
edge mounting, 434–435
electronic studio flash, 322–323
electronic viewfinder, 99
elliptical marquee, 393
emphasis, 15, 194, 270, 272
emulsion, 173–174
enlargers, 458–459
 equipment and accessories, 460–462
entertainment, 9
entrepreneurship, 58–59
environmental portraits, 319
equivalent exposures, 156, 217–223
Eraser tool, 397–399
ethics, 363
 and image manipulation, 392
evaluative metering, 214–215
event photography. *See* action and event
 photography
exclusion, 195
EXIF (Exchangeable Image File Format), 357
exposure, 147
 adjusting local, 375

 adjusting overall, 372–375
 controlling, 147–150
 correcting problems, 215–217
 determining, 214–215
 effect of ISO settings, 222–223
 equivalent, 156, 217–223
 highlights and shadows, 213–214
 local control, 467–469
exposure bracketing, 215–216
exposure compensation, 29, 216–217
exposure modes, 25–27
exposure numbering, 34
extension tubes, 288
extracting images, 196–197
Eyedropper tool, 348

F

fair use, 352
FB papers. *See* fiber-base (FB) papers
feathering, 327
feature photography. *See* soft news
 photography
ferrotype, 83
fiber-base (FB) papers, 464–465
 drying, 463
field camera, 112
file formats, 170
fill flash, 224, 320
fill light, 324, 331–332
film, 105
 black-and-white, 173
 color, 173–174
 drying, 455
 effect of light on, 174–176
 forms of, 179–181
 physical structure, 173–174
 size and grain, 177
 traveling with, 299
 types, forms, and sizes, 177–180
film cassette, 106, 179
 loading, 180–181
film development
 35 mm film, 451–456
 chemicals, 449
 developing steps, 453–455
 development time, 435
 equipment, 448
 mixing chemicals, 449–451
film grain, 222–223
film holder, 105
film loader, 180
film scanners, 349–350
film speed, 150, 176–177

filter decals, 167
filter factor, 146–147
filters, 141–142
 applying in Photoshop, 410–412
 cleaning, 36
 color-changing, 145–146
 controlling color saturation, 143–144
 controlling reflection, 143–144
 diffusion, 146
 image-modifying, 146
 reducing light, 145
 special effects, 145–146
 using for emphasis, 142–143
finishing, 469–471
firmware, 166
first generation, 349–350
fish-eye lenses, 125
fixer, 449, 454, 480
fixing, 81
flags, 328
flare, 121, 266
flash
 techniques, 253–257
 types of units, 251–253
 working with, 251–257
flash meter, 152, 329
flatbed scanner, 344
flatwork, copying, 351
flower photography, 269–272
 environmental guidelines, 274
fluorescent light, 136
flush mounts, 436
f-numbers, 148
foam board, 432
focal length, 121–124
 and depth of field, 220
 and image size, 122–123
focal plane shutters, 103
focal point, 118
focus lock/exposure lock, 29
focusing aid, 100, 461, 478
focusing mark, 220
focusing methods, 99–101
focusing rail, 290
focus techniques, 236–237
follow focus, 236
formal balance, 194
formal studio portrait, 318
Foveon X3 sensor, 167–168
frame, 15, 199
 within a frame, 200
framing, vertical or horizontal, 196
framing viewer, 17

free image sources, 353–354
freelancers, 8, 12
frequency, 136
front-focusing, 126
f-stop, 147
 and depth of field, 220
f-stop system, 147–148
full-frame sensor, 167–168
funding, 63–64
future of photography, 90–91

G

ghost image, 121, 234–235
giclée, 427
glassware, 333
gobo, 328
grain, 177
grain focuser, 461, 478
grand vistas, 262–263
graphics tablet, 364
gray levels, 166
grayscale mode, 380
grid, 326–327
ground glass focusing, 100
guide number, 252

H

hair light, 325–326, 332
hand-holding the camera, 40–43
handle-mount flash units, 253
handles, 394
hard light, 327
hard news, 240
hard news photography, 240–242
haze filter, 36
heated-adhesive mounting, 436
high key, 212
highlights, exposing for, 213–214
high-voltage power pack, 253
hinges, 434–435
histogram, 31, 213, 346, 348, 373–374
history
 of digital photography, 87–90
 of photography, 80–90
horizon, 267
 correcting tilted, 410
hot lights, 321
hot shoe, 252
Hue/Saturation adjustment layer, 378–379
hyperfocal distance, 221–222

I

image capture
 digital, 165–172
 digital vs. film, 164–165
 film, 172–177
image editor, 363–364
image file, 165
 sizes, 169
image input
 commercial processing, 342–343
 copying, 351–352
 downloading to computer, 343–344
 from a camera, 342–343
 scanners, 344–350
image management, 354–357
 database programs, 355–357
 filing/cataloging methods, 354
image manipulation, 362–363
 ethics, 392
image processing, 362–363
image quality settings, 32
image receiver system, 104–108
Image Size dialog, 367–368
image sources, 353–354
image stabilization, 43, 104
image storage, 169–172
image-editing software, 363–364
image-editing window, 364
incandescent light, 136
incident light reading, 151, 153–154
inclusion, 195
income, 70–72
indoor photography, 310–312
informal balance, 194
infrared photography, 274–276
infringement, 352
inkjet printers, 427–429
inks, 428
inputting files. *See* image input
instant-print film, 177, 179
integral tri-pack film, 173–174
intellectual property, 70
Internet, 66–67
 downloading from, 352
internship, 57
interpolation, 369
inverse-square law, 329–330
inversion tanks, 448, 453
invoice, 71, 73
ions, 174
iris, 102
ISO rating, 150

ISO selection, 27
ISO settings, effect on exposure, 222–223

J

JPEG, 170

K

key light, 323–324, 331–333
keywords, 355–356
knifing, 471

L

landscape mode, 196
landscape photography, 262–276
 flowers, 269–272
 insects and flowers, 273–274
 panoramic views, 263–265
 shooting tips, 266–268
 smaller-scale subjects, 268–274
 water, 276–280
large format cameras, 108
large-format inkjet printers, 428
Lasso tool, 393–394
latent image, 81, 174
layer mask, 403–405
layers, 370
 adding, 400–402
 changing opacity of, 401–402
 changing order of, 401
 creating, 371–372
 working with, 370–372
LCD screen, 30–31
 as viewfinder, 99
 cleaning, 36–37
leadership, 69–70
leading lines, 200
lens blur filter, 412–413
lens collar, 241
lens elements, protecting, 36
lenses, 118–130
 aberrations, 118–120
 camera phone accessory, 130
 changing, 35
 cleaning, 36
 coatings, 121
 elements, 118
 focal length, 121–124
 shapes and light, 118
 specialty, 128–130
 speed, 149
 types, 124–130

Library of Congress, 353
light, 136
 absorption and reflection, 137–138
 basic theory, 136–141
 color, 137
 controlling with filters, 141–147
 effect on film, 174–176
 measuring, 150–156, 328–331
 movement, 136
light-control devices, 328
light control system, 101–104
light-emitting diode (LED), 136
light falloff, 329
lighting
 3-point, 326
 ambient, 225–226, 319–321
 for close-up work, 291
 mixed, 226–227, 321
 studio, 321–335
 types, 223–227
lighting ratio, 330–331
light meters, 150–156
 displays, 151
 types of meter readings, 151–152
light reading
 averaged reading, 153–154
 making, 152–156
 metering subjects that are not average, 154–155
 reading the meter, 155–156
light trap, 448
limited liability company, 61–62
line, 192
LLC. *See* limited liability company
lossy, 32, 170
low key, 212
luminances, 157

M

macro lens, 128, 287
macro photo range, 288
Magic Eraser tool, 397, 398
magic hour, 305
Magic Wand tool, 392, 395, 398
Magnetic Lasso tool, 393–394
magnification, 287–289
magnification rate, 287
manual exposure, 26
manual focusing, 99–100
marketing, 64–68
 Internet and social media, 66–67
 methods, 65–68
 personal contact, 67–68
marquee tools, 392

mass marketing, 65
mat board, 431–434
 color, 432–433
 composition, 432
 other substrates, 433–434
 size, 433
 thickness, 432
medium format cameras, 108
medium format digital cameras, 107
memory card, 169, 170–171
 capacities, 171–172
 for travel photography, 298–299
Memory Stick card, 171
meniscus lens, 118
metadata, 357
metamerism, 431
metering modes, 214
Micro Four Thirds sensor, 168
microdrive devices, 171
microprism focusing aid, 100
MicroSD card, 171
middle gray, 154
mirror image, 280
mirrorless camera, 111
mixed lighting, 226–227, 321
model release, 73
monochrome, 380
 adding color to, 414
 converting color to, 380–382
 printing, 428–429
monolight, 323
monopod, 43–44, 241
morphing, 399
motion
 blur, 203, 238–239
 stopping, 233–236
mounting prints, 431–440
 methods, 434–440
 surfaces, 431–434
mounting tissue, 436
multiple exposure, digital, 206–207
multiple flash, 256–257
multiple-image filter, 146
multiple-image printing, 481
multiplier effect, 123–124
museum board, 432

N

nanometer, 136
natural light, 223–224
 mixed with artificial light, 226, 321
naturalistic photography, 10
nature photography, 262

ND filter. *See* neutral-density (ND) filter
neck strap, 39
negative
 cleaning equipment, 462
 discovery of, 82
 reading, 456–458
negative carrier, 460, 476–477
negative/positive film, 177–178
negative/positive system, 82
negative space, 199
neutral-density (ND) filter, 145
news and feature photography, 240–243
niche, 62–63
Niépce, Joseph Nicéphore, 80–81
night photography, 305
nodal point, 265
nonderivative license, 425
noninversion tanks, 448, 454
normal lenses, 125

O

off-camera flash, 254
on-board flash, 32–33
online gallery, 424
online photofinishing sites, 342
onsite camera supports, 45
open flash, 256
optical resolution, 345
optical zoom, 128
organizations, 74–75
outdoor photography, 262–291
 animals, 280–291
 landscapes, 262–280
overmat, cutting, 441–443
oversharpening, 385
oxidation, 450

P

pack-and-head system, 323
painting with light, 256
panchromatic film, 141
pan head, 48
panning, 203, 238–239
panorama, 263–265
panoramic views, 263–265
paper
 selecting for printing, 464–465
 storage, 461–462
paper safe, 461–462
parallax error, 98
partial metering, 215
partnership, 58, 60

part-time business, 63
passive autofocus, 101
path, 394
pattern, 15, 192
peak of action, 235–236
pentaprism, 111
Pen tool, 392, 394–395
people photography, 6–7. *See also* portrait
 photography
people skills, 12
permissible circle of confusion, 219
perspective, 123
pet photography, 282
pH, 432
photographic business. *See* business
photoflood, 321–322
photogram, 80
photographic assistant, 12, 57–58
photographic daylight, 137
photojournalism, 239–245, 248–251
 community events, 245, 248
 family milestones, 248–249
 news and feature photography, 240–243
 school event and yearbook photography,
 243–245
 street photography, 249–251
 types, 240
photojournalists, 8
photomicrography, 288
photo-sharing sites, 343
picture story, 243
pictures within a picture, 196–197
pigment-based inks, 428
pincushion distortion, 120
pinhole camera, 80
pixels, 106, 165, 168
plane of focus, 219
plate-based photography, 82–84
point, 191
polarizing filter, 143–144
Polaroid process, 86–87
Polygon Lasso tool, 394
portfolio, 18
portrait mode, 196
portrait photography, 318–332. *See also* studio
 photography
 lighting situations, 331–332
 types of, 318–319
portraiture, 6–7
prefocusing, 237
preset exposure modes, 26–27
pressure-sensitive adhesive material, 435–436
preview image, 346
printer, 427

dye sublimation, 429–430
inkjet, 427–429
print film, 178
printing easel, 461
printing-out paper, 82
printing paper, 427, 464–465
printing techniques, special, 480–485
print positioner, 439–440
print processing equipment, 462–463
prints
 developing, 479
 drying, 480
 evaluating and improving, 465–469
 finishing, 469–471
 fixing, 480
 making, 426–431, 474–485
 mounting, 431–440
 overmatting, 441–443
 positioning, 436–437, 439–440
 processing, 479–480
 quality, 430–431
 removing defects, 470–471
 spotting, 470–471
 tack mounting tissue to, 439
 tacking to board, 440
 trimming, 439
 types of, 465
 washing, 480
print washer, 462
privacy of subjects, 245
product photography, 6, 318, 325, 333–335
professional growth, 73–75
Professional Photographers of America (PPA), 74–75
profile, 430
profit, 70
Program AE, 25
projection print, 465
projection printing, 476–478
proper exposure, 212–214
prosumer, 89
public domain, 353
pull processing, 456
push processing, 456

Q

quad-tone ink set, 428
Quick Mask, 395, 396–397
Quick Selection tool, 392, 395

R

rangefinder cameras, 110
rangefinder focusing, 100
RAW, 32, 170, 321

RAW converter, 365
RC papers. *See* resin-coated (RC) papers
rear-curtain synchronization, 235
reciprocity failure, 156
reciprocity law, 156
record shots, 232
recreational travel, 296
rectangular marquee, 393
Rectangular Marquee tool, 365–366
recycle, 251
red eye, 253–254
reflected light reading, 151
reflections, 143–144
reflective subjects, 333–334
reflectors, 327
reflex cameras, 110–111
refraction, 118
relative aperture, 148–149
relative motion, 233–235
release paper, 438
removable storage devices, 170–171
repetition, 272
replenisher, 450
reproduction ratio, 129, 287–288
resin-coated (RC) papers, 464–465
 drying, 463, 480
resizing images, 367–369
resolution, 32, 430–431
 changing, 367–369
 scanner, 344–345
restoring damaged photos, 415–418
retrofocus, 126
reveal mat, 441
reversal film, 177
reversed lens, 288–289
reversing ring, 288–289
rhythm, 192
rights-managed images, 354
rim light, 325
ringaround, 456–458
roll film, 105–106, 173, 180
 history of, 84–86
royalty, 354
royalty-free images, 354
rule of thirds, 196, 199

S

Sabattier prints, 482
safelight, 461
scanners, 344–350
 considerations, 345–346
 drum, 350
 dynamic range, 345

film, 349–350
 resolution, 344–345
 software, 346, 348–349
scanning backs, 168–169
school event photography, 243–245
scientific photography, 9
scrap pixels, 399
scratches, eliminating, 384
search engine, 296
second-generation, 350
Secure Digital (SD) card, 170
seeing photographically, 13–14
selections, refining, 396–398
selection tools, 392–396
selective bleaching, 483–484
selective focus, 203, 205, 270
selective framing, 195
self-contained flash units, 251–252
self-contained system, 323
sensitivity specks, 174
sensor, 106–108
 cleaning, 37–38
 sizes, 106–107, 167–168
 types, 106, 164–165
separate viewfinder, 98
shadows, 213–214
shape, 192
share alike license, 425–426
sharpening, 385–387
sheet film, 105, 180
shoe-mount flash unit, 252–254
shortcut keys, 364
shoulder stock, 44
shutter, 102–104, 149
shutter lag, 28, 236
shutter priority, 25–26
shutter release, 28
shutter speed, 104, 149–150
 and motion control, 104
 for stopping movement, 217–218
 hand-holding a camera, 41–43
sidelighted, 224
silver bromide, 174
silver halides, 454, 480
simple cameras, 108–110
single-lens reflex (SLR) camera, 86, 89, 111
 hand-holding, 40–41
skylight filter, 36
slave unit, 257
slides, copying, 351–352
SLR camera. *See* single-lens reflex (SLR)
 camera
small format cameras, 108
smartphone, 90

accessory lenses, 130
snoot, 326
social media, 66–67
soft focus, 203
soft light, 327
soft news, 240
soft news photography, 242–243
softbox, 322
sole proprietorship, 60
solid-state, 170
solutions, 449
specular reflections, 138
spherical aberration, 119
split-prism focusing aid, 100
sports photography, 241–242
Spot Healing Brush tool, 417
spot meter, 152
spot metering, 215
spotting, 382–384, 470–471
sRGB, 33–34
stabilizing systems, 43, 104
star filter, 146
stock photo agencies, 354
stock solution, 450
storage card. *See* memory card
street photography, 232, 249–251
studio cameras, 168–169
studio lighting
 controlling light, 326–328
 lighting methods, 323–326
 measuring light, 328–331
 typical lighting situations, 331–335
 working with, 321–335
studio photography, 318–335
 working with ambient light, 319–321
 working with studio light, 321–335
subbing layer, 173
subject blur, 104
subject brightness range (SBR), 157
subject selection, 14
sublimate, 430
subtractive color process, 86, 139
subtractive primaries, 377
supercoat, 173
superwide lenses, 126
superzooms, 121
surge marks, 454

T

Talbot, William Henry Fox, 82
targeted marketing, 65
team, 69–70
technical photography, 9

teleconverter, 128
telephoto lenses, 126–127
tenting, 333
theatrical gel, 324–325
through-the-lens (TTL) flash system, 252
through-the-lens (TTL) meters, 151, 289
through-the-lens viewing system, 98–99
thumbnails, 355
TIFF, 170
tilt-shift lens, 129
timer, 461, 462
tintype, 83
TLR camera, 110–111
toning, 484–485
transformations, 410–412
travel guides, 297–298
travel photography, 296–313
 equipment, 298–299
 photographing buildings, 300, 302
 photographing people, 302, 304
 researching in advance, 296–298
 shooting indoors, 310–312
 unfavorable conditions, 306, 308, 310–312
 when to shoot, 305–306
trilinear array, 107–108
tripod, 46–50
 advantages and disadvantages, 49
 choosing, 49–50
 components, 46–47
 heads, 47–48
 legs, 47
 using, 50
TTL flash system, 252
TTL meters, 151, 289
tungsten-balanced, 140
tungsten-halogen bulb, 322
twin-lens reflex (TLR) camera, 110–111
type, combining with photos, 408–409

U

ultraviolet (UV) filter, 36
Unsharp Mask filter, 385–387, 418
upload, 342
upsampling, 368

V

variable contrast filter set, 460
variable contrast paper, 465
VC filters, 465
videographers, 9
view camera, 112
viewing/focusing system, 98–101

viewing methods, 98–99
viewpoint, selecting, 189–190
vignette, 408, 482–483
visible spectrum, 136
visualization, 188–189

W

warming filter, 143, 145–146
washing aid, 454
water photography, 276–280
 water in motion, 278, 280
Waterhouse stops, 102
watermarking, 352
wavelength, 136
wedding photography, 249
wet-plate collodion process, 82
wet side, 458
wetting agent, 455
wet-weather protection, 34–35
white balance, 31, 320–321
 and film selection, 140–141
 bracketing, 227
 control, 146
white light, 137
white point, 348
wide-angle lenses, 125
wildlife photography, 282–284
windbreak, 272
window clamp, 44–45
wireless transfer, 344
working copy, 365
working distance, 290–291
workshops, 75

Y

yearbook, 243–245

Z

zone focusing, 237
Zone System, 156–159
 adjusting for highlights, 159
 and digital cameras, 159
 placing an exposure value, 158
 simplified exposure method, 158–159
 ten step scale, 156–157
zooming, 203, 238–239
zoom lens, 127–128
zoom range, 128
zoo photography, 284–286